Neanderthals
in Context

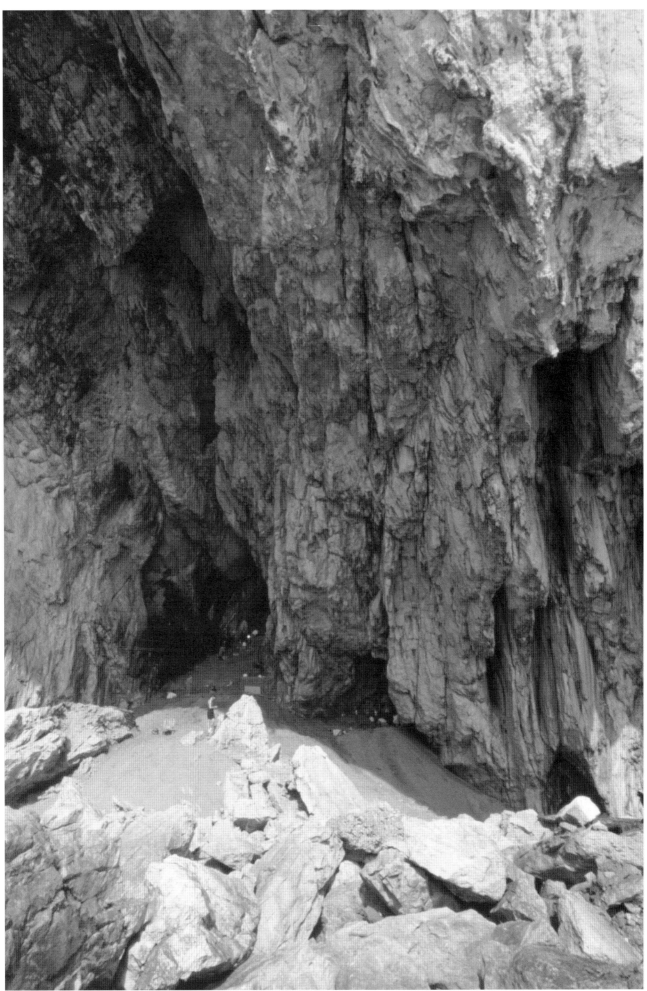

Vanguard Cave under excavation; view of the entrance (copyright NHM).

Neanderthals
in Context

A report of the 1995–1998 excavations at

Gorham's and Vanguard Caves, Gibraltar

Edited by

R. N. E. Barton, C. B. Stringer and J. C. Finlayson

Oxford University School of Archaeology: Monograph 75
Institute of Archaeology, University of Oxford

Copyright © Oxford University School of Archaeology
and individual authors, 2012

Published by the School of Archaeology
36 Beaumont Street, Oxford OX1 2PG

ISBN 978-1-905905-24-9

Designed and produced by Chris Hulin, Oxford Book Projects
Printed by Information Press, Eynsham, Oxford

Contents

Contents

List of Figures

Colour versions of images in these chapters are available
at *www.arch.ox.ac.uk/monographs/gibraltar*

List of Tables

List of Contributors

R. N. E. Barton, Institute of Archaeology, University of Oxford, 36 Beaumont Street, Oxford OX1 2PG, UK.

F. Brock, Research Laboratory for Archaeology and the History of Art (RLAHA), University of Oxford OX1 3QY, UK.

C. Bronk Ramsey, Research Laboratory for Archaeology and the History of Art (RLAHA), University of Oxford OX1 3QY, UK.

I. Cáceres, IPHES/URV. Area de Prehistòria, Universitat Rovira i Virgili, PL. Imperial Tarraco 1, 43005-Tarragona, Spain.

W. Carruthers, Sawmills House, Llantrisant, Mid Glamorgan CF72 8LQ, UK.

S. N. Collcutt, Oxford Archaeological Associates, 1 Divinity Road, Oxford OX4 1LH, UK.

A. P. Currant, Dept. Of Palaeontology, The Natural History Museum, Cromwell Road, London SW7 5BD, UK.

H. Cheney, Research Laboratory for Archaeology and the History of Art (RLAHA), University of Oxford OX1 3QY, UK.

J. H. Cooper, Bird Group, Department of Zoology, The Natural History Museum, Akeman Street, Tring, Hertfordshire, HP23 6AP, UK.

K. Douka, Research Laboratory for Archaeology and the History of Art (RLAHA), University of Oxford OX1 3QY, UK.

Y. Fernández-Jalvo, Museo Nacional de Ciencias Naturales (CSIC), Jose Gutierrez Abascal 2, 28006-Madrid, Spain.

R. Gale, Bachefield House, Kimbolton, Leominster, HR6 0EP, UK.

C. Gleed-Owen, CGO Ecology, 5 Cranbourne House, 12 Knole Road, Bournemouth, Dorset BH1 4DQ, UK.

P. Goldberg, MicroStratigraphy Laboratory, Archaeology – Boston University, 675 Commonwealth Avenue, Boston, MA 02215, USA.

T. F. G. Higham, Research Laboratory for Archaeology and the History of Art (RLAHA), University of Oxford OX1 3QY, UK.

R. P. Jennings, Department of Archaeology, Connolly Building, University College Cork, Cork, Ireland.

R. I. M. Macphail, Institute of Archaeology, University College London, 31-34 Gordon Square, London WC1H 0PY, UK.

C. Price, Institute of Archaeology, University of Oxford, 36 Beaumont Street, Oxford OX1 2PG, UK.

E. J. Rhodes, Department of Earth and Space Sciences, University of California, Los Angeles, CA 90095, USA.

C. B. Stringer, Dept. Of Palaeontology, The Natural History Museum, Cromwell Road, London SW7 5BD, UK.

S. Ward, School of Geography, Centre for the Environment, University of Oxford, South Parks Road, Oxford, OX1 3QY, UK.

Foreword

When I first got behind the scenes at the Natural History Museum in 1967 while an undergraduate student at University College London, I vividly remember getting my first glimpse of the Neanderthal skull from Forbes' Quarry, courtesy of Don Brothwell. It was an exciting moment for a budding palaeoanthropologist, and four years later I measured it as part of my data collection on Neanderthals for my PhD. In 1973 I followed Brothwell into the Museum as a member of staff and have worked there ever since, but the allure of working on the Gibraltar Neanderthal fossils has never worn off for me. As an undergraduate I also took a course on the World Palaeolithic with John Waechter, who showed us pictures and material from his excavations in Gorham's Cave.

For many years I harboured a secret wish to excavate in Gibraltar for further Neanderthal material, and in 1984 I finally began to develop plans for fieldwork there. Five years later I organized a short exploratory excavation of the surviving cave deposits in Gorham's Cave, in collaboration with Jill Cook of the British Museum and the then Director of the Gibraltar Museum, Joaquin Bensusan. Unfortunately that work did not develop into a long-term project, but in the early 1990s Nick Barton (then at Oxford Brookes University) and I began discussions with Bensusan's successor Clive Finlayson, for a new programme of excavations which were to form the core of the multidisciplinary Gibraltar Caves Project. A short season of work at the daunting and high-altitude Ibex Cave in 1994 was followed by four annual seasons of excavations nearer sea level in Gorham's and the neighbouring Vanguard Cave.

This volume describes the results of the excavations conducted between 1995–1998, to recover and date further evidence of the Neanderthal occupation of the region. Excavating the caves properly required a large team of up to 30 excavators and supervisors on site, finds assistants to process material both in Gibraltar and London, site managers/drivers, specialists to run sieving operations, and beyond those, experts in lithics, dating, faunal and floral remains, sedimentology and taphonomy. This volume contains many contributions by these specialists, and others who have worked on the materials subsequently, although it has not been possible to include all of the results of the project here. We were also regularly joined by other Gibraltar Museum staff and associates, local volunteers who willingly worked through their holidays for us, and a group of Spanish archaeologists, whose roles included particular study of sediments at the back of Gorham's Cave. These colleagues have continued their work with Clive Finlayson since 1999. Our excavations have also provided the raw material for a number of Masters and PhD theses by workers such as Joanne Cooper (avifaunas), Richard Jennings (palaeoenvironmental reconstructions), Steven Ward (Late Pleistocene vegetation dynamics), Isabelle Cáceres (taphonomy) and Alison Bell (molluscan evidence).

I would like to particularly thank Nick Barton for his considerable work in pulling this volume together and Clive Finlayson for his involvement and support for the Gibraltar Caves Project over many years, as well as all the participants and collaborators in the project (both on and off-site). We are grateful to the following funding bodies for their support for the project: National Geographic Society, Leakey Foundation, British Academy, Natural History Museum, Society of Antiquaries, NERC, Oxford Brookes University, Oxford University, the Gibraltar Heritage Trust, Gibraltar Earth Sciences and Archaeology Trust, and the Government of Gibraltar. Thanks are also due to the staff of the Oxford Radiocarbon Accelerator Unit for their work in producing AMS radiocarbon dates.

Chris Stringer

Preface and acknowledgements

Compiling and editing this volume has entailed a lengthy gestation process. There are 24 chapters in this monograph, some of which were readied for publication in 2007 while others took much longer to prepare and, allowing for editorial comments and corrections, were completed at the end of 2010. The volume grew out of a multidisciplinary research project with the main excavation occurring in month-long field seasons over four years from 1995 to 1998. Some of the preliminary results of this work appeared in 'Neanderthals on the Edge' (edited by Stringer, Barton and Finlayson 2000) and a companion volume on 'Gibraltar during the Quaternary' (edited by Finlayson, Finlayson and Fa, 2000). The excavations were led by the Natural History Museum and were funded by generous grants from the British Academy, National Geographic Society, Leakey Foundation, Natural History Museum, Society of Antiquaries, NERC, Oxford Brookes University, and Oxford University. The project was in partnership with the Gibraltar Museum who also secured funding for the excavations via the Gibraltar Heritage Trust, Gibraltar Earth Sciences and Archaeology Trust, and the Government of Gibraltar. We would like to thank them and all of the volunteers from Gibraltar, Spain, UK and other areas of the world who worked with us on the excavations of the caves.

The volume is divided into two main sections that focus on the results of excavations at Gorham's and Vanguard Caves. This is preceded by an introduction to the project and there is a final section that reflects on the wider implications of the study of these two major Neanderthal occupation sites. Each cave may be read as an separate site report, with the primary evidence and analysis presented by stratigraphic context and according to the area of specialism. The specialist topics are arranged broadly in the same order for each of the sites to facilitate comparison. Where overlap occurs, for example in presentation of the coprolitic evidence, a single chapter covers the results of both caves. Some of the chapters have grown out of postgraduate theses and the titles of these dissertations are provided below for further reference. In one instance, the initial study of molluscs was not written up as chapter. This will be dealt with as part of another volume being prepared by members of Gibraltar Museum. Inevitably, in editing this monograph, some concessions have had to be made and these include the use of black and white illustrations in place of colour. In cases where colour is important to the interpretation we have compensated by making images available on-line and these can be found on the Oxford University website

(*www.arch.ox.ac.uk/monographs/gibraltar*). In bringing this monograph to its final publication stage, I have relied very heavily on the help of a small group of people who have given unstintingly of their time and assistance. In particular I would like to thank Ian Cartwright and Alison Wilkins of the Institute of Archaeology's Photography and Illustration Unit and to Cath Price and to Lynda Smithson of Oxford University for their eagle-eyed attention to detail in spotting typographical and other mistakes, and for their all round copy-proofing skills. As co-editor, I take full responsibility for any errors that have survived this process. Clive Finlayson would also like to state that not all of the views expressed in this monograph are necessarily shared by himself.

In a rapidly evolving field of scientific endeavour, there are undoubtedly some aspects of work in this monograph that will require updating and development sooner than others. We hope, however, that the data presented here will provide a narrative of the excavation and site archives that others will find relatively easy and useful to follow.

The 1995–1998 project excavations gave rise to a number of postgraduate dissertations and provided raw material for some of the chapters. These include:

Bell, A. 2002: *Climate and environmental evaluation of two Neanderthal-occupied cave sites on Gibraltar, using molluscan evidence.* (Unpublished MSc Dissertation, Reading University).

Cáceres, I. 2002: *Tafonomía de yacimientos antrópicos en Karst. Complejo Galería (Sierra de Atapuerca, Burgos), Vanguard Cave (Gibraltar) y Abric Romaní (Capellades, Barcelona).* (Unpublished Doctoral Thesis, Universitat Rovira i Virgili, Tarragona)

Cooper, J. H. 1999: *Late Pleistocene Avifaunas of Gibraltar and their Palaeoenvironmental Significance.* (Unpublished PhD Thesis, Royal Holloway, University of London).

Jennings, R. P. 2007: *The Human Occupation of Southern Iberia in the Late Pleistocene* (Unpublished DPhil Thesis, Oxford University).

Ward, S. 2007: *Reconstructing Late Pleistocene Vegetation Dynamics from Archaeological Cave Sites in the Western Mediterranean: Links with Climate and Cultural Changes.* (Unpublished DPhil Thesis, Oxford University).

Nick Barton
Oxford, December 2011

Resumen

Gorham's Cave

Estratigrafía y datación

En esta cueva llevamos a cabo la descripción una secuencia sedimentaria de unos 16 metros de potencia, que resumimos en la figura 3.1. Dicha secuencia está formada mayoritariamente por sedimentos de origen terrestre, que se superponen a un complejo de depósitos formados a partir de playas marinas fechadas probablemente en el MIS (Estadio Isotópico Marino) 5. Tenemos evidencias de al menos dos estadios con el nivel del mar alto. El inferior lo definimos a partir de una playa fósil con una serie de depósitos interestratificados, mientras que el nivel superior está formado por una serie de arenas de origen marino que contienen gran cantidad de conchas. Entre ambos niveles aparece una brecha de origen terrestre. Las arenas de las series superiores llegaron probablemente a la cueva por la acción eólica procedente de la cercana línea de costa. Considerándolos conjuntamente, los sedimentos parecen representar dos momentos clave durante el MIS 5e (~125 ka) y el MIS 5c (~105 ka). Sus altitudes actuales sobre el nivel del mar, aproximadamente unos +3.25 m y +7.2 m, o quizás algo más, se explican a partir de una pequeña elevación tectónica a escala local, combinada con una suave oscilación de Gibraltar hacia el sur. En el capítulo 3 se expone en profundidad la propuesta de formación de la secuencia inferior. Hay que incidir especialmente en la abundante presencia de una gran diversidad de conchas marinas, que se extiende hasta la altura de la unidad *Carbonate Sands & Silts*.

Por encima de las arenas de grano grueso más altas de la unidad CSm (*Coarse Sands member*) se observa una serie de lechos de arenas de cuarzo de grano medio y fino interestratificados con brechas cementadas y, en ocasiones, con espeleotemas. Encontramos estalagmitas y estalactitas fragmentadas en la parte más baja de estos depósitos, en el RSSm (*Reddish Silt & Sands member*), que también contienen un subnivel de sedimentos más finos, entre los que se encuentran materials fuertemente fosfatados. Estos depósitos más finos representan importantes fases de lavado, presentes también en episodios superiores de la secuencia (véase más abajo). A su vez, éstos son sustituidos por niveles de sedimentos más limpios y normalmente no consolidados, los VSSm (*Variegated Sands & Silts member*) y SSLm (*Sands & Stony Lenses member*). En ambos se observa un incremento de arenas finas que contienen pequeñas estructuras en *cross-bedding*, lo que nos está indicando un origen eólico. La datación del SSLm por OSL ha proporcionado fechas entre 67.9 ka y 89.6 ka que, a grandes rasgos, nos sitúa en el MIS 4, lo cual nos permite

especular con el amplio margen de error de dichas fechas (véase capítulo 6)

En los niveles intermedios, sobre *c.* +11 m, los depósitos que forman el LBSm (*Lower Bioturbated Sands member*) contienen arcillas y limos, que se localizan en delgadas laminaciones que nos están indicando repetidos episodios de finos lavados y, en algunos casos, estancamientos de aguas de larga duración. Las unidades arenosas que se encuentran en esta secuencia muestran señales de alteraciones animales, lo que nos lleva a considerar la bioturbación. Pese a encontrarse en los límites del método radiocarbónico, los carbones asociados al LSBmcf.4 han proporcionado una fecha entre 55.9 y 45.3 ka en años calendario (capítulo 5), lo que situaría estos niveles en el momento inicial del MIS 3. El UBSm (*Upper Bioturbated Sands member*) está separado del LBSm por el BeSm (*Bedded Sands member*), una secuencia que no hemos podido estudiar bien y que debe relacionarse probablemente con la formación de grandes dunas, pero también con episodios locales de lavado sedimentario; la secuencia presenta una clara discontinuidad, probablemente relacionable con un intervalo de marcada humedad. Las fechas de las arenas bioturbadas superpuestas sugieren que la sedimentación debió producirse en un corto espacio de tiempo. Por encima se encuentran series formadas por grandes depósitos que contienen hogares (*CHm – Cemented Hearth member*), el más antiguo de los cuales puede fecharse con seguridad entre 34 y 33.2 ka cal BP. Los sedimentos atribuibles al MIS 2 no están bien representados en esta zona de la cueva. En este area, la parte superior de la secuencia está recubierta por arenas, encima de las cuales se encuentra una acumulación de piedras, posiblemente del MIS 1 (Holoceno)

Reconstrucción paleoambiental

La información acera de las antiguas condiciones climáticas y ambientales procede de un buen número de indicadores proxy, tales como sedimentos, carbones, anfibios, reptiles, restos de avifauna, y pequeños y grandes mamíferos (capítulos 3, 4 y 7-11).

La parte basal de la secuencia tiene 7–8 m de potencia y cubre diversos subestadios del MIS 5. Desafortunadamente no se recogieron muestras de estos niveles para realizar análisis paleoambientales, por lo que las interpetaciones que hacemos de ellos proceden de extrapolaciones hechas a partir de los análisis sedimentarios y de las dataciones (capítulos 2–6). El crecimiento de las estalagmitas y la formación de suelos nos están indicando una condiciones cálidas y húmedas propias de un momento interglacial. Entre estas fases se intercala por lo menos un período de

Gorham's Cave: cronología radiométrica

Estratigrafía	AMS Cariaco-Hulu BP (95.2% probabilidad)	Resultados por OSL calibrados a 1 sigma	Estadio Isotópico Marino (MIS)
Bem. 1-3	No datado		MIS 1
USFm.1	No datado		MIS 1-2
CHm.3	31 540 – 29 860		MIS 3
CHm.5	34 000 – 33 200		
UBSm.2	34 280 – 32 916		
UBSm.4	35 820 – 32 210		
UBSm.6	38 070 – 35 070	38 500 ± 5800	
UBSm.7	48 520 – 43 130 30 350 – 27 040*		
BeSm (OSsm).1	55 130 – 44 190 55 910 – 43 000 62 720 – 45 620 40 450 – 34 060*		
BeSm (PLSsm).3		48 700 ± 4000	
LBSmcf.4	55 920 – 45 340		MIS 3
SSLm (Usm).5		67 900 ± 5150	MIS 4
SSLm (Lsm).10		89 600 ± 7700	
CSm		119 300 ± 14 800	MIS 5

* Posible contaminación

potencial empeoramiento climático, que detectamos en los depósitos de brecha de la "Unidad D".

Los entornos paleoambientales posteriores al MIS 5 están representados en los niveles SSLm y superiores. En el SSLm 8–7 observamos unas condiciones de mayor sequía estacional a partir del aumento de la movilidad de las arenas por efecto del viento; sin embargo no se llega a la aridez suficiente para impedir el crecimiento del pino piñonero (*Pinus pinea*) (capítulo 7). Entre los pequeños mamíferos identificados en estos niveles encontramos el ratón de campo (*Apodemus* sp.); pero la ausencia de la rata de agua (*Arvicola* sp) nos está indicando claramente un entorno más seco. En la parte baja de la unidad SSLm(Lsm).6 detectamos unas condiciones de habitación en cierta manera más frías y áridas, como nos lo demuestra la persencia de un micrótido extinguido (*Microtus cabrerae* cf. *dentatus*) (capítulo 10). Del mismo modo, los pequeños reptiles y anfibios nos sugieren la sustitución, en estos mismos depósitos, de un entorno boscoso por uno arbustivo mediterrráneo más seco (capítulo 8). Entre los mamíferos de gran tamaño la escasa aparición del caballo (*Equus ferus*) en los SSLm 5 y 1 confirma la presencia local de entornos relativamente abiertos.

En los niveles medios de +11 m, y por encima de ellos, podemos deducir que hubo unas condiciones relativamente húmedas a partir de ligeros recrecimientos en las estalagmitas y de repetidos episodios de aguas estancadas en las unidades más bajas del LBSm; sin embargo, la movilidad de las arenas también nos está indicando unas condiciones más secas.

La secuencia sedimentaria nos muestra una amplia fluctuación de las condiciones paleoambientales, pero sin episodios extremos. En el paisaje circundante encontramos una diversidad botánica relativamente grande. La presencia de pinos, robles, enebros y otros arbustos, detectada a partir de la observación macroscópica de las muestras de carbones, nos está indicando una sabana boscosa, con una gran cobertura herbácea y una desigual distribución de arbustos y de árboles. Los reptiles y los anfibio no presentan

grandes cambios, si exceptuamos la aparición del sapo de espuelas en las unidades LBSm, hecho que parece corresponder a unas condiciones ligeramente más húmedas y con estancamiento de aguas en la cueva. La avifauna se corresponde muy bien con las condiciones ligeramente boscosas que se daban fuera de la cueva, si exceptuamos la aparición de ejemplares inmaduros de negrón común (*Melanitta nigra*) y de negrón especulado (*M. fusca*) en la unidad 8 de la secuencia LBSmff, lo que nos señala procesos de anidamiento de dichas aves durante los breves intervalos más fríos dentro del MIS 3. La continuidad en los elementos bióticos nos está indicando claramente que las especies que encontramos en la zona podían tolerar la variabilidad del entorno ambiental; las evidencias de cambio que hemos podido reconocer hasta el momento son sutiles y centradas casi exclusivamente en la fauna marina (pájaros y mamíferos), seguramente más sensibles a los grandes cambios de la circulación oceánica.

Las señales que nos indican un cambio paleoambiental en la parte superior de la secuencia estratigráfica siguen sin ser claras. En el UBSm (*Upper Bioturbated Sands*), parte de la herpetofauna desaparece, casos del sapo común, de la culebra de collar, de la víbora o de los lagartos escincos y ocelados (capítulo 8). Sin embargo este hecho no viene acompañado por cambios sustanciales en otras especies, tanto de vegetales (que conocemos a partir de los estudios antracológicos) como de animales, ya sean grandes o pequeños mamíferos, ya sean aves. En el CHm (*Cementented Hearths member*) creímos, en un principio, que los típicos pinos de las zonas bajas habían sido reemplazados por los propios de las zones altas, lo que habría tenido importantes implicaciones en la determinación de los cambios del clima. Sin embargo hemos revisado esta interpretación; es más plausible que la degradación de algunas muestras de carbón haya llevado a una identificación errónea de las especies. Pese a ello, sigue siendo interesante el hecho de la presencia testimonial de huesos de foca gris (*Halichoerus grypus*) en el nivel D de las excavaciones de Waechter, equivalentes a nuestro CHm.5, así como la de arenas y pequeñas piedras, identificadas en el CHm, que podrían estar indicándonos unas condiciones climáticas estacionalmente más frías. Por otro lado, no tenemos, en estos niveles, ningún indicador típico de clima frío entre los restos de pequeños mamíferos o de la avifauna.

Las evidencias arqueológicas

Parece que la cueva fue utilizada de manera intermitente por los seres humanos y por otros animales. En prácticamente todas las muestras de sedimento que hemos estudiado micromorfológicamente a partir de las láminas delgadas hemos identificado restos de guano de pájaros y de murciélagos (capítulo 4). El estudio de otros fosfatos, procedentes de coprolitos de carnívoros, nos está indicando que las hienas visitaron asíduamente la cueva. La actividad humana queda evidenciada por la presencia de instrumentos líticos, huesos y materiales quemados como carbón, hueso y, más excepcionalmente, ceniza. Los análisis a partir de láminas delgadas nos indican que, excepto en los niveles más altos de la secuencia (CHm y superiores), no hay evidencia de la presencia de hogares *in situ*. En la mayoría de

los casos hubo pequeños desplazamientos de los carbones debido a episodios menores de lavado sedimentario; la escasez de cenizas puede deberse perfectamente a los procesos de descalcificación causados por el guano.

En los niveles inferiores y medios de la secuencia de Gorham's Cave tenemos industrias líticas típicas del Paleolítico medio (capítulo 12). La técnica de talla a partir de núcleos discoidales fue la más usada, pese a que se observa un significativo aumento de las lascas laminares obtenidas a partir de núcleos Levallois bipolares en el SSLm.5-6, en depósitos que podrían ser del MIS 4. Los momentos finales del Paleolítico medio podrían estar representados por una punta Levallois hallada en el UBSm.4. Los instrumentos típicos del Paleolítco superior han sido identificados a partir del CHm.5 de nuestras excavaciones, equivalente al nivel D de las colecciones de Waechter. Entre los útiles diagnósticos tenemos núcleos de laminitas, talla de láminas y laminitas, junto a otras piezas retocadas como una laminita de retoque marginal que no desentonaría en una industria del Auriñaciense o del Paleolítico superior inicial. En el mismo CHm.5 apareció una pequeña concha de cauri con ínfimos restos de ocre (capítulo 12). Esto tipo de elementos son esperables en contextos de Paleolítico superior inicial. También apareció en el CHm.3 un pequeño conjunto de instrumentos en el que podríamos encontrar afinidades con el Graventiense mediterráneo.

Si consideramos los recursos alimentarios que tenían a mano los habitantes de la cueva, en sus alrededores podían obtener una amplia variedad y diversidad de elementos comestibles. Los restos encontrados en los niveles del Paleolítico medio nos demuestran que los Neaderthales explotaron los piñones del pino piñonero (*Pinus pinea*) y los procesaron dentro de la cueva (capítulo 7). Entre los animales tenemos grandes mamíferos como el ciervo (*Cervus elaphus*), la cabra montés (*Capra ibex*) y los bóvidos, identificados a partir de huesos carbonizados o que presentan marcas de corte (capítulo 11). También tenemos restos de animales más pequeños, como placas quemadas de caparazón de tortuga y huesos de conejo (capítulo 10). En los niveles del LBSm había grandes cantidades de huesos quemados de patos y de palomas, lo que sugiere que dichos animales fueron asados y comidos, para lanzar luego los huesos al fuego (capítulo 9). Otro uso del hueso lo identificamos a través de un retocador o compresor de este material, hallado en los niveles del LBS (capítulo 12); era utilizado para retocar útiles líticos como las raederas, y tenemos otro ejemplar en Varguard Cave. En estos niveles del Paleolítico superior aparecieron muy pocos restos de fauna (CHm.5 y superiores), pese a que los informes procedentes de las colecciones de Waechter sugieren la abundancia de ciervo, cabra salvaje y caballo en el nivel D (CHm.5), y de jabalí en el nivel B (CHm.3).

Vanguard Cave
Estratigrafía y datación

Vanguard Cave presenta una estratigrafía menos compleja que la de Gorham's Cave. La cueva presentaba una secuencia de casi 17 m de potencia que llegaba casi hasta el techo y tenía un suave buzamiento hacia el interior de la misma. En el Holoceno los sedimentos de la zona más cercana al mar

fueron erosionados, lo que hizo que la parte más antigua de la secuencia fuera recubierta por una fina capa superficial de arenas que formó una pendiente desde la parte de atrás de la cueva hasta la playa. El yacimiento no había sido excavado nunca, por lo que, después de eliminar las arenas superpuestas, aparecieron series de unidades *in situ* formadas por capas de arenas de grano grueso y medio (probablement la cola del sistema de dunas costeras) que alternaban con arenas más oscuras de aluvión y limosas. Estas unidades alternantes pueden observarse especialmente en tres áreas principales que hemos denominado (1) Área superior, (2) Áreas media e inferior, y (3) Alcove norte (capítulo 13, Fig. 1). El estudio sedimentológico no llegó a la base de la secuencia ya que la parte más baja de la pendiente, que estaba más allá de la boca de la cueva, estaba sembrada de grandes cantos rodados. Pese a ello era posible observar que que en la misma base había unas arenas de playa fuertemente cementadas, asentadas sobre una plataforma cortada en la roca, muy cercana al actual nivel del mar y a la misma altura que en Gorham's Cave.

La datación por OSL de los sedimentos del Área superior nos indica que hace unos 75 ka la cueva ya había quedado prácticamente colmatada; pese a ello, es posible que la erosión posterior afectara a algunas de las arenas de la parte superior de la secuencia y que hubiera un depósito posterior, ya que la fecha de OSL se obtuvo en brechas pegadas a la pared de la cueva. En el capítulo 14 exponemos las bases en las que se fundamentan las dataciones por OSL y llegamos a la conclusión de que son más coherentes que las de Gorham's Cave, si atendemos a las más rápidas tasas de sedimentación y al menor grado de bioturbación que tenemos en Varguard Cave. Estos estudios ponen en cuestión la fecha de un hogar del Área superior datado anteriormente por C14, pese a que hay que tener en cuenta que su edad se aproximaba a los límites del método. Una serie de fechas obtenidas en el Área media e inferior nos confirma que los sedimentos de esta parte de la cueva se depositaron durante el último Interglaciar (MIS 5). Todos los sedimentos se dataron a partir de muestras de granulometría diversa, con la excepción de la X729-SG.

Reconstrucción paleoambiental

En los capítulos del 15 al 18 estudiamos las evidencias paleoambientales procedentes de esta cueva, teniendo siempre en cuenta que todas ellas son más antiguas que las que describimos para Gorham's Cave. El análisis macroscópico de los carbones (capítulo 15) nos indica la presencia de vegetación tipica de unas condiciones interglaciares,

Vanguard Cave: Cronología por Optically Stimulated Luminescence (OSL).

Estratigrafía Fig. 14.1	Código de Laboratorio	Resultados por OSL calibrados a 1 sigma	Estadio Isotópico Marino (MIS)
Área superior	X730	75 100 ± 5300	MIS 4-5
Área superior	X729-SG	108 500 ± 7000	MIS 5
Área superior	X724	114 000 ± 5000	MIS 5
Área media e inferior	X728	118 000 ± 4500	MIS 5
Área media e inferior	X369	121 600 ± 4600	MIS 5
Área media e inferior	X720	123 200 ± 5000	MIS 5
Área media e inferior	X722	126 500 ± 6800	MIS 5

con plantas termófilas como la cornicabra (*Pistachia* sp.) y el acebuche (*Olea* sp.). El clima cálido y estable que nos está indicando la vegetación se confirma con la presencia de reptiles y anfibios termófilos como la culebrilla ciega (*Blanus cinereus*), los lagartos (*Chalcides* sp.) y la ranita meridional (*Hyla meridionalis*); todos ellos los encontramos actualmente en el área meridional europea. Estos datos concuerdan con los restos de avifauna (capítulo 17), que nos indican la continuidad de un bosque abierto cerca de la cueva, con árboles maduros de hoja ancha; podemos deducirlo a partir de la presencia de pájaros como el autillo europeo (*Otus scops*) y la becada (*Scolopax rusticola*). En cuanto a los restos de grandes mamíferos (capítulo 18), los tenemos casi todos en el Área media e inferior y son prácticamente los mismos que identificamos en Gorham's Cave. En este área y en la Alcove norte tenemos, como novedad, la presencia de la foca monje del Mediterráneo (*Monachus monachus*) y del delfín común (*Delphinus delphis*); algunos de sus restos tienen señales de modificaciones antrópicas, lo que nos está indicando claramente su introducción en la dieta. Aunque fueran producto de capturas ocasionales más que de una caza deliberada, estos animales fueron transportados a la cueva para ser consumidos desde la cercana línea de costa. También tenemos restos de hiena manchada (*Crocuta crocuta*), de lobo (*Canis lupus*) y de oso pardo (*Ursus arctos*), lo que, junto a coprolitos muy parecidos a los del lobo (capítulo 19), nos están indicando la presencia de los carnívoros en la cueva durante los períodos sin presencia humana.

Las evidencias arqueológicas

Los hallazgos más significativos proceden del Área media e inferior. Las industrias líticas (capítulo 20) y los huesos de animales modificados (capítulos 18 y 21) nos señalan que los Neanderthales se asentaron de forma repetida la cueva en ocupaciones de corta duración. Las principales actividades que desarrollaron fueron el despiece, procesado y consumo de la carne de las carcasas de los animales cazados, tales como ciervos (*Cervus elaphus*), cabras salvajes (*Capra ibex*) y jabalíes (*Sus scrofa*). También podemos conocer su comportamiento alimentario a través de los huesos quemados, fracturados y con marcas de corte de la foca monje del Mediterráneo (*Monachus monachus*), de las conchas de mejillones y de las cáscaras de piñones; tenemos testimonio además de otras fuentes suplementarias de alimento como la tortuga (*Eurotestudo* sp.) y los lagartos (*Chalcides* sp.). La aparición, en menor cantidad, de miembros anteriores y posteriores de patos pueden estar indicándonos el consumo de aves acuáticas (capítulo 17). Una de las más importantes características del comportamiento alimentario de los Neanderthales que podemos deducir del estudio tafonómico de la fauna (capítulo 21) es la correlación entre el quemado superficial de los huesos y los esquemas de fractura de los mismos; este hecho nos está indicando con mucha certeza que los Neanderthales utilizaron sistemáticamente un pretratamientos calorífico del hueso antes de proceder a la extracción del tuétano.

Las industria líticas que tenemos en el Área media e inferior y en la superior se caracterizan por la utilización de cuarcitas locales para obtener lascas que luego se transformaban en pequeños núcleos discoidales. Y las piezas retocadas son muy pocas. Las ocupaciones del yacimiento, repetidas pero efímeras, podemos reconocerlas a partir de hogares poco profundos excavados en la arena. La única excepción, que exponemos en el capítulo 15, es un gran hogar de forma ovalada identificado en el Área media; dicha estructura (contexto 150) tenía un diámetro máximo de 1'5 m y estaba constituída por numerosos niveles de cenizas y de arena rubefactada, lo que dejaba claros los diversos momentos de utilización de este fuego. Uno de los hogares más interesantes lo encontramos en el Área superior, asociado a una relativamente alta densidad de mejillones (*Mytilus galloprovincialis*); éstos se encontraban en depósitos grises formados por cenizas, lo que nos sugiere la forma en la que los Nenderthales debían haber abierto las valvas de estos animales, poniéndolos en el fuego y luego comiéndoselos.

Algunas lascas de cuarcita procedentes del mismo hogar, sin rastro de haberse quemado, pueden ser objeto de remontaje en núcleos de tamaño superior, lo que nos da una plausible secuencia de los acontecimientos. En un primer momento habría habido una talla de lascas que habrían quedado encima de las cenizas frías del hogar; algunas de ellas habrían ido a parar fuera de esta zona de talla o habrían sido seleccionadas para su uso, lo que queda marcado por vacíos en el remontaje del núcleo, mientras que otras habrían quedado *in situ*. El hecho de que, en la zona del hogar, aparezcan algunas piezas retocadas, rotas y muy utiizadas, nos está también señalando un comportamiento previsor en lo concerniente al reabastecimiento y a la circulación de dichos instrumentos, que estaban hechos de sílex de grano fino, al contrario de lo que sucedía con la mayoría de las grandes lascas. Dado que no hemos encontrado restos de talla de este tipo de sílex debemos deducir que estos útiles llegaron ya configurados como tales a la cueva. Esta constatación nos proporciona evidencias significativas acerca de las formas de abastecimietno y utilización de las materias primas por parte de los Neanderthales de Gibraltar. Finalmente cabe señalar que hemos emprendido los estudios de los anillos de crecimiento de las valvas de los mejillones encontrados en este mismo hogar del Área superior, tal como describimos en el capítulo 22; a partir de ellos podemos llegar a sólidas deducciones de estacionalidad y de planificación en su consumo, ya que constatamos que se recogían y se comían a mediados de primavera en entornos cercanos de estuario o marinos.

J. M. Fullola Pericot

Résumé

La Grotte de Gorham
Stratigraphie et datation

Nous proposons une description de la lithostratigraphie (d'environ 16 mètres de hauteur) avec un sommaire graphique (figure 3.1). La séquence se compose principalement de dépôts terrestres, superposés à un complexe sédimentaire représentant un cordon littoral fossile surélevé, qui daterait du **stade isotopique marin ('SIM') 5.** Au moins deux périodes de niveau marin élevé sont séparés par une brèche terrigène; on trouve à la base une vraie plage fossile avec des dépôts intertidaux et plus haut une série de sables bien classés avec des débris de coquillages. Ces sables supérieurs (le membre des sables grossiers – *Coarse Sands member – CSm*) ont été façonnés, à l'origine, dans une zone intertidale probablement peu éloignée mais ont été introduits dans la grotte par la saltation due à l'action du vent. Ces hauts niveaux marins dateraient respectivement du SIM 5e (~125 ka) et SIM 5c (~105 ka). Leurs altitudes au dessus du niveau actuel de la mer d'environ +3,25 m et +7,20 m (ou légèrement plus haut pour ce dernier) s'expliqueraient par un soulèvement tectonique peu important probablement accompagné par un léger basculement de Gibraltar vers le sud. Dans le chapitre 3, nous discutons en détail des modes de formation qu'impliquerait cette séquence inférieure.

Au dessus de ces sables clairement 'marins' se trouve une succession de couches contenant normalement des sables quartzitiques d'une granulométrie moyenne ou plus fine, entrecoupés de brèches cimentées, voire des spéléothèmes, en commençant par le membre des sables et limons carbonatés (*Carbonate Sands & Silts member – CSSm*). Cependant, on notera l'occurrence répétée de divers coquillages marins jusque dans ce membre, ainsi que de rares lits de sables grossiers. Dans le membre suivant, les limons et sables rougeâtres (*Reddish Silts & Sands member - RSSm*), on trouve des fragments de stalagmites et de stalactites mais un intervalle de sédiments plus fins contient des éléments fortement phosphatisés. Ces dépôts fins représentent des phénomènes importants de ruissellement diffus, phénomènes qui se reproduisent plus haut dans la séquence (voir ci-dessous). Au-dessus du *RSSm*, on trouve des sédiments mieux classés et normalement meubles tels que les sables et limons multicolores (*Variegated Sands & Silts member – VSSm*) et les sables et les éboulis lenticulaires (*Sands & Stony Lenses member – SSLm*). Ceux-ci contiennent de plus en plus souvent des sables fins à litage entrecroisé à l'échelle centimétrique, typiques d'une origine éolienne. La datation du *SSLm* par luminescence stimulée optiquement ('LSO') donne des âges entre 67,9 ka et 89,6 ka, ce qui correspondrait en gros, donné la fourchette d'erreur, avec le SIM 4 (voir chapitre 6).

Dans les niveaux moyens, au dessus de +11 m environ, les sables bioturbés inférieurs (*Lower Bioturbated Sands member – LBSm*) contiennent des argiles et des limons organisés localement en fines laminae typiques de ruissellement diffus et répété, et même dans certains cas, d'une saturation persistante. Dans les unités plus sableuses, les signes de creusement animal sont à la base de la référence à la bioturbation. La datation des charbons de la couche *LSBmcf.4* (chapitre 5) bien que près de la limite de la méthode, est comprise entre 55,9 ka et 45,3 ka (après calibration), ce qui placerait ces niveaux dans la première phase du SIM 3. Les sables bioturbés supérieurs (*Upper Bioturbated Sands member – UBSm*) sont séparés du *LBSm* par une séquence peu étudiée de sables lités (*Bedded Sands member – BeSm*). Ces derniers sont probablement liés à une importante formation dunaire extérieure, mais dans la grotte, les sables sont entrecroisés par des dépôts dus au ruissellement diffus. A l'intérieur de la séquence *BeSm*, on trouve une discordance angulaire majeure, probablement due à un intervalle particulièrement humide. La datation des sables bioturbés sus-jacents (*UBSm*) impliquerait que l'on n'est pas en présence d'un important hiatus de sédimentation. Encore plus haut se trouve une série d'éboulis cimentés contenant des foyers étendus, 'foyers cimentés' (*Cemented Hearth member – CHm*), dont le plus ancien a donné une date ferme d'entre 34,0 et 33,2 ka (après calibration). Les sédiments du SIM 2 ne sont pas bien représentés dans cette partie de la grotte.

Grotte de Gorham: Chronologie radiométrique.

Stratigraphie	AMS Cariaco-Hulu BP (95.2% probabilité)	Résultats LSO Ages modelés à 1 sigma	Stade Isotopique Marin (SIM)
Bem. 1-3	Non daté		SIM 1
USFm.1	Non daté		SIM 1-2
CHm.3	31 540 – 29 860		SIM 3
CHm.5	34 000 – 33 200		
UBSm.2	34 280 – 32 916		
UBSm.4	35 820 – 32 210		
UBSm.6	38 070 – 35 070	38 500 ± 5800	
UBSm.7	48 520 – 43 130 30 350 – 27 040*		
BeSm (OSsm).1	55 130 – 44 190 55 910 – 43 000 62 720 – 45 620 40 450 – 34 060*		
BeSm (PLSsm).3		48 700 ± 4000	
LBSmcf.4	55 920 – 45 340		SIM 3
SSLm (Usm).5		67 900 ± 5150	SIM 4
SSLm (Lsm).10		89 600 ± 7700	
CSm		119 300 ± 14 800	SIM 5

* contamination possible

Là, le sommet de la séquence se compose de sables surmontés par un plancher stalagmitique qui daterait du SIM 1 (Holocène).

Reconstruction paléoenvironnementale

Les conditions climatiques et environnementales se déduisent à partir d'un nombre de données indirectes, y compris les sédiments, les charbons, les amphibiens, les reptiles et l'avifaune ainsi que les petits et grands mammifères (chapitres 3-4 et 7-11).

Les 7-8 mètres à la base de la séquence couvrent les nombreux sub-stades du SIM 5. Malheureusement, ces niveaux n'ont pas été échantillonnés pour des restes paléoenvironnementaux et donc l'interprétation s'appuie entièrement sur les sédiments et les analyses chronométriques (chapitres 2-6). Les conditions humides et chaudes, compatibles à une période interglaciaire, sont indiquées par l'accroissement stalagmitique et une formation active de sols externes. Ces conditions sont peut-être interrompues par au moins une période de détérioration climatique comme l'indiquerait les brèches cimentées de l'unité D (*Unit D*).

La séquence post-SIM 5 commence avec les niveaux du *SSLm*. Dans le *SSLm.8-7*, les saisons plus sèches, quoique pas suffisamment arides pour empêcher la croissance du pin parasol (*Pinus pinea*) (chapitre 7), sont marquées par la mobilité des sables éoliens. A ces niveaux, les petits mammifères tels que le mulot (*Apodemus* sp.) sont présents, mais les conditions légèrement plus sèches sont indiquées par l'absence presque absolue du campagnol (*Arvicola* sp.). Dans le *SSLm(Lsm).6*, le microtiné disparu (*Microtus cabrerae* cf. *dentatus*) impliquerait des habitats quelque peu plus arides et plus frais (chapitre 10). De même, dans ces sédiments, les petits reptiles et les amphibiens suggèrent le remplacement d'un environnement assez boisé et humide par une garrigue de type méditerranéen (chapitre 8). Parmi les grands mammifères, le cheval (*Equus ferus*) n'apparaît que rarement (*SSLm 5* et *1*) ce qui confirmerait des habitats relativement ouverts à proximité.

Dans les niveaux moyens, au dessus +11 m environ, la croissance renouvelée de petites stalagmites ainsi que les signes de fréquentes inondations en flaques dans les dépôts inférieurs du *LBSm* montreraient des conditions relativement humides bien que des intervalles plus secs sont indiqués par la mobilité évidente des sables. La séquence sédimentaire se caractérise par une fluctuation environnementale mais probablement sans extrêmes. La diversité floristique était élevée dans le paysage environnant. Une savane boisée avec de hautes herbes parsemées d'arbustes et d'arbres est représentée par les charbons macroscopiques de pins, chênes, genévriers, pistachiers lentisques (arbre au mastic) et d'une gamme d'autres arbustes. On observe peu de changement en ce qui concerne les reptiles et les amphibiens à part l'augmentation du nombre des pélobates à couteaux (*Pelobates cultripes*) dans le *LBSm*, une réaction possible aux conditions un peu plus humides dans la grotte, voire des flaques. Dans l'ensemble, l'avifaune est compatible avec un environnement légèrement boisé, à l'exception de l'apparition d'individus juvéniles de la macreuse noire (*Melanitta nigra*) et de la macreuse brune (*M. fusca*) dans la couche 8 du *LBSmff* qui pourrait indiquer la nidification

pendant de courts intervalles plus froids au sein du SIM 3. La persistance de la majorité du biote indique clairement que les espèces de la région pouvaient tolérer la variabilité de l'environnement physique. Les indicateurs de changements observés jusqu'ici sont subtils et pour la plupart se restreignent à la faune marine (oiseaux et mammifères) qui aurait pu être plus susceptible aux modifications à grande échelle de la circulation océanique.

Les signes des changements paléoenvironnementaux dans la partie supérieure de la séquence stratigraphique restent peu importants. Dans les sables bioturbés supérieurs (*UBSm*), certaines espèces de l'herpétofaune, telles que le crapaud commun, la couleuvre à collier, la couleuvre vipérine, le scinque et le lézard ocellé, disparaissent (chapitre 8). Cependant, cette disparition n'est pas accompagnée par des changements majeurs dans la composition des charbons, des petits et grands mammifères ou des oiseaux. Au départ, nous avons cru que dans les foyers cimentés (*CHm*), les pins typiques des plaines avaient été remplacés par des espèces de hautes terres ce qui aurait certainement impliqué un changement de climat. Toutefois, nous avons révisé cette interprétation car il semblerait plus vraisemblable que l'état dégradé de certains charbons a entraîné une identification incorrecte. Cependant, il est intéressant de noter que les ossements du phoque gris de l'Atlantique (*Halichoerus grypus*), bien que peu abondants, ont été signalés dans le Niveau D des fouilles de Waechter (équivalent du *CHm.5*) et que les sables et éboulis fins dans le *CHm* pourraient indiquer des saisons plus fraîches. Par contre, à ces niveaux, on trouve aucun indicateur typique de climat froid, ni parmi les petits mammifères, ni parmi les oiseaux.

Données archéologiques

La grotte elle-même semble avoir été utilisée d'une manière intermittente par l'homme et par d'autres animaux. Presque tous les sédiments examinés contiennent des restes de guano d'oiseaux et de chauves-souris, restes qui apparaissent dans l'étude micromorphologique (chapitre 4). D'autres phosphates provenant de coprolithes de carnivores indiqueraient que les hyènes fréquentaient couramment la grotte. L'activité humaine se voit dans les artefacts lithiques, les ossements modifiés et les matériaux brûlés y compris des charbons de bois, des os et plus rarement des cendres. L'analyse micromorphologique suggère qu'à part dans les couches les plus hautes (*CHm* et au-dessus) il n'y a aucun foyer *in situ*. Dans la majorité des cas, les charbons ont été, tout probablement, déplacés par des ruissellements diffus locaux, tandis que le manque évident de cendres pourrait s'expliquer par la décalcification due au guano omniprésent.

Des industries lithiques typiques du Paléolithique Moyen se trouvent partout dans les parties inférieures et moyennes de la séquence de la Grotte de Gorham (chapitre 12). Le débitage discoïde était couramment utilisé bien que l'on observe une augmentation du nombre des éclats laminaires obtenus des nucléus Levallois bipolaires dans le *SSLm 5-6*, dépôts qui dateraient du SIM 4. Le Paléolithique Moyen le plus tardif est tout probablement représenté par une pointe Levallois dans le *UBSm.4*. Des artefacts de type paléolithique supérieur ont été identifiés dans le *CHm.5* de nos fouilles ainsi que dans la Couche D de Waechter. Parmi

les objets diagnostiques on notera des nucléus à lamelles, des débitages lamellaires (lames et lamelles) et un nombre d'outils dont une lamelle à retouches marginales qui ne seraient pas incongrus dans une industrie de l'Aurignacien ou du Paléolithique Supérieur Initial. On notera la présence, dans le *CHm.5*, d'une petite porcelaine portant de minuscules traces d'ocre rouge (chapitre 12). On s'attendrait à de tels objets au commencement du Paléolithique Supérieur. Nous avons trouvé, dans le *CHm.3*, une industrie dans laquelle, malgré le petit nombre d'artefacts, nous avons reconnu des affinités au Gravettien Méditerranéen.

En ce qui concerne la nutrition, il est évident que les divers environnements autour de la grotte offraient une large gamme d'aliments. D'après les fouilles dans les niveaux paléolithiques moyens, on constate que les Néandertaliens exploitaient les pignons (*Pinus pinea*) et que ceux-ci étaient traités à l'intérieur de la grotte (chapitre 7). La gamme probable des grands mammifères exploités est indiquée par les ossements de cerfs (*Cervus elaphus*), de bouquetins (*Capra ibex*) et de bovidés portant des traces de boucherie et parfois brûlés (chapitre 11). Les ossements de lapin et les écailles de tortue, tous deux brûlés, montrent la disponibilité et l'utilisation des petits animaux (chapitre 10). Des quantités d'ossements brûlés de canards et de pigeons ont été retrouvés particulièrement dans les couches du *LBSm* ce qui suggérerait qu'ils aient été rôtis et mangés et/ou rejetés dans le feu (chapitre 9). La présence d'un retouchoir en os ou 'compresseur', provenant aussi de l'un des niveaux *LBSm* et typique des objets utilisés pour retoucher les silex tels que les racloirs, témoigne d'une autre utilisation de ce matériau (un autre exemplaire provient de la Grotte Vanguard). Très peu de restes de faune, quelques soient leurs formes, ont été trouvés dans les couches paléolithiques supérieurs (*CHm.5* et au-dessus) bien que le rapport contemporain aux fouilles de Waechter fasse état d'une abondance de cerfs, de bouquetins et de chevaux dans la Couche D (*CHm.5*) et de sangliers dans la Couche B (*CHm.3*).

Grotte Vanguard
Stratigraphie et datation
Ce site contient une stratigraphie moins complexe que celle de la Grotte de Gorham. Une séquence d'environ 17 mètres d'épaisseur remplissait la grotte presque jusqu'au toit toujours avec un épandage faible vers l'intérieur. Pendant l'Holocène, les sédiments qui faisaient face à la mer transgressive ont été érodés et l'ancienne séquence a été recouverte, en contre pente, d'une mince couche de sables meubles, du fond de la grotte jusqu'à la plage. Ce site n'avait jamais été fouillé et une fois les sables meubles enlevés, la séquence ancienne est apparue montrant une alternance entre d'une part, des séries de sables de granulométrie grossière à moyenne (probablement l'arrière du cordon dunaire littoral) et d'autre part, des limons et sables limoneux aux couleurs plus foncées. Cette alternance était particulièrement visible dans les trois zones principales de la grotte: (1) Zone Supérieure (*Upper Area*), (2) Zone Moyenne et Inférieure (*Middle and Lower Area*) et (3) Alcôve Nord (*Northern Alcove*) (chapitre 13, figure 1). La base de la séquence n'a pas pu être fouillée à cause des grands blocs sur la pente immédiatement à l'extérieur de la grotte. Néanmoins, nous

avons pu observer qu'à l'extrême base se trouve une plateforme d'abrasion fossile surmontée par des sables intertidaux fortement cimentés, le tout près du niveau de la mer actuelle et donc à la même altitude que de semblables phénomènes à la Grotte de Gorham.

La datation des sédiments de la Zone Supérieure par LSO suggère que le remplissage de la grotte ait été largement complété aux environ de 75 ka. Néanmoins, puisque cette datation a été faite sur un sédiment cimenté à la paroi, il est possible que l'érosion ait enlevée plus tard certains des sables supérieurs avant un dépôt final. Dans le chapitre 14, nous expliquons la logique de la série de datations pour la Grotte Vanguard. On note que les résultats sont plus cohérents que dans le cas de la Grotte de Gorham, ce qui est en accord avec les déductions, et d'une vitesse de sédimentation plus rapide et d'un degré moindre de bioturbation dans le premier site. Cette étude met en question l'âge d'un foyer dans la Zone Supérieure, daté auparavant par le radiocarbone. Il faut noter que cette ancienne datation se trouve près de la limite de cette méthode. Une série de dates LSO provenant de la Zone Moyenne et Inférieure confirment que les sédiments dans cette partie de la grotte ont été déposés pendant le dernier interglaciaire (SIM 5). A l'exception d'un seul échantillon (X729-SG), tous les sédiments ont été datés en utilisant la méthode 'multigrains'.

Reconstruction paléoenvironnementale
Dans les chapitres 15 à 18, nous traitons des données paléoenvironnementales de cette grotte sans oublier que ces collections sont toutes plus anciennes que celles de la Grotte de Gorham décrites dans cette monographie. L'analyse des charbons macroscopiques (chapitre 15) montre la présence de flore typiquement interglaciaire y compris des thermophiles tels que le pistachier lentisque/térébinthe (*Pistachia* sp.) et l'olivier (*Olea* sp.). Les climats chauds et stables suggérés par les données botaniques sont confirmés par la présence d'espèces de reptiles et d'amphibiens thermophiles (chapitre 16) comme l'amphisbène (*Blanus cinereus*), le scinque (*Chalcides* sp.) et la rainette méridionale (*Hyla meridionalis*), des espèces que l'on retrouve toutes aujourd'hui dans l'Europe du sud. Cette déduction est en accord avec l'avifaune (chapitre 17) qui témoigne, tout au long de la séquence, de la persistance d'un environnement légèrement boisé près de la grotte. Cependant, la présence d'oiseaux tels que le petit duc scops (*Otus scops*) et la bécasse des bois (*Scolopax rusticola*) indiquerait des bois plus continus de grands feuillus. Quant aux grands mammifères (chapitre 18) que nous avons trouvés principalement dans la Zone Moyenne

Grotte Vanguard: Chronologie par luminescence stimulée optiquement (LSO)

Stratigraphie figure 14.1	Code Laboratoire	Résultats LSO Ages modelés à 1 sigma	Stade Isotopique Marin (SIM)
Zone Supérieure	X730	75 100 ± 5300	SIM 4-5
Zone Supérieure	X729-SG	108 500 ± 7000	SIM 5
Zone Supérieure	X724	114 000 ± 5000	SIM 5
Zone Moyen. & Inf.	X728	118 000 ± 4500	SIM 5
Zone Moyen. & Inf.	X369	121 600 ± 4600	SIM 5
Zone Moyen. & Inf.	X720	123 200 ± 5000	SIM 5
Zone Moyen. & Inf.	X722	126 500 ± 6800	SIM 5

et Inférieure, il s'agirait plus ou moins des mêmes espèces que celles de la Grotte de Gorham. Dans cette Zone ainsi que l'Alcôve Nord, on notera en particulier, les ossements du phoque moine de Méditerranée (*Monachus monachus*) et du dauphin commun à bec court (*Delphinus delphis*) dont certains portent des signes de modification humaine indiquant clairement la contribution des mammifères marins dans l'alimentation. Même si ces animaux étaient charognés plutôt que chassés, ils étaient apportés d'un littoral voisin lors d'une période de niveau marin élevé. Les restes d'hyène tachetée (*Crocuta crocuta*), de loup (*Canis lupus*), d'ours brun (*Ursus arctos*) et des coprolites ressemblant à celles du loup (chapitre 19) indiquent que les carnivores fréquentaient la grotte entre les visites des hommes.

Données archéologiques

Les trouvailles les plus importantes proviennent de la Zone Moyenne et Inférieure. L'industrie lithique (chapitre 20) et les os d'animaux modifiés (chapitres 18 et 21) montre que la grotte a été occupée par les Néandertaliens à maintes reprises, mais pour de courtes périodes. Les activités principales étaient le démembrement, la transformation et la consommation de la viande de petits ou moyens gibiers tels que le cerf (*Cervus elaphus*), le bouquetin (*Capra ibex*) et le sanglier (*Sus scrofa*). Les autres indices alimentaires proviennent des os de phoque (*Monachus monachus*) qui portent des traces de boucherie ou qui ont été cassés ou brûlés, des moules et des restes (écailles de pignes et coques de pignons) de pin carbonisé (*Pinus pinea*). De plus, la tortue (*Eurotestudo* sp.) et le scinque (*Chalcides* sp.) ont pu servir de supplément alimentaire. La plus grande proportion de membres postérieurs de canard pourrait indiquer que les oiseaux d'eau étaient aussi mangés (chapitre 17). L'étude taphonomique de la faune fait ressortir un comportement intéressant (chapitre 21) à savoir la corrélation entre les traces superficielles du feu et des formes de cassures, ce qui constituerait une preuve que les Néandertaliens ont systématiquement utilisé le traitement thermique préalable de l'os pour en extraire la moelle.

Les quartzites locaux ont été employés pour la production des éclats à partir de petits nucléus discoïdes dans les industries contenues dans les deux Zones. On ne trouve que peu d'outils. Les séjours répétés mais éphémères sont indiqués par de petits foyers peu épais dans des cuvettes creusées dans le sable. La seule exception, discutée au chapitre 13, présente un foyer ovale (contexte 150) dans la Zone Moyenne, d'un diamètre maximum de 1,5 m et constitué par de multiples couches de cendres et de sables rubéfiés, révélant plusieurs épisodes de combustion. Un autre foyer intéressant se trouve dans la Zone Supérieure. Celui-ci est associé à une densité relativement élevée de moules (*Mytilus galloprovincialis*) encastrées dans des sédiments gris cendreux, ce qui suggère que les Néandertaliens auraient pu faire ouvrir les moules à une température peu élevée pour les manger immédiatement sur place. Des éclats de quartzite non brûlés, provenant de ce foyer, peuvent être remontés pour former de plus grands nodules. On peut en déduire la séquence suivante: avant le départ, les éclats étaient taillés au-dessus des cendres tièdes, certains étaient emportés (indiqués par les vides dans le remontage) alors que le débitage général était abandonné. Le petit nombre d'outils cassés et très utilisés à proximité du foyer montre ce même comportement anticipatoire avec un renouvellement et une circulation des artefacts. Ces outils contrairement à la majorité des éclats ont été fabriqués à partir d'un chert microcristallin. Etant donné l'absence de débitage de ce matériau, on peut en déduire que les outils étaient introduits préfabriqués dans le site, un intéressant aperçu de la manière dont les Néandertaliens de Gibraltar se procuraient et utilisaient la matière première. Finalement, l'étude des anneaux de croissance de moule de ce même foyer (chapitre 22) montre qu'avant leur consommation, ces coquillages étaient ramassés au milieu du printemps sur le littoral ou dans un estuaire voisin. Cette observation donne l'une des indications la plus claire de la saisonnalité et de l'organisation à long terme de ces groupes humains.

S. N. et C. A. F. Collcutt

1 The Gibraltar Neanderthals and excavations in Gorham's and Vanguard Caves 1995–1998:

Introduction and history of the excavation project

C.B. Stringer

In that cave are also found human bones, crusted with a very thick, stony coating, and wise men have ventured to say that those men not only lived before the flood, but as much as ten thousand years before it. It may be true – it looks reasonable enough – but as long as those parties can't vote anymore, the matter can be of no great public interest.

> Mark Twain, writing on Gibraltar
> in *Innocents Abroad* (1869).

Introduction

The Rock of Gibraltar has been a landmark for the peoples of the Mediterranean for countless millennia. In classical times it was known as 'Mons Calpe', the northern half of the legendary 'Pillars of Hercules', visited by Odysseus and through which brave seafarers sailed from the known world to face the hazards of the Atlantic Ocean. For much of the Pleistocene, it must also have been a dominant landmark, but often a land-locked one when glaciation lowered sea levels by up to 120 m. The landscape then would also have been quite different, sometimes with sand dunes rolling away from the east face of the Rock, sometimes with marshes and a river estuary, now drowned beneath the Mediterranean. Herds of game would have roamed the coastal plains around Gibraltar – horse, deer, at times even elephants and rhinoceros – and the Rock itself was home to ibex (wild goat) and vultures. It was also home to Neanderthals who would have used the vantage point of the Rock to survey the surrounding lands in their search for food. The Gibraltar limestones contain many caves and rock shelters, and some of these preserve important evidence of the Neanderthals and their way of life. The Rock of Gibraltar was one of the first places to yield up finds of these ancient people, and it may have been one of their last refuges before extinction. This volume describes the results of excavations conducted between 1995–1998 in two Gibraltar caves, Gorham's and Vanguard, to recover and date further evidence of the Neanderthal occupation of the region.

Forbes' Quarry and Devil's Tower

The accidental discovery of a fossilized human cranium, blasted out of Forbes' Quarry, below the North Face of the Rock, nearly placed Gibraltar in the forefront of prehistoric studies about 150 years ago. In September 1864, 16 years after its discovery, George Busk exhibited this cranium at the British Association for the Advancement of Science meeting in Bath (Busk 1864), and Hugh Falconer suggested that it be made the type of a new human species 'Homo calpicus', named after Mons Calpe. But this proposal was overtaken by the publication in the same year of the species name *Homo neanderthalensis*, by William King, based on the Neander Valley (Feldhofer) skeleton from Germany, the first time a new species of human had been properly and scientifically proposed. The German skeleton thus got most of the scientific attention, and such famous scientists as Thomas Huxley, Rudolf Virchow and even Charles Darwin commented on the Neanderthal find, disregarding the equally informative Gibraltar specimen.[1] If things had gone differently, we might have talked of 'Gibraltar Woman' rather than 'Neanderthal Man', since the Forbes' Quarry individual is judged from its size and shape to have been a relatively small female (Fig. 1.1).

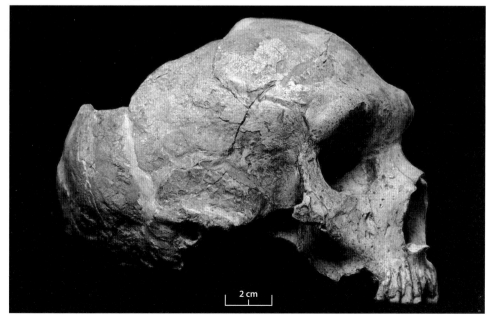

2 cm

Fig. 1.1 The Gibraltar cranium from Forbes' Quarry, found in 1848. Photo: Natural History Museum, London.

1 In a letter to J.D. Hooker dated the 1st. September, 1864, Darwin wrote: 'F. (Falconer) brought me the wonderful Gibraltar skull' (cf. Menez, A. (ed), 2009: *Human Evolution. 150 Years After Darwin* (Gibraltar: Calpe Conference, Gibraltar Museum, Gibraltar), 9–16).

The Forbes' Quarry cranium had to wait nearly 50 years to get the attention it deserved, from a subsequent generation of scientists, such as William Sollas (1907) and Arthur Keith (1911). Comparative studies of its anatomy showed that the Forbes' Quarry specimen was similar to other western European Neanderthals from sites such as the Neander Valley, Spy (Belgium) and La Chapelle-aux-Saints and La Ferrassie (France). Unfortunately, even today, the age and exact provenance of the Gibraltar skull within Forbes' Quarry is uncertain, although work is in progress to date surviving cave sediments and matrix from the skull itself. Nevertheless, it remains one of the best-preserved Neanderthal crania yet found, and as a probable female individual, it provides valuable data on Neanderthal skeletal variation.

A second significant Neanderthal find was made in Gibraltar in 1926, at the Devil's Tower site, surrounding a cleft in the North Face limestone, not far east of Forbes' Quarry (Garrod *et al.* 1928). Excavated systematically, it had associated animal bones, Mousterian artefacts, and charcoal. At present, new dating work is also in progress on some of these materials. The fossil remains consist of parts of the upper and lower jaws and braincase of a Neanderthal child (Fig. 1.2). The original assumption that they represented a single child about five years old at death was challenged by Tillier (1982), who proposed that these bones might instead derive from two children, one aged about three years at death (the temporal bone) and the other about five (the rest of the bones). However, subsequent studies using incremental lines on the teeth and comparisons with recent individuals of known age at death reaffirmed the unity of the cranial material, but suggested that the child might have been about four years old at death (Stringer *et al.* 1990). More recently, the Gibraltar Neanderthals have been the subject of several Computerized Tomographic (CT) studies (Zollikofer *et al.* 1995), and the distinctive form of the inner ear now known for Neanderthals was first recognized in these specimens (Spoor et al. 2003). Such studies have shown that marked quantitative differences in skull morphology can be demonstrated between Neanderthals and modern humans at an early stage in their development, further strengthening the interpretation of their evolution as separate species (Ponce de Leon and Zollikofer 2001).

The Gibraltar Caves Project

Over the last 20 years there has been remarkable progress in documenting the evolutionary lineages of the Neanderthals in Europe, and of modern humans in Africa, and recent studies in the Iberian peninsula have raised intriguing issues about the coexistence and possible interaction of the last Neanderthals and the earliest modern humans in the region (d'Errico *et al.* 1998). Evidence from south of the Ebro in central-southern Spain and Portugal suggests that late Mousterian industries persisted in these regions until 30 ka BP or even later (Zilhão 2006; Finlayson *et al.* 2006). Thus areas in the south of the peninsula may have provided a last refugium for Neanderthals, with their disappearance being due to the eventual spread of *Homo sapiens* into the region, either replacing (Mellars 2006) or assimilating them (Zilhão 2006). Alternatively, the Neanderthals may have become extinct because of unfavourable changes in climate and habitat (Finlayson 2004; Stewart 2007), with little interaction with early modern humans. Sites on Gibraltar undoubtedly have important contributions to make to this debate, and the Gibraltar Caves Project (GCP) developed as a collaboration between UK and Gibraltar Institutes in order to realize this potential through new excavations.

While the sites of Forbes' Quarry and Devil's Tower are now, respectively, unpromising and probably too dangerous for further excavation, there are several other sites in Gibraltar preserving evidence of Neanderthal activities. One, Ibex Cave, is high on the eastern face of the Rock, while four others lie to the south-east, close to the sea at 'Governor's Beach' (Fig. 1.3). When new excavations in Gibraltar began to be planned from 1984 onwards, these sites were

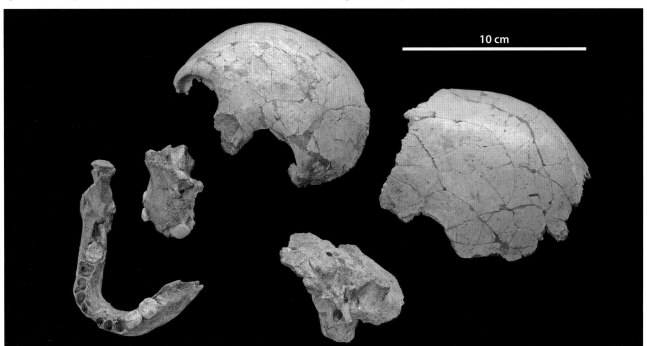

Fig. 1.2 Devil's Tower human remains, found in 1926. Photo: Natural History Museum, London.

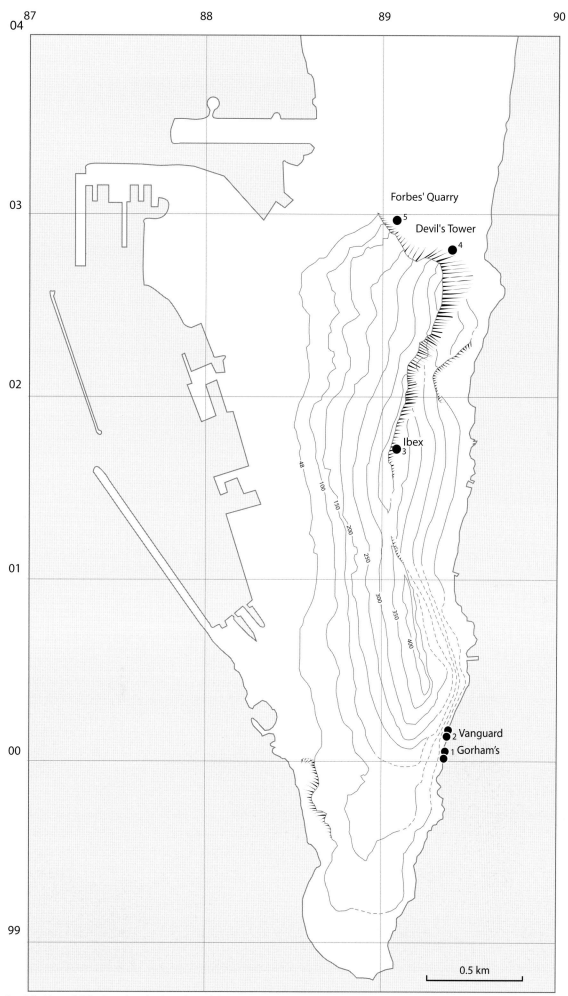

Fig. 1.3 Map of Gibraltar, showing location of sites mentioned in text.

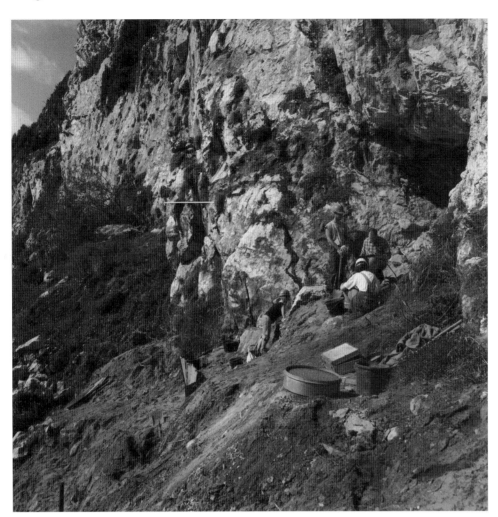

Fig. 1.4 View of Ibex Cave under excavation in 1994. Photo: Natural History Museum, London.

considered for further investigation in preference to Forbes' Quarry and Devil's Tower. Ibex Cave is located at about 260 m above sea level on the east side of the Rock, at the top of the former water catchments (Fig. 1.4). These huge expanses of metal sheeting were mainly constructed at the beginning of the last century over a natural slope of Pleistocene breccias and wind-blown sand. The cave was first exposed in 1975, during quarrying operations on the sands and breccias, following the first stages in the dismantling of one of the highest levels of catchment sheeting. Workmen at the site collected over 50 artefacts of Middle Palaeolithic character from the sands filling the cave entrance, and a small excavation was also undertaken at that time in the cave entrance, producing some vertebrate material, and marine and terrestrial mollusca. In 1994, systematic excavations were carried out at the site by the GCP, with the collection of further artefacts and faunal remains. Many of the tools are made from a dark red chert, local to Gibraltar, but the raw material was probably transported to the site in the form of beach cobbles (Barton 2000a). However, taphonomic work on the Ibex Cave faunas suggests that human impact on the faunas was negligible (see Fernández-Jalvo and Andrews 2000). Human occupation was probably sporadic, with the main body of Ibex lithics apparently deriving from a single discrete episode of activity during the period of deposition of Unit 2. Tooth enamel from a cervid and ibex excavated from the underlying Unit 3 was dated using ESR (Rhodes et al. 2000), giving mean age estimates of about 37 ka (Early Uptake) and 49 ka (Linear Uptake). The dates certainly support a mid-last glaciation age for the

fauna of Unit 3 and they provide a maximum age for the overlying Unit 2 and its contained Middle Palaeolithic artefacts. While Ibex Cave produced some interesting evidence of denning by foxes and wolves, the phase of Neanderthal occupation seemed to have been relatively brief, and this, combined with the severe logistical problems of the site, persuaded the GCP to switch attention to the caves on Governor's Beach in 1995.

Today, this beach mainly consists of fine limestone blast debris from military tunnelling operations, but there are also remnants of a more ancient cemented beach which probably accumulated during Marine Isotope Stage (MIS) 5e, which was the last substantial period of time with a climate and sea level like that of the present day (Rodríguez-Vidal et al. 2004). The stretch of coastline around Governor's Beach is under military control, which has helped to protect the caves from casual visitors, although they have been used for military training. There are four main caves in a row facing the sea – from the north, these are Boat Hoist, Vanguard, Gorham's and Bennett's Caves (Figs. 1.3 and 1.5). Boat Hoist and Bennett's have long been emptied of most of their ancient sediments by marine erosion, a process that has continued throughout the Holocene, because of the high sea level. Nevertheless, the surviving deposits which cling to the cave walls bear witness to occupation by the Neanderthals – their stone tools can still be seen in the sediments in places. In contrast, Vanguard Cave was a pristine site that appeared entirely filled with sand, while Gorham's, the largest of these caves, displayed a mixture of disturbed and untouched deposits.

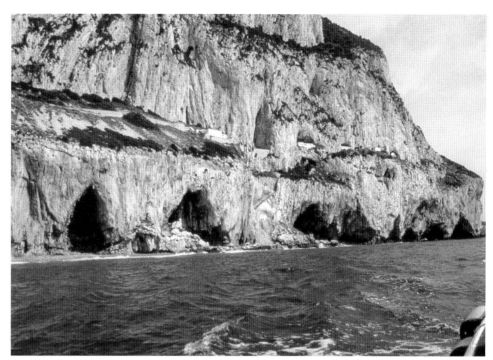

Fig. 1.5 The caves of Governor's Beach. From left: Bennett's Cave, Gorham's Cave, and the double arch of Vanguard and Boat Hoist Caves. Photo: Natural History Museum, London.

Although Captain A. Gorham is credited with the discovery in 1907 of the cave that bears his name, it was not systematically investigated until after 1945, when access was still only possible by sea from below, or by ropes from above. A geologist serving in the British Army, G. B. Alexander, conducted excavations at the back of Gorham's Cave and, although his work was never published, he showed that the highest deposits at the back of the cave contained valuable historic and prehistoric material. The cave had obviously been a sacred site for the sailors of Phoenicia, Carthage and Rome for they had regularly visited it to deposit offerings to their gods, presumably in the hope of securing a safe passage through the Straits of Gibraltar. The dark earthy deposits that Alexander excavated were rich in pottery, coins, jewellery and scarabs (tiny, engraved replicas of the sacred Egyptian dung beetle). The deposits extended for at least a couple of metres in depth, and reached as far back as the Neolithic. Below these layers were much more ancient levels, extending beyond the Holocene and into the Pleistocene, in places containing Upper and Middle Palaeolithic artefacts. These were subsequently investigated by the British archaeologist John d'Arcy Waechter.

Waechter supervised a largely untrained team who removed major portions of the Gorham's Cave sequence from 1947–1954 (Fig. 1.6), and in doing so established that the cave contained an immense record of human occupation, spanning much of the last 130,000 years. He recorded that a raised beach, probably belonging to the last interglacial (MIS5), lay towards the base of Gorham's Cave, and hence all the higher archaeological levels were younger than that age. Above this, there was at least 10 m of evidence of Neanderthal occupation, marked by Middle Palaeolithic tools, and then a couple of metres of deposits containing Upper Palaeolithic tools. Capping the whole sequence were the Holocene levels of the last few thousand years, discussed already. Waechter also reported the presence of ancient hearths at various levels in the cave, especially in the Upper Palaeolithic, and animal bones throughout the sequence, dominated by the remains of ibex, rabbit, and

numerous species of bird. Unfortunately, many aspects of Waechter's excavations were never properly published, and much of the material he recovered remains unaccounted for. However, elsewhere in this volume we have published for the first time an account of the mammalian fauna from Waechter's excavations, written by A. J. Sutcliffe in 1958 (Chapter 11).

Waechter's stratigraphic sequence of layers running approximately horizontally east–west must have been considerably simplified compared with the complex reality which we have since observed (Waechter 1951; 1964). However, he delineated a series of Layers G, K, M, P, R and S1 as Mousterian, with Layers H, J, L, N, O, Q, S2–3 and T as sterile (by which he meant lacking in artefacts), and as already mentioned he reported a 'fossil beach' at 9.7 m above mean sea level forming his Layer U at the base of his sequence. At that time the basal deposits at the cave entrance were masked by recent beach deposits so that he was unaware of the true raised beach that lay outside the cave (Chapter 2). Waechter also recognized a number of Upper Palaeolithic Layers (B, D, E and F), capped by the historic 'Punic' Layer A. Typologically, Waechter noted the presence of prepared cores throughout the Mousterian levels, even including an example from Layer U. However, he believed that Layer G was separated from the lower levels by an interstadial (represented by Layer J), and was distinctive in having only a few, inferior, prepared cores, but large blades. Regarding the Upper Palaeolithic levels, Waechter eventually recognized the industries of each Layer B, D and F as distinct, but avoided assigning them to existing categories such as Aurignacian or Solutrean (he was aware that there was little evidence of true Aurignacian or Châtelperronian industries elsewhere in southern Iberia). Waechter's attempts at dating the archaeological sequence were heavily influenced by Frederick Zeuner's assessment of the stratigraphy (Zeuner 1953), and the models underlying this, but some independent chronological control was provided from charcoal samples collected by Topp and Oakley in 1957. Gröningen radiocarbon determinations

dated the Upper Palaeolithic of Layer D at about 28,000 years BP and the Middle Palaeolithic of G to at least 47,000 years BP (Waechter 1964).

When one of us (CS) began to develop the first stages of fieldwork in Gibraltar from 1984, Gorham's Cave looked the most promising site for further excavation, particularly because Waechter had evidently, and very fortunately, not excavated out all the sediments. In 1989, CS organized a short exploratory excavation of the surviving cave deposits in collaboration with Jill Cook of the British Museum and the then Director of the Gibraltar Museum, Joaquin Bensusan. A study of the cave's geoarchaeology employing soil micromorphology techniques was also begun at this time by Paul Goldberg of Boston University. Sand blowing up into the cave for 35 years since Waechter had left, and repeated training visits by soldiers, had obscured the sequence. But three weeks of fieldwork showed that significant parts of the Middle Palaeolithic and Upper Palaeolithic levels still survived and a number of bones and artefacts were recovered from Waechter's spoil heaps in front of the cave, since his team cannot have screened (sieved) the deposits for small finds before dumping them. The British Museum continued limited excavations in 1991, and then a new and more ambitious phase of work was planned with the current Director of the Gibraltar Museum, Clive Finlayson. This began with the excavation of Ibex Cave in 1994, and then between 1995–1998 our work at Gorham's and Vanguard Caves concentrated on re-exposing, recording and sampling what survived of Waechter's sections in Gorham's Cave, and excavating selected Middle and (where possible) Upper Palaeolithic levels containing lithics, fauna, charcoal and other plant material in both sites (Fig. 1.7).

Excavating the caves properly required a large team of up to 30 excavators and supervisors on site, finds assistants to process material both in Gibraltar and London, site managers/drivers, specialists to run sieving operations, and beyond those, experts in lithics, dating, faunal and floral remains, sedimentology and taphonomy (Fig. 1.8). This volume contains many contributions by these specialists, and others who have worked on the materials subsequently. We were also regularly joined by other Gibraltar Museum staff and associates, local volunteers, who willingly worked through their holidays for us, and a group of Spanish archaeologists, whose roles included particular study of sediments at the back of Gorham's Cave. These colleagues have continued their work with Clive Finlayson since 1999 (e.g. see Finlayson et al. 2006).

Gorham's Cave

When we began our work at Gorham's Cave in 1995, our immediate objectives were to locate and date late Middle and early Upper Palaeolithic occupation levels in order to

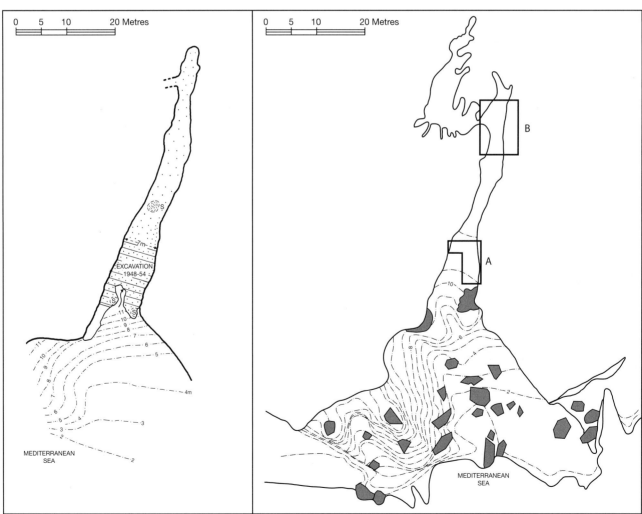

Fig. 1.6 Gorham's Cave. *Left*: plan of Waechter's 1948–1954 excavations (after Waechter 1951), 's' indicates position of stalagmite boss. *Right*: areas investigated by the Gibraltar Caves Project teams, A = excavated in 1995–1998, B = area at the back of the cave excavated in 1997–2005 (after Finlayson et al. 2008).

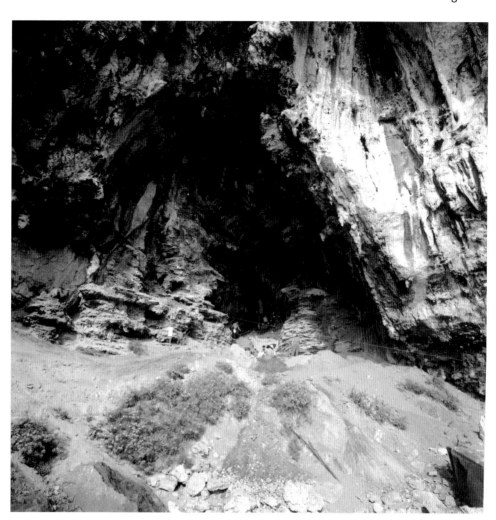

Fig. 1.7 Gorham's Cave. View of the cave entrance, showing the cemented cornices and disturbed material in the foreground. Photo: Natural History Museum, London.

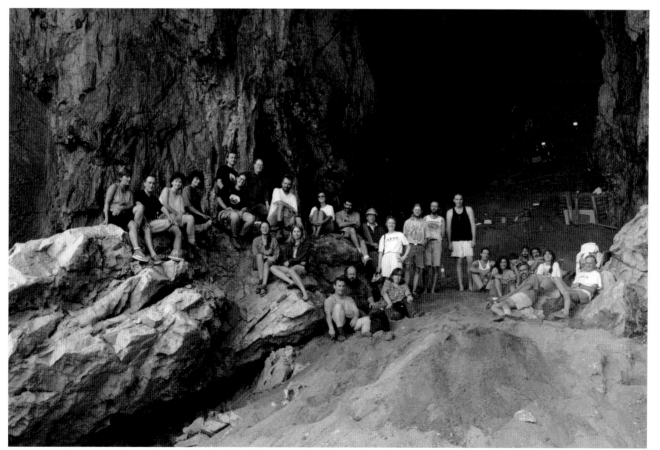

Fig. 1.8 Some of the members of the excavation team in the 1997 season, photographed in front of Vanguard Cave. Photo: Natural History Museum, London.

Fig. 1.9 Gorham's Cave, looking north-east; archaeological material in Area III, D106 within the SSLm(Usm).2 unit. Photo: Natural History Museum, London.

investigate the local transition between Neanderthal and modern humans, using their archaeological signatures. If the deposits were rich enough, we also hoped to compare the way these different populations had utilized the cave through time. The assumption was that Gorham's would be the main focus of attention, but with the hope that investigations would also reveal significant evidence beneath the undisturbed sands of Vanguard Cave, a hope that was soon realized.

At Gorham's Cave, we quickly re-exposed the areas cleaned in 1989 and 1991 and began to excavate in Middle Palaeolithic levels (Fig. 1.9), while at Vanguard we cut a series of steps into the sand, initially showing only sparse evidence of bones and artefacts. The 1995 season at Gorham's (in our designated Areas I–II) concentrated on some of the uppermost Middle Palaeolithic levels where Waechter must also have excavated (Figs. 1.6 and 1.10). In Area I there were rich collections of stone tools, bones, burnt nuts, seeds and charcoal, mapping areas where the Neanderthals had fireplaces and processed meat and vegetable foods. A radiocarbon date for charcoal came out at close to the limits of the method – about 45,000 years – and we planned to work up from that level until we reached the oldest Upper Palaeolithic layers. However, the following winter was one of the wettest on record in the region, causing extensive erosion in Gorham's Cave. This led to massive amounts of the unexcavated Upper Palaeolithic levels to collapse onto the Middle Palaeolithic sediments we had been digging, which meant we had to modify our plans and areas of excavation from 1996 onwards. Further excavations focused on exposed stratigraphic units of Area III and the northern cornice (Fig. 1.11), and further back (Areas I–II), where a range of dating methods have been applied to the stratigraphic sequence, especially radiocarbon accelerator dates on bone and charcoal (Pettitt and Bailey 2000; and Chapter 5) and OSL measurements (Chapter 6). In the last season of this phase of work, in 1998, we extended our sampling seawards to the east of the cave entrance (Area IV), and also returned to clean and excavate the deposits in upper Area I affected

by the post-1995 collapse, and believed to bracket the Middle–Upper Palaeolithic transition. One of the subsidiary objectives of our work at Gorham's was to throw further light on the deposits excavated by Waechter some 25 years earlier, and it is pleasing that our initial pessimism about correlating our excavations with his has receded somewhat through the studies recorded later on in this monograph.

Vanguard Cave

Up to 1995, the Pleistocene sediments in Vanguard Cave were largely buried under a natural sand slope, although surface finds of artefacts and fauna could be made. Exploratory sampling work was carried out in 1995, and larger-scale excavations were planned for 1996 (Figs. 1.12, 1.13 and 1.14), although it was very early in the season – at the end of the first week – that there was a major surprise that almost caused the dig to be abandoned. A trench was opened up at the base of the sand slope, and some human foot bones

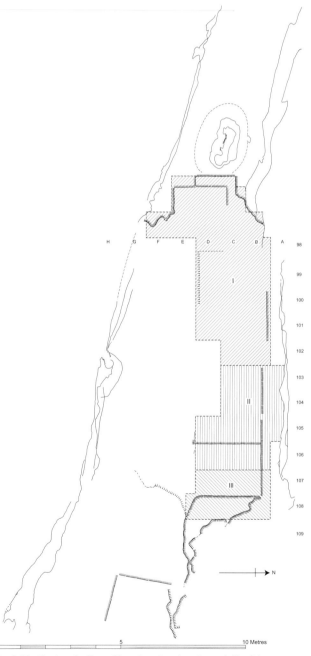

Fig. 1.10 Gorham's Cave. Site plan showing Areas I–III of the 1995–1998 excavations.

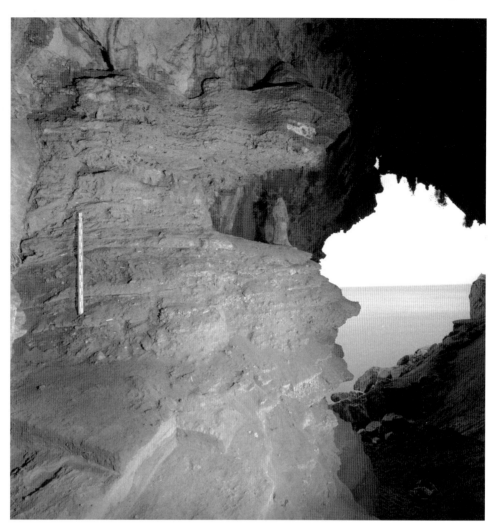

Fig. 1.11 Gorham's Cave. View eastwards out of the cave, with the sediments of the northern cornice on the left. Photo: Natural History Museum, London.

were discovered not far below the surface. These were not fossilized and seemed quite recent, and we therefore telephoned the Gibraltar Police. Two days later, following police instructions, the skeleton of a teenage girl had been exposed. The apparent burial had clearly been carried out with care, and the body laid face up, with arms by the side and legs extended. The teeth in the skull were in good condition, with no evidence of dental treatment, and this led the police to surmise that this body was not that of a local, but of someone who had been brought in by a small boat for burial – perhaps even that of an illegal immigrant from North Africa. The girl concerned remained unidentified at

Fig. 1.12 Vanguard Cave, view of cave entrance. Photo: Natural History Museum, London.

Fig. 1.13 Vanguard Cave during an early stage of excavation in the Middle Area, 1995. Photo: Natural History Museum, London.

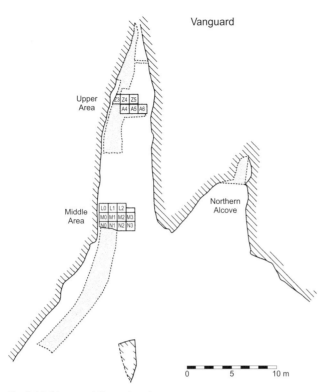

Fig. 1.14 Vanguard Cave: site plan.

the time of the inquest, and an open verdict on the circumstances of the burial was returned.

Following this unfortunate interruption, excavations at Vanguard were allowed to resume and further upslope exposed a series of rich Middle Palaeolithic levels separated by intervening deposits of sand (Fig. 1.15). The whole sediment sequence of the cave is about 17 m thick and sits upon the same wave-cut platform as seen at the base of Gorham's Cave. If it equates with one of the higher sea-level episodes of Marine Isotope Stage (MIS) 5 (Rodríguez-Vidal *et al.* 2004) then it would be an important chronological marker, providing a *terminus post quem* for the age of the archaeological deposits. Our excavation strategy was to develop a number of step-like trenches into the sloping section in order to follow well preserved Middle Palaeolithic occupation horizons. These were defined by more or less horizontal layers of finely laminated organic-rich silts and clay that were continuous and clearly extended further into the cave.

A particularly remarkable find from the upper levels of Vanguard provides the strongest evidence yet found that Neanderthals utilized marine food resources. In 1997, a discrete Middle Palaeolithic layer was excavated containing mussel shells of consistent size, alongside ash, charcoal, coprolites and refitting lithics (Barton *et al.* 1999; Barton 2000b; Fernández-Jalvo and Andrews 2000). The presence of the mussels implies that they were selected and transported to the cave (presumably in containers) from their marine or estuarine source. As well as revealing new information on consumption patterns we are now able to add some further detail on the likely season of occupation and place the layer within a more secure chronological framework.

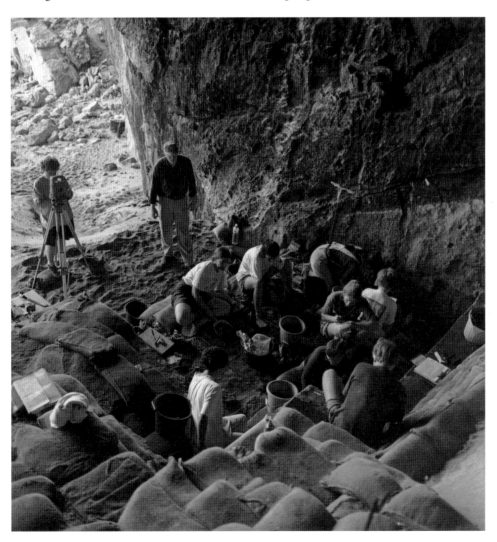

Fig. 1.15 Vanguard Cave: excavations in progress in the Middle Area of the cave. Photo: Natural History Museum, London.

Lower in the cave sequence are a more thickly developed series of occupation horizons that contain at least one hearth and considerable quantities of artefacts and bones, as well as further evidence for the exploitation of marine resources by Neanderthals. In 1998, part of the mandible of a monk seal was recovered from one of these lower stratigraphic levels, with apparent cut-marks and in association with Middle Palaeolithic artefacts, although it is not known whether its presence is the result of scavenging or hunting. Optically Stimulated Luminescence (OSL) age determinations demonstrate that much of this sequence and the deposits above accumulated during early parts of MIS5.

A small alcove in the north of the site was also subjected to exploratory investigation.

Besides a shallow scooped-out hearth there were relatively few associated lithic artefacts. The deposits seem to have been mostly disturbed by hyaena activity (*Crocuta* bones and chewed food debris) which makes it all the more remarkable that the hearth survived. Small fragments of pine charcoal retrieved from this feature provided an infinite radiocarbon age of >44,100 BP but otherwise there were few other clues as to its associations. Despite the recovery of different kinds of botanical evidence from these and other levels in both caves, repeated attempts to retrieve pollen (even from coprolites mentioned above) proved negative.

Finally, study of the lithostratigraphy and micromorphological analyses of samples from Gorham's and Vanguard Caves have provided valuable data for palaeoenvironmental and taphonomic analyses. These studies show that the neighbouring caves have rather different sedimentological histories, but their records are fortunately complementary rather than conflicting. A coastal environment dominated by sand dunes influenced both, and this served to mediate any direct marine influence on sedimentation, *contra* the views of Waechter and Zeuner. Whereas Vanguard shows rather uniform patterns through the areas we have excavated, with only a few relatively undisturbed combustion zones separated by large volumes of sand input, Gorham's shows much more complex depositional and post-depositional processes both vertically and horizontally, and much greater signs of biological influences. While some palaeoclimatic signals may still be deduced from these sequences, they are far from the straightforward reflections of sea level and glacial fluctuation envisaged in some of the earlier work at Gorham's.

Several preliminary reports on aspects of our excavations have been published (see e.g. Stringer *et al.* 1999; Barton *et al.* 1999; Finlayson *et al.* 2000; Stringer *et al.* 2000), but in the detailed presentation of evidence that follows, contributors cover the lithostratigraphy and sediment micromorphology of the two caves (Collcutt, Currant, Goldberg, Macphail), chronology (Higham et al., Rhodes), palaeobotany (Ward, Gale, Carruthers), herpetofauna (Gleed-Owen, Price), avifauna (Cooper), small mammals (Price) and large mammals (Currant, Jacobi, Stringer, Sutcliffe, Price), coprolitic evidence (Macphail, Cruse), taphonomy (Fernández-Jalvo, Cáceres) and lithic artefacts (Barton, Jennings). The monograph concludes with modelled data on the palaeoecology and past climates of southern Iberia (Jennings) and the overall pattern of human occupation

recorded in the caves (Barton, Stringer *et al.*). Although the original primary objectives of finding and dating the Middle–Upper Palaeolithic transition at the sites remained elusive, the rich records uncovered in our excavations have undoubtedly transformed our understanding of Neanderthals and their adaptations during the Late Pleistocene of Iberia.

Acknowledgements

The author would like to thank all the many participants in the Gibraltar Caves Project (on-site and post-excavation), and the following funding bodies for their support of the project: National Geographic Society, Leakey Foundation, British Academy, Natural History Museum, Society of Antiquaries, NERC, Oxford Brookes University, Oxford University, the Gibraltar Heritage Trust, Gibraltar Earth Sciences and Archaeology Trust, and the Government of Gibraltar. Thanks are also due to the staff of the Oxford Radiocarbon Accelerator Unit for their work in producing AMS radiocarbon dates, and to Erik Trinkaus for the quote from Mark Twain.

References

Barton, R. N. E. 2000a: Raw material exploitation and lithic use at the Mousterian site of Ibex Cave, Gibraltar. In Finlayson, C., Finlayson, G. and Fa, D. (eds.), *Gibraltar During the Quaternary* (Gibraltar: Gibraltar Government Heritage Publications, Monograph 1), 127–134.

Barton, R. N. E. 2000b: Mousterian hearths and shellfish: late Neanderthal activities on Gibraltar. In Stringer, C. B., Barton, R. N. E. and Finlayson, J. C. (eds.), *Neanderthals on the Edge* (Oxford: Oxbow Books), 211–220.

Barton, R. N. E., Currant, A. P., Fernández-Jalvo, Y., Finlayson, J. C., Goldberg, P., Macphail, R., Pettitt, P. B. and Stringer, C. B. 1999: Gibraltar Neanderthals and results of recent excavations in Gorham's, Vanguard and Ibex Caves. *Antiquity* 73, 13–23.

Busk, G. 1864: Pithecoid Priscan Man from Gibraltar. *The Reader* 4, 109–110.

D'Errico, F., Zilhao, J., Julien, M., Baffier, D. and Pelegrin, J. 1998: Neanderthal acculturation in western Europe? A Critical Review of the Evidence and Its Interpretation. *Current Anthropology* 39, supplement, S1–S44.

Fernández-Jalvo, Y. and Andrews, P. 2000: The taphonomy of Pleistocene caves, with particular reference to Gibraltar. In Stringer, C. B., Barton, R. N. E. and Finlayson, J. C. (eds.), *Neanderthals on the Edge* (Oxford: Oxbow Books), 171–182.

Finlayson, C. 2004: *Neanderthals and Modern Humans: an Ecological and Evolutionary Perspective* (Cambridge: Cambridge University Press).

Finlayson, C., Finlayson, G. and Fa, D. (eds.) 2000: *Gibraltar During the Quaternary* (Gibraltar: Gibraltar Government Heritage Publications, Monograph 1).

Finlayson, C., Giles Pacheco, F., Rodriguez-Vidal, J., Fa, D., Guiterrez Lopez, J., Santiago Perez, A., Finlayson, G., Allue, E., Baena Preysler, J., Caceres, I., Carrion, J., Fernández-Jalvo, Y., Gleed-Owen, C., Jiminez Espejo, F., Lopez, P., Lopez Saez, J., Riquelme Cantal, J., Sanchez Marco, A., Giles Guzman, F., Brown, K., Fuentez, N.,

Valarino, C., Villapando, A., Stringer, C., Martinez Ruiz, F. and Sakamoto, T. 2006: Late survival of Neanderthals at the southernmost extreme of Europe. *Nature* 443, 850–853.

Finlayson, J.C., Fa, D., Jimenez Espejo, F., Carrión, J., Finlayson, G., Giles Pacheco, F., Rodríguez-Vidal, J., Stringer C. and Martinez Ruiz, F. 2008: Gorham's Cave, Gibraltar. The Persistence of a Late Neanderthal Population. *Quaternary International* 181, 64–71.

Garrod, D.A.E., Buxton, L.H.D., Smith, G. Elliot and Bate, D.M.A. 1928: Excavation of a Mousterian Rock-shelter at Devil's Tower, Gibraltar. *Journal of the Royal Anthropological Institute* 58, 33–113.

Keith, A. 1911: The early history of the Gibraltar cranium. *Nature* 87, 313–314.

Mellars, P. 2006: A new radiocarbon revolution and the dispersal of modern humans in Eurasia. *Nature* 439, 931–935.

Pettitt, P.B. and Bailey, R.M. 2000: AMS radiocarbon and luminescence dating of Gorham's and Vanguard Caves, Gibraltar, and implications for the Middle to Upper Palaeolithic transition in Iberia. In Stringer, C.B., Barton, R.N.E. and Finlayson, J.C. (eds.), *Neanderthals on the Edge* (Oxford: Oxbow Books), 155–162.

Ponce de León, M.S. and Zollikofer, C.P.E. 2001: Neanderthal cranial ontogeny and its implications for late hominid diversity. *Nature* 412, 534–538.

Rhodes, E., Stringer, C., Grun, R., Barton, R.N.E., Currant, A. and Finlayson, C. 2000: Preliminary ESR dates from Ibex Cave, Gibraltar. In Finlayson, C., Finlayson, G. and Fa, D. (eds.), *Gibraltar During the Quaternary* (Gibraltar: Gibraltar Government Heritage Publications, Monograph 1), 109–112.

Rodríguez-Vidal, J., Caceres, L.M., Finlayson, J.C., Gracia, F.J. and Martinez-Aguirre, A. 2004: Neotectonics and shoreline history of the Rock of Gibraltar, southern Iberia. *Quaternary Science Reviews* 23, 2017–2029.

Sollas, W. 1907: On the cranial and facial characters of the Neanderthal race. *Phil. Trans. R. Soc. London B* 199, 281–339.

Spoor, F., Hublin, J.-J., Braun, M. and Zonneveld, F. 2003: The bony labyrinth of Neanderthals. *Journal of Human Evolution* 44, 141–165.

Stewart, J.R. 2007: Neanderthal extinction as part of the faunal change in Europe during Oxygen Isotope Stage 3. *Acta zoologica cracoviensia* 50A (1–2), 93–124.

Stringer, C.B., Dean, M.C. and Martin, R.D. 1990: A comparative study of dental and cranial development within a recent British sample and among Neanderthals. In DeRousseau, C.J. (ed.), *Primate Life History and Evolution* (New York: Wiley-Liss), 115–152.

Stringer, C., Barton, R.N.E., Currant, A.P., Finlayson, J.C., Goldberg, P., Macphail, R. and Pettit, P. 1999: The Gibraltar Palaeolithic revisited: new excavations at Gorham's and Vanguard caves 1995–7. In Davis, W. and Charles, R. (eds.), *Dorothy Garrod and the progress of the Palaeolithic* (Oxford: Oxbow), 84–96.

Stringer, C.B., Barton, R.N.E. and Finlayson, J.C. (eds.) 2000: *Neanderthals on the Edge* (Oxford: Oxbow Books).

Tillier, A.M. 1982: Les enfants néanderthaliens de Devil's Tower (Gibraltar). *Zeitschrift für Morphologie und Anthropologie* 73, 125–148.

Waechter, J.d'A. 1951: The excavation of Gorham's Cave, Gibraltar: preliminary report for the seasons 1948 and 1950. *Proceedings of the Prehistoric Society* NS 17, 83–92.

Waechter, J.d'A. 1964: The excavation of Gorham's Cave, Gibraltar 1951–54. *Bulletin of the Institute of Archaeology (University of London)* 4, 189–221 (plus plate 13 on p. 269).

Zeuner, F.E. 1953: The chronology of the Mousterian at Gorham's Cave, Gibraltar. *Proceedings of the Prehistoric Society* NS 19, 180–188.

Zilhão, J. 2006: Neandertals and moderns mixed, and it matters. *Evolutionary Anthropology* 15, 183–195.

Zollikofer, C.P., Ponce de León, M.S., Martin, R.D. and Stuckl, P. 1995: Neanderthal computer skulls. *Nature* 375, 283–285.

Gorham's Cave

This section deals with the excavations at Gorham's Cave between 1995 and 1998. The early chapters provide a lithostratigraphic description of the 16 m cave sequence and cover other essential aspects of the sediments including a study of their micromorphology (Chapters 2 to 4). This is followed by chapters on the AMS and OSL dating of the deposits (Chapters 5 and 6) and the detailed consideration of palaeoenvironmental remains and their interpretation (Chapters 8 to 11). The final chapter (12) gives a full description of the Middle and Upper Palaeolithic artefact assemblages recovered from each of the layers. An overview of results is provided in the summary at the end of this section.

2 Gorham's Cave lithostratigraphy

S.N. Collcutt and A.P. Currant

Introduction

Despite its present position close to the current marine shore, Gorham's Cave appears to be a terrestrial cave which has been opened up and modified by the sea, rather than being a true sea-cave (Fig. 2.1). It is formed along a near-vertical fault or fissure, which dips north in relation to the limestone bedrock structure. The cave is high-roofed and the walls tend towards the vertical in many places. The limestone 'floor' has never been reached. The internal deposits consist primarily of bedded sands that, prior to the earliest excavations, would have formed an eroding vertical sea 'cliff' across the whole of the 50 m wide entrance; these deposits extend for about 80 m inwards beyond the present dripline. The sediments of the cave mouth are now very heavily excavated and/or disturbed. Part of that original cliff still survives on the north side of the entrance, but it has been largely obliterated across most of the central and much of the southern zone, predominantly by modern military activity.

The history of exploration of the cave is described in Chapter 1. The grid system used by the Gibraltar Caves Project was the same as that set up during a short exploratory season at the cave in 1989. The edges of the grid were marked by metal hooks on the cave wall which we subsequently enhanced by adding white-painted markings with numbers. The metre squares are aligned with respect to the long axis of the cave (roughly east–west) and identified via a system of letters and numbers. The numbers of the squares run parallel to the wall (increasing outwards, to the east) and the letters (from A in the north and then ordered alphabetically southwards) across the width of the cave (Fig. 2.2). The 1995–1998 excavations are indicated by the dashed line in this figure; these excavations were also divided into three 'Areas' along the cave axis, with the Area I/II boundary at the 100/101 easting and the Area II/III boundary at the 106/107 easting. There are very faint survey marks on the walls that survive from Waechter's excavation. We estimate that the area of his excavations (Fig. 1.6) extended into the cave as far as our 101–102 boundary but most of his trenches have been obliterated by sediment collapse; as it passes between the two cemented remnants of deposits which we have called the North and South Cornices, the outer end of Waechter's excavation area is intersected by the present

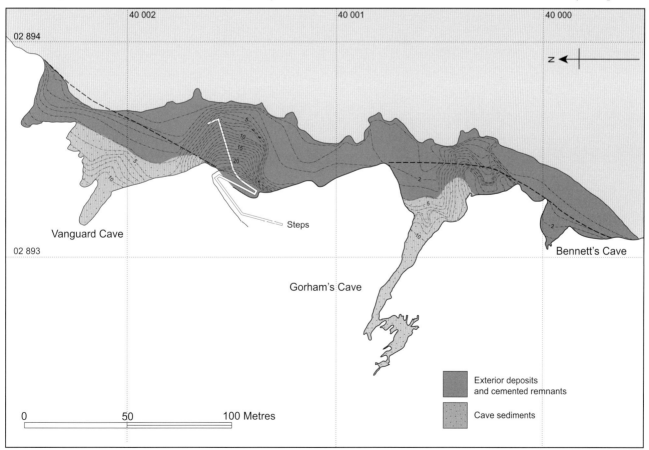

Fig. 2.1 Location of Gorham's Cave on the east side of Gibraltar.

main erosion slope at the cave entrance. Our reference point (to which we tied our vertical measurements) was established on the north wall of the cave by a painted marking close to the dripline near the entrance; the Site Datum 'zero' in this system is equivalent to a level approximately 1–2 m above current mean sea level, and levels above this are given as 'cmaSD' or 'maSD', as the case may be.

Procedure

Due to the relatively long duration of the present excavation programme, the changing personnel, and the dispersed and/or overlapping nature of work within and between study seasons and specialisms, lithostratigraphic nomenclature has been varied and somewhat inconsistent, a problem exacerbated by the difficulty (see below) in understanding how to correlate with Waechter's reported stratigraphy. This is true for the main excavation zone as well as for the lower, less well studied levels of the cave sequence. It was therefore decided

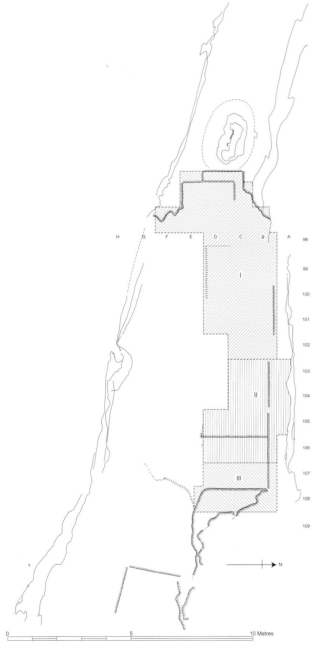

Fig. 2.2 Gorham's Cave. The main 1995–1998 excavations are indicated by the dashed line. Most of the original Waechter trenches have been obliterated by sediment collapse and later work.

to define the (macroscopic) sequence using a new lithostratigraphic system, with the hierarchy uNIT, mEMBER and fORMATION (the 'inversed' capitalization here indicating the informality of the system, since these sediment bodies cannot be traced over sufficient lateral distances to satisfy formal international nomenclature standards). This system is used throughout the volume. In one case, it has been necessary to define a 'dual' mEMBER level sequence, composed of two markedly different but interdigitating lateral facies, prior to internal cross-correlation. The normal sedimentological terms 'bed', 'lens', 'lamination', etc. refer to sedimentary structures, either in a general manner or as constituents of particular uNITS. Note that the term 'brecciated' of most observers (other than Cooper 1996) is equivalent (unless otherwise indicated) to the term 'cemented' of the present chapter.

The full system and supporting observational data are set out in Appendix 2.1. Each mEMBER (in a fORMATION) is first named. Each constituent uNIT is labelled (a simple numbering system appended to the mEMBER code) in the left-hand column of the tabulation; this column also shows the uNIT names formerly used (including those used in previous publications by the team). Previously published correlations with Waechter's stratigraphy have been ignored in Appendix 2.1, pending the dedicated discussion in the main text below. The next column shows the (local) altitude range ('cmaSD') and 'average' thickness of the uNITS as they appear in the excavation section drawings. In the third column appear the descriptive details observed by the team members responsible for recording at various points during the project, and collated by Collcutt.[1]

Figure 2.3 shows the geometry of mEMBERS in a composite long section of the cave, accompanied by key cross-sections and a schematic location plan. The main text below contains a summary at mEMBER level with a brief description of the unifying attributes, but also with references to certain significant subdivisions and uNITS, bringing out the main elements of lithology and deposit geometry relevant to the stratigraphic objective (cf. Chapter 3). The figures in sections of the text are details from Figure 2.3 showing the mEMBER in question highlighted and the component uNITS.

The sequence is more or less continuous (but surviving mostly as a series of oblique deposits in echelon, currently exposed in steps), from the recent surface (high in the back of the cave) to a point at about 6.50 m above Site Datum near the front of the cave (at the base of the standing, partially cemented erosion face of the Northern Cornice), save for any significant deposits which have wedged out or been eroded at unconformities before the extant sections. There is then a significant gap (debris-covered interval, no exposures) to c.5.00 maSD, before the cemented remnants on the northern cave wall and exterior cliff wall, which can be

1 SNC studied most of the final sections on site in 2001 and 2002; APC took part in the original excavations and finalized the lithostratigraphic framework on site with SNC in 2002. The material described in the present chapter lies in that part of the cave from Easting 96 outwards; the exploratory excavations in 2001 westward of the stalagmitic column (seen in Figure 2.5 for instance) encountered increasing bioturbation inwards in the uppermost c.1 m of deposit tested. Those samples described in Chapter 5 from slightly deeper into the cave (further west still) come from Levels III and IV of a separate excavation programme (cf. Finlayson *et al.* 2006).

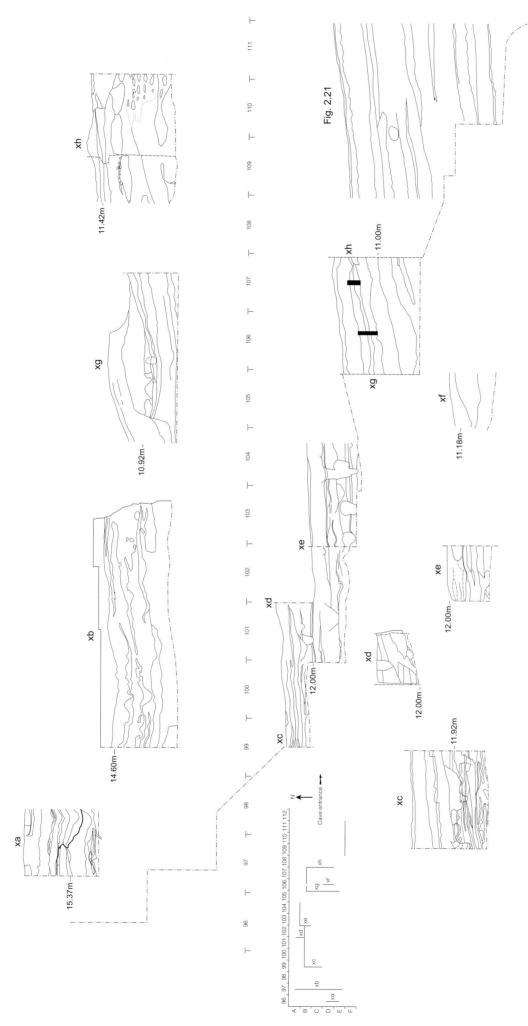

Fig. 2.3 Geometry of mEMBERS in a composite long section of the cave, accompanied by key cross-sections (the locations of individual section lines are shown in plan in the inset).

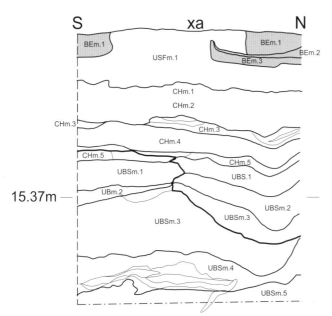

Fig. 2.4 BEm highlighted on detail of Section xa.

traced more or less continuously (and apparently internally conformably) downwards to the littoral deposits cemented to the rock platform close to modern sea level.

Lithostratigraphy and sequence
Upper Gorham's Cave fORMATION (UGCf)
Bioturbated Earth mEMBER (uNITS BEm.1–3)

(Fig. 2.4). These superficial deposits are reddish to dark 'earths', that is, stony loams rich in organic matter and powdery carbonates. The observable stratification is commonly confused, largely due to very strong bioturbation (intercutting burrow forms at various scales). These deposits are assumed originally to have been present throughout the cave interior; closer observation has taken place only towards the back of the cave.

Upper Stalagmitic Floor mEMBER (uNIT USFm.1)

(Figs. 2.5, 2.6 and 2.9). This is a thick banded speleothem, including occasional stalagmites and columns, probably

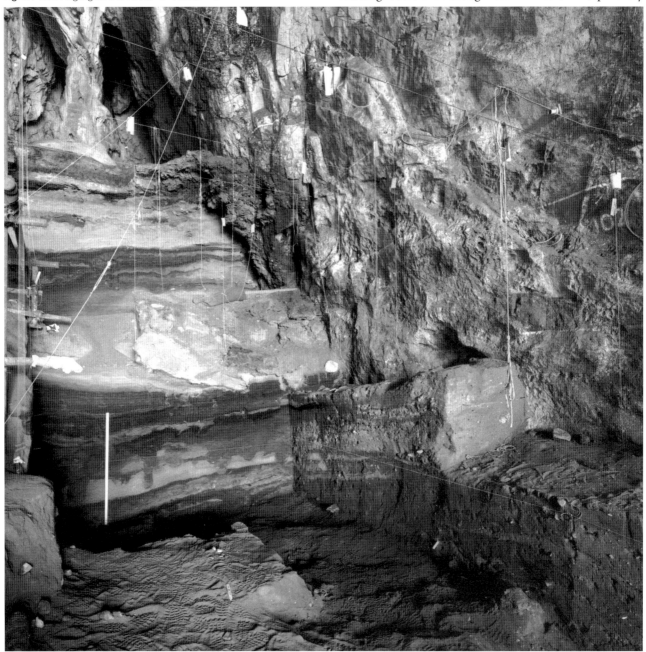

Fig. 2.5 Upper and middle parts of the sequence (Sections xa, xb and xc stacked on the left, USFm to LBSmff; main long section to the right in 99–102, LBSmcf). Photo: Natural History Museum, London.

coeval with the majority of stalactitic masses still adhering to the cave roof. At Easting 96 (at least), there is a gradational (interstratified) upper boundary with the lower intervals of the BEm. It is suspected that some burrows originating within the BEm may pierce the USFm, such that there may be some downward transmission of young objects (bones, artefacts, etc.). This stalagmitic deposit is assumed originally to have been present throughout the cave interior, forming a continuous floor sloping gently downwards towards the back (west); closer observation has taken place only towards the back of the cave.

Exposed Unconformity.

A major angular unconformity (erosion notch) has developed right across the mouth of the cave to form a 'cliff', eventually reaching right down to the BCSm (Governor's Beach fORMATION, see below). This unconformity is plausibly referred to the Holocene marine transgression (and must therefore itself be time-transgressive). The only higher-energy deposits lying above the unconformity are ballistic (i.e. supratidal) marine fine gravels (unconsolidated) in pockets over the lower, flatter part of the unconformity. There should also be considerable volumes of local collapse, derived from

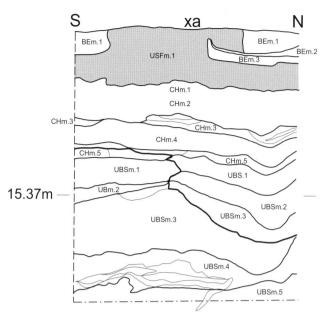

Fig. 2.6 USFm highlighted on detail of Section xa.

the standing Upper Pleistocene sequence behind; some of the deposits briefly described below, under *Deposits of Uncertain Attribution*, will be referable to such a collapse

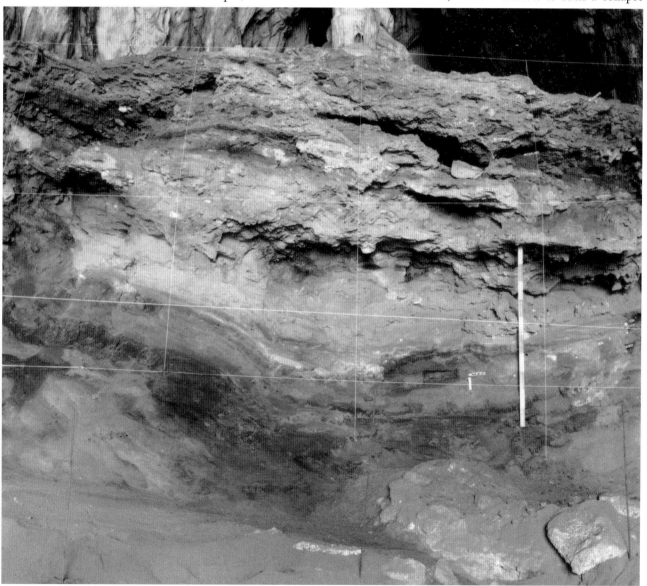

Fig. 2.7 Upper parts of sequence (early view of western exposures in c.E–D/97–98; USFm and CHm at the top, UBSm below largely slumped/disturbed, collapsed cemented fragments on the right). Photo: Natural History Museum, London.

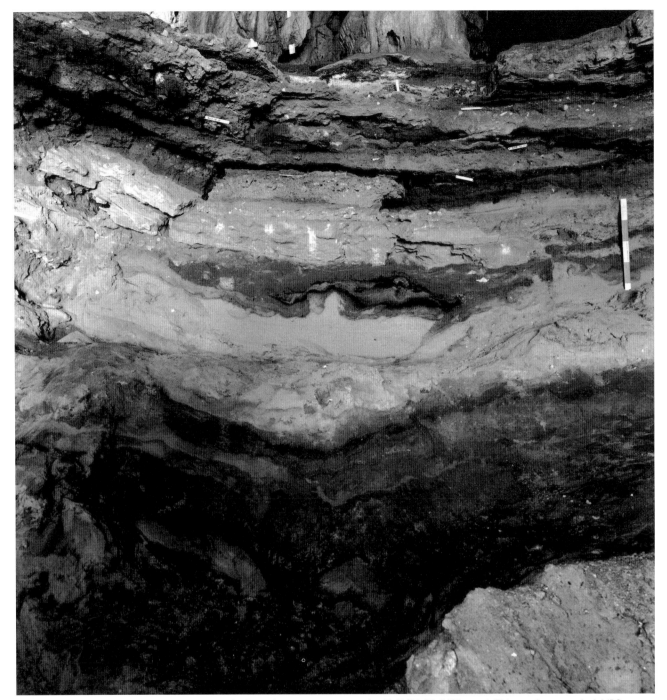

Fig. 2.8 Upper parts of sequence (relatively early view of western exposures in c.E–D/96–98; USFm and CHm at the top at 'xa', UBSm below, relatively undisturbed downwards until the darker contorted beds of UBSm.4 and the top of the lighter sands of UBSm, slumped/disturbed below this). Photo: Natural History Museum, London.

body. The spoil from recent archaeological campaigns and the debris dumped from above by military engineers have greatly obscured the lower parts of the cave mouth.

Cemented Hearths mEMBER (uNITS CHm.1–5)
(Figs. 2.5 and 2.7–2.10). In respect of 'natural' sediments, this mEMBER comprises a stratified series of beds with sandy or silty loam and limestone clasts, sometimes as coherent coarse lenses; beds are often slightly to strongly carbonate cemented. However, there are common intervals showing masses of charcoal, burnt stone, larger limestone clasts and shell (interpreted as anthropogenic accumulations). These deposits are assumed originally to have been present throughout the cave, although they appear to be thinning inwards and may be thicker (if heavily altered and recemented) near the top

of the surviving cornices towards the cave mouth. Closer observation has taken place over only a relatively restricted area (Squares A–E 96); here, the upper and lower mEMBER boundaries appear discrete (save for breaches by bioturbation structures) but internal bedding mode includes lenticular occurrences as well as more laterally continuous units.

Upper Bioturbated Sands mEMBER (uNITS UBSm.1–7)
(Figs. 2.5, 2.7–2.9 and 2.11). This mEMBER comprises bedded (sometimes laminated) sands, with some siltier intervals and dispersed limestone clasts. There are major dark organic-rich lenses mid-way up the sequence, thickened along the central cave axis. The stratification is disturbed by common and major bioturbation (burrow forms at various scales) and penecontemporaneous plastic

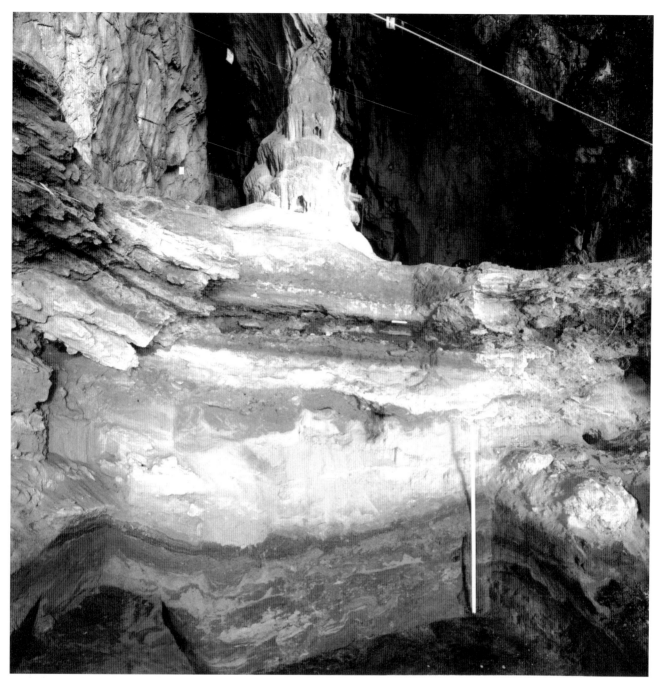

Fig. 2.9 Upper parts of sequence (developing view of western exposures in c.E–D/96–97; USFm and CHm at the top at approximately 'xa', UBSm below, down to near the base of UBSm.6, although this last uNIT is still slightly disturbed in this view). Photo: Natural History Museum, London.

deformation structures; some burrows demonstrably involve the CHm above. Closer observation has taken place in Squares A–F(G) 96–97; here, the uppermost beds are strongly cemented, with the boundary welded to the lowest of the CHm bed(s) above, whilst the lower boundary is sharp but slightly contorted and locally bioturbated.

Bedded Sand mEMBER (BeSm)
This mEMBER has been divided (after re-inspection by APC and SNC on site in June 2002) into two sUBmEMBERS:

Orange Sand sUBmEMBER (uNITS BeSm(OSsm).1–2)
(Fig. 2.12). This interval comprises well bedded (often laminated), relatively clean, orange sands. They are moderately

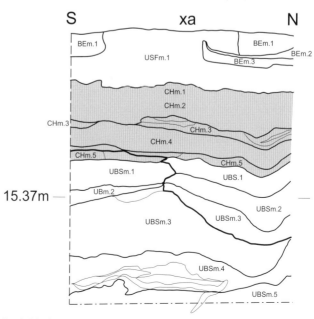

Fig. 2.10 CHm highlighted on detail of Section xa.

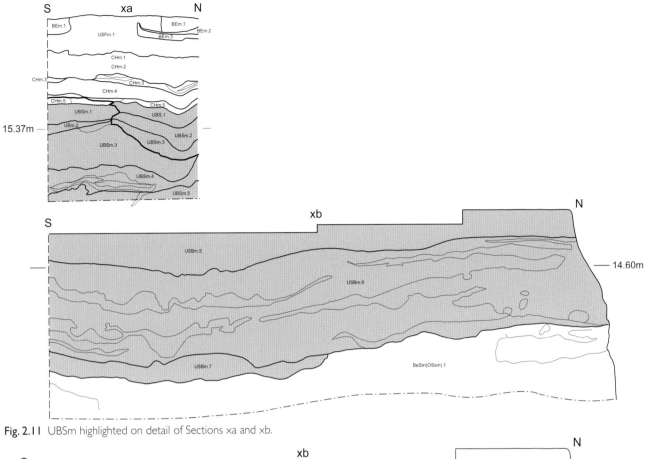

Fig. 2.11 UBSm highlighted on detail of Sections xa and xb.

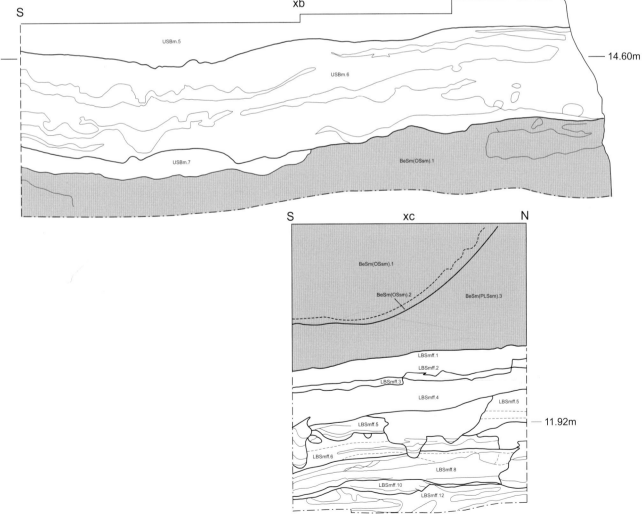

Fig. 2.12 Top of BeSm(OSsm) highlighted on detail of Section xb, bottom and part of BeSm(PLSsm) on detail of Section xc.

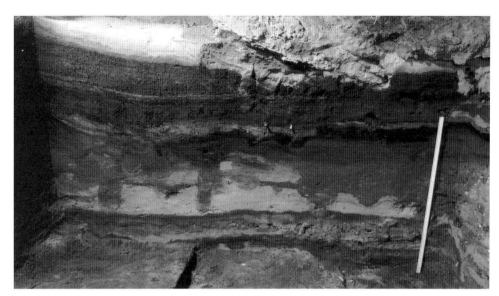

Fig. 2.13 Middle part of the sequence (Section xc in D–B99, LBSmff; the cemented slabs at the top right are recent collapse material, covering much of the BeSm). Photo: Natural History Museum, London.

to strongly cemented in upper levels, although these same levels are penetrated by some burrows. The sUBmEM-BER fills a deep erosive feature (a steep cross-cave angular unconformity has been observed at the northern side of the feature, with a similar cut assumed to exist on the southern side) along the central cave axis. There is a significant and persistent outward (easterly) dip in the contained laminae, with some clast lag, and phosphate and manganese nodule formation, at the base; the lower boundary is sharp (erosive) but welded by subsequent P/Mn precipitation. The upper boundary is slightly contorted and locally bioturbated. Closer observation has taken place only in Squares A–E 97–99, with the lower boundary in Square D99 reaching down (at the base of the feature) to 12.65 maSD. The observed lower boundary obviously constitutes a marked angular unconformity but it is uncertain whether or not a significant time gap is involved.

Pale Loose Sand sUBmEMBER (uNIT BeSm(PLSsm).3)
(Fig. 2.12). These are pale, carbonate-rich sands, with gritty phosphatic matter. They are extremely loose and running, almost impossible to cut to a near-vertical section (and thus giving only extremely poor and localized exposures, obscured for almost all of the present campaign by collapsed deposits). Undisturbed laminae appear in the relatively thin interval at the base, which is not cut by the basal OSsm feature from above, but, higher in the sequence laterally to the feature (observed on the north side), laminae are disturbed, even totally slumped. The upper part only has been observed in Squares A–B 98 up to 13.70 maSD, and the lower part only in Squares B–D 99 (at least 1.3 m thickness in all, later cut out by erosion). Only that part of the upper boundary which is erosive has been observed (the uppermost contact nearer the northern cave wall being obscured by cemented patches and burrows); the lower boundary appears sharp but has only been observed in contact with the Fine Facies of the LBSm.

The geometry of the overall BeSm is unclear in the present exposures. In the surviving cornices near the cave mouth, what might be a corresponding interval is represented by a current absence of sediment (notches almost to the cave walls, suggesting an original lack of cementation or other factor encouraging erosion). No earlier excavator has

mentioned the central feature; the excavation cut pre-dating the current campaign could have accommodated a trough/channel, passing right out of the cave eastwards, but a more local drain/sump, possibly of more closed (conical) form, down a near-vertical (subsidence) feature, is not impossible (although the underlying LBSm deposits are almost depositionally bedded and show no sign of bulk slumping; also see below the [5]–[6] interval in the discussion of correlation with Waechter's earlier excavation).

Lower Bioturbated Sands mEMBER (LBSm)
This interval is represented by two lateral facies sets which may be characterized, as an 'average' condition, as, respectively, comparatively fine and coarse.

Fine Facies (uNITS LBSmff.1–12)
(Figs. 2.13–2.15). This facies occurs in the inner, westward, part of the cave (wedging out by Easting 99, 100 at the most, along the central cave axis); the best exposure was in Squares C and D 99–100 (cf. Section xc). The interval contains a complex sequence of variegated laminated silts/clays/fine sands, rich in organic and phosphatic matter and in ashy lenses, with some bioturbation and common plastic deformation (load) structures. Because of the complexity and the small scale of some beds/lenses, not all units identified during excavation can now be located on the extant sections.

Coarse Facies (uNITS LBSmcf.1–13)
(Figs. 2.16 and 2.17). Further eastwards (in Squares B–E 100–104, cf. Main Section in the interval 'xc–xd'), there is a complex sequence of silty sands and clay/silt partings, with very common phosphatic nodules and dispersed decayed limestone clasts. The bedding is mostly laminated but disturbed, even homogenized in some zones, by strong bioturbation structures (including apparently within-sequence burrows as well as those penetrating from above near the cave walls).

Although these two facies overall are quite distinct, and the shift occurs over a very narrow lateral distance, there are a number of 'markers' (mostly distinctive boundary modes and clay laminae but also some minor sandy units) which pass across the transition to allow correlation

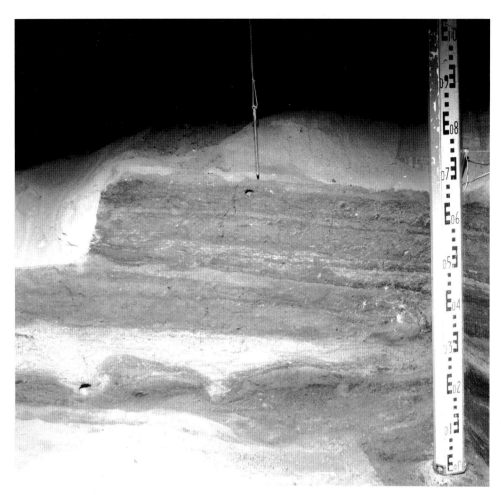

Fig. 2.14 Middle part of the sequence (looking southwards at a temporary section on line D/E in 99–100, with the southward continuation of Section xc at right angles on the right; detail of the 'transition' between the coarse facies (left) and fine facies (right) of the LBSm; the light-coloured load-casted bed is LBSmff.3). Photo: Natural History Museum, London.

within what is essentially a large-scale lenticular sequence. The classification of this mEMBER cannot be simplified without compromising both the finds retrieval record and any subsequent interpretation of depositional mode. Since the resulting 'dual' lithostratigraphy for the mEMBER is complex, a simple correlation diagram (arbitrary thicknesses/heights) is offered below, between the actual section details for the two facies.

The upper boundary of the mEMBER has only been observed between the Fine Facies and the BeSm, where it is sharp but apparently accretive/conformable (rather than erosive). The lower boundary has only been observed in Squares B 103–104, where there is a sharp, thin but persistent basal bed of reddish 'clayey silt' (clayey/silty medium sand). Most uNITS in this mEMBER show roughly horizontal bedding in the S–N (cross-cave) direction, although there is some down-warping along the centre line of the cave (i.e. uNITS now appear slightly curved, concave-up). There is generally a gentle dip into the cave (westwards) of *c*.3–4°; there may be a greater dip in these uNITS in the cemented 'cornices' nearer the front of the cave (not studied in detail during this campaign).

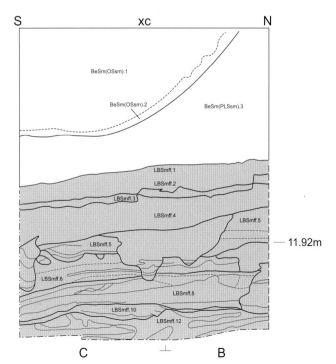

Fig. 2.15 LBSmff highlighted on detail of Section xc.

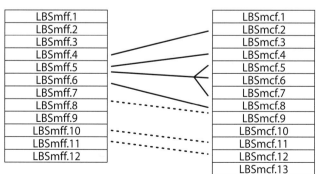

Sands & Stony Lenses mEMBER (uNITs SSLm(Usm).1–5 and SSLm(Lsm).6–11)
(Figs. 2.18–2.21). This mEMBER comprises cleaner, unconsolidated sands, well bedded, rarely low-angle cross-bedded, with consistent bed and cross-bed dip to the west (inwards);

Fig. 2.16 Middle part of the sequence (Main Section in 103–104; LBSmcf.9–13 (with micromorphology samples Gor96-54 to 58) above SSLm(Usm).1). Photo: Natural History Museum, London.

there are limestone clasts and some discrete clast lenses and stringers, uNIT SSLm(Usm).5 nearer the cave mouth having the most obvious angular limestone clast content in the exposed sequence. The beds are often cemented eastwards and downwards, and there are some minor (increasingly strong eastwards) floor speleothem subunits from mid-way down the sequence, which have been used to define the break between Upper and Lower sUBmEMBERS. Closer observation has taken place in Squares B–D 103–107 and E/F 108–110; the upper boundary is sharp but only very slightly angular, whilst the lower boundary is relatively sharp and (at least locally) conformable, at 9.90 maSD at the Squares E 109/110 interface. However, uNITS SSLm(Usm).2–4 show increasing dip into the cave, a 'plunging' attribute which, in the excavation notebook, was suggested as indicating the possibility of a 'sink hole' or at least 'deformational basin' a little further into the cave (still unexcavated).

Variegated Sands & Silts mEMBER (uNITS VSSm.1–4)

(Fig. 2.21). This mEMBER comprises sediments that are generally intermediate in character between those of the SSLm above and the RSSm below. Closer observation has taken place in Squares B–D 103–107 and E/F 108–110; the upper boundary is sharp but only very slightly angular, whilst the lower boundary is sharp and (at least locally) conformable, at 9.12 maSD at the Squares E 109/110 interface.

Reddish Silts & Sands mEMBER (uNITS RSSm.1–8)

(Figs. 2.21 and 2.22). This mEMBER comprises well bedded (thin bedding, laminated or microlenticular) reddish silty and loamy sands, with stalactitic fragments especially towards the base. Very common terrestrial molluscan fragments make a significant contribution to the sediment. Closer observation has taken place in Squares E–G 110–112; here, the upper and lower boundaries are sharp and conformable, the latter being at 8.27 maSD at the Squares E 111/112 interface.

Carbonate Sands & Silts mEMBER (uNITS CSSm.1–4)

(Figs. 2.21–2.23). This mEMBER comprises well bedded (thin bedding, laminated or microlenticular) carbonate-rich silty and cleaner sands, some thin lenses of clean finer coarse sands, and very common terrestrial and marine mollusca; there are true floor speleothem spreads, especially strong towards the top of the sequence. This mEMBER is extremely variable (in both vertical and lateral dimensions) and subdivision into labelled uNITS has so far been undertaken only with a very broad brush. Closer observation has taken place in Squares E–G 111–113; here, the upper and lower boundaries are sharp and conformable, the latter being at 7.18 maSD at the Squares E 112/113 interface.

Coarse Sands mEMBER (CSm)

This mEMBER comprises well bedded, but slightly contorted (foundered?), sand beds, including thicker and continuous coarse sand units, commonly cemented; there are common mollusca, of marine species in the coarser units. This mEMBER has not been logged in any detail, so that constituent units have not yet been separately defined. The closest observation (still cursory, with no attempt at section drawing) has taken place in Squares E–G 113; the upper boundary is sharp and conformable, whilst the lower boundary has not

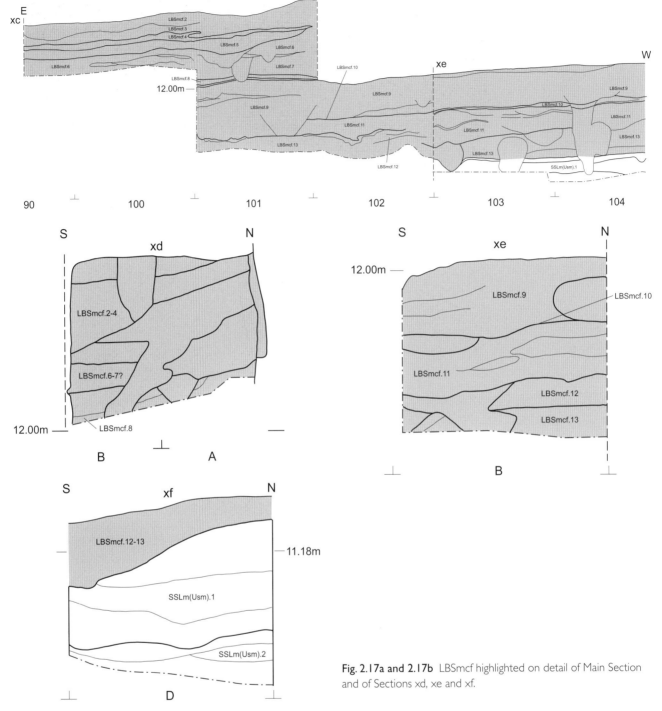

Fig. 2.17a and 2.17b LBSmcf highlighted on detail of Main Section and of Sections xd, xe and xf.

been observed/defined (the mEMBER continues downward to below 6.50 maSD at the Squares E 111/113 interface).

Units of Uncertain Attribution

There are three basic categories of material under this rubric:

1 Poorly consolidated yet coarsely bedded sands (with Pleistocene artefacts/fauna) generally at lower levels in the 'mouth' of the cave; these are probably mostly due to progressive collapse (accounting for the neo-stratification) from the main sequence during the Holocene transgression (see above).
2 Poorly exposed but apparently well bedded deposits towards the southern side of the cave entrance and outside, beyond the overhang; these could be in-sequence

(in the UGCf) but could otherwise represent remnants earlier than the GBf (BCSm) transgression (see below).

3 Various cemented 'cave-earths', sands and floor speleothems, surviving as discontinuous remnants adhering to the northern cave wall, lower in the entrance area; at least the lowest of these deposits appear to lie conformably above the RSCm but have not yet been described in detail (cf. Fig. 2.24).

There are also significant, wholly exterior deposits, flanking the cave on each side, which cannot yet be correlated with the cave sequence.

Rubified Speleothem Clast mEMBER (RSCm)
(Fig. 2.25). This material may be described as a 'puddingstone', comprising large speleothem clasts (mostly convoluted

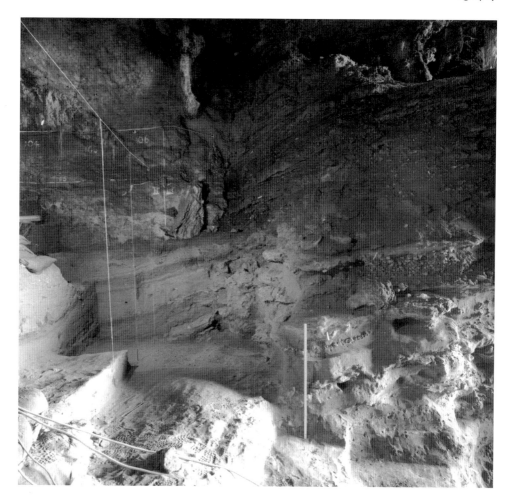

Fig. 2.18 Middle part of the sequence (Main Section in 105–107 northwards on the left, with the base of the LBSmcf above SSLm.1–8; Main Section in foreground (southwards) in 109–111 on the right, with the stony SSLm(Usm).5 overlying the fallen stalagmitic boss in SSLm(Usm).6 at mid-height). The white-painted square and Area markings are visible in the background.

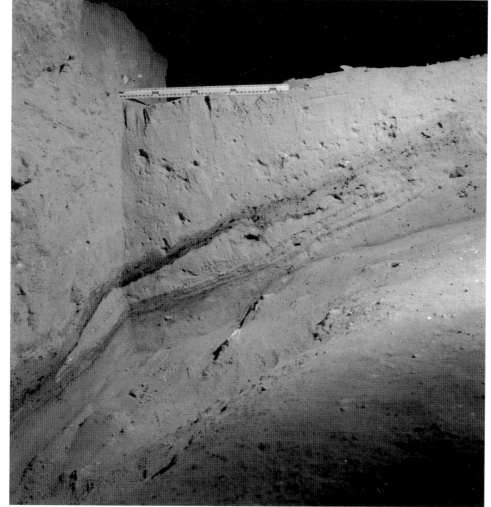

Fig. 2.19 Middle part of the sequence (temporary W–E section (with 'xf' at right angles on the left); the dipping, charcoal-rich laminae of SSLm(Usm).2 are apparent at mid-height). Photo: Natural History Museum, London.

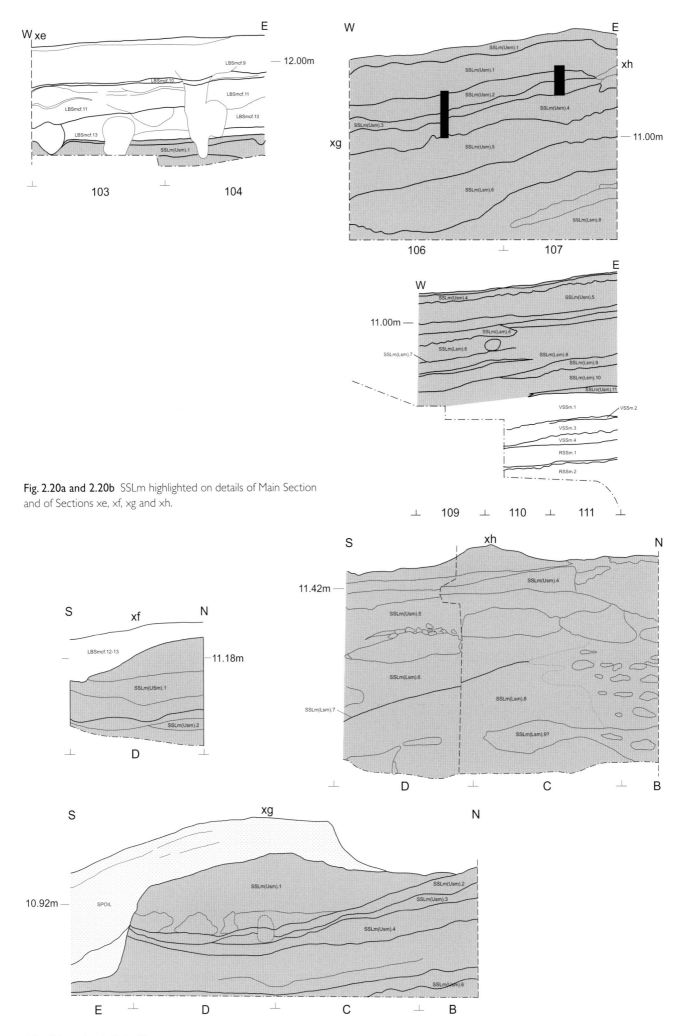

Fig. 2.20a and 2.20b SSLm highlighted on details of Main Section and of Sections xe, xf, xg and xh.

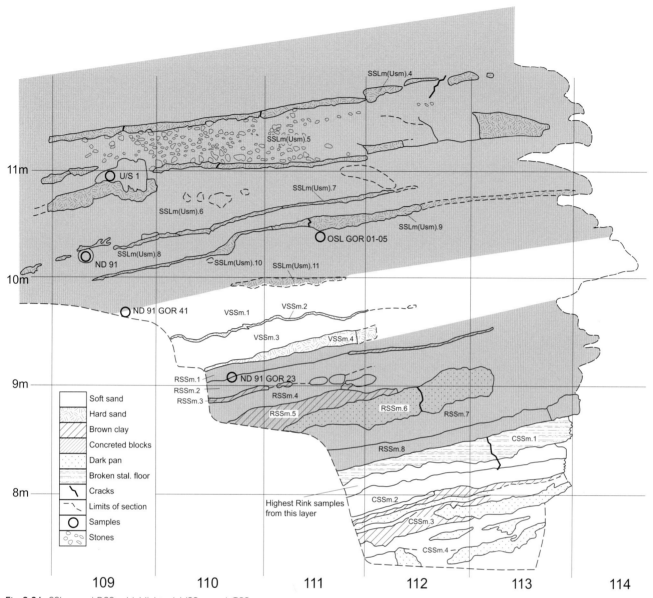

Fig. 2.21 SSLm and RSSm highlighted, VSSm and CSSm un-highlighted, on detail of outermost Main Section.

stalactite and curtain fragments) and less common limestone clasts set in a hard-cemented reddish matrix (this matrix shows strong secondary recrystallization in a mode typical of material affected by exposure to sea-spray). The mEMBER has been observed across the mouth of the cave and beyond, somewhat northwards; the upper boundary is not yet exactly defined (since it is only exposed in a highly weathered zone) but the lower boundary is relatively sharp.

Governor's Beach fORMATION (GBf)
Basal Coarsest Sands mEMBER (uNITS BCSm.1–2)
(Fig. 2.25). This mEMBER comprises well bedded coarse sands and fine gravel (well rounded pebbles); there are simple tubular ichnofossils and (corroded) marine shell fragments. The whole is strongly cemented (this material shows strong secondary recrystallization in a mode typical of material affected by exposure to sea-spray). The mEMBER has been observed across the mouth of the cave and beyond, both southwards and northwards; the upper boundary is relatively sharp against the RSCm, and the lower boundary (so far observed) is unconformable at a rock-cut platform.

Since this 'raised beach' can be recognized much more widely than Gorham's Cave, it has been set in its own fOR-MATION (GBf).

Possible Buried Pleistocene Unconformity.
The observable sequence (in the UGCf) appears insufficiently rich in limestone clasts, carbonates and insoluble residues (as opposed to exterior sands and soil-derivatives) to account for the large cave cavity. Consequently, it is inferred that a significant cave (probably a true karstic feature) existed prior to this observed sequence. It is therefore possible that, buried behind the known deposits, the cave holds a pre-GBf (BCSm) sediment sequence, bounded by a 'cliff' unconformity, similar to the exposed (Holocene) unconformity. Such potential, if realized, could be classified within a Lower Gorham's Cave fORMATION (LGCf).

Lithostratigraphic correlation with Waechter excavations
From the outset of the recent campaigns, extreme difficulties were experienced in trying to understand the stratigraphy reported by Waechter (1951; 1964). Reflecting the

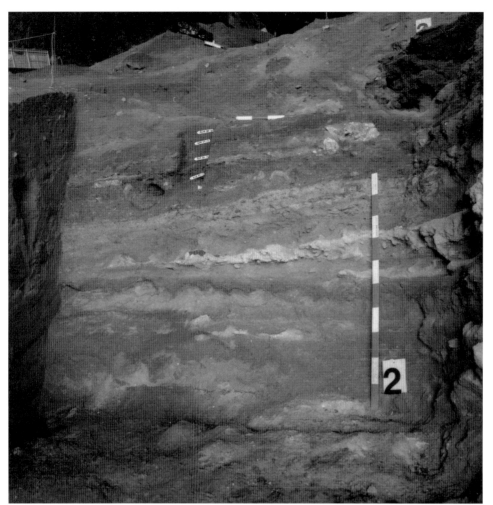

Fig. 2.22 Lower part of the sequence (south–north section in G/F-III; RSSm (with micromorphology samples Gor89-12 to 15 down to RSSm.5) and CSSm below (CSSm.1 is the light cemented bed wedging out southwards/left, the top passing the metre rod at 27 cm from its top). Photo: Natural History Museum, London.

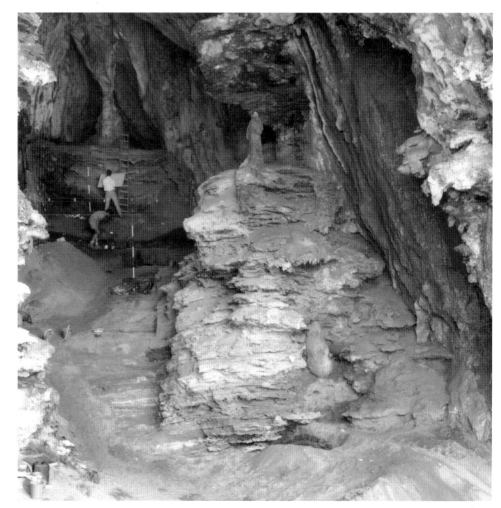

Fig. 2.23 Full exposed interior sequence (wide view westwards between the entrance cornices, CSSm exposed at base). Photo: Natural History Museum, London.

Fig. 2.24 Lowermost (outer) part of the sequence (north side of cave mouth, with cemented 'Units D and E' remnants; the beach (since removed by storms) in the foreground was a recent Holocene feature). Photo: Natural History Museum, London.

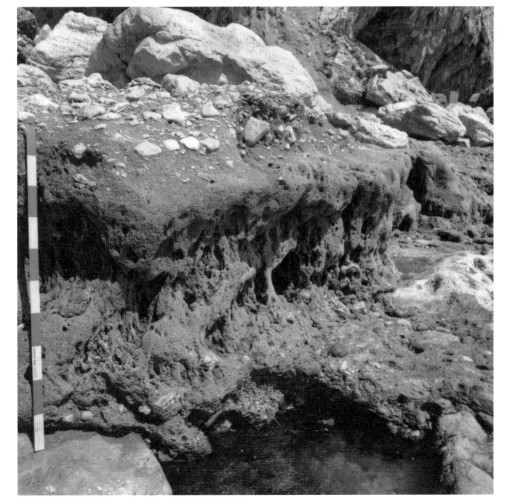

Fig. 2.25 Basal (outermost) part of the sequence (base of RSCm at top, over BCSm.1, above pot-holed rock platform, east of (outwards from) cave mouth). Photo: Natural History Museum, London.

teams' frustration in this regard, one of us (Currant 2000, 203) wrote:

> Recent work at the site [...] shows major discrepancies between Waechter's recorded stratigraphy and the surviving deposits. His sections seem to have been drawn up from notes, possibly after he had left the site. In the longitudinal section presented by [f]igure 1 of his 1964 report, about 10 metres of cave sediments are entirely missing. One must assume that Waechter's finds do actually represent some kind of sequence, and that the discrepancies in his account result from mis-correlation from one area of the cave to another. His longitudinal section of the Gorham's Cave sediments shows roughly horizontal stratigraphy. Even a brief examination of the remaining sediments shows this to be seriously in error. The deposits at the mouth of the cave dip back into the interior, while post-depositional slumping and localised solution of the carbonate fraction have created steeply sloping unit boundaries in the sediments further back inside the cave. Some of these features can be clearly seen on published photographs of the site. For these reasons, no attempt is made here to relate the fauna identified by Sutcliffe to Waechter's recorded stratigraphy.

Having established that Waechter's reports were unreliable, an attempt was first made to pin down at least part of the sequence by means of what appeared to be the most striking of Waechter's units, the tough brown, very clayey, silty sand over orange clayey sand of his Layer J. The only likely looking deposits exposed early in the recent campaigns were certain levels in what is now called the Reddish Silts & Sands mEMBER. If Layer J could be pinned at that level, a correlation of the lower sequence reported by Waechter could be attempted with the units exposed near the mouth of the cave. Such an attempt (based upon the consensus within the team at the time) was published by Cooper (1996), with correlates suggested for Waechter's Layers J down to P. However, the result was far from comfortable, not only highlighting the deficiencies noted by Currant above, but also failing to resolve new problems. For instance, there was an unavoidable but improbable correlation of a reported 0.7 m thick bed of sand and angular limestone clasts (Waechter's Layer N/O) with a now observed 0.1 m thick unit of shelly sand containing unusual black grains. Again, Waechter's Layers K (from which he recovered 1498 artefacts) and M (from which he recovered 1467 artefacts) would have to fall in a zone at the mouth of the cave where it can be demonstrated beyond all doubt that Waechter dug only a very small area.

The sequence described by Cooper from the front of the cave is summarized here in Table 2.1. Of greater interest than the then assumed correlations with Waechter's work (shown by labels in inverted commas and prefixed with 'C' for Cooper) is the firmer correlation (dotted lines) that can be made with the sequence described in full in the present text, as shown on the right-hand side of the tabulation. Note that, in order to depict a continuous 'column' of sediment (such a record not having been studied during the most recent work), the 'average' thickness of mEMBER-level uNITs is accumulated downwards against a scale of metres starting at the (arbitrary) Site Datum level of '+16.18 m' (the top of the deposits in the cave interior); whilst giving a reliable idea of relative thickness, the dominant down-inwards dip

of uNITs causes the 'accumulated' level to drop much lower that the true datum height reached in excavated exposures (the actual height ranges are shown in brackets for each mEMBER to remind the reader of this fact). Cooper's observations were measured from an arbitrary zero at the base of the more nearly vertical exposure then available to her.

In the upper, generally heavily cemented and altered levels of Cooper's sequence, the correlation with the present system is unclear, although Cooper's Red Bone Beds (RBBs) sequence would seem to correlate best with the LBSm. However, from Cooper's Occupation Bed (OCC) (which fits well with the concentration of archaeological finds in the lower part of the LBSm coarse facies further into the cave) downwards, correlation appears good. Cooper's Breccia is equivalent to the upper sUBmEMBER of the SSLm. Cooper's Red Marker Bed (RMK) is the top of the VSSm. Cooper's 'unhappy' unit 'J' is the top of the RSSm. These correlations work individually (the units indicated are relatively idiosyncratic deposits and the section locations are all known and still extant) as well as in sequence. This allows Cooper's faunal assemblages from this interval, comprising deposits which were not sampled at any other time, to be integrated with and to amplify the total site record. In addition, Cooper's units (C) 'L' (with pebbles and coarse sand) and (C) 'N/O' (with black grains, in an otherwise pale, shelly sand) are important elements in a correlation with the CSSm.

Placing Waechter's Layer J low in the observable sequence would tend to cause severe 'stretching' of the upper part of his sequence: Waechter's Layers B to H (originally reported to be 2.3 m thick in all) would have to be 'stretched' into about 7.5 m of surviving sequence. As an alternative approach, Goldberg and Macphail (2000) took the upper part of the Waechter sequence more at face value but then had to contemplate a 'stretching' of the lower part. They suggested that their 'Upper Levels' (in a height range of 14.00–15.80 m on the same Site Datum as used in the present system, and corresponding to the UBSm) were equivalent to Waechter's Layers K to F; this would place that problematical Layer J very high, presumably correlating with the convoluted, strongly organic lenses observable in the middle of this mEMBER. They then suggested that their 'Middle Levels' (in a height range of 12.50–12.65 m, and corresponding to the topmost beds in the LBSm) were roughly equivalent to Waechter's Layer P; this would lose Waechter's artefact-rich Layer M in an interval (BeSm) very unclearly observed at that time during the recent campaign. Finally, they suggested that their 'Lower Levels' (in a height range of 8.00–8.80 m, and corresponding to parts of the VSSm, RSSm and upper CSSm) were equivalent to Waechter's Layers S1–S3; this particular correlation now appears broadly plausible (see below) but, in Goldberg and Macphail's overall scheme, Waechter's Layers Q and R (originally reported to be 1.3 m thick in all) would need to be some 4 m thick.

Attempts at correlating Waechter's reported stratigraphy with the upper deposits in the cave have also been made with the help of radiocarbon dating. On general descriptive similarities, Pettitt and Bailey (2000) correlated Waechter's Layers B, D and E with uNITS CHm.4 to UBSm.2; in particular, the original Groningen dates for Layer D were said to

Table 2.1 Stratigraphic correlation. Cooper (1996) compared to Currant system. Depths/thicknesses in metres. See text.

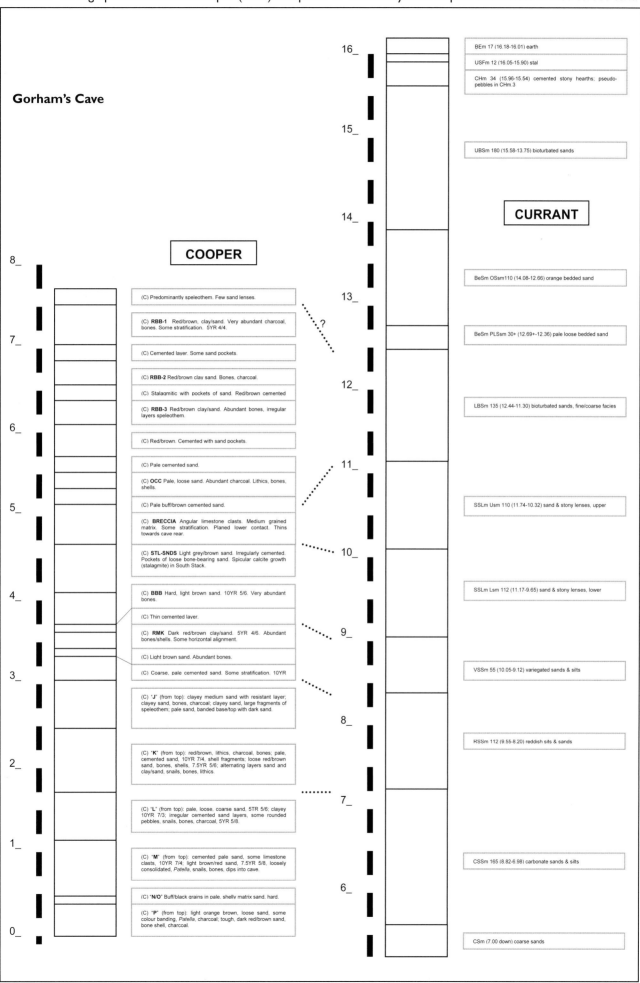

be statistically identical to AMS dates on charcoal for uNIT CHm.5, the basal uNIT in that mEMBER (see also Barton *et al.* 1999). On slightly less exact comparisons, Pettitt and Bailey then suggested a correlation between Waechter's Layer G and uNITS LBSmff.1–5, which would require the intervening Layer F to be stretched from 0.4 m to about 2.5 m in thickness.

After more detailed analysis, it remains obvious that Waechter's work is an exceedingly imprecise example of stratigraphic reporting. Nevertheless, a cautious inquiry will be made here into the possibilities of a more secure correlation, both in order to be able usefully to compare Waechter's finds with more recent assemblages and further to evaluate the earlier suggested correlations set out in publications between those of Waechter and the present (as discussed above).

It is very clear that Waechter's so-called section drawings (1951; 1964) must be rejected as wholly misleading with respect to unit geometry (dips and thicknesses). We have therefore taken as a starting point the non-graphic record (1953) of the more experienced quaternarist, Frederick Zeuner (even though it is not known whether he actually visited the cave), which simply shows height ranges in metres AOD. Unfortunately, since most of the units are known to be, and to have been, strongly dipping, Zeuner's record cannot be true, either, since the absolute range for one layer would automatically need to overlap considerably with the altitudinal ranges for neighbouring units. If, however, one takes Zeuner's figures as something more akin to 'average unit thickness' with a few points pinned against crucial heights AOD (such as the assumed 'raised beach' in Layer U), something more useful emerges (although one must bear in mind that, because of the implicit pinning to heights AOD at unknown points, at least some of the 'thicknesses' will tend to be underestimates precisely due to the dip). Zeuner's list of layers and descriptions (which contains a few more units than Waechter's scheme, especially with respect to additional 'stalagmites'), augmented by the purely descriptive elements from Waechter (1951; 1964), is summarized here in Table 2.2. Each suggested correlation (contacts or intervals defined by dotted lines, numbered in square brackets for ease of reference) with the present lithostratigraphic system is discussed below.

[1] The base of the stalagmitic floor (Zeuner's Stal 4) in Layer (Z) B correlates unequivocally with the base of the USFm, which must once have been more or less continuous throughout the cave.

[1]–[2] Layers (Z) E and (Z) D are together a good general match for the CHm. It should be remembered that these deposits do contain lenticular intervals, such that attempting specific correlation between individual lenses observed in the recent work and bedding phenomena reported by Waechter may not be valid.

[2]–[3] Zeuner reports Stal 3 at this level; uNIT UBSm.1 is heavily cemented, possibly with thin lenses of true stalagmite in places.

[3]–[4] Layer (Z) F had some lenses of cemented limestone clasts (and it contained the oldest occurrence of Upper Palaeolithic artefacts in its upper part); Waechter noted

combustion layers. The uNITS UBSm.2–4 show similar characteristics, although the essentially lenticular nature of these sediments (complicated by overprinting by common load structures and bioturbation features) means that the exact correlation of the base of Layer (Z) F cannot now be achieved.

[4]–[5] The generally well sorted sand of Layer (Z) G had a 'sticky' or 'streaky' middle portion; this was Waechter's youngest and richest Mousterian context. This fits very well with the interval UBSm.5–7, which has very striking, wavy or convoluted lenses of dark organic-rich clayey silty sand in the middle interval (corresponding to the Layer 'J' correlate in the 'Upper Levels' proposed in the Goldberg and Macphail scheme). This would appear to be the stack of down-warped dark lenses in the centre of the mid-level section shown in plate 13 of Waechter (1964, 269).

[5]–[6] Layer (Z) H was a clean sand, with cementation (Zeuner's Stal 2) at its base, the two units together recorded as having a 'thickness' of only 0.55 m. It is at this point where there is the most severe (apparent) discrepancy between the early observations and those made during the recent campaign. It is proposed that Layer (Z) H and Stal 2 be very loosely correlated with the BeSm (probably only the OSsm), relatively clean sandy beds which can now be observed to be at least 1.4 m thick overall. The BeSm is very peculiar in its bedding and unconformity plane angles (see above), and may represent a sequence of idiosyncratic events (including localized erosion) that was missed, or possibly was not even widely present, in Waechter's excavation area. However, in plate 13 of Waechter (1964, 269), there is a strongly oblique lighter zone associated with contorted laminar bedding, close to the central person in the photograph standing on the right-hand side of the mid-level section (to the west, further away from the observer), and there is what just might be a trough/channel base right at the top of the low-level section, on a 'step-riser' considerably further east (closer to the observer). As these sections have eroded and been cut back westwards since Waechter's day, the combination of the present restricted exposure and Waechter's photograph would suggest that the 'eastward-dipping trough/channel' hypothesis for the base of the BeSm(OSsm) may be a little more likely than the 'subsidence drain/sump' alternative (although our micromorphologist colleagues maintain a healthy scepticism on this point).

[6]–[7] The possible erosional phenomena above [6] would therefore leave all of Layers (Z) J to M as corresponding to the various uNITs of the LBSm. These deposits are often lenticular and, in any case, show very strong lateral variation, such that precise correlation may not be achievable. Nevertheless, it is noteworthy that Layers (Z) J, Stal 1 and K were reported as brightly coloured, banded, sometimes cemented (phosphate and ash being observed as more common than carbonate during the recent campaign) and often 'tough' or clayey, as are the Fine Facies (with a generally 'stratigraphically higher' and 'inner' spatial distribution) of the LBSm, whilst Layers (Z) L and M comprised laminated sands (with strong archaeological levels), more like the Coarse

Table 2.2 Stratigraphic correlation. Zeuner (1963) and Waechter (1961, 1964) compared to Currant system. Depths/thicknesses in metres. See text for details.

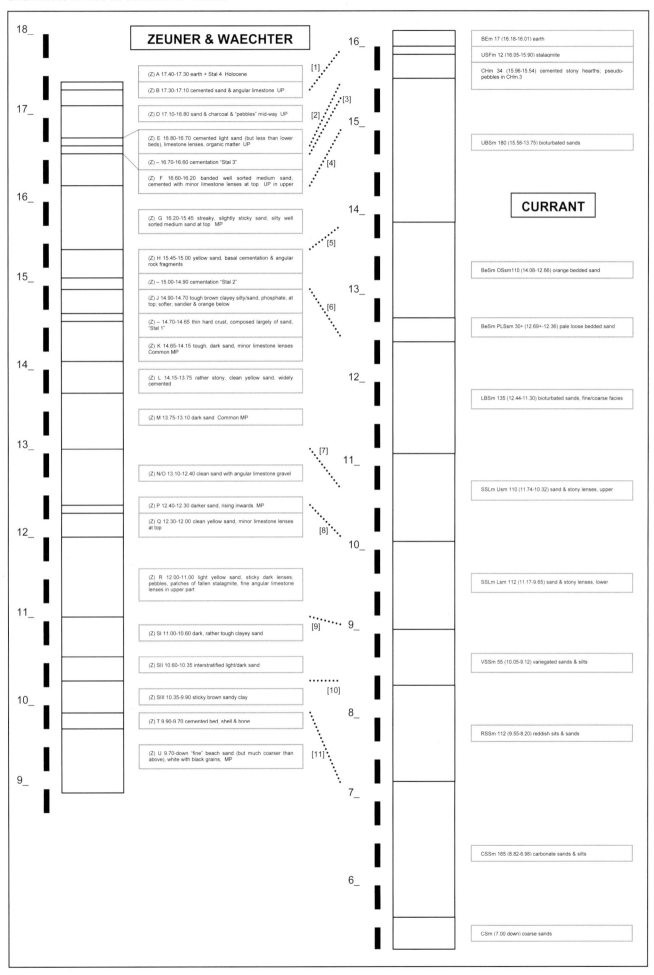

ZEUNER & WAECHTER

(Z) A 17.40-17.30 earth + Stal 4 Holocene

(Z) B 17.30-17.10 cemented sand & angular limestone UP

(Z) D 17.10-16.80 sand & charcoal & "pebbles" mid-way UP

(Z) E 16.80-16.70 cemented light sand (but less than lower beds), limestone lenses, organic matter UP

(Z) – 16.70-16.60 cementation "Stal 3"

(Z) F 16.60-16.20 banded well sorted medium sand, cemented with minor limestone lenses at top UP in upper

(Z) G 16.20-15.45 streaky, slightly sticky sand, silty well sorted medium sand at top MP

(Z) H 15.45-15.00 yellow sand, basal cementation & angular rock fragments

(Z) – 15.00-14.90 cementation "Stal 2"

(Z) J 14.90-14.70 tough brown clayey silty/sand, phosphate, at top; softer, sandier & orange below

(Z) – 14.70-14.65 thin hard crust, composed largely of sand, "Stal 1"

(Z) K 14.65-14.15 tough, dark sand, minor limestone lenses Common MP

(Z) L 14.15-13.75 rather stony, clean yellow sand, widely cemented

(Z) M 13.75-13.10 dark sand Common MP

(Z) N/O 13.10-12.40 clean sand with angular limestone gravel

(Z) P 12.40-12.30 darker sand, rising inwards MP

(Z) Q 12.30-12.00 clean yellow sand, minor limestone lenses at top

(Z) R 12.00-11.00 light yellow sand, sticky dark lenses, pebbles, patches of fallen stalagmite, fine angular limestone lenses in upper part

(Z) SI 11.00-10.60 dark, rather tough clayey sand

(Z) SII 10.60-10.35 interstratified light/dark sand

(Z) SIII 10.35-9.90 sticky brown sandy clay

(Z) T 9.90-9.70 cemented bed, shell & bone

(Z) U 9.70-down "fine" beach sand (but much coarser than above), white with black grains, MP

CURRANT

BEm 17 (16.18-16.01) earth

USFm 12 (16.05-15.90) stalagmite

CHm 34 (15.96-15.54) cemented stony hearths; pseudo-pebbles in CHm.3

UBSm 180 (15.58-13.75) bioturbated sands

BeSm OSsm110 (14.08-12.66) orange bedded sand

BeSm PLSsm 30+ (12.69+-12.36) pale loose bedded sand

LBSm 135 (12.44-11.30) bioturbated sands, fine/coarse facies

SSLm Usm 110 (11.74-10.32) sand & stony lenses, upper

SSLm Lsm 112 (11.17-9.65) sand & stony lenses, lower

VSSm 55 (10.05-9.12) variegated sands & silts

RSSm 112 (9.55-8.20) reddish sits & sands

CSSm 165 (8.82-6.98) carbonate sands & silts

CSm (7.00 down) coarse sands

[1] [2] [3] [4] [5] [6] [7] [8] [9] [10] [11]

Facies (with a generally 'outer' spatial distribution) of the LBSm. In plate 13 of Waechter (1964, 269), the darker unit at the base of the mid-level section would seem to be Layer J (which would fit with Waechter's statements, in 1951 and 1964, that excavation ceased at this level on this particular step); whether or not this attribution is correct, the dark unit in the photograph shows considerable channelling and distortion from above, with a relief in cave cross-section of some 0.3–0.4 m. This whole (Z) J to M interval would be equivalent to Cooper's (1996) Red Bone Beds and Occupation Bed (observed at the mouth of the cave) and to Goldberg and Macphail's Middle Levels. As an entirely independent check on the lithostratigraphic correlation, one may mention here Cooper's recent suggestion (Chapter 9) of a strict (bio) stratigraphic correlation, based upon two bones likely to be from an individual owl, one excavated by Waechter from his Layer M and the other retrieved subsequently from uNIT LBSmcf.11.

[7]–[8] The correlation of the Layer (Z) N/O with at least part of the SSLm(Usm) seems most secure, given that these are the only truly 'scree-like' bodies in the middle part of the cave sequence (cf. Cooper's distinctive Breccia).

[8]–[9] Layers (Z) P (sands), Q (limestone clast lenses) and Layer (Z) R (sands, lenses of limestone clasts and disturbed stalagmites) are together a good match for the SSLm(Lsm).

[9]–[10]–[11] Layers (Z) SI, SII and SIII are a good match for the VSSm and the RSSm combined (as noted by Goldberg and Macphail in their Lower Levels), which are variegated, banded/laminated and increasingly clayey. It is plausible that the SII/SIII boundary corresponds exactly to the mEMBER boundary defined recently, although the lithological change is gradational and/or interstratified such that the boundary correlation at this level is best taken as approximate. One may note the original team suggestion (cf. Cooper's unit (C) 'J') that Waechter's Layer J lay at the level of the RSSm, and compare this with Waechter's own comment (1964, 193): '[…]; and S3, a very tough brown clay not unlike Layer J, but much damper and stickier'.

[11] The cemented unit of Layer (Z) T probably represents the top of the CSSm, which contains true floor speleothem (although this is difficult to see in the weathered sections at the mouth of the cave and was overlooked even by Cooper). The description of Layer (Z) U as containing coarse sands, with some black grains, is striking (cf. Cooper's unit (C) 'N/O') and leads to correlation with the highest occurrence of such material as lenses within the CSSm. Because Waechter and Zeuner believed Layer U represented a 'raised beach', the highest altitude of occurrence was most important for them; taking likely dip into account, their measurement (assumed to have been relatively accurately surveyed to a military datum) was probably made as far forward (eastwards) as possible, which could well explain why the overlying Layer (Z) SIII seems to be so thin, compared with the observation of the true thickness of the RSSm.

Reviewing the tabulation in Table 2.2 as a whole, it is felt that a reasonable level of correspondence has been demonstrated with the reported results of Waechter's excavations, on the grounds of lithological similarity, sequence and likely unit thickness (using Zeuner's figures). The only marked discrepancies lie around the [5]–[6] interval (involving the BeSm), where it is known that complex factors (including the generation of high-angle unconformities) were at play, factors which are still not fully understood today.

Acknowledgements

The editors would like to thank Alison Wilkins for her help in producing the site cross-sections and other figures.

References

Barton, R. N. E., Currant, A. P., Fernández Jalvo, Y., Finlayson, J. C., Goldberg, P., Macphail, R., Pettitt, P. B. and Stringer, C. B. 1999: Gibraltar Neanderthals and results of recent excavations in Gorham's, Vanguard and Ibex Caves. *Antiquity* 73, 13–23.

Cooper, J. H. 1996: Quaternary micromammals from Gorham's Cave, Gibraltar, and their palaeoenvironmental significance. *Revista de Estudias Campogibraltarenos* 15, 69–85.

Currant, A. P. 2000: A review of the Quaternary mammals of Gibraltar. In Stringer, C. B., Barton, R. N. E. and Finlayson, J. C. (eds.), *Neanderthals on the Edge* (Oxford: Oxbow Books), 201–205.

Finlayson, J. C., Pacheco, F. G., Rodríguez Vidal, J., Fa, D. A., Gutierrez López, J.-M., Santiago Pérez, A., Finlayson, G., Allue, E., Preysler, J. B., Cáceres, I., Carrión, J., Fernández Jalvo, Y., Gleed-Owen, C. P., Jiménez Espejo, F. J., López, P., Sáez, J. A., Riquelme Cantal, J. A., Sánchez Marco, A., Guzman, F. G., Brown, K., Fuentes, N., Valarino, C. A., Villalpando, A., Stringer, C. B., Martinez Ruiz, F. and Sakamoto, F. 2006: Late survival of Neanderthals at the southernmost extreme of Europe. *Nature* 443, 850–853 (and Supplementary Information).

Goldberg, P. and Macphail, R. I. 2000: Micromorphology of sediments from Gibraltar caves: some preliminary results from Gorham's Cave and Vanguard Cave. In Finlayson, C., Finlayson, G. and Fa, D. (eds.), *Gibraltar During the Quaternary* (Gibraltar: Gibraltar Government Heritage Publications, Monograph 1), 93–108.

Pettitt, P. B. and Bailey, R. M. 2000: AMS radiocarbon and luminescence dating of Gorham's and Vanguard Cave, Gibraltar, and implications for the Middle to Upper Palaeolithic transition in Iberia. In Stringer, C. B., Barton, R. N. E. and Finlayson, J. C. (eds.), *Neanderthals on the Edge* (Oxford: Oxbow Books), 155–162.

Waechter, J. d'A. 1951: The excavation of Gorham's Cave, Gibraltar: preliminary report for the seasons 1948 and 1950. *Proceedings of the Prehistoric Society* NS 17, 83–92.

Waechter, J. d'A. 1964: The excavation of Gorham's Cave, Gibraltar 1951–54. *Bulletin of the Institute of Archaeology (University of London)* 4, 189–221 (plus plate 13 on p. 269).

Zeuner, F. E. 1953: The chronology of the Mousterian at Gorham's Cave, Gibraltar. *Proceedings of the Prehistoric Society* NS 19, 180–188.

3 Gorham's Cave: lithological and lithogenetic patterns

S.N. Collcutt

Introduction

In this chapter the most obvious patterns, geometries and themes observed macroscopically in the deposits will be discussed. This picture is enlarged and completed in Chapter 4.

Cavity and fill cycles

Gorham's Cave appears to be primarily a karstic rift, developed upon the near-vertical (sharply northerly dipping) bedrock structure. Whilst an element of bedrock (which could be a bridge, rather than the true cavity base) has been reached at the very back of the cave at a high level (very approximately 1600 cmaSD), the rock-floor drops outwards (unknown profile) to sea level and the mouth widens to over 20 m (cf. the plan and section in Giles Pacheco *et al.* 2000, fig. 3).

Even though there are signs of quite radical post-depositional and diagenetic modification in many of the cave deposits, since the dominant observed bedding angles involve inward dip, there seems to be a true 'deficit' in limestone clasts, carbonates and/or insoluble residues. It is not likely that this cave developed (approximately) its current dimensions in parallel with (over the same period as) the deposition of the currently observable sediments, a much more probable history being that a large cavity already existed in the Middle Pleistocene and that the high sea levels of the Last Interglacial (Marine Isotope Stage (MIS) 5) succeeded in removing at least most of any previous fills (see below). Nevertheless, there is still a possibility that some remnant of an old fill cycle survives (probably behind a cemented erosional cliff) below/behind the observable Upper Pleistocene fill. On the other hand, whilst always a risk, no evidence has been noted that there is any significant unconformity in the cemented (and sometimes isolated) wall remnants on both sides of the cave mouth; at present, it is assumed that these are all part of the Upper Pleistocene sequence.

Lateral continuity, geometrical patterns, bedding styles, unconformities and deformation

It is currently (and probably has always been) almost impossible to trace lithologically stable units from the front to the back of the cave, because all units shift facies bewilderingly quickly along (and even across) the chamber. This appears to be a characteristic of the local cave fills; for instance, similarly rapid facies changes seem to have been observed even in the much smaller rift cave of Devil's Tower (Garrod *et al.* 1928). The youngest stalagmitic floor (USFm) is the only obvious exception at present. This characteristic

is of lithogenetic interest, in its own right, but the absence of 'marker horizons' also constitutes a lithostratigraphic difficulty (see Chapter 2).

The dominant observed bedding angles involve inward (westerly) dip at nearly all levels (*contra* Finlayson *et al.* 2008). The currently exposed long-sections are poor (short lengths stepped back through the stratigraphy) and it should be noted that, whilst the 'local' bedding style often appears laminated, a lenticular (possibly in echelon) style seems likely (i.e. contemporary surfaces may often have been oblique to the currently most obvious, major unit boundaries). A major dune field beyond (east of) the cave has commonly been implied as the cause of the inward dip at Gorham's Cave (i.e. the cave deposits would be the 'tail' of higher exterior dunes); this is a misconception or, at the very least, a gross oversimplification. The main cause of the persistently high depocentre towards the front of the cave would certainly have been the 'talus effect' (the crest now all but lost to erosion) at the intersection of sediment input routes: lateral exterior slopes, cliff overhang and (with respect to carbonates and fines) the outer part of the structural roof rift. At nearly every level (time), there would have been an outer, easterly dipping slope to the cave deposits.

The common sharp contacts, especially where there are minor angular non-conformities, demonstrate that, as in the majority of cave sequences, there are many erosive gaps, although in most cases there is no reason to think that much of the time record has been lost. There is no evidence for significant disconformities (non-sequences, non-depositional unconformities), although sedimentation rate probably varied quite significantly with changing sediment type, depositional mechanism and surface morphology; for instance, towards the back of the cave, there is very little sediment to cover the last *c.*5000 years at the top of the sequence and there also seems to be a surprisingly poor representation of the late Last Glacial (MIS 2). There are a few more significant unconformities in the sequence. At the base of unit CSSm.3, there is a relatively minor angular feature cutting out a few tens of centimetres of underlying material locally. From the section drawings alone (cf. Sections xf and xg, the relevant interval not being exposed in August 2001), it seems possible that there may be a stronger unconformity (implying a significant deformation event) at the contact between unit SSLm(Usm).1, with horizontal bedding filling a concave-up 'basin', and the underlying beds (themselves with concave-up curvature suggesting subsidence); there does not appear to be a marked change in sedimentation pattern across this divide

and there need not be any particularly significant hiatus in the surviving sequence. A much stronger feature is seen between the BeSm(PLSsm) (with clear bedding dipping into the cave) and the BeSm(OSsm) and also the overlying unit UBSm.7 (with bedding dipping out of the cave), at least one high-angle contact having been observed at the unconformity (cf. the further discussion in Chapter 2); there is no great lithological change across the boundary (there being dominantly sandy material above and below) but there could still be a significant gap in the record. The most extreme unconformity yet observed in Gorham's sequence is that which was caused by the Holocene transgression, which produced a 20 m high erosion 'cliff' across the mouth of the cave.

The final category of local unconformity (and potential stratigraphic dislocation) comprises deformation structures at various scales. Small-scale, demonstrably pene-contemporaneous ichnofossils (mostly filled burrows) have been noted at many levels in the sequence and may be quite common in some units (see below). However, the stratigraphic origin of many filled burrows, and especially most of the common larger-scale ('mouse/snake-to-rabbit') features, cannot be proven; it should be noted that there are cases where a burrow has demonstrably cut over 3 m of vertical sequence. There are only a few instances of more generalized and/or multiphase turbation, assumed to be dominated by bioturbation. Geological deformation structures (mostly plastic load structures but with a little microfaulting) are also quite common, especially where there is interstratification of lenses with differing textures (e.g. sand/silt/clay) and where there are signs of volume-loss during chemical alteration.

With respect to taphonomy, it may be noted that a degree of stratigraphic dislocation of some larger objects (e.g. artefacts and bones) may have occurred in almost any part of the sequence, although observation of the patterns of structures suggests that the vertical (thus, apparent temporal) range of displacement would usually have been relatively restricted. The potential for errors in interpretation will have been reduced by rigorous excavation technique and further controlled by the intrinsic characters (e.g. preservation state, taxonomic coherence, even 'refitting') of assemblages (as discussed in each of the relevant chapters of this monograph). The common signs of sheetwash (sometimes rapidly alternating with dry conditions) at many levels, coupled with the density of bioturbation structures already noted, are particularly relevant to smaller charcoal fragments, which could have been extremely mobile, both laterally and vertically (see Chapter 5). It is germane to the archaeological and palaeoanthropological questions of the day that the stratigraphic interval covering the Middle to Upper Palaeolithic 'transition' (assumed to correlate with a change in hominin), as observed in the inner (western) part of the present excavations, is more than usually affected by deformation, microfaulting and bioturbation (shown both by discrete burrow-forms and bulk mixing in places); these mechanical processes do not preclude the partial survival of primary sedimentary structure (cf. Chapter 4) or of gross trends in elemental chemistry due to factors such as

the abundance of combustion and organic debris, nor need they have been significantly reduced by lower depositional angle or a location deeper within the cave. The site's long stratigraphy is of very obvious importance overall but the present author would question whether Gorham's Cave is capable of furnishing the exceptional evidence necessary to support exceptional claims concerning this particular 'transition' (cf. Finlayson et al. 2006 and the response from Zilhão and Pettitt 2006; Finlayson et al. 2008).

Primary and proximal marine phenomena

Much has been said (and unsaid) concerning phenomena thought to be the result of past high sea levels, at and near Gorham's Cave. Most modern authors are agreed that strict attention must be paid to the evidence on the ground locally and that simplistic altitudinal correlations (e.g. those of Zeuner 1953) over longer distances within the Mediterranean are not valid. Even the nearby mainland coast appears to have been affected by strong and varied neotectonic mechanisms, including significant diapirism.

A true raised beach (consisting of rock-cut platform, pebbles and shingle and, possibly, some true coarse swash sands, defined here as the Governor's Beach fFORMATION; cf. Rose and Rosenbaum 1991; Rose and Hardman 2000) is indeed present across the cave mouth just above modern sea level; this is usually called the '1–3 m raised beach'.

Rose and Hardman (2000, 47–48) stated:

> Hoyos et al. (1994) recognized three marine levels at the cave's exterior: one at 1.5 m (dated to between 78,000 ± 1,000 and 33,000 ± 500 yr bp) covered with an aeolian sand; another at 2.5 m containing marine conglomerates preserved in hollows; and a third at 5 m indicated only by an erosion level. We too have observed a notch at about 5 m above present sea level, eroded into a (middle) unit of limestone breccia exposed at the cave entrance and representing a transgressive marine phase later than that marked by the 1–3 m beach.

The lower 'two' observations would appear to refer to the same '1–3 m raised beach' (the significance of the cited dates is unclear; see below). The upper 'notch' was also noted by Zeuner (1953) at 3.5–6.0 m, cut into cemented cave deposits. The present author has been unable to find a convincing marine notch in the Gorham's Cave sediments. However, in the 'corner', against the northern wall and immediately below the Northern Cornice, there is indeed a broad erosive 'notch' in the sediments (at approximately the altitudinal range cited by other authors), in which lies a considerable volume of totally uncemented/unconsolidated shingle and finer marine pebbles; it is suggested that this marine-derived sediment is due to a recent storm surge (perhaps just before the Waechter excavations, when dumping of military engineering debris had created a temporary graded 'beach' right up into the cave mouth), which may have contributed somewhat to the enlargement of a normal subaerial erosion form in the differentially cemented sediments behind. Rodríguez Vidal and Cáceres Puro (2005, fig. 4) showed various notches in the bedrock at the mouth (northern side) of Gorham's Cave (labelled as <5 m, 8–10 m, 15–17 m and 25 m levels), none of which appear to be necessarily of primary marine origin to the

present author, although the lowest one (at 5 m and below) seems to be the best candidate.

Rose and Hardman (2000, 45–47) reviewed the evidence on Gibraltar for a '7–9 m raised beach', generally assumed to have formed earlier than the '1–3 m beach'; the evidence for a highstand (especially where rock and existing cemented breccias show the borings of marine fauna, e.g. at Devil's Tower and possibly Forbes' Quarry, cf. Garrod *et al.* 1928) appears acceptable. However, there is considerable confusion as to whether or not there is evidence for a 'raised beach' at roughly this height at Gorham's Cave.

Waechter (1964, 193) reported that his Layer U 'consisted of white sand with black grains, the grain size being much larger than in the sands above; it was in fact the upper part of the "9 metre" beach'. He noted that 'the sand of Layer U only represents the light sand at the very top of the beach', and that 'coarser beach material was not reached' at a depth of 90 cm into this layer. Relying upon Zeuner's view of Mediterranean high sea levels, Waechter did indeed see a 'beach' at this point. However, a somewhat different picture emerges if one differentiates between the primary marine interpretation (wrong) and the actual observations reported.

Returning to Rose and Hardman (2000, 48; cf. also Rose and Rosenbaum 1991, 64), a similar set of observations were reported:

> However, a well-cemented sandstone with fragments of large marine bivalves at its base is discontinuously exposed within the cave with its base upon a breccia of speleothem clasts about 7.5 m above sea level, and maximum thickness of about 1.5 m. This structureless sand is predominantly of quartz (50%) with some (15%) metamorphic lithoclasts, but is richer in bioclasts (of foraminifera, coralline algae, and molluscs) than the sandy matrix of overlying and underlying breccias. Its top correlates with the height recorded for Waechter's '9 m' beach.

With slightly different details (plausibly due merely to the fact that true comparison between observations could only be made if the exact location, geometry and altitude of the study material were known in each case), the present author has observed beds containing coarse, partially bioclastic sands within this same general interval (the CSm).

Currant (2000, 203) stated:

> We must also discount Waechter's claim to have discovered a 'raised beach' deposit at the base of his recorded sequence at the cave mouth somewhere around 6 to 7 metres above present sea level. There is unquestionably a fossil beach at or just above modern high sea level which is associated with the deposits lying immediately on top of the present rock platform, but in spite of cutting a continuous section right through the deposits at the cave entrance we have found nothing resembling beach deposits any higher in the sequence.

Whilst the criticism of Waechter's records is probably justified, and whilst Currant was no doubt right about the absence of a true marine beach surviving higher than the '1–3 m' level, the above statement does not help to explain the primary observations.

The present author reiterates that there are definitely substantial beds of coarse (estimated as commonly falling mostly within the 0.50–0.71 mm range, with little material above 1.00 mm), well sorted, marine-derived sands, lying conformably within the Gorham's Cave Upper Pleistocene sequence at altitudes of (approximately) 7–9 m above modern sea level. These sands are most unlikely to be part of a true beach (i.e. these are not intertidal/subaqueous deposits) but they must certainly be derived, probably by wind action, crossing a true shoreline within only a very short distance (no more than 100–200 m eastwards). This last point is very important: such coarse sands will not travel (repeatedly) across broad dune fields or other terrestrial surfaces. These sands therefore certainly imply relatively high sea level. The purest coarse sand occurrences are in the CSm, as noted, but there are also lenses of such material in some of the overlying units of the CSSm, suggesting a fading of shoreface influence. Both the CSm and the CSSm contain small quartzitic pebbles (truly rounded forms), either individually or in restricted stringers, suggesting direct ballistic or seaweed-associated input. The marine shell component from the recent campaign at Gorham's Cave has not yet been studied but it is worth noting that the CSm contains mostly coarse sand-grade bioclasts (assumed to be aerodynamically equivalent to the generally slightly finer mineral grains) and that the CSSm contains very significant marine shell accumulations, apparently with a relatively wide size and taxonomic range (whether these are natural or anthropogenic, a proximal shore is again implied). At no point in the Gorham's Cave sequence above *c*.840 cmaSD in the present author's observations is there the slightest trace of coarse sand bodies. The medium (and occasionally fine) sands which are indeed ubiquitous in the upper deposits (and which do not have an intrinsic marine shell component and which do not include nearly so common dark mineral grains) provide a much more plausible fit with the hypothesis of wide dune fields at times of lower sea level (Last Glaciation) (see below).

The sands at *c*.7–9 m at Gorham's Cave are not grossly dissimilar to the sands which immediately overly the true '1–3 m raised beach' along this stretch of coast (although the latter are a little coarser still). Moving slightly further north, to points between Gorham's Cave and Vanguard Cave, there is a very significant cemented dune composed of medium coarse sand banked at very high angles against the cliff; this deposit is observable by *c*.5–6 m above current sea level (there being recent debris at a lower level) and appears to continue upwards for perhaps as much as 10 m more). The dune is then truncated, at a very high-angle unconformity, and there is a coarse cemented breccia plastered above and over the dune remnant. The present author has not had the opportunity to study the Vanguard Cave sequence but, during a very brief visit, it was noted that relatively coarse sand is present on the disturbed outer face of the deposits to a remarkably high altitude; this sand must be derived from the underlying, inward-dipping deposits (it is obviously not material currently being driven up such a steep erosion slope by wind action). It is therefore suggested that, presumably due to the more open morphology of the slope and cave mouth, broadly interglacial deposits might continue to even higher altitudes at Vanguard Cave than they do at Gorham's Cave (although detailed study would be

needed to rule out a recycled origin from a flanking, older high-level dune).

The Catalan Sands, well north of Governor's Bay, probably comprise quite a complex sequence. Rose and Rosenbaum (1991, 120), in addition to reporting a 1.5 m thick palaeosol (a bleached horizon with calcareous rhizoliths above a reddened Fe-rich horizon, with weathered limestone blocks throughout) near the base of the sequence, noted some coarse sands (0.5–2.0 mm), unfortunately without reporting altitudes; if coarse-mode (rather than merely coarse-tail) sands are present lower in the sequence, they (and any major palaeosols) might be associated with broadly interglacial conditions.

Finally, it is interesting to note a similar, but obviously much earlier, cycle of sedimentation at Monkey's Cave. Rose and Hardman (2000) described a rock-cut platform at 55 m above modern sea level, followed by thin raised beach sands and gravels, followed ('without a detectable break') by the aeolian Monkey Cave Sandstone. The latter is a cemented, cross-bedded, pale yellow coarse sand (0.5–1.0 mm) sequence, up to 30 m thick; grains are dominantly carbonate in composition (including bioclastic material). There are terrestrial mollusca (as well as marine material) in the sands, including two taxa of current North African distribution. Note, in passing, that it would not be possible for significant quantities of 'pure' loose sand to be reworked from this (or another similar ancient) stock without the loss of the carbonate bioclastic component; thus, the coarse sands in the Gorham's Cave sequence could not derive from such 'perched' stocks (even if there were an explanation of why the secondary sources contributed to only very specific strata, dominantly the CSm). Rose and Hardman noted conformable breccia above the coarse sands (which seems plausible to the present author from the outcrop still observable immediately above Monkey's Cave).

The geomorphological context and dating of the marine-related deposits at Gorham's Cave is by no means straightforward.

Rodríguez Vidal and colleagues (Rodríguez Vidal and Gracia 2000; Rodríguez Vidal et al. 2002; 2003; 2004; Rodríguez Vidal and Cáceres Puro 2005) devised a 'morphotectonic' model for Gibraltar, which sought to explain the apparent Pleistocene geomorphology through a combination of the effects of eusostasy and general tectonic uplift. According to this model, as long as uplift remained relatively low, successive deposits ('morphosedimentary units' (MSUs)), including fossil marine beaches, would accumulate by offlap (sedimentation over and then down and beyond the 'snout' of previous deposits); however, when uplift accelerated, a bedrock cliff would form. Thus, any particular 'stack' of offlap deposits (MSUs) would be limited, both above (shorewards) and eventually below (seawards), by cliffs, the whole being referred to as a 'morphotectonic unit' (MTU). For the present purposes, it is MTU5 which is of most interest since, in the view of Rodríguez Vidal and colleagues, this unit contains deposits which span the last 250 ka, including marine terraces in the range 1–25 m above modern mean sea level, referable to MIS 1, 5 and 7.

This model can only be quantified if the rates of uplift and eustatic change can somehow be estimated (the tidal range of the Mediterranean is so small as to allow this parameter to be ignored). Rodríguez Vidal and colleagues originally relied upon two uranium-series dates on interstitial carbonate (citing Hoyos et al. 1994 and Zazo et al. 1994) to calibrate MTU5 on Gibraltar. At Europa Point, a terrace remnant at 5.25 m amsl was dated at 92.5 ka and at the mouth of Gorham's Cave another remnant (presumably the Governor's Beach fORMATION of the present report) at 1.0 m amsl was dated at 81 ka. Rodríguez Vidal and colleagues took these dates to correspond to points during MIS 5c and 5a respectively. They then calculated (see in particular Rodríguez Vidal et al. 2004) that a mean tectonic uplift value of 0.05 ± 0.01 mm/yr would have been maintained from 200 ka to the present.

Now, this estimate of uplift rate is not implausible in itself, although rather different figures have been derived for the nearby mainland coast (cf. Zazo et al. 1999; Gracia et al. 2003) and, using fossil shorelines dated at c.100 ka, it has been suggested that the Straits of Gibraltar constitute the zone with the greatest uplift rate, of 0.11 mm/yr (cf. Zazo et al. 2000). The problem is that the absolute (eustatic) heights of the MIS 5 transgressions (prior to the effects of any uplift) were not obviously integrated into this calculation. Before any further discussion of the Gibraltar situation, it will be necessary to examine relevant data sets from better studied areas around the world.

It would appear, from particularly tectonically stable regions, that interglacial maximum sea levels have not differed greatly from the present level over much of the Pleistocene. For instance, Murray-Wallace (2002) reviews data from southern Australia, where fossil shorelines can often be traced horizontally over hundreds of kilometres, concluding that, for at least the past 11 interglacials, sea level highstands did not deviate by more than about 6 m from the present level, with MIS 5.5 (5e) falling in the bracket 2–6 m above present mean sea level. Studies of cores from the Red Sea are generally considered to provide more accurate sea level estimates (based mainly upon oxygen isotope composition) than is the case in more 'open' basin cases. Siddall and colleagues (Siddall et al. 2003; 2007) suggest that their sea level data are accurate to within ±12 m over a timescale of 470 ka and at centennial scale resolution; they note that the MIS 5.5 peak was not significantly higher than the present sea level, and that the 5c (5.3) and 5a (5.1) peaks were at least 15 m below that of 5.5. Recent data from the Barbados fossil reefs (Potter et al. 2004; Schellmann et al. 2004) again suggest that, after MIS 5.5, sea level did not rise above approximately –15 m (relative to current sea level, the best available adjustment having been made for steady uplift). Furthermore, on the basis of coherent sets of both uranium-series and ESR dates, there appear to have been more than one peak within each of the three 'classic' transgressive substages of MIS 5. Thus, according to these indicators, sea level reached its interglacial maximum during MIS 5.5.3 and MIS 5.5.2 between 132 and 128 ka ago. Subsequently, in MIS 5.5.1, sea level declined reaching a level of c.–11 m by c.118–120 ka ago. During substage 5.3 (5c) sea level was always lower than in substage 5.5; it reached

relative maxima at *c.*–13 m, –20 m and –25 m during MIS 5.3 (grouped around 105 ka) and formed three distinct coral reef terraces probably in relative short time intervals. A double sea level oscillation is recognized during MIS 5.1 (5a), an early 5.1.2 interval (*c.*85 ka) with a sea level at *c.*–21 m, and a late 5.1.1 interval (*c.*74 or 77 ka) with a sea level at *c.*–19 m. In the Bahamas, a similar picture is emerging. Hearty and Neumann (2001) report that, early in MIS 5.5 (132–125 ka), the sea maintained a level of *c.*+2.5 m. A mid-5.5 regression around 124 ka is well documented, followed by a new rise to a slightly higher level than the previous one, allowing reef growth to a maximum elevation of less than +3 m. This near stillstand was short lived, however: at the end of the period (towards 118 ka), sea level rose to +6 to +8.5 m. The subsequent fall to the substage 5.4 lowstand was rapid. Siddall *et al.* (2007) give additional data from around the world, showing a generally consistent picture, although there continue to be some dissenting voices (cf. Dorale *et al.* 2010). Even along the southern Spanish coast, multiple highstands within each MIS 5 substage have been reported (cf. Zazo *et al.* 2000).

Returning to the Gibraltar case, it will be remembered that Rodríguez Vidal and colleagues originally suggested a MIS 5.3 peak at 5.25 m above current sea level, and a MIS 5.1 peak at +1.0 m. The best worldwide estimate for the maximum MIS 5.3 level is *c.*–13 m, implying uplift of 18.25 m over *c.*105 ka (*c.*0.17 m per 1000 years). The best worldwide estimate for the maximum MIS 5.1 level is *c.*–19 m, implying uplift of 20.25 m over *c.*75 ka (*c.*0.27 m per 1000 years). The best worldwide estimate for the maximum MIS 5.5 levels is +2 m to +6 m; if the apparent uplift rates just calculated are applied, one would now expect the MIS 5.5 fossil beach(es) (dating from, say, 125 ka) to be lying somewhere within the range +23.25 m to +39.75 m on Gibraltar (+15.75 m to +19.75 m, even if the general Straits of Gibraltar rate is used). Alternatively, if one uses the uplift rate originally suggested by Rodríguez Vidal and colleagues (0.05 m per 1000 year), one would expect to find a MIS 5.5 125 ka beach at +8.25 m to +12.25 m, a MIS 5.3 105 ka beach at –7.75 m (below current sea level), and a MIS 5.1 75 ka beach at –15.25 m.

Four different hypotheses concerning the Gibraltar low-level raised beaches (all of which assume that the area was not subjected to any significant degree of tilting, reversal of tectonic trend, or greatly significant changes in movement rates during the Upper Pleistocene – assumptions of unknown reliability at present) can be put forward:

High Uplift Rate Model. Assuming an uplift rate of *c.*0.27 m per 1000 years, an MIS 5.3 beach dating from 105 ka would now lie at +15.4 m, an MIS 5.1 beach dating from 75 ka at +1.25 m. Pinning the label '5.1' to the '1–3 m beach' (GBf), the '5.3' calculation clearly does not fit the Gorham's Cave observations, such that surviving (if any) 5.3 deposits in the Gorham's sequence would have to be hidden at an unconformity behind the present exposures. Any MIS 5.5 beach would lie above +35 m today. If the possibility of an earlier 5.1 interval in a composite substage is considered (as evidenced in Barbados), the 5.1.2 beach at 85 ka would now lie at +1.95 m; more to the point, although the 5.1.2 beach

would have risen 2.7 m by 5.1.1 times, since the peak of 5.1.1 was intrinsically 2 m higher than that of 5.1.2, this would surely not have been enough for the 5.1.2 material to escape total obliteration. The derived marine sands of the CSm would remain unexplained and a complicated series of perhaps 10 m of sediments would have to be squeezed in before the earliest plausibly post-MIS 5 levels in the cave.

Medium Uplift Rate Model. Assuming an uplift rate of *c.*0.15 m per 1000 years, an MIS 5.3 beach dating from 105 ka would now lie at +2.75 m; deposits of any slightly later 5.3 intervals (such as those evidenced in Barbados), as well as any from MIS 5.1, would still lie well below modern sea level. MIS 5.5 beaches would lie well above the Gorham's Cave sequence. The derived marine sands of the CSm would remain unexplained and the unequivocal '7–9 m beach' phenomena elsewhere on Gibraltar would have to date from some relatively low sea level event pre-dating MIS 5.

Low Uplift Rate Model. Assuming an uplift rate of *c.*0.05 m per 1000 years, an MIS 5.5 beach dating from 125 ka would now lie at +8.25 m or a little higher; all MIS 5.3 and 5.1 beaches would still be well below modern sea level. Such a disposition would fit the Devil's Tower observations reasonably well, and might even explain the CSm at Gorham's Cave. However, the '1–3 m beach' of the GBf would then be difficult to explain, other than by reference to some relatively low sea level event pre-dating MIS 5 or to some unexplained post-5.5 'intermediate' regressive standstill.

Very Low Uplift Rate Model. Assuming an uplift rate of *c.*0.01 m per 1000 years, an MIS 5.5 beach dating from 125 ka would now lie at +3.25 m, an MIS 5.3 beach dating from 105 ka at –11.75 m, and an MIS 5.1 beach dating from 75 ka at –18.25 m. If there were a brief 'pulse' of yet higher sea level at 118 ka (as evidenced in the Bahamas), a related beach would now lie at +7.2 or even a little higher (cf. Dabrio *et al.* 2011). This might explain the derived marine sands of the CSm at Gorham's Cave, as well as the less equivocal traces of a '7–9 m beach' elsewhere on Gibraltar. This hypothesis need assume no major hidden unconformity between the true beach of the GBf and the rest of the (so far observed) Gorham's sequence, although there would not have been much time for the deposits up to the base of the CSm to have accumulated. Alternatively, it would seem mechanically possible for coarse sands to be emplaced in the CSm from an MIS 5.3 sea level as low as *c.*–8 m, thus giving more time for the intervening deposits to have accreted, although ballistic input of pebbles would appear less probable under such circumstances.

The currently available observations would seem to fit the (locally) 'Very Low Uplift Model' best. This proposition would seem to be supported by more recent work by Rodríguez Vidal *et al.* (2007), who, at Vanguard Cave, recognize a main +5 m bedrock notch and a pot-holed wave-cut platform at +1.5 m, the latter covered by (penecontemporary) foreshore and backshore deposits up to +4 m and now cemented ('fossilizing'). Two uranium-series (Th/U a) determinations on well preserved shell from these deposits

gave dates of 114.4 ± 6.5 ka and 109.9 ± 7.3 ka. Also recognized are 2 m of coarse backshore aeolian sands, capped by fully terrestrial deposits. Rodríguez Vidal *et al.* attribute all these phenomena to MIS 5.5, although they do not comment upon the implications for rates of tectonic uplift. The OSL dates from the terrestrial deposits overlying the marine phenomena at Vanguard Cave are broadly consistent (cf. Chapter 14).

Were the actual geometry of uplift for Gibraltar to involve a slight southerly tilt component (i.e. were the apparent uplift rate towards the south of the 'island' to be slightly less than in the north, a not implausible suggestion given the position of Gibraltar between the rising Baetics and the sinking Alboran Basin and a factor which might help explain the reported observation of MIS 5.5 and 5.3 shorelines at significantly higher altitudes northwards along the mainland coasts), observations might fit the model even better. Indeed, a tilt would be a necessary element if the CSm at Gorham's Cave is significantly younger than the '7–9 m beach' at sites such as Devil's Tower near the North Face of the Rock; a correlation of the GBf at Gorham's Cave with the beach at Devil's Tower, some 2.76 km distant, would only involve a very modest southerly tilt component of about 1:400, that is, less than 0.15°. It is reiterated that the observed geometry of the Gorham's Cave deposits (principally the consistent westerly dips) makes it extremely unlikely that a correlation exists between the coarse sands at *c*.7–9 m (CSm) and the '1–3 m raised beach' (GBf). Taken on face value, the intervening deposits seem to be conformable, including the RSCm and perhaps some of the units in category (3) of uncertain attribution (including the better bedded sands noted by Currant, 'Unit D' and even 'Unit E', see Appendix 2.1).

Main lithological components
Coarse clastic carbonate input
Limestone clasts are most common in externally derived slope deposits (at and beyond cave entrances) on Gibraltar. On a point of nomenclature (and to avoid any misunderstanding) a 'breccia' (Italian 'broken') is a deposit dominated by coarse, angular clasts (as opposed to a 'conglomerate' with its coarse rounded particles); the term 'breccia' alone does not imply cementation. Most of the coarse slope deposits in the vicinity are thus cemented breccias (usually with a reddish, heavily recrystallized carbonate-rich matrix). Rose and Hardman (2000, 55–68) discussed the Gibraltar 'scree breccias' in general, concluding that, whilst there are complexities of detail, it 'seems clear that the massive scree breccias of Gibraltar formed as rockfalls triggered by cryoclastic (freeze-thaw) action during climatic conditions more extreme than those on present day Gibraltar (whose mean maximum daily temperature falls only to 12°C in the coldest month, January)' (2000, 68).

In Gorham's Cave, bedrock clasts rarely dominate the sediment at any point in the deposits, although they are quite common, either as matrix-supported elements or as clast-supported lenses, in the CHm, the SSLm (especially in the Upper submember) and in cemented remnants low in the sequence; there would seem to be a general tendency for clasts (larger than sand grade) to become more common

towards the front of the cave at all stratigraphic levels. Such clasts are traditionally ascribed a cryoclastic (freeze-thaw) origin (see Rose and Hardman, above). Whilst it is quite possible that this explanation is correct for some of the Gorham's Cave material, not enough is known about the likely climates of the Last Glaciation in Gibraltar to be sure; there are certainly no geological or palaeontological data known at present which would provide unequivocal proof of a correlation between significantly colder climate and clastic limestone debris on Gibraltar. In addition, Goldberg (pers. comm.) stresses that there is no micromorphological evidence for ground-ice lensing in any of the finer deposits at Gorham's Cave. On the other hand, data from nearby marine cores would seem to suggest a depression of mean sea surface temperatures, compared to the present, of at least 9°C during many intervals in MIS 4–2 (cf. Colmenero-Hidalgo *et al.* 2004), which would certainly make intermittent winter freezing on Gibraltar plausible. It should nevertheless be remembered that there are many other possible causes for rock fracture, for instance, crystal-wedging (e.g. salt), root-wedging, low humidity (increasing diurnal rock surface temperature fluctuation), cliff-base erosion and individual earthquake events (this is a tectonically active zone) (cf. Woodward and Goldberg 2001); even human activity within a cave, especially if repeated burning is involved, may accelerate bedrock breakdown. If the processes responsible for the input of limestone clasts to the cave sequence are broadly the same as those responsible for the external slope breccias, it may be relevant to note that major breccias and aeolian sands appear to be more or less mutually exclusive (i.e. the breccias tend not to have sandy matrices and the sands tend to be relatively stone-free) in any given slope sequence; this might suggest that breccias do not form well during the drier episodes best suited for dune accretion (see below). For the present, it may be best to view significant limestone debris as indicative of some form of instability or change (for instance, in climatic factors, such as temperature and humidity, or, less directly in vegetational/pedological factors or in geomorphological factors, such as sea level), with a rider that relatively cool and damp conditions (if corroborated by other evidence) ought to favour scree production. Some levels of the sequence (such as the LBSmcf) have quite common thin lenses or stringers of fine limestone grit, interstratified with finer units, an overall motif which perhaps indicates environmental fluctuation (see below).

Stalactite fragments comprise one very special type of coarse clast. Such fragments seem to appear in many of the Gorham's Cave deposits but they are particularly common, and large, in two observed horizons. The first (oldest) is in what would appear to be a (coarsely) horizontally bedded (and thus probably very local) cemented reddish breccia (RSCm), across the cave mouth, just above the coarse sands capping the so-called '1–3 m raised beach' (GBf); by far the dominant proportion of clasts in this level of the breccias is provided by large stalactite fragments. The second occurrence of sometimes very large stalactite fragments is immediately above (and annealed to, or oven 'spearing' through) a major composite stalagmitic floor (CSSm, at *c*.870 cmaSD

in the outer face of the Northern Cornice). Such occurrences could be interpreted anywhere along a continuum: on the one hand, one might have continual stalactite formation/availability with specific intervals of clastic activity giving the phased fragmentation or, on the other, one might have continual (if varied) clastic processes with the phased fragmentation reflecting a time immediately after strong stalactite formation. A point nearer the latter end of the continuum seems more likely (cf. discussion of speleothem formation, below).

Speleothem formation

Major speleothem formation requires sufficiently high temperature and humidity in the regional climate, plus dampness in the cave environment itself (implying relatively 'closed' cave conditions, without too much ventilation, dust precipitation and/or biological interference); Rose and Rosenbaum (1991, 69) suggested that Gibraltar speleothems (mostly inactive today) 'indicate periods of more humid climate in the past, such a climate encouraging growth of more vegetation than at present at the ground surface, with the release of greater quantities of humic acid […]'. There are very significant speleothems at Gorham's Cave but the fact that the whole sequence is not dominated by carbonate precipitates is perhaps the most obvious illustration of lower temperature and/or humidity at various depositional stages.

A massive stalagmitic floor (USFm) has formed (judging from artefacts above, within and below), perhaps towards the end of the Last Glaciation and certainly into the earlier Holocene, capping the whole of the main cave sequence. Considerable erosive regression has occurred within the outer cemented remnants (the 'Cornices') since the cessation of floor formation; there are no drapes of speleothem down the 'faces' of any of the existing remnants. This gives a general climatic baseline, as long as it is remembered that the actual cave void was quite restricted (presumably cool, damp and deficient in light) at the time of floor deposition. It is significant that the most active dripstone noted recently is on the inner side of the large stalagmitic column above Section xa (very specifically within the narrow vertical band which receives no light); it is suggested that biological factors needing light are currently inhibiting dripstone formation within the cave.

Floorstone formation also occurred earlier in the sequence. The only currently known floors which appear to have been anything like as thick/crystalline as the recent floor occur in remnant ledges (with some stalagmitic columns above) attached, over at least 10 m laterally, to the north entrance wall of the cave at c.400–500 cmaSD (capping the material informally referred to as 'Units D and E', the higher 'Unit E' occurrence being the more persistent). Although available exposures are poor, these floors do seem to post-date the high sea level of the '1–3 m raised beach' (GBf, see above). Floors higher in the sequence all peter out quickly into the cave. Even the major composite floor exposed at c.870 cmaSD (in unit CSSm.1) in the North Cornice seems to fade quickly inwards and southwards to little more than a 'chalky' crust; that this floor was never massive is shown by the inclusion of large quantities of marine shell and other

clasts (including artefacts). It would seem best to think of these higher 'floors' more as stalagmitic bosses with wide aprons, forming immediately below the main drip/seep points (cf. the main roof fissure, opening slightly north of the mid-line of the cave chamber) but not continuing far back into what was still a largely open cavity. Apart from the recent floor, all the more extensive floor speleothem observed so far in Gorham's Cave occurs in the lower parts of the sequence, although there are small stalagmitic bosses at some intermediate levels. There are also quite strongly cemented sediment intervals at various levels, so much so that Zeuner (1953) referred to some of them as 'stalagmite'. Goldberg and Macphail (2000) and Macphail *et al.* (2000) reported micritic grounds (cements derived from autochthonous fine-grained carbonates, sometimes including ash) but comparatively rare sparite (allochthonous calcite cement, akin to dripstone); despite post-depositional and longer-term diagenetic effects, these authors (Chapter 4) recognize in their full micromorphological analyses more subtle variations in the broadly syndepositional input of carbonate precipitates.

Stalactites require similar conditions of temperature and humidity in the overall climate for their formation (it was noted above that major fragmentation beds occur immediately above the deposits of the '1–3 m raised beach' in the GBf and above the 870 cmaSD floor in the CSSm). However, it may be that the reticulate stalactites most commonly seen at Gorham's Cave (in cross-section, complex ribbed forms, not simple concentric 'cones'), which one could liken to poorly crystallized 'curtain formations', would continue to form in significantly drier (i.e. still well watered but better aired) locations. At Gorham's Cave (and to a lesser extent at Vanguard Cave), there are today large, 'knobbly' stalactites pendant from the very outer edges of the cliff overhang. It also seems likely that well illuminated stalactites are attractive as substrates for bacteria, algae, mosses and lichen, all of which cause carbonate precipitation, adding irregular bulk to the stalactites. Even today, there is a light dusting on most surfaces of carbonate grains and more structured aggregates as these mechanically weak biogenic precipitates 'rain' from the roof and walls. Goldberg and Macphail (2000, 100) stated that, in thin section, 'travertine/tufa fragments typically display irregular wavy laminae and are presumed to be algal in origin, at least in part'. There is no absolutely correct name for the subaerial forms most common in cave entrance facies, although many cave sedimentologists use the term 'eucladiolith' (etymologically, a form precipitated by mosses) to avoid confusion with subaqueous forms. Note that the original precipitates occur on rock walls and ceiling, whilst the most obvious occurrence in sedimentary sequences is in the form of 'clastic (pseudo) tufa', when fragments have fallen and built up a secondary deposit on the floor below. These biogenic precipitates definitely require (at least seasonal) climatic humidity but it is not clear how cool a regime would be needed to curtail their formation (it is assumed that different taxa might take on the same sedimentary role as the climate cooled); as possibly relevant points of comparison, such precipitates have formed only under fully (but mostly early and

late, not 'high') interglacial conditions in the mouths of British caves, but such tufaceous input is very common in cave units recently observed (and interpreted as indicating significantly more humid conditions than at present) by the present author in the Northern Rif (Tingis Peninsula, Morocco), units which appear (from the artefact content) to be of full Last Glaciation (equivalent to MIS 2 and very late MIS 3) age (Barton *et al.* 2005). Goldberg and Macphail (2000, 100) also referred to numerous 'oncolites' observed in the field in their 'Lower Levels' (*c.*880–800 cmaSD). The terms 'oncolite'/'oncoid' properly apply to those algal concretions which are formed under water but it is assumed here that these were 'eucladioliths' (which certainly occur at those levels). Currant (see Appendix 2.1) noted cave pearls in unit CSSm.1, a globular or spherical form produced by calcite deposition on a loose, moving 'seed' lying in a pool of water.

Medium- and fine-grained quartzitic sands

Goldberg and Macphail (2000) noted well rounded quartz sand in the range *c.*0.2 to 0.75 mm, particularly strongly present in their Lower Level observations (880–800 cmaSD), less so upwards and into the cave (the matter of coarser mode sands was discussed above in conjunction with consideration of primary and proximal marine phenomena). Finer quartzitic sands are more or less ubiquitous in the cave sequence.

The 'classic' model for external slope deposits on Gibraltar involves earlier breccias covered by later aeolian sands (e.g. the Catalan Sands) (cf. Rodríguez Vidal and Gracia 2000); it is noteworthy that Rose and Hardman (2000) describe the bulk of the Catalan Sands as dominated by quartzitic grains, mostly in the 0.250–0.125 mm range and poor in carbonate. Such a model appears plausible for main Last Glaciation sequences, involving cycles with early slope-instability breccias (see above), followed by relatively arid and perhaps even a little cooler climate fine to medium aeolian sands derived from coastal plains exposed by lowered sea level. Aridity promotes sand mobility due to such factors as low interparticle surface tension, low interstitial cement or other binding matrix, and low vegetational cohesion. Siddall *et al.* (2003) give sea levels of –100 m at 65 ka (MIS 4) and –120 m at 24 ka (MIS 2) for the Red Sea. Finlayson and Giles Pacheco (2000) suggested that 60–25 ka (MIS 3) sea levels would have lain mostly in the range –75 m to –85 m; taking the present –80 m submarine contour, they noted that a 2.5 to 4.5 km wide emergence zone would be produced on the east side of Gibraltar (a proposition already put forward by Garrod *et al.* 1928). Not all authors have accepted the growing worldwide evidence for low MIS 3 sea level minima; for instance, Gracia *et al.* (2003) inferred a MIS 3 sea level only some tens of metres below the present mean value, probably less than 30 m, in the Bay of Cadiz. However, most researchers dealing with more continuous records have identified substantial millennial- or even centennial-scale fluctuations, not only in MIS 3 but in much of the MIS 6–2 span. Perez-Folgado *et al.* (2004) report 42 biostratigraphic faunal events in the interval from 150 ka to 60 ka in Alboran cores, due to rapid sea surface temperature (and

presumably sea level) fluctuations. Siddall *et al.* (2003) report fluctuation of level of up to 35 m, at rates as high as 2 m per century, during the period 70 ka to 25 ka in the Red Sea. Davies *et al.* (2000) and Voelker (2002) have reviewed global short-term climatic oscillations in MIS 3, Moreno *et al.* (2005) have documented high frequency oscillations in the Alboran cores back to 50 ka and Huguet et al. (2011) have considered the whole MIS 5-2 interval in these cores. This marked variability is of interest in a primary palaeoclimatic sense but it also has great significance with respect to landward sediment supply and depositional mode. Fluctuations in aridity would tend to cause aeolian transport to be punctuated by stops and starts, whilst the continual tracking of shorelines back and forth across tens of metres of altitude (hundreds of metres laterally) would have caused the repeated interruption of nearshore vegetational and pedological development, ensuring the renewal of sand exposures upon which wind deflation could continue to act.

It may be that the signs of such climatic fluctuation are too subtle to have been identified as yet in the major exterior fossil dune sequences on Gibraltar, but it is possible that the more sheltered micro-environment of caves, in which humidity would probably have remained generally higher, may have preserved a more obvious (if erosionally incomplete) record of variability. Many levels of Gorham's Cave are certainly very rich in medium and fine sands, which were probably delivered to the proximity of the cave by wind. However, the laminated bedding in most of the sandy deposits is not classic aeolian bedding and final deposition was certainly aided by surface wash in most cases. To date, there are only a very few cases (in uNITS SSLm(Usm).2, SSLm(Lsm).7, SSLm(Lsm).10 and VSSm.3) in which very small-scale cross-bedding has been unequivocally observed, possibly referable to sand ripples of true aeolian origin. Some possible cross-stratification was noted in the sands of the BeSm but the recent exposures have been too poor to be sure; certainly, the whole of BeSm(PLSsm) could be the (inner) tail of a major dune. On the other hand, deposits such as those in the LBSm not only show clear wash deposition in the sands but also contain frequent and quite persistent water-lain laminae of finer sediments still (see below).

Clays and silts

Markedly fine-grained sediments are most common in two broad intervals in the sequence.

In the middle levels, and especially in the LBSm, most occurrences are in the form of relatively thin but often persistent laminae, or more localized lenses, interstratified with sandy or silty sandy units and gritty (limestone) stringers and lenses. These fine laminae show all the signs of repeated emplacement by wash, with ponding (and subsequent desiccation cracking) at some levels; they therefore contribute an element to the model of climatic fluctuation already noted above with respect to laminated sands. Goldberg and Macphail (2000, 106–107) summarized their findings concerning sediments in approximately the interval 1265–1250 cmaSD (predominantly the LBSm) as follows:

In the Middle Levels, similar biogenic/anthropogenic factors are also visible in the form of noticeable amounts of bone and coprolites, as well as charcoal/organic matter. Here, sediments are clearly more cultural, as is clearly evident in the field by numerous ashy and burned levels. The sediments from Sq. C102 (revealed clearly in the 1996 season), however, exhibit extensive small-scale cut-and-fill features that suggest erosion by wind or running water. The presence of fine laminae of organic mineral origin in these units, as well as from C99, also point to ponding of water, a hypothesis supported by the abundance of frog bones in the calcareous layers; bone preservation is lacking from sediments further inside (e.g. Sq. C99); here phosphate diagenesis is marked. Some of the apparent ashy hearth layers when studied in thin section seem to be composed of water-lain silts, ash and organic matter, indicating local reworking of hearth materials.

The micromorphological (and chemical) techniques used by Goldberg, Macphail and Linderholm (see also this volume, Chapter 4) are by far the best adapted to provide useful information on the types of finer sediment occurring through much of the middle parts of the Gorham's Cave sequence. The present author would simply add a note concerning load structures (penecontemporaneous deformation). Whilst some 'load' structures seen in sandier units at various points in the sequence are probably collapse structures associated with larger-scale burrowing or other single-event stress release in softer sediments, there are some features associated with the darker laminated sediments in the 'middle levels' (cf. those in uNIT LBSmff.5) which resemble true rotational (incremental) load-casting structures. Such structures imply persistent plasticity and thus waterlogging. Indeed, it is difficult to see how any other mechanism than the relatively widespread ponding suggested by the micromorphologists could possibly account for the radical lateral facies shift (the necessary 'ff/cf' distinction in the LBSm stratigraphy) between, say, the S–N exposure in 'xc' (downslope and deeper into the cave) and the immediately adjacent W–E exposure in 'xc–xd'. Loss of more vulnerable components (organics, soluble minerals) through time will also cause general down-warping of cave deposits, especially away from the walls; the release of stress is therefore not always syndepositional, and both more diffuse plastic deformation and 'brittle' microfaulting may occur long after a deposit has been buried (indeed, faulting at one level may trigger plastic deformation at another, or *vice versa*, depending upon the sediment characteristics and saturation state). In Gorham's Cave, there appear to be good examples of both penecontemporaneous and markedly 'delayed' deformation.

The second main interval with finer sediments centres around the RSSm, with some similar inputs starting towards the top of the underlying CSSm and then petering away again as units in the VSSm interstratified with increasingly sandy and stony material upwards. The inputs in question give strong reddish beds with significant matrix silt/clay (probable eroded soil peds), sometimes organized in discrete laminae, and abundant terrestrial mollusca fragments; other features, such as eucladioliths, dark lenses or speckles of iron and manganese salts, tiny

spreads of bright orange-yellow material (assumed to be phosphatic and confirmed by Goldberg (pers. comm.) to comprise crusts of apatite derived from surface accumulations of guano), and fine (intraformational) bioturbate structures resembling insect burrows, are also associated at many levels. Goldberg and Macphail (2000, 106), noting micromorphological evidence of running water (such as micro-graded bedding), interpreted these fine reddish inputs as being of a colluvial ('slope-wash') origin; they also catalogued cultural and biogenic components, such as charcoal, artefacts, coprolites, bone, shell and guano, and finely divided organic matter. Macphail *et al.* (2000) noted that these lower levels have unexpectedly high magnetic susceptibility, organic phosphate and combustible organic matter; they suggested colluvial washing from surfaces with organic matter and bird droppings, and with Mousterian hearths (in areas as yet unobserved). Magnetic susceptibility enhancement can certainly be caused by anthropogenic burning and by the concentrated turnover of magnetotactic bacteria in decaying organic matter; however, materials derived from soils formed under warmer conditions (e.g. the *terra rossa* often associated with limestone substrates) usually have generally elevated susceptibility levels in their own right. Further micromorphological description and discussion of this sedimentary facies is given in Chapter 4.

Organic matter

Micromorphological observations have revealed organic matter of various types surviving at a number of levels in the sequence (see Chapter 4). Goldberg and Macphail (2000, 97) gave field observations of sedimentary facies in the interval *c.*1580–1400 cmaSD (in squares C–D/97–98); these facies included 'dry, brown, crumbly silty clay' and 'brownish, organic-rich clayey sand'. Unit UBSm.6 would fall in the right location (at the lower end of this altitude range) and contains thick layers of very strongly organic material, behaving almost like degraded sandy peat in places (low-density, slightly elastic, shrinkage-cracked, largely combustible); it seems possible that these may be accumulations of herbivore droppings (ibex?), although primary vegetable material and guano (bird nesting?) are probably alternative/additional sources, along with more obvious carnivore coprolites. Goldberg (pers. comm.) has noted that phosphatic organic clay at these levels often contains fine silt within it, suggesting that it is derived/inherited part and parcel with the guano itself, implying thorough mixing of organic and mineral phases.

Sequence of events

A general sequence of geological events is offered in Figure 3.1, including data with possible chronological and palaeo-environmental implications where available. However, it is stressed that the chapters on micromorphology, palaeontology and chronometry should be consulted before any overall conclusions are reached, although there remain significant intervals from the overall sequence at Gorham's Cave for which the general sedimentological description (cf. Appendix 2.1) is the only information currently available.

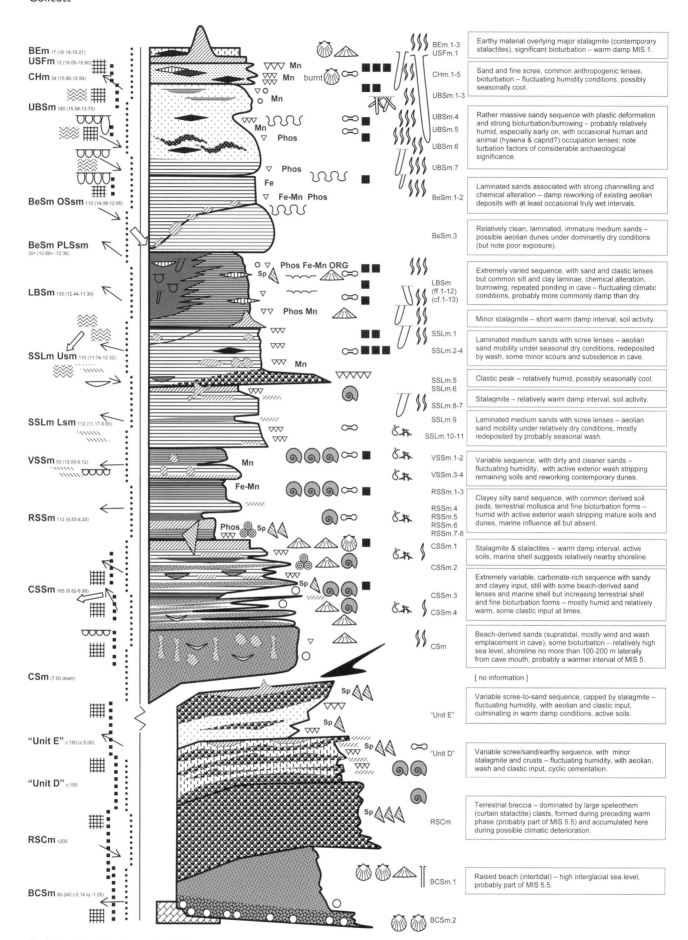

Fig. 3.1 Gorham's Cave, geological sequence.

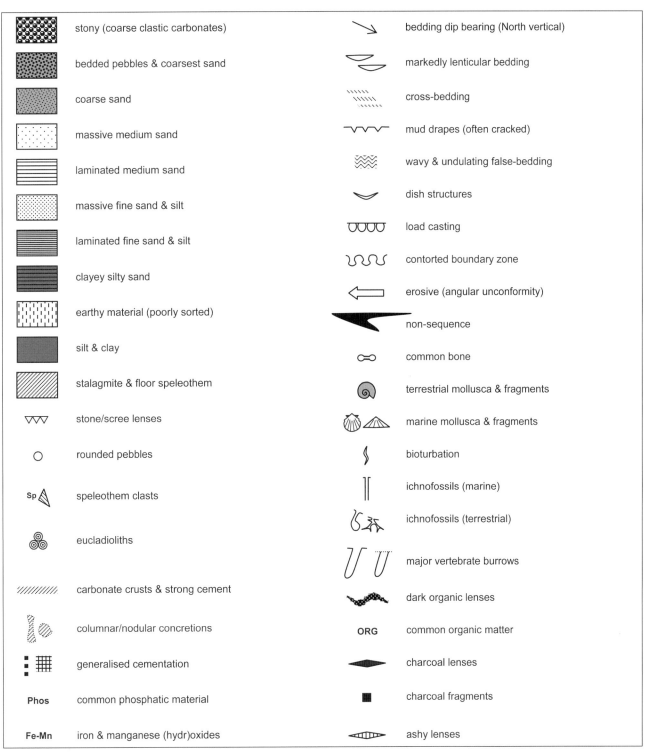

stony (coarse clastic carbonates)	bedding dip bearing (North vertical)
bedded pebbles & coarsest sand	markedly lenticular bedding
coarse sand	cross-bedding
massive medium sand	mud drapes (often cracked)
laminated medium sand	wavy & undulating false-bedding
massive fine sand & silt	dish structures
laminated fine sand & silt	load casting
clayey silty sand	contorted boundary zone
earthy material (poorly sorted)	erosive (angular unconformity)
silt & clay	non-sequence
stalagmite & floor speleothem	common bone
stone/scree lenses	terrestrial mollusca & fragments
rounded pebbles	marine mollusca & fragments
speleothem clasts	bioturbation
eucladioliths	ichnofossils (marine)
carbonate crusts & strong cement	ichnofossils (terrestrial)
columnar/nodular concretions	major vertebrate burrows
generalised cementation	dark organic lenses
Phos common phosphatic material	ORG common organic matter
Fe-Mn iron & manganese (hydr)oxides	charcoal lenses
	charcoal fragments
	ashy lenses

Graphic key to Figure 3.1

References

Barton, N., Bouzouggar, A., Collcutt, S.N., Gale, R., Higham, T., Malek, F., Parfitt, S., Rhodes, E. and Stringer, C.B. 2005: The Late Upper Palaeolithic occupation of the Moroccan northwest Maghreb during the Last Glacial Maximum. *African Archaeological Review* 22(2), 77–100.

Colmenero-Hidalgo, E., Flores, J.A., Sierro, F.J., Barcena, M.A., Lowemark, L., Shonfeld, J. and Grimalt, J.O. 2004: Ocean surface water response to short-term climate changes revealed by coccolithophores from the Gulf of Cadiz (NE Atlantic) and Alboran Sea (W Mediterranean). *Palaeogeography, Palaeoclimatology, Palaeoecology* 205, 317–336.

Currant, A.P. 2000: A review of the Quaternary mammals of Gibraltar. In Stringer, C.B., Barton, R.N.E. and Finlayson, J.C. (eds.), *Neanderthals on the Edge* (Oxford: Oxbow Books), 201–205.

Dabrio, C.J., Zazo, C., Cabero, A., Goy, J.L., Bardají, T., Hillaire-Marcel, C. Gonzáles-Delgado, J.A., Lario, J. Silva, P.G., Boria, F. and García-Blázquez, A.M. 2011: Millennial/submillennial-scale sea-level fluctuations in western Mediterranean during the second highstand of MIS 5e. *Quaternary Science Reviews* 30, 335-346

Davies, W., Stewart, J. and Van Andel, T.H. 2000: Neanderthal landscapes – a preview. In Stringer, C.B., Barton, R.N.E. and Finlayson, J.C. (eds.), *Neanderthals on the Edge* (Oxford: Oxbow Books), 1–8.

Dorale, J.A., Onac, B.P., Fornós, J.J., Ginés, J., Ginés, A., Tuccimei, P. and Peate, D.W. 2010: Sea-level highstand 81,000 years ago in Mallorca. *Science* 327, 860–863.

Finlayson, C. and Giles Pacheco, F. 2000: The southern Iberian Peninsula in the Late Pleistocene: geography, ecology and human occupation. In Stringer, C.B., Barton, R.N.E. and Finlayson, J.C. (eds.), *Neanderthals on the Edge* (Oxford: Oxbow Books), 139–153.

Finlayson, J.C., Pacheco, F.G., Rodríguez Vidal, J., Fa, D.A., Gutierrez López, J.-M., Santiago Pérez, A., Finlayson, G., Allue, E., Preysler, J.B., Cáceres, I., Carrión, J., Fernández Jalvo, Y., Gleed-Owen, C.P., Jiménez Espejo, F.J., López, P., Sáez, J.A., Riquelme Cantal, J.A., Sánchez Marco, A., Guzman, F.G., Brown, K., Fuentes, N., Valarino, C.A., Villalpando, A., Stringer, C.B., Martinez Ruiz, F. and Sakamoto, F. 2006: Late survival of Neanderthals at the southernmost extreme of Europe. *Nature* 443, 850–853 (and Supplementary Information).

Finlayson, J.C., Fa, D.A., Jiménez Espejo, F.J., Carrión, J., Finlayson, G., Pacheco, F.G., Rodríguez Vidal, J., Stringer, C.B. and Martinez Ruiz, F. 2008: Gorham's Cave, Gibraltar – The persistence of a Neanderthal population. *Quaternary International* 181, 64–71.

Garrod, D.A.E., Buxton, L.H.D., Smith, G.E. and Bate, D.M.A. 1928: Excavation of a Mousterian rock-shelter at Devil's Tower, Gibraltar. *Journal of the Royal Anthropological Institute* 58, 33–113.

Giles Pacheco, F., Santiago Pérez, A., Gutierrez López, J.M., Mata Almonte, E. and Aguilera Rodriguez, L. 2000: New contributions to the Upper Palaeolithic sequence of Gibraltar and its importance in the south-western Palaeolithic framework of the Iberian Peninsula. In Rodríguez Vidal, J., Diaz del Olmo, F., Finlayson, C. and Giles Pacheco, F. (eds.), *Gibraltar During the Quaternary* (Seville: AEQUA Monographs No. 2), 159–168.

Goldberg, P. and Macphail, R.I. 2000: Micromorphology of sediments from Gibraltar caves: some preliminary results from Gorham's Cave and Vanguard Cave. In Finlayson, C., Finlayson, G. and Fa, D. (eds.), *Gibraltar During the Quaternary* (Gibraltar: Gibraltar Government Heritage Publications, Monograph 1), 93–108.

Gracia, F.J., Rodríguez Vidal, J., Belluomini, G., Cáceres, L.M., Benavente, J. and Alonso, C. 2003: Rapid coastal diapiric uplift in Cádiz Bay (SW Spain): implications on OIS 3 sea level reconstruction. *GI²S Coast, Research Publication 4* (Project IGCP 437, Final Conference, Puglia – Quaternary Coastal Morphology and Sea Level Changes), 113–116.

Hearty, P.J. and Neumann, A.C. 2001: Rapid sea level and climate change at the close of the last interglaciation (MIS 5e): evidence from the Bahama Islands. *Quaternary Science Reviews* 20(18), 1881–1895.

Hoyos, M., Lario, J., Goy, J.L., Zazo, C., Dabrio, J.C., Hillaire-Marcel, C., Silva, P., Samoza, L. and Bardiji, T. 1994: Sedimentacion karstica: processos morfosedimentarios en la zona del Estrecho de Gibraltar. In Rodríguez Vidal, J., Diaz del Olmo, F., Finlayson, C. and Giles Pacheco, F. (eds.), *Gibraltar During the Quaternary* (Seville: AEQUA Monographs No. 2), 36–48.

Huguet, C., Martrat, B., Grimalt, J.O., Sinninghe Damsté, J.S., and Schouten, S. 2011: Coherent millennial-scale patterns in U$_{37}^{k'}$ and TEX$_{86}^{H}$ temperature records during the penultimate interglacial-to-glacial cycle in the western Mediterranean. *Paleoceanography* 26, PA2218, doi:10.1029/2010PA002048.

Macphail, R.I., Goldberg, P. and Linderholm, J. 2000: Geo-archaeological investigation of sediments from Gorham's and Vanguard Caves, Gibraltar: microstratigraphical (soil micromorphological and chemical) signatures. In Stringer, C.B., Barton, R.N.E. and Finlayson, J.C. (eds.), *Neanderthals on the Edge* (Oxford: Oxbow Books), 183–200.

Moreno, A., Cacho, I., Canals, M., Grimalt, J.O., Sánchez Goñi, M.F., Shackleton, N. and Sierro, F.J. 2005: Links between marine and atmospheric processes oscillating on a millennial time-scale. A multi-proxy study of the last 50,000 yr from the Alboran Sea (Western Mediterranean Sea). *Quaternary Science Reviews* 24, 1623–1636.

Murray-Wallace, C.V. 2002: Pleistocene coastal stratigraphy, sea-level highstands and neotectonism of the southern Australian passive continental margin – a review. *Journal of Quaternary Science* 17(5), 469–489.

Perez Folgado, M., Sierro, F.J., Flores, J.A., Grimalt, J.O. and Zahn, R. 2004: Paleoclimatic variations in foraminifer assemblages from the Alboran Sea (Western Mediterranean) during the last 150 ka in ODP Site 977. *Marine Geology* 212, 113–131.

Potter, E.-K., Esat, T.M., Schellmann, G., Radtke, U., Lambeck, K. and Mcculloch, M.T. 2004: Suborbital-period sea-level oscillations during marine isotope sub-stages 5a and 5c. *Earth & Planetary Science Letters* 225, 191–204.

Rodríguez Vidal, J. and Cáceres Puro, L.M. 2005: Niveles escalonados de cuevas marinas cuaternarias en la costa oriental de Gibraltar. *Geogaceta* 37, 147–150.

Rodríguez Vidal, J. and Gracia, J. 2000: Landform analysis and Quaternary processes of the Rock of Gibraltar. In Finlayson, C., Finlayson, G. and Fa, D. (eds.), *Gibraltar During the Quaternary* (Gibraltar: Gibraltar Government Heritage Publications, Monograph 1), 31–38.

Rodríguez Vidal, J., Cáceres, L.M., Gracia, F.J., Martinez Aguirre, A., Finlayson, C., Giles, F., Santiago, A. and Peguero, C. 2002: El relieve kárstico de Gibraltar como registro morfosedimentario durante el Cuaternario (Mediterráneo occidental). *Sociedad Española de Espeleología y Ciencias del Karst* 3, 6–15.

Rodríguez Vidal, J., Cáceres, L.M. and Gracia, F.J. 2003: Quaternary staircased model of marine terraces and linked coastal formations (Gibraltar, Southern Iberia). *GI²S Coast, Research Publication 4* (Project IGCP 437, Final Conference, Puglia – Quaternary Coastal Morphology and Sea Level Changes), 187–189.

Rodríguez Vidal, J., Cáceres, L.M., Finlayson, J.C., Gracia, F.J. and Martinez Aguirre, A. 2004: Neotectonics and shoreline history of the Rock of Gibraltar,

southern Iberia. *Quaternary Science Reviews* 23(18–19), 2017–2029.

Rodríguez Vidal, J., Cáceres, L. M., Abad, M., Ruiz, F. and Martinez Aguirre, A. 2007: Morphosedimentary evidences of the last interglacial maximum on the coast of Governor's Beach, Gibraltar. *Geogaceta* 42, 107–110.

Rose, E. P. F. and Hardman, E. C. 2000: Quaternary geology of Gibraltar. In Finlayson, C., Finlayson, G. and Fa, D. (eds.), *Gibraltar During the Quaternary* (Gibraltar: Gibraltar Government Heritage Publications, Monograph 1), 39–84.

Rose, E. P. F. and Rosenbaum, M. S. 1991: *A Field Guide to the Geology of Gibraltar* (Gibraltar: The Gibraltar Museum and Gibraltar Heritage Trust).

Schellmann, G., Radtke, U., Potter, E.-K., Esat, T. M. and Mcculloch, M. T. 2004: Comparison of ESR and TIMS U/Th dating of marine isotope stage (MIS) 5e, 5c, and 5a coral from Barbados – implications for palaeo sea-level changes in the Caribbean. *Quaternary International* 120, 41–50.

Siddall, M., Rohling, E. J., Almogi-Labin, A., Hemleben, C., Meischner, D., Schmelzer, I. and Smeed, D. A. 2003: Sea-level fluctuations during the last glacial cycle. *Nature* 423, 853–858.

Siddall, M., Chappell, J. and Potter, E.-K. 2007: Eustatic sea level during past interglacials. In Siroko, F., Litt, T., Claussen, M. and Sánchez Goñi, M.-F. (eds.), *The Climate of Past Interglacials* (Amsterdam: Elsevier, Developments in Quaternary Science Series No. 7), 75–92.

Voelker, A. H. L. 2002: Global distribution of centennial-scale records for marine isotope stage (MIS) 3: a database. *Quaternary Science Reviews* 21, 1185–1212.

Waechter, J. d'A. 1964: The excavation of Gorham's Cave, Gibraltar 1951–54. *Bulletin of the Institute of Archaeology (University of London)* 4, 189–221 (plus plate 13 on p. 269).

Woodward, J. C. and Goldberg, P. 2001: The sedimentary records in Mediterranean rockshelters and caves: archives of environmental change. *Geoarchaeology* 16(4), 327–354.

Zazo, C., Goy, J. L., Hillaire-Marcel, C., Dabrio, C. J., Hoyos, M., Lario, J., Bardiji, T., Somoza, L. and Silva, P. G. 1994: Variaciones del nivel del mar: estadios isotópicos 7, 5 y 1 en las costas peninsulares (S y SE) e insulares españolas. In Rodríguez Vidal, J., Diaz del Olmo, F., Finlayson, C. and Giles Pacheco, F. (eds.), *Gibraltar During the Quaternary* (Seville: AEQUA Monographs No. 2), 26–35.

Zazo, C., Silva, P. G., Goy, J. L., Hillaire-Marcel, C., Ghaleb, B., Lario, J., Bardaji, T. and Gonzáles, A. 1999: Coastal uplift in continental collision plate boundaries: data from the Last Interglacial marine terraces of the Gibraltar Strait area (south Spain). *Tectonophysics* 301, 95–109.

Zazo, C., Goy, J. L., Hillaire-Marcel, C., Lario, J., Dabrio, C. J., Hoyos, M., Bardaji, T., Silva, P. G. and Somoza, L. 2000: The record of highstand sea-level during the last interglacials (Isotope Stages 7, 5 and 1) in the Atlantic-Mediterranean linkage area. In Finlayson, C., Finlayson, G. and Fa, D. (eds.), *Gibraltar During the Quaternary* (Gibraltar: Gibraltar Government Heritage Publications, Monograph 1), 87–92.

Zeuner, F. E. 1953: The chronology of the Mousterian at Gorham's Cave, Gibraltar. *Proceedings of the Prehistoric Society* NS 19, 180–188.

Zilhão, J. and Pettitt, B. 2006: On the new dates for Gorham's Cave and the late survival of Iberian Neanderthals. *Before Farming* 2006/3, 1–9.

4 Gorham's Cave sediment micromorphology

P. Goldberg and R. I. Macphail

Introduction

Fieldwork, sampling and sediment micromorphology together with X-Ray EDAX and bulk sample analyses were carried out at Gorham's Cave. The site's micromorphology was first studied by Goldberg in 1989 and was followed by further work at Gorham's Cave (1995, 1996, 1998), as well as new studies at Vanguard Cave during the same latter period; results are reported in Goldberg and Macphail (2000), and Macphail and Goldberg (2000). To achieve consistency within the present volume this current presentation attempts to follow the lithostratigraphic units identified in Chapter 2. It should be noted, however, that stratigraphic sections exposed in 1989 and later are not necessarily those observed at the end of the 1990s, because of erosional events, slumping and excavation. In Appendix 4.1, 'sediment types' have been simply termed Guano, Hearth, Sand and Silt; in the text below, bulk analyses refer to these broad categories for different lithostratigraphic units. Micromorphological analysis also revealed broad microfacies characteristics, including B (burrows), Ca (calcium carbonate), G (guano), Om (organic matter), S (sand) and Si (silt); details of these microfabrics are described according to lithostratigraphic unit/sample (see Chapter 13).

As is apparent from the profiles and descriptions below, the cave does not present a simple vertical stratigraphic section (Chapter 2). For example, the stratigraphically highest sediments are exposed further back in the cave, where conditions are quite damp (dripping water, reduced evaporation, greater abundance of bats, etc.), and where diagenesis (e.g. calcification, decalcification, leaching and phosphatization) is more likely to be common. In contrast, the stratigraphically oldest deposits are situated nearer the front of the cave, which is more exposed, effectively drier, and closer to the source of sand exterior to the cave. We also note micromorphological evidence that substantiates field observations that the roof of the cave mouth has receded, i.e., the current morphology of the cave mouth does not reflect the original extent of the cave seawards. Thus, the geological history of the site (depositional and both syn- and post-depositional events) is pieced together from these stepped exposures.

Fieldwork was complemented by a micromorphological study of 95 thin sections and the analysis (organic matter by loss on ignition – LOI at 550°C, magnetic susceptibility, phosphate (as total P) and pH) of 50 associated bulk samples (Goldberg and Macphail 2000; Macphail and Goldberg 2000). We present here only a selection of all the collected thin sections, but for archival purposes all thin section samples are indicated in Figure 4.1. Methods

are described in Chapter 13; the 1989 thin sections were analysed semi-quantitatively. The location of thin section samples is indicated in Figure 4.1, and bulk samples and data are listed in Appendix 4.1. Multiple samples and coprolites (see Chapter 19) were prepared for pollen analysis, but all were found to be devoid of pollen (Gill Cruise, pers. comm.). It is important to note that because the sediment micromorphology at Gorham's Cave was carried out in parallel with studies of the simpler sequence at Vanguard Cave (Chapter 13), we often refer to processes that were clearly observed and investigated at this second site, including the use of microprobe for example.

Results

Results are presented unit by unit (see Fig. 4.1; Chapter 2).

Cemented Hearths (CHm. 1–5)

Thin section sample Gor96-52 records an ash-rich hearth that was highly organic (8.1% LOI) and yielded the highest magnetic susceptibility values (χ=418 × 10⁻⁸ SI/Kg) recorded at Gorham's Cave (Appendix 4.1).

Overall, these deposits are characterized by being organic rich in places, and locally, layers contain numerous hyaena coprolites (e.g. samples Gor89-23, Gor96-51) that indicate extensive denning of hyaenas (thus suggesting periodic abandonment of the site by humans, as both do not normally occupy the same space at the same time). Furthermore, many of these deposits (e.g. Gor96-51) are indurated with microsparite, typically with radiating crystals (meniscus cement), which were likely tied to conditions of inundation associated with dripping water, and indicative of a wetter period, particularly in the upper part. Interestingly, some samples (e.g. Gor89-21) show that this cementation pre-dates a diagenetic phosphatization phase where apatitic crusts can be seen to replace some of this calcite (Figs. 4.2 and 4.3). This sequence – of unknown length – took place relatively rapidly on the former surface, although its total duration cannot be determined.

In addition, both intact and partly disturbed combustion features were seen. In sample Gor96-53, for example (Figs. 4.4 and 4.5), we observed a chaotic mixture of burned bone, charcoal and rounded soil/silty clay aggregates, which would point to a trampled combustion feature or one that has been reworked by cleaning (e.g. rake-out and see Fig. 4.24). The lack of calcareous ashes associated with this sample is due to either incomplete combustion (note the abundance of charcoal) and/or dissolution of carbonate (which is not shown in the micrograph but can be observed in the upper part of the slide, in which only patchy remains

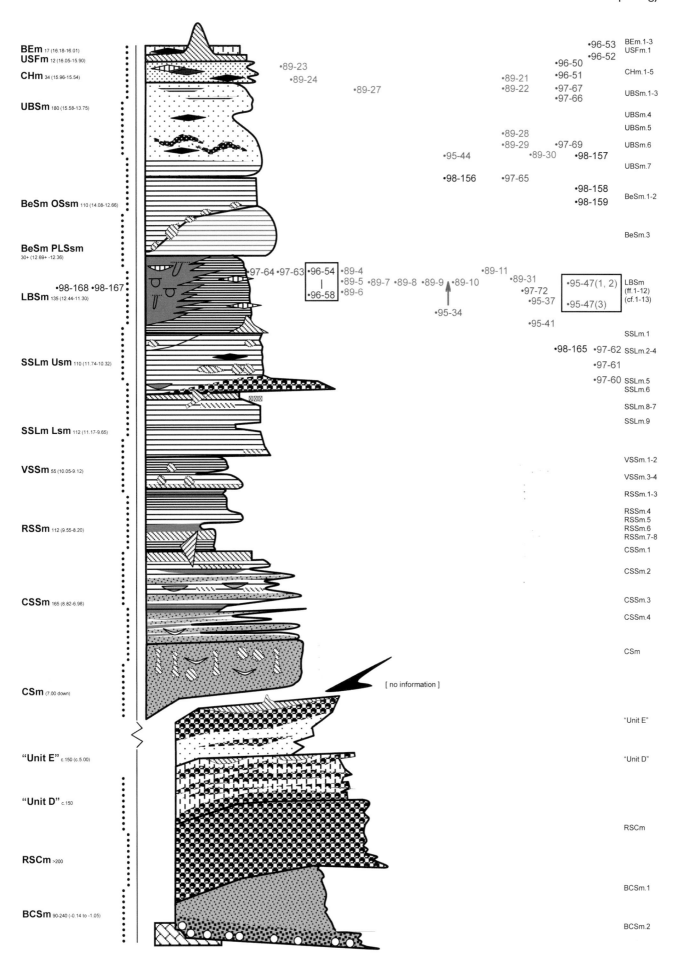

Fig. 4.1 Gorham's Cave, micromorphology sample locations in relation to lithostratigraphic units (see Chapter 2).

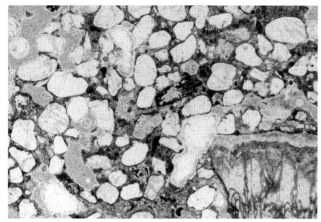

Fig. 4.2 Micromorphology thin-section sample Gor89/21; detail showing square piece of travertine in the lower right-hand corner and charcoal in the centre. The upper surface of the travertine has been phosphatized, a common phenomenon in these uppermost samples in the cave. PPL (plane-polarized light), frame width is ~3.9 mm. Photo: P. Goldberg and R. Macphail. (Colour versions of all thin sections available online.)

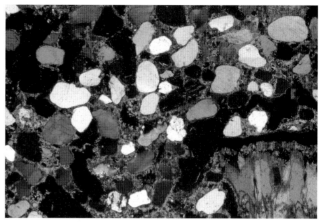

Fig. 4.3 Micromorphology thin-section sample Gor89/21 in XPL (crossed-polarized light); note that the calcite in the vughs (particularly in centre) is made of subsequent crystals of calcite meniscus cements, which are likely to result from saturation of dripping water rather than inundation with groundwater (Scholle and Ulmer-Scholle, AAPG Memoir 77). These cements are typical in these uppermost deposits. Photo: R. Macphail and P. Goldberg.

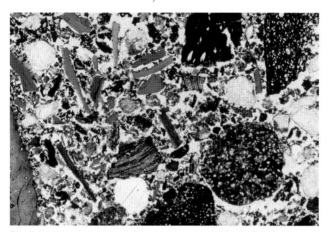

Fig. 4.4 Micromorphology thin-section sample Gor96/52; burned bone and charcoal mixed with quartz and fluffy silty clay associated with biological reworking by small fauna associated with guano; evidence of locally reworked combustion feature. PPL, frame width is ~3.9 mm. Photo: P. Goldberg and R. Macphail.

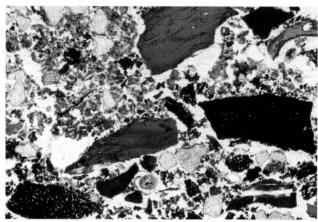

Fig. 4.5 Micromorphology thin-section sample Gor96/52; similar to Fig. 4.4, with chaotic mixture of burned bone, charcoal and rounded soil/silty clay aggregate. This appears to represent a trampled combustion feature or one that has been reworked by cleaning (e.g. rake-out). The lack of calcareous ashes associated with this sample is due to either incomplete combustion (note the abundance of charcoal) and/or dissolution of carbonate (which is not shown here but can be observed in the upper part of the slide, in which only patch remains of calcite are preserved). PPL, frame width is ~3.9 mm. Photo: P. Goldberg and R. Macphail.

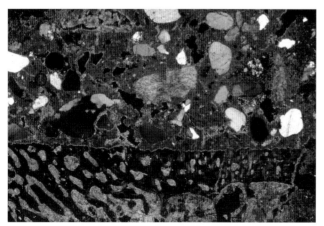

Fig. 4.6 Micromorphology thin-section sample Gor97/67; ash-cemented bone; bone fragment at the base filled with sparry calcite, perhaps representing recrystallized calcareous ashes. The overlying matrix is phosphatic clay. XPL, frame width is ~3.9 mm. Photo: P. Goldberg and R. Macphail.

of calcite are preserved). In sample Gor97-67 (Fig. 4.6), a bone fragment at the base of the thin section is infilled with sparry calcite, which may be the remains of recrystallized calcareous ashes. This cementation likely pre-dates sealing-in of this bone by phosphate-rich clay.

Finally, we note in sample Gor96-53 that numerous sand-size grains are coated with organic silty clay, which we interpret to indicate rolling of material downslope; the massive, unbedded nature of the sand in this sample would support this interpretation.

Upper Bioturbated Sands (UBSm.1–7)

UBSm deposits comprise interbedded sand and organic silty sand, rich in coprolites, phosphatized limestone clasts, small bones and soil animal excrements representing reworking of guano, as well as ash residues (see samples

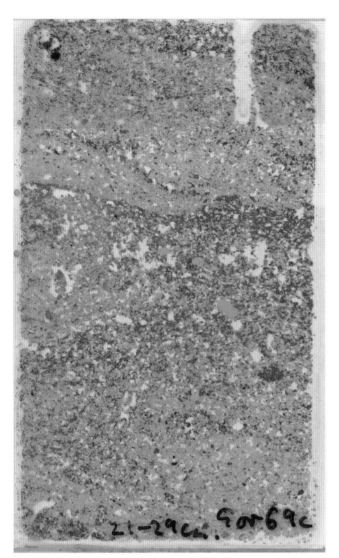

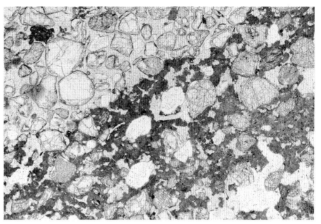

Fig. 4.8 Micromorphology thin-section sample Gor97/69c; typical bedded phosphatic surface crust within overall sandy phosphate mix (see Fig. 4.7). Note the sharp contact between the crust and the loose sand above, indicating at least a short period of exposure during which the guano-derived crust formed. PPL, frame width is ~3.9 mm. Photo: P. Goldberg and R. Macphail.

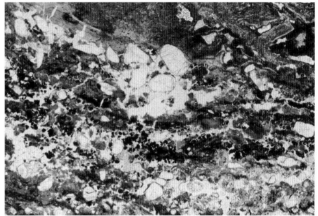

Fig. 4.7 Macroscan of thin-section of Gor97/69c from monolith thin-section sample series Gor97/69a, 69b, 69c, showing interbedded sand and phosphate-rich layers (see Fig. 4.8). Frame width is ~50 mm. Photo: P. Goldberg and R. Macphail.

Fig. 4.9 Micromorphology thin-section sample Gor89/28b; finely bedded organic matter and silty organic clay. Note the fine pellety nature of some of the reddish material, microfaunal excrements. At the upper part is a partially phosphatized piece of bedrock; phosphate is in the form of apatite. PPL, frame width is ~3.9 mm. Photo: P. Goldberg and R. Macphail.

Gor97-69a, Gor97-69b and Gor97-69c; Fig. 4.7). The macro views of these samples clearly show continuous and discontinuous phosphate-rich layers (e.g. sample Gor97-69c contains a well developed silty phosphatic layer within the overall sandy deposit; Fig. 4.8) or clumps of phosphate worked into the sandy matrix by biological reworking as shown by the porous nature of the lower half of the sample. In sample Gor89-29 from Square C98, sand is intercalated with organic silty clay of variable thickness that contains phosphatic crusts and hyaena coprolites, along with some bone. In the overlying sample Gor89-28, limestone clasts show apatitic weathering rinds, which rest upon sand and finely laminated charcoal and phosphatic silty clay (Fig. 4.9). Some of this fine fraction exhibits a flecked/pellety nature indicative of microfaunal reworking of guano material (Shahack-Gross *et al.* 2004).

Eight bulk samples from UBSm were analysed (Appendix 4.1). Typically, sandy microfacies are very poorly organic (0.1–0.6% LOI), with low amounts of phosphorus (810 ppm P) as compared to hearths (2.5–5.0% LOI; e.g. 41,800 ppm P) and guano layers (0.5–4.1% LOI;

1890–32,800 ppm P). Some silty layers are also humic (5.9% LOI) and evidently contain burned mineral material ($\chi=167 \times 10^{-8}$ SI/Kg) presumably eroded from hearths. It can also be noted that whilst minerogenic sands are highly alkaline (pH 9.1), silts containing organic matter are less so (pH 7.8).

Bedded Sands (BeSm) and Orange Sand (BeSm(OSsm).1–2)

The erosional nature of the sand is shown in thin section Gor97-65e that comes from the very top of the BeSm, which directly underlies the UBSm. The fact that the relatively clean sand erodes phosphatic, dusty silty sand and shows a vertical and sharp contact demonstrates that the underlying material must have been compacted. In addition, it demonstrates that for this material to be eroded, there must have been a certain existing topographic relief to permit this erosion: i.e. a flat surface would not result in erosion. This latter point also supports the notion that the inclinations and wavy nature of the overlying UBSm are not solely due to soft sediment deformation but also

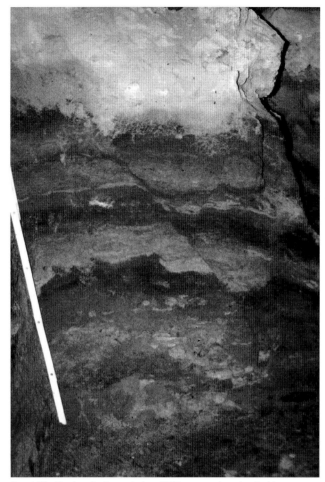

Fig. 4.10 Gorham's Cave during 1997 season showing faulting and slumping of lower part of UBSm; these deposits have a 'downthrown' side on the right (north).

result from a certain degree of subsidence of the underlying substrate (Fig. 4.10).

Lower Bioturbated Sands Fine Facies (LBSmff.1–12)

LBSmff was sampled extensively in Square C99 in the form of two overlapping core/monoliths (Gor95-47 Cores 1–2 represent an interval apparently near the top of the LBSmff, approximately LBSmff.1; Gor95-47 Core 3 likely falls within the sequence LBSmff.2–4). In addition, 17 associated bulk samples were analysed (e.g. as subsampled from monoliths Gor97-63, Gor97-64 and Gor97-72).

Gor95-47 is composed of finely bedded to laminated, organic matter-rich clays and sands that tend to thicken towards the centre of the cave. The bottom third or so is characterized by two thick ashy sand lenses that appear truncated at the top. In 1997 additional samples were studied. These include two samples:

Sample Gor97-63. The lower ~50 cm or so of the monolith is generally sandier, more massive, and lighter in colour than the upper part which seems to contain an ashy lens and associated burned substrate. Above, at ~12 m, there is a shift to more of an organic facies grading up to finely laminated waterlain sediments. Gor97-64 is the lateral equivalent to 97-63 and consists of finely laminated organic clays and silts and coarse bedded brown sands. Brown laminae are more compact than the silty and sandy ones. Basically three subunits were observed:

a dark reddish brown (5YR3/3), massive to crudely

bedded, organic-rich sand with flecks of red (fire-reddened clay);

b dark red (2.5YR5/4) organic clay, finely laminated;

c strong brown (7.5YR5/4), laminated to coarsely bedded, organic-rich sand, which is not apparently phosphatized but appears to be burrowed.

Sample Gor97-72 is a large block forming an upward continuation of 97-63 and comprises finely laminated, organic-rich silty/sandy clay. Basically two subunits occur: a) 5YR3/2 dark red brown with some pale brown spots that in hand lens appear to represent washed sands devoid of matrix; very fluorescent in UV indicative of phosphatic organic matter; and b) similarly 5YR3/2 dark reddish brown but with lower fluorescence under UV, and is darker brown and or red at the very bottom of this subunit.

Lower Bioturbated Sands Coarse Facies (LBSmcf.1–13)

Micromorphological data support the field observations (Chapter 2), with the sediments being quite sandy. Yet, different types of inclusions were observed:

– eggshell and a phosphatic dropping (e.g. sample Gor96-55);

– charcoal, bone, shell and bands of organic silty clay (e.g. sample Gor96-56);

– interbedded, organic silty clay and sand (e.g. samples Gor95-39, Gor96-41b, Gor96-41c).

It appears that much of this material is waterlain (cf. bedding in sample Gor89-21 from CHm.2), although it differs from the 95-47 series of LBSmff, which is much finer, and is situated closer to the central axis of the cave where one might expect to have pooling/ponding of water.

Bulk data reflect the mixed microfacies characteristics of the sediment types (Appendix 4.1), with sands (mean 1.15% LOI, n=6; 5060–17,800 ppm P) showing the inclusion of phosphatic grains, although less organic- and phosphate-rich compared to guano-rich layers (mean 4.0% LOI, n=8; mean 24,460 ppm P, n=8, range 9160–72,100 ppm P). EDAX analysis of guano in sample 89-9b clearly showed peaks of Ca and P (presumed hydroxyapatite or dahllite; cf. Wattez *et al.* 1990) (Fig. 4.21). Hearths/combustion zones also show enrichment in organic matter and phosphorus (2.6–6.3% LOI; 7860–31,000 ppm P).

Sands & Stony Lenses (SSLm(Usm))

In sample Gor97-62 from Square D105, for example, the sand appears generally as a micrite-cemented blown sand, with many coarse bone fragments (see bulk analyses below), and some limestone. Most of the sand fraction is coated with a clotted clayey micrite, and we see more than one phase of post-depositional cementation: the first clotted micrite phase is followed by microsparite filling in the remaining void space. Rounded bone fragments suggest movement/rolling and possible sandblasting. Furthermore, the vertical orientation of the bone suggests some reworking (e.g. trampling or bioturbation) when the sand was still unconsolidated and mobile.

Further out towards the entrance in Square B108 in SSLm(Usm).2 (e.g. sample Gor98-165), we observe essentially a massive to finely bedded sandy deposit with thin stringers and zones of phosphatic guano crusts (as clumps and remnants of stabilized surfaces); some charcoal and burned bone

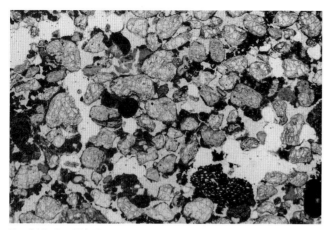

Fig. 4.11 Gor98/165; sands containing guano; phosphatic crust on burned bone. Overall these sediments show moderate phosphate enrichment (see Fig. 4.1). PPL, frame width is ~3.9 mm. Photo: P. Goldberg and R. Macphail.

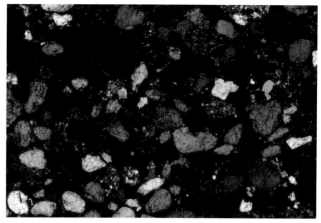

Fig. 4.12 Micromorphology thin-section sample Gor98/165; sands containing guano; phosphatic crust on charred or humified organic matter. XPL, frame width is ~3.9 mm. Photo: P. Goldberg and R. Macphail.

(reworked from hearths?) are preserved, and in some cases are covered with a phosphatic crust (Figs. 4.11 and 4.12).

Bulk analyses show, once again, that sands are generally poorly humic (0.2–1.4% LOI), but included bone and guano have led to moderate enrichment in phosphorus (1700–2630 [97-62] ppm P).

Lower units

For the following units it has not been possible to provide an absolute correlation with the new lithostratigraphic sequence for the cave. We have therefore reverted to our original descriptions and each of the micromorphological samples is described according to depth and position in the cave. Two similar-looking samples are described from near the top of the lower units, Gor98-154 and Gor98-155, that are rather alike both in the field and in thin section. In the field they appear as finely bedded to laminated, dark reddish brown organic silty clay sand with charcoal fragments and white limestone clasts. In thin section (both Gor98-154a and Gor98-154b), we observe finely bedded sand interbedded with organic-rich clay. Scattered throughout the sample are fragments of bone and coprolites of both carnivore (see Figs. 4.22 and 4.23) and bird guano origin; some of the bone is burned and also exhibits calcareous ash adhering to it. Localized domains of ash that are irregularly incorporated into the matrix attest to the reworking of ash along with slaking crusts composed of bedded silt and organic-rich clay. Moreover, we see that this type of deposition and reworking of sand and silty/clayey slaking crusts by run-off has resulted in the incorporation of bone fragments – some of which are burned – and calcareous ash. It points to previously existent combustion features that were in cases penecontemporaneously reworked in antiquity and redeposited. Biological inputs of carnivore coprolites and phosphatic bird guano indicate the presence of former exposed surfaces.

Sample Gor98-155 is similar at the base but the overlying part is more sandy and cleaner. Hyaena coprolites, shell fragments and charcoal pieces have been reworked by water.

Many samples were collected from reddish sands of the lower units in the entrance of the cave, in and near Square G111 (samples Gor89-12 through to Gor89-17). These samples are overall similar in make-up but different in proportions and arrangements of the sand and finer fractions. Sample Gor89-12, for example, is close to the top of this sampled sequence and comprises quartz sand, charcoal, coprolite fragments, bone (some of which is rounded), and bright reddish yellow phosphatic chunks of guano crusts; the fine fraction is in the form of coarse sand/granular aggregates that are organized into diffuse, non-continuous laminae, and locally the clay contains silt-size inclusions of brown, fibrous organic matter. Fragments of guano crusts and guano occur as orange brown isotropic inclusions that are highly autofluorescent under blue light epifluorescence (Figs. 4.13 and 4.14). The fine fractions represent interstitial, mesofauna-worked (pellets) guano-rich cave earth. In addition, the deposit exhibits rip-up clasts reworked from nearby sediments by sheet flow and mud flow.

Similar types of sediments, although with a higher proportion of fine material, are seen in sample Gor89-13. Here, the coarse fraction in this sample is composed mostly of quartz sand, which takes the form of distinct laminae or is porphyrically distributed throughout the finer fraction of the sample. In addition, sand- and granule-size coprolite grains are fairly abundant (c.3 per cent). Localized graded bedding of coarse to fine silt, especially rich in mica, implies some sheet flow. Some bone fragments were observed, as well as phytoliths. Other coarse components in this sample are a sand-size, red brown clay papule, and a rounded, sand-size herbivore faecal pellet. One fragment of phosphatized limestone was observed.

The red brown, organic-rich fine fraction exhibits paler yellow brown mm-size domains; these areas have a tendency to be isotropic and are probably phosphatic. The latter are supported by their high degree of autofluorescence under blue light illumination. In addition, the matrix locally contains silt-size inclusions of detrital calcite, in the form of either mosaic sparite or micritic aggregates; these are also present in graded beds. At higher magnifications (e.g. 200×), the matrix is seen to be composed of finely comminuted, reddish brown organic debris, which is also autofluorescent and appears to be guano.

Sample Gor89-14 is similar and photomicrographs in blue light epifluorescence show the phosphatic nature of individual grains that make up an otherwise homogeneous

Fig. 4.13 Micromorphology thin-section sample Gor89/14; detail of undifferentiated mass of reddish brown and speckled orange brown fragments with an angular quartz grain at the top. PPL, frame width is ~1.2 mm. Photo: P. Goldberg and R. Macphail.

Fig. 4.14 Micromorphology thin-section sample Gor89/14, as at left, but under blue light epifluorescence. The bright grains are apatite derived from guano that have been incorporated into the organic clayey matrix. Blue light (BL), frame width is ~1.2 mm. Photo: R. Macphail and P. Goldberg.

and undifferentiated yellow brown fine fabric in visible light (see Figs. 4.13 and 4.14).

Sample Gor89-17 is noteworthy by the inclusion of large amounts of weathered calcareous ash aggregates and bone which is dusted with ash, a fragment of burned eggshell, and roof fall. The lack of structure of these burned components, such as we would witness in an *in situ* combustion feature, indicates reworking of hearths and implies occupation upslope from this location.

In all, these samples represent organic-rich guano deposits mixed with sand and inputs of finer silty clays derived from undifferentiated mud flows and layered sheet flows. These flows have resulted in the reworking of many of these components from perhaps *in situ* locations and combustion features, resulting in redistribution of ashes and bones. These deposits have been accompanied by inputs of phosphate-rich guano producing phosphatic surface crusts on stabilized and exposed surfaces.

Nine bulk samples were analysed, including guano, silts and sands, and these recorded an enhanced magnetic susceptibility (mean $\chi=200 \times 10^{-8}$ SI/Kg, $n=4$; range $\chi=100$-302 $\times 10^{-8}$ SI/Kg; Appendix 4.1). These values clearly corroborate the identification of hearth debris in thin section. Guano layers (mean 6150 ppm P, range 990–10300 ppm P, $n=3$) generally show far less magnetic susceptibility enhancement that is indicative of included burned materials (mean $\chi=71 \times 10^{-8}$ SI/Kg; range $\chi=24$-230 $\times 10^{-8}$ SI/Kg; $n=5$).

Three samples were observed below those of the reddish sands (samples 89-12 through 89-17). These samples (Gor89-18, Gor89-20 and Gor89-19, from top to bottom) are not dissimilar to the overlying ones in terms of basic composition, but there are some clear differences. Sample Gor89-18, for example, macroscopically shows bedding, with a *c*.2 cm band of more cemented sand running through the middle of the sample. Overall, in comparison to the clayey ones above, this sample appears somewhat less biological and more 'chemical' in character, with extensive calcite precipitation. There are abundant mm-size, well rounded quartz (~20 per cent) but relatively few bones coprolites and charcoal. Coprolites are in fact virtually absent, and bone (~1 per cent) often displays rounded edges, possibly due to digestion or other

chemical attack. A few isolated echinoderm fragments occur, with some shell fragments (2 per cent) and cemented bioclasts; the last are probably derived from aeolianite deposits found just above the cave. In addition, fragments of travertine are less abundant than in sample Gor89-17 and are smaller in size; some tufa grains ~1 mm in diameter were observed.

The matrix is composed of calcareous clay with micritic coatings that range in thickness from ~60 to 200 µm. Many of these coatings, as well as the 'travertine fragments', look algal, particularly in the lower part of the slide where aggregates and domains of the original red clay have been invaded by micritic calcite. These commonly take on a rounded clotted morphology ~100 µm in diameter, but it is not clear whether this reflects an original depositional feature or one due to break up of original fabric by calcite impregnation. Some of the clayey and calcareous grains are clearly polygenetic, showing several phases of formation. It seems that the micritic impregnation of most of the groundmass is responsible for the pink colour observed in the field. Finally, we note the presence of eggshell, perhaps as a non-cultural accumulation from nests in the walls and ceiling; bone is embedded in micrite, which is in part derived from ash. In sum, we interpret this sample as representing calcareous mud flows, dipping towards the rear of the cave, which transported many kinds of materials, including limestone, shell and sands, as well as guano reworked mesofauna pellets and ash aggregates that are cemented on to the bone. Eventually the deposits were partially re-cemented in their present position.

A cemented lens in this deposit (sample Gor89-20; see field photo showing light-coloured wedge which thickens to the right – north) was observed in the field and became more indurated towards the north. In thin section, most of the sample is clay-free and generally consists of rounded coarse sand and granules comprising principally siliceous grains (quartz, quartzite), clayey aggregates, and tufa-like fragments and bioclasts, which tend to be more abundant and coarser at the bottom. Cementation is patchy. Where it is massive, it consists of fine micritic envelopes (~10 µm thick) around grains superposed by microsparite that occludes the pores (Figs. 4.15 and 4.16). Such massive cementation occurs only locally. At the base, remnants of

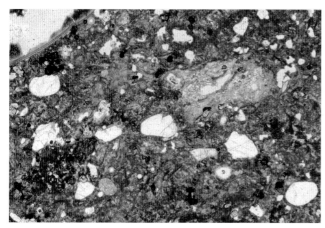

Fig. 4.15 Micromorphology thin-section sample Gor89/20; reddish brown domains of organic-rich clay and quartz sand cemented by microsparite; in the centre right is a yellow, irregularly shaped, phosphatized piece of guano. PPL, frame width is ~3.9 mm. Photo: P. Goldberg and R. Macphail.

Fig. 4.16 Micromorphology thin-section sample Gor89/20 in XPL; note the porosity within the fine calcite and the isotropic nature of the guano fragment described above. Photo: P. Goldberg and R. Macphail.

the underlying unit can be found; these consist of micritic impregnations of more poorly sorted clayier material containing clayey aggregates as in sample Gor89-19. Elsewhere, grains show patchy rims and braces of micrite, ~10 to 20 μm thick.

The sequence of events for Gor89-20 thus appear to be:

1 sand deposition;
2 micritic coatings and fine fabric;
3 localized amorphous organic mesofauna pellets; and finally,
4 microsparitic partial cementation (Figs. 4.15 and 4.16).

The last event represents meteoric phreatic conditions associated with the flowstone crust. The pelletal fabrics show influence of guano. Whilst this sample is notably rich in rounded marine bioclasts (e.g. sea urchin spines among others), their absence in other samples could be related to decalcification of the deposits. Thus, while a marine origin is tempting, it is not unequivocal, especially in light of the presence of clasts of cave roof and tufa, which point to a location within the cave receiving subaerial gravity-derived clasts.

Eleven bulk samples were analyzed and clearly show variations in sediment composition. Sands (mean 1.5% LOI, range 0.1–4.0% LOI, n=6; mean 2510 ppm P, range 410–2660 ppm P, n=8) clearly show a marked variation in amounts of included organic matter and phosphate materials, as noted in thin section. An example of the silts (1.0% LOI; 1970 ppm P) clearly contrasts with guano-rich layers (4.3–4.5% LOI; 7270–14,700 ppm P).

Exposed in Square H113 is a sequence of sandy deposits with alternately bedded whitish and reddish bands. Sample Gor89-01 comes from a lighter band in the sequence and comprises rounded to subround quartz grains and rock fragments (including travertine fragments) with relatively little matrix. The latter consists of small (75 μm) clayey aggregates within intergranular pores or as discontinuous patches or coats around quartz grains. A few grains of limpid bright yellow and reddish amber clay papules occur. It is locally cemented with micrite (in some cases clayey micrite), some in the form of nodules; however, most calcite appears to be undergoing dissolution. Sample Gor89-3 is from a slightly sandier layer, but shows the same

components of sand mixed with organic-rich pellets of silty clay.

Both samples show that the fine pellety, silty clay fraction material between grains is composed of very thin organo-mineral excrements of mesofauna that represent biological working of guano inputs contemporary with sand blowing and bird/bat activity. Furthermore, the sand/fine silty clay pellet mix demonstrates that sand – whether of marine or aeolian origin – was repeatedly stabilized and exposed subaerially to allow for the accumulation and reworking of organic material by soil mesofauna. No evidence for marine-derived sands could be seen.

Base of main sequence (cave entrance deposits)

A sample of reddish clay sand was collected from a ledge on the north side of the cave entrance at ~1.5 to 2.0 m above sea level.

It is massive and concreted, and forms a ledge (Fig. 4.17); laterally, it grades into sandy deposits mixed with stones and shells. In thin section, it consists of quartzitic sand in a somewhat clayey calcareous matrix (Fig. 4.18). It is a mud-supported rock with clotted texture as in sample Gor98-160. Also present are traces of shells and numerous 30–50 μm dark brown specks and spots, which are probably manganese impregnations. The sample shows calcareous mud associated with aeolian sand which was later cemented by seeping water resulting in the formation of a breccia-like deposit. The pellets show again, as in samples Gor89-01 through Gor89-03, that subaerial reworking by soil mesofauna took place on an exposed surface. The amount of fine fraction, furthermore, suggests that the deposition was likely colluvial as this is a mud-supported deposit. Unfortunately, the cementation has obscured some of the original character of the fine fraction pellets (Fig. 4.18).

The lowermost micromorphological samples (Gor98-160 through Gor98-163) come from this unit. All samples in this section are quite similar. Sample Gor98-160 at the top of the profile comprises medium, well sorted quartzitic sand with bioclasts, micritic clots and coatings, and remnants of possible aeolianite. Bone is present but poorly preserved, and some is associated

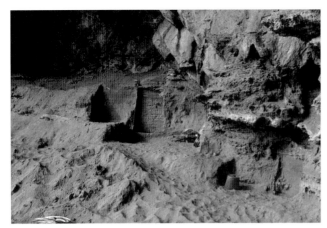

Fig. 4.17 Gorham's Cave, left hand side of cave entrance. A sample of reddish clay sand was collected from this ledge on the north side of the cave entrance at ~1.5 to 2.0 m above sea level; soil micromorphology suggests it was formed by calcareous mud cementation associated with aeolian sand; later cementation by seeping water resulting in the formation of a breccia-like deposit (see Fig. 4.18). Photo: P. Goldberg and R. Macphail.

Fig. 4.18 Micromorphology thin-section sample Gor89/32; the sediment is composed of clotted micrite and quartz sand that was later cemented by microsparite. The rounded micro aggregates are mesofaunal excrements and show the presence of reworking of organic material of this subaerial deposit; microsparitic cement resulted from later water saturation. XPL, frame width is ~3.9 mm. Photo: P. Goldberg and R. Macphail.

Fig. 4.19 Micromorphology thin-section sample Gor98/162; sandy sediment containing angular piece of algal tufa detached from the walls or cave roof. Its freshness indicates lack of transport and likelihood that the roof extended over this location at the time of deposition during the last Interglacial. Coatings of micrite and with locally clotted appearance. XPL, frame width is ~3.9 mm. Photo: P. Goldberg and R. Macphail.

Fig. 4.20 Micromorphology thin-section sample Gor98/164; phosphate and organic-rich guano mixed with quartzitic sand grains; elsewhere clay coatings are present. Clearly this deposit must have formed within the cave (although now exposed by cave mouth retreat). PPL, frame width is ~3.9 mm. Photo: P. Goldberg and R. Macphail.

with calcareous clay. In any case, the sample suggests the possibility of the remains of cave occupation being mixed with locally reworked beach sand. A similar view is seen in sample Gor98-162, which is below Gor98-160. It exhibits more micritic cementation and a greater degree of grain coating, locally with a clotted appearance. Moreover, this sample has a number of pieces of tufa fallen from the roof (Fig. 4.19). Their occurrence strongly suggests that this part of the cave was covered with a roof at the time of accumulation of this sediment. It is not likely that these calcareous fragments were transported very far as they are quite angular, as are the trace amounts of angular bone fragments.

Discussion and conclusions
Sediments, penecontemporaneous and post-depositional processes
A Sand and silt
The major component of the sediments in Gorham's Cave is sand (see Figs. 4.2, 4.3, 4.7 and 4.8). This is derived either from direct aeolian inputs or from continual reworking of sand, ultimately of aeolian origin, but derived either locally from adjacent deposits or from outside the cave. As there have been a number of slumping events, local reworking is a reasonable assumption. Also, because of the slumping and predominant 'depositional dip' inwards originating from the possible presence of a dune in front of the cave, as clearly demonstrated by the sequence at Vanguard Cave (see Chapter 13), some of the sediment could be derived from closer to the entrance, either as aeolian grain fall or as colluvium. Certainly, there is evidence for inwashing of silt and clay clearly derived from soils overlying the cave, as shown by the soil aspect of the material in thin section (cf. Vanguard Cave, Figs. 13.16 and 13.17), numerous graded beds, and the fact that both textural classes are not produced within the cave confines. Thus, some reworking of sand with this wash is likely although volumetrically this is not a major factor in importing sand into the cave (e.g. samples Gor96-56, Gor96-59).

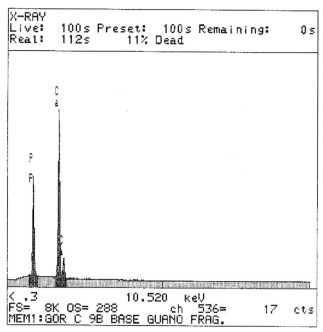

X-RAY
Live: 100s Preset: 100s Remaining: 0s
Real: 112s 11% Dead

C
a

P
P

< .3 10.520 keV
FS= 8K OS= 288 ch 536= 17 cts
MEM1:GOR C 9B BASE GUANO FRAG.

Fig. 4.21 EDAX analysis of Gor89/9B showing peaks of P and Ca identifying calcium phosphate (here guano).

B. Phosphate

Almost all sediments show the direct or indirect effects of inputs of guano, *sensu lato* (see Appendix 4.1; Fig. 4.21; see also Figs. 4.7–4.9 and 4.11–4.14). Such inputs are demonstrated by several micromorphological features, which include 1) phosphatic crusts that accreted during periods of local stabilization when bird and bat guano could accumulate on the surface (see samples Gor89-8, Gor89-10, Gor95-47, Gor98-164 and Gor98-165). Such crusts appear throughout the entire sequence at Gorham's Cave (see also Fig. 13.21). 2) Ubiquitous flecked or pellety microfabrics (e.g. samples Gor89-8, Gor89-5, Gor89-19, Gor95-47, Gor96-55, Gor97-65), which are microfaunal excrements that represent insect reworking of organic inputs by bird/bat droppings. For Gorham's Cave it is reasonable to imagine a rich surface fauna reworking guano accumulations. (The chief factor cited to explain the lack of preserved pollen in these sediments is biological working and oxidation; Gill Cruise, pers. comm.). Cave guano insect fauna are also well known, as discussed in Gillieson (1996, 233). Other phosphate inputs are carnivore coprolites, particularly hyaena (see Chapter 19). Hyaena activity and individual whole coprolite remains are particularly visible in the upper deposits (e.g. samples Gor89-28 – elevation of 1445, UBSm, Gor96-51, Gor89-23), where in the initial season of 1989 a dark organic layer exhibited a stringer of several individual, whole coprolites of hyaenas. Many thin sections from this layer and above contain coprolite fragments (Figs. 4.22 and 4.23; see Chapter 19), generally including whole ones, as clearly visible in the field. Finally, phosphate alteration derived from guano is expressed by fallen pieces of roof (e.g. macroscan of Gor89-28b), in which limestone bedrock develops weathering rinds of apatite (probably dahllite). These rinds commonly break off as thin 'exfoliation' crusts and become incorporated into the deposits. Again, sediments from the upper part of the profile are relatively rich in this material.

Fig. 4.22 Micromorphology thin-section sample Gor98/155; a piece of hyaena coprolite with grey calcined bone fragment (see Chapter 18). PPL, frame width is ~3.9 mm. Photo: P. Goldberg and R. Macphail.

Fig. 4.23 Micromorphology thin-section sample Gor98-155, as above but in XPL; note typical isotropic nature of coprolite (apatite). Photo: P. Goldberg and R. Macphail.

C. Calcite

Cementation by calcite is patchy throughout the section. It is striking in the lower units, where cementation occurs as lenses that thicken in the direction of the large pillar on the north side of the cave (Square B110). It is also evident in upper deposits CHm and UBSm. Furthermore, it is possible that calcite cementation was more widespread, but since many of the deposits are non-calcified (particularly in the central section) or have been decalcified, it is difficult to evaluate clearly the effects of calcite cementation, let alone its hydrological and climatic significance. The acid nature of guano and organic matter accumulation is adverse to calcite preservation.

In certain cases, two phases of calcite precipitation are evident: first a micritic, clotted-micrite phase in which grains become coated; this is followed by a second phase, which is characterized by the precipitation of microsparite within intergranular voids (see Figs. 4.15, 4.16 and 4.18). These two successive phases would seem to point to a change in regime from calcite precipitation first under evaporative conditions thus coating the grains, followed by less evaporative and more water-saturated conditions producing the microsparite. As such, it may be indicative of conditions occurring more on a regional scale, such as climatic conditions of greater overall precipitation.

D. Human activity

Human inputs are variously striking or subtle (see Figs. 4.4–4.6, 4.11 and 4.12). Striking inputs take the form of charcoal-rich horizons that can be readily seen in the field as combustion features, as at the top of the stratigraphic profile in the Upper Palaeolithic deposits (sample Gor97-68), but also in the sandier areas of the Middle Palaeolithic sediments, where sandy deposits are enriched in charcoal. For the most part, the latter, charcoal-rich sands do not represent *in situ* burning features but rather scatters of charcoal that have been displaced from their original location of combustion, even if only on the scale of centimetres. Charcoal was mobilized by wind and also by trampling, as can be seen in the rather chaotic organization of this material (e.g. Gor96-52, Gor95-47, Gor96-57) (Fig. 4.24; see Figs. 4.4 and 4.5). Intact combustion features, such as those at Kebara Cave, are rare to non-existent at Gorham's Cave, except possibly for those features at the top of the section

Also interesting at Gorham's Cave is the general lack of carbonate ashes, although cemented ashes can be found in the Upper Palaeolithic deposits. This is intriguing in light of the amount of burnt bone and charcoal observed in many of the thin sections. The lack of ashes might be related to the fact that they got blown away as the site is quite exposed; ashes are quite light and fluffy and would not be expected to remain, or they would become cemented quickly (Karkanas and Goldberg 2008). Alternatively, there was incomplete combustion and the charcoal was not reduced completely to ashes, although this seems a rather remote possibility as many bones are burnt; and if wind is a factor, then most fires should have been hot enough to sustain complete combustion, unless they were terminated early. Finally, ashes were originally present but were dissolved, or diagenetically altered by phosphate mineralization. Decalcification is an ongoing process at Gorham's and most deposits show the effects of carbonate dissolution; calcite does not appear to be precipitating in any of the deposits today from dripping water. Phosphate mineralization was observed at Kebara Cave, where ashes can be transformed into apatite. Although the original ash rhombs are not visible in normal transmitted light illumination, they can be seen using ultra violet and blue light illumination. Unfortunately, we did not make extensive observations in blue light of all the Gorham's thin sections but in those that were studied in 1989 we could plainly see the guano particles, suggesting an agent for decalcification (see sample Gor85-14 (Figs. 4.13 and 4.14), and Vanguard Cave (Figs. 13.4 and 13.21–13.28).

Subtle human inputs are represented by thin charcoal stringers or accumulations that are not differentiable as intact features in the field. In the case of sample Gor95-47, for example, the charcoal is finely laminated, and was deposited by sheet flow or washed into very shallow pools of water. In fact, the LBSm is characterized by features indicative of water deposition. Even in the lower deposits in the cave observed by us (samples Gor89-160 through Gor89-163), isolated sand-size scraps of charcoal were observed.

There is a marked coincidence between the presence of burned debris and enhanced magnetic susceptibility (Appendix 4.1), which reinforces the view that Middle

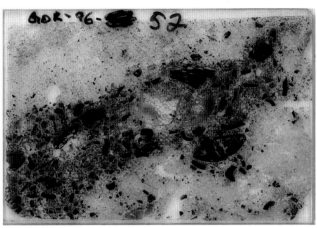

Fig. 4.24 Micromorphology thin-section sample Gor96-52; macroscan showing a complex sample composed of silty/clayey sand at the base, a band of charcoal and burned bone in the centre, and a capping of more uniform quartz sand. The chaotic nature of the burned materials suggests trampling or hearth rake-out (see Figs. 4.4 and 4.5). Frame height is ~50 mm. Photo: P. Goldberg and R. Macphail.

Palaeolithic hearths were present (see relationship between well preserved combustion zones in Vanguard Cave, Figs. 13.11, 13.31 and 13.32) but have been reworked downslope and are no longer visible in their original locations.

Conclusions

In short, both field observations by us between 1989–1998 and micromorphological results show that much of the geological history of the cave is represented by sand inputs penecontemporaneous with those of organic silty clay washed in from outside or derived from joints in the cave (as at Vanguard, Chapter 13), coupled with bird/bat guano, and punctuated by human occupation and that of hyaenas. Depending on the relative rates of occupation of these sources, we observe either massive sands, or sands with stringers of guano (e.g. samples Gor98-16, Gor98-165; Figs. 4.10–4.12) that represent short standstill periods of sand accumulation. All these findings are corroborated by the bulk data.

The cave at the time of the earliest deposition was probably more closed and the brow/entrance extended further out than it does today. This statement is supported by, and consistent with, the presence of pellety, guano-related microfabrics that indicated a semi-enclosed environment; fragments of carbonate ornaments ('algal/biological' crusts) formed on the cave ceiling and walls; and the presence of clay coatings (though weak) in sample Gor98-164. These coatings indicate subaerial and somewhat protected exposure, which is possibly related to dripping water.

The earliest occupation of the cave could have taken place during the formation of the lowermost sediments exposed at the cave entrance, in which there are fragments of bone and some traces of charcoal. The presence of these materials does not necessarily indicate that these are the remains of human occupation, but the evidence is quite suggestive. In fact, it is necessary to consider that they represent colluvial reworking of cultural deposits that are no longer visible, as is the case in Vanguard with the absence of the Middle Palaeolithic hearths/combustions (Macphail and Goldberg

2000; Chapter 13). Logically, this could also be a reflection of how the sedimentary sequence at Gorham's Cave is more complicated than at Vanguard Cave, where rapid sedimentation with only very localized reworking of hearths seems to have taken place.

Acknowledgements

The authors thank the National Geographic Society for funding this research, and the Natural History Museum and Gibraltar Museum for discussion, collaboration and support, and especially through Chris Stringer and Clive Finlayson, respectively. Like all the contributors we are very grateful to Nick Barton (Oxford University) for overall discussion, and for organizing, integrating and editing this volume. We also thank Simon Collcutt and Andy Currant for providing the lithostratigraphic framework for this chapter. The Institute of Archaeology, University College London is also thanked for support especially through Sandra Bond (SEM/EDXRA), Kevin Reeves (microprobe) and Cyril Bloomfield (analysis of Phosphorus); additional analyses including magnetic susceptibility were carried out by Johan Linderholm (Environmental Archaeology Laboratory, Umeå University, Sweden), who is gratefully acknowledged. Thin sections were manufactured at the Natural History Museum, and by Spectrum Petrographics (Vancouver, Washington, USA). In addition we gratefully thank the following for all their various contributions to this study: Peter Andrews, Nick Barton, Gerry Black, Andy Currant, Clive and Geraldine Finlayson, Lorraine Cornish, Jo Cooper, Yolanda Fernández-Jalvo, Frank Greenway and Chris Stringer.

References

Gillieson, D. 1996: Caves: *Processes, Development, Management* (Oxford: Blackwell).

Goldberg, P. and Macphail, R.I. 2000: Micromorphology of Sediments from Gibraltar Caves: Some Preliminary Results from Gorham's Cave and Vanguard Cave. In Finlayson, C., Finlayson, G. and Fa, D. (eds.), *Gibraltar During the Quaternary* (Gibraltar: Gibraltar Government Heritage Publications, Monograph 1), 93–108.

Karkanas, P. and Goldberg, P. 2008: Micromorphology of sediments: Deciphering archaeological context. *Israel Journal Earth Sciences* 56, 63–71.

Macphail, R.I. and Goldberg, P. 2000: Geoarchaeological investigation of sediments from Gorham's and Vanguard Caves, Gibraltar: Microstratigraphical (soil micromorphological and chemical) signatures. In Stringer, C.B., Barton, R.N.E. and Finlayson, J.C. (eds.), *Neanderthals on the Edge* (Oxford: Oxbow Books), 183–200.

Shahack-Gross, R., Berna, F., Karkanas, P. and Weiner, S. 2004: Bat guano and preservation of archaeological remains in cave sites. *J. Archaeol. Sci.* 31, 1259–1272.

Wattez, J., Courty, M.A. and Macphail, R.I. 1990: Burnt organomineral deposits related to animal and human activities in prehistoric caves. In Douglas, L.A. (ed.), *Soil Micromorphology: a basic and applied science* (Amsterdam: Elsevier), 431–441.

5 The radiocarbon chronology of Gorham's Cave

T.F.G. Higham, C. Bronk Ramsey, H. Cheney, F. Brock and K. Douka

Introduction

Obtaining a reliable chronology for the excavated areas at Gorham's and Vanguard Caves was a key aim of the Gibraltar Caves Project (Barton *et al.* 1999; Stringer *et al.* 1999; Finlayson *et al.* 2001; Stringer 2000; Stringer *et al.* 2000). Dating is critical, because it is in the Iberian Peninsula, and by implication, Gibraltar, that there appear good grounds to suggest a late survival of Neanderthal populations compared with other parts of Europe (Finlayson *et al.* 2006; and see Zilhão 2000 and references therein). Previous evidence for contemporaneous Neanderthal populations in other parts of Europe and Eurasia, for example at Vindija (Croatia) and Mezmaiskaya (Russia), can be more or less discounted based on recent work (Higham *et al.* 2006; Zilhão 2006). Recently published data from the site of Gorham's Cave obtained by Finlayson *et al.* (2006) appear to give support to the interpretation of the late Middle Palaeolithic lasting until perhaps as late as 24,000 BP, although this claim has been strongly criticized (Zilhão and Pettitt 2006). The precise timing of Neanderthal extinction and of the arrival of the first modern human populations into the region, therefore, still remains uncertain and, consequently, there is a strong need for accurate dating of late Middle Palaeolithic and early Upper Palaeolithic archaeological deposits. As we shall see in this chapter, this is no easy task.

Previous radiocarbon dates obtained from the Gibraltar Caves have been published and discussed already (Pettitt and Bailey 2000). The main research focus in Gorham's Cave, as they outline, centred upon the reinvestigation of previous excavations of the cave deposits, most notably by Waechter during the 1950s (1951; 1964), who established that the entrance of the cave contained Middle and early Upper Palaeolithic layers in stratigraphic sequence. Waechter recorded many layers during an extensive phase of excavation of deposits in the front of the cave. He attributed layers B, D and E to the Upper Palaeolithic and layer G as the uppermost Middle Palaeolithic deposit of the cave. The Groningen Laboratory dated three charcoal samples of the latter layer to 49,200 ± 3200 BP (GrN-1556), 47,700 ± 1500 BP (GrN-1473) and 47,000 BP (humic fraction) (GrN-1678). Unfortunately, Waechter's excavations were not fully recorded or published, and much of the material recovered has subsequently disappeared (Barton *et al.* 1999; Finlayson *et al.* 2001; Stringer *et al.* 2000). This has made it quite difficult to correlate precisely his results to the sections currently standing.

The Gibraltar Caves Project undertook an extensive sampling of standing sections of the Waechter excavations in order to obtain archaeological, palaeoenvironmental and dating evidence. This has led to the identification of a series of stratigraphic units that have been classified independently of the Waechter layer designations. A full analysis of these units is outlined by Collcutt and Currant (Chapter 2).

Radiocarbon dating: methods

Radiocarbon measurements were obtained from the Oxford Radiocarbon Accelerator Unit (ORAU) on charcoal and shell carbonate samples from Gorham's Cave. Tables 5.1, 5.3 and 5.5 show the radiocarbon dates of charcoal and burnt bone, whilst the shell carbonate results are shown in Table 5.6. The initial set of radiocarbon results (Pettitt and Bailey 2000) requires some additional comment. The carbonate results are reported here for the first time.

The charcoal samples were treated with one of two techniques. Samples denoted with the term 'ZR' are those prepared with the standard ABA protocol at ORAU. This involves a 1M HCl wash at 80°C (for one hour), a rinse with hot 0.2M NaOH (one hour) and a final HCl wash for the same period of time. Interspersed within each wash the sample is rinsed to neutral pH with MilliQ™ ultrapure water. Samples with the code 'RR' were treated using a milder version of the ZR treatment, incorporating a 1M HCl wash at room temperature (RT), followed by rinsing with ultrapure water, a further acid wash in HCl at RT with 0.1M acid, and a final water rinse. This method is used where the material being treated is fragile, small or fragmented. The RR method is much less rigorous than the ZR method because the expectation is that the application of the latter method would result in the recovery of a very low, or no, yield after pretreatment. It is, therefore, something of an assumption that contaminating carbon present in a sample treated with this method is either removed or negligibly low. This is not ideal, but is the reflection of a pragmatic approach. Usually, judgement is applied regarding the degree to which humic material is freed in the pretreatment process, with clearly humic-contaminated fragile charcoals not dated. Table 5.4 shows that only one sample from the initial series at Gorham's was treated using the ZR method, whilst there are two more recently dated ZR samples (see below).

Sample loss on treatment was high, even when the more gentle chemical treatment approach was applied. Up to 98% loss by weight was recorded for some samples of charcoal and charred seeds, while the $\delta^{13}C$ values and the %C values diverged markedly from expected values (Table 5.4 shows all analytical data associated with the dated samples). The carbon content of pretreated charcoal usually averages 60%, but some of the samples disclosed quite different and

Table 5.1 AMS radiocarbon determinations of charcoal and burnt bone from Gorham's Cave, Gibraltar.
$\delta^{13}C$ values are expressed in ‰ wrt to VPDB with a measurement precision of ± 0.2—0.3‰. Comparison is made in each case against the radiocarbon record from the Cariaco Basin, Venezuela (Hughen *et al.*, 2006) at one and two standard deviations, as discussed in the text. In three instances (OxA-7790, 8526 and 8542), the ages were at, or over, the limit of comparison, therefore these ages should be carefully considered in terms of their reliability, particularly towards the old end of the range.

Lab code	Sample code	Context	Original context	Material/species identification	$\delta^{13}C$ (‰)	Radiocarbon age BP	Comparison age vs. Cariaco/Hulu			
							[68.2% range]		[95.2% range]	
							from	to	from	to
OxA-6997	GOR96 526	CHm.3	7	burnt bone	-21.2	25680±280	31300	30390	31540	29860
OxA-7792	GOR97 7	CHm.3	15	Charcoal, *Pinus* sp. Cone scale	-24.5	28680±240	33610	32760	33990	32320
OxA-7074	GOR96 511	CHm.5	9	Charcoal, *Pinus* sp	-24.2	30200±700	35840	34030	35870	33240
OxA-7075§	GOR96 512a	CHm.5	9	Charcoal, *Pinus* sp	-27.3	29800±700	34980	33390	35850	32920
OxA-7076§	GOR96 512b	CHm.5	9	Charcoal, *Pinus* sp.	-25.2	30250±700	35840	34050	35870	33250
OxA-7077	GOR96 514	CHm.5	9	Charcoal, *Pinus* sp	-24.7	29250±650	34330	32960	35000	32310
OxA-7388	GOR96 517	UBSm.2	11	Burnt longbone fragment	-23.1	29100±340	34010	33250	34280	32916
OxA-7110	GOR96 528	UBSm.4	13a	Charcoal, *Pinus* sp.	-24.4	29250±750	34360	32940	35820	32210
OxA-7857	GOR97 119	UBSm.6	24	Charcoal	-22.8	32280±420	37960	35650	38070	35070
OxA-7791	GOR97 132	UBSm.7	18	Charcoal	-23.9	42200±1100	46690	44170	48520	43130
OxA-7979	GOR97 167	UBSm.7	18	Charcoal	-21.7	23800±600	29470	27830	30350	27040
OxA-8525	GOR98 951	BeSm.1 (OSsm1)	19	Charcoal, *Juniperus/Tetraclinus*	-20.9	43800±1300	48610	45320	55130	44190
OxA-8526†	GOR98 952	BeSm.1 (OSsm1)	19	Charcoal, *Pistacea*	-23.7	46700±1900	55360	47470	62720	45620
OxA-8541	GOR98 928	BeSm.1 (OSsm1)	19	Charcoal, dicotyledonous shrub	-24.9	31900±1400	38550	34980	40450	34060
OxA-8542	GOR98 1099	BeSm.1 (OSsm1)	19	Charcoal, *Juniperus/Tetraclinus*	-24.4	42800±2100	51580	43290	55910	43000
OxA-7790	GOR97 131	LBSmff.4	22d	Charcoal	-24.5	51700±3300	63720	53450	...	49810
OxA-6075	GOR95 240	LBSmcf.4	4d/22	Charcoal	-25.2	45300±1700	51780	45720	55920	45340

§ denotes determinations made on the same charcoal sample (Pettitt & Bailey, 2000:155); the error-weighted mean of these two determinations is 30095 ± 495 BP (χ^2-Test: df=1 T=0.2(5%:3.8). Note that OxA-205 (in Pettitt and Bailey, 2000:156) is not an OxA number, -205 refers instead to the code used to denote an 'autoduplicate' run as part of the ORAU inhouse programme as a duplicate, as they state, of OxA-8526. The duplicate was statistically identical to OxA-8526 (47900 ± 2100 BP compared with OxA-8526; 46700 ±1900 B()).
† This sample was taken for reanalysis using ABOX-SC methods (see Bird et al. 1999) but furnished insufficient yield. See Table 5.2 for analytical data associated with these determinations.

Table 5.2 Results summary of the XRD and SEM analyses.
See text for details of the assessed preservation state. Samples outlined in bold were AMS dated.

Context	Sample	XRD result	SEM assessment
CHm.2	**Gor97(1) 6**	**Aragonite**	**Reasonably well-preserved**
CHm.3	**Gor97(1) 52**	**Aragonite**	**Well-preserved**
CHm.4	Gor01 15	Aragonite (major calcite)	Well-preserved
CHm.5	Gor97(1) 20	Aragonite (possible calcite traces)	Poorly preserved
CHm.5	Gor01 26	Aragonite	Poorly preserved
CHm.5	Gor97(1) 98	Aragonite (possible calcite traces)	Poorly preserved
CHm.5	**Gor97(1) 100**	**Aragonite**	**Reasonably well-preserved**
UBSm.4	**Gor97(1) 33**	**Aragonite**	**Well-preserved**
UBSm.4	**Gor97(1) 28**	**Aragonite**	**Well-preserved**
BeSm (OSsm).1	**Gor98(1) 836**	**Aragonite (possible calcite traces)**	**Well-preserved**
BeSm (OSsm).1	Gor98(1) 865	Aragonite	Poorly preserved (possible calcite traces) (bands of recrystallisation)
BeSm (OSsm).1	**Gor98(1) 869**	**Aragonite**	**Well-preserved**
LBSmff.4	Gor97(1) 177	Aragonite (major calcite)	Recrystallised
LBSmcf.4	**Gor95 212a**	**Aragonite**	**Well-preserved**
LBSmcf.4	Gor95 212b	Aragonite (possible calcite traces)	Well-preserved
LBSmcf.5	Gor95 293	Calcite	Recrystallised
LBSmcf.5	Gor95 346	Aragonite	Poorly preserved (bands of recrystallisation)
LBSmcf.6	Gor95 329	Aragonite	Well-preserved
LBSmcf.6	**Gor95 348**	**Aragonite (possible calcite traces)**	**Well-preserved**
LBSmcf.7	Gor95 401	Aragonite (major calcite)	Reasonably well-preserved
LBSmcf.7	**Gor95 427**	**Aragonite (possible calcite traces)**	**Well-preserved**
LBSmff.10	Gor98(1) 820	Aragonite (major calcite)	Recrystallised
LBSmff.10	**Gor98(1) 829**	**Aragonite (possible calcite traces)**	**Well-preserved**
160	Van98 1010	Aragonite (possible calcite traces)	-
160	**Van98 1022**	**Aragonite (possible calcite traces)**	**Well-preserved**
160	**Van98 1024**	**Aragonite**	**Poorly preserved**
160	**Van98 1044**	**Aragonite**	**Poorly preserved**

Table 5.3 Determinations obtained in Oxford for charcoal samples from the rear of Gorham's cave.

Lab code	Sample code	Context	Material/species identification	$\delta^{13}C$ (‰)	Radiocarbon age BP
OxA-10183	GOR00/B10/125		charcoal, tuber or rhizome	-22.3	2530±40
OxA-10230	GOR00/BB1/12		charcoal, *Pinus* sp. cone scale	-26.9	32330±390
OxA-10295†	GOR00/C23/47		charcoal, *Pinus* sp.	-21.6	34600±900

† This sample was analysed subsequently using ABOX-SC methods (after Bird *et al.*, 1999) but produced no yield. See text for details. In 2000, when these samples were originally dated, this sample produced no yield after the ZR treatment.

Table 5.4 Pretreatment and analytical data associated with the Gorham's Cave charcoal samples. (see text for details)

OxA	Material	Pretreatment	Weight used (mg)	Yield (mg)	%Yld	Excess (mg)	%C	$\delta^{13}C$ (‰)
6075	charcoal	ZR	121.1	25.5	21.1	15.4	62.2	-25.2
6997	bone	RR	1280	260.2	20.3	260.2	22	-21.2
7074	charcoal	RR	72.2	39.7	55	35	65.3	-24.2
7075	charcoal	RR	25	7.8	31.2	4.1	74.6	-27.3
7076	charcoal	RR	59.9	32	53.4	28.5	63.1	-25.2
7077	charcoal	RR	64.9	25.8	39.8	22.1	65	-24.7
7110	charcoal	RR	2.1	1	47.6	0	53.9	-24.4
7388	charred bone	RR	149.6	13.4	9	9.4	57.7	-23.1
7790	charcoal	RR	127.9	64.1	50.1	60.3	68.6	-24.5
7791	charcoal	RR	29.8	4.5	15.1	0.7	46.3	-23.9
7792	charcoal	RR	86.7	46.8	54	42.9	63.3	-24.5
7857	charcoal	RR	526.2	241.4	45.9	186.1	16.8	-22.8
7979	charcoal	RR	56	34.4	61.4	1.3	0.9	-21.7
8525	charcoal	RR	34.9	11	31.5	7.4	60.8	-20.9
8526	charcoal	RR	41.3	11.8	28.6	11.8	58	-23.7
8541	charcoal	RR	3.6	1.3	36.1	0	49.9	-24.9
8542	charcoal	RR	7.7	3.2	41.6	0	55.7	-24.4
10183	charred seeds	RR	24.26	8	33	4.3	55.4	-22.3
10230	charred seeds	RR	10	4.1	41	0.9	59.5	-26.9
10295	charcoal	RR	24.28	6	24.7	1.8	29.3	-21.6
17587	charcoal	ZR	87.68	1.6	1.8	0.29	54.9	-25.3
17588	charcoal	ZR	48.41	2.87	5.9	0.58	54.3	-21.6

Table 5.5 New determinations from Gorham's Cave, attempting to compare paired determinations obtained using ABA and ABOx-SC methods. The ABA, or acid-base-acid treatment was applied twice, one a so-called 'ZR' full treatment, eg OxA-17588 and the other a milder 'RR'-treatment, eg OxA-6075 (see text for details). Unfortunately, the third determination, an ABOx-SC treatment, failed to produce enough carbon for analysis.

Lab code	Sample code	Context	Material/species identification	Pretreatment method	$\delta^{13}C$ (‰)	Radiocarbon age BP
OxA-8525	GOR98 951	BeSm.1	charcoal, Juniperus/Tetraclinus	ABA RR	-20.9	43800 ± 1300
OxA-17588				ABA ZR	-21.6	40850 ± 500
				ABOx-SC		Failed due to low yield
OxA-6075	GOR95 240	LBSmcf.4	Charcoal	ABA RR	-25.2	45300 ± 1700
OxA-17587				ABA ZR	-25.2	44000 ± 1000
				ABOx-SC		Failed due to low yield

Table 5.6 AMS determinations of shell carbonate from units in the Gorham's Cave excavation. (see text for details).

OxA no.	Sample no.	Context	Conventional radiocarbon age BP	$\delta^{13}C$ (‰)
OxA-12514	Gor97(1) 6	CHm.2	13,545 ± 60	1.80
OxA-12507	Gor97(1) 52	CHm.3	30,590 ± 160	2.00
OxA-12649	Gor97(1) 100	CHm.5	29,020 ± 160	1.30
OxA-12645	Gor97(1) 33	UBSm.4	30,740 ± 180	-0.20
OxA-12508	Gor97(1) 28	UBSm.4	29,250 ± 150	1.90
OxA-12624	Gor98 869	BeSm (OSsm).1	31,140 ± 180	-0.50
OxA-12625	Gor98 836	BeSm (OSsm).1	35,370 ± 240	1.40
OxA-12511	Gor95 212a	LBSmcf.4	39,650 ± 340	2.00
OxA-12510	Gor95 348	LBSmcf.6	44,650 ± 650	3.00
OxA-12509	Gor95 427	LBSmcf.7	44,250 ± 600	-1.00
OxA-12626	Gor98 829	LBSmff.10	1.068 ± 0.003 fM	0.90

extremely low values, possibly indicating that degraded charcoal is being dated, with the potential for contamination, or that non-parenchymous material is being analysed. OxA-7979, for instance, yielded a carbon combustion value of 0.9%C, which strongly suggests it is not charcoal, but rather more likely composed of low carbon sediment. This date ought to be viewed with caution, if not dismissed from consideration outright. OxA-7857 and 10295 are both low in terms of their %C as well (16.8% and 29.3% respectively) and similar caveats apply. OxA-8541 is higher but the size of the analysed charcoal was excessively low (3.6 mg of charcoal was treated to produce 1.3 mg of carbon). Larger samples are required if accuracy and precision are to be maintained.

A new approach, that of dating shell carbonates, was attempted at both Gorham's and Vanguard Caves. A large number of shellfish remains are evidenced at the Gibraltar Caves sites (Barton 2000; Fernández-Jalvo and Andrews 2000). As noted by previous workers, marine shell carbonates can be challenging for dating (Chappell and Polach 1972; Stuiver et al. 1986; Bezerra et al. 2000). Problems most often identified include the reservoir effect (the difference between the concentration of contemporary atmospheric and marine reservoirs, a difference that averages 400 years, but does fluctuate temporally and spatially) and the subsequent conversion of the dates into calendar ages (calibration). In addition, the hard-water effect may be a significant influence. The dissolution of carbonaceous rocks of infinite radiocarbon age acts to dilute the activity of a radiocarbon reservoir, but this varies with respect to the nature of the rock substrate within catchments. The most important concern, however, is the assessment of the preservation state of the material to be dated.

Molluscan skeletons are polycrystalline biominerals mainly composed of calcium carbonate ($CaCO_3$) in its two principal polymorphs, calcite and aragonite, precipitated as distinct layers within a proteinaceous matrix. The two different forms have identical chemical compositions but quite different crystal structures and thermodynamic equilibria. Aragonite is meta-stable at present earth-surface conditions and so is expected to decompose and recrystallize as the thermodynamically most stable phase, low-magnesium calcite, after the animal's death and the weakening of the organic matrix. The carbon isotopic ratios of the secondary phase are likely to be different to that of the original material, thus causing discrepancies in the measured ^{14}C ages, from a few years to a few millennia. Rigorous screening and effective pretreatment are required to reduce the possibility of contamination with secondary $CaCO_3$.

Shell carbonate dating of Gibraltar material focused on a selection of *Mytilus galloprovincialis* (Lamarck 1819) shells, the majority of which were from contexts in Gorham's Cave (n=87), with a further five from Vanguard Cave. The initial aim was to determine with confidence whether or not the marine shells had been diagenetically altered and therefore were suitable for dating.

Mytilus sp. is composed of an inner nacreous layer of aragonite and an outer layer of prismatic calcite. A test of the nacreous aragonite for trace, secondary calcite prior to any AMS dating is therefore a strong requirement. Three techniques were applied for examining shell microstructures

and determining mineralogical preservation of the archaeological shells: Scanning Electron Microscope (SEM), powder X-ray Diffraction (XRD) and Fourier Transform Infra-Red spectroscopy (FTIR). These are used widely in geological studies of carbonate mineralogy (see for example Ditchfield 1997; Ditchfield et al. 1994; Hendry et al. 1995; Maliva and Dickson 1992; Marshall 1992; Marshall et al. 1993), but in archaeological AMS radiocarbon dating they are generally less widely applied, or applied singly rather than jointly.

Shells were first visually examined, and those that retained a nacreous aragonitic layer were selected for analysis. Twenty-three mussel shells from Gorham's and four from Vanguard Cave were suitable. The outer surface of the nacreous layer of the shells was cleaned by shot blasting using fine aluminium oxide powder to remove surface contaminants adhering to the shell. A freshly broken section of each shell was prepared for examination under the SEM, and a part of that reserved for XRD and FTIR. Technical and methodological details are described in the Appendix to this chapter.

The XRD and SEM assessment assigned to each sample tested is listed in Table 5.2. Generally speaking, shell carbonates from Vanguard Cave were less well preserved than those from Gorham's and therefore it is questionable whether they constitute a reliable background material (see Appendix 1). Samples outlined in bold in Table 5.2 were eventually selected for AMS dating.

We found that 3.7% of the samples showed wholly calcitic carbonate, which we interpret as original aragonite that has undergone complete recrystallization (denoted 'calcite' in Table 5.2) (n=1) (see Fig. 5.1e). These were rejected for AMS dating. Of the remaining shells, 44% showed wholly aragonite spectra (n=12) within the resolution of the instrument, 37% showed an aragonite spectrum with calcite trace levels or 'possible calcite traces' ((n=10) of c.<1% (see Fig. 5.1c, d and f), and 15% showed an aragonitic spectrum with a 'major calcite' peak present (n=4) (see Fig. 5.1b).

Results

Gorham's Cave: charcoal dates reconsidered

The results reported by Pettitt and Bailey (2000), in general, appeared to correlate well with the stratigraphy presented in the Waechter sequence. Their contexts 8, 9, 10a and 11 (units CHm.4, CHm.5, UBSm.1 and UBSm.2) were correlated with Waechter's layers B, D and E, and Context 22d tentatively with layer G.

The initial radiocarbon determinations obtained from Gorham's Cave are shown in Table 5.1. The uppermost diagnostically Middle Palaeolithic assemblage from this cave was recovered from the Upper Bioturbated Sands member (UBSm.4) (Chapter 12). This was originally (wrongly) attributed to UBSm.7 and BeSm(OSsm).1. There was a noticeable absence of any definitive Upper Palaeolithic artefact in units below the CH member (Chapter 12). The samples dated from all of these horizons are either composed of discrete charcoal lumps in the same bed as diagnostic lithics or are charcoal samples taken from well within what was initially interpreted as a remnant combustion zone at the contact of UBSm.6 and UBSm.7 (Contexts 16 and 18).

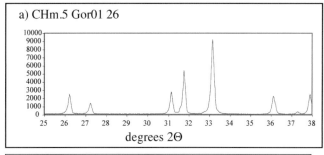

a) CHm.5 Gor01 26

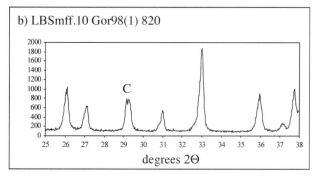

b) LBSmff.10 Gor98(1) 820

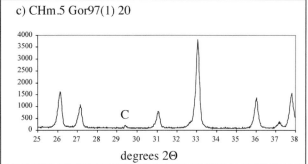

c) CHm.5 Gor97(1) 20

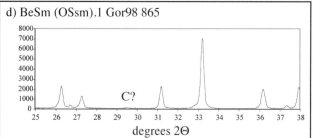

d) BeSm (OSsm).1 Gor98 865

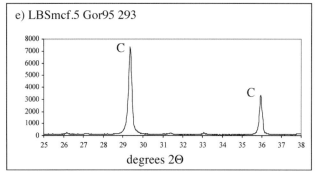

e) LBSmcf.5 Gor95 293

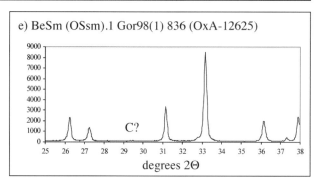

e) BeSm (OSsm).1 Gor98(1) 836 (OxA-12625)

Fig. 5.1 Typical XRD spectra obtained in the shell study. In Table 5.2 the qualitative analysis associated with such spectra is given.

a is classified as aragonite, there is no evidence of any calcite peak.

b is classed as contaminated with a major proportion of calcite, and was not dated.

c is contaminated with a 'minor calcite' peak clearly visible at 29.4°2θ.

d and f are both described as 'possible calcite trace'.

e is calcite.

Pettitt and Bailey (2000) argued that the spread in radiocarbon ages from these contexts clearly indicates stratigraphic mobility. The choice of small lumps of charcoal, in the absence of any other dating substrate, probably aggravated the problem further (see also Zilhão and Pettitt 2006, 4). Such mobility was suspected from the analysis of the sections, and the discovery of a bilaterally retouched bladelet with marginal retouch within UBSm.6 supports this observation. Pettitt and Bailey (2000) suggested that OxA-7979[1] was clearly intrusive from above. As mentioned previously, however, this sample was dubious on the basis of its sample chemistry and is demonstrably not charcoal; therefore, there may be grounds other than stratigraphic mobility for its young age. At present it is not possible to resolve which is the more likely explanation. There are questions, too, regarding OxA-8541, in terms of its minute size as discussed above. This result should perhaps be omitted from any proper discussion of the chronology of these sections of the site.

There is a major unconformity between UBSm.7 and BeSm.1 (although note that in Chapter 2 Collcutt identifies

the unconformity within BeSm at sub-member level). The conventional radiocarbon results indicate an age of between c.29,000 and c.51,000 BP for these contexts. In view of the dates for the underlying LBSmff.1–5 of between c.42,000 and c.56,000 BP it is conceivable that most of the charcoal fragment dates from UBSm.7 and BeSm(OSsm) derive from lower down the sequence, moved up by the soft sediment loading. Pettitt and Bailey (2000) proposed a similar interpretation. It is tempting to consider OxA-8541 (31,900 ± 1400 BP) as reflecting the age of the latest Middle Palaeolithic occupation of the cave, but for the reasons outlined above, we ought to view this measurement as potentially problematic. Indeed, our chronometric analysis (below) shows that this is 100% likely to be an outlier within the sequence.

Samples dated from above UBSm.7 and BeSm(OSsm), which have yielded small archaeological assemblages lacking in diagnostic pieces (Chapter 12), have dates ranging from c.28,000 to 31,000 BP and c.25,000 to 26,000 BP. The authors have concluded that there is no doubt that Waechter's (1951) early Upper Palaeolithic Level D correlates with the Cemented Hearths member although the latter yielded few typologically diagnostic lithics. Pettitt and Bailey (2000, 156) suggested that the Oxford dates from CHm.5 (Context 9)

1 Pettitt and Bailey (2000) suggest that actually OxA-7971 is the outlier and too young, but they must in fact mean OxA-7979 which is the markedly younger determination.

were strong evidence supporting a stratigraphic correlation between these two stratigraphic units because they were statistically indistinguishable from Waechter's dates from the Groningen Laboratory (28,700 ± 200 and 27,860 ± 300 respectively). In fact, whilst the Oxford dates are statistically indistinguishable as a group, the Groningen dates, when added, are not (T'=20.52; df=6 (c²=11.07)). The Waechter Groningen dates are younger. There is closer agreement, however, between them and the determination from CHm.3 (OxA-7792) of 28,680 ± 240 BP (formerly Context 15, this sample of charcoal came from a discrete area of carbonized material within Context 7 (CHm.3) (Pettitt and Bailey 2000). Barton finds parallels between the backed bladelets in this level and those from other well contexted Gravettian assemblages in Mediterranean Spain. In terms of the Gravettian, this date is interestingly similar to those emerging from early Gravettian contexts in western European sites such as La Ferrassie and Maisières-Canal (Higham et al. 2006). Alternatively, OxA-6997 could reflect, more reliably, subsequent Upper Palaeolithic ('Gravettian') use of the cave. However, it is a determination of burnt bone, which is not as reliable a sample type for AMS dating as charcoal and should be viewed as a minimum age only. Burnt bone is not a wholly dependable sample for AMS dating, because of the significant reduction in bone protein due to heating. The resulting low carbon content means that it is difficult to distinguish between autochthonous pyrolized carbon derived from the collagen itself, and allochthonous (probably sediment-derived carbon). The latter may be a contaminant, of course. Clearly further work is required.

Radiocarbon determinations reported here from the back of Gorham's Cave are potentially problematic (Table 5.3). They derive from excavations beyond the area of the 1995–1998 project and in sediments described in Finlayson et al. (2006). OxA-10295 comes from a small trench excavated at least 7 m further inside the cave than the main series of dates. The pine charcoal, from a well stratified context, was in close proximity to undiagnostic flakes, but in raw materials commonly used in the Middle Palaeolithic. The date overlaps with those for the latest Middle Palaeolithic. OxA-10183 is clearly a very recent sample. It derives from layer III, a loose, heavily bioturbated, humic-rich deposit near the back of the cave, which contains a mixture of historic and prehistoric material. Some of this material may have been deposited during later periods of the cave's use. Phoenicians, Iberians and Carthaginians between the seventh and third centuries BC have been suggested as likely candidates when the cave was used as a coastal sanctuary (Finlayson et al. 2006). The date may correspond with a late Phoenician presence; thus, it is excluded from the modelling of the dates below. OxA-10230 is from layer IV, an apparently in situ deposit underlying layer III containing only Middle Palaeolithic artefacts and fauna. It is a date of a small fragment (10 mg) of a pine cone scale and suggests that latest Middle Palaeolithic activity extended to the back of Gorham's Cave.

Shell determinations

Turning now to the shell determinations from Gorham's Cave, these have been compared with paired charcoal samples from the same contexts, where applicable, with respect to the Cariaco Basin (Venezuela) radiocarbon record of Hughen et al. (2006) (see below). The conventional radiocarbon age of OxA-12514 (13,545 ± 60 BP) is younger than any of the other samples (Table 5.6); however, it is stratigraphically consistent and comes from one of the uppermost archaeological contexts in the site (CHm.2). The XRD analysis showed a wholly aragonitic spectrum (Table 5.2) and the SEM micrograph showed parallel arrangement of the sheets of laths without any traces of dissolution or cementation.

The sample obtained from CHm.3 (OxA-12507) showed well preserved aragonite on XRD and SEM examination (Fig. 5.1b). The conventional radiocarbon age of 30,590 ± 160 BP ought, therefore, to be reliable. However, it is older than both AMS determinations from this context. A fragment of burnt bone found near it yielded a radiocarbon date of 25,580 ± 280 BP (OxA-6997), but for reasons described earlier it can be considered less reliable than the shell date. The inconsistency between the shell date and the charcoal date within a discrete level in a combustion zone in CHm.3 (OxA-7792; 28,680 ± 240 BP) still needs to be explained.

CHm.5 is the best dated horizon at Gorham's Cave, with four charcoal determinations already obtained from identical contexts showing acceptable statistical agreement (Pettitt and Bailey 2000). The mussel dated from this context (Gor97(1) 100) showed no detectable calcite in its XRD spectrum; however, the SEM micrograph evidenced slight dissolution of the aragonite laths. The result of 29,020 ± 160 BP (OxA-12649), after reservoir correction, appears to be too young in comparison with the other determinations from the same context. If one accepts the reliability of the previously obtained charcoal dates, one possible explanation might be that, despite the apparently acceptable preservation state, small amounts of reprecipitated carbonate with a higher ¹⁴C concentration have influenced the radiocarbon result and made it slightly too young. Nevertheless, despite this, the result for the shell determination is not substantially in error compared with the charcoal results from the same context. This is borne out by our Bayesian analysis, which suggests it is not, in fact, an outlier.

The conventional radiocarbon ages obtained from UBSm.4 (OxA-12508 and OxA-12645) are in reasonable agreement with the dated charcoal from the same depositional context (OxA-7110; 29250 ± 750 BP). Both appeared well preserved under the SEM and contained no calcite when analysed by XRD (the SEM micrograph for OxA-12508 is shown in Figure 5.2a).

Two shell samples dated from BeSm.1 also appeared to be well preserved under SEM and produced wholly aragonitic XRD spectra with respect to the resolution of the instrument. The conventional radiocarbon ages obtained were 31,140 ± 180 BP (OxA-12624) and 35,370 ± 240 BP (OxA-12625). There is no immediate reason to doubt the reliability of the two shell determinations; however, the Bayesian analysis shows that OxA-12624 is a statistical outlier in the model.

The conventional radiocarbon age of OxA-12511 from LBSmcf.4 (39,650 ± 340 BP) is younger than a charcoal date from an identical unit of 45,300 ± 1700 BP. The SEM

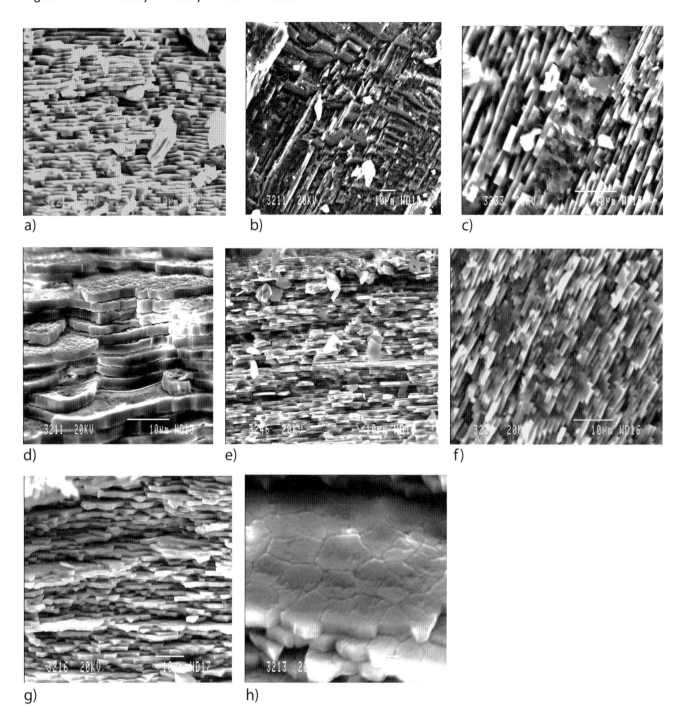

Fig. 5.2 Scanning electron micrographs of:

a OxA-12508 (Gorham's Cave Context UBSm.4) showing well preserved aragonite, with the sheets of laths arranged in parallel and clearly visible. The spaces between the laths show that there has been no cementation, and there are no other signs of diagenetic alteration. This specimen is typical of examples denoted as 'well-preserved' in Table 5.2;

b Sample Gor97(1) 177 (Gorham's Cave Context LBSmff 1–5) (undated) showing complete recrystallization of aragonite to calcite (termed 'recrystallized' in Table 5.2);

c Sample Gor98(1) 865 (Gorham's Cave Context BeSm.1) (undated) showing partial recrystallization, with bands of calcite in the nacreous structure. This was termed 'poorly preserved: bands of recrystallization' in Table 5.2;

d Sample Gor97(1) 20 (Gorham's Cave Context CHm.5) (undated) showing dissolution on the surface of the laths of aragonite. This was denoted 'poorly preserved';

e OxA-12511 (Gorham's Cave context LBSmcf.4) shows 'well-preserved' aragonite with the sheets of laths arranged in parallel. The sample is not pristine but there are no obvious signs of diagenetic alteration;

f OxA-12507 (Gorham's Cave Context CHm.3) again illustrating 'well-preserved' aragonite;

g OxA-12648 (Van98 1022) from Vanguard Cave shows well preserved aragonite, with the laths retaining sharp edges and the hexagonal laths still discernible in the parallel sheets. There are no obvious signs of diagenetic alteration;

h OxA-12512 (Vanguard Cave Context 1024) shows poorly preserved aragonite, with evidence of dissolution on the surface of the laths, and etching along their edges, causing the hexagonal laths to shrink in size and resulting in the mosaic pattern. It is also possible that there is cementation on the surfaces of, and between, the laths. Scale bar is 10 microns unless stated.

micrograph revealed well preserved aragonite; however, this was from a different area of the shell fragment to that sampled for radiocarbon dating. This mussel shell was fractured into several pieces, and the nacre from the dated fragment was used for XRD so that none remained to be analysed by SEM. The sample was dated on the assumption that both fragments of the shell shared the same diagenetic history (see Hendry *et al.* 1995). However, because the results of the SEM examination and XRD analysis were not always consistent, possibly implying that there was intra-shell variation in diagenetic effects, the shell fragment that was examined under the SEM was subsequently analysed by XRD. While the XRD analysis of the dated fragment revealed no calcite, a second XRD scan was undertaken on the other fragment, which appeared to show a trace amount of calcite. This uncertainty makes the reliability of this date open to question. Further dating of the second sampled fragment could help confirm internal consistency, and confirm the reliability of the conventional radiocarbon age obtained.

Two shell samples from units LBSmcf.6 and 7 were dated. SEM examination revealed well preserved specimens. XRD analysis implied the presence of trace amounts of calcite in OxA-12510. Both conventional radiocarbon ages of 44,650 ± 650 BP (OxA-12510) and 44,250 ± 600 BP (OxA-12509), respectively, fall within the range estimated on the basis of the other radiocarbon determinations mentioned above (e.g. OxA-6075; 45,300 ± 1700 BP). The determinations are acceptable within the model as well, which further supports their reliability.

OxA-12626, from the lowest context, is clearly intrusive and dates from modern times.

Interpretation of results
One problem with AMS radiocarbon dating of the Middle to Upper Palaeolithic is that of calibration. At present, there is no internationally agreed curve covering the period prior to 26,000 cal BP (Reimer *et al.* 2004). For this chapter we have, therefore, tentatively 'compared' (see van der Plicht *et al.* 2004) our dataset with the Cariaco Basin record published by Hughen *et al.* (2006). The dataset offers substantially improved resolution owing to an increase in the number of radiocarbon analyses over the previous version (Hughen *et al.* 2004). The Cariaco δ¹⁸O dataset has been tuned to the Hulu Cave δ¹⁸O speleothem record from China, itself pinned calendrically by a sequence of ~70 U/Th dates, and the use of this in the Cariaco age model has been argued to provide a more reliable calendrical framework. This approach enables us to 'calibrate' tentatively our results and also to begin to address the question of climatic-related correlations for the dates of human occupation on Gibraltar. Further comparison between Hulu Cave's δ¹⁸O record and the equivalent record from the recently published NGRIP (GICC05) δ¹⁸O dataset from Greenland shows good correspondence within published errors, suggesting synchroneity between these geographically disparate records. There is also emerging agreement between the Cariaco ¹⁴C record and the Barbados coral data published by Fairbanks *et al.* (2005), although the latter has fewer measurements prior

to 30 ka BP at the time of writing.[2] For these reasons, we feel compelled to compare our Gibraltar radiocarbon chronology against the Cariaco radiocarbon dataset/Hulu-derived age model and the NGRIP δ¹⁸O record (Andersen *et al.* 2006; Svensson *et al.* 2006), in order to interpret the potential significance of the results in a wider sphere.[3]

We utilized a Bayesian modelling approach to analyse the Gibraltar ¹⁴C chronology. We used the stratigraphy of the excavated sequence as a prior constraint upon the individual radiocarbon likelihoods. The calibration model using Cariaco06 was run using OxCal 4.0 with a Markhov Chain Monte Carlo (MCMC) sampler of $c.10^6$ iterations collected at a sampling resolution of 20. Within each phase we assumed the samples being dated were contemporaneous with each other. This assumption was tested using outlier detection analysis (Bronk Ramsey 2009), which assesses the degree to which individual likelihoods diverge from others within the phase or sequence. These are downweighted if they are clear outliers. A General Outlier model (t) was applied to the dataset ('General',T(5),N(0,100),0,'t'). This method assigns an outlier probability based on the fit of the radiocarbon likelihoods to the posterior data. For the problematic determinations described earlier we gave a higher probability of being an outlier. The different outlier values ascribed are shown in Table 5.7. We modelled the Gibraltar sequence by including all phases within the sediment record (Chapter 2), even if no chronometric data existed, since this reflects more accurately the prior archaeological evidence. We tested the sensitivity of the models to varying these parameters, as discussed below. We subtracted 420-years from the shell carbonate determinations prior to any comparison with Cariaco, thus accounting for the reservoir effect. We assume here that the reservoir offset is time-independent. Temporal variation in the reservoir offset is a source of uncertainty mitigated to an extent by the fact that with increasing age the magnitude of the error is less significant in its absolute effect on the ages calculated.

The final age model is shown in Figure 5.3. It was analysed multiple times to determine convergence and reproducibility, and no significant variation in sensitivity tests of repeat analyses was noted. The results of the outlier detection analysis show that five determinations returned significantly high outlier probabilities (OxA-12624, 7791, 7979, 12511 and 12507), whilst another two yielded higher

2 This work builds on the results of important research undertaken over the past few years which evidences links between the climatic variability in the North Atlantic and Greenland, and the variation identified in Iberia, based on pollen and sediment analysis of two key cores on the Atlantic coast and the Alboran Sea respectively (Cacho *et al.* 1999; Sánchez-Goni *et al.* 2002; Moreno *et al.* 2005). This interpretation is based largely upon the varying influences of Atlantic or Scandinavian Mobile Polar Highs (MPHs), airmasses which act as transfer mechanisms between polar and temperate latitudes. Comparison between SST (Sea Surface Temperature) reconstructions from the Alboran Sea core MD95-2043 and the GISP2 d¹⁸O record shows persuasive linkage between Dansgaard-Oeschger events in Greenland ice and variations in the SST in the Alboran Sea.

3 Tzedakis *et al.* (2007) recently compared radiocarbon determinations directly against the Cariaco Basin ¹⁴C record. They used some of the Gorham's Cave radiocarbon determinations published by Finlayson *et al.* (2006) to explore the linkages between climate changes and Neanderthal extinction.

Table 5.7 Outlier detection results from the modelling of the radiocarbon determinations in OxCal

Element	Prior	Posterior probability
OxA-12510	5.0	2.0
OxA-12509	5.0	2.0
OxA-12511	20.0	100.0
OxA-6075	5.0	2.0
OxA-7790	5.0	26.0
OxA-8526	5.0	16.0
OxA-8541	5.0	26.0
OxA-8542	5.0	4.0
OxA-12624	5.0	100.0
OxA-12625	5.0	21.0
OxA-8525	5.0	4.0
OxA-17588	5.0	4.0
OxA-7791	5.0	84.0
OxA-7979	5.0	100.0
OxA-7857	5.0	2.0
OxA-7110	5.0	2.0
OxA-12645	5.0	2.0
OxA-12508	5.0	40.0
OxA-7388	5.0	1.0
OxA-7074	5.0	3.0
OxA-7077	5.0	1.0
OxA-12649	5.0	2.0
OxA-7076	5.0	4.0
OxA-7075	5.0	2.0
OxA-12507	5.0	100.0
OxA-6997	5.0	18.0
OxA-7792	5.0	16.0

Table 5.8 Outlier detection results for the Beta determinations of Finlayson *et al.* (2006), after the modelling of the radiocarbon determinations in OxCal.

Element	Prior	Posterior probability
Beta-196782 (23)	5.0	99.0
Beta-185345 (15)	5.0	98.0
Beta-196775 (16)	5.0	98.0
Beta-196785 (9)	5.0	97.0
Beta-196773 (17)	5.0	96.0
Beta-196770 (28)	5.0	12.0
Beta-196784 (10)	5.0	8.0
Beta-196771 (30)	5.0	7.0
Beta-196791 (18)	5.0	4.0
Beta-196789 (26)	5.0	3.0
Beta-196787 (13)	5.0	2.0
Beta-196772 (25)	5.0	2.0
Beta-196769 (27)	5.0	2.0
Beta-184048 (29)	5.0	2.0
Beta-196786 (12)	5.0	1.0
Beta-196792 (14)	5.0	1.0
Beta-196779 (19)	5.0	1.0
Beta-196776 (20)	5.0	1.0
Beta-184045 (21)	5.0	1.0
Beta-196778 (22)	5.0	1.0
Beta-196768 (24)	5.0	1.0

than expected values (26 and 40% respectively) (Table 5.7). The outlier detection suggests these five are true outliers within the sequence, with posterior probabilities of between 90–100%. We tested the sensitivity of the results by increasing the prior outlier probabilities for some determinations but the overall results remained robust.

As mentioned previously, no diagnostic Upper Palaeolithic artefacts are found below CHm.5; therefore, the boundaries between this and the UBSm.1–4 contexts are of some interest in the overall chronology of the site. The boundary probability distribution between CHm.5 and UBSm.1 yields a range of 34000–33200$_{\text{Cariaco-Hulu}}$ BP at 95.4% prob. The uppermost diagnostically Middle Palaeolithic assemblage from this cave was recovered from UBSm.4 (Chapter 12). The boundary probability distribution for UBSm.5/UBSm.4 yielded a range of 35900–34200$_{\text{Cariaco-Hulu}}$ BP at 95.4% prob.

More work is required to derive a robust chronology for the lower sections of the site, or to conclude with more data that the problems are caused by bioturbation and taphonomic influences as suspected. In terms of the use of the Cariaco Basin record, there is little doubt that further research will yield a calibration curve within two–five years that is able to be used with full confidence; in fact within the year the INTCAL09 preliminary curve spanning to 50,000 years will be published in *Radiocarbon*. This model and interpretation are offered cautiously in the interim[4].

4 Since this chapter was written INTCAL09 has appeared and the calibration model presented therefore requires modification.

Discussion

The radiocarbon determinations obtained suggest that shell has potential for dating archaeological contexts of early Upper Palaeolithic age, but with a number of caveats. Reasonable agreement was found between some of the new measurements and those contexts previously dated with charcoal, but in other cases the shell determinations were slightly at odds (in total four appeared in good agreement within the age model, three were demonstrably not, and two were slightly high in the outlier posteriors). We think that the most likely explanation for some of the shell determinations may be trace diagenetic alteration and recrystallization. Once again, to invoke a quantitative argument, a 40,000-year-old shell sample with an addition of 0.1% reprecipitated carbonate of a modern age would result in a determination 1000 years too young. One of the major challenges in dating these types of samples reliably is the elimination of contaminants between 0.1–1% detection limits. XRD is not sufficiently accurate *routinely* to these limits (Hakanen and Koskikallio 1982; Hardy and Tucker 1988; Dickinson and McGrath 2001) without careful calibration

Fig. 5.3 Modelled results of the Gorham's Cave AMS chronology. The Bayesian model was analysed and produced using OxCal 4.0 (Bronk Ramsey 2001) obtained by comparison against the Cariaco Basin data of Hughen et al. (2006) against the chronology derived from the Hulu Cave, China (Wang et al. 2001). As a guide, the model is plotted against the NGRIP $\delta^{18}O$ record with Greenland interstadials given where relevant (data from Svensson et al. 2006 and Andersen et al. 2006). Radiocarbon determinations of shell have -420 year subtraction to account for the marine reservoir offset. The model is based on the series of separate excavated phases, and boundaries delineate the separation between each. Individual likelihoods are shown by the light shaded distributions, whilst the darker outlines represent the posterior probability distributions.

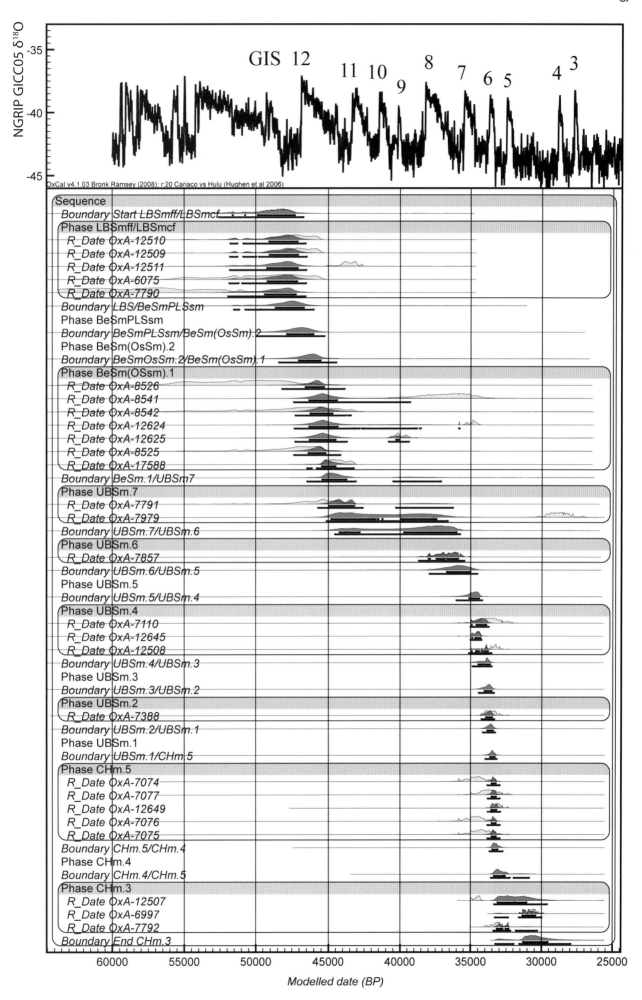

and testing. This is currently being undertaken by one of us (KD, see Douka *et al.* 2010) and this will hopefully ensure greater reliability in the dating of this material in future.

The results summarized in this chapter suggest that the uppermost Upper Palaeolithic levels at Gorham's Cave, despite being poorly characterized in terms of their lithic remains, date to after ~29,000 BP (modelled as being after 34000–33200$_{\text{Cariaco-Hulu}}$ BP at 95.4% prob., when compared against the Cariaco Basin radiocarbon record tuned to Hulu Cave). The results also imply a good deal of complexity in terms of the deposition of sediments and archaeological remains below Middle Palaeolithic level UBSm.6, where radiocarbon results are variable and not well ordered. A Bayesian approach incorporating the stratigraphic sequence provides a greater clarity to the chronometric data obtained. The upper parts of the sequence, where the putative Middle to Upper Palaeolithic transition layers are located, provide a consistent picture.

This conclusion is important, because recent work published by Finlayson *et al.* (2006) has yielded evidence used to claim support for a much later Middle Palaeolithic than that described here. Excavations between 1999–2005 in parts of the same cave but located further inside produced a series of AMS results in the Mousterian levels spanning 23,000–33,000 ka BP. If accepted, these results would imply a far greater period of contemporaneity between Neanderthals and early modern humans (the former represented by Mousterian industries of course, and the latter represented by both initial Upper Palaeolithic and Gravettian industries) in this region, than hitherto thought. How do these results sit with the conclusions presented in this chapter?

Zilhão and Pettitt (2006) have already criticized both the data and interpretation of Finlayson *et al.* (2006) on a number of grounds. The results described in this chapter have some relevance to the discussion, as does other work undertaken more recently at ORAU concerned with charcoal contamination, which is one of the points addressed partially by Zilhão and Pettitt (2006). Finlayson *et al.* (2006), for example, suggest that the dates discussed by Pettitt and Bailey (2000) were from potentially problematic, wet, exterior sections of the site, where contamination might become a significant issue. Zilhão and Pettitt (2006) suggest that the Stringer and Barton excavations were by no means exterior.

We have attempted to tackle the issue of contamination by undertaking tests of the reliability of some of the original charcoal dates from the Stringer and Barton excavations at Gorham's by redating spare material using the ABOx-SC method outlined originally by Bird *et al.* (1999). This technique incorporates an additional oxidation pretreatment step as well as a series of stepped-combustions, and is much more rigorous than the methods routinely applied by radiocarbon facilities. Significant benefits have accrued through the application of this technique in different archaeological contexts, particularly for charcoal >30 ka BP (Bird *et al.* 1999, 2003; Turney *et al.* 2001). It is now being applied more commonly in the dating of ancient charcoals at ORAU. We attempted to redate four samples of charcoal using ABOx-SC of spare material archived in ORAU to compare the results with those previously determined to establish their reliability. Unfortunately, the ABOx samples failed

to produce a large enough carbon yield, owing to the rigorous nature of the chemical steps. We were only able to compare ZR and RR treatments (see above for description). The results (Table 5.5) show no statistically significant difference between either of the successfully dated pairs. This implies that there is a less significant level of contamination in the charcoal and provides some confidence in the reliability of the results, although the sampled population is necessarily low. This is because the addition of a base wash to the ZR treatments, which solubilizes humic complexes, failed to produce a different age. Further work on dating other charcoals is necessary, and we are working to this end.

Of course this has no bearing on potential taphonomic problems as described above; it merely hints that there might be less of a contamination signal within the site here. Two other samples that we attempted to redate failed to produce measurable carbon after the NaOH stage of the pretreatment process, owing to their fragility (these were samples from the same charcoals that furnished OxA-8526 and 10295). Our experience at other sites (Brock and Higham 2009), however, suggests that the effects of ABOx-SC dating in some sites may be quite variable, and dependent upon individual samples. In some cases we have obtained substantially different AMS results when using ABOx, compared with ABA pretreatments, which implies contamination, usually unremoved by the less rigorous techniques previously applied (e.g. Higham *et al.* 2008a; 2008b).

Zilhão and Pettitt (2006) argue that Finlayson *et al.'s* (2006) younger dates are more likely to represent contaminated samples than those that are older. Generally speaking, this is more likely. However, our treatment comparison data, despite the low number of dated samples, suggest that at the front of the cave at least, this is not the case. The wide range of radiocarbon ages, many of which originate from a single hearth feature, is a serious cause for concern. One might expect more consistency in the ages derived from such an archaeological feature, despite Finlayson *et al.'s* (2006) suggestion that the results represent a repeated use of a feature over many thousands of years. Zilhão and Pettitt (2006) consider the wide suite of ages to be related to post-depositional displacement resulting in six younger dates being either intrusive, or contaminated, within a corpus that otherwise overlaps at ~30 ka BP. Taken together, the results presented here would suggest that a post-depositional displacement is the more likely explanation for variable radiocarbon results in these sections of the site. In general it seems reasonable to expect a similar date for the end of the Middle Palaeolithic in such a circumscribed context as Gorham's.

In Figure 5.4, we model the Finlayson *et al.* (2006) radiocarbon data against the Cariaco Basin dataset. The model includes a cross-referenced boundary, which correlates the probability distribution for the UBSm.4/UBSm.3 boundary (corresponding to the boundary marking the latest Middle Palaeolithic) with the end boundary for the Level IV radiocarbon determinations of Finlayson *et al.* (2006). Effectively, then, this model constrains the date for the transition from the Middle Palaeolithic to be the same for both sequences. Perhaps unsurprisingly given the priors in this model, the results show that there are only five outliers

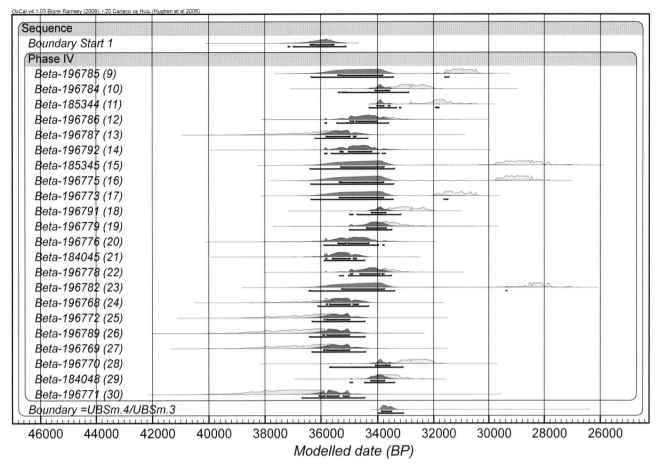

Fig. 5.4 Comparison between the Finlayson *et al.* (2006) radiocarbon chronology and the boundary representing the *terminus ante quem* for the initial Upper Palaeolithic of the Gorham's excavations outlined in this monograph. It can be seen that six of the Finlayson *et al.* (2006) results are clearly much younger than the TAQ distribution, raising questions over their reliability within the overall chronology for the site. See Figure 5.3 caption for relevant description of the model constraints and data.

in the Finlayson *et al.* (2006) dataset, and that these are all the younger ages (Beta-196782, 185345, 196775, 196785 and 196773) in the model. Included within the list of outliers are two of the determinations superposed within the hearth sequence (samples 16 and 17). The analysis suggests that, overall, most of the dates are in agreement with the data published here.

Conclusions

Lower parts of the Middle Palaeolithic levels at Gorham's yield a complex picture, probably influenced less by contamination than bioturbation and taphonomic factors. Precisely which of the two influences accounts for variable results, however, is difficult to determine in specific cases, but sedimentary studies refer frequently to the presence of bioturbated features. This probably explains the majority of the aberrant results obtained.

- This conclusion is supported by a small study of the effects of pretreatment chemistry on the ages of previously dated samples. The application of a rigorous ABOx-SC treatment step, used for dating ancient charcoals, failed to yield enough carbon for analysis, but the comparison of dates obtained using two other treatment methods implies that in at least some cases there is likely to be minimal contamination in the charcoals that were initially dated. This needs to be tested by further analysis of charcoals from the site generally. Taken together, the

weight of evidence suggests a reduced influence of contamination in the dated samples, but again definite proof is difficult to obtain.

- Further dating of material from the Middle Palaeolithic levels may be useful to examine the variation in the radiocarbon age of carbonaceous samples from these locations.

- Radiocarbon dates of shell carbonates suggest great potential for the material for dating these types of contexts, but caution is required in carefully checking the crystallinity of the samples before dating. This is probably the reason why some values are divergent from expected ages, although it is difficult to compare in some instances with charcoal samples which may themselves be subject to slightly different taphonomic and contamination influences.

- Analysis of the Gorham's chronology using a Bayesian approach conservatively shows that the initial Upper Palaeolithic at Gorham's Cave dates to after ~29,000 BP in radiocarbon terms, or after 34,000–33,200 BP, when compared against the Cariaco Basin radiocarbon record. A clearly diagnosed transitional date between the Middle and Upper Palaeolithic at Gorham's beneath the CH member is hampered hugely by the nature of the lithic evidence, which is small and largely non-diagnostic.

- A comparison between the Finlayson *et al.* (2006) results and those published here suggests that five of the former group are outliers.

Acknowledgements

We are particularly grateful to Professor R.N.E. Barton for his invaluable input and advice on aspects of this chapter. We thank N. Charnley (Earth Sciences, University of Oxford), P. Ditchfield, A. Shortland, C. Doherty and M. Walton (RLAHA, University of Oxford) for assistance with the SEM/FTIR and P. Frampton (Department of Chemistry, University of Oxford) for the XRD analysis. The shell carbonate AMS dates published here resulted from an M.Sc. project (HMCC) undertaken in 2003 at the RLAHA, University of Oxford that was supported by funding from an EFCHED (NERC) grant to Professor R.N.E. Barton (Institute of Archaeology, University of Oxford). Darren Fa, Claire Valarino (Gibraltar Museum) and Richard Jennings (Oxford) are thanked for their assistance with the preparation, identification and transportation of the mussel samples used in this project. KD is supported by a Ph.D. studentship from IKY-Greece, the Leventis Foundation and the RLAHA (Oxford). A. Bowles, M. Humm, P. Leach, C. Sykes and C. Tompkins (ORAU, University of Oxford) provided invaluable laboratory assistance. The ABOx-SC determinations that were attempted in this chapter were funded by the NERC-AHRC ORADS programme (FB and TH). Rachel Wood (ORAU) made very valuable comments on an earlier version of this chapter.

References

Andersen, K.K., Svensson, A., Johnsen, S.J., Rasmussen, S.O., Bigler, M., Rothlisberger, R., Ruth, U., Siggaard-Andersen, M.-L., Steffensen, J.P., Dahl-Jensen, D., Vinther, B.M. and Clausen, H.B. 2006: The Greenland ice core chronology 2005, 15–42 ka. Part 1: Constructing the time scale. *Quaternary Science Reviews* 25(23–24), 3246–3257.

Balmain, J., Hannoyer, B. and Lopez, E. 1999: Fourier transform infrared spectroscopy (FTIR) and X-ray diffraction analyses of mineral and organic matrix during heating of mother of pearl (nacre) from the shell of the mollusc Pinctada maxima. *Journal of Biomedical Materials Research* 48(5), 749–754.

Barton, R.N.E. 2000: Mousterian hearths and shellfish: Late Neanderthal activities on Gibraltar. In Stringer, C.B., Barton, R.N.E. and Finlayson, J.C. (eds.), *Neanderthals on the Edge* (Oxford: Oxbow Books), 211–220.

Barton, R.N.E., Currant, A.P., Fernández-Jalvo, Y., Finlayson, J.C., Goldberg, P., Macphail, R., Pettitt, P.B. and Stringer, C.B. 1999: Gibraltar Neanderthals and results of recent excavations in Gorham's, Vanguard and Ibex Caves. *Antiquity* 73, 13–23.

Bezerra, F.H.R., Vita-Finzi, C. and Lima Filho, F.P. 2000: The use of marine shells for radiocarbon dating of coastal deposits. *Revista Brasileira de Geociências* 30(1), 211–213.

Bird, M.I., Ayliffe, L.K., Fifield, L.K., Turney, C.S.M., Cresswell, R.G., Barrows, T.T. and David, B. 1999: Radiocarbon dating of 'old' charcoal using a wet oxidation-stepped combustion procedure. *Radiocarbon* 41, 127–140.

Bish, D.L. and Post, J.E. 1993: Quantitative mineralogical analysis using the Rietveld full-pattern fitting method. *American Mineralogist* 78(9–10), 932–940.

Brock, F. and Higham, T.F.G. 2009: AMS radiocarbon dating of Palaeolithic-aged charcoal from Europe and the Mediterranean rim using ABOx-SC. *Radiocarbon* 51(2), 839–846.

Bronk Ramsey, C. 1995: Radiocarbon calibration and analysis of stratigraphy: The OxCal program. *Radiocarbon* 37(2), 425–430.

Bronk Ramsey, C. 2001: Development of the radiocarbon calibration program OxCal. *Radiocarbon* 43(2A), 355–363.

Bronk Ramsey, C. 2009: Dealing with outliers and offsets in radiocarbon dating. *Radiocarbon* 51(3), 1023–1045.

Bronk Ramsey, C. and Hedges, R.E.M. 1997: Hybrid ion sources: Radiocarbon measurements from microgram to milligram. *Nuclear Instruments and Methods in Physics Research* B 123, 539–545.

Bronk Ramsey, C., Higham, T.F.G. and Leach, P. 2004: Towards High Precision AMS: Progress and Limitations. *Radiocarbon* 46(1), 17–24.

Cacho, I., Grimault, J.O., Pelejero, C., Canals, M., Sierro, F.J., Flores, J.A. and Shackleton, N. 1999: Dansgaard-Oeschger and Heinrich event imprints in Alboran Sea paleotemperatures. *Paleoceanography* 14(6), 698–705.

Chappell, A. and Polach, H.A. 1972: Some effects on partial recrystallisation on ¹⁴C dating late Pleistocene corals and molluscs. *Quaternary Research* 2, 244–252.

Chiu, T.-C., Fairbanks, R.G., Mortlock, R.A. and Bloom, A.L. 2005: Extending the radiocarbon calibration beyond 26,000 years before present using fossil corals. *Quaternary Science Reviews* 24, 1797–1808.

Compere, E.L., Jr. and Bates, J.M. 1973: Determination of Calcite: Aragonite Ratios in Mollusc Shells by Infrared Spectra. *Limnology and Oceanography* 18(2), 326–331.

Dickinson, S.R. and McGrath, K.M. 2001: Quantitative determination of binary and tertiary calcium carbonate mixtures using powder X-ray diffraction. *The Analyst* 126, 1118–1121.

Ditchfield, P.W. 1997: High northern palaeolatitude Jurassic-Cretaceous palaeotemperature variation: new data from Kong Karls Land, Svalbard. *Palaeogeography, Palaeoclimatology, Palaeoecology* 130, 163–175.

Ditchfield, P.W., Marshall, J.D. and Pirrie, D. 1994: High latitude palaeotemperature variation: New data from the Tithonian to Eocene of James Ross Island, Antarctica. *Palaeogeography, Palaeoclimatology, Palaeoecology* 107, 79–101.

Douka, K., Hedges, R.E.M. and Higham, T.F.G. 2010: Improved AMS 14C dating of shell carbonates using high-precision X-Ray Diffraction and a novel density separation protocol (CarDS). *Radiocarbon* 52(2–3), 735–751.

England, J., Cusack, M., Dalbeck, P. and Pérez-Huerta, A. 2007: Comparison of the Crystallographic Structure of Semi Nacre and Nacre by Electron Backscatter Diffraction. *Crystal Growth and Design* 7(2), 307–310.

Fairbanks, R.G., Mortlock, R.A., Chiu, Tzu-Chien, Li Cao, Kaplan, A., Guilderson, T.P., Fairbanks, T.W., Bloom, A.L., Grootes, P.M. and Nadeau, M.-J. 2005: Radiocarbon calibration curve spanning 0 to 50,000 years BP based on paired ²³⁰Th/²³⁴U/²³⁸U and ¹⁴C dates

on pristine corals. *Quaternary Science Reviews* 24, 1781–1796.

Fernández-Jalvo, Y. and Andrews, P. 2000: The taphonomy of Pleistocene caves, with particular reference to Gibraltar. In Stringer, C.B., Barton, R.N.E. and Finlayson, J.C. (eds.), *Neanderthals on the Edge* (Oxford: Oxbow Books), 171–182.

Finlayson, J.C., Barton, R.N.E. and Stringer, C.B. 2001: The Gibraltar Neanderthals and their extinction. In Zilhão, J., Aubry, T. and Faustino Carvalho, A. (eds.), *Les premiers hommes modernes de la Péninsule Ibérique. Actes du Colloque de la Commission VIII de l'UISPP* (Lisboa: Instituto Português de Arqueologia), 117–122.

Finlayson, J.C., Pacheco, F.G., Rodríguez-Vidal, J., Fa, D.A., Gutierrez López, J.-M., Santiago Pérez, A., Finlayson, G., Allue, E., Preysler, J.B., Cáceres, I., Carrión, J., Fernández Jalvo, Y., Gleed-Owen, C.P., Jimenez Espejo, F.J., López, P., Sáez, J.A., Riquelme Cantal, J.A., Sánchez Marco, A., Guzman, F.G., Brown, K., Fuentes, N., Valarino, C.A., Villalpando, A., Stringer, C.B., Martinez Ruiz, F. and Sakamoto, F. 2006: Late survival of Neanderthals at the southernmost extreme of Europe. *Nature* 443, 850–853.

Gavish, E. and Friedman, G.M. 1973: Quantitative analysis of calcite and Mg-calcite by X-ray diffraction: effect of grinding on peak height and peak area. *Sedimentology* 20(3), 437–444.

Gunatilaka, H. and Till, R. 1971: A precise and accurate method for the quantitative determination of carbonate minerals by X-ray diffraction using a spiking technique. *Mineral. Mag.* 38, 481–487.

Hakanen, E. and Koskikallio, J. 1982: Analysis of aragonite and calcite in precipitated calcium carbonate by X-ray diffraction and infrared spectroscopic methods. *Finnish Chemical Letters* 3–4, 34–37.

Hardy, R. and Tucker, M. 1988: X-ray powder diffraction of sediments. In Tucker, M.E. (ed.), *Techniques in Sedimentology* (Oxford: Blackwell Scientific), 191–228.

Hendry, J.P., Ditchfield, P.W. and Marshall, J.D. 1995: Two stage neomorphism of Jurassic aragonitic bivalves: Implications for early diagenesis. *Journal of Sedimentary Research* A65(1), 214–224.

Higham, T.F.G., Bronk Ramsey, C., Karavanic, I., Smith, F.H. and Trinkaus, E. 2006: Revised direct radiocarbon dating of the Vindija G1 Upper Paleolithic Neandertals. *Proceedings of the National Academy of Sciences of the United States of America* 103(3), 553–557.

Higham, T.F.G., Barton, H., Turney, C.M.T., Barker, G., Bronk Ramsey, C. and Brock, F. 2008a: Radiocarbon dating of charcoal from tropical sequences: Results from the Niah Great Cave, Sarawak and their broader implications. *Journal of Quaternary Science* 24(2), 189–197.

Higham, T.F.G., Brock, F., Peresani, M., Broglio, A., Wood, R. and Douka, K. 2008b: Problems with radiocarbon dating the Middle to Upper Palaeolithic transition in Italy. *Quaternary Science Reviews* 28 (2009), 1257–1267.

Hillier, S. 2003: Quantitative analysis of clay and other minerals in sandstones by X-ray powder diffraction (XRPD). *International Association of Sedimentologists Special Publications* 34, 213–251.

Hughen, K., Lehman, S., Southon, J., Overpeck, J., Marchal, O., Herring, C. and Turnbull, J. 2004: ¹⁴C activity and global carbon cycle changes over the past 50000 years. *Science* 303, 202–207.

Hughen, K., Southon, J., Lehman, S., Bertrand, C. and Turnbull, J. 2006: Marine-derived ¹⁴C calibration and activity record for the past 50,000 years updated from the Cariaco Basin. *Quaternary Science Reviews* 25, 3216–3227.

Kontoyannis, C.G. and Vagenas, N.V. 2000: Calcium carbonate phase analysis using XRD and FT-Raman spectroscopy. *Analyst* 125(2), 251–255.

Lamarck, J.-B., De 1819: *Histoire Naturelle des Animaux sans Vertèbres* (Paris, Librairie Verdière).

Maliva, R.G. and Dickson, J.A.D. 1992: The mechanism of skeletal aragonite neomorphism: evidence from neomorphosed molluscs from the upper Purbeck Formation (Late Jurassic-Early Cretaceous), southern England. *Sedimentary Geology* 76, 221–232.

Marshall, J.D. 1992: Climatic and oceanographic isotopic signals from the carbonate rock record and their preservation. *Geological Magazine* 129, 143–160.

Marshall, J.D., Ditchfield, P.W. and Pirrie, D. 1993: Stable isotope palaeotemperatures and the evolution of high palaeolatitude climate in the Cretaceous. *Antarctic Special Topic,* 71–79.

Milliman, J.D. 1974: *Marine carbonates* (Berlin, New York: Springer).

Moreno, A., Cacho, I., Canals, M., Grimalt, J.O., Sánchez-Goni, F., Shackleton, N. and Sierro, F.J. 2005: Links between marine and atmospheric processes oscillating on a millennial time-scale. A multi-proxy study of the last 50,000 yr from the Alboran Sea (Western Mediterranean Sea). *Quaternary Science Reviews* 24, 1623–1636.

Nadeau, M.-J., Grootes, P.M., Voelker, A., Bruhn,vF., Duhr, A. and Oriwall, A. 2001: Carbonate ¹⁴C background: Does it have multiple personalities? *Radiocarbon* 43, 169–176.

Pettitt, P.B. and Bailey, R.M. 2000: AMS radiocarbon and Luminescence dating of Gorham's and Vanguard Caves, Gibraltar, and implications for the Middle to Upper Palaeolithic transition in Iberia. In Stringer, C.B., Barton, R.N.E. and Finlayson, J.C. (eds.), *Neanderthals on the Edge* (Oxford: Oxbow Books), 155–162.

Reimer, P.J., Baillie, M.G.L., Bard, E., Bayliss, A., Beck, J.W., Bertrand, C.J.H., Blackwell, P.G., Buck, C.E., Burr, G.S., Cutler, K.B., Damon, P.E., Edwards, R.A., Kromer, B., McCormac, G., Manning, S., Bronk Ramsey, C., Reimer, R.W., Remmele, S., Southon, J.R., Stuiver, M., Talamo, S., Taylor, F.W., Van Der Plicht, J. and Weyhenmeyer, C.E. 2004: IntCal04 Terrestrial Radiocarbon Age Calibration, 0–26 Cal Kyr BP. *Radiocarbon* 46, 1029–1058.

Reimer, P.J., Baillie, M.G.L., Bard, E., Warren Beck, J., Blackwell, P.G., Buck, C.E., Burr, G.S., Lawrence Edwards, R., Friedrich, M., Guilderson, T.P., Hogg, A.G., Hughen, K.A., Kromer, B., McCormac, G., Manning, S., Reimer, R.W., Southon, J.R., Stuiver, M., Van Der Plicht, J. and Weyhenmeyer, C.E. 2006: Comment on

"Radiocarbon calibration curve spanning 0 to 50,000 years BP based on paired 230Th/234U/238U and ¹⁴C dates on pristine corals" by R. G. Fairbanks et al. (*Quaternary Science Reviews* 24 (2005) 1781–1796) and "Extending the radiocarbon calibration beyond 26,000 years before present using fossil corals" by T.-C. Chiu et al. (*Quaternary Science Reviews* 24 (2005) 1797–1808). *Quaternary Science Reviews* 25(7–8), 855–862.

Sánchez-Goni, F., Cacho, I., Turon, J.-L., Guiot, J., Sierro, F. J., Peypouquet, J.-P., Grimalt, J. O. and Shackleton, N. 2002: Synchroneity between marine and terrestrial responses to millennial scale climatic variability during the last glacial period in the Mediterranean region. *Climate Dynamics* 19, 95–105.

Schleicher, M., Grootes, P. M., Nadeau, M.-J. and Schoon, A. 1998: The carbonate background and its components. *Radiocarbon* 40, 85–94.

Sivan, D., Potasman, M., Almogi-Labin, A., Bar-Yosef Mayer, D. E., Spanier, E. and Boaretto, E. 2006: The Glycymeris query along the coast and shallow shelf of Israel, southeast Mediterranean. *Palaeogeography, Palaeoclimatology, Palaeoecology* 233(1–2), 134–148.

Stringer, C. B. 2000: Gibraltar and the Neanderthals 1848–1998. In Stringer, C. B., Barton, R. N. E. and Finlayson, J. C. (eds.), *Neanderthals on the Edge* (Oxford: Oxbow Books), 133–137.

Stringer, C. B., Barton, R. N. E., Currant, A. P., Finlayson, J. C., Goldberg, P., Macphail, R. and Pettitt, P. B. 1999: Gibraltar Palaeolithic revisited: New excavations at Gorham's and Vanguard caves 1995–5. In Charles, R. and Davis, W. (eds.), *Dorothy Garrod and the Progress of the Palaeolithic. Studies in the Prehistoric Archaeology of the Near East and Europe* (Oxford: Oxbow Books), 84–96.

Stringer, C. B., Barton, R. N. E. and Finlayson, J. C. (eds.) 2000: *Neanderthals on the Edge* (Oxford: Oxbow Books).

Stuiver, M., Pearson, G. and Braziunas, T. 1986: Radiocarbon age calibration of marine samples back to 9000 cal yr BP. *Radiocarbon* 28(2B), 980–1021.

Subba Rao, M. and Vasudeva Murthy, A. R. 1972: A Rapid Method for the Quantitative Analysis of Binary Mixtures of Calcite and Aragonite. *Current Science* 41, 774–776.

Svensson, A., Andersen, K. K., Bigler, M., Clausen, H. B., Dahl-Jensen, D., Davies, S. M., Johnsen, S. J., Muscheler, R., Rasmussen, S. O., Rothlisberger, R., Stefensen, J. P. and Vinther, B. M. 2006: The Greenland Ice Core Chronology 2005, 15–42 ka. Part 2: Comparison to other records. *Quaternary Science Reviews* 25(23–24), 3258–3267.

Turney, C. S. M., Bird, M. I., Fifield, L. K., Roberts, R. G., Smith, M. A., Dortch, C. E., Grün, R., Lawson, E., Ayliffe, L. K., Miller, G. H., Dortch, J. and Cresswell, R. G. 2001: Early human occupation at Devil's Lair, southwestern Australia 50,000 years ago. *Quaternary Research* 55, 3–13.

Tzedakis, P. C., Hughen, K. A., Cacho, I. and Harvati, K. 2007: Placing late Neanderthals in a climatic context. *Nature* 449, 206–208.

Vagenas, N. V., Gatsouli, A. and Kontoyannis, C. G. 2003: Quantitative analysis of synthetic calcium carbonate polymorphs using FT-IR spectroscopy. *Talanta* 59(4), 831–836.

Van Der Plicht, J., Beck, J. W., Bard, E., Baillie, M. G. L., Blackwell, P. G., Buck, C. E., Friedrich, M., Guilderson, T. P., Hughen, K. A., Kromer, B., McCormac, F. G., Bronk Ramsey, C., Reimer, P. J., Reimer, R. W., Remmele, S., Richards, D. A., Southon, J. R., Stuiver, M. and Weyhenmeyer, C. E. 2004: NOTCAL04: comparison/calibration ¹⁴C records 26–50 ka calBP. *Radiocarbon* 46, 1225–1238.

Waechter, J. d'A. 1951: Excavations at Gorham's Cave, Gibraltar. *Proceedings of the Prehistoric Society* 17, 83–92.

Waechter, J. d'A. 1964: The excavations at Gorham's Cave, Gibraltar, 1951–1954. *Bulletin of the Institute of Archaeology of London* 4, 189–221.

Wang, Y. J., Cheng, H., Edwards, R. L., An, Z. S., Wu, J. Y., Shen, C.-C. and Dorale, J. A. 2001: A high-resolution absolute-dated Late Pleistocene monsoon record from Hulu Cave, China. *Science* 294, 2345–2348.

Weber, K. 1967: Neue Absorptionsfaktortafeln fuer den Kreiszylinder. *Acta Crystallographica* 23(5), 720–725.

Xyla, A. G. and Koutsoukos, P. G. 1989: Quantitative analysis of calcium carbonate polymorphs by infrared spectroscopy. *J. Chem. Soc., Faraday Trans. I* 85, 3165–3172.

Zilhão, J. 2000: The Ebro Frontier: A model for the late extinction of Iberian Neanderthals. In Stringer, C. B., Barton, R. N. E. and Finlayson, J. C. (eds.), *Neanderthals on the Edge* (Oxford: Oxbow Books), 111–121.

Zilhão, J. 2006: Neandertals and moderns mixed, and it matters. *Evolutionary Anthropology* 15, 183–195.

Zilhão, J. and Pettitt, B. 2006: On the new dates for Gorham's Cave and the late survival of Iberian Neanderthals. *Before Farming* 2006(3), 1–9.

6 OSL dating of sediments from the lower part of Gorham's Cave

E.J. Rhodes

Introduction

Six sediment samples were collected for OSL dating in August 2001, using opaque black PVC tubes pushed into cleaned sediment sections. *In situ* NaI gamma spectrometer measurements were made at each sampling location, in order to provide a direct measurement of gamma dose rate. Standard sample preparation methods (described in detail below) were used to extract quartz grains from each sediment, and these were measured using a conventional multiple grain single aliquot regenerative-dose (SAR) protocol (Murray and Wintle 2000; 2003). Owing to concerns about the completeness of OSL signal zeroing during transport and deposition, single grain (SG) OSL measurements were also made, using quartz grains from sieved subsets of the same sample separates.

For cave and rock shelter sediments, grains may experience reduced light levels during transport and deposition, and the possibility of age over-estimation owing to incomplete signal zeroing must be considered. Several of the conventional multiple grain OSL determinations from Gorham's Cave display a relatively high degree of variation between individual dose estimates (equivalent dose or D_e), raising the possibility of incomplete zeroing or post-depositional grain mixing. For this reason, these samples were also measured using single grain measurements. In order to help dating specialists understand these complex measurements and analysis procedures, a relatively complete record of the procedures used has been included; for a summary of the OSL results considered to be the most robust depositional age model, the reader is referred to Figure 6.1, Tables 6.3 and 6.4, and the summary of single grain OSL age estimates, provided below.

Considerations for quartz single grain OSL

In single grain OSL measurements, several different criteria are used to exclude data from grains which display luminescence behaviour not considered compatible with the requirements for reliable application of the SAR protocol. In many cases, these relate simply to grains with insufficient luminescence intensity to produce a reliable equivalent dose determination. In principle, results from the remaining grains should be internally consistent within their measurement uncertainties plus the additional effects of grain-scale variations in dose rate (Nathan *et al.* 2003), if the sample was well bleached at deposition. That is, if all the grains present within a sample were exposed to sufficient daylight to zero the OSL signal prior to deposition, the only variation in equivalent dose that should be observed between grains should be caused by measurement uncertainties and

variations in dose rate experienced while buried. The latter effect has been estimated to be in the range of ± 10 to 15% at 1 sigma, for sediment samples of typical composition (Nathan *et al.* 2003).

For poorly bleached samples, that is, samples containing grains which were not exposed to sufficient daylight at the time of deposition to zero their OSL signals, a wider range of single grain equivalent dose values is expected and observed (e.g. Olley *et al.* 2004). In such cases, application of the minimum age model of Galbraith *et al.* (1999) can isolate a meaningful dose value corresponding to the depositional age of the sample, effectively excluding single grain equivalent dose values which are statistically higher owing to incomplete signal zeroing. However, if a well bleached sample has grains from a younger horizon introduced, for example by grain transport down an animal burrow from above, the reverse situation will pertain. That is, the depositional age is represented by the highest equivalent dose values, lower single grain dose values corresponding to younger, introduced material. In such cases, it is possible to estimate the 'maximum age' by inverting the data, and applying the minimum age model.

For a sample from a context in which the completeness of OSL signal zeroing is not known, and in which the degree of bioturbation, which may introduce grains from older as well as younger horizons, is not independently quantified, the interpretation of single grain OSL observations can present problems. It may in some cases be possible to resolve the magnitudes of these different effects; for example, if some samples in a succession show little variation, it may be assumed that they are well zeroed and unaffected by bioturbation, and their stratigraphic position may be used to restrict the interpretation of dispersion or multiple values observed in related samples (e.g. Rhodes 2007a).

Two further complicating factors must also be considered in the interpretation of single grain OSL data. The first is the possibility of luminescence signal artefacts which may affect single grain equivalent dose determinations, discussed further below. The second is the effect of variations in OSL sensitivity, in particular sensitivity increases caused by heating, for example in and around hearths constructed by hominin populations. The implications of such variations in single grain populations have been modelled by Rhodes (2007b), in particular the degree to which incomplete zeroing or bioturbation can be detected by multiple grain OSL measurements. In principle, the introduction of a relatively small volume of younger sensitized grains down a burrow could have a disproportionate effect on the apparent OSL dose distribution.

Bearing in mind these potential pitfalls, the single grain OSL data from Gorham's Cave have been analysed by applying a finite mixing model (Galbraith 1988; Galbraith and Green 1990). A range of dose values was present for each sample, providing potentially ambiguous results even when the proportions of grains at each dose value and the stratigraphic relationships between samples are taken into account. However, when the results are compared to radiocarbon age estimates in the upper horizons, where the two data sets overlap, and these [14]C estimates are used to constrain the timing of deposition for the top two OSL samples, the single grain data do appear to provide a coherent age model. This OSL age model was further refined using Bayesian methods, which provides improved chronological estimates and reduced uncertainties. The degree of coherence within these results supports the approach adopted here, but it should be stressed that the application of these techniques is still relatively novel, and it is likely that further improvements in both measurement and analysis will take place in the future. The results presented below represent a chronological hypothesis to be tested by further age determination, both using luminescence techniques and by other methods.

Sample collection and locations

Six samples were collected as a pilot or rangefinder set in Gorham's Cave, spanning the sediment succession in the lower part of the cave, from unit UBSm.5 down to unit CSm. Sample locations comprising eastings, northings and altitude relative to the site datum of 2001 are given in Table 6.1, and the stratigraphic positions and both multiple grain and single grain OSL age estimates are shown in Figure 6.1. Samples were collected in August 2001, using opaque black PVC tubes pushed into cleaned vertical sediment profiles. Samples were collected in well-sorted sandy horizons where possible, as it was considered likely that these units represent short-lived episodes during which aeolian sand was introduced from outside the cave.

After removal of the sampling tube, a water content sample was collected, and the hole deepened to 30 cm using a small hand auger. *In situ* measurements were made at each sampling location using an EG&G Ortec portable microNomad multichannel NaI gamma spectrometer. These measurements were used to calculate total gamma dose rate using the threshold method, and concentrations of K, U and Th for each sample location, based on calibration in concrete blocks doped with radioisotopes (Rhodes and Schwenninger 2007). This *in situ* total gamma dose rate value was used in the age calculations. Beta dose rates were based on Neutron Activation Analysis (NAA) measurements of 10 g of dry sediment from within each sample tube. This provides a more representative determination of the beta flux which has a range in sediment of around 3 mm, and is also more buffered against the effects of uranium disequilibrium.

Sample preparation

Samples were transported to the Research Laboratory for Archaeology and the History of Art (RLAHA), University of Oxford, UK, within their collection tubes. These were opened in controlled laboratory lighting which was used for all subsequent treatments, and the outer 1 to 2 cm from both ends of each tube was set aside for water content determination and NAA measurement. Sediment from the inner part of each tube was treated with dilute HCl to remove carbonate and disaggregate grains. Samples were then wet sieved, and grains of between 180 and 255 μm were treated in concentrated (40%) HF with a small volume of additional concentrated HCl continuously agitated for around 100 minutes. This treatment is to remove feldspar grains and to etch the surface of each quartz grain, and the HCl is designed to prevent the precipitation of fluorides. After rinsing, each sample was dried and heavy minerals were removed using a solution of sodium polytungstate with a density of 2.68 g.cm^{-3}. The remaining quartz-rich lighter fraction was thoroughly rinsed and dried, and sieved a second time to remove grains smaller than 180 μm. For conventional multiple grain measurement, grains were mounted on 9.7 mm diameter aluminium or stainless steel discs using a viscous silicone oil, with the sample covering approximately the central 5 mm, corresponding to around 300 grains per aliquot. For single grain OSL measurement, each sample was re-sieved using a 212 μm mesh, and only the finer fraction used, owing to size restrictions imposed by the Risø anodised aluminium holders which have 100 holes in a square array (Bøtter-Jensen *et al.* 2003).

OSL measurement

OSL measurements were made at RLAHA, Oxford, UK, in November 2001 for the multiple grain determinations, and from April to June 2002 for the single grain measurements. All conventional OSL measurements were made using 12 aliquots mounted on aluminium discs, except for sample X714, for which six aliquots were measured in this manner (giving an equivalent dose determination of 20.7 ± 0.4 Gy), and six were mounted on stainless steel discs (giving an equivalent dose determination of 20.1 ± 0.2 Gy). Measurements were made in Risø automated TL-OSL readers, fitted with either a 75W halogen lamp filtered to provide 420–560 nm stimulation or an array of Nichia blue light-emitting diode (LED) arrays providing between 16 and 20 mW.cm^{-2} intensity respectively. The blue LEDs were filtered using Schott GG420 filters, providing peak stimulation wavelength of 470 Δ 20 nm. Single grain OSL measurements were made with a focused 10 mW green laser at 532 nm. OSL signals were detected using EMI 9235QA photomultiplier tubes through Hoya U340 glass filters.

All SAR measurements used the same preheating procedure, with a 10 s 260°C preheat before OSL measurement of the natural and regenerated OSL signals, and a 10 s heat of 220°C before each sensitivity determination OSL measurement (Rhodes *et al.* 2006). Each SAR measurement included seven cycles, comprising measurement of the natural, four regenerative dose points, a zero point for thermal transfer determination, and a repeat of the first regenerative dose point, to monitor the veracity of sensitivity correction (Murray and Wintle 2003). OSL was measured at 125°C for every determination.

Equivalent dose values were determined using linear interpolation between the closest regenerative dose points

Table 6.1 Positions and stratigraphic locations of the six OSL samples from Gorham's Cave, relative to site datum, 2001.

Field code	Laboratory code	Stratigraphic context	Eastings x-coord. (m)	Northings y-coord. (m)	Height z-coord. (m)
GOR01-01	X714	UBSm.5	-11.167	4.167	14.927
GOR01-02	X715	BeSm PLsm.3	-9.213	5.048	12.942
GOR01-03	X716	SSLm Usm.2	0.284	6.687	11.290
GOR01-04	X717	SSLm Usm.5	0.372	6.774	10.919
GOR01-05	X718	SSLm Lsm.10	4.362	4.131	10.312
GOR01-06	X719	CSm	6.602	3.258	6.657

Table 6.2 Conventional quartz multiple grain SAR OSL age estimates from Gorham's Cave, Gibraltar. A water content value of 10 ± 5% was used for all calculations. See text for further discussion.

Field code	Laboratory code	Stratigraphic context	Height z-coord. (m)	K (%)	Th (ppm)	U (ppm)	Gamma dose rate (mGy/a)	1 sigma uncertainty (mGy/a)	Total dose rate (mGy/a)	1 sigma uncertainty (mGy/a)	Equivalent dose (Gy)	1 sigma uncertainty (Gy)	Age (yrs before present)	1 sigma uncertainty (years)
Muliple grains														
GOR01-01	X714	UBSm.5	14.9	0.14	1.27	0.35	0.16 ±	0.01	0.34 ±	0.02	20.6 ±	0.6	63400 ±	3300
GOR01-02	X715	BeSm PLsm.3	12.9	0.14	1.50	0.27	0.17 ±	0.01	0.31 ±	0.01	31.6 ±	0.8	98700 ±	5000
GOR01-03	X716	SSLm Usm.2	11.3	0.19	1.52	0.53	0.20 ±	0.01	0.40 ±	0.02	37.3 ±	0.8	91200 ±	4500
GOR01-04	X717	SSLm Usm.5	10.9	0.21	1.49	0.60	0.21 ±	0.01	0.42 ±	0.02	40.1 ±	1.0	91300 ±	4800
GOR01-05	X718	SSLm Lsm.10	10.3	0.29	2.07	0.74	0.19 ±	0.01	0.48 ±	0.02	51.5 ±	1.4	102900 ±	6200
GOR01-06	X719	CSm	6.7	0.28	2.16	0.59	0.23 ±	0.01	0.50 ±	0.02	53.9 ±	1.4	104300 ±	5700

Table 6.3 Single grain equivalent dose values (in Gy), proportions at each value, and age estimates (in ka) calculated using the mean total dose rates (Table 6.2) with associated 1 sigma uncertainties, using a finite mixture model. Underlined age values represent those which are considered to be the best estimates of depositional age; see text for details. Values are arranged so that similar dose estimates for different samples are in vertical alignment.

Field code	Lab. code	Stratigraphic context	Height z-coord. (m)		Value	1 sigma uncertainty	Value	1 sigma uncertainty	Value	1 sigma uncertainty	Value	1 sigma uncertainty	Value	1 sigma uncertainty	Value	1 sigma uncertainty	Value	1 sigma uncertainty
GOR01-01	X714	UBSm.5	14.9	Dose (Gy)	1.18 ±	0.48	7.13 ±	0.99	12.7 ±	2.1	19.4 ±	0.9	46.9 ±	5.4				
				Proportion	0.01 ±	0.01	0.07 ±	0.03	0.15 ±	0.09	0.71 ±	0.10	0.06 ±	0.03				
				Age (ka)	3.64 ±	1.49	22.0 ±	3.2	39.2 ±	6.6	59.9 ±	3.8	144 ±	18				
GOR01-02	X715	BeSm PLsm.3	12.9	Dose (Gy)					15.8 ±	1.2	25.4 ±	1.4	46.7 ±	9.1				
				Proportion					0.34 ±	0.11	0.61 ±	0.12	0.05 ±	0.04				
				Age (ka)					49.4 ±	4.4	79.2 ±	5.7	146 ±	29				
GOR01-03	X716	SSLm Usm.2	11.3	Dose (Gy)			17.2 ±	8.4	22.2 ±	3.6	28.3 ±	4.4	47.6 ±	6.0			78.5 ±	8.3
				Proportion			0.03 ±	0.12	0.39 ±	0.39	0.41 ±	0.39	0.09 ±	0.05			0.09 ±	0.04
				Age (ka)			42.0 ±	20.6	54.2 ±	9.0	69.2 ±	11.2	116 ±	15			192 ±	22
GOR01-04	X717	SSLm Usm.5	10.9	Dose (Gy)					17.3 ±	2.4	29.6 ±	2.1	45.3 ±	6.5				
				Proportion					0.14 ±	0.08	0.66 ±	0.14	0.20 ±	0.13				
				Age (ka)					39.3 ±	5.8	67.2 ±	5.6	103 ±	16				
GOR01-05	X718	SSLm Lsm.10	10.3	Dose (Gy)			8.0 ±	1.6	18.1 ±	2.8	28.8 ±	1.8	45.1 ±	3.4	65.8 ±	5.2		
				Proportion			0.02 ±	0.02	0.06 ±	0.04	0.38 ±	0.08	0.37 ±	0.09	0.16 ±	0.07		
				Age (ka)			16.0 ±	3.2	36.1 ±	5.9	57.5 ±	4.8	90.0 ±	8.2	131 ±	12		
GOR01-06	X719	CSm	6.7	Dose (Gy)							27.1 ±	2.5	44.0 ±	7.8	61.4 ±	7.8	80.4 ±	19.2
				Proportion							0.29 ±	0.09	0.21 ±	0.15	0.39 ±	0.22	0.11 ±	0.19
				Age (ka)							52.5 ±	5.5	85.1 ±	15.6	119 ±	16	156 ±	38

Table 6.4 Results from a Bayesian age model based on the highlighted single grain OSL age estimates in Table 6.3. The Bayesian age model takes account of the stratigraphic relationships between samples, and provides an improved estimate of age and uncertainty.

Field code	Laboratory code	Stratigraphic context	Height z-coord. (m)	Equivalent dose (Gy)	1 sigma uncertainty (mGy/a)	SG OSL Age (years before present)	1 sigma uncertainty (mGy/a)	Model Age (years before present)	1 sigma uncertainty (mGy/a)
Single grains									
GOR01-01	X714	UBSm.5	14.9	12.7 ±	2.1	39200 ±	6600	38500 ±	5800
GOR01-02	X715	BeSm PLsm.3	12.9	15.8 ±	1.2	49400 ±	4400	48700 ±	4000
GOR01-03	X716	SSLm Usm.2	11.3	22.2 ±	3.6	54200 ±	9000	56500 ±	5700
GOR01-04	X717	SSLm Usm.5	10.9	29.6 ±	2.1	67200 ±	5600	67900 ±	5150
GOR01-05	X718	SSLm Lsm.10	10.3	45.1 ±	3.4	90000 ±	8200	89600 ±	7700
GOR01-06	X719	CSm	6.7	61.4 ±	7.8	118900 ±	16200	119300 ±	14800

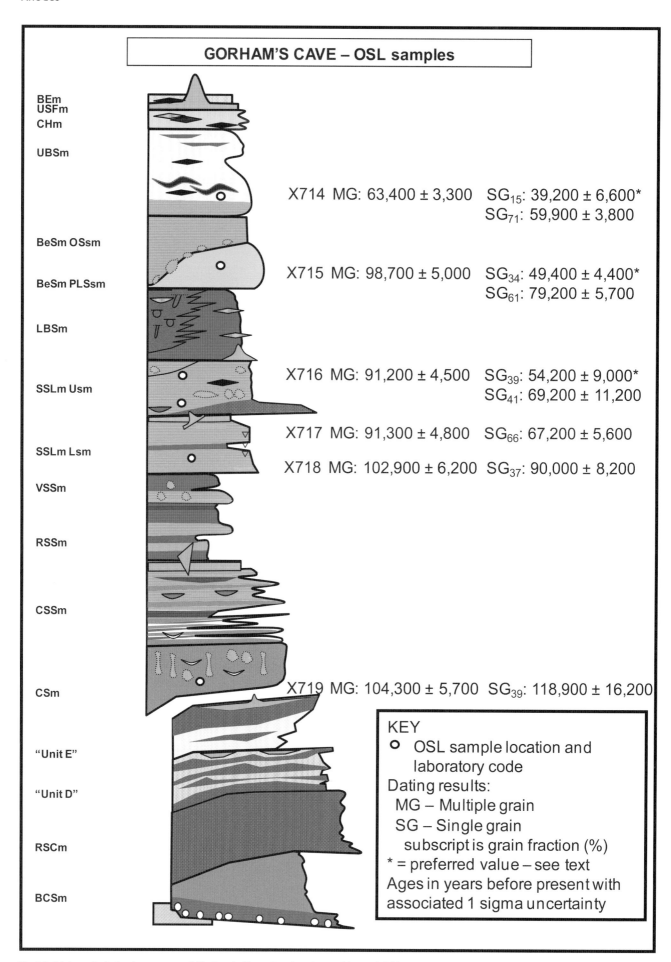

GORHAM'S CAVE – OSL samples

BEm
USFm
CHm

UBSm

X714 MG: 63,400 ± 3,300 SG_{15}: 39,200 ± 6,600*
 SG_{71}: 59,900 ± 3,800

BeSm OSsm

BeSm PLSsm

X715 MG: 98,700 ± 5,000 SG_{34}: 49,400 ± 4,400*
 SG_{61}: 79,200 ± 5,700

LBSm

SSLm Usm

X716 MG: 91,200 ± 4,500 SG_{39}: 54,200 ± 9,000*
 SG_{41}: 69,200 ± 11,200

X717 MG: 91,300 ± 4,800 SG_{66}: 67,200 ± 5,600

SSLm Lsm

X718 MG: 102,900 ± 6,200 SG_{37}: 90,000 ± 8,200

VSSm

RSSm

CSSm

CSm

X719 MG: 104,300 ± 5,700 SG_{39}: 118,900 ± 16,200

KEY
○ OSL sample location and
 laboratory code
Dating results:
 MG – Multiple grain
 SG – Single grain
 subscript is grain fraction (%)
* = preferred value – see text
Ages in years before present with
associated 1 sigma uncertainty

"Unit E"

"Unit D"

RSCm

BCSm

Fig 6.1 Main units in the lower part of Gorham's Cave showing the positions of OSL samples, laboratory codes, conventional multiple grain (MG) OSL age estimates and single grain (SG) OSL age estimates. Also see Figure 3.1 for key to symbols, and further details of the stratigraphy and sedimentology. Note that Table 6.4 presents results from a Bayesian age model, using the single grain age estimates shown in this figure, which provides improved resolution of age and uncertainty values.

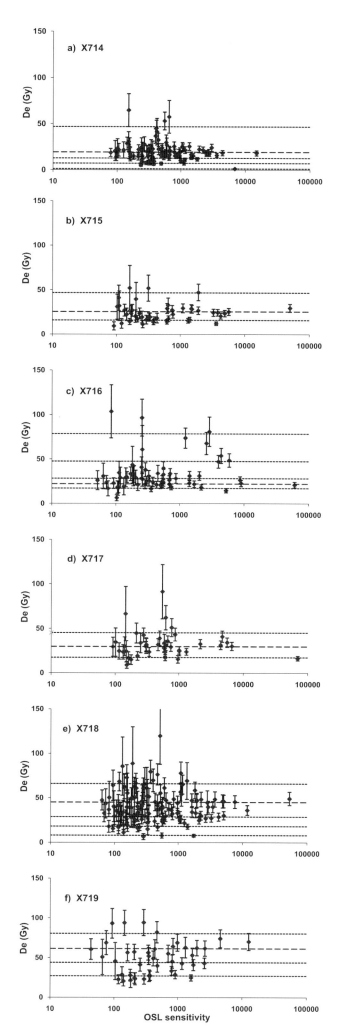

for multiple grain OSL measurements, and using an exponential or an exponential plus linear function to fit the full data set for single grain determinations. In order to remove data from unreliable single grains, a threshold of recycling within 20 per cent (i.e. R > 0.8 and > 1.2) was used (Murray and Wintle 2000; Rhodes 2007a), irrespective of R value uncertainties. Other selection criteria were left at their maximum values; fractional equivalent dose uncertainty < 50 per cent equivalent dose value; test dose error < 50 per cent. All measurement uncertainties were rigorously propagated along with other sources of uncertainty in the age calculations, which followed the same procedures, and used the same measurement equipment as that of Rhodes *et al.* (2003), who found excellent agreement between OSL age estimates of young archaeological sediments and independent age control based on AMS ^{14}C dating of burnt seeds.

Results

The single aliquot regenerative-dose (SAR) protocol of Murray and Wintle (2000; 2003) represents a significant advance in OSL dating because it provides an assessment of the quality of each age estimate. The primary parameter of interest which may be used to assess the validity of SAR OSL age estimates is the degree of variation between different single aliquot measurements. For the conventional, multiple grain SAR OSL measurements of these samples, based on 12 aliquots each comprising around 300 grains, the observed equivalent dose standard deviation values ranged from 7 to 19 per cent. Samples displaying wider variation, such as X719, showed a characteristic asymmetric distribution of equivalent dose values, with a lower peak and a high dose tail. This type of distribution is expected when the majority of grains are well zeroed, but a minority are not well zeroed (Rhodes 2007b). Following the assumption that incomplete zeroing is the main source of equivalent dose variation for these samples, equivalent dose values used in age calculations presented below were derived using the mean of the lowest group of aliquots for each sample. This approach was adopted, based on the modelling results of Rhodes (2007b); the results are presented in Table 6.2.

Both the magnitude and form of the inter-aliquot variation suggested that incomplete zeroing was a significant feature of these samples. To assess the magnitude of this effect, single grain measurements were performed using a sieved subset of the same quartz samples. However, in contrast to the expected clear indications of incomplete zeroing, these samples displayed a wide range of equivalent dose values, with individual grains providing values well below, as well as above, the dose value derived from the conventional multiple grain measurements. The distribution patterns are different for each sample, and Figure 6.2

Fig. 6.2 Single Grain OSL data for samples in stratigraphic order. Each plot shows equivalent dose (in Gy) as a function of SG OSL sensitivity (note the logarithmic x-axis). Hatched lines indicate equivalent dose values identified using a finite mixture model (see text for details); coarse hatching indicates the equivalent dose value representing the greatest proportion of grains for samples X714, X715, X717 and X719, while for X716 and X718 this is the value used in the Bayesian age model (Tables 6.3 and 6.4, Figure 6.4).

displays the results of grains which fulfilled the selection criteria, plotting equivalent dose as a function of grain sensitivity (total net counts in the 0.1 s of the first sensitivity measurement); each uncertainty includes a 15 per cent overdispersion (OD) component added in quadrature to the measurement and fitting errors. The samples are displayed in correct stratigraphic order.

Several systematic features of these quartz single grain OSL measurements may be observed in Figure 6.2. Firstly, the observed single grain equivalent dose values are not consistent with a single dose value for each sample, even with a 15 per cent OD allowance. Secondly, although some samples, notably X716, have several grains with dose values significantly higher than those of the remaining grains, which is a pattern consistent with incomplete zeroing, samples X714, X717, X718 and X719 each have a significant minority of grains with dose values substantially lower than the majority. Thirdly, for many samples, notably X714 and X718, the grains with highest and lowest sensitivities have approximately consistent dose values, while grains of intermediate sensitivity have higher and lower values.

Discussion

Although the observed multiple grain inter-aliquot variation suggested these samples suffered from the effects of incomplete OSL signal zeroing at deposition, most of the single grain results presented in Figure 6.2 are not straightforward to interpret in this manner. When examining this figure, sample X716 is perhaps the one sample for which this (incomplete zeroing at deposition) seems to be the simplest single explanation. The single grain equivalent dose values for this sample have a consistent lower limit at around 20 Gy, with only one or two grains significantly beneath this. For the remaining samples, there is a spread of SG equivalent dose values, with relatively few grains having higher and lower dose values.

One possible interpretation of these single grain data is that the observed SG equivalent dose values are derived from a series of different events, with grains subsequently reworked or transported without light exposure to form a mixture of values. In this case, one of the isolated dose values may correspond to the true depositional age of that sediment, though it need not be the lowest (minimum age) or highest (maximum age) values.

OSL signal artefacts

A second, alternative, explanation of these data is that much of the observed dispersion between dose values of individual grains is caused by luminescence signal artefacts. In this case, it is not clear whether any of the apparent dose values would have any validity. However, conventional multiple grain OSL dating is performed on aliquots which are composed of many grains (typically several hundred to thousand grains). OSL dating using multiple grain aliquots, measured using a SAR protocol, has been tested extensively by comparison with independent age control over the last decade, and has been shown capable of providing robust and reliable age estimates for a range of sedimentary contexts, spanning at least the last 130,000 years or so (Rhodes et al. 2003; Murray and Funder 2003).

For the second hypothesis to be correct (dispersion is caused dominantly by luminescence signal artefacts), yet the results from multiple grain OSL data to be valid (at least for the majority of samples), dispersion would have to be approximately symmetrical around some central dose value. If this were not the case, conventional multiple grain OSL age estimates would be systematically too old or too young, depending on the dominant effects of these artefacts in individual samples.

Measurements of single grains from other samples by the present author and by other researchers do not indicate the widespread presence of such artefacts, at least at the magnitude that would be required to account for the majority of dispersion witnessed for the samples from Gorham's Cave.

One such signal artefact is widely noted by researchers. This is the effect of a natural OSL level in excess of the regenerated OSL level reached at signal saturation, henceforth referred to as 'super-saturation'. This effect has been observed in conventional OSL (Armitage et al. 2000), and has been observed commonly by researchers making quartz single grain OSL measurements (e.g. Jacobs et al. 2003). It is usual for these grains to be omitted from any further analysis as a) no equivalent dose value can be determined for them, and b) they are considered not to conform to the signal characteristics and behaviour required for the successful application of the SAR protocol. It should be noted, however, that similar grains are included in conventional multiple grain OSL dating, except for rare instances where individual aliquots suffer from 'super-saturation'.

In summary, signal artefacts have been noted in single grain OSL determinations. Grains showing 'super-saturation' are clearly suffering from signal artefacts, but those with zero or very low dose values may be explained in other ways. The critical issue for the meaningful interpretation of single grain data is the magnitude of such effects. The approach taken by other researchers has been to remove super-saturated grains, remove zero-dose grains, apply a range of other performance 'filters' (also referred to as 'exclusion criteria'), and then assume that the remaining grains represent the full range of environmental events recorded by the sediment under investigation.

Single grain age model

For the remaining parts of this paper, the above approach has been taken. That is, after removal of grains using standard exclusion criteria, it is implicitly assumed that no further significant signal artefacts affect the observed data. In order to determine meaningful equivalent dose values from these large spreads of single grain data, a finite mixture model was used (Galbraith 1988; Galbraith and Green 1990), an approach now relatively widespread in the treatment of single grain OSL data (e.g. Duller 2006). The finite mixture model is a statistical procedure to isolate populations within a mixture of values, and uses the uncertainties on individual equivalent dose estimates to allot each value to one of several bands. These bands will only represent meaningful dose values if the data were originally derived from a number of discrete dose values. The finite mixture model also provides the proportions of grains at each dose value, providing one potential criterion for

isolating the correct dose value. However, the dose value with the highest number of grains need not necessarily represent the depositional age; many different depositional and post-depositional mixing scenarios are possible, and the incorporation of external data, for example based on detailed sedimentological or micromorphological observations, may be helpful in elucidating the origins and evolution of each context. It is worth noting that in the future, for contexts with independent age control, single grain OSL dose distributions may be useful in helping to understand mechanisms and rates of deposition and post-depositional processes.

The exclusion criteria used are listed above; the main criterion was that of recycling. This is the ratio of the sensitivity-corrected OSL from the repeated final regenerative dose value to that of the first, and represents a test of grain performance. Grains were included if the recycling ratio was within 20 per cent of unity, irrespective of uncertainty in that value. Equivalent dose values and their associated uncertainties from Risø Analyst software (written by G. Duller) were exported, and an additional 15 per cent overdispersion (OD) added in quadrature. Figure 6.2 presents the single grain OSL data for each sample as equivalent dose (in Gy) vs. natural OSL sensitivity (in counts/0.1 s). Equivalent dose values and their associated uncertainties (including the OD component) were then used as input for fmix.s, finite mixing model software supplied by R. Galbraith. For each sample, the data were fitted with models ranging from one component up. In all cases, single population models would not fit, and in most cases, either five or six population models and greater would not fit. For each sample, between these values, models with two, three, four or five populations generated dose values. The values presented in Table 6.3 represent those from the maximum population number, before a) a significant rise in the parameter BIC, or b) duplication of dose values. Fitting was restricted to 100 iterations in each case. This technical discussion is included as a complete record of the approach adopted here, and for the benefit of luminescence dating specialists.

Table 6.3 presents, for each sample listed in stratigraphic order, the dose value and standard error (in Gy) for each of the populations output by the mixing model. Also presented are the proportions at each dose value (and associated uncertainty), and the age estimate (and uncertainty) for each dose value, calculated using the mean total dose rate for that sample. This provides a range of possible age estimates for each sample, and clearly the correct depositional age can relate to only one value (and possibly none).

In order to establish which of the range of values presented may be correct, the stratigraphic order of the samples is important. The sediments represent a succession of approximately flat-lying sandy deposits. It is assumed that they must have been laid down in stratigraphic order, the basal sediments first, following the 'law of superposition'. Following this sedimentological model, the depositional age of any sampled horizon must be younger than any below, and older than the ones above. In this manner, not all age populations identified using the finite mixture model are possible. For example, the fact that sample X716 is from above sample X717 means that the population giving an age estimate at 192 ± 22 ka is not possible and must therefore be caused by reworking, unless every one of the grains in sample X717 has been introduced by post-depositional mixing from above. As these samples provide a number of peaks for every sample, stratigraphic constraints do not restrict the possible scenarios a great deal.

Additional information is provided by the proportion of grains measured for each of the identified peaks. It may be that the highest proportion of grains represents the best depositional age estimate, in which case sample X714 would correspond to an age of 59.9 ± 3.8 ka, corresponding to 71 per cent of the measured grains, and lower layers would be constrained to be higher in age. For these samples, however, comparison to new radiocarbon age estimates, discussed by Higham et al. (Chapter 5), shows a striking agreement between the majority and consistent grouping of radiocarbon ages and the SG OSL age estimates underlined in Table 6.3 (39.2 ± 6.6 ka for sample X714, representing just 15 per cent of the single grains measured).

If age estimates representing fewer than 10 per cent of grains are ignored as unlikely to reflect depositional age (but in-mixed or non-zeroed populations instead), then two SG depositional age models appear likely. The 'young scenario' includes age estimates underlined in Table 6.3, and is in agreement with the radiocarbon age model. An 'older scenario' includes the next higher age peak for the upper three samples (X714, X715 and X716) with the same ages for the lower three samples in both scenarios. This older scenario may look more likely when the OSL data are considered in isolation. Although there is some age inversion between samples X717 and X716 with X715, these peaks represent the greatest proportions of grains in samples X714, X715 and X716. In resolving this issue, the possibility that the radiocarbon ages represent introduced material must be considered. Other scenarios are possible for the ages of the lower OSL samples, but introduce either age inversions or a high degree of in-mixing, making them less likely. A fuller analysis of these data, beyond the scope of this paper, would include an assessment of all the possible scenarios, their internal compatibility and the degree of reworking and incomplete zeroing that they imply.

It must be borne in mind that this approach to single grain data analysis, based on the use of a finite mixture model, implicitly assumes that the grains measured for each sample represent the mixture of a small number of discrete age events. This approach cannot necessarily handle grains from continuous or semi-continuous dose distributions, which might result, for example, from significant partial bleaching at deposition, or by the mixture of grains from a large number of age events. If these situations have contributed more than a small proportion of grains in each sample, the finite mixture model may produce results of severely reduced reliability.

Refining the single grain age model using Bayesian statistics

From the above analysis, it appears that a coherent age model for the deposition of sediments in the lower part of Gorham's Cave has been constructed. It is possible to assess the degree of internal consistency of the proposed

age estimates using a statistical approach based on Bayesian methods (Rhodes *et al.* 2003). Figure 6.3 presents the output of the Bayesian age model, constructed following the method described by Rhodes *et al.* (2003), using the age estimates underlined in Table 6.3. The statistical analysis provides a measure of internal consistency called the agreement index (Bronk Ramsey 1995; 2000); values over 60 per cent are considered to represent an acceptable age model. Analysis of the highlighted age estimates from Table 6.3 provided agreement index values of between 102 and 117 per cent for each estimate in the 'young scenario', presented in Table 6.4. These values are higher than for the 'older scenario' discussed above. The resultant age model (young scenario) is considered the best representative of depositional age for these sediments. Table 6.4 presents the SG Bayesian age model results for these six sediments. The application of Bayesian analysis through the addition of the stratigraphic relationships between samples decreases the size of the uncertainties in the single grain OSL age estimates. The results in Table 6.4 represent a robust age model for the deposition of sediments in the lower part of Gorham's Cave, a chronological hypothesis waiting to be tested. The model ages for the uppermost (X714) and lowermost (X719) samples may be affected by an artefact of the Bayesian modelling (Bronk Ramsey 2000), and consequently, the raw single grain OSL age estimates for these samples may be more reliable.

Summary of single grain OSL age estimates

In Table 6.3, one set of single grain dose, proportion and age estimate values for each sample is underlined, to indicate the values here considered to best represent depositional age. This set of age estimates, based on one of the dose values isolated by the finite mixture model for each sample, fulfils two important concurrent criteria. Firstly, these age estimates, within their associated uncertainties, are internally stratigraphically consistent. Secondly, for all samples except X718, the underlined values represent the lowest significant population (X714, X715, X716) or the greatest proportion of grains (X717, X719). For sample X718, very slightly more grains (38 per cent) are consistent with an age estimate of 57.5 ± 4.8 ka than are consistent with the underlined age of 90.0 ± 8.2 ka (37 per cent). However, the age inversion that this would imply makes this unlikely.

Implications of single grain data

If the single grain OSL age model for the timing of sediment deposition presented above and in Tables 6.3 and 6.4 is correct, then there are some interesting implications for the history of the cave. For samples X714, X715 and X717, peaks with the highest proportions of grains, 71 per cent, 61 per cent and 66 per cent respectively, were consistent with reworking without light exposure during deposition, or post-depositional in-mixing of older grains. The less well represented lower dose values appear to reflect depositional age. This is perhaps to be expected for deposition within a cave.

However, lower in the cave stratigraphy, for sample X717, a strong age inversion would be implied if the lowest significant peak represents depositional age. There are

similar considerations for the two lower samples, X718 and X719, and for these three samples, it appears that in-mixing of younger grains from higher levels was significant. For sample X718, 46 per cent of grains are apparently from younger contexts, and for X719 this is the case for 50 per cent of grains. These inferred proportions of introduced grains seem very high. However, it should be noted that in Figure 6.1, many of the sampled layers are shown as containing burrows. This figure was constructed by S. Collcutt, and is based on very detailed *in situ* examination of the sediments. Detailed micromorphological investigations also led Macphail and Goldberg (2000) to conclude that these sediments were heavily burrowed. Table 6.3 has been laid out so that, where possible, similar dose values observed in different samples are arranged vertically. It can be seen that every sample contains some grains (between 5 to 37 per cent) with a dose value of around 44 to 48 Gy. This is interpreted as corresponding to the depositional age for sample X718 of around 90,000 years ago. The similar dose values independently isolated by the finite mixture model for these six samples are considered evidence that these peaks are not artefacts, either of some unknown luminescence effect, or of the statistical modelling. There is a much lower range of dose values (44 to 48 Gy) than of age estimates (85 to 146 ka), which suggests that the mixing took place relatively recently. However, the departures from a single dose value are in the opposite direction to those expected for the variation to be caused by exposure to the present dose rates for a short time after acquisition of a uniform dose value.

In discussing the proportions of grains at a range of dose values, it should be borne in mind that different populations of grains, for example those originating from different sedimentary contexts, may have distinct sensitivity distributions (Rhodes 2007b). The OSL sensitivity of a grain may be an important factor in controlling whether it passes the SG exclusion criteria, and is included in subsequent analysis. Further data analysis, beyond the scope of this paper, may reveal whether this is a significant control for the present data set.

Relationship between multiple and single grain data

The single grain data provide evidence for the introduction of grains from other horizons. It should be clearly stated here that owing to this effect, the multiple grain OSL age estimates *cannot* be reliable. However, the indications from the pattern of scatter between different multiple grain aliquots of each sample was that the dominant effect was of incomplete signal zeroing. In contrast, the introduction of grains from younger horizons represents a significant effect for the single grain data (Fig. 6.2; Table 6.3). How can this difference between multiple and single grain data be understood?

There are two differences in the populations of grains that comprise the multiple and single grain data. The first is grain size. The multiple grain aliquots were made of material from a 180–250 μm quartz fraction, while the single grain data were re-sieved to remove grains coarser than 212 μm. In addition, the multiple grain discs are constructed by lowering an inverted disc with silicone oil adhering into a

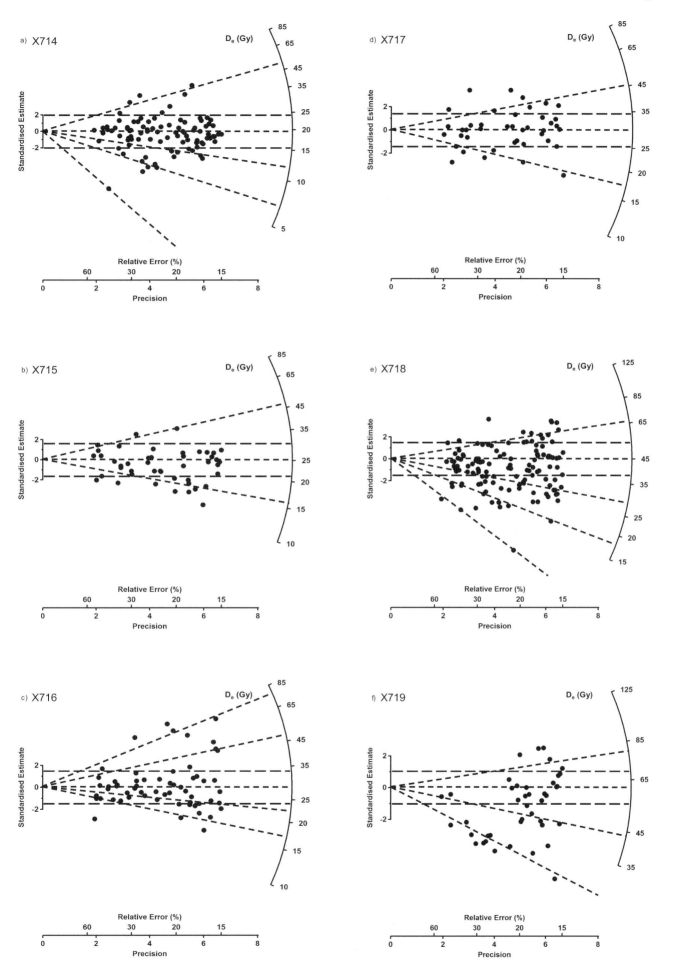

Fig. 6.3 Single Grain OSL data from Figure 6.2 presented on radial plots. Fine hatched lines indicate equivalent dose values identified using a finite mixture model; the equivalent dose value indicted by a horizontal line represents the greatest proportion of grains for samples X714, X715, X716, X717 and X719, while for sample X718 this is the value used in the Bayesian model (Table 6.3).

pile of grains. This technique provides a good monolayer of grains, but may bias the population towards coarser grains.

The second difference is in the rejection criteria used to omit grains with poor luminescence characteristics from the single grain data. This includes insensitive grains, but also supersaturated grains and those which fail to recycle adequately (see above for details). Also, grains which do not display a regular regenerative-dose growth pattern are rejected, as fitting is either not possible, or the equivalent dose value has a large uncertainty associated.

Given these differences, it is not possible to comment further on the divergent behaviour, but these observations highlight some of the difficulties in the interpretation of OSL data, in particular for multiple grain OSL data. If grain size played a significant role in causing these differences, it implies an increased tendency for smaller grains to be translocated, and an increased tendency for smaller grains to be better zeroed. Both of these effects seem highly credible.

Previous chronological estimates

These six OSL samples span sediments previously dated by Rink *et al.* (2000) and Volterra *et al.* (2000). The former authors used a different site datum from the 2001 datum used here. However, when these samples were collected in 2001, the location of OSL sample JR95 Gor L1 was clearly indicated on the section by a labelled tag, and it is clear that there is very little difference in the elevation or height coordinates of the two datum points. In 2001, an additional gamma spectrometer reading was made in the position of JR95 Gor L1, to compare with the value published in Rink *et al.* (2000). The new reading (0.286 ± 0.006 mGy.a^{-1}) is consistent with the value of Rink *et al.* (2000) of 0.296 mGy.a^{-1}. This sample lies between X719 and X718, for which the Bayesian age model results are $119,300 \pm 14,800$ and $89,600 \pm 7700$ years before present, respectively. The OSL results in Rink *et al.* (2000) are quartz multiple grain age estimates, using a multiple aliquot additive dose (MAAD) approach (Rees-Jones *et al.* 1997), performed with grains of 90–150 μm. The results for sample JR95 Gor L1 ranged between 43 ± 14 to 55 ± 18 ka, depending on which water content model was used. It is clear that this age estimate is significantly lower than the new data presented here. It seems likely that their samples also suffered from the effects of post-depositional intrusive grains, as this effect was found to be ubiquitous for the six samples studied using single grains (Table 6.3). The smaller grain size used by Rink *et al.* (2000) may also have inadvertently exaggerated this effect, based on the differences between multiple and single grain data discussed above.

The uppermost OSL sample of Rink *et al.* (2000), Gor OSL 2 provides age estimates ranging between 50 ± 9 ka using 2% moisture content, and 62 ± 11 ka (30% moisture). If a similar water content value is assumed as was used for the age estimates presented here (10%), the age for Gor OSL 2 would be approximately 54 ± 10 ka. This sample lies close to samples X714 and X715, probably between the two, and the single grain Bayesian model ages for these are $38,500 \pm 5,800$ and $48,700 \pm 4,000$ a respectively. Sample Gor OSL 2 is slightly greater in age

than suggested by the new age model, probably owing to the magnitude of older intrusive grains in this part of the sequence (Table 6.3). Rink *et al.* (2000) found samples at elevations of 6.92 and 6.12 m to be saturated, and estimated an age in excess of 200 ka. Sample X719 with a z coordinate of 6.7 m gives a single grain age estimate consistent with deposition in MIS 5, and the observed differences in behaviour probably relate primarily to differences in the dating protocol used.

In summary, the finite OSL age estimates of Rink *et al.* (2000) differ from the ages based on the new single grain OSL determinations (Table 6.4), because of differences between the measurement protocols employed and the translocation of grains within the sediment sequence after deposition, which are only clear using single grain measurements.

Rink *et al.* (2000) also report ESR ages of two mammal teeth. Gor ESR 49 from 11.0 m z coordinate provides ages ranging between 35.0 ± 4.0 ka (early U uptake) and 43.6 ± 5.0 ka (late U uptake). Gor ESR 43 from -1.15 m z coordinate (using a different, non-specified datum) has virtually no uranium, and gives 39.4 ± 5.0 ka (EU) and 39.5 ± 5.0 ka (LU). Both ages appear slightly low in comparison to the new SG OSL chronology. Volterra *et al.* (2000) provide age estimates for 13 mammal teeth from the Gibraltar Museum collection, from the original excavations by Waechter (1954). These came from Waechter's levels G, K, M, P and R. The 12 samples from layers G, K, M and P show no significant variation in age; U concentrations are presumably low, as LU uptake ages are only around 20 per cent greater than EU ages. Note that the LU result for sample #9 is presumably a typographic error – the LU result must be greater than the EU result. For these Mousterian horizons, the means of these 12 samples provide estimates of 30 ± 5 ka (EU) and 35 ± 5.0 ka (LU), assuming only 2% moisture content. However, it is not clear what the relationship of Waechter's levels is to the 1995 or 2001 datum points. The single sample from Waechter's level R gave 56.5 ± 4.9 ka (EU) and 62.4 ± 5.1 ka (LU). Rink *et al.* (2000) speculate that Waechter's level R may have been in the vicinity of the lower part of their OSL sequence (c.6.1 to 8.2 m elevation above datum), but it is not clear that there is any independent evidence to support this. The ESR age is certainly significantly lower than the SG age estimates from X718 and X719.

Rink *et al.* also report two speleothem uranium-series age estimates from elevations above datum of 8.44 m and 8.38 m respectively. These give age estimates of 97.1 ± 1.3 ka (JR95 GOR MSUS5?1) and 96.1 ± 0.9 ka (JR95 GOR MSUSU1?3). These age estimates are in excellent agreement with the new SG age model. However, Rink *et al.* (2000) note that they were unable to tell whether these were fallen pieces of earlier speleothem (which would give age overestimates), calcitic deposits from cave floor pools (roughly contemporaneous with sediment deposition), root casts (post-dating sediment deposition) or other concretions (post-dating sediment deposition), though their morphology was characteristic of fallen stalactites or root casts. The consistency between these U-series results and the SG OSL results suggests that further studies into the nature of these

speleothem deposits is warranted, as they may prove to be a very valuable chronological tool in the future.

Pettitt and Bailey (2000) provide a summary of [14]C dating in Gorham's Cave. The radiocarbon age estimates show several striking inversions, in particular in contexts 18 and 19. However, the older age estimates appear broadly consistent with the new SG OSL age model (Table 6.4). The possibility of the translocation of organic material down burrows must be borne in mind, in view of the single grain OSL results (Table 6.3).

Higham *et al.* (Chapter 5) also survey these and more recent [14]C age estimates, based both on charcoal and sub-samples of complete shells. They also observe age inversions, and note that some samples included by Pettitt and Bailey had very low organic carbon contents, and were therefore probably unsuitable for radiocarbon dating. Higham *et al.* (Chapter 5) make a closely argued case for the veracity of their radiocarbon age model; they are very confident in results for horizons down to UBSm.4, while lower samples demonstrate an increase in problematic behaviour.

Conclusions

The OSL dating results presented in this paper provide a chronology for sediment deposition in the lower part of Gorham's Cave. The single grain data demonstrate that each sample does not comprise a single population of grains well zeroed at the time of deposition (Fig. 6.2; Table 6.3). The SG age estimates presented, and the Bayesian age model (Table 6.4) derived from these, represent one interpretation of these complex data. However, the proportions of single grains corresponding to each grouping identified using a finite mixture model (Table 6.3), the stratigraphic ordering of the six samples and comparison to the radiocarbon data presented by Higham *et al.* (Chapter 5) render this interpretation of the SG data the most likely. This interpretation indicates a high level of incomplete zeroing for the upper levels dated, and a significant amount of post-depositional grain mobility between horizons within the cave. The new OSL data are consistent with two uranium-series ages presented by Rink *et al.* (2000), but suggest older depositional ages than do two ESR ages of mammal teeth and four multiple grain OSL estimates. The new OSL chronology provides older age estimates for lower samples than suggested by radiocarbon determinations of Pettitt and Bailey (2000), though these data show limited increase in age with depth, and show significant inversions. The new SG OSL chronology and the Bayesian age model presented in Table 6.4 represent a robust age model for the deposition of sediments in the lower part of Gorham's Cave, and represent a chronological hypothesis waiting to be tested.

These measurements and the resulting Bayesian age model confirm sediments of MIS 5 age near the base of the sequence, with deposition occurring into early to mid MIS 3 (Fig. 6.1; Table 6.4). They highlight, and for the first time quantify, the significant degree of post-depositional grain movement within the sediment succession. These results emphasize the importance of the parallel application of different dating techniques, and underline the complex nature of sediment deposition and remobilization in cave and rock shelter environments.

Acknowledgements

The author would like to thank Roger Nathan for helping to collect the samples, Jean-Luc Schwenninger for laboratory preparation, and Nick Barton, Simon Collcutt, Clive Finlayson and Chris Stringer for useful discussion of the results.

References

Armitage, S. J., Duller, G. A. T. and Wintle, A. G. 2000: Quartz from southern Africa: sensitivity changes as a result of thermal pretreatment. *Radiation Measurements* 32, 571–577.

Bøtter-Jensen, L., Andersen, C. E., Duller, G. A. T. and Murray, A. S. 2003: Developments in radiation, stimulation and observation facilities in luminescence measurements. *Radiation Measurements* 37, 535–541.

Bronk Ramsey, C. 1995: Radiocarbon calibration and analysis of stratigraphy: the OxCal program. *Radiocarbon* 37, 425–430.

Bronk Ramsey, C. 2000: Comment on the use of Bayesian statistics for [14]C dates of chronologically ordered samples: a critical analysis. *Radiocarbon* 42, 199–202.

Duller, G. A. T. 2006: Single grain optical dating of glacigenic deposits. *Quaternary Geochronology* 1, 296–304.

Galbraith, R. F. 1988: Graphical display of estimates having differing standard errors. *Technometrics* 30, 271–281.

Galbraith, R. F. and Green, P. F. 1990: Estimating the component ages in a finite mixture. *Nuclear Tracks and Radiation Measurements* 17, 196–206.

Galbraith, R. F., Roberts, R. G., Laslett, G. M., Yoshida, H. and Olley, J. M. 1999: Optical dating of single and multiple grains of quartz from Jinmium rock shelter, northern Australia: Part I. Experimental design and statistical models. *Archaeometry* 41, 339–364.

Jacobs, Z., Duller, G. A. T. and Wintle, A. G. 2003: Optical dating of dune sand from Blombos Cave, South Africa: II—single grain data. *Journal of Human Evolution* 44, 613–625.

Macphail, R. I. and Goldberg, P. 2000: Geoarchaeological investigations of sediments from Gorham's and Vanguard Caves, Gibraltar: microstratigraphical (soil micromorphological and chemical signatures) signatures. *Neanderthals on the Edge* (Stringer, C. B., Barton, R. N. E. and Finlayson, J. C., eds.), Oxbow, Oxford, UK, 183–200.

Murray, A. S. and Funder, S. 2003: Optically stimulated luminescence dating of a Danish Eemian coastal marine deposit: a test of accuracy. *Quaternary Science Reviews* 22, 1177–1183.

Murray, A. S. and Wintle, A. G. 2000: Luminescence dating of quartz using an improved single-aliquot regenerative-dose protocol. *Radiation Measurements* 32, 57–73.

Murray, A. S. and Wintle, A. G. 2003: The single aliquot regenerative dose protocol: potential for improvements in reliability. *Radiation Measurements* 37, 377–381.

Nathan, R. P., Thomas, P. J., Jain, M., Murray, A. S. and Rhodes, E. J. 2003: Environmental dose rate heterogeneity of beta radiation and its implications for luminescence dating: Monte Carlo modelling and experimental validation. *Radiation Measurements* 37, 305–313.

Olley, J. M., Pietsch, T. and Roberts, R. G. 2004: Optical

dating of Holocene sediments from a variety of geomorphic settings using single grains of quartz. *Geomorphology* 60, 337–358.

Pettitt, P. B. and Bailey, R. M. 2000: AMS radiocarbon and luminescence dating of Gorham's and Vanguard Caves, Gibraltar, and implications for the middle to upper palaeolithic transition in Iberia. *Neanderthals on the Edge* (Stringer, C. B., Barton, R. N. E. and Finlayson, J. C., eds.), Oxbow, Oxford, UK, 155–162.

Rees-Jones, J., Hall, S. J. B. and Rink, W. J. 1997: A laboratory inter-comparison of quartz optically stimulated luminescence (OSL) results. *Quaternary Science Reviews (Quaternary Geochronology)* 16, 275–280.

Rink, W. J., Rees-Jones, J., Volterra, V. and Schwarcz, H. 2000: ESR, OSL and U-series chronology of Gorham's Cave, Gibraltar. *Neanderthals on the Edge* (Stringer, C.B., Barton, R.N.E. and Finlayson, J.C., eds.), Oxbow, Oxford, UK, 165–170.

Rhodes, E. J. 2007a: *Barford Road, St. Neots, Cambridgeshire: Optically Stimulated Luminescence dating of single grains of quartz from sedimentary fills of two cursus monuments.* English Heritage Research Department Report Series no. 32/2007.

Rhodes, E. J. 2007b: Quartz single grain OSL sensitivity distributions: implications for multiple grain single aliquot dating. *Geochronometria* 26, 19–29.

Rhodes, E. J., Bronk-Ramsey, C., Outram, Z., Batt, C., Willis, L., Dockrill, S. and Bond, J. 2003: Bayesian methods applied to the interpretation of multiple OSL dates: high precision sediment age estimates from Old Scatness Broch excavations, Shetland Isles. *Quaternary Science Reviews* 22, 1231–1244.

Rhodes, E. J. and Schwenninger, J.-L. 2007: Dose rates and radioisotope concentrations in the concrete calibration blocks at Oxford. *Ancient TL* 25, 5–8.

Rhodes, E. J., Singarayer, J. S., Raynal, J.-P., Westaway, K. E. and Sbihi-Alaoui, F. Z. 2006: New age estimates for the Palaeolithic assemblages and Pleistocene succession of Casablanca, Morocco. *Quaternary Science Reviews* 25, 2569–2585.

Volterra, V., Schwarcz, H. and Rink, W.J. 2000: Results of the current program of ESR dating of Gorham's Cave teeth from the Gibraltar Museum. *Neanderthals on the Edge* (Stringer, C. B., Barton, R. N. E. and Finlayson, J. C., eds.), Oxbow, Oxford, UK, 163–164.

Waechter, J. d'A. 1951: The excavation of Gorham's Cave, Gibraltar: preliminary report for the seasons 1948 and 1950. *Proceedings of the Prehistoric Society* NS 17, 83–92.

7 Late Pleistocene vegetation reconstruction at Gorham's Cave

S. Ward, R. Gale and W. Carruthers

Introduction

The analysis of macroscopic charcoal and charred seeds, and microscopic phytoliths from archaeological sediments can provide valuable environmental information for reconstructing local past vegetation communities (Madella *et al.* 2002; Vernet 1980; Heinz 1991; Badal 1998; 2001; Hansen 2001; Ntinou 2000; Albert *et al.* 2003). Most of these botanical materials are well preserved at Gorham's and in this chapter we examine the data from a number of different but related perspectives: to reconstruct local vegetation dynamics, to determine the human exploitation of plants and, more broadly, to investigate Late Pleistocene environmental change in the western Mediterranean region.

Excavations at the cave produced very large quantities of botanical remains. Sieving was routinely employed and pieces of charcoal were extracted during the course of hand excavation. Bulk sediments were mostly wet sieved using fine mesh sizes either on site or in the museum and the charcoal and macrofossil materials floated, leaving dried sub-samples ready for identification. In this study particular focus was given to sedimentary units of archaeological significance.

Methodology
Macroscopic charcoal

Charcoal fragments are scattered throughout deposits and ideally, for the purposes of vegetation reconstruction, should represent materials accumulated over a prolonged period of time (Badal-Garcia 1992; Asouti and Austin 2005). The charcoal flot from Gorham's was separated into size categories using a stack of sieves at graded mesh apertures of >4 mm and 2–4 mm, in order to minimize any potential size bias. The majority of flotation samples retrieved provided low quantities of charcoal, and were thus analysed in their entirety.

Charcoal fragment identifications were shared between the Long-term Ecology Laboratory (OxLEL), Oxford University, and a private microscope laboratory in Andover. Examinations of charcoal fragments at OxLEL were made using a Nikon Eclipse ME600L reflective light microscope, under light and dark field, at magnifications of ×100 to ×500. A Nikon Labophot incident light microscope was used in the Andover laboratory at magnifications of up to ×400. Charcoal fragments were prepared for examination by manual fracturing, and were supported in a matrix of clean sand to allow manipulation of the specimen.

Anatomical characteristics were observed in each of the three planes, transversal (TVS), Tangential Longitudinal (TLS) and Radial (RLS) (Fig. 7.1), and entered into a specially designed charcoal floristic database. Determination

was usually possible down to genus level, although sometimes it can be more precise depending on the nature of the fragment, or if biometric measurements are taken (Terral and Mengual 1999; Terral *et al.* 2004). Anatomical wood reference atlases were employed from a wide variety of literature (Greguss 1955; Jacquiot 1955; 1973; Schweingruber 1978; 1990; Neumann and Richter 2000), and computer databases such as *www.woodanatomy.ch* (Schoch *et al.* 2004) were utilized. Furthermore, thin section and charred extant wood reference collections were examined from the OxLEL charcoal reference collection and from Jodrell Laboratory, Royal Botanic Gardens, Kew. Raw macroscopic charcoal and phytolith taxonomical data were transformed into diagram form using the Psimpoll 4.10 program (Bennett 2002). Psimpoll postscript files were interpreted using the Ghostscript computer program, which were then displayed using GSview (Ghostgum Software Pty Ltd 2006).

In addition to the anatomical features of the charcoal, notes were taken of a variety of dendrological aspects exhibited in the individual fragment. Qualitative dendrological examination can provide critical supplementary information on firewood management, such as the physiological state of the wood (green or dry), the health of the wood (degree of weathering), and wood collection strategies (e.g. ring curvature). These included green/dead wood, ring growth and curvature, evidence of fungal/insect activity, and the presence of pith/bark, compression wood, tyloses and vitrification. Furthermore, a Preservation/Fragmentation (Pr/Fr) Index, devised by Asouti (2001), was employed in order to measure the effects of taphonomic processes on the wood charcoal assemblage, using the following formula:

$$\frac{\text{Total number of indeterminate fragments from the same context}}{\text{Total number of identified items per sample context}}$$

Low fragmentation and good preservation in a sample were interpreted from Pr/Fr Index values of <1, while values of 1–5 were indicative of moderate to high proportions of indeterminate fragments. Values of >5 were taken to reflect high proportions of indeterminate fragments, whereas a Pr/Fr Index score of zero would represent a sample with no indeterminate fragments observed.

Charred seeds

In addition to the analysis of charcoal fragments, 4911 more complete plant macrofossil fragments from Gorham's have been identified. These were examined under a dissecting microscope at magnifications from ×10 to ×100. Comparisons were made with reference material from the herbarium of the National Museum of Wales, Cardiff.

Table 7.1 Phytolith sample data for Gorham's Cave

Prefix	Sample Number	Excavation grid square	Stratum	Context	pH	Weight of initial sediment (g)	Weight of final sediment (g)	Weight of sediment on slide (g)	Number of Slide Crossings
01	40	D96	CHm.5	General sediment	7.15	3	0.35270	0.00065	46
01	66	D95	CHm.5	General sediment	6.72	3	0.15710	0.00074	49
98	801	B97	BeSm (OSsm).1	General sediment	7.34	3	0.01190	0.00056	52
98	1022	c101	LBSmcf.1-4	General sediment	6.91	3	0.03740	0.00077	44
96	312	D106	SSLm (Usm).2	General sediment	7.02	3	0.00750	0.00075	46

Table 7.2 Charred seed/nut data for Gorham's Cave (developed from raw data generated by Dr. Carruthers)

	Absolute Fragment Count									% Fragment Count							
Stratum	No. samples	P. pinea Cone scale	cf. P. pinea Cone scale	P. pinea Nut shell	cf. P. pinea Nut shell	Pine Kernel	Other charred remains	Unidentified fragments	Total	P. pinea Cone scale	cf. P. pinea Cone scale	P. pinea Nut shell	cf. P. pinea Nut shell	Pine Kernel	Other charred remains	Unidentified fragments	Total
CHm.3	3	5	0	89	0	0	0	11	105	4.76	0.00	84.76	0.00	0.00	0.00	10.48	100.00
CHm.5	6	2262	0	34	0	0	0	2	2298	98.43	0.00	1.48	0.00	0.00	0.00	0.09	100.00
UBSm.5	1	129	0	88	0	0	0	0	217	59.45	0.00	40.55	0.00	0.00	0.00	0.00	100.00
UBSm.6	1	0	0	0	0	0	2 cf. vetches	0	2	0.00	0.00	0.00	0.00	0.00	100.00	0.00	100.00
LBSmff.1-5/LBSmcf.2	3	61	0	36	1	0	0	0	98	62.25	0.00	36.73	1.02	0.00	0.00	0.00	100.00
LBS.mff.11	2	26	22	0	0	0	0	0	48	54.17	45.83	0.00	0.00	0.00	0.00	0.00	100.00
SSLm (Usm).2	12	227	1804	96	0	1	2	0	2130	10.66	84.69	4.51	0.00	0.05	0.09	0.00	100.00
SSLm (Usm).5	1	2	4	5	2	0	0	0	13	15.39	30.77	38.46	15.38	0.00	0.00	0.00	100.00
Total		2712	1830	211	3	1	4	13	4774								

Phytoliths

Phytoliths are silicified cells, either isolated or in tissues, which form through the uptake of monosilicic acid from the soil water and the subsequent precipitation by evaporation and metabolism of silica (Pearsall 2000).

Five samples covering four stratigraphic layers were analysed for the presence of phytoliths (Table 7.1). An adapted version of the Missouri Protocol (Pearsall 2000) was employed for all samples, consisting of acid treatment, the dispersal and sedimentation of clays, and flotation of phytoliths (fully outlined in Fig. 7.2). Following laboratory preparation, the end phytolith residue was mounted in non-permanent fluid, and observed at the Long-term Ecology Laboratory (OxLEL), Oxford University using a Nikon Eclipse ME600L, at magnifications of between ×200 and ×1000.

Results
Macroscopic charcoal analysis

From the Gorham's excavations 99 flotation samples were analysed for macroscopic charcoal from a total available of 181. In sum, 1763 charcoal fragments have been identified covering 19 stratigraphical contexts, within five sedimentary members. Ten taxa (amongst 21 taxonomic entities) are identified in the macroscopic charcoal record, which is strongly dominated by *Pinus* sp. and *Pinus pinea*. The assemblage is ordered into the two main seed-bearing plant groups, 'Gymnosperms', whose seeds are not enclosed within an ovary, and 'Angiosperms', which are flowering plants whose seeds are enclosed within an ovary.

Quantified results (Fig. 7.3)

The macroscopic charcoal sequence for Gorham's was categorized into four zones, termed G-1 to G-4, using optimal splitting by information content and representing statistically distinct patterns in the assemblage data.

Zone G-1

This zone incorporates basal sequence sedimentary layer SSLm.(Lsm).6. In total, 29 charcoal fragments were identified from four sediment sub-samples, from the upper part of SSLm.(Lsm).6. The assemblage is dominated by pines, particularly *P. pinea* and *Pinus pinea/pinaster* (stone/maritime pine). In the latter, high mineralization meant that the anatomical differences between the two pine species could not be distinguished. The zone total sum diagram is largely dominated by gymnosperms (62.1 per cent), with a significant percentage of degraded 'Gymnosperm deteriorated' fragments (34.5 per cent). The remainder is composed of 'unidentified' fragments (3.4 per cent).

Zone G-2

This zone consists of five sedimentary layers, four from SSLm.(Usm).5–.2 and one from the basal LBSmff (LBSmff.12). The assemblage is dominated by *Pinus* sp. throughout the zone apart from SSLm.(Usm).3, in which a more detailed identification of *Pinus pinea/pinaster* was possible. However, the statistically insignificant fragment counts for some levels in this zone, especially in SSLm.(Usm).4 and .3 (three and two charcoal fragments respectively) may distort the relative frequency patterns.

The sum percentage diagram is characterized by the complete dominance of gymnosperms throughout, and the absence of angiosperm taxa. A small exception is evidenced in SSLm.(Usm).3 (96.1 per cent gymnosperms), although the remainder is still composed of 'Gymnosperm deteriorated' (3.4 per cent) and 'unidentified' (0.5 per cent), and absent of angiosperm taxa.

Zone G-3

This zone incorporates six sedimentary layers covering two members, comprising five samples from the LBSmff.

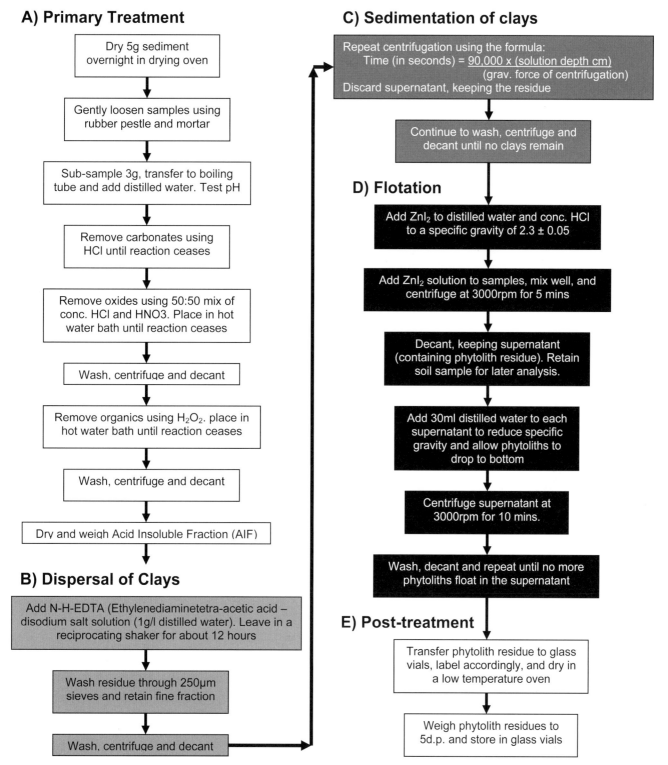

Fig. 7.1 Flowchart showing the phytolith preparation protocol used in this study.

mEMBER (beds 10, 8, 7, 6 and 1–5) and one from the overlying BeSm.1. The wood assemblage composition of this zone is the most complex and diversified of the whole sequence. G-3 remains generally dominated by pine, with *P. pinea* and *Pinus* sp. *Pinus pinea* declines initially from 26.5 per cent (LBSmff.10) to 9.6 per cent (LBSmff.8), and then increases consistently to 32.9 per cent (LBSmff.1–.5). *Pinus pinea/pinaster* follows a similar initial pattern to that of *P. pinea*, declining from 4.5 per cent to 1.2 per cent. However, in contrast with *P. pinea*, *Pinus pinea/pinaster* then rapidly expands again to 20.5 per cent (LBSmff.7) before declining

to 10.2 per cent (LBSmff.1–.5). Both *P. pinea* and *Pinus pinea/pinaster* are absent from the BeSm.1. *Pinus* sp. however is present throughout both LBSmff. and BeSm, alternatively fluctuating between individual beds at ~20–1 per cent before reaching 10.5 per cent at the zone summit.

Juniperus sp. (juniper) is the second most important taxon in the G-3 wood assemblage, introduced in the basal layer of zone G-3 (LBSmff.10) at 3 per cent, before immediately increasing to 9.6 per cent and then slowly decreasing to 0.4 per cent in the uppermost LBSmff. units (1–5). *Juniperus* sp. then exhibits a large increase in BeSm.1 to 21.1 per

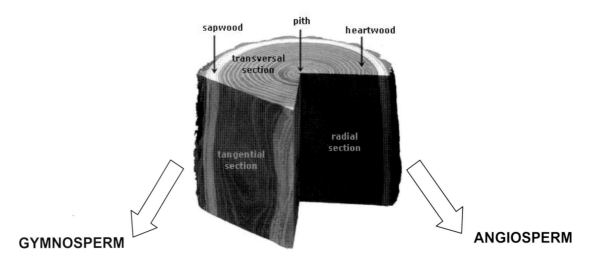

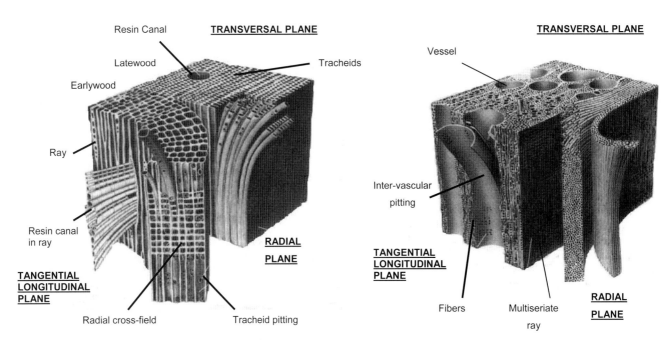

Fig. 7.2 Basic anatomical features of gymnosperms and angiosperms. After Johnson (1994).

cent, also witnessed in the cf. *Juniperus* sp. category, which sees an increase from 0 to 10.5 per cent.

Angiosperms are quite sporadic throughout G-3, with no individual taxa remaining consistent throughout the zone. Angiosperm taxa appear in significant numbers, yet largely in isolation. For example, *Pistacia* sp. (terebinth/lentisc/pistachio) is absent throughout the zone apart from the uppermost BeSm.1, showing a dramatic appearance at 31.6 per cent. Similarly, 'dicot shrub' (broadleaved species of shrubby habit, not identified to genus) appears solely in BeSm.1 at 26.3 per cent. Likewise, Legumines are largely absent from the zone assemblage, apart from in LBSmff.6 (26.1 per cent). Apart from these sudden rapid introductions in angiosperm taxa, a low frequency presence of *Arbutus* sp. (strawberry tree) and cf. *Ephedra* sp. (joint pine) (increasing from 0.5 per cent to 3 per cent and stable at 3 per cent respectively) through LBSmff.10 and .8 is demonstrated. These low levels of angiosperm species are opposed by high 'Angiosperm deteriorated' percentages (23.5 per cent to 45.2 per cent between LBSmff.10 and .8). Further, a single

appearance of *Quercus* sp. (0.4 per cent) occurs in LBSmff.1–.5. Whilst the levels of identified angiosperm species are low, there are comparatively high percentages of 'Angiosperm deteriorated' (i.e. in poor condition and not identifiable to species), suggesting that angiosperms were not uncommon in the area but that the charcoal is poorly preserved.

The sum charcoal diagram is characterized by a fluctuating pattern of expanding/contracting gymnosperms, at the expense of angiosperms and 'Angiosperm deteriorated' fragments. The zone witnesses an initial contraction of gymnosperms from 100 per cent (in the uppermost layer of zone G-2) to 34.3 per cent due to an expansion in 'Angiosperm deteriorated' (from 0 per cent in zone G-2 to 45.2 per cent) within LBSmff.8. Subsequently, gymnosperms increase rapidly to 68 per cent, while 'Angiosperm deteriorated' declines to 6.6 per cent in LBSmff.7, before contracting once more (to 52.2 per cent) as angiosperm levels (previously between ~0–7.2 per cent in the zone) expand to 26.1 per cent (in LBSmff.6). Gymnosperms then increase once more in units LBSmff.1–.5 to 74.8 per cent as

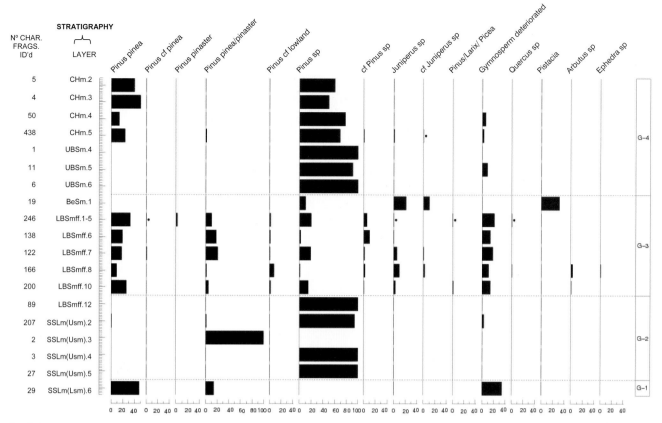

Fig. 7.3 Macroscopic charcoal relative percentage diagram for Gorham's Cave (all terrestrial charcoal).

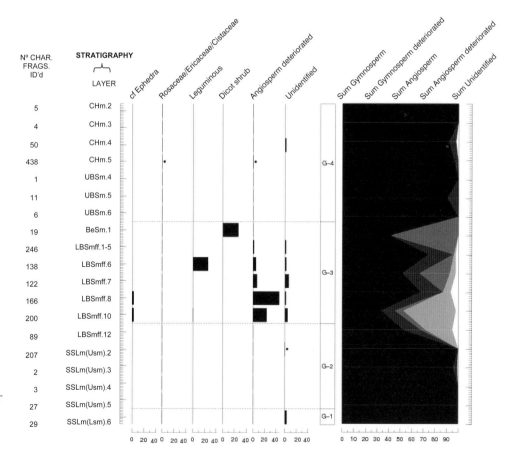

Fig. 7.4 Macroscopic charcoal relative percentage diagram for Gorham's Cave (all terrestrial charcoal).

angiosperm taxa decline from the uppermost LBSmff. Gymnosperms then decrease rapidly once again in the uppermost layer of zone G-3, BeSm.1 (to 42.1 per cent), due to a rapidly increasing angiosperm assemblage (expanding to 57.9 per cent). Throughout the zone, apart from in BeSm.1, 'Gymnosperm deteriorated' remains fairly stable between ~15–20 per cent, alongside 'unidentified', which fluctuates between 2–5 per cent.

Zone G-4

This zone consists of seven units spanning two sedimentary members, the lower three covering UBSm.6–.4 and the upper four beds covering CHm.5–.2. This zone is characterized by a persistent decline in *Pinus* sp. from 100 per cent (UBSm.6) to 50 per cent (CHm.3), before increasing again to 60 per cent in the uppermost CHm.2. *P. pinea* makes a sudden appearance coincident with the CHmEMBER, initially at 24 per cent before declining to 14 per cent. *P. pinea* then increases to 50 per cent in CHm.3 before declining once again to 40 per cent, thereby symmetrical to changes exhibited by *Pinus* sp. in the uppermost CHm.3 and .2. This can be explained by the very low numbers of fragments available for identification from these two sedimentary layers (four and five respectively). *Juniperus* sp. makes a sole appearance in CHm.5 (0.4 per cent).

Angiosperm taxa are extremely rare in zone G-4, with the only appearances made in layer CHm.5. Here, low frequencies of *Rosmarinus* sp. (rosemary) and 'Angiosperm deteriorated' (both 0.2 per cent) are demonstrated.

The sum charcoal diagram demonstrates a resumption of significant gymnosperm dominance, between 90.9 per cent and 100 per cent. The remainder is largely 'Gymnosperm deteriorated' (between 0 per cent and 9.1 per cent), with the minimal appearance of angiosperms and 'Angiosperm deteriorated' in the basal part of CHm.5, both at 0.2 per cent. 'Unidentified' features solely in CHm.4 at 2 per cent.

Density/fragmentation/preservation

Density measurements for the Gorham's samples were unavailable, since volumetric measurements were not taken in the field. In terms of preservation, the charcoal fragments from Gorham's were generally quite fragile and difficult to handle, and were often highly mineralized (Fig. 7.4), which often restricted identification to genus level. However, the Preservation/Fragmentation (Pr/Fr) Index (Fig. 7.5) is generally quite low (mean = 0.21), indicating good preservation. Several of the layers' Index scores, however, are slightly larger than others. For example, LBSmff.8 has an Index score of 1.41 compared with the remainder of the LBSmff unit, which exhibits a mean Pr/Fr Index score of 0.64. Despite the high significant levels of partial vitrification in the charcoal fragments from CHm, the majority still permitted an identification to genus level, and so did not affect the Pr/Fr Index, producing low scores (mean = 0.06 for CHm.4 and .5).

However, these statistical methods are restricted by the limited number of macroscopic charcoal fragments available for identification. When comparing the number of samples from which identifications were made, the absolute number of macroscopic charcoal fragments identified from these samples, and the floristic diversity of the layer (Fig. 7.6), demonstrate a close correspondence. This indicates that the excavation sampling strategy and consequent macroscopic charcoal abundance are a significant influence on the robustness of this dataset.

Dendrological aspects

Ring-curve estimates were taken on charcoal fragments from seven sedimentary layers from the Gorham's sequence (Fig. 7.7). Results show that the majority of fragments analysed exhibited no observable curvature of the growth ring.

The observation of shrinkage cracks, often identified as being indicative of greenwood (e.g. Thery-Parisot 2001), was negligible throughout the charcoal assemblage. In contrast, charcoal fragments showing varying degrees of vitrification, also linked with greenwood, were frequent and a regular complication in the identification process. Evidence of vitrification was particularly common in CHm.4 and CHm.5, where approximately 60 per cent showed signs of partial vitrification, although identification to genus level was still achieved. Levels of mineralization were high in the Gorham's macroscopic charcoal fragments, affecting >50 per cent of fragments, which also constrained the identification process. The presence of fungal/insect activity was limited to samples examined under a scanning electron microscope, and was minimal, as was the presence of pith/bark, compression wood and tyloses.

Charred seed analysis

A sum of 4774 plant macrofossil fragments from Gorham's has been identified (Table 7.2), all of which were charred. The vast majority of these were identified as being either cone scales or nutshells derived from the stone pine, *P. pinea*. The cone scales of stone pines are large, thick and have five or six characteristic ridges radiating from a prominent rounded apex (Fig. 7.8a).

In slight contrast to the macroscopic charcoal record, the plant macrofossil assemblage is also solely dominated by *P. pinea* cone scale fragments and nutshell fragments, indicating that the charcoal, indeterminable beyond genus level due to poor preservation, may also be *P. pinea*. Macrofossil identifications of *P. pinea* were confirmed by analysing all *P. pinea* Herbarium species native to the area. Some of the cone scale fragments were quite large (e.g. max. width 14 mm, length 18 mm) and a whole scale was recovered from one sample (Fig. 7.8b). The nutshell fragments were small, but all of the material was well preserved and showed no signs of weathering (Gale and Carruthers 2000).

Phytolith analysis

No phytoliths were found in any of the samples studied. The two samples from CHm.5 were composed almost entirely of micro-charcoal fragments, with only one to three indeterminable stained silica forms per analysed slide. Similarly, the three remaining phytolith samples were almost entirely composed of silt particles. Once again, an average of one to three indeterminable silica morphotypes was observed per slide and so no statistically significant assemblage was gathered. The Gorham's sediment samples had been processed in three separate batches alongside sediment samples from other sites. The presence of phytoliths in these other site samples corroborates the methodological robustness of the phytolith extraction and confirms the absence from the Gorham's analysed deposits.

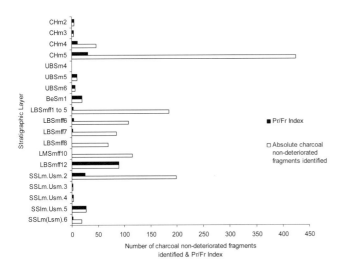

Fig. 7.5 Preservation/Fragmentation Index for Gorham's Cave macroscopic charcoal assemblage, alongside non-deteriorated absolute charcoal fragment numbers for comparison.

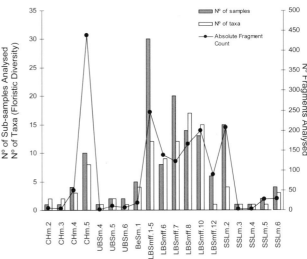

Fig. 7.6 High influence of sampling strategy illustrated through strong correspondence between sub-samples, floristic diversity and the number of macroscopic charcoal fragments retrieved and analysed.

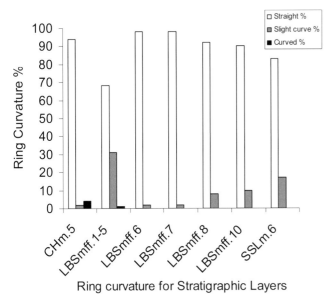

Fig. 7.7 Ring-curve estimates for macroscopic charcoal fragments from selected stratigraphic layers in Gorham's Cave, Gibraltar.

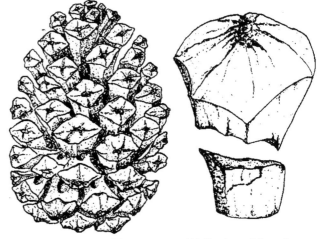

Fig. 7.8 a) Pine cone of *Pinus pinea*; and b) Pine kernel from *Pinus pinea*.

Discussion

Reconstruction of vegetation dynamics and palaeoenvironmental change

The record of macroscopic charcoal and charred seed from Gorham's provides an intermittent record of the Last Glacial period. Macroscopic charcoal deposits from Gorham's are consistent with punctuated, low density occupation of the cave, as implied by the lithics (Barton 2000, chapter 12), and from sedimentological evidence (Macphail and Goldberg 2000; Goldberg and Macphail 2000; and Chapter 4). At the time of writing this chapter, the chronology of the cave sequence is still being refined so that what is offered here is a very tentative interpretation that will likely be subject to amendment and modification.

MIS 5–4 (c.89–59ka BP)

It would appear that the early macroscopic charcoal record of Gorham's probably covers late MIS 5 and 4, comprising sedimentary units SSLm.(Lsm).10 to SSLm.(Usm).2. The lowermost of these units, the SSLm.(Lsm), are not sufficiently abundant in charcoal to be statistically significant, and are therefore analysed on a presence/absence basis only.

The early Gorham's macroscopic charcoal assemblage is strongly dominated by *Pinus* sp., most likely *Pinus pinea*, as this species was identified more precisely in several of the sedimentary layers. *P. pinea* is the archetypal vegetation found throughout the Mediterranean region, with Iberian populations accounting for almost 60 per cent of the total land covered by the species globally. The majority of these populations are located in Spain, covering an estimated *c.*175,679 ha (Prada *et al.* 1997; cf. Martínez Ruiz and Montero 2005). Although it does not presently grow on Gibraltar, dense stone pine woodland still exists not far away in Tarifa, Spain. The species thrives in humid, coastal sandy areas with moist but well drained soils and grows up to 900 m a.s.l. It also generally forms open forests with a sparse understorey (Prada *et al.* 1997; cf. Fady *et al.* 2004). This seems to fit well with a postulated sandy dune landscape immediately outside the cave during periods of low sea level leading up to and during the Last Glacial period (Finlayson and Giles Pacheco 2000; Macphail and

Goldberg 2000; Finlayson 2004). But for more information see chapters 2 and 3.

It is worth noting, however, that *P. pinea* does show a certain amount of ecological plasticity (Alexandrian 1982), growing on most substrates (Djaziri 1971), and forming stable ecosystems on degraded land (Plaisance 1977). It is also pH indifferent, has a high salt tolerance, and is less sensitive to diseases and pests than other Mediterranean pines (Alexandrian 1982). Thus, the presence of *P. pinea* in the Gorham's macroscopic charcoal record may reflect collection from a wider range of habitats than just those outside the cave.

The presence of *P. pinea* in the lowermost unit SSLm. (Lsm).6 has additional significance. Despite its being recognized as a western Mediterranean species, the origin and natural range of *P. pinea* during the Late Pleistocene have been the subject of debate over the past century (see Martínez and Montero 2005 for a recent review). Palaeobotanical data have contributed significantly to this discussion, with macroscopic charcoal and *P. pinea* cone/nut fragments from Nerja Cave, southern Spain, demonstrating that this pine species played a significant role in the vegetation use and diet of human occupants throughout the Lateglacial period (Badal 1996; 1998). In addition, Metcalf (1964) identified *P. pinea* from Gorham's within potentially much earlier contexts corresponding to our lower units, but based on a very limited number of charcoal and cone/nut fragments. If the proposed dating of the sediments is correct then it would demonstrate a record of presence in the region extending as far back as the end of the last interglacial.

MIS 3 (c.59–30ka BP)

The overlying LBS (Lower Bioturbated Sands) sedimentary member displays a distinct increase in floristic diversity, which may in part be reflective of the sampling volume in these sedimentary layers, but also possibly indicating a relative increase in charred material, and thus a potential intensification of human cave habitation. The arboreal assemblage is solely dominated by pine, in particular *P. pinea* and *Pinus pinea/pinaster*. *P. pinaster* (maritime pine) is characterized by its wide ecological tolerance, typically growing from sea level up to altitudes of 2000 m a.s.l., and on a wide range of soil types with diverse nutrient availability (Tapias *et al.* 2001). Currently, it is largely restricted to the western Mediterranean region (Mariette *et al.* 2001), forming highly fragmented and isolated patches of woodland (González-Martínez *et al.* 2002).

The shrub layer was likely to have been dominated by *Ephedra* (joint pine), *Erica* (heather) and *Arbutus* (strawberry tree). *Ephedra fragilis* is quite common on the upper Rock at present, within the clearings in the maquis, the garrigue and cliffs on the east side (Linares *et al.* 1996). *Ephedra* sp. features in several of the layers within the LBSm sedimentary member and is commonly recognized as an indicator of semi-arid to cool steppe conditions when accompanied by other indicator species such as *Artemisia* sp. (wormwood). However, in the Gorham's assemblage it is more likely reflective of a schlerophylous shrub layer, joined by other similar species such as *Arbutus* sp. and Leguminosae. All of these species are also known markers

of nutrient-deficient sediments and degraded soils (Figueiral 1995; Heinz and Thiébault 1998), preferring bright, open conditions. This is consistent with an open pine forest landscape with a relatively sparse understorey and shrub layer in the landscape surrounding Gorham's at this time.

Further support for the reconstructed landscape is provided in the model of Finlayson and Giles Pacheco (2000). Using a range of parameters the authors predicted that the vegetation surrounding Gorham's would have been akin to a wooded savanna, with high grass cover and a patchy distribution of shrubs and trees. The dominant tree species predicted by the model was *P. pinea,* which exhibited a high probability of reaching a wide distribution. This was supported by patches of juniper (*Juniperus phoenicea*) and cork or round-leafed oaks (*Quercus suber/rotundifolia*). The macroscopic charcoal evidence for this period indicates an open forest of *P. pinea,* supported by a sparse shrub layer of *Pistacia lentiscus* (mastic), *Juniperus* sp., *Quercus* sp., *Ephedra* sp. and *Arbutus* sp., and is thus highly consistent with the proposed model.

Sedimentary unit BeSm.1, also now believed to be MIS 3 in age (Chapter 6), is restricted to just 19 macroscopic charcoal fragments. As such, only presence/absence interpretations can be made. The presence of *Pinus* sp., *Juniperus* sp. and *Pistacia* sp. is consistent with a vegetation assemblage similar to that observed in the lower part of the sequence. In the present day, *Pistacia* sp. is considered to be indicative of Mediterranean evergreen plant communities (Polunin and Smythies 1973) in the thermo-Mediterranean ecotone (Rivas-Martínez 1987). Communities of lentisc (*P. lentiscus*) are present on the rock above the cave today, alongside *Ephedra* sp. and *Olea* sp. (olive) forming part of the maquis vegetation. As a thermo-Mediterranean bio-climatic indicator, the presence of *Pistacia* sp. would appear to indicate a floral assemblage that may not be too dissimilar to that evidenced in Gibraltar today.

Finlayson and Giles-Pacheco's reconstruction (2000) seems to under-estimate the presence of *Pistacia lentiscus* (lentisc), when compared to the macroscopic charcoal results. This problem was first identified by Gale and Carruthers (2000), who ascribed the differences to edaphological requirements of these species, which preferentially grow in rocky areas with alkaline soils (Valdéz *et al.* 1987). However, it should be noted that the charcoal quantities are far too small to give statistically significant results and there may be other (anthropogenic) reasons for a highly localized concentration of *Pistacia* sp. charcoal in this layer. The validity of the model is thus difficult to evaluate.

The sedimentary units from UBSm.6 to CHm.2 at the top of the stratigraphic column would appear also to fit within MIS 3 and the early part of MIS 2. On current dating evidence, the macroscopic charcoal assemblage recovered in these units most probably covers the period between *c.*35–25ka BP.

The assemblage shows a predominance of *Pinus* sp. and *P. pinea,* indicating that this species was especially prevalent in the local environment surrounding Gorham's. However, the extremely low charcoal abundance in the majority of sedimentary units means that interpretation is largely based on a presence/absence basis. Despite this, the statistically significant charcoal assemblages of CHm.5 and

CHm.4 present a local landscape strongly dominated by *P. pinea*. *Juniperus* sp. is present in low frequencies alongside Rosaceae/Ericaeae/Cistaceae, indicating a local landscape dominated by *P. pinea* with patches of *Juniperus* sp. and schlerophylous shrubs.

The vegetation composition in MIS 3 bears a close resemblance to that observed in the older assemblages. As such, it opens the possibility of a stable vegetation composition surrounding Gorham's during several time intervals of the Last Glacial period. Further support is provided in recent research by Finlayson *et al.* (2008), who reconstruct the environment surrounding Gorham's at the time of the Last Glacial Maximum (LGM). Utilizing macroscopic charcoal and pollen evidence from the back of the cave, they observe a very similar vegetation assemblage to that presented in this research, dominated by *P. pinea* and *Pinus pinaster*, with *Juniperus*, Cistaceae (Cistus/rockrose family), *Fagaceae*, *Erica* and *Olea* in lesser frequencies. They conclude that the vegetation assemblage of the LGM shows close affinities to that of the present day in Gibraltar. As such, this provides further evidence that the vegetation dynamics of Gibraltar has changed very little throughout the Late Pleistocene and into the Holocene. Whilst the cave sediments as observed during excavation showed distinct signs of disturbance through burrowing (A. Currant, pers. comm.), the lack of any anomalous species anywhere in the sequence suggests that the possibility of reworking does not change our conclusions.

A montane influence?

During an initial anthracological investigation of Gorham's, Gale and Carruthers (2000) identified the presence of upland pines, *Pinus sylvestris/nigra*, in the Cemented Hearths mEMBER (CHm), dating to *c*.30ka BP. Both *P. sylvestris* (Scots pine) and *Pinus nigra* (black pine) species exhibit very similar anatomical features, and are typically grouped together since they are difficult to distinguish (Figueiral and Carvaillet 2005). Today, *P. sylvestris* and *P. nigra* are characteristically located at high altitudes (>1000 m a.s.l.) in the western Mediterranean region and their presence in the Gorham's charcoal record led Finlayson and Giles Pacheco (2000) to propose a significant altitudinal displacement of vegetation, with the montane pines reaching the coast, and expanding at the expense of existing thermophilous pines, e.g. *P. pinea*, *P. pinaster* or *P. halepensis* (Aleppo pine).

However, subsequent observation of macroscopic charcoal from the CHm member revealed that the original identification of *Pinus sylvestris/nigra* may have been flawed (Gale, pers. comm.). A key anatomical feature of upland pines, such as *P. sylvestris* or *P. nigra*, is the presence of large fenestriform (window-like) cross-field pitting in the radial plane (Fig. 7.9). In contrast, pines located in lower altitudes, such as *P. pinea*, generally exhibit numerous small spheroid pits (Fig. 7.10). Importantly, upon re-examination of the charcoal fragments initially identified as *Pinus sylvestris/nigra* in Gale and Carruthers' (2000) study, it was observed that numerous charcoal fragments exhibited radial cross-field pitting that resembled fenestriform types, positioned directly adjacent to spheroid cross-field pitting. As such, the affected charcoal fragment identifications were subsequently altered to *Pinus* sp. as these fragments could not be confirmed as upland or lowland pines (Gale, pers. comm.). This ambiguity was confirmed during the present research with the observation of several CHm.5 charcoal fragments displaying both fenestriform and spheroid pitting (Fig. 7.11). Unfortunately, the fragments identified in the initial investigation could not be retrieved for re-examination.

Consequently, there exist two possible scenarios. Firstly, these charcoal fragments could represent *Pinus sylvestris/nigra* charcoal in the record, possibly indicating the hybridization between upland and lowland pines. However, hybridization seems unlikely, particularly between an upland pine and the dominant lowland pine species in the Gorham's record, *P. pinea*, which does not hybridize with any other pine species (Fady *et al.* 2004). Recent excavations at Gorham's have noted the minor presence of *Pinus sylvestris/nigra* during the LGM (*c*.20ka BP), from macroscopic charcoal evidence (Finlayson *et al.* 2008). Further evidence of the low altitude presence of *P. nigra* in the Late Pleistocene has been demonstrated in the macroscopic charcoal assemblage at Nerja Cave, and Coca de la Cendres, southern Spain, around the LGM (Badal *et al.* 1991; Badal 1996; 1998). Like Gorham's, Nerja Cave is situated close to present sea level (152 m a.s.l.), and so the presence of upland pine in the Nerja charcoal record demonstrates that a significant altitudinal shift in vegetation could be possible. Badal also observed several thousand *P. nigra* cones/nutshells at Nerja Cave, whereas at Gorham's the several thousand charred seeds discovered in CHm.5 were solely from *P. pinea*, and none derived from *P. nigra*. However, the absence of *Pinus nigra* charred seeds at Gorham's may simply be reflective of different food preferences of the human occupants, favouring *P. pinea* instead.

An alternative possibility is that the fenestriform pitting actually represents structurally deteriorated lowland pine species, such as *P. pinea*. The anatomical degradation in the CHm.5 fragments was extensive, displaying signs of both vitrification and mineralization. It is entirely possible for the structural breakdown of spheroid pitting within the radial cross field to develop into what resembles a window-like pit. Such a scenario would explain the presence of both shapes of pitting in the same sample, and would be consistent with the absence of upland pines in the CHm.5 Gorham's macroscopic charcoal record. This would also explain the modelling results of Finlayson and Giles-Pacheco (2000) that advocated no such montane species in the Gorham's landscape at this time.

Unfortunately, the deteriorated state of the affected charcoal fragments in CHm.5 means that neither of these two possible scenarios can be safely affirmed. Consequently, all charcoal fragments in CHm.5 that displayed this anatomical trait have been incorporated into *Pinus* sp., thereby maintaining the integrity and consistency of the research. However, it is important to note that there remains a distinct possibility that *Pinus sylvestris/nigra* was of minor presence in the local landscape surrounding Gorham's *c*.30ka BP.

Phytolith analysis

The complete lack of phytoliths at Gorham's is a curiosity which requires explanation. Amongst possible reasons for

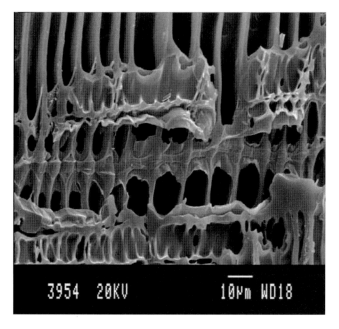

Fig. 7.9 SEM images of radial cross-field 'fenestriform' pitting in upland pine, *Pinus nigra*. Photo: S. Ward.

Fig. 7.10 SEM image of radial cross-field pitting in lowland pines. Photo: S. Ward.

this absence is that they were removed from the sediments by downward percolation. However, phytolith accumulations would still have been expected in some sedimentary layers, overlying impermeable barriers such as the numerous cemented sedimentary layers at Gorham's. Furthermore, the absence of phytoliths in micro-scale *in situ* hearths at the cave would be unlikely if widespread microscopic percolation was a major factor. While not ruling out the influence of particle movement, the evidence instead suggests that either phytoliths did not enter Gorham's (highly improbable), or an environment existed that did not permit their durability.

Anthropogenic plant use
Wood collection strategies
Ring curvature results from Gorham's show that macroscopic charcoal fragments were strongly dominated (>70 per cent) by straight growth rings. Although the

small size of the charcoal fragments restricts the application of these data, it can be inferred that the majority of collected wood was of medium to large branch size (also seen at Vanguard Cave). This observation is supported by the negligible frequencies of pith or bark. Since the proportion of internal wood structure to bark/heartwood increases with increased wood piece diameter, it is logical to assume relatively fewer charcoal fragments with bark/heartwood present derived from larger pieces of wood. This suggests that there was little difference in the collecting strategies of humans throughout the Last Glacial period (*c*.132–12ka BP). However, as dead pine branches, which naturally occur in the lower parts of trees, often lose their bark and would provide good fuel, it is possible that the lack of bark in the charcoal is the result of positive selection of these dead branches rather than a reflection of branch size.

At Gorham's, part-vitrified charcoal fragments were more frequently observed in gymnosperms, particularly within the *P. pinea*-dominated sedimentary members such as CHm, *c*.32–25ka BP. This is consistent with recent research by Py and Ancel (2006), who observed a close association between vitrification and highly resinous wood such as gymnosperms, additionally suggesting a seasonal control on the charcoal assemblages due to many gymnosperms concentrating the storage of resin during spring and summer. Despite also being linked to the presence of greenwood (Thery-Parisot 2001), the dendrological results from Gorham's indicate a stronger correlation with resinous vegetation, possibly reflecting cave occupation during spring/summer periods. The analysis of marine shell from Vanguard Cave (Chapter 22) concludes that mussel shells were collected mid-spring, and while it cannot be assumed that the two caves were not used in different seasons, the parallel seen here is interesting.

Human diet
The presence of substantial deposits of charred *P. pinea* cone scales and nutshells in several of the stratigraphic members

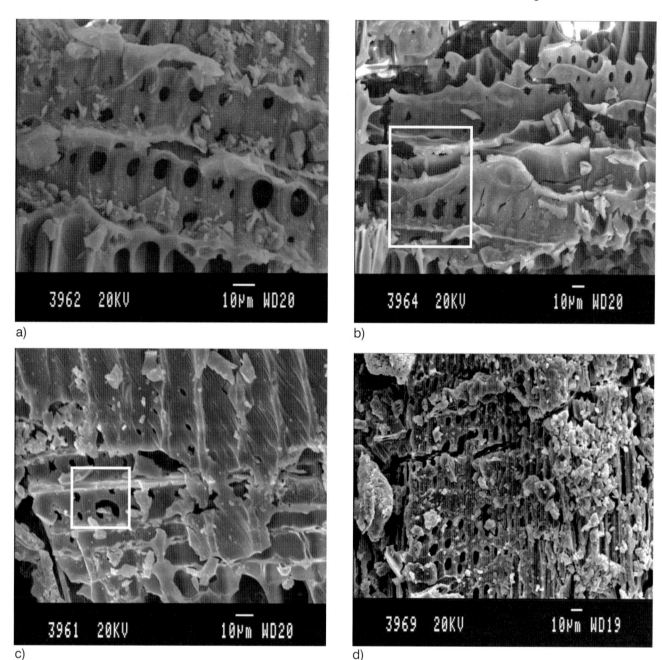

a)

b)

c)

d)

Fig. 7.11 a-d SEM images of radial cross-field pitting in archaeological pine charcoal fragments from CHm.4, demonstrating both fenestriform-like pits and spheroid pitting. Photo: S. Ward.

at Gorham's and Vanguard Caves suggests that they were deposited by human activity, while the widespread charring of the macrofossil seeds indicates that the inhabitants may have used fire for processing cones. The use of heat to assist in the ripening and opening of pine cones has been observed in North American Indian tribes, with the roasting process often making the nuts more palatable and prolonging storage life (Dixon 1905; Vestel 1952). *P. pinea* cones possess edible seeds, pine nuts, that have long been used in the Mediterranean region for human consumption because of their high nutritional value (50 per cent fats and 35 per cent proteins) (Gil 1999; Moussouris and Regato 1999; Badal 2001).

It is probable that the anthropogenic processing of the pine cone scales extends back to the last interglacial period (Vanguard Cave). At Gorham's there is a particularly substantial accumulation of pine cone scales in

SSLm.(Usm).2 (2128 individual pine cone/nut fragments). It illustrates that at certain times in the past *P. pinea* nuts comprised a significant component of the Gibraltar Neanderthals' diet.

Additionally, a total of 2262 *P. pinea* cone scales and 34 *P. pinea* nutshells were retrieved from the upper sequence (CHm.5) at Gorham's, while a further five *P. pinea* cone scales and 89 *P. pinea* nutshells were identified from CHm.3. Both of these sedimentary units have been attributed to Upper Palaeolithic occupation layers, a finding that indicates that *P. pinea* nuts continued to form an important part of modern human diets in Gibraltar in the Last Glacial period. This pattern is also repeated at sites like Nerja Cave, near Malaga, where 9392 *P. pinea* cone fragments and 547 kernel shells were identified (Badal 1996; 1998), and were interpreted as a major constituent of the human diet in the Upper Palaeolithic.

Conclusions

The Gorham's macroscopic charcoal record provides an excellent archive of past vegetation, and provides evidence for environmental stability throughout the Last Glacial period. Further work is now required so as to generate statistically significant charcoal assemblages throughout the stratigraphic section, in order to understand fully the vegetation dynamics during this critical interval of time. Analysis of dendrological features of macroscopic charcoal suggests that wood collection centred upon medium- to large-sized wood pieces, while records of charred seeds indicate that *P. pinea* nuts probably formed a major constituent of the Neanderthal and Anatomically Modern Human cave inhabitants' diet in the Upper Pleistocene.

Acknowledgements

The funding for this D. Phil. research was provided by the Natural Environmental Research Council (NERC). We thank Dr Tina Badal (Universitat de València) for assistance with identification of deteriorated charcoal fragments, and Dr Marco Madella for advice on phytolith methodology. Further thanks go to Dr Stephen Jury (University of Reading), Dr Norman Charnley (University of Oxford), and members of the Gibraltar Caves Project, past and present. Finally, many thanks to Professor Kathy Willis and Professor Nick Barton for their valuable comments and advice throughout.

References

Albert, R. M., Bar-Yosef, O., Meignen, L. and Weiner, S. 2003: Quantitative phytolith study of hearths from the Natufian and Middle Palaeolithic levels of Hayonim Cave (Galilee, Israel). *Journal of Archaeological Science* 30(4), 461–480.

Alexandrian, D. 1982: Le pin pignon. *Forêt Méditerranéen* 4, 323–326.

Asouti, E. 2001: *Charcoal Analysis from Çatalhöyük and Pinabarşi, Two Neolithic Sites in the Konya Plain, South-Central Anatolia, Turkey* (London: University College London), 275.

Asouti, E. and Austin, P. 2005: Reconstructing woodland vegetation and its exploitation by past societies, based on the analysis and interpretation of archaeological wood charcoal macro-remains. *Environmental Archaeology* 10, 1–18.

Badal, E. 1996: La vegetation du paleolithique superieur et de l'Epipaleolithique aux alentours de la Cueva de Nerja. *Actes du Colloque de Periguéux 1995, Supplément à la Revue d'Archéométrie*, 171–176.

Badal, E. 1998: El interés económico del pino piñonero para los habitantes de la Cueva de Nerja, I Simposio de Prehistoria Cueva de Nerja. *Las culturas del Pleistoceno en Andalucía. Homenaje al Profesor Francisco Jordá Cerdá* (Nerja: Fundación Cueva de Nerja), 287–300.

Badal, E. 2001: La recolección de piñas durante la prehistoria en la Cueva de Nerja (Málaga). *De neandertales a cromañones-el inicio del poblamiento humano en las tierras valencianas*, Villaverde, V. (ed.) (València: Universitat de València), 101–104.

Badal-Garcia, E. 1992: L'anthracologie prehistorique: a propos de certains problemes methodologiques. *Bulletin de la Societe Botanique de France* 139, 167–189.

Barton, R. N. E. 2000: Raw material exploitation and lithic use at the Mousterian sites of Ibex Cave, Gibraltar. *Gibraltar during the Quaternary*, Finlayson, C., Finlayson, G., and Fa, D. A. (eds.) (Gibraltar: Gibraltar Government Heritage Publications, Monograph 1), 127–134.

Bennett, K. D. 2002: *Psimpoll Computer Program* (Belfast: Queen's University of Belfast).

Dixon, R. B. 1905: The Northern Maidu. *Bulletin of the American Museum of Natural History* 17, 119–381.

Djaziri, A. 1971: *Etude stationnelle du pin pignon en Italie* (Tunis: Institut de Nationale de Recherches Forêt de Tunisie, variete scientifique, 9).

Fady, B., Fineschi, S. and Vendramin, G.G. 2004: *EUFORGEN Technical guidelines for genetic conservation and use for Italian stone pine (Pinus pinea)* (Rome: International Plant Genetic Resources Institute).

Figueiral, I. 1995: Evidence from charcoal analysis for environmental change during the interval late Bronze Age to Roman, at the archaeological site of Castro de Penices, N.W. Portugal. *Vegetation History and Archaeobotany* 4, 93–100.

Figueiral, I. and Carvaillet, C. 2005: A review of Late Pleistocene and Holocene biogeography of highland Mediterranean pines (*Pinus sylvestris*) in Portugal, based on wood charcoal. *Quaternary Science Reviews* 24, 2466–2476.

Finlayson, C. 2004: *Neanderthals and Modern Humans: An Ecological and Evolutionary Perspective* (Cambridge: Cambridge University Press).

Finlayson, C. and Giles Pacheco, F. 2000: The southern Iberian Peninsula in the Late Pleistocene: geography, ecology and human occupation. *Neanderthals on the Edge*, Stringer, C. B., Barton, R. N. E. and Finlayson, C., (eds.) (Oxford: Oxbow Books), 139–154.

Finlayson, C., Finlayson, G., Giles Pacheco, F., Rodríguez-Vidal, J., Carrión, J. and Recio Espejo, J. M. 2008: Caves as archives of ecological and climatic changes in the Pleistocene – the case of Gorham's Cave, Gibraltar. *Quaternary International* 181, 55–63.

Gale, R. and Carruthers, W. 2000: Charcoal and charred seed remains from Middle Palaeolithic levels at Gorham's and Vanguard Caves. *Neanderthals on the Edge*, Stringer, C. B., Barton R. N. E. and Finlayson, C. (eds.) (Oxford: Oxbow Books), 207–210.

Gil, L. 1999: La transformación histórica del paisaje: la permanencia y la extinción local del pino piñonero. *Jornadas de historia, socioeconomía y política forestall. Los montes y su historia-una perspectiva política, económica y social*, Marín, F., Domingo, J., and Calzado, A. (eds.) (U. Huelva), 151–185.

Goldberg, P. and Macphail, R. I. 2000: Micromorphology of sediments from Gibraltar Caves: some preliminary results from Gorham's Cave and Vanguard Cave. *Gibraltar during the Quaternary*, Finlayson, C., Finlayson, G., and Fa, D. A. (eds.) (Gibraltar: Gibraltar Government Heritage Publications, Monograph 1), 93–108.

González-Martínez, S. C., Gerber, S., Cervera, M. T., Martínez-Zapater, J. M., Gil, L. and Alía, R. 2002: Seed gene

flow and fine-scale structure in a Mediterranean pine (*Pinus pinaster* Ait) using nuclear microsatellite markers. *Theoretical and Applied Genetics* 104, 1290–1297.

Greguss, P. 1955: *Identification of Living Gymnosperms on the Basis of Xylotomy* (Budapest: Akademiai Kiado).

Hansen, J. 2001: Macroscopic plant remains from Mediterranean caves and rockshelters: avenues of interpretation. *Geoarchaeology* 18(4), 401–432.

Heinz, C. 1991: Upper Pleistocene and Holocene vegetation in the south of France and Andorra. Adaptations and first ruptures: new charcoal analysis data. *Review of Palaeobotany and Palynology* 69(4), 299–324.

Heinz, C. and Thiébault, S. 1998: Characterisation and palaeoecological significance of archaeological charcoal assemblages during late and post-glacial phases in southern France. *Quaternary Research* 50(1), 56–68.

Jacquiot, C. 1955: *Atlas d'Anatomie des Bois des Conifers* (Paris: Centre Technique du Bois).

Jacquiot, C. 1973: *Atlas d'Anatomie des Bois des Angiosperms* (Paris: Centre Technique du Bois).

Linares, L., Harper, A. and Cortés, J. 1996: The flowers of Gibraltar. *Gibraltar*, Rose, E. P. F., and Rosenbaum, M. S. (eds.) (Gibraltar: The Gibraltar Museum).

Macphail, R. I. and Goldberg, P. 2000: Geoarchaeological investigations of sediments from Gorham's and Vanguard Caves, Gibraltar: microstratigraphical (soil micromorphological and chemical) signatures. *Neanderthals on the Edge*, Stringer, C. B., Barton, R. N. E. and Finlayson, C. (eds.) (Oxford: Oxbow Books), 183–200.

Madella, M., Jones, M. K., Goldberg, P., Goren, Y. and Hovers, E. 2002: The exploitation of plant resources by Neanderthals in Amud Cave (Israel): the evidence from phytolith studies. *Journal of Archaeological Science* 29(7), 703–719.

Mariette, S., Chagné, D., Lézier, C., Pastuszka, P., Raffin, A., Plomion, C. and Kremer, A. 2001: Genetic diversity within and among *Pinus pinaster* populations: comparison between AFLP and microsatellite markers. *Heredity* 86, 469–479.

Martínez Ruiz, F. and Montero, G. 2005: The *Pinus pinea* L. woodlands along the coast of South-western Spain: data for a new geobotanical interpretation. *Plant Ecology* 175, 1–18.

Metcalf, C. R. 1964: Gorham's Cave, Gibraltar: report on the plant remains. *Bulletin, Institute of Archaeology* 4, 219.

Moussouris, Y. and Regato, P. 1999: Forest harvest: an overview of non-timber forest products in the Mediterranean region. Retrieved from *http://www.fao.org/docrep/x5593e/x5593e03.htm*.

Neumann, K. and Richter, H. G. 2000: *Woods of the Sahara and the Sahel, an anatomical atlas* (Bern and Stuttgart: Paul Haupt Publisher).

Ntinou, M. 2000: *El paisaje en el Norte de Grecia desde el Tardiglaciar al Atlantico. Formaciones vegetales, recursos y usos* (València: Universitat de València, Unpublished Ph. D. Thesis).

Pearsall, D. M. 2000: *Palaeoethnobotany: a handbook of procedures* (San Diego: Academic Press).

Plaisance, G. 1977: Le pin parasol. *Forêt Privée* 115, 47–54.

Polunin, O. and Smythies, B. E. 1973: *Flowers of South-West Europe: A Field Guide* (London, New York and Toronto: Oxford University Press).

Prada, M. A., Gordo, J., De Miguel, J., Mutke, S., Catalán-Bachiller, G., Iglesia, S. and Gil, L. 1997: Las regiones de procedencia de Pinus pinea L. en España. Ministerio de Medio Ambiente, Organismo Autónomo Parques Nacionales, Madrid. *EUFORGEN Technical guidelines for genetic conservation and use for Italian stone pine (Pinus pinea)*, Fady, B., Fineschi, S. and Vendramin, G. G. (eds.) (Rome: International Plant Genetic Resources Institute).

Py, V. and Ancel, B. 2006: Archaeological experiments in fire setting: protocol, fuel and anthracological approach. *Charcoal analysis: new analytical tools and methods for archaeology*, Dufraisse, A. (ed.) (Oxford: BAR International Series 1483), 71–82.

Rivas-Martínez, S. 1987: *Memoria del mapa de series de vegetacíon de España. 1:400.000* (Madrid: I.C.O.N.A).

Schoch, W., Heller, I., Schweingruber, F. H. and Kienast, F. 2004: *Wood anatomy of central European species*. Online version: *www.woodanatomy.ch*.

Schweingruber, F. H. 1978: *Microscopic wood anatomy, mikroskopische Holzanatomie* (Birmensdorf: Swiss Federal Institute for Forest, Snow and Landscape Research, CH-8903).

Schweingruber, F. H. 1990: *Anatomy of European Woods* (Stuttgart and Berne: Haupt).

Tapias, R., Gil, L., Fuentes-Utrilla, P. and Pardos, J. A. 2001: Canopy seed banks in Mediterranean pines of southeastern Spain: a comparison between *Pinus halapensis* Mill., *P. pinaster* Ait., *P. nigra* Arn. and *P. pinea* L. *Journal of Ecology* 89, 629–638.

Terral, J. and Mengual, X. 1999: Reconstruction of Holocene climate in southern France and eastern Spain using quantitative anatomy of olive wood and archaeological charcoal. *Palaeogeography, Palaeoclimatology, Palaeoecology* 153(1–4), 71–92.

Terral, J.-F., Alonso, N., Buxó I Capdevila, R., Chatti, N., Fabre, L., Fiorentino, G., Marinval, P., Peréz Jordá, G., Pradat, B., Rovira, N. and Alibert, P. 2004: Historical biogeography of olive domestication (*Olea europaea* L.) as revealed by geometrical morphometry applied to biological and archaeological material. *Journal of Biogeography* 31, 63–77.

Thery-Parisot, I. 2001: *Economie des combustibles au Paleolithique. Experimentation, taphonomie, anthracologie* (Paris: Dossier de Documentation Archaeologique, 20 C.N.R.S.-C.E.P.A.M).

Valdéz, B., Talavera, S. and Fernández-Galiano, E. 1987: *Flora Vascular de Andalucía* (Barcelona: Ketres).

Vernet, J.-L. 1980: The vegetation of the Aude Basin between the Pyrenees and the Massif Central during Late Glacial and Postglacial time on the basis of charcoal analysis. *Review of Palaeobotany and Palynology* 30(1–2), 33–35.

Vestel, P. A. 1952: *Ethnobotany of the Ramah Navaho: reports of the Ramah Project No.4* (Boston: Papers of the Peabody Museum of American Archaeology and Ethnology, 40).

8 Amphibians and reptiles from Gorham's Cave

C.P. Gleed-Owen and C. Price

Introduction and background

The modern herpetofauna of the Iberian Peninsula contains 64 non-marine species, comprising eight newts and salamanders, 16 frogs and toads, four tortoises and terrapins, 23 lizards and 13 snakes (Pleguezuelos 1997). Collectively they occupy a wide range of habitats and climatic regimes, but many species have restricted ecological and climatic tolerances. As such, amphibians and reptiles can be sensitive indicators of environmental change. They are ectothermic and therefore dependent on ambient temperature. Amphibians are typically nocturnal and operate at lower temperatures, but reptiles are generally diurnal and need to thermoregulate via direct insolation or lying beneath warm objects. Most species undergo a period of hibernation during the winter, and some undergo periods of aestivation during the summer, particularly further south. Southern parts of Europe support greater herpetofaunal diversity, and are home to numerous thermophilic species that cannot tolerate cooler climates. The mean summer temperature is normally the determining factor, but also the number of sunshine hours in some cases.

Most amphibian and reptile skeletal remains are comparable in size to remains of rodents, birds and fish. Subfossil herpetofaunal remains are often identifiable to a high taxonomic level. Even where the species cannot be identified, it is normally possible to identify the genus, and almost always the family. Taphonomy has a strong control over the condition of herpetofaunal remains, but even apparently delicate bones can be preserved intact. General shape and size often allow instant diagnosis, but examination of subtle morphological features and ornamentation is necessary in many cases. In contrast to small mammals, much of the identification focuses on postcranial remains. Specific identification is possible for many skeletal elements in toads, and for some elements in frogs. Generic identification is possible from most skeletal elements in anurans (frogs and toads). For newts, salamanders, lizards and snakes, vertebrae and cranial bones are the most useful elements for specific or generic identification. Vertebrae are typically the most abundant elements too, being numerous in the body, especially for snakes. Hence, even a modest sample can yield a surprisingly diverse assemblage. Herpetofaunal remains are often well preserved in caves, and frequently identifiable to species level. Their modern environmental tolerances permit the interpretation of palaeoclimatic conditions and habitat types. These characteristics make them a useful group to study palaeoecologically.

A preliminary analysis of herpetofaunal remains from 1995–1996 excavations at Gorham's and Vanguard Caves (Gleed-Owen 2001) demonstrated the richness of this resource and the value of the information it contained. The list contained at least 28 amphibian and reptile species, making it one of the richest European assemblages ever identified. Note that most of the Gorham's material came from Mousterian 'context 4d' (layer LBSmcf.4 in the new stratigraphy). Further work was essential to achieve wider chronological coverage and enable robust interpretations. The aims of the current study were therefore to identify and evaluate the herpetofauna from as much of the stratigraphy as possible. A further 200 or so samples have since been studied, and the new data fill significant gaps in faunal chronology, and enable palaeoecological and palaeoenvironmental reconstructions.

Methods

The herpetofaunal material was picked by CP from bulk sample sieve residues, and sorted by eye and low power microscope at the Natural History Museum, London (NHM). The material was studied by CGO from 2002–2007 using a binocular reflected-light microscope (model МБС-10), with ×5–×32 magnification. The remains were separated taxonomically, sub-bagged within each sample, and sub-labelled accordingly. Some bones of small herpetofauna such as newts, small lizards and amphisbaenians are typically lost during sample processing if a sieve mesh greater than 0.5 mm is used, and it is possible that some smaller remains are lost from this material. The herptofaunal material is held at the Natural History Museum, London.

Remains were identified to the highest taxonomic level possible using CGO's reference collection, as well as notes and drawings from collections at the Museo Nacional de Ciencias Naturales (MNCN) in Madrid (courtesy of B. Sanchíz), and J. Barbadillo's personal collection at the Universidad Autónoma (UAM) in Madrid. Owing to the preponderance of southern spadefoot toad *Pelobates cultripes* bones in the samples, most of its skeletal elements were well represented and therefore used in identification (Fig. 8.1). Relatively few bones were encountered for other anurans (usually ilia, vertebrae and long bones). A few vertebrae represented the newts (Fig. 8.2) and salamanders. Numerous shell fragments and some long bones identified the tortoises and terrapins. The lizards were mainly identifiable from dentaries, maxillae (Fig. 8.3), vertebrae (Fig. 8.4), innominates and long bones. Snake vertebrae were fairly ubiquitous and much more frequently encountered than cranial elements. Complete identification of the snake and lizard remains would require much further work, but adequate data have been acquired so far.

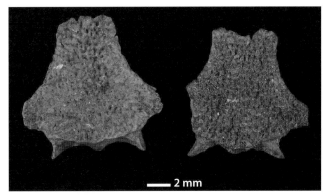

Fig. 8.1 Spadefoot toad *Pelobates cultripes* frontoparietals (Gor96/103). Photo: Museo Nacional de Ciencias Naturales, Madrid.

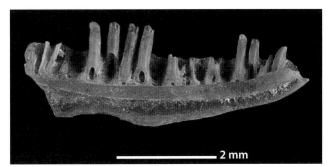

Fig. 8.3 Lizard *Sauria* maxilla. Photo: Museo Nacional de Ciencias Naturales, Madrid.

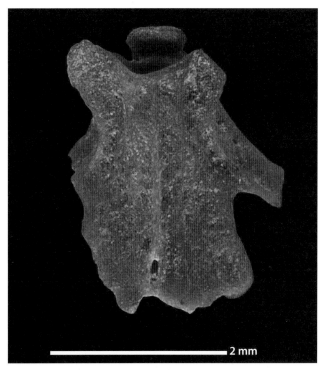

Fig. 8.2 Pygmy marbled newt *Triturus pygmaeus* vertebra (Gor96/103). Photo: Museo Nacional de Ciencias Naturales, Madrid.

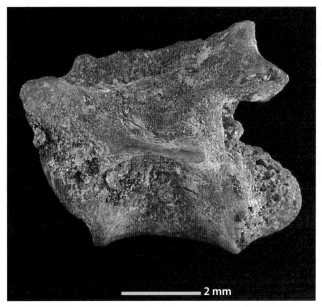

Fig. 8.4 Ocellated lizard *Timon lepidus* vertebra (Gor95/248). Photo: Museo Nacional de Ciencias Naturales, Madrid.

Results

The total assemblage contains at least 28 species, a gain of one species from the previous report (Gleed-Owen 2001). This is the minimum number of species present, however, and almost certainly an underestimate. Small lizards are difficult to identify palaeontologically, and with many lizard remains not diagnosed to species level, the assemblage probably contains additional lizard species in particular.

Table 8.1 shows the minimum number of species identified from each stratigraphic unit. Between SSLm(Lsm).8 (the earliest herpetofaunal remains recovered) and CHm.2 (the latest), species diversity fluctuates greatly but is consistently greater in the lower half of the sequence. After an initial spike in SSLm(Lsm).6, it dips but then remains moderate to high until LBSmff.7 and then declines. It continues to fluctuate through the upper half of the sequence, with a further spike in UBSm.6.

Table 8.2 shows the occurrence of individual taxa through the sequence. The most frequent species is the southern spadefoot toad (*Pelobates cultripes*) which is almost ubiquitous (29 out of 30 layers). These would have thrived in the sandy habitats of the adjacent coastal plain.

The largest assemblage is from LBSmcf.11 which yielded 21 species. However, there are five other strata with almost equal diversity, and most layers have a reasonably diverse herpetofauna. Of the 53 layers in the official stratigraphy, herpetofaunal remains have been studied from 30, and these produced a mean species diversity of 9.13. Southern spadefoot toad is ubiquitous and southern smooth snake (*Coronella girondica*) is almost ubiquitous. In contexts with rich species diversity, the fauna is very similar to that of present-day Coto Doñana near Sevilla in Andalusia, southern Spain (Hilbers 2005), but with the addition of species that like rocky places, such as

southern smooth snake and false smooth snake (*Macroprotodon cucullatus*).

Most species that are present in the peak of species diversity in the earlier half of the sequence make a brief or sporadic reappearance in the later peak, presumably reflecting a repetition of similar conditions. The long early peak and brief later peak in diversity may reflect warmer periods. Most of the colubrid snake species are frequent in the lower sequence and also appear in the later peak in UBSm.6 and UBSm.7. Tree frogs, newts and some lizards follow a similar pattern.

There are some notable exceptions to this pattern, however. The common toad (*Bufo bufo*) and natterjack toad (*Epidalea calamita*) occur regularly earlier on, but are absent from the later spike in species diversity. Skink

Table 8.1 Identified herpetological specimens from Gorham's Cave.

Where number of identified specimens is not available, presence is marked +.

	CHm.2 or above	CHm.3-5	UBSm.1	UBSm.2	UBSm.5	UBSm.6	UBSm.7	BeSm(OSsm).1	BeSm(OSsm).2	LBSmff.3	LBSmff.4	LBSmff.6	LBSmff.7	LBSmff.8	LBSmff.10	LBSmff.11	LBSmcf.8	LBSmcf.9	LBSmcf.11	LBSmcf.12	LBSmcf.13	SSLm(Usm).1	SSLm(Usm).2	SSLm(Usm).3	SSLm(Usm).5	SSLm(Lsm).6	SSLm(Lsm).7	SSLm(Lsm).8
Pleurodeles waltl			+										1		+											4		
Triturus marmoratus						+			+																			
Triturus pygmaeus										3				1	2				4	1						1		
Triturus sp.										+				1				1	1									
Anura indet.	19						+			25	14		40	28		42			29	72	7	1						
Discoglossus sp.		?											1		1	3			1	1						1		
Alytes sp.																1												
Pelobates cultripes	256	+	+	+	+	+	+	+	+	323	24		172	166	1077	561	116	1519	1282	549	70	142	69	59	787	1231	36	4
Bufo bufo spinosus	2									1			1	1	3				4	3						1		
Epidalea calamita													1	2	1				1	1								
Bufo sp													1		1				2									
Hyla meridionalis	2				+	+			+	2	1		2	8	8			6	17				1	1				
Rana sp.		+				+										1										1		
Pelophylax perezi																												
Chelonia indet.			+		+	+	+		+	5				3	13			1	13	4	1	5	1		1			
Eurotestudo hermanni																4	1	1	6			1						
Eurotestudo cf graeca ibera																						1						
Eurotestudo sp.									+	3				1	4	6			6	9	6	3		1		1		
Emydidae indet.																				1	1							
Gekkonidae indet.														1														
Sauria indet.			+		+	+			+	14				85	71	16	16	37	243	56	10	8	1		19	65		
Tarentola mauritanica	?2			+						1			1	5	8	1		10	6	8		2						
Psammodromus sp.						+			+																			
Acanthodactylus erythrurus						+	+	+	+				1	4	1			1	4							1		
Lacertidae indet.						+	+	+		2			7	18		5	3	2	4	14		3	5			3		
Timon lepidus														3	1				1							1		
Lacerta schreiberi																				1								
Podarcis sp.																				2								
Podarcis cf hispanica									+																			
Chalcides sp.												1	1	19	1	2		2	11	5	1		1		1	17		
Ophidia indet.	2		+			+	+						2	8	5	35		17	16	12	3	2						
Colubridae indet.		+	+			+	+		+	22	2		9	9	87	12	17	231	96	52	11	14		1	36	13		
Malpolon monpessulanus						+	+						3	1	4	1		2	4	1	1				6	1		
Hemorrhis hippocrepis						+	+			4				1	14	5		8	10	7		3	1					
Rhinechis scalaris						+	+			1		1	1	2	1	9		12	3	2	3	2			3	3		
Natrix sp.			+											1	1			19		1				?1	1	3		
Natrix natrix			+											2		2				1								
Natrix maura			+															36		1					2	1		
Coronella girondica		+	+	+	+	+			+	14	1		10	5	22	25	4	120	35	26	4	6	1	1	7		1	
Macroprotodon cucullatus														3		6												
cf. *Telescopus* sp.		?												1				12										
Vipera sp.						+							1		4				3	1								
Vipera berus/ seoanei					+										3				1									
Vipera latasti								+		+		1		6	10	2												
Total No. ID Specimens	283									517	49		294	405	1414	801	173	1519	1707	839	122	196	84	65	865	1353	37	4

Table 8.2 Number of amphibian and reptile species per stratigraphic unit.

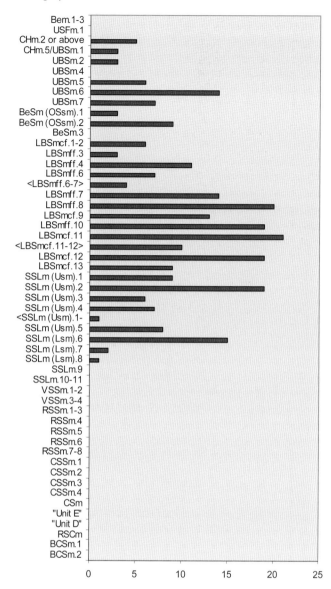

and one with Iberian tortoise (*Eurotestudo ibera*). The later units produced a few remains of indeterminate tortoise.

The few tiny trunk vertebrae have similarities to those of the snake genus cf. *Telescopus* sp. (Z. Szyndlar, pers. comm.). They are short and squat with small parapophyses and a broad indistinct keel, but the material is too scant to be conclusive. There is no Quaternary or modern record of this genus from the Iberian Peninsula, and its presence here would mean a hitherto unrecognized occurrence and subsequent extinction.

Unsurprisingly, herpetofaunal species diversity tends to be roughly proportional to the volume of herpetofauna bones through the sequence. In other words, the more bones in the assemblage, the more species they represent.

Modern ecology of the herpetofauna

Ecological and distribution information has been drawn from Arnold and Ovenden (2002), Gasc *et al.* (1997), Pleguezuelos (1997) and Street (1979). The ecologies and habitat preferences of individual species provide us with the basis for interpretation of the palaeoenvironments inferred collectively. Each species is briefly considered here, in taxonomic order.

At least two salamander species are represented in the Gorham's assemblages. Sharp-ribbed salamander (*Pleurodeles waltl*) is found in southern Iberia and Morocco. It is highly aquatic and mainly nocturnal, living in ditches, ponds, slow-moving rivers and occasionally temporary pools. It aestivates beneath stones when waterbodies dry up. Pygmy marbled newt (*Triturus pygmaeus*) is distributed in Iberia and south-west France, with a range that is largely mutually-exclusive to that of its larger sister species the marbled newt (*Triturus marmoratus*) with which it was formerly conspecific. It occupies still or slow moving water with good aquatic weed growth for much of the year, but during its terrestrial phase may be found in fairly dry woods and scrub as well as open habitats.

There are at least seven anuran (frog and toad) species here. Scarce remains of *Discoglossus* sp. (painted frogs) could be *D. pictus* or *D. galganoi* in southern Iberia. These are usually in or around still or running water, preferring shallow areas to live and breed. They are active day and night. Midwife toads of the genus *Alytes* are scarcely represented. They could be *A. cisternasii* which is only found in west and central Iberia or *A. obstetricans* which ranges throughout western Europe. *A. cisternasii* mostly occupies open sandy habitats, whereas *A. obstetricans* is more associated with woodlands, scrub, rock piles, etc. Both are mainly nocturnal. By far the most dominant species within the assemblages, the western spadefoot toad (*P. cultripes*) is a burrowing species found in sandy areas throughout most of Iberia, and western and southern France. Spadefoots are nocturnal and make deep burrows to hide and avoid desiccation during the day and in periods of drought. They may be found in large numbers on sandy coasts, which explains their predominance at Gorham's. They are also found in open marshy areas with shallow water where they breed.

Two species of toad occur in the Gorham's material that range across Europe, including Britain today. European common toad (*B. bufo*) is tolerant of a wide variety

remains (*Chalcides* sp.) are found in seven earlier units, but not in the later units. A similar pattern is seen in grass snake (*Natrix natrix*), viperine snake (*Natrix maura*), and ocellated lizard (*Timon lepidus*). None of these species appears after LBSmff.4/LBSmcf.2, suggesting they may have been locally or regionally absent later on. Cooler summer temperatures are not a likely cause, as some distinct thermophiles do occur later on. One possibility might be a climatic shift such as decreased humidity during the later diversity spike centred on UBSm.6, resulting in broad changes to vegetation structure in the local landscape. The disappearance of common toad, grass snake, viperine snake, skink and ocellated lizard fits with a notion of reduced vegetation density overall, such as woodland disappearance and sparser ground cover. The lack of toads and natricine snakes might also reflect a decline in the availability of waterbodies.

It is striking that tortoise remains occur more or less consistently in one form or another. They tend to be more identifiable earlier on (i.e. better preserved or less fragmentary), but this is probably due to their being more abundant. Hence, specific identification was possible in five earlier layers, four with Hermann's tortoise (*Eurotestudo hermanni*)

of wooded, scrubby and open habitats, including fairly dry ones. It is mainly nocturnal and congregates in large ponds to breed. The Mediterranean subspecies *B.b. spinosus* found at Gorham's is typically larger and may have spiny skin. Specimens from Gorham's include very large ones, up to approximately 180 mm snout-vent length. The smaller natterjack toad (*Epidalea calamita*) is found across western and central Europe, typically in more open habitats than *B. bufo*. It sometimes breeds in brackish ponds and is also nocturnal. In northern Europe where summers are cooler, it is restricted to sandy habitats such as coastal dunes, and breeds in the summer. In Iberia it lives on a wider range of soils, and breeds in the cooler winter and early spring.

Tree frog remains are found in many samples. Some of the ilia could be identified to species level as stripeless tree frog (*Hyla meridionalis*) which is found in Iberia, southern France, north-west Italy and also north-west Africa. They live in well vegetated habitats where they climb in bushes, trees or reedbeds. They are mainly nocturnal and breed in ponds and marshy waterbodies. Very few remains were attributable to *Rana* sp. ('true frogs'). The pan-European species *R. temporaria* is absent from Iberia, and of the three species found in Iberia, one bone was identifiable as Perez's water frog (*R. perezi*). This is a species of temperate woodland, Mediterranean shrubby vegetation, rivers, swamps, lakes, marshes and sandy shores. It is mainly diurnal and, like other water frogs, basks in the sun beside ponds and on emergent vegetation.

Tortoise remains are well represented throughout the herpetofaunal material from the Gorham's sequence. Some are attributable to Hermann's tortoise (*E. hermannii*) which is distributed around southern Europe, including some coastal areas of southern Iberia. It is restricted to areas with hot summers and sufficient sunshine days. It lives in a variety of habitats, from lush meadows, to scrub, light woodland and stabilized coastal dunes. It prefers dense vegetation where it can remain hidden from predators. At least one shell fragment belongs to Iberian spur-thighed tortoise (*E. ibera*). It is found in southern Spain and is the sister species of *E. graeca* which occupies other parts of the Mediterranean and was formerly conspecific. It lives in habitats similar to *E. hermannii*. At least a few of the remains are of terrapins (aquatic freshwater turtles) of the family *Emydidae*. They could belong to European pond terrapin (*E. orbicularis*) or Iberian terrapin (*M. leprosa*), but none have been identified to species level yet. Both species occupy still or slow-moving water with good growth of aquatic plants and overhanging vegetation. They readily traverse land and can inhabit ditches, swamps and brackish areas. They lay eggs in burrows in warm sandy banks near water.

At least seven lizard species have been identified, but the remains almost certainly include several more species. These represent three families: Gekkonidae (geckos), Lacertidae (true lizards), Scincidae (skinks). Most of the remains are lacertids that have not been identified beyond family level, and specific identifications have only been attempted on a few jaw bones and on the distinctively large bones of ocellated lizard (*T. lepidus*) (Fig. 8.4). The seven species identified are all typical of southern Iberia today. Moorish gecko

(*T. mauritanica*) has a Mediterranean distribution, mainly in warm, dry coastal areas where it inhabits rock piles, cliffs, etc. It is nocturnal or diurnal depending on seasonal temperatures, and is an agile climber. Remains of lizards of the genus *Psammodromus* could not be identified to species. Of the two species in modern Iberia, both like dense bushy vegetation. Spanish Psammodromus (*P. hispanicus*) is more common in open areas such as coastal sandy plains. Spiny-footed lizard (*Acanthodactylus erythrurus*) is widespread in southern Iberia and north-west Africa. It lives in open sandy habitats, including bare and scarcely vegetated areas, and rocky places. Ocellated lizard (*T. lepidus*) is distributed across Iberia, southern France, north-west Italy and north-west Africa. It occupies a wide variety of open woodland and scrubby habitats, including high altitudes with cooler climates. It prefers dry places, including rocky or sandy areas. Schreiber's green lizard (*Lacerta schreiberi*) is found today in north-west, west and central Iberia, in comparatively moist, hilly areas with lots of bushy vegetation.

Wall lizard remains from Gorham's probably belong to Iberian wall lizard (*Podarcis hispanica*) which is found in Iberia, the Mediterranean coast of France and north-west Africa. It lives on rocky outcrops, overgrown screes and scrubby well drained slopes. Skink remains (*Chalcides* sp.) are distinctive to genus level, but could belong to either of the two Iberian species, Bedriaga's skink (*C. bedriagai*) and three-toed skink (*C. chalcides*). Bedriaga's skink is typical of sandy places with sparse or low-lying dense vegetation. Three-toed skink is usually found in damp places with low but dense herbaceous plants, such as water meadows and grassy slopes. Both species are diurnal.

There are at least ten species of snake within the Gorham's assemblage, eight colubrids and two viperids. They are all diurnal at least seasonally, and some are distinctly crepuscular or nocturnal, especially on warm summer nights. Montpelier snake (*Malpolon monspessulanus*) is found today in Iberia, Mediterranean France, Italy, south Balkans and north-west Africa. It lives in dry habitats with scrubby or patchy vegetation cover. It prefers open, rocky or sandy country with bushy vegetation, and may occur in salt-marsh or sand dune vegetation in coastal areas. Its prey includes other snakes. Horseshoe whip snake (*Hemorrhois hippocrepis*) is found in Iberia and north-west Africa where it occupies dry and often rocky places such as scrub-covered hillsides. Recent genetic work suggests that both *M. monspessulanus* and *H. hippocrepis* colonized Iberia from north-west Africa during the Late-Middle to Early-Late Pleistocene between 168,000–83,000 years ago (Carranza *et al.* 2006). They had colonized Iberia earlier in the Pleistocene too, but the modern populations originated from animals that appear to have crossed the Strait of Gibraltar at approximately the same time period that the Gorham's assemblage was accumulated.

Ladder snake (*Rhinechis scalaris*) is found in Iberia and coastal Mediterranean France today. It is often associated with sunny, stony habitats, typically with scrubby vegetation or open woodland. Grass snake (*N. natrix*) is distributed across nearly all of Europe (including Britain). It is usually found in damp scrubby and herbaceous habitats, never very far from water where it hunts for amphibians and fish. It

is less aquatic than the other two European *Natrix* species, but is still distinctly aquatic. Viperine snake (*N. maura*) is found in Iberia, France and north-west Africa. It is highly aquatic and usually found in or near water (still or flowing) where it hunts fish. It prefers weedy freshwater ponds and rivers, but may also tolerate brackish conditions.

Southern smooth snake (*C. girondica*) is the commonest snake in the Gorham's assemblage, and second only to spadefoot toad in overall frequency in the sequence. Its modern range extends through Iberia, southern France, Italy, Sicily and north-west Africa. It is typically crepuscular, but as with all herpetofauna species, will vary its behaviour according to seasonal temperatures. Southern smooth snake lives in a variety of dry scrubby habitats and open woods, as well as rocky places and screes. False smooth snake (*Macroprotodon cucullatus*) occupies southern Iberia, the Balearics and North Africa. It is typically crepuscular and nocturnal in its activity. It is a lowland species, occupying various warm, dry habitats, including sandy, open woods and scrub areas, stony places and rock piles.

A few enigmatic vertebrae from Gorham's have raised the interesting possibility of a species not found today in Iberia. Unfortunately the identifications are only tentative and cannot be confirmed. The vertebrae bear some resemblance to the genus of cat snakes, cf. *Telescopus* sp. (Z. Szyndlar, pers. comm.). The sole European representative of the genus today, *T. fallax*, is found on the eastern Adriatic coast and islands, Malta, Greek islands, south Balkans, Caucasus and south-west Asia. It is a lowland species of stony places and occasionally sandy areas with bushy plant cover.

At least two of the three Iberian vipers are present in the Gorham's material. A few vertebrae could belong to either Seoane's viper (*Vipera seoanei*) an Iberian endemic, or Northern viper (*Vipera berus*) which is pan-European except Iberia. Northern viper (known in Britain as the adder) is unlikely in Iberia given its modern Palearctic range. It is extremely well adapted to cool climates and reaches beyond the Arctic Circle. Seoane's viper is more likely in a southern Iberian subfossil context, although it is restricted to northern Iberia today. Under a cooler glacial maximum regime, it could have extended into southern Iberia. It is active diurnally and found in a range of moist habitats, including mountainous areas. Lataste's viper (*Vipera latasti*) is restricted to the Iberian Peninsula (except the extreme north) but also north-west Africa. It prefers dry, hilly landscapes, rocky areas, open woods and may be found on sandy coastal areas. It is mainly diurnal but nocturnal in warm conditions.

Palaeoecology

Palaeoecological interpretation relies upon the assumption that species' ecologies have not changed since the Late Pleistocene. For example, in a given climatic regime, they might be associated with a specific suite of habitat types (with the caveat that certain habitats and ecotones might have existed in the past that do not exist today). Virtually all European herpetofauna species speciated during the Tertiary, and have been anatomically stable for several million years. Repeated range expansions and contractions in response to Pleistocene glaciations resulted in subspeciation, as

might be expected with extended isolation in multiple southern refugia (Hewitt 1996), but essentially the species have remained the same. Thus, it can be assumed that the ecological preferences of individual species are well established, although they may also have ecological plasticities that have been well tested by multiple glaciations.

Making palaeoecological interpretations therefore requires careful assessment of the ecological tolerances of each species, and how these may vary across the species' modern geographical range. The natterjack toad (*E. calamita*) provides an example of the difficulty in transferring modern scenarios through space and time to make inferences about palaeoecology and palaeoclimate. In Britain it is restricted to sandy soils and breeds during the summer, whereas in Iberia it lives in a wider range of soils and breeds during the winter and spring. Iberia was the glacial refugium for the global population of the natterjack toad (Beebee and Rowe 2000), and so one of these modern breeding modes must have been an adaptation during the natterjack's range expansion at the beginning of the current interglacial. (Hence, it is important to consider this ecological plasticity when inferring what the climate was like during MIS 5–3 in Gibraltar.) The period of postglacial northward expansion may have lasted several thousand years overall, but probably involved rapid expansion over decades and hundreds of years. The natterjack's early arrivals in Britain, before and immediately after the Younger Dryas, suggest that it is able to make rapid phenological adaptations in response to rapid climatic shifts. Presumably this behavioural plasticity was exhibited throughout the Pleistocene, and it makes sense that during glacial maxima in the Iberian refugium, it may have bred during the summer if climate was cooler than today.

Such plasticity is essential for any species to survive rapidly fluctuating Pleistocene climates, and must be a characteristic of all species that have a wide latitudinal range. Nevertheless, the environmental tolerances of individual species, such as the types of habitat they live in, are broadly consistent across their ranges and can be applied to palaeoecological situations.

Using ecological information from Arnold and Ovenden (2002), we identified a series of broad habitat groupings for the Gorham's amphibians and reptiles, wherein species with similar habitat preferences are grouped together. This should offer insights into the palaeoecology of the assemblage. The groups are as follows:

A Still or slow-moving water: *Pleurodeles waltl, Triturus pygmaeus, Discoglossus* sp., *Pelophylax perezi, Mauremys leprosa, Natrix maura, Natrix natrix.*

B Dunes and sandy areas: *Alytes* sp., *Pelobates cultripes, Epidalea calamita, Pelophylax perezi, Psammodromus hispanicus, Acanthodactylus erythrurus, Malpolon monspessulanus, Macroprotodon cucullatus.*

C Dry Mediterranean shrubby vegetation: *Pelophylax perezi, Eurotestudo hermanni, Eurotestudo ibera, Psammodromus* sp., *Timon lepidus, Malpolon monspessulanus, Hemorrhois hippocrepis, Rhinechis scalaris, Coronella girondica.*

D Stony habitats: *Alytes obstetricans, Tarentola mauritanica,*

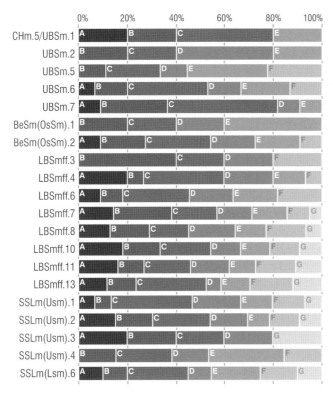

Fig. 8.5 Habitat group representation in stratigraphic units, by percentage.

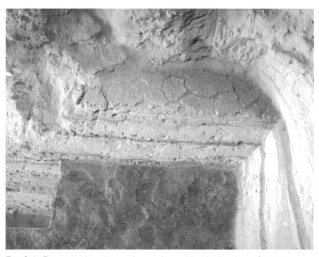

Fig. 8.6 Deposit showing polygonal cracking indicative of *in situ* desiccation of wet puddles in the cave floor (Vanguard Cave). Photo: Natural History Museum. London.

Podarcis sp., *Hemorrhis hippocrepis*, *Coronella girondica*, *Macroprotodon cucullatus*, (cf. *Telescopus* sp.), *Vipera latasti*.

E Open woodland: *Bufo bufo spinosus*, *Pelophylax perezi*, *Eurotestudo hermanni*, *Eurotestudo ibera*, *Timon lepidus*, *Coronella girondica*, *Macroprotodon cucullatus*, *Vipera latasti*, *Vipera seoanei*.

F Comparatively moist, well vegetated areas: *Bufo bufo spinosus*, *Hyla meridionalis*, *Pelophylax perezi*, *Eurotestudo hermanni*, *Eurotestudo ibera*, *Lacerta schreiberi*, *Podarcis muralis*, *Chalcides chalcides*, *Natrix natrix*, *Natrix maura*, *Vipera seoanei*.

G Swamps and marshes: *Discoglossus* sp., *Pelobates cultripes*, *Pelophylax perezi*, *Emys orbicularis*, *Natrix natrix*, *Natrix maura*.

The bar graph Figure 8.5 attempts to assess the importance of each of the seven habitat groups. For every stratigraphic unit, the size of each group's representation (i.e. the number of members present) is expressed as a percentage. This should make it possible to highlight any significant changes over time, such as the predominance or decline of any one group. Where species are members of more than one group, they are counted in each of the groups where they occur. Note that where fewer than ten group members in total were recorded from a context, the context was not included.

Overall, some interesting patterns emerge from this exercise. Group G (swamps and marshes) is continuous throughout the lower sequence up to LBSmff.7, but then disappears and remains absent from LBSmff.6 onwards. This is the most consistent pattern, but fluctuations and trends occur throughout the sequence.

Starting from the lowest contexts and moving upwards through time, from SSLm(Lsm).6 to SSLm(Usm).1, the woodland and comparatively moist, well vegetated habitats decrease over time whilst drier Mediterranean shrub vegetation increases. Species diversity fluctuates between one and 16 during this phase, with two distinct spikes.

Between LBSmcf.13 and LBSmff.10 there is an increase in species using freshwater and marshy habitats (groups A and G), open woodland species are relatively stable, and those preferring Mediterranean shrubby vegetation decrease. The subsequent layers LBSmff.9 to 6 show a decline in swamp and marsh species, and a relative increase in dry shrubby habitat. Species diversity generally remains high for this part of the sequence, but then fluctuates for the remainder of the sequence. LBSmcf.8 was omitted from this part of the research, as the overall number of identified specimens was insufficient, but it should be noted that field observation of the surface of this context showed polygonal cracking indicative of *in situ* desiccation of wet puddles in the cave floor (cf. Fig. 8.6, showing a similar deposit in Vanguard Cave). The surface was recorded as containing numerous *Pelobates cultripes* frontopareitals, taken to indicate a specific mortality event wherein numbers of the creatures perished as their aestivation site dried up.

In LBSmff.6 there is an increase in the percentage of woodland habitat indicators. LBSmff.4 shows a decrease in woodland indicators and a marked increase in dry Mediterranean shrub, although there is also a rise in the percentage of freshwater species. LBSmff.3 lacks the still and slow-moving water group altogether. Species diversity rises and then falls during this sequence of three units.

BeSm(OSsm).2, returns to a mixture of all groups (except F which does not reappear), and then in BeSm(OSsm).1, open woodland seems to dominate. In contrast, the subsequent layer UBSm.7 is dominated by dry Mediterranean shrubby vegetation. This correlates with the spike in species diversity discussed earlier, where a general depletion of vegetation cover and reduced humidity would explain the disappearance of common toad, skinks, ocellated lizard and natricine snakes. Both of these layers lack the comparatively moist, well vegetated areas group which is almost continuous until that point and reappears in subsequent layers. This corroborates a general reduction in

precipitation and humidity in the period represented by BeSm(OSsm).1/UBSm.7. It should be noted that very significant thicknesses of loose sand (all of BeSm(PLSsm).3 and most of BeSm(OSsm).2), immediately below the units discussed here, were not excavated and thus not sampled for herpetofauna; such sands would not be inconsistent with generally reduced humidity during this period (S. Collcutt pers comm., cf. Fig. 3.1)

UBSm.6 and UBSm.5 show a reversal of this trend, with dry Mediterranean shrub species decreasing, and freshwater species and inhabitants of moister, well vegetated areas increasing. Stony habitat species dominate UBSm.2. Species of moist, well vegetated habitats disappear again at the top of the sequence in CHm.5/UBSm.1 and 2.

The fluctuation between wetter and drier habitat types seen here is likely to be the result of minor climate changes affecting the landscape pattern around the cave, through natural habitat succession, which sees areas of still water (pools, marshes, etc.) developing over time into carr and then drier woodland.

One caveat, however: the number of species involved in the calculations is very low in some contexts. Minor presences and absences can therefore affect the group patterns disproportionately.

Palaeoenvironment

The most striking characteristic of the Gorham's herpetofauna is its species diversity and close similarity to the modern herpetofauna of southern Iberia. It is impossible to ignore the implication that palaeoclimate during the Late Pleistocene on Gibraltar was not drastically different to today, at least for some of the time. Most of the species are Mediterranean thermophiles which could not tolerate great reductions in summer temperatures, although many could probably tolerate much colder winters. The faunal make-up is broadly consistent throughout the stratigraphy, but there are some subtle changes. Some species are more or less consistently present, most are intermittent, and a few are scarce. In theory, the 'pool' of species present in Iberia must have been consistent throughout the Late Pleistocene, as the south-western tip of the Iberian Peninsula was a glacial refugium for many of the species present there today. Nevertheless, there is genetic evidence that some species may have arrived in Iberia during the Late Pleistocene (Carranza et al. 2006).

During glacial maxima, species either survived in southern refugia within the European peninsulas, or they became extinct if climate there was too cool. Nearly all the Gorham's species are found in modern southern Iberia today, and with nowhere else to go during glacial maxima, all must have survived there continuously. Nevertheless, there are some notable patterns within the Gorham's sequence that may reflect local patchiness and temporal changes. Against a background of broad herpetofaunal stability, climatic and other environmental changes would have influenced the herpetofaunal assemblage at Gorham's through time. Herpetofaunal diversity would not have varied in south-west Iberia as radically as it did in northern Europe (where no herpetofauna survived during glacial maxima), but there would still have been significant faunal changes at landscape and local scale. These should be reflected in the subfossil record at Gorham's, which in turn should provide us with insights into the palaeoenvironmental history of the area.

There are important taphonomic considerations, however. Depositional agents (e.g. raptor or predatory mammal species) may have changed over time, with resultant fluctuations in bone accumulation. Also, preservation varies in different sedimentary contexts and under different environmental conditions. The sedimentary rate must have influenced preservation too, by determining the length of time that bones were exposed at the surface.

Glacial refugia in Iberia?

As discussed, all of the Iberian herpetofauna must have survived somewhere within the peninsula during the last glaciation. This requires the climate to have always been warm enough, during the summer at least, for them to survive somewhere in the peninsula. This has been corroborated in recent years by phylogeographical work showing that many species survived in Iberian refugia and recolonized western Europe from there (Beebee and Rowe 2000; Gómez and Lunt 2007; Hewitt 1996). Moreover, it seems that a growing number of species had multiple Iberian refugia (Gómez and Lunt 2007). Thus, more than ever, the concept of climate being far from cold in southern Iberia during glacial maxima is gaining credence. A subfossil assemblage resembling a modern one may imply that climate was not too different to the modern climate, even if it flies in the face of accepted wisdom on the last glacial maximum. After all, the amphibian and reptile species in latest MIS 5 to MIS 2 sediments (as sampled) at Gorham's are still found in Iberia today, which proves quite conclusively that their thermophilic tolerances must have been met continuously in order for them to survive.

Human exploitation of herpetofauna

Virtually all amphibians and reptiles are edible by humans. Tortoises/turtles, frogs/toads, salamanders, lizards and snakes are all exploited somewhere in the world today. It is inconceivable that humans would not also have exploited them during the Pleistocene. With many of these species being abundant and catchable, there were many opportunities for humans to have eaten amphibians and reptiles during the Late Pleistocene in the Mediterranean. Tortoises are among the best studied of these groups, although this is probably partly due to the larger size of their remains and the more obvious signs of exploitation. Stiner has published extensively on human consumption of tortoises in the Levant, and even speculated that reduced carapace sizes over time reflected over-exploitation (Stiner et al. 2000). Nearer to Gibraltar, Blasco (2008) examined in detail the exploitation of tortoises by humans at Bolomor Cave, Valencia, and categorized various types of evidence.

The question of whether any herpetofaunal remains recovered from Gorham's Cave indicate human or Neanderthal exploitation of such species is difficult. None of the tortoise remains show unequivocal signs of being humanly modified, though eight burnt fragments were collected from

Table 8.3 Modified tortoise remains, Gorham's Cave.

CHm.5/UBSm.1	1 peripheral frag, cracked & calcined on lower surface only
LBSmff.4	1 burnt neural
LBSmff.8	Tortoise bone with possible impact crater
LBSmff.10	2 burnt carapace fragments
LBSmff.11	2 burnt fragments, one burnt on exterior surface only
SSLm(Usm).1	1 burnt carapace fragment
SSLm(Usm).2	1 burnt tortoise bone

Table 8.4 Tortoise remains showing signs of digestion, Gorham's Cave.

LBSmff.11	1 tortoise femur (juvenile) – very digested
LBSmcf.11-12	1 plastral element, ?eaten
SSLm(Usm).2	1 carapace fragment, possibly digested.

numbered contexts, and a further seven from redeposited sediments. One tortoise bone was observed to have a 'possible impact crater'. The peripheral (outer shell) fragment from CHm.5/UBSm.1, described as 'cracked and calcined on lower surface only' possibly offers the best indication of having been cooked. The burnt specimens are distributed across several contexts, as shown in Table 8.3.

It is unlikely that these few, small fragments indicate regular 'butchery' and cooking of tortoises in the cave, though it must be remembered that the majority of human/ Neanderthal feeding remains seem to have been regularly cleared out of the cave by the inhabitants, and only small fragments remain (Chapter 11).

The effect of cooking on tortoise remains is known from ethnographic studies, but we have no personal experience of them. As the creatures are now protected, experimental roasting would be both illegal and unethical.

There are also clear indications that at least some of the tortoise remains are derived from carnivore scats, as specimens showing signs of digestion are present in three contexts (Table 8.4).

Recent work on tortoise remains from Bolomor Cave, Valencia, shows clear indications that tortoises were a common dietary component for the human inhabitants of the cave in layer IV which covers MIS MIS 9 – 5e of the later Middle Pleistocene (Blasco 2008). It would therefore not be surprising if tortoise were also consumed at Gorham's Cave, albeit at a slightly later date. Stiner *et al.*, in their study of small game exploitation in the Mediterranean (2000), conclude that the use of small prey species is a response to population growth and reduced mobility in hunter-gatherers. There is no evidence from Gorham's Cave suggesting that either of these factors affected the residents. The relatively small number of tortoise remains from the assemblage could indicate a more opportunistic exploitation of the species, rather than regular consumption. It is almost impossible to draw meaningful parallels with extant hunter-gatherer societies, as none exist in environments similar to that offered by the coastal plain around Gibraltar at the time of deposition. It seems likely, though, that the slow-moving tortoises were seen as a 'gathered' rather than 'hunted' resource, and if Neanderthal society was at all similar to more modern hunter-gatherer populations, collected by the women and children as a useful but low-status source of food. The bone from Bolomor Cave displayed a range of modifications indicating the preparation and consumption of tortoises – percussion notches and impact flakes from breaking the carapace and plastron, cut-marks on shell fragments and long bones, and evidence of burning (Blasco 2008, 2845). It is suggested,

however, that the lack of such evidence does not necessarily mean that tortoises were not exploited. The most frequent degree of burning seen in carapace fragments from Bolomor is a 'brown stain more or less homogeneous across the bone surface' (ibid., 2844) rather than an obvious blackening. This could have been missed while analysing the Gorham's material. Cooking methods must also be considered. The 'recipe' suggested in the 'SAS Survival Handbook' reads 'Roast ungutted in embers, when the shell splits they are ready' (Wiseman 2003, 130). The edible parts could be accessed without resort to cutting, and burning of bones other than the shell during cooking would suggest the meat would be overdone to the point of inedibility. The 'tidy' cave-dwellers would then have removed all but the smallest remains from the cave (see above). Absence of evidence cannot be taken as evidence of absence.

No other reptile or amphibian remains show any unequivocal indication of hominid exploitation. There are scorched and calcined bones of other amphibian and reptile species, but it is generally difficult to tell whether these are incidental results of bones lying at or near the surface beneath fires.

Conclusions

The reptile and amphibian bones from Gorham's Cave offer a rich resource for the study of the palaeoecology of the area surrounding the cave during the Pleistocene. Their study demonstrates the wide range of habitats available in the locality, many of which could have provided resources for the Neanderthal and later inhabitants. Further work is required to refine the use of reptiles and amphibians as palaeoecological indicators. The application of a weighting system for each species' use of different habitats, for example, would allow a more exact reconstruction of the local conditions at the time of deposition.

Analysis of the herpetofauna broadly agrees with that of the small mammals and of the avian remains, showing no evidence for extended periods of cold conditions. Indeed, indications are that the climate would have been similar to that of Gibraltar today, assuming the species represented have not changed their ecological tolerances in the intervening time. The main contrasts were probably in the slightly greater range and therefore increased complexity of the types of habitats offered by the extension of the dryland coastal plain surrounding the Rock at periods of lower sea level. It shows once again why Gibraltar made such an attractive living area for hominins and other animals.

Acknowledgements

Sincere thanks to Nick Barton for perservering with the project, and to all the other project staff.

References

Arnold, E. N. and Ovenden, D. 2002: *A Field Guide to the Reptiles and Amphibians of Britain and Europe.* Harper-Collins, London.

Beebee, T. J. C. and Rowe, G. 2000: Microsatellite analysis of natterjack toad Bufo calamita Laurenti populations: consequences of dispersal from a Pleistocene refugium. *Biological Journal of the Linnean Society* 69, 367–381.

Blasco, R. 2008: Human consumption of tortoises at Level IV of Bolomor Cave (Valencia, Spain). *Journal of Archaeological Science* 35, 2839–2848.

Carranza, S., Arnold, E. N. and Pleguezuelos, J. M. 2006: Phylogeny, biogeography, and evolution of two Mediterranean snakes, *Malpolon monspessulanus* and *Hemorrhois hippocrepis* (Squamata, Colubridae), using mtDNA sequences. *Molecular Phylogenetics and Evolution* 40(2), 532–546.

Gasc, J.-P., Cabela, A., Crnobrnja-Isailovic, J., Dolmen, D., Grossenbacher, K., Haffner, P., Lescure, J., Martens, H., Martinez Rica, J. P., Maurin, H., Oliveira, M. E., Sofia-Nidou, T. S., Veith, M. and Zuiderwijk, A. (eds.) 1997: *Atlas of Amphibians and Reptiles in Europe.* Societas Europaea Herpetologica, and Museum National d'Histoire Naturelle, Paris.

Gleed-Owen, C. P. 2001: A preliminary report on the Late Pleistocene amphibians and reptiles from Gorham's Cave and Vanguard Cave, Gibraltar. *Herpetological Journal* 11, 167–170.

Gómez, A. and Lunt, D. H. 2007: Refugia within refugia: patterns of phylogeographic concordance in the Iberian Peninsula. In Weiss, S. and Ferrand, N. (eds.), *Phylogeography of Southern European Refugia* 155–188. Springer, Dordrecht, Netherlands.

Hewitt, G. M. 1996: Some genetic consequences of ice ages, and their role in divergence and speciation. *Biological Journal of the Linnean Society* 68, 247–276.

Hilbers, D. 2005: *The Nature Guide to the Coto Doñana and Surrounding Coastal Lowlands.* Crossbill Guides, KNNV, Netherlands.

Pleguezuelos, J. M. (ed.) 1997: *Distribución y biogeografía de los anfibios y reptiles en España y Portugal. Monografía de Herpetología Volume 3.* Universidad de Granada, Granada.

Stiner, M. C., Munro, N. D. and Surovell, T. A. 2000: The tortoise and the hare: small game use, the broad-spectrum revolution, and palaeolithic demography. *Current Anthropology* 41(1), 39–73.

Street, D. 1979: *The Reptiles of Northern and Central Europe.* B. T. Batsford Ltd, London.

Wiseman, J. 'L'. 2003: *The SAS Survival Handbook (New Edition).* Collins, London.

9 The Late Pleistocene avifauna of Gorham's Cave and its environmental correlates

J.H. Cooper

Introduction
Late Pleistocene birds and the Rock of Gibraltar

Located on the junction of two major migration bottle-necks, the Rock of Gibraltar and the Strait of Gibraltar are ranked amongst the most ornithologically important areas in Europe, where every year hundreds of thousands of birds migrate between Europe and Africa or the Mediterranean and the Atlantic (Heath and Evans 2000). In addition to passage migrants, the Strait region also harbours wintering and breeding migrants and diverse permanently resident communities, including a number of endemic species. In all, some 186 breeding species are known from the region, and approximately 90 wintering or passage species, with records of accidental vagrants bringing the total to *c*.400 species known from the Strait region (Finlayson 1992). Even allowing for the inclusion of vagrants and some recent introductions, there are few other parts of the Western Pal-aearctic where similar diversity exists.

The physical geography of the region means that even during Late Pleistocene changes in sea-level or in the precise nature and extent of migration, the Strait of Gibral-tar would have remained a bottleneck that migrating birds would have been constrained to use. Additionally, southern Iberia also has biogeographic significance as having been one in a chain of Late Pleistocene temperate refugia located along the southern edge of Europe (Harrison 1982). It is no coincidence that the caves of the Rock preserve one of the most diverse and abundant Late Pleistocene avifaunas in the Western Palaearctic, recovered from four principal sites: Gorham's Cave, Vanguard Cave, Ibex Cave and Devil's Tower Cave (Cooper 1999).

Other Iberian sites (mostly archaeological) yielding Pleistocene avifaunal remains have an uneven distribution across the peninsula, with concentrations along the north coast, in the Pyrenees and in the south-east, particularly in Valencia and around Granada and Almeria, together with a few coastal sites in Portugal (Hernández Carrasquilla 1993; Tyrberg 1998). In central and south-western Spain and in Portugal, there are relatively few Pleistocene sites. The southern Iberian sites nearest to Gibraltar (in the Granada region) appear to have fairly impoverished avifaunas, apart from one or two notable exceptions such as the Cueva de Nerja (Hernández Carrasquilla 1995; Tyrberg 1998). There are a number of archaeologically interesting caves located considerably closer to Gibraltar, including the Cueva de la Pileta, north-east of Gibraltar, but no birds have yet been recorded from them (cf. Hernández Carrasquilla 1993; Tyrberg 1998; Sánchez Marco 2004). Consequently, the Gibraltar sites fill an important geographic gap in the Iberian Pleistocene record, and are also critical in the context of the wider Western Palaearctic as the most south-erly Pleistocene sites in western Europe.

Previous works on Gorham's Cave

Gorham's Cave in particular has held a significant place in Late Pleistocene palaeornithology since the first report of its fossil avifauna by Anne Eastham (1968), following the exca-vations of John Waechter in the 1950s. Eastham recorded an assemblage of 45 species based on some 500 remains; together with the earlier work of Dorothea Bate (1928) on the Pleistocene birds recovered during the excavations of Dorothy Garrod from Devil's Tower Rock Shelter (33 species reported) these publications have been until recently the most complete available descriptions of Gibraltar's avifaunal assemblages. However, these reports now appear relatively limited in their scope, offering little more than an annotated species list for each site, and clearly under-explored the full significance of assemblages, particularly as a source of pal-aeoenvironmental information. This partly reflects contem-porary attitudes to the use of bird remains in archaeological research, with an emphasis on anthropocentric interpreta-tions. Nevertheless, these initial works established Gibral-tar's Late Pleistocene avifaunas as being both unusual and important, demonstrating in particular their diversity and abundance, and have consequently sustained widespread interest in them (e.g. Sánchez Marco 1996; Tyrberg 1999).

Present work

The present study reports on the palaeoenvironmental significance of the Late Pleistocene avifaunal assemblages recovered by the Gibraltar Caves Project from Gorham's Cave during its 1995–1996 campaigns. Areas of particu-lar interest were the taphonomy of the avian assemblages, including the possible role of Neanderthals in the accumu-lation of bird remains; the reconstruction of the Late Pleis-tocene palaeoenvironments of Gibraltar; and the avifaunal evidence of palaeoenvironmental change across the cave's sedimentary sequence.

The data presented here originally formed part of a doctoral thesis conducted on the Late Pleistocene birds of Gibraltar (Cooper 1999), as a contribution to the Gibraltar Caves Project.

Material and methods
Origins of the samples

The avifaunal samples considered here were generated by excavations in 1995–1996 under the auspices of the Natural History Museum, London, and the Gibraltar Museum. The

bulk of the assemblage is derived from sieved residues, from 2 mm or 5 mm sieves. Some dry sieving was carried out in the field, the loose sands of a number of units passing readily through the mesh. Samples from more silt-rich layers, or particularly fossiliferous layers, were treated with an initial wet sieving on site, to reduce bulk, and the residues removed in their entirety to the UK for further processing at the Natural History Museum, London. This consisted of further wet sieving over 1 mm mesh, then picking out the fossil fraction, including bones, charcoal, mollusca and any other items of interest, such as lithic artefacts. Samples were picked partly by eye, but also with the aid of a binocular microscope. To maximize the retrieval of avian remains, I was personally responsible for the separation of the bird material from all of the resulting bone fractions. It is possible that some specimens were overlooked – those that were so damaged as to be unrecognizable as avian, or particularly small elements such as pedal phalanges. Neither of these categories affects the identifiable assemblage, but could have a minor taphonomic impact.

The avian assemblages from Gorham's Cave 1995–1996 are now held by the Gibraltar Museum. Pending final registration of the collection, reference numbers given for individual specimens are the original excavation find numbers.

Identifications

Identifications of the avian assemblages were made using the recent comparative collections of the Natural History Museum, Tring, supplemented by the collections of the Museo Nacional de Ciencias Naturales, Madrid and the Institut d'Avançats de les Illes Balears, Palma de Mallorca.

Identification was considered in two broad groupings, with slightly different methodology in each. Amongst the non-passerines, all suitably preserved material was identified. Within the Passeriformes, the order's extremely conservative skeletal morphology leaves very few elements which can be reliably used for identification. The only passerine material identified in its entirety is that of the family Corvidae, whose larger size and relatively small range of genera/species allow for easier identification. Amongst the other families, identification was restricted to complete or proximal humeri, together with occasional well preserved mandibulae or premaxillae. Although some other elements may be used, the skull and the humerus are generally the most reliable (Janossy 1983; Moreno 1985; 1986; 1987). Intact passerine skulls were not found in the assemblages, but humeri, which are fairly robust and survive well, are quite common.

Included in the passerines, the humeri of thrushes *Turdus* sp. are practically impossible to separate on grounds of morphological characters (Weesie 1988; Stewart 1992; Seguí *et al.* 1997). To establish at least some indication of thrush diversity, intact humeri were assigned to one of ten species groups, based on the overlaps between humerus greatest length in the six Western Palaearctic *Turdus* species, Group 1 being the smallest (Cooper 1999). However, *Turdus* thrushes were not used in palaeoenvironmental analyses.

The assemblages include substantial numbers of broken specimens, and many from osteological conservative families or genera. Consequently, many identifications are prefixed at genus or species level with 'cf.' or '?'. Apart from

indicating uncertainty, 'cf.' has been used to indicate a comparison made on the grounds of morphology and '?' to indicate one made with regard to size.

The avian taxonomy used here follows Snow and Perrins (1998).

Skeletal part relative frequencies

Skeletal part relative frequencies are more commonly used in taphonomic analyses to identify potential predators involved in the accumulation of small mammal material (e.g. Andrews 1990; Fernández-Jalvo 1995). In birds, the main aim has been to try to distinguish human-generated accumulations from 'natural' assemblages (Mourer-Chauviré 1983; Bramwell *et al.* 1987; Ericson 1987; Livingstone 1989).

The relative frequencies of skeletal elements in different taxa groups were calculated for both Gorham's and Vanguard Caves using the commonly applied formula expressed by Andrews (1990): $R_i = N_i/MNI \times E_i$

where

$R_i =$ the relative abundance of element i

$N_i =$ the minimum number of element i within the sample

MNI = the minimum number of individuals

$E_i =$ the number of element i in the skeleton

Usually expressed as a percentage, this represents the proportion of specimens recovered in relation to the expected total for the minimum number of individuals (MNI) present. As most of the avian skeleton can be identified at least to family level, it is possible to derive detailed sets of frequencies based on individual taxa or on taxa groups. However, by using groups of taxa rather than individual species, it is possible to include material undetermined beyond family level, thus increasing the available sample size and eliminating problems associated with potentially incorrect species level identifications.

Taxa groups were selected in order to compare groups of species likely to have a broadly similar taphonomic background (Table 9.1). On the whole the selections correlate to a single family or order, but in two cases, Birds of Prey and Marine Birds, more than one order is included.

Frequency calculations were carried out on all data from each site and also on two combined horizons from Gorham's with particularly abundant assemblages and also evidence of human activity (Tables 9.2–9.5).

A further calculation was carried out on each taxa group to determine the ratio of anterior limb elements (humerus, ulna, carpometacarpus) to posterior limb elements (femur, tibiotarsus, tarsometatarsus), as defined by Ericson (1987). The ratio is expressed as a percentage of anterior elements in relation to the combined total of identified anterior and posterior elements (Tables 9.3 and 9.5).

Results
Overview

Eighteen stratified units produced bird remains and further finds were obtained from surface debris and other unstratified locations. The majority of the stratified finds were obtained from the Lower Bioturbated Sands member,

Table 9.1 Taphonomic taxa groups used in Gorham's and Vanguard Caves

Marine	*Fulmarus; Pterodroma; Calonectris; Puffinus; Hydrobates; Sula; Phalacrocorax; Larus; Rissa; Sterna; Chlidonias;* undetermined Laridae and Sternidae; *Pinguinis; Uria; Alca; Fratercula.*
Ducks	*Branta; Tadorna; Anas; Aythya; Somateria; Clangula; Melanitta;* undetermined Anatidae.
Birds of Prey	*Milvus; Haliaetus; Gypaetus; Neophron; Gyps; Aegypius; Circus; Accipiter; Buteo; Aquila; Hieraeetus; Falco; Otus; Bubo; Athene; Strix; Asio;* undetermined Accipitridae and Strigidae.
Partridges	*Alectoris; Coturnix.*
Waders	*Haematopus; Burhinus; Glareola; Vanellus; Pluvialis; Charadrius; Scolopax; Gallinago; Limosa; Numenius; Tringa; Arenaria; Calidris; Phalaropus,* undetermined Scolopacidae.
Pigeons	*Columba; Streptopelia.*
Swifts	*Apus, Tachymarptis.*
Crows	*Cyanopica; Pica; Pyrrhocorax; Corvus;* undetermined Corvidae.
Small passerines	All identified non-corvid passerine genera; undetermined Passeriformes

particularly from within the Coarse Facies (LBSmcf). A limited amount of material was recovered from the overlying Bedded Sands member or the underlying Sands and Stony Lenses member.

From an overall total of some 9000 remains, about 2600 were identifiable at least to family level, representing approximately 90 species (Cooper 1999) (Appendix 4). Generally, bird remains were relatively scarce in most levels, but a few units yielded assemblages of considerable diversity and abundance. However, even in units with low numbers of recovered remains, relative diversity could still be high.

A typical core assemblage of common taxa is apparent throughout the sequence, consisting of Rock/Stock Dove *Columba livia/oenas* (present in all units), partridge *Alectoris* sp. (present in 16 units), at least one species of chough *Pyrrhocorax* sp. (present in at least 14 units), and Common/Pallid Swift *Apus apus/pallidus* (present in 13 units). Most of these taxa are recorded in even the lowest-yielding units.

As recovery rates increase, certain groups of birds begin to become apparent although the species composition within them varies. These groups are indeterminate medium-sized ducks and geese (Anatidae: Medium) (present in 13 units); small falcons *Falco* sp. (present in 12 units); smaller waders (present in 13 units); owls (in 14 units), in particular Little Owl *Athene noctua* (in 11 units); indeterminate medium-sized crows (Corvidae: Medium) (in 16 units); and smaller passerines, Passeriformes (in 13 units).

The highest-yielding units, including over 50 taxa, preserve a number of birds rarely found in the fossil record of Gibraltar, Iberia or in some cases the Western Palaearctic. However, scarce species may occur in any unit. A good example of this potential is the occurrence of pelagic petrels and/or shearwaters, Family Procellariidae, in eight units. The most frequently occurring procellarid remains are those of gadfly petrel *Pterodroma* sp. in seven units; Gibraltar's Pleistocene records of this genus appear to be the earliest known continental examples of it in the Northern Hemisphere. Furthermore, comparison of the size range of the fossil *Pterodroma* material, particularly the tarsometatarsi (Fig. 9.1), compared to the ranges of modern species suggests that two species may be represented (cf. Cooper and Tennyson 2008). Further analysis is required to establish whether this is in fact the case.

Another hallmark of the assemblages is the repeated occurrence of non-analogue species associations, usually of 'warm' Mediterranean species with 'cold' Boreal or Arctic species, e.g. Hoopoe *Upupa epops* and Velvet Scoter

Melanitta fusca, or Lesser Kestrel *Falco naumanni* with Long-tailed Duck *Clangula hyemalis*. Critically, the 'cold' elements are all marine species – no cool climate terrestrial species were recovered.

Eastham (1968) identified a left femur and partial synsacrum as Snowy Owl *Nyctea scandiaca*. *Nyctea* has recently been incorporated into the genus *Bubo*, becoming *Bubo scandiacus*, on the basis of insufficient differences between the DNA and osteology of the two genera (Sangster *et al.* 2004; see also Ford 1967). However, it would still appear that the two species may be cautiously separated on the grounds of osteological characters.

On the femur, the Linea intermuscularis cranialis in *Bubo bubo* at its proximal end runs parallel to the Crista trochanter, whereas in *Bubo scandiacus* it appears to converge with the Crista trochanter. There is some variation in the character, but these are the dominant states. The Eastham specimen clearly shows the parallel state. Additionally, the distal profile across the condyles in cranial view differs. In *Bubo bubo*, the profile is flattened and the crests bordering the Sulcus patellaris are of equal length. In *Bubo scandiacus* the profile is diagonal, as the lateral condyle is proportionally larger. The crests are unequal in length, with the lateral crest less developed. The Eastham specimen shows equal crests and a flatter distal profile. The combination of these characters appears to indicate that it should be referred to *Bubo bubo*. In the synsacrum, the shape of the ilium margin in dorsal view appears to differ between the genera, but is prone to variation. In *Bubo bubo*, the rim of the margin tends to be thickened, with a pronounced corner at its widest point. The concave curve of the margin where it forms a waist is usually shallow in *Bubo bubo* and steep in *Bubo scandiacus*. The Eastham synsacrum is badly damaged, but appears closer to the usual *Bubo bubo* morphology. I would therefore suggest a revised identification of cf. *Bubo bubo* for this specimen. These reidentifications remove two of the most southerly records of *Bubo scandiacus* in Late Pleistocene Europe, leaving it with an Iberian fossil distribution confined to northern Spain.

The majority of the *Bubo* remains recovered by the 1995–1996 excavations are juvenile specimens, with incomplete morphological characters. However, given the strong association between *Bubo bubo* and caves as nest sites, the long-documented presence of *Bubo bubo* on Gibraltar (Reid 1871–1890; Garcia 2005) and the reidentification of the Eastham specimens, these juvenile remains may be reasonably referred to cf. *Bubo bubo*.

Table 9.2 Overall relative frequencies of avian axial elements, Gorham's Cave.
MNI - Minimum number of individuals; N - Minimum number elements.

	MNI	COR		SCAP		FURC		STERN		SYN		MAN		PREM		CRAN	
		N	%	N	%	N	%	N	%	N	%	N	%	N	%	N	%
Marine	12	15	62.5	4	17	2	17	2	17	0	0	2	17	3	25	0	0
Ducks	14	19	68	10	36	6	54.5	10	91	1	9	0	0	0	0	0	0
Birds of Prey	18	17	47	20	56	2	11	6	33	0	0	6	33	6	33	0	0
Partridges	18	30	83	11	31	2	11	14	78	0	0	3	17	1	6	1	6
Waders	18	30	83	15	42	0	0	9	50	0	0	0	0	3	17	0	0
Pigeons	77	140	90	140	90	22	29	72	93.5	2	2.5	5	6.5	39	51	0	0
Swifts	10	4	20	6	30	0	0	2	20	0	0	0	0	0	0	0	0
Crows	25	38	76	26	52	1	4	8	32	0	0	1	4	0	0	0	0
Small Passerines	78	90	58	25	16	25	32	42	54	0	0	0	0	17	22	0	0

Table 9.3 Relative frequencies avian axial elements LBSmcf.2 and LBSmcf.4, Gorham's Cave.

	MNI	COR		SCAP		FURC		STERN		SYN		MAN		PREM		CRAN	
		N	%	N	%	N	%	N	%	N	%	N	%	N	%	N	%
Marine	9	1	6	2	11	0	0	2	22	0	0	0	0	3	33	0	0
Ducks	9	8	44	3	17	1	3	3	33	0	0	0	0	0	0	0	0
Birds of Prey	11	3	14	3	14	0	0	1	9	0	0	1	9	2	18	0	0
Partridges	3	5	83	5	83	0	0	1	33	0	0	0	0	1	33	0	0
Waders	11	8	36	5	23	0	0	1	9	0	0	0	0	0	0	0	0
Pigeons	31	44	71	53	85.5	6	19	15	48	0	0	1	3	15	48	0	0
Swifts	3	1	17	2	33	0	0	0	0	0	0	0	0	0	0	0	0
Crows	10	11	55	7	35	0	0	3	30	0	0	1	10	0	0	0	0
Small Passerines	16	22	69	4	12.5	11	69	9	56	0	0	2	12.5	1	6.2	0	0

Table 9.4 Overall relative frequencies of avian limb elements and anterior element ratios, Gorham's Cave.

	MNI	HUM		ULN		RAD		CMC		FEM		TBT		TMT		%ANT
		N	%	N	%	N	%	N	%	N	%	N	%	N	%	
Marine	12	7	29	8	33	0	0	0	0	3	12.5	5	21	14	58	40.5
Ducks	14	8	29	1	4	1	4	6	21	13	46	21	75	23	82	20.8
Birds of Prey	18	15	42	21	58	4	11	24	67	7	19	18	50	27	75	53.6
Partridges	18	12	33	13	36	1	3	11	31	13	36	16	44	18	50	43.4
Waders	18	22	61	15	42	1	3	18	50	4	11	20	56	20	56	55.6
Pigeons	77	102	66	77	50	34	22	85	55	41	27	35	23	95	62	60.7
Swifts	10	8	40	14	70	1	5	12	60	5	25	8	40	10	50	59.6
Crows	25	29	58	37	74	1	2	49	98	24	48	21	42	40	80	57.5
Small Passerines	78	115	74	115	74	10	6	135	86.5	51	33	95	61	88	56	60.9

Not included at Gorham's: Podicipedidae, NISP=2/MNI=2; Rallidae, NISP=12/MNI=3; Otidae, NISP=1/MNI=1; Caprimulgidae, NISP=1/MNI=1; Upupidae, NISP=1/MNI=1; Picidae, NISP=10/MNI=3.

Table 9.5 Relative frequencies of avian limb elements and anterior element ratios LBSmcf.2 and LBSmcf.4, Gorham's Cave.

	MNI	HUM		ULN		RAD		CMC		FEM		TBT		TMT		%ANT
		N	%	N	%	N	%	N	%	N	%	N	%	N	%	
Marine	9	1	6	1	6	0	0	0	0	0	0	2	11	5	28	22.2
Ducks	9	2	11	0	0	0	0	5	28	6	33	9	50	8	44	23.3
Birds of Prey	11	4	18	6	27	0	0	6	27	2	9	5	23	11	50	47.1
Partridges	3	2	33	1	17	1	17	3	50	4	7	5	83	6	100	28.6
Waders	11	7	32	4	18	0	0	7	32	4	18	3	14	6	27	58.1
Pigeons	31	28	45	21	34	5	8	21	34	12	19	11	18	26	42	58.8
Swifts	3	1	17	1	17	0	0	4	67	0	0	3	50	3	50	50.0
Crows	10	6	30	11	55	1	5	19	95	5	25	10	50	11	55	69.2
Small Passerines	16	29	91	23	72	3	9	24	75	9	28	29	91	23	72	55.5

Assemblages recovered from individual units are summarized below, from the top down, following the stratigraphic scheme of Collcutt and Currant (Chapter 2). The sampled units span approximately 4–5 m of the overall described sequence of some 15–16 m, and include some of the cave's most fossiliferous units.

Bedded Sands

Orange Sand sUBMEMBER (BeSm (OSsm).1)
Very few bird bones were recovered from this horizon, possibly due in part to limited availability of samples. Only a small selection of species is present, all of which are core common taxa. However, the remains from this horizon

Fig. 9.2 Premaxilla of Bullfinch *Pyrrhula pyrrhula* (**Gor95/73**, LBSmff.1-2), dorsal view. Photo: J. Cooper, Natural History Museum, London.

Fig. 9.1 Remains of unknown gadfly petrel(s) *Pterodroma* sp., demonstrating size range of material. Left to right: left tarsometatarsus (**Gor95/165/167**, LBSmcf.2); left tarsometatarsus (**Gor95/140**, context undetermined); distal right tarsometatarsus (**Gor95/196**, LBSmcf.4). Photo: H. Taylor, Natural History Museum, London.

demonstrate the potential for diversity in even a restricted assemblage, with at least five taxa from only seven identifiable specimens.

Pale Loose Sand sUBMEMBER (BeSm (PLSsm).3)

Amongst the highest NISP (number of identified specimens) of certain core species, including *Alectoris* sp. and *Athene noctua*. A number of waders are also present, from the more frequently occurring species such as Woodcock *Scolopax rusticola*, Sanderling/Dunlin *Calidris alba/alpina* and Whimbrel *Numenius phaeopus*. Also noteworthy are specimens of *Melanitta fusca* and Housemartin *Delichon urbica*, the latter one of only two identified bones from this species.

Lower Bioturbated Sands

Fine Facies (LBSmff.1–2)

A large proportion of indeterminate specimens were recovered, mostly non-passerines. The small number of identified specimens is dominated by *Columba livia/oenas*. However, a single specimen of Bullfinch *Pyrrhula pyrrhula* was also recovered, a distinctive robust premaxilla, the only record of it in Gibraltar (Fig. 9.2).

Coarse Facies (LBSmcf.1)

Few remains were recovered, but the assemblage is notable for single specimens of *Pterodroma* sp. and Razorbill *Alca torda*, both of which are pelagic taxa. This horizon may mark the upper limit of a stratigraphic cluster of pelagic species.

Coarse Facies (LBSmcf.2)

Another specimen of *Pterodroma* sp. and also of Puffin *Fratercula arctica* were found. Additional marine taxa are present, most importantly *Clangula hyemalis*; this bed and the underlying LBSmcf.4 include over 70 per cent of the total site NISP for this species. A possible specimen of Common Scoter cf. *Melanitta nigra* was also recovered. Within the terrestrial assemblage were remains of *Falco naumanni*, Turtle Dove *Streptopelia turtur*, and possible Calandra Lark

?*Melanocorypha calandra* and possible Greenfinch cf. *Carduelis chloris*. However, the dominant terrestrial taxon was *Columba livia/oenas* with a NISP of over 100.

Coarse Facies (LBSmcf.4)

This unit yielded a total of just over 1900 bird bones, with a final NISP of 535, making it the richest unit sampled. It also produced the most diverse avifauna of any single unit, with approximately 57 taxa identified. In addition to the common core taxa this unit is characterized by good representation of ducks and waders, including the only Gorham's finds of shelduck *Tadorna* sp. and Stone-curlew *Burhinus oedicnemus*. It also has the highest unit NISP of *Clangula hyemalis* and *Scolopax rusticola*. Also amongst the waders are two specimens from separate individuals of a phalarope, possibly Grey Phalarope *Phalaropus* ?*fulicarius*. Marine taxa are well represented, including *Pterodroma* sp. (NISP = 9); the only Gorham's find of Fulmar *Fulmarus glacialis*; Cory's Shearwater *Calonectris diomedea*; a possible Balearic Shearwater *Puffinus* ?*mauretanicus*; and *Fratercula arctica*. Other aquatic species are present, including a left femur from a grebe, comparable to that of the Horned Grebe *Podiceps* cf. *auritus*.

Amongst the terrestrial species, predators have a strong presence with at least six different diurnal raptors and two owls recovered. A fragmentary premaxilla of Goshawk *Accipiter gentilis* is the only Gorham's find for this species.

Two woodpecker species are present, Green Woodpecker *Picus viridis* and probably Greater Spotted Woodpecker *Dendrocopos* ?*major*. The passerines also include some key finds, for example the only Gibraltar finds of a large wheatear, tentatively referred to Black Wheatear *Oenanthe* ?*leucura* on grounds of its size, and a *Parus* tit, tentatively referred to Great Tit *Parus* ?*major*. However, the most important passerine discovered is a proximal left humerus of Azure-winged Magpie *Cyanopica cyanus*, a species with an extreme disjunct distribution, with a Western Palaearctic population resident in the Iberian Peninsula and a Far Eastern population in China, Japan and Korea. This specimen and two other proximal left humeri identified from LBSmcf.5 and the North Alcove of Vanguard Cave (Chapter 17, Fig. 17.5) constituted the first Pleistocene fossil record for this species in the Western Palaearctic, confirming the Iberian population's origin as a refugium relict (Cooper 2000b).

Coarse Facies (LBSmcf1–4)

Two units originally excavated as individual horizons are now known to have been lateral variations within the Coarse Facies of the Lower Bedded Sands, but cannot be accurately

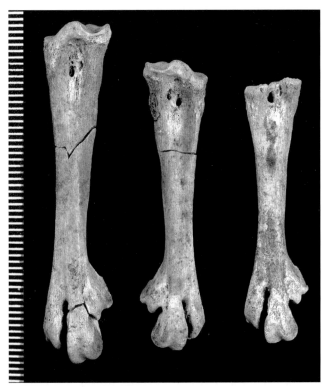

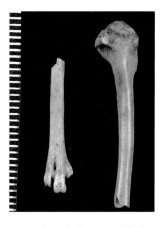

Fig. 9.4 Aquatic rails from Gorham's Cave.
Left: distal right tarsometatarsus (Spotted) Crake *Porzana* *?porzana* (**Gor96/1**, surface), cranial view.
Right: proximal right humerus Water Rail *Rallus aquaticus* (**Gor96/97**, LBSmcf.9), caudal view.
Photo: J. Cooper, Natural History Museum, London.

Fig. 9.3 Tarsometatarsi of immature scoters from Gorham's Cave, from right to left (all in dorsal view): Velvet Scoter *Melanitta fusca* (**Gor96/276**, LBSmcf.8); Common Scoter *Melanitta nigra* (proximal **Gor96/92** and distal **Gor95/293**, both LBSmcf.5); *Melanitta nigra* (**Gor96/5**, surface), lacking proximal epiphysis. Photo: J. Cooper, Natural History Museum, London.

assigned to the revised stratigraphic scheme (Chapter 2). A small number of samples from these 'units' yielded bird bones, principally of relatively common species well represented in other units.

Coarse Facies (LBSmcf.5)

Another high-yielding unit, with just over 1650 bird bones recovered in total, with a NISP of 453, from approximately 52 taxa. This unit has a very similar species composition to LBSmcf.4, with good numbers of ducks, waders, raptors, etc. Amongst the ducks, a significant find is the tarsometatarsus from an immature *Melanitta nigra* (Fig. 9.3). Also worth noting in these two units is the presence of gulls Laridae, which are generally rare in the Pleistocene fossil record (Stewart 2002), and the only Gorham's finds of Coot *Fulica atra*.

In the terrestrial fauna, particularly significant finds were a fragment of possible Egyptian Vulture *Neophron percnopterus* and a distal right carpometacarpus of *Upupa epops*, the only Gibraltar record for this species.

Coarse Facies (LBSmcf.6)

Amongst the 49 identifiable bird bones in this unit, the most significant find was a proximal left femur of Great Bustard *Otis tarda*. Represented by this specimen alone, this is the heaviest species found in the Gibraltar fossil avifauna. Also noteworthy is one bone of *Dendrocopos ?major*.

Coarse Facies (LBSmcf.7)

Yielding less than 60 identifiable specimens, the key finds in this unit were individual remains of the tiny pelagic

Storm Petrel *Hydrobates pelagicus* and a phalaropus *Phalaropus ?fulicarius*.

Coarse Facies (LBSmcf.8)

A more diverse marine presence is recorded in this horizon, including a shearwater *Puffinus ?mauretanicus*, *Alca torda* and *Clangula hyemalis*. Of particular significance is a right tarsometatarsus from an immature *Melanitta fusca* (Fig. 9.3).

Also recovered from this unit were several small passerine taxa, including the only specimens of a small *Carduelis* finch and a possible Rock Sparrow *Petronia petronia*.

Coarse Facies (LBSmcf.9)

This is stratigraphically the lowest of the high-yielding units, with a total of 1596 bird bones recovered, a NISP of 384, from approximately 39 taxa. Of interest here amongst the marine species is the highest unit NISP of *Pterodroma* sp. (NISP = 16, MNI = 2). However, a strong freshwater component also occurs, including Water Rail *Rallus aquaticus* (Fig. 9.4); a crake, comparable with Spotted Crake *Porzana ?porzana*; Collared Pratincole *Glareola pratincola*; and probable Black-winged Tern *Chlidonias* cf. *niger*. A further noteworthy identification is the only Gibraltar Pleistocene record of a nightjar, a proximal right humerus compared to the endemic Red-necked Nightjar *Caprimulgus ruficollis* on grounds of its size.

Coarse Facies (LBSmcf.10)

Another unit represented by a low NISP, most species identified were of the common core taxa. However, this unit also yielded the only Gorham's example of a shrike, Great Grey/Lesser Grey Shrike *Lanius excubitor/minor*.

Coarse Facies (LBSmcf.11)

Particularly striking in this unit is the diversity of owl species present, with a total of four species represented. Most important are the remains of juvenile cf. *Bubo bubo*, comprising an intact left humerus (Fig. 9.5) and right ulna, both at the same stage of development. Although not found articulated, the close association and condition of these specimens suggest they represent a single individual. Additionally, a right humerus from a juvenile cf. *Bubo bubo* was amongst the bird remains recovered by Waechter, but was originally described by Eastham (1968) as Demoiselle Crane *Anthropoides virgo* (Cooper 1999). The Eastham specimen is almost identical to the left humerus in terms

of size, preservation and stage of development. It seems entirely possible that the Eastham humerus comes from the same individual, indicating a potential correlation between this unit and Waechter's Layer M.

Coarse Facies (LBSmcf.12)

A diverse selection of marine taxa is again present in this horizon, including *Pterodroma* sp., *Calonectris diomedea* and *Alca torda*. A cold climatic signal may be given by possible specimens of *Clangula hyemalis* and *Melanitta nigra*. A possible specimen of Turnstone *Arenaria interpres* was the only material from the Gibraltar assemblages referred to this species.

Coarse Facies (LBSmcf.13)

Another unit with relatively low numbers of recovered bird remains, with a NISP of 31. Amongst this were several specimens of possible *Clangula hyemalis* and one bone of the scarce *Rallus aquaticus*.

Sands and Stony Lenses

(SSLm(Usm).2)

Very few samples from this member were available from the 1995–1996 excavations. Although these samples yielded a reasonable total number of specimens, NISP was low at only 24. Amongst these remains were the only Gorham's finds of White-tailed Eagle *Haliaeetus albicilla* and a possible Kittiwake cf. *Rissa tridactyla*.

(SSLm(Usm).3)

Only one sample from this bed was examined, with a total of 11 bones recovered. Only *Columba livia/oenas* was identifiable.

Unstratified finds

Numerous bird bones were recovered in the loose surface sediment removed during the cleaning of the excavation areas and also from section collapses. Additionally, a small number of samples could not be accurately related to the revised stratigraphic scheme. However, although these collections cannot be linked to the stratigraphic sequence, they do include a number of significant taxa not otherwise represented within the cave sequence that should also be regarded as part of the Late Pleistocene avifauna. Key taxa include Great Crested/Red-necked Grebe *Podiceps cristatus/grisegena*; an unfused right tarsometatarsus from a juvenile Common Scoter; an *Aquila* eagle, possibly Golden Eagle *Aquila* cf. *chrysaetos*; a harrier, possibly Hen Harrier *Circus cyaneus*; a right quadrate of Great Auk *Pinguinis impennis*; and one of the smallest taxa in the Gibraltar avifauna, a *Sylvia* warbler, Blackcap/Orphean Warbler *Sylvia atricapilla/hortensis*. Finally, a small amount of material was retrieved from a small chamber in the cave roof, which cannot be at present related to the main sequence. All taxa identified from this chamber were also found in the main cave, with the exception of Short-eared Owl *Asio flammeus*.

Evidence of human activity

Direct evidence of human exploitation is most reliably provided by cut-marks, usually the result of butchery. No

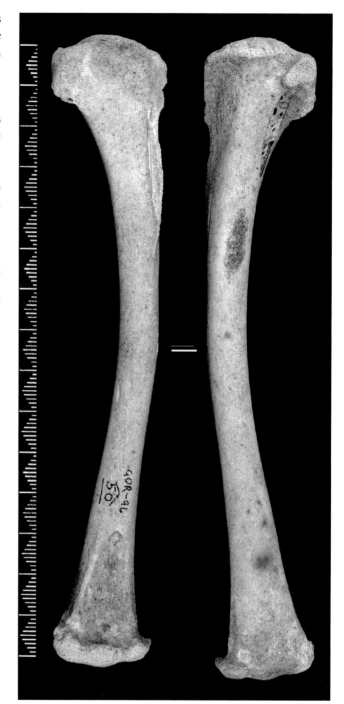

Fig. 9.5 Juvenile left humerus of probable Eagle Owl cf. *Bubo bubo* (**Gor96/50**, LBSmcf. II), cranial and caudal views. Photo: J. Cooper, Natural History Museum, London.

cut-marks were observed on any bird material from the 1995–1996 Gorham's Cave collections.

Charring also provides evidence of human activity in relation to bones, but is not necessarily a sign of direct exploitation, as incidental burning can occur. In Gorham's the overall levels of charring are fairly low, but there is a concentration of burnt specimens in LBSmcf.2 and LBSmcf.4, most of which are confined to the base of LBSmcf.2. The majority of these specimens are pigeons and ducks, with 9.2 per cent and 17.2 per cent charring respectively (Table 9.6). By comparison, in the other high-yielding units LBSmcf.5 and LBSmcf.9, there are no charred ducks in either and less than 2 per cent of the pigeon remains show charring.

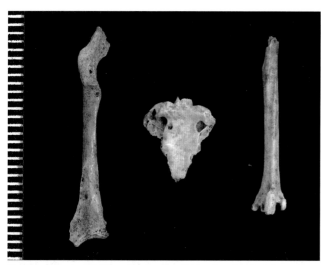

Fig. 9.6 Remains of (Greater) Spotted Woodpecker *Dendrocopos ?major* from Gorham's Cave. Left to right:
left coracoid (**Gor96/224**, LBSmcf.12)), caudal view;
fragment of anterior sternum (**Gor96/87**, LBSmcf.9), dorsal view;
distal right tarsometatarsus (**Gor96/40**, LBSmcf.9), ventral view.
Photo: J. Cooper, Natural History Museum.

Taphonomy
Attritional accumulation
The simplest form of fossil accumulation is the on-site death and burial of a specimen. Primarily, this will apply to birds nesting or roosting within a site, but birds visiting the cave for other purposes, such as foraging, may also be incorporated. While candidates for attritional accumulation will mainly be those associated with cave environments, species not normally encountered in caves may also occur, for example by seeking shelter during migration.

In Gorham's and Vanguard Caves at present, attrition is an ongoing and observable process as the caves continue to accumulate bird corpses. Finds between 1994–1997 included locally breeding Peregrine Falcon *Falco peregrinus*, Yellow-legged Gull *Larus cachinnans* and swift *Apus* sp. (a live juvenile Pallid Swift *Apus pallidus* was also rescued from the floor of Vanguard Cave); Crag Martin *Hirundo rupestris* casualties are also well known from winter roosts at Vanguard Cave (Finlayson 1992).

The presence of significant quantities of guano within the Gorham's Cave sediments suggests long-term use of the cave by birds (Macphail and Goldberg 2000). This impression is strengthened by the abundant presence throughout the sampled sequence of cliff-nesting taxa such as Rock Dove *Columba livia* (most of the material identified as *Columba livia/oenas* is undoubtedly *Columba livia*) and *Apus apus/pallidus*. The presence of numerous juvenile pigeon and swift remains, some from very young birds, suggests persistent nesting within the site. Particularly striking in the *Columba livia/oenas* material is the frequency of normally fragile elements; the species overall MNI in Gorham's Cave is actually based on the right scapula as the most commonly occurring element (Table 9.2).

Swifts and pigeons today are reasonably tolerant of benign human presence, with substantial colonies occurring in modern-day human settlements. If left undisturbed, they may have continued to use the cave during periods of human occupation. However, if persecuted perhaps as a

food resource, for example the taking of pigeon squabs and eggs, the cave may have been abandoned as a nesting site.

Another nesting resident appears to have been *Bubo bubo*, represented by the probable juvenile remains in LBSmcf.11. It seems likely that this material represents the on-site deposition of a single nestling. It is worth noting that whilst *Bubo bubo* regularly uses caves as nest sites, *Bubo scandiacus* is not a cave-nesting species (Cramp 1985; Lorenc 2006). The presence of a large resident predator has considerable additional taphonomic implications. However, based on the species' modern preferences, it seems highly unlikely that *Bubo bubo* and humans would have co-existed on the site (Cramp 1985).

Predation
Non-human activity
Given the presence of juvenile cf. *Bubo bubo* and the hunting behaviour of this large predator, it seems likely that much of the avian assemblage is attributable to this species' activities. *Bubo bubo* has a very wide-ranging diet, and is capable of taking even very large prey items. Most of the Gorham's bird species list is consistent with its known prey preferences (Cramp 1985). *Bubo bubo* typically has a hunting range of some 10 km, usually over open and wetland habitats. Whole prey items are brought back to the nest, where they are dismembered for the juveniles. Excess prey is often cached nearby, for example in crevices. All of this behaviour makes *Bubo bubo* an excellent agent of accumulation. Furthermore, adult birds show a high fidelity to their nesting sites, permitting the ongoing deposition of vertebrate remains for years at a time (Cramp 1985). Taphonomic studies of diet based on modern European *Bubo bubo* pellet remains have suggested that fossil assemblages accumulated by this taxon may be characterized by a dominance of galliformes (partridges and grouse) and also waterfowl, particularly ducks, if the owls are hunting over wetland or shoreline habitats (Lorenc 2006). These characteristics certainly apply to the Gorham's Cave assemblages. Furthermore, *Bubo bubo* shows a distinct tendency to take other owls and smaller raptors, which may explain the relatively high incidence of small birds of prey (cf. Cramp 1985; Lorenc 2006).

However, it is important to note that partridges, pigeons and waterfowl would also likely constitute key prey items for other predators, including humans. Other non-human predators may well have had a role in the accumulation of avian remains at Gorham's Cave, but it is not yet possible to identify the taphonomic signatures of individual predators and their identities remain unknown.

Human activity
It is clear that the human inhabitants of Gorham's and Vanguard Caves were resourceful, utilizing a wide range of food resources. It is therefore reasonable to anticipate some degree of exploitation of birds. However, lacking the positive evidence of cut-marks, identification of a potential human taphonomic signature becomes more difficult.

The absence of any cut-marked bird bone at Gorham's Cave may reflect a butchering technique, if indeed any were used, simply of pulling carcasses apart by hand. On the whole, larger birds which might have conceivably required tools to butcher are absent from the assemblages. However,

Table 9.6 Incidence of charring in Lower Bioturbated Sands Member, Gorham's Cave. Numbers refer to number of charred specimens.

	LBSmcf.1	LBSmcf.2	LBSmcf.4	LBSmcf.5	LBSmcf.6	LBSmcf.7	LBSmcf.8	LBSmcf.9	LBSmcf.11
Ducks	-	9	1	-	1	-	1	-	1
Partridges	-	1	-	-	-	-	-	-	-
Waders	-	-	-	1	-	-	1	1	1
Pigeons	1	19	12	3	-	2	-	3	-
Crows	1	-	4	-	-	-	-	-	-

LBSmcf.2-4	Ducks NISP = 58	% charring = 17.2	Pigeons NISP = 338	% charring = 9.2
LBSmcf.5	Ducks NISP = 26	% charring = 0	Pigeons NISP = 174	% charring = 1.7
LBSmcf.9	Ducks NISP = 26	% charring = 0	Pigeons NISP = 157	% charring = 1.9

at the Upper Palaeolithic site of Grotta Romanelli, Italy, extensive evidence of bird butchery was found, with cutmarks identified on a wide range of large and small species (Cassoli and Tagliacozzo 1997). In comparison with the patterns of systematic dismembering at Grotta Romanelli, it seems that processing of avian carcasses in the earlier Gibraltar sites, if occurring, may have been relatively casual.

The quantities of charred ducks may be significant (Table 9.6). However, the charring may not represent cooking. At Grotta Romanelli, a recurring pattern of specific burnt portions of certain elements, humeri in particular, was identified and thought to be related to systematic processing (Cassoli and Tagliacozzo 1997). The Gibraltar specimens, principally possible Long-tailed Duck cf. *Clangula hyemalis* and indeterminate medium-sized Anatidae (Cooper 1999), show no such patterning. Perhaps an alternative explanation is that waste bones were tossed into the fire after a bird had been eaten. Possibly the same may be true of the charred pigeons, but it is likely that, given the overall low occurrence of charring in the family, the higher incidence in LBSmcf.2 and LBSmcf.4 may simply reflect the more extensive use of fire at this horizon, with increased levels of incidental charring.

In other studies, skeletal part relative frequencies have been used to derive possible signatures for human activity in the absence of direct evidence. Based on the comparison of anterior and posterior element representation in particular, it has been suggested that over-representation in posterior limb elements may be characteristic in human-generated accumulations (Ericson 1987; Baales 1992). In natural accumulations, it has been argued that anterior limb elements may dominate. However, other studies have demonstrated that the situation is more complex. Anterior/posterior representation can be affected by functional morphology, suggesting that survivorship is attributable to robustness rather than the accumulating agent (Livingstone 1989).

Much of the skeletal part representation work carried out has used species of grouse *Lagopus* spp. (Mourer-Chauviré 1983; Baales 1992), one of the most common species in Western Palaearctic fossil sites, and which represents regular prey for a range of predators. Ducks have also been analysed (Ericson 1987; Livingstone 1989).

In both Gorham's and Vanguard, the lowest percentage of anterior elements is recorded in the Ducks taxa group (Table 9.4). At 25.0 per cent in Vanguard and 20.8 per cent in Gorham's, these are lower than any of the ratios described by Livingstone (1989) or Ericson (1987). Isolated from the overall data, the Ducks' anterior percentage in LBSmcf.2

and LBSmcf.4 is 23.3 per cent (Table 9.5). Undoubtedly, the Ducks' taphonomic situation is made more complex by the likelihood of *Bubo bubo* also contributing to this part of the assemblage. However, modern studies have suggested that prey remains of *Bubo bubo* may over-represent wing elements (Bochenski 1997).

With regard to the significance of the low anterior ratios in Ducks, the question of element survivorship as a function of morphology is pertinent. Conditions clearly exist on site for the preservation of even small, fragile specimens, the scapulae of *Columba livia/oenas* being a good example. During the course of natural decay, the pectoral girdle (sternum, coracoids, furcula, scapulae and wings) is generally the last part of the skeleton to disarticulate and can survive intact for a considerable length of time (Jeffrey Bickart 1984; Serjeantson *et al.* 1992). The high relative frequencies of Duck sterna and coracoids in Gorham's suggest that it is not simply an absence of pectoral girdles causing the low anterior ratio, but that the wings have been affected by a different process of preservation (Table 9.2). This parallels Mourer-Chauviré's (1983) observations of higher proximal element frequencies in human-generated assemblages. It therefore seems that the low anterior ratios could indeed reflect some form of human activity, e.g. stripping off the wings for ease of transport.

The apparently unusually low frequencies of Ducks' anterior elements and the relatively high incidence of charring in LBSmcf.2 and LBSmcf.4 may well be an indication that Neanderthals were exploiting this group of birds. But without positive evidence of Neanderthal behaviour, such as cut-marks, this must remain at best a suggestion based on circumstantial evidence.

Eastham initially appeared to consider humans as the primary source of bird remains in Gorham's and used the avian assemblage to infer the seasonal timing of human occupation (Eastham 1968; 1989). However, birds may accumulate all year round, and, unless human activity can be isolated from other sources, the season of occupation cannot be derived.

With regard to the possible hunting of ducks by Neanderthals, it is worth noting that European species generally endure an annual period of up to a month's flightlessness during mid-summer to mid-autumn, due to the simultaneous moult of all flight feathers (Ginn and Melville 1983). Marine ducks such as scoters generally spend this period at sea, but may still approach to within 500 m of land (Cramp and Simmons 1977). If Neanderthals were indeed taking ducks, freshwater or marine, it may be they would take advantage of this vulnerable period to do so.

More interesting, especially for possible human exploitation strategies, is the extreme rarity of larger species such as geese and bustards. For example, in the Upper Palaeolithic at Grotta Romanelli, although 109 species were identified, 68 per cent of the remains were attributable to a single species, Little Bustard *Tetrax tetrax*. *Otis tarda* and three species of geese, including *Branta bernicla*, were also present in considerable numbers (Cassoli and Tagliacozzo 1997). Although *Otis tarda* and *Branta bernicla* at least were available to the human inhabitants of Gorham's, there was clearly no systematic strategy to pursue them, despite the fact that these species would have made useful catches. For example, males of *Otis tarda* can weigh over 15 kg (Cramp and Simmons 1979). Contrasting the Gibraltar assemblages with Grotta Romanelli's, which represents anatomically modern humans' activity, strongly suggests that any Neanderthal bird hunting was essentially opportunistic.

Combining this lack of systematic bias with the lack of direct evidence for exploitation, it appears that birds may not have been particularly valued prey items of the Gibraltar Neanderthals. A similar pattern is observed elsewhere in the Middle Palaeolithic of the Mediterranean and it is only during the Upper Palaeolithic that birds appear to become increasingly exploited by anatomically modern humans (Stiner *et al.* 1999).

Other trends in bird exploitation are apparent from the assemblages, which could apply to almost any of the predators, and in particular the scavengers, which may have brought bird remains to any of the caves. Of these, probably the most striking characteristic of the species lists of Gorham's (and indeed Vanguard) is its diversity, not only in taxonomic, but also in ecological terms.

There are some implications in this for the interpretation of hunting strategies, either of humans or other predators. Predators are often characterized in assemblages by prey preferences. In this respect, the Gibraltar assemblages are of little help, as the most abundant species, in particular *Columba livia/oenas* and partridge *Alectoris* sp., are important prey for a wide range of carnivores and birds of prey. The abundance of these species is therefore not particularly surprising and may also be related to their local availability, as these were probably amongst the most common species near, or even in, the cave.

A notable absence from Gibraltar sites as a whole is that of herons, egrets, ibises or other larger freshwater wading birds. The only specimen from these families is the single distal tibiotarsus of heron *Ardea* identified by Eastham (1968). Their scarcity is a recurring characteristic of Late Pleistocene avifaunas (Weesie 1988; Alcover *et al.* 1992; Tyrberg 1998). The absence is probably taphonomic rather than palaeoecological, as the presence of suitable freshwater habitats is indicated by a range of other species, such as *Rallus aquaticus* and *Fulica atra*. Instead, it seems that these species are targeted by relatively few predators, and also were rarely encountered by scavengers.

Scavenging

Scavenging may represent an important source of bird material in Gorham's Cave and elsewhere. Indeed, for some species it undoubtedly represents the primary source of material.

This applies especially to birds within the Marine taxa group, represented in the assemblages by a diverse range of species unusual on continental fossil sites, particularly pelagic taxa such as *Pterodroma* sp. The terrestrial presence of such species is frequently invoked as evidence of terrestrial predation (especially human) without considering broader aspects of the life and death of marine birds (Stewart 2002).

Most of the marine species present are regularly found washed up on European beaches. Additionally, sea-ducks such as *Melanitta nigra* and *Melanitta fusca* and *Clangula hyemalis*, as well as waders, are affected by beaching (Heubeck 1987; Skov *et al.* 1989; Granadeiro *et al.* 1997). In the Southern Hemisphere, *Pterodroma* petrels are also regularly identified as beached victims (Avery 1989). Occasionally, beached casualties may occur in considerable numbers in wreck events, which can occur over a geographically very wide area and may be related to extreme weather conditions (Carter 1984; Skov *et al.* 1989). If such events occurred in the Strait of Gibraltar during the Late Pleistocene, they would have represented important carrion bonanzas for local scavengers and may also in part account for the relatively common presence of smaller waders. Humans are also known to have exploited beached birds as a food resource (Avery and Underhill 1986).

The inclusion of the extinct *Pinguinis impennis* is also likely to be due to scavenging of beached birds, although its presence in other Iberian sites has been used to infer its Pleistocene breeding range (e.g Mourer-Chauviré and Antunes 1991; Mourer-Chauviré 1999). This interpretation is based on its being hunted by humans when ashore to breed, as for most of the year it remained offshore and therefore inaccessible to terrestrial predators. On its breeding grounds it was extremely vulnerable to terrestrial predators, one critical reason why its known recent breeding grounds were on offshore islands (Montevecchi and Kirk 1996). Given that a breeding colony would have represented a significant source of easy prey, its robust remains are strangely rare in Mediterranean Pleistocene sites, for example only six finds from Gibraltar, one of which is of uncertain provenance (Cooper 1999), and there are no juveniles. By contrast, in more recent archaeological sites where human contact with breeding colonies was made, remains of adults and juveniles are very common (Montevecchi and Kirk 1996). The pattern of the species' Mediterranean Pleistocene recoveries appears more consistent with scavenging of occasional beached carcasses, either by humans or other large carnivores (Cooper 2005).

Palaeoecology
Habitats

A wide range of habitats are represented by the Gorham's Cave avifauna. In part this reflects the generalist tendencies of the predators and scavengers involved in the accumulation of the assemblage. However, it also reflects the fact that the Rock is effectively a mountain in a lowland coastal setting, providing a catchment area with a diverse combination of environmental situations rarely encountered together in the fossil record. The value of this juxtaposition is demonstrated by the inclusion of species rare

or unknown from other Iberian sites due to the apparent under-representation of species from certain habitats.

Cliffs

A wide variety of cliff-associated species are present, including two species of chough *Pyrrhocorax* sp. and (Blue) Rock Thrush *Monticola ?solitarius*, in addition to *Columba livia* and *Apus* sp. Also well represented, but in terms of diversity rather than abundance, are cliff-dwelling predators, including *Falco naumanni*, *Falco peregrinus*, *Gyps fulvus* and *Aquila* cf. *chrysaetos*.

Cliff communities could be regarded as being over-represented, for example in the high recoveries of pigeon remains, but this bias is not necessarily misleading; the assemblages simply reflect the proximity of these habitats and, to some extent, the relative proportions of their inhabitants.

The inferred cliff communities of Late Pleistocene Gibraltar find close parallels in the species composition of existing southern Iberian cliff communities (Finlayson and Giles Pacheco 2000). Furthermore, it is only during the last century that Bonelli's Eagle *Hieraaetus fasciatus*, *Neophron percnopterus* and Raven *Corvus corax* have been lost as breeding species on the Rock itself (Cortés 1980). *Bubo bubo*, which had also disappeared from Gibraltar, has recently been recorded breeding again on the upper Rock (Garcia 2005, 28).

Matorral

Matorral is the characteristic scrub vegetation of the Mediterranean, and its persistence in refugia across the region throughout the Last Glaciation has been associated with the evolution of a number of endemic birds (Covas and Blondel 1998). There are no species restricted to the habitat included in the Gorham's assemblages, though many of the birds present are characteristic of it. It seems likely that matorral was present on the Rock itself, where it might have been occupied by species such as *Caprimulgus ?ruficollis*, *Oenanthe ?leucura*, *Monticola* cf. *solitarius* and *Phoenicurus ?ochruros*. Additionally, scrub communities were probably also well developed on the sandy plains around the Rock, supporting a further group of species, amongst which *Alectoris* sp. should have been very common, alongside the ubiquitous Rabbit *Oryctolagus cuniculus* (Chapter 10).

Woodlands

A variety of woodland types are suggested by the Gorham's avifauna, ranging from open parkland to mature, closed woods. A greater number of species associated with open woodlands are present, including *Picus viridis*, *Otus scops*, *Cyanopica cyanus* and *Upupa epops*, potentially suggesting a greater prevalence of this habitat than mature woodlands. However, this bias may be due in part to the hunting preferences of *Bubo bubo*, which tends to avoid close-canopy woods (Cramp 1985).

Most species present are generalist in terms of vegetation types, being found at present in both conifers and broadleaves; amongst these are *Picus viridis*, *Dendrocopos ?major* and *Parus ?major*. Several species prefer broadleaf woodland, including *Scolopax rusticola* and *Otus scops*. *Pyrrhula*

pyrrhula, now a scarce vagrant in the Strait region, is often associated with broadleaf woodland in the temperate parts of its range, but also uses coniferous habitats in its more marginal northern ranges (Cramp and Perrins 1994).

Open ground

Many of the assemblage species might potentially be found occupying open ground situations, but only two species are specific to the habitat: *Otis tarda* and *?Melanocorypha calandra*. *Otis tarda* is a particularly valuable indicator, strongly suggesting substantial areas of steppe-like vegetation. Represented only by a single specimen from Gorham's (Gor-95-332), the extreme rarity of *Otis tarda* (a potentially attractive prey species, if available) might suggest that open grasslands were not found in the immediate vicinity of the Rock.

Wetlands

The combination of species within the assemblages suggests that a variety of wetland habitats were present. Of particular interest are *Rallus aquaticus* and *Porzana ?porzana*, which both prefer thick waterside or marsh vegetation (Fig. 9.4); *Chlidonias ?niger*, which is suggestive of freshwater marsh with reedy growth; and *Branta ?bernicla*, which uses coastal and estuarine mudflats in winter. Further evidence of marshes and coastal mudflats is provided by the wide variety of waders, including Curlew *Numenius arquata*, Sanderling/Dunlin *Calidris alba/alpina* and Oystercatcher *Haematopus ostralegus*.

Marshes can provide raptors with rich hunting grounds; in southern Iberia at present, a wide variety of birds of prey hunt over marshes from cliffs or woodlands bordering them (Finlayson 1992). This may well be the reason for the good representation of wetland species in the assemblages.

Marine

Both coastal and offshore pelagic marine species are represented in the Gorham's avifauna. Most of these probably remained offshore, taking advantage of the resources offered by the fertile waters of the Strait, such as the mussel beds also used by the Neanderthals (Barton 2000).

It has been suggested that the cliffs of Gibraltar may have been used by breeding marine species during periods of raised sea-level (Eastham 1968). However, it should be noted that many marine birds in the Western Palaearctic nest exclusively on offshore islands due to the predation pressure posed by terrestrial mammalian predators. Shoreline scavenging of wrecked birds can account for most or all of the marine avifauna present, including the offshore species normally not encountered by mammalian predators. Nevertheless, the occurrence of numerous remains of *Pterodroma* sp. is particularly interesting. *Pterodroma* petrels are pelagic, only using offshore islands for breeding purposes. The genus is recorded at sea very rarely off Portugal (Patterson 1997) and the nearest breeding colonies to the Strait are on Madeira, where the two endemic species Fea's Petrel *Pterodroma feae* and Zino's Petrel *Pterodroma madeira* are considered endangered (Harrop 2004). However, recently published Holocene finds from Scotland and Sweden indicate that at least one

Pterodroma species, possibly *Pterodroma feae*, had a considerably wider former range (Serjeantson 2005; Ericson and Tyrberg 2004). While the Gibraltar finds cannot be regarded as direct evidence of breeding on the Rock, it seems likely that breeding colonies were established somewhere in the region, possibly on islets exposed by lower sea-levels.

Migration and seasonal status

As a result of migratory movements in response to seasonal climatic changes, most modern temperate continental avian communities are very fluid in their composition, with different species associations occurring at different times of the year. Gibraltar's location on the convergence of some of the Western Palaearctic's most important migration routes makes the diverse communities of the Strait region particularly dynamic.

Migratory behaviour represents a particular problem in avian palaeoecology (Cooper 2005). A species identified in an assemblage which might have been a migrant may potentially represent one of several palaeoecological situations: its summer breeding grounds, its wintering grounds or on passage. This choice of possibilities can have habitat implications, as species often use somewhat different situations for wintering and breeding. However, primarily it has climatic implications, as migration is essentially a reflection of seasonal conditions.

The probable status of a number of Gibraltar's Late Pleistocene birds may be deduced from an examination of their present Palaearctic seasonal distribution in the light of the possible effects of retreat southwards in response to climatic deterioration (Tables 9.7 and 9.8).

Residents

Residents are defined as species with non-migratory populations still occurring in southern Iberia. Twenty-five per cent of the species identified as residents on this basis from Gorham's Cave are also those with positive breeding records, based on the presence of juvenile or immature specimens or adult specimens with medullary bone (additional bone laid down in the cavities of limb bones by female birds in the breeding season).

Most of the resident group have a broad Western Palaearctic range, but four have a considerably narrower, 'southern edge' distribution, closely paralleling the chain of Late Pleistocene avian refugia identified across the Western Palaearctic (Harrison 1982).

Summer migrants

A species presently occurring in southern Iberia only as a summer migrant to breed is unlikely to have been present outside this season under conditions of climatic deterioration. If it winters south of the region under current interglacial conditions, this should also be true for colder periods. Ten species from Gorham's are probably summer migrants (Table 9.7). A number of these occur widely across Europe in summer at present, but these ranges were probably significantly reduced during cold phases. Their presence in southern Iberia may well have been only marginal during these times.

Table 9.7 Seasonal status of taxa in Gorham's Cave.

Resident	Summer migrant	Probable winterer
Broad range taxa		
Phalacrocorax aristotelis	cf. *Neophron percnopterus*	*Podiceps* cf. *auritus*
**Alectoris* sp.	*Falco naumanni*	*Fulmarus glacialis*
Otis tarda	*Glareola pratincola*	*Branta ?bernicla*
**Columba* cf. *livia*	*Chlidonias ?niger*	**Melanitta fusca*
**cf. Bubo bubo*	*Streptopelia turtur*	*Clangula hyemalis*
Strix aluco	*Otus scops*	*Pinguinis impennis*
Picus viridis	*Caprimulgus ?ruficollis*	
Dendrocopos ?major	**†Apus apus/pallidus*	
Parus ?major	*Upupa epops*	
Pica pica	*Delichon urbica*	
**Pyrrhocorax pyrrhocorax*		
Corvus corax		
Southern edge taxa		
Melanocorypha ?calandra		
Oenanthe ?leucura		
Petronia petronia		
Cyanopica cyanus		

Evidence of breeding: * indicates juvenile or immature specimens; † indicates medullary bone
Additional breeding species: **Melanitta nigra; *Hirundo* sp.; **cf. Corvus corone/frugilegus*

Winter migrants

The Strait region at present is an important wintering ground for a wide diversity of species. However, the Late Pleistocene status of species currently wintering in the Strait and breeding in more northerly territories must remain uncertain. Under conditions similar to those at present, they may have been wintering; in colder phases, with a shift in range southwards, they may have been breeding. Most of the waders and a number of the ducks identified in the assemblages fall into this category.

Species in the Gibraltar assemblages which I consider to represent mainly wintering birds are those which currently winter well to the north of southern Iberia, and are recorded only rarely, if at all, in the Strait region at present. *Pinguinis impennis* is included in this group, based on what is known about its breeding and wintering habits (Brown 1985; Nettleship and Evans 1985).

A further possible winterer is *Pyrrhula pyrrhula* which at present shows some winter movement into central Spain and is resident in northern Spain (Purroy Iraizoz 1997). Its southerly displacement is not as pronounced as that seen in other species and it was relatively widespread in the Late Pleistocene (Tyrberg 1998). It seems possible that its presence in the Gibraltar assemblages represents a more extensive resident range rather than birds on migration. Several other species in the assemblages had greater ranges, including Alpine Chough *Pyrrhocorax graculus*, which had a particularly extensive Late Pleistocene range (Tyrberg 1991; Mourer-Chauviré 1983).

Comparison of Pleistocene records and modern distributions of various species of geese and duck has revealed southerly displacement of both breeding and wintering grounds during the Last Glaciation (Jenkinson and Sutherland 1984). Similar displacements have been inferred for a variety of other marine species, particularly those whose northern breeding grounds would have been affected by ice-cover (Mourer-Chauviré 1993). Mourer-Chauviré (1983) suggests that nesting of these species may have occurred up to Gibraltar and along the northern Mediterranean coast.

Table 9.8 Taxa of probable seasonal status from high-yielding units, Gorham's Cave.

Taxon	LBSmcf.2	LBSmcf.4	LBSmcf.5	LBSmcf.9
Residents				
Phalacrocorax aristotelis		x	x	
Alectoris sp.	x	x	x	x
Columba cf. *livia*	x	x	x	
Strix aluco	x			
Dendrocopos ?*major*		x		x
Melanocorypha ?*calandra*	x			
Oenanthe ?*leucura*		x		
Parus ?*major*		x		
Cyanopica cyanus		x	x	
Pica pica		x		
Pyrrhocorax pyrrhocorax	x	x	x	
Summer migrants				
Neophron cf. *percnopterus*			x	
Falco naumanni	x	x	x	x
Glareola pratincola				x
Chlidonias ?*niger*		x		x
Streptopelia turtur	x	x	x	
Otus scops		x	x	x
Caprimulgus ?*ruficollis*				x
Apus apus/pallidus	x	x	x	x
Hirundo ?*rustica*		x		
Probable winterers				
Podiceps cf. *auritus*		x		
Fulmarus glacialis		x		
Branta ?*bernicla*	x		x	
Clangula hyemalis	x	x	cf.	x
Melanitta fusca		cf.		

However, it is difficult to distinguish breeding grounds from wintering grounds in the fossil record. Identification of breeding areas should ideally be based on the presence of juveniles or medullary bone, which are the only reliable skeletal means of confirming breeding in the fossil record. Immature specimens also indicate breeding, but the possibility of fledgling dispersal from the original nesting area should be considered.

Only two of the northern displaced species in the Gibraltar assemblages are represented by any immature or juvenile remains. Two immature specimens of Common Scoter *Melanitta nigra* (one with unfused proximal epiphysis), and one of Velvet Scoter *Melanitta fusca* were recovered from Gorham's Cave, the palaeoecological implications of which will be discussed later. *Melanitta nigra* currently winters in the Strait region and its likely Late Pleistocene status cannot be reliably deduced; evidence of its breeding is the only means to determine its seasonal status.

Palaeoenvironmental change

Change in the terrestrial environment

The majority of the species in the Gorham's assemblages are presently extant in southern Iberia, with either resident or seasonal populations. A hallmark of Gibraltar's Late Pleistocene sites overall, this indicates a long-term stability in the area's bird communities and reflects the status of the region as a refugium.

However, four terrestrial species found in Gorham's are now only vagrants in southern Iberia, highlighting at least

some temporal variation. The disappearance of *Pyrrhula pyrrhula* and *Pyrrhocorax graculus* (formerly widespread in Europe) seems related to climatic amelioration causing a retraction in southern European ranges. The same may also be true of Carrion Crow/Rook *Corvus corone/frugilegus*, but the retreat is less pronounced. Human disturbance rather than climatic is likely to have been the cause of the local extinction of *Haliaeetus albicilla*, given that it still maintains a small Mediterranean presence (Cramp and Simmons 1979); two other large raptors in the Gibraltar assemblages, Black Vulture *Aegypius monachus* (Devil's Tower) and Lammergeier *Gypaetus barbatus* (Ibex Cave) appear to have suffered the same fate (Cooper 1999).

With the reidentification of the putative remains of *Bubo scandiacus* as *Bubo bubo*, it is important to note that no signature 'cold' terrestrial species are known to be present. The Iberian Pleistocene record of *Bubo scandiacus* is now confined to a few sites along the northern Spanish coast, where it occurs in association with another significant 'cold' taxon, *Lagopus mutus* (Tyrberg 1998). These 'cold' taxa also occur in other Mediterranean sites during the mid-Late Pleistocene, for example in southern France (Sánchez Marco 2004).

Change in the marine environment

Diverse marine avifaunas are rare on Late Pleistocene sites in the Western Palaearctic, and as mentioned, when they do occur, interpretation is often biased towards analysing their terrestrial presence rather than using them to interpret marine palaeoenvironments (for further discussion see Tyrberg 1999; Stewart 2002).

In Gorham's Cave, contrasting strongly with the terrestrial avifauna, the marine avifauna records major shifts in the marine environments with the presence of six Arctic/Boreal species in the high-yielding units (Table 9.8). 'Cold' marine taxa are also found at Vanguard Cave, Ibex Cave (including *Pinguinis impennis*) and Devil's Tower Cave (including Little Auk *Alle alle*) (Cooper 1999; 2000a; 2005).

A useful way of interpreting Pleistocene marine avifaunas is the use of present-day areas of sympatry. Tyrberg (1999) applied this method to the three marine species identified by Eastham (1968) from Waechter's Layer K (Shag *Phalacrocorax aristotelis*, *Pinguinis impennis*, *Alle alle*), with a resulting area comprising the coasts of the north-eastern British Isles, western Scandinavia and western Iceland. Tyrberg's analyses were based on total assemblages; using species' potential seasonal status may help refine the signal.

Lacking positive breeding evidence, most of the displaced northern species present are considered to have been primarily wintering in the Mediterranean. The current southernmost mutual wintering range of most of Gorham's northern marine assemblage is (broadly speaking) the English Channel and north-eastern Bay of Biscay, with the exception of *Clangula hyemalis* which winters in the northwestern British Isles, the Baltic and parts of the North Sea. Additionally, *Melanitta fusca* can be found wintering along northern Spanish coasts (Harrison 1982).

Two taxa are represented by juvenile or immature remains, and are therefore considered to have been

breeding at times during the Late Pleistocene either within the Strait itself or on the adjacent Spanish Atlantic coast. Immature tarsometatarsi of *Melanitta nigra* in LBSmcf.5 and *Melanitta fusca* in LBSmcf.8 may have come from individuals already at sea, and may therefore represent breeding grounds not in the immediate area. A further immature specimen of *Melanitta nigra* is at an earlier stage of fusion and therefore suggestive of breeding grounds close by. Unfortunately, as this was found in the superficial layers its original stratigraphic and temporal context cannot be assessed. Presently, the nearest mutual breeding range to Iberia of *Melanitta nigra* and *Melanitta fusca* is central Scandinavia (Cramp and Simmons 1977). It is also worth noting that *Melanitta nigra* is now associated with freshwater habitats for breeding, so may have been using local wetlands not coastal locations.

The marine distribution of seabirds is closely related to sea surface temperatures (Voous 1960; Cramp and Simmons 1977). For example, in North Atlantic auks, both breeding and wintering distributions are affected by the convergence of Polar and Atlantic water masses, due to the high productivity and resulting food availability in this zone (Nettleship and Evans 1985). It would seem that the presence of Arctic/Boreal marine species in the Mediterranean during the Late Pleistocene must be directly related to regular southerly extensions of cold northern water masses into lower latitudes.

The young scoter bones indicate extreme displacement of these birds' breeding ranges, related to extreme fluctuations in the oceanic environment. A plausible cause of these distributional shifts is the impact of the repeated massive discharges of ice-bergs from the Laurentide ice-sheet known as Heinrich Events, at least six of which have been recognized over the past 80ka BP (Bond *et al.* 1993; Andrews 1998). Foraminiferal evidence of significantly lowered sea surface temperatures interpreted as the effects of Heinrich Events has been obtained from the Mediterranean (Pérez-Folgado *et al.* 2003). The breeding scoters from Gorham's Cave appear to provide a similar palaeoenvironmental signal.

Conclusions

Gorham's Cave remains one of the outstanding Late Pleistocene avifaunal sites of the Western Palaearctic and is undoubtedly the most important avifaunal site on Gibraltar. Its long excavation history has produced a rich and diverse avifaunal assemblage which records in detail local and regional avifaunas, including critical evidence of Late Pleistocene climatic deterioration.

The 1995–1996 excavations yielded an excellent avian assemblage, but concentrated on a relatively narrow section of the overall stratigraphic sequence, particularly the Lower Bioturbated Sands. Analysis of material across a wider range of the sequence is now essential. It is likely that species diversity may not be greatly increased, but it is hoped that further evidence of breeding species, especially marine birds, could be obtained. The avifauna of Gorham's Cave retains significant potential to continue adding to our knowledge of Late Pleistocene environmental change in southern Iberia and the Strait of Gibraltar.

Acknowledgements

My original Ph.D. research (1995–1999) was funded by a Royal Holloway, University of London (RHUL) Studentship, in association with the Departments of Geology and Geography, RHUL; the Departments of Zoology and Palaeontology of the Natural History Museum, London; the Gibraltar Museum; and with additional support from the Bill Bishop Memorial Trust. Anne Eastham, and the staff and researchers of the Museo Nacional de Ciencias Naturales and the Institut d'Avançats de les Illes Balears kindly allowed me access to their respective osteological collections. Many colleagues assisted with discussion and data, but particular thanks are due to Antoni Alcover, Nick Barton, Clive Finlayson, the late Colin Harrison, John Stewart, Tommy Tyrberg and the late Cyril Walker. Finally, I wish also to thank my former supervisors, Edward P. F. Rose, Robert P. Prŷs-Jones and Jim Rose, and all members of the Gibraltar Caves Project, past and present, for their valuable contributions.

References

Alcover, J. A., Florit, F., Mourer-Chauviré, C. and Weesie, P. D. M. 1992: *The avifaunas of the isolated Mediterranean islands during the Middle and Late Pleistocene*, ed. E. Campbell Kenneth (Los Angeles, Natural History Museum).

Andrews, J. T. 1998: Abrupt changes (Heinrich events) in Late Quaternary North Atlantic marine environments: a history and review of the data and concepts. *Journal of Quaternary Science* 13(1), 3–16.

Andrews, P. 1990: *Owls, caves and fossils: predation, preservation and accumulation of small mammal bones in caves, with an analysis of the Pleistocene cave faunas from Westbury-sub-Mendip, Somerset, UK* (London, Natural History Museum Publications).

Avery, G. 1989: Results of patrols for beached seabirds conducted in Southern Africa in 1984 and 1985. *Cormorant* 17, 57–71.

Avery, G. and Underhill, L. G. 1986: Seasonal exploitation of seabirds by Late Holocene coastal foragers: analysis of modern and archaeological data from the Western Cape, South Africa. *Journal of Archaeological Science* 13, 339–360.

Baales, M. 1992: Accumulations of bones of *Lagopus* in Late Pleistocene sediments. Are they caused by man or animals? *Cranium* 9(1), 17–22.

Barton, R. N. E. 2000: Mousterian hearths and shellfish: late Neanderthal activities on Gibraltar. *Neanderthals on the Edge*, eds. C. B. Stringer, R. N. E. Barton and C. Finlayson (Oxford, Oxbow Books), 211–220.

Bate, D. M. A. 1928: The animal remains. In D. A. E. Garrod, L. H. Dudley-Buxton, G. Elliot Smith and D. M. A. Bate, Excavation of a Mousterian rock shelter at Devil's Tower, Gibraltar. *Journal of the Royal Anthropological Institute* LVIII, 92–110.

Bochenski, Z. 1997: Preliminary taphonomic studies on damage to bird bones by Snowy Owls *Nyctea scandiaca*, with comments on the survival of bones in palaeontological sites. *Acta Zoologica Cracoviensa* 40(2), 279–292.

Bond, G., Broecker, W., Johnsen, S., McManus, L., Labeyrie, L., Jouzel, J. and Bonani, G. 1993: Correlations

between climate records from North Atlantic sediments and Greenland ice. *Nature* 365, 143–147.

Bramwell, D., Yalden, D. and Yalden, P. E. 1987: Black Grouse as the prey of Golden Eagle at an archaeological site. *Journal of Archaeological Science* 14, 195–200.

Brown, R. G. B. 1985: The Atlantic Alcidae at sea. *The Atlantic Alcidae: the evolution, distribution and biology of the auks inhabiting the Atlantic Ocean and adjacent water areas*, eds. D. N. Nettleship and T. R. Birkhead (London, Academic Press), 383–426.

Carter, M. 1984: A petrel strike. *RAOU Newsletter* 61, 1.

Cassoli, P. F. and Tagliacozzo, A. 1997: Butchering and cooking of birds in the Palaeolithic site of Grotta Romanelli (Italy). *International Journal of Osteoarchaeology* 7, 303–320.

Cooper, J. H. 1999: *Late Pleistocene Avifaunas of Gibraltar and their Palaeoenvironmental Significance* (London, Royal Holloway, University of London).

Cooper, J. H. 2000a: A preliminary report on the Pleistocene avifauna of Ibex cave, Gibraltar. *Gibraltar during the Quaternary*, eds. C. Finlayson, G. Finlayson and D. A. Fa (Gibraltar, Gibraltar Government Heritage Publications), 272–232.

Cooper, J. H. 2000b: First fossil record of azure-winged magpie *Cyanopica cyanus* in Europe. *Ibis* 142, 150–151.

Cooper, J. H. 2005: Pigeons and pelagics: interpreting the Late Pleistocene avifaunas of the continental 'island' of Gibraltar. *Proceedings of the International Symposium 'Insular Vertebrate Evolution: the Palaeontological Approach'*. Monografies de la Societat d'Historia Natural de les Balears 12, eds. J. A. Alcover and P. Bover, 101–112.

Cooper, J. H. and Tennyson, A. J. D. 2008: Wrecks and residents: the fossil gadfly petrels (*Pterodroma* sp.) of the Chatham Islands, New Zealand. *Oryctos* 7, 227–248.

Cortés, J. E. 1980: *The Birds of Gibraltar* (Gibraltar, Gibraltar Bookshop).

Covas, R. and Blondel, J. 1998: Biogeography and history of the Mediterranean bird fauna. *Ibis* 140, 395–407.

Cramp, S. (ed.) 1985: *The Birds of the Western Palaearctic. Vol. IV: Terns to Woodpeckers* (Oxford, Oxford University Press).

Cramp, S. and Perrins, C. M. (eds.) 1994: *The Birds of the Western Palaearctic. Vol. VIII: Crows to Finches* (Oxford, Oxford University Press).

Cramp, S. and Simmons, K. E. L. (eds.) 1977: *The Birds of the Western Palaearctic. Vol. I: Ostrich to Ducks* (Oxford, Oxford University Press).

Cramp, S. and Simmons, K. E. L. (eds.) 1979: *The Birds of the Western Palaearctic. Vol. II: Hawks to Bustards* (Oxford, Oxford University Press).

Eastham, A. 1968: The avifauna of Gorham's Cave, Gibraltar. *Bulletin of the Institute of Archaeology, London* 7, 37–42.

Eastham, A. 1989: Cova Negra and Gorham's Cave: evidence for the place of birds in Mousterian communities. *The Walking larder: patterns of domestication, pastoralism, and predation*, ed. J. Clutton-Brock (London, Unwin Hyman), 350–357.

Ericson, P. G. P. 1987: Interpretations of archaeological bird remains: a taphonomic approach. *Journal of Anthropological Archaeology* 14, 65–75.

Ericson, P. G. P. and Tyrberg, T. 2004: *The Early History of the Swedish Avifauna*. Kungl. Vitterhets Historie och Antikvitets Akademiens Handlingar, Antivariska serien 45.

Fernández-Jalvo, Y. 1995: Small mammal taphonomy at Trinchera de Atapuerca (Burgos, Spain). A remarkable example of taphonomic criteria used for stratigraphic correlations and palaeoenvironmental interpretations. *Palaeogeography, Palaeoclimatology, Palaeoecology* 114, 167–195.

Finlayson, C. 1992: *Birds of the Strait of Gibraltar* (London, Poyser).

Finlayson, C. and Giles Pacheco, F. 2000: The southern Iberian Peninsula in the Late Pleistocene: geography, ecology and human occupation. *Neanderthals on the Edge*, eds. C. B. Stringer, R. N. E. Barton and C. Finlayson (Oxford, Oxbow Books), 139–154.

Ford, N. L. 1967: *A Systematic Study of the Owls based on Comparative Osteology* (Ann Arbor, University of Michigan).

Garcia, E. 2005: Birds in Gibraltar. *Gibraltar Bird Report*, 9–45.

Ginn, H. B. and Melville, D. S. 1983: *Moult in Birds* (Norfolk, British Trust for Ornithology).

Granadeiro, J. P., Silva, M. A., Fernandes, C. and Reis, A. 1997: Beached bird surveys in Portugal 1990–1996. *Ardeola* 44(1), 9–17.

Harrison, C. 1982: *An Atlas of the Birds of the Western Palaearctic* (Glasgow, William Collins and Son, Co. Ltd).

Harrop, A. H. J. 2004: The 'soft-plumaged petrel' complex: a review of the literature on taxonomy, identification and distribution. *British Birds* 97, 6–15.

Heath, M. F. and Evans, M. I. (eds.) 2000: *Important Bird Areas in Europe: Priority Sites for Conservation. Vol. 2: Southern Europe*. BirdLife Conservation Series 8 (Cambridge, BirdLife International).

Hernández Carrasquilla, F. 1993: Catalogo provisional de los yacimientos con aves del Cuarternario de la Peninsula Iberica. *Archaeofauna* 2, 231–275.

Hernández Carrasquilla, F. 1995: Cueva de Nerja (Málaga): las aves de las campanas de 1980 y 1982. *Trabajos sobre de la Cueva de Nerja* 5, 221–293.

Heubeck, M. 1987: The Shetland beached bird survey, 1979–1986. *Bird Study* 34, 97–106.

Janossy, D. 1983: Humeri of Central European smaller Passeriformes. *Fragmenta Mineralogical et Palaeontologica* 11, 85–112.

Jeffrey Bickart, K. 1984: A field experiment in avian taphonomy. *Journal of Vertebrate Paleontology* 4(4), 525–535.

Jenkinson, R. D. S. and Sutherland, S. 1984: Changes in European geese and duck migration patterns during the Quaternary. *In the shadow of extinction: a quaternary archaeology and palaeoecology of the lake, fissures and smaller caves at Creswell Crags SSSI*, eds. R. D. S. Jenkinson, R. Gould-Zvelebil and D. D. Gilbertson (Sheffield, John R. Collis), 101–109.

Livingstone, S. D. 1989: The taphonomic interpretation of avian skeletal part frequencies. *Journal of Anthropological Archaeology* 16, 537–547.

Lorenc, M. 2006: On the taphonomic origins of Vistulian

bird remains from cave deposits in Poland. *Acta Zoologica Cracoviensa* 49A(1–2), 63–82.

Macphail, R. I. and Goldberg, P. 2000: Geoarchaeological investigations of sediments from Gorham's and Vanguard Caves, Gibraltar: microstratigraphical (soil micromorphological and chemical) signatures. *Neanderthals on the Edge*, eds. C. B. Stringer, R. N. E. Barton and C. Finlayson (Oxford, Oxbow Books), 183–200.

Montevecchi, W. A. and Kirk, D. A. 1996: Greak Auk (*Pinguinus imprennis*). *The Birds of North America: No.260*, eds. A. Poole and F. Gill (Philadelphia and Washington, D. C., The Academy of Natural Sciences and the American Ornithologists' Union).

Moreno, E. 1985: Clave osteológia para la identificatión de los passeriformes ibéricos, I. *Ardeola* 32(2), 295–378.

Moreno, E. 1986: Clave osteológia para la identificatión de los passeriformes ibéricos, II. *Ardeola* 33(1–2), 69–130.

Moreno, E. 1987: Clave osteológia para la identificatión de los passeriformes ibéricos, III. *Ardeola* 34(2), 243–374.

Mourer-Chauviré, C. 1983: Les oiseaux dans les habitats Paleolithiques: gibier des hommes ou proies des rapaces? *Animals and Archaeology 2: Shell Middens, Fishes and Birds*, eds. C. Grigson and J. Clutton-Brock (Oxford, BAR International Series 183), 111–124.

Mourer-Chauviré, C. 1999: Influence de l'homme préhistorique sur la répartition de certains oiseaux marins: l'exemple du Grand Pingouin *Pinguinus impennis*. *Alauda* 67(4), 273–279.

Mourer-Chauviré, C. and Antunes, M. T. 1991: Présence du Grand Pingouin *Pinguinis impennis* (Aves, Charadriiformes) dans le Pléistocene du Portugal. *Geobios* 24(2), 201–205.

Nettleship, D. N. and Evans, P. G. H. 1985: Distribution of the Atlantic Alcidae. *The Atlantic Alcidae: the evolution, distribution and biology of the auks inhabiting the Atlantic Ocean and adjacent water areas*, eds. D. N. Nettleship and T. R. Birkhead (London, Academic Press), 53–154.

Patterson, A. M. 1997: *Las Aves Marinas de Espana y Portugal* (Barcelona, Lynx Edicions).

Pérez-Folgado, M., Sierro, F. J., Flores, J. A., Cacho, I., Grimalt, J. O., Zahn, R. and Shackleton, N. 2003: Western Mediterranean planktonic foraminifera events and millennial climatic variability during the last 70 kyr. *Marine Micropaleontology* 48, 49–70.

Purroy Iraizoz, F. J. 1997: *Atlas de las aves de Espana (1975–1995)* (Barcelona, Lynx Edicions).

Reid, P. S. G. 1871–1890: *Stray notes on Ornithology; a record of ornithological observations in Gibraltar, Bermuda, the British Isles, New York, the Canary Islands and Spain* (Tring, Ornithology Library, Natural History Museum).

Sánchez Marco, A. 1996: Aves fosiles del Pleistoceno Iberico: rasgos climaticos, ecologicos, y zoogeograficos. *Ardeola* 43(2), 207–219.

Sánchez Marco, A. 2004: Avian zoogeographical patterns during the Quaternary in the Mediterranean region and palaeoclimatic interpretation. *Ardeola* 51(1), 91–132.

Sangster, G., Collinson, J. H., Helbig, A. J., Knox, A. G. and Parkin, D. T. 2004: Taxonomic recommendations for British birds: second report. *Ibis* 146(1), 153–157.

Seguí, B., Mourer-Chauviré, C. and Alcover, J. A. 1997: Upper Pleistocene and Holocene fossil avifauna from Moleta Cave (Mallorca, Balearic Islands). *Bolleti de la Societat d'Historia de Natural Balears* 40, 223–252.

Serjeantson, D. 2005: Archaeological records of a gadfly petrel *Pterodroma* sp. from Scotland in the first millennium AD. *Feathers, grit and symbolism: birds and humans in the ancient old and new worlds*, eds. G. Grupe and J. Peters (Rahden/Westf., Verlag Marie Leidorf), 235–246.

Serjeantson, D., Irving, B. and Hamilton-Dyer, S. 1992: Bird bone taphonomy from the inside out: the evidence of gull predation on the Manx Shearwater *Puffinus puffinus*. *Archaeofauna* 2, 191–204.

Skov, H., Danielsen, F. and Durinck, J. 1989: Dead seabirds along European coasts, 1987 and 1988. *Sula* 3(1), 9–19.

Snow, D. W. and Perrins, C. M. (eds.) 1998: *The Birds of the Western Palaearctic*. Concise Edition (Oxford, Oxford University Press).

Stewart, J. R. 1992: *The Turdidae of Pin Hole Cave, Derbyshire* (London, City of London, North London and Thames Polytechnics).

Stewart, J. R. 2002: Seabirds from coastal, non-coastal, archaeological and 'natural' Pleistocene deposits or not all unexpected deposition is of human origin. *Acta Zoologica Cracoviensa* 45, 167–178.

Stiner, M. C., Munro, N. D., Surovell, T. A., Tchernov, E. and Bar-Yosef, O. 1999: Paleolithic population growth pulse evidenced by small animal exploitation. *Science* 283, 190–194.

Tyrberg, T. 1991: Arctic, montane and steppe birds as glacial relics in the West Palearctic. *Ornithologisiche Verhandlungen* 25, 29–49.

Tyrberg, T. 1998: *Pleistocene birds of the Palearctic: a catalogue* (Cambridge, Mass., Nuttall Ornithological Club).

Tyrberg, T. 1999: Seabirds and Late Pleistocene marine environments in the Northeast Atlantic and the Mediterranean. *Avian paleontology at the close of the 20th century: proceedings of the 4th International Meeting of the Society of Avian Paleontology and Evolution, Washington, D. C., 4–7 June 1996*, eds. S. L. Olson and P. Wellnhofer (Washington, D. C., Smithsonian Institution Press), 139–157.

Voous, K. H. 1960: *Atlas of European birds* (London, Nelson).

Weesie, P. D. M. 1988: The Quaternary avifauna of Crete, Greece. *Palaeovertebrata* 18(1), 1–94.

10 The small mammal fauna of Gorham's Cave

C. Price

Introduction

The Gibraltar Caves Project excavations produced a prodigious number of sediment samples, which provided a wealth of environmental evidence in the form of bones, shells and charcoal, in addition to cultural materials. The small mammal bones were examined in order to establish the ecology of the landscape surrounding the cave, making it possible to place the Neanderthal and early modern human occupation of the cave in its environmental setting – an important consideration when analysing patterns of use of the cave. The benefit of this approach is that small mammals are relatively sedentary, and most have distinct habitat preferences which make them a useful proxy for reconstructions of this kind.

Methodology

During the four seasons of excavation undertaken between 1995 and 1998, samples were recovered from all major identified strata. A total of 761 samples yielded small mammal remains and were examined in this study.

The samples were treated in a variety of ways on site. Many were initially sieved in the sea using 2 mm or 1 mm sieves, to reduce the bulk to be returned to the Natural History Museum. These were then resieved in the museum, using 4 mm, 2 mm and 1 mm stacked sieves. Samples which were returned to the museum unprocessed were sieved using an additional 0.5 mm mesh. Other samples were dry sieved on site using a 2 mm mesh. Records of the treatments used are not available in every case.

The small mammal remains were identified to species where possible, by comparison with modern comparative material. In rodents, this is usually limited to teeth and jaws, or fragments thereof, as the postcranial elements are very standardized. Individual teeth are the most durable part of the skeleton, so the impossibility of identifying other skeletal parts does not cause a problem. In the case of moles (*Talpa* sp.), however, there are occasions where the presence of the species was apparent through the identification of their distinctive limb bones. In moles, these are particularly large, solid bones and therefore likely to be better preserved than the smaller, more delicate equivalents in voles, mice and shrews.

Results

Tables 10.1 and 10.2 show the range of species present in each context from which samples were collected, and Tables 10.3–10.5 give the actual numbers of individual identified finds from contexts within the series of deposits forming the main part of the sequence. There is considerable variation in the size and number of samples recovered from each context, which should be remembered when comparing the results. For example, the Cemented Hearths member (CHm.2 to CHm.5) yielded a very limited quantity of small samples, and this naturally restricted the number of identifiable small mammal bones recovered. It is thus impossible to tell whether this is due to the small size of the sample or to a genuinely restricted fauna at the time of deposition. To show the species ratio within the microfaunal composition, Figures 10.1–10.3 give percentages of the five main species, and a single percentage of other species.

Bioturbated Earth
(BEm.3)

The range of species present is shown in Table 10.1. The small mammals from this level come from only four samples, from which 25 specimens could be identified to species. Of these, 16 were rabbit (*Oryctolagus cuniculus*). The collection is too small to allow much to be said about environmental indications, but it is worth noting that the *Microtus* vole in this level is Cabrera's vole (*M. cabrerae*) rather than Cette's vole (*M. brecciensis*). Cabrera's vole appears in Spain during the Upper Pleistocene, and has been shown to be a direct descendant of *M. brecciensis* (Cabrera-Millet *et al.* 1982), and now has a wide but scattered distribution throughout Iberia, where it is endemic. The teeth of this species are similar to those of *Microtus brecciensis*, but lack their extreme angularity and asymmetry. This indicates a movement towards a less coarse diet, and perhaps a general availability of softer grass species. The absence of bats or other insectivores (shrews or moles) is probably either a product of the limited sample, or indicative of the agent of accumulation rather than a true reflection of the fauna at the time of deposition. Owls commonly eat insectivores, but the mammalian carnivores which prey on rodents tend to avoid shrews and moles because of their bad taste.

Cemented Hearths
(CHm.2–5)

Again, there were few, small samples from these levels. The bone recovered is fragmentary, with only one near complete mandible. This specimen, a rabbit mandible from CHm.5, shows damage typical of owl predation, having a complete tooth row but damaged ascending ramus (personal observation). There are also two rabbit maxilla fragments from CHm.2. The smaller mammals are restricted to isolated teeth. Only three species were identified – rabbit, fieldmouse (*Apodemus sylvaticus*) and Cabrera's vole.

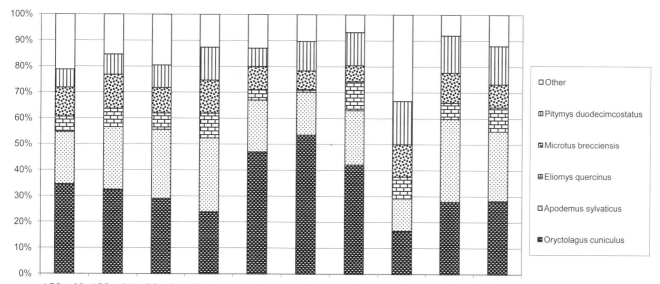

Fig. 10.1 Gorham's Cave LBSmcf small mammals by percentage.

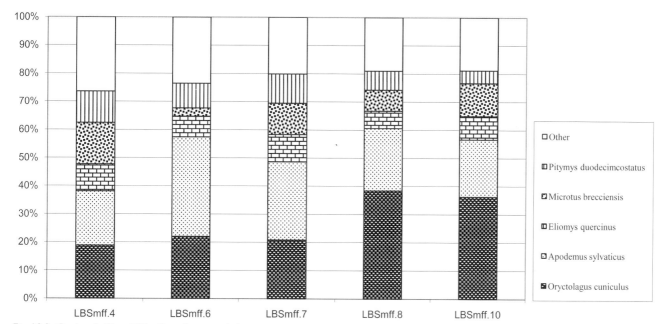

Fig. 10.2 Gorham's Cave LBSmff small mammals by percentage.

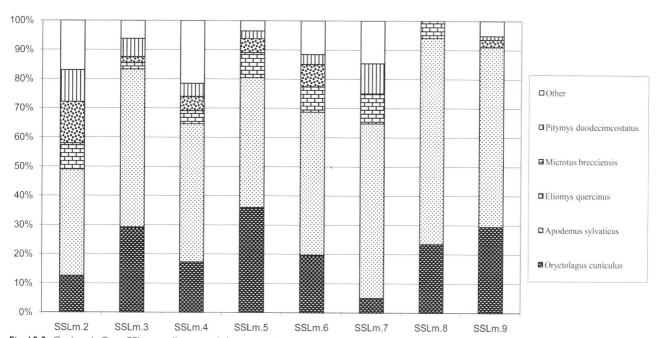

Fig. 10.3 Gorham's Cave SSLm small mammals by percentage.

Upper Bioturbated Sands
(UBSm.4)

One sample was studied from this level. The identifiable bones were two nasal ends of a rabbit maxilla, two mandibles and one maxilla of fieldmouse, and one mandible of water vole (*Arvicola* cf. *sapidus*). The southern water vole is found only near water, either streams or marshes, unlike the more widespread *Arvicola terrestris*, which has both aquatic and fossorial populations (Mitchell-Jones *et al.* 1999). Water voles are relatively uncommon in owl pellets, except in areas where the fossorial form is abundant. The condition of this specimen, with the first and second molars in place but no ascending ramus, is indicative of owl predation. While the absence of the species from the higher levels of the deposit does not prove its absence from the fauna, its presence here can be taken to demonstrate the availability of either flowing water or marsh in the area at this time.

(UBSm.5)

Three samples were studied, containing mostly fragmentary rabbit bone. One sample included a near complete rabbit mandible.

(UBSm.6)

Three samples from this level, containing few identifiable specimens. One rabbit mandible fragment and a bat mandible fragment are burnt. This is unlikely to have been deliberate. The bat remains from the site are not identifiable to species, as most are too fragmentary to provide a definite identification.

(UBSm.7)

Three samples were examined. The species representation is similar to UBSm.6, with the addition of one fragment of *Microtus brecciensis*. The bones are generally in a less complete condition.

Bedded Sand, Orange Sand sUBMEMBER
(BeSm(OSsm).1–2)

Only two small samples were available, yielding five fragments identified as rabbit and a single fragment of *Microtus brecciensis* molar.

Lower Bioturbated Sands, Fine Facies
(LBSmff.1–12)

This block of deposits occupies a similar stratigraphic position to the Coarse Facies (LBSmcf.1–13) and can be considered to have accumulated at the same time. There is nothing in the faunal list to suggest otherwise. The species presence/absence (Table 10.2) is given separately to avoid confusion. The only species recovered from LBSmff but not LBSmcf is *Mustela nivalis* (weasel). This small carnivore is widely distributed throughout Europe, from the Mediterranean islands to northern Fennoscandia. It preys principally on mice and small voles, with occasional rabbits and water voles. It is not a noted cave dweller, but will nest in holes between rocks. It is most likely to have been the prey of a larger species of carnivore or of a raptor. The identified remains from this level are two isolated teeth.

Table 10.1 Gorham's Cave small mammals, faunal composition.

	Oryctolagus cuniculus	Apodemus sylvaticus	Eliomys quercinus	Microtus brecciensis	Pitymys duodecimcostatus	Microtus cf. cabrerae dentatus	Microtus cf. cabrerae	Arvicola cf. sapidus	Talpa europaea	Crocidura russula	Lepus sp.	Bat	Erinaceus europaeus	Mustela nivalis	Sorex sp.
Bem.3	+	+	+		+		+								
CHm.2	+	+													
CHm.3	+														
CHm.4	+						+								
CHm.5	+														
UBSm.4	+	+						+							
UBSm.5	+														
UBSm.6	+	+			+					+					
UBSm.7	+	+		+	+					+					
BeSm.1	+			+											
BeSm.2	+	+	+	+	+		+		+	+	+	+			
LBSmcf.1	+	+	+	+	+				+		+				
LBSmcf.2	+	+	+	+	+	+		+	+	+	+	+			
LBSmcf.4	+	+	+	+	+	+	+	+	+	+	+	+			
LBSmcf.5	+	+	+	+	+				+	+		+			
LBSmcf.6	+	+	+	+	+				+	+		+			
LBSmcf.7	+	+	+	+	+				+	+		+	+		
LBSmcf.8	+	+	+	+	+				+	+		+	+		
LBSmcf.9	+	+	+	+	+			+	+	+		+			
LBSmcf.10	+	+	+	+	+					+					
LBSmcf.11	+	+	+	+	+			+	+	+		+			
LBSmcf.12	+	+	+	+	+			+	+	+		+			
SSLm(Usm).1	+	+	+	+	+										
SSLm(Usm).2	+	+	+	+	+		+		+	+		+			
SSLm(Usm).3	+	+	+	+	+				+						
SSLm(Usm).4	+	+	+	+	+		+			+	+				
SSLm(Usm).5	+	+	+	+	+			+	+	+					
SSLm(Lsm).6	+	+	+	+	+	+		+	+	+	+	+		+	+
SSLm(Lsm).7	+	+	+		+				+	+					
SSLm(Lsm).8	+	+	+							+			+		
SSLm(Lsm).9	+	+	+	+	+				+	+					
VSSm.1–4	+	+							+						
RSSm.1	+	+	+	+	+								+		
RSSm.5	+	+	+	+				+	+						

Table 10.2 Gorham's Cave LBSmff sequence faunal composition.

	Oryctolagus cuniculus	Apodemus sylvaticus	Eliomys quercinus	Microtus brecciensis	Pitymys duodecimcostatus	Microtus cf. cabrerae dentatus	Microtus cf. cabrerae	Arvicola cf. sapidus	Talpa europaea	Crocidura russula	Lepus sp.	Bat	Erinaceus europaeus	Mustela nivalis
LBSmff.3	+	+			+					+				
LBSmff.4	+	+	+	+	+	+		+	+	+	+			
LBSmff.6	+	+	+	+	+			+		+	+			
LBSmff.7	+	+	+	+	+	+		+	+	+				
LBSmff.8	+	+	+	+	+	+		+	+	+	+		+	+
LBSmff.10	+	+	+	+	+			+	+	+	+			+
LBSmff.11	+	+							+	+				
LBSmff.12	+												+	

Table 10.3 Gorham's Cave LBSmcf series small mammals, absolute numbers.

	LBSmcf.2	LBSmcf.4	LBSmcf.5	LBSmcf.6	LBSmcf.7	LBSmcf.8	LBSmcf.9	LBSmcf.10	LBSmcf.11	LBSmcf.12
Oryctolagus cuniculus	182	240	83	42	47	52	403	4	125	61
Apodemus sylvaticus	106	178	76	18	20	16	200	3	143	58
Eliomys quercinus	31	52	18	6	4	1	107	2	28	20
Microtus brecciensis	59	97	28	8	9	7	59	3	52	19
Pitymys duodecimcostatus	37	58	25	8	7	11	122	4	64	32
Microtus cf. cabrerae dentatus	1	4	0	0	0	0	0	0	0	0
Microtus cf. cabrerae	0	2	0	0	0	0	0	0	0	0
Microtus sp.	0	0	0	0	0	1	3	0	0	6
Arvicola cf. sapidus	4	5	0	0	0	0	15	0	2	1
Talpa europaea	10	18	6	1	2	3	18	0	6	1
Crocidura russula	15	27	16	5	1	1	7	0	3	5
Lepus sp.	3	4	0	0	0	0	0	0	0	0
Bat	13	36	16	2	2	1	12	4	10	4
Vole indet.	8	18	14	0	3	3	10	0	13	8
Leporid indet.	60	2	4	0	0	0	2	4	2	1
Erinaceus europaeus	0	0	0	0	5	1	0	0	0	0
Mustela nivalis	0	0	0	0	0	0	0	0	0	0
Sorex sp.	0	0	0	0	0	0	0	0	0	0
Total	529	741	286	90	100	97	958	24	448	216

Lower Bioturbated Sands, Coarse Facies (LBSmcf.1–13)

This series of levels was extensively sampled, providing large numbers of small mammal remains. These are presented in Table 10.3 and Figure 10.1, showing absolute numbers of identified remains and percentages of the five main species.

The fauna is remarkably consistent through the deposits. There is a persistent presence of the five main species found in the cave – rabbit, fieldmouse, garden dormouse (*Eliomys quercinus*), Cette's vole (*Microtus brecciensis*) and Mediterranean pine vole (*Pitymys duodecimcostatus*). Rabbit is dominant in all levels of LBSmcf except in LBSmcf.6, where a slightly higher percentage of fieldmouse is found. LBSmcf.10 appears aberrant, but this is no doubt due to the low numbers of identified specimens available from relatively small number of samples.

The specimen identified as *Microtus cabrerae* in unit LBSmcf.4 is almost certainly *Microtus brecciensis*. *Microtus* voles have variable tooth morphology, and as the former is a direct descendant of the latter it is not improbable that individuals showing a tendency towards a similar morphology should be found within the ancestral population. Similarly, *Microtus cabrerae dentatus* is now recognized as a subspecies of *M. cabrerae* rather than a discrete species as 'morphological differences between them are negligible … which makes their validity questionable' (Mitchell-Jones *et al.* 1999). The Gorham's Cave specimens identified as *M. cabrerae dentatus* follow the descriptions given for *Microtus dentatus* in Miller (1912), and show a distinct difference in the lower third molar, having a completely closed triangle on the outer side. The teeth are also larger.

Crocidura russula (greater white-toothed shrew) is present in almost every stratum in this member. This species has an extensive distribution through Iberia and much of western Europe as far north as the River Elbe. It inhabits a wide variety of habitats including open grassland and areas of low shrub. Its modern preference for drystone walls (Mitchell-Jones *et al.* 1999) suggests that areas of broken rock and scree might have been a favoured environment in prehistoric times.

In addition to rabbits another lagomorph, the hare, is present in LBSmcf.2, LBSmcf.4 and LBSmcf.12. The hares now present in southern Spain are *Lepus granatensis* (Iberian hare), a species similar to, but genetically distinct from, *Lepus capensis* (Cape hare) (Mitchell-Jones *et al.* 1999). Corbet posits the theory that 'during the last glaciation the presence of rabbits in Iberia and their absence from the other refugia … may well have led to the differentiation of the hares, with the Iberian hares … remaining closer to the plains-adapted *L. capensis* of Africa' (Corbet 1994, 6), while the more versatile brown hare (*L. europaeus*) evolved in the rabbit-free Italian peninsula. In Doñana the rabbits tend to live close to scrub, while the hares occupy the open grassland. Other authors have described the Iberian hare as more adaptable, occurring in habitats ranging from open forest to sand dune (Mitchell-Jones *et al.* 1999). It is probable that in an area where the two species live in close proximity, as was evidently the case in prehistoric Gibraltar, there is a natural division of resources such as is seen in Doñana. Hares are not present in modern Gibraltar.

A small number of *Erinaceus europaeus* (hedgehog) remains were recovered from LBSmcf.7 and LBSmcf.8. This is another widespread species, and not especially indicative of climate, though in the Mediterranean it is uncommon in dry habitats. It is commonly found in ecotonal scrub and grassland. It is likely to have been predated by a mammalian carnivore rather than an owl, though eagle owls are known to eat hedgehogs occasionally. The remains identified were isolated teeth.

Taken as a whole, the fauna of the LBS Coarse Facies deposits indicates a temperate climate, without severe winters of prolonged frost and snow cover. A variety of habitats are likely to have occurred in the area around the cave, including areas of open grassland or dehesa (Mediterranean savanna) interspersed with scrub or maquis. Freshwater streams or marsh are indicated by the presence of water voles in several layers.

Table 10.4 Gorham's Cave LBSmff series small mammals, absolute numbers.

	LBSmff.4	LBSmff.6	LBSmff.7	LBSmff.8	LBSmff.10
Oryctolagus cuniculus	37	15	30	194	210
Apodemus sylvaticus	38	24	40	112	118
Eliomys quercinus	19	5	14	31	48
Microtus brecciensis	29	2	16	38	68
Pitymys duodecimcostatus	22	6	15	34	26
Microtus cf. *cabrerae dentatus*	3	0	1	4	0
Microtus cf. *cabrerae*	0	0	0	0	0
Microtus sp.	2	0	0	13	8
Arvicola cf. *sapidus*	1	1	2	2	2
Talpa europaea	6	0	5	8	13
Crocidura russula	8	2	4	14	16
Lepus sp.	1	1	4	11	4
Bat	6	2	0	2	3
Vole indet.	6	2	0	6	2
Leporid indet.	19	8	13	33	60
Erinaceus europaeus	0	0	0	1	0
Mustela nivalis	0	0	0	2	1
Sorex sp.	0	0	0	0	0
Total	197	68	144	505	579

Table 10.5 Gorham's Cave SSLm series small mammals, absolute numbers.

	SSLm.2	SSLm.3	SSLm.4	SSLm.5	SSLm.6	SSLm.7	SSLm.8	SSLm.9
Oryctolagus cuniculus	45	14	31	92	251	2	4	23
Apodemus sylvaticus	131	26	85	114	623	24	12	48
Eliomys quercinus	32	1	8	22	110	4	1	10
Microtus brecciensis	51	1	9	12	98	0	0	2
Pitymys duodecimcostatus	39	3	8	7	43	4	0	1
Microtus cf. *cabrerae dentatus*	0	0	0	0	2	0	0	0
Microtus cf. *cabrerae*	3	0	2	0	0	0	0	0
Microtus sp.	0	0	0	0	3	0	0	0
Arvicola cf. *sapidus*	0	0	0	1	14	0	0	0
Talpa europaea	5	1	2	2	24	3	0	0
Crocidura russula	7	0	2	2	29	2	0	1
Lepus sp.	0	0	2	0	6	0	1	1
Bat	1	0	0	1	4	0	0	0
Vole indet.	17	2	0	0	21	0	0	1
Leporid indet.	30	0	18	3	41	0	1	1
Erinaceus europaeus	0	0	0	0	0	0	0	0
Mustela nivalis	0	0	0	0	2	0	1	0
Sorex sp.	0	0	0	0	1	0	0	0
Total	361	48	167	256	1272	39	20	88

Sands and Stony Lenses, upper sUBMEMBER (SSLm(Usm).1–5)

The notable difference in the fauna in these levels is that the dominant species is *Apodemus sylvaticus* (fieldmouse) rather than *Oryctolagus cuniculus* (rabbit), though rabbit is still present in higher numbers than any of the other species. This could be due to a genuine population change, or, more likely, to a difference in predator or predators using the cave. If, for example, tawny owls rather than eagle owls were using the cave at this time, one would expect a higher proportion of smaller prey species in the detritus they produced. It is thought improbable that more than one species of owl would occupy the cave simultaneously, as the largest sort present would be more likely to see smaller owls as dinner rather than as cousins. However, it is quite probable that the cave was used by different species of owl at different times, even within the same phase of deposition, each contributing a different ratio of small mammal bones to the cave fill.

There is no indication that the environment during deposition of SSLm(Usm) was notably different from that described from the evidence in the LBSmcf and LBSmff. It is possible that the area was slightly drier, as *Arvicola* remains were only recovered from SSLm(Usm).5.

Sands and Stony Lenses, lower sUBMEMBER (SSLm(Lsm.6–11)

SSLm(Lsm.6) yielded the largest number of small mammal bones of all the layers. A total of 1272 items were identified. This may explain why the species list for this layer is longer. As in the overlying SSLm(Usm), fieldmouse remains are more abundant than rabbit. (Lsm.6) is the only level to produce evidence of a *Sorex* (red toothed) shrew – a single incomplete mandible with incisor and one premolar. The specimen was not sufficiently complete to allow identification to species.

SSLm(Lsm).7 to *SSLm(Lsm).9* have much more restricted faunal lists. *Apodemus* is again the dominant

Length

Width

Fig. 10.4 Measurement points for biometric analysis of *Microtus brecciensis*.

small mammal, with few insectivores and a low proportion of *Microtus brecciensis*. Because relatively few identifiable specimens were recovered from (Lsm.7) and (Lsm.8), it is not possible to tell whether this is a genuine faunal difference, or brought about by the simple statistical fact that the more identified specimens one has, the more species are likely to be represented.

Variegated Sands and Silts
(VSSm.4)

These levels are represented only by samples collected in 1994, prior to the main seasons of excavation. The samples were small and few. The species present are consistent with a temperate environment similar to that indicated by the higher levels. The inclusion of mole (*Talpa* sp.) shows the availability of good soil cover with active microfauna such as worms.

Reddish Silts and Sands
(RSSm.1–8)

Again, only a few samples from the 1994 excavations are available from this stratum. The five main species – rabbit, fieldmouse, garden dormouse, Cette's vole and Mediterranean pine vole – are in evidence, though the number of specimens is too low to give any statistical indication of the population balance. The absence of Mediterranean pine vole from RSSm.5 is not evidence of its absence from the fauna, as the available sample is very small. A single weasel incisor was recovered from RSSm.1, and single isolated teeth of greater white-toothed shrew and mole from RSSm.5.

Analysis

The most obvious finding of this work is that the small mammal fauna of Gorham's Cave is remarkably stable throughout the period of deposition. There are five dominant species which appear almost ubiquitous in the different levels. These are augmented by a selection of other species occurring in lower numbers, which are also widely distributed through the stratigraphic sequence. The five main species identified will be considered individually before investigating their role as part of the fauna.

Oryctolagus cuniculus (rabbit)

Remains of this creature are present in every context for which samples are available, frequently in high concentrations. The rabbit originated in Iberia, and had evolved

into the extant species by the Middle Pleistocene at the latest (Corbet 1994). The European rabbit shows a marked north–south gradient in body size, with average body weights varying between 1710 g in northern France to 923 g in south-western Spain (Rogers *et al.* 1994). The behaviour of the prehistoric rabbits in Gibraltar would probably be similar to those studied at Doñana National Park in Spain, where the wetlands for which the area is famous are separated from the sea by a large dune system offering the sandy habitats preferred by rabbits for burrowing. The coastal plain between Gorham's Cave and the sea would be similarly suitable for rabbits, whereas the Rock as it exists today is far from ideal – in fact, rabbits are now 'in decline' on Gibraltar (GOHNS 2006), probably due to the lack of suitable habitat combined with pressure from human occupation. Studies of rabbits in southern Spain show that rabbits 'thrive best where sand ridges suitable for warren building interdigitate with or abut moist feeding grounds' (Rogers *et al.* 1994, 34). In Doñana, the rabbits feed on a mixture of grasses and forbs, but their diet appears to be regulated by the feeding habits of larger herbivores – 'it appears the rabbits in Doñana really eat only what is left by the other herbivores' (ibid., 36) – and they will browse on woody plants where softer forage is unavailable.

The dominance of rabbit in the Gorham's Cave sequence is possibly exaggerated by two factors. As the creature is larger than the other species in the small mammal fauna except the hare, more rabbit remains would be recovered where coarser sieving methods were used. However, there is also a high proportion of rabbit in samples which were sieved at 1 mm. Secondly, lagomorphs have a more extensive dentition than mice and voles, with incisors identifiable to species and 28 teeth while the smaller rodents have very similar incisors, not identifiable to species, and only 16 teeth. However, studies of modern population dynamics show that rabbits in Iberia are heavily predated – 'In the west Mediterranean in general, and in southern Spain in particular, the number of species of predator is exceptionally high [40, compared with 30 in France and 17 in the UK]' and that 'rabbits are an important part of most predators' diet, especially in southern Spain, where, with the exception of the wolf, all predators of medium and large size (3 kg for mammals, 1.5 kg for birds) rely to a large extent on rabbits for food' (Rogers *et al.* 1994, 47). It seems likely that prehistoric Iberia supported a similar situation. Predators generally exploit the largest possible prey, according to their size, to gain maximum calorific benefit from their hunting effort.

Apodemus sylvaticus (wood mouse or long-tailed fieldmouse)

Although it can be an indicator of woodland when found in combination with other specifically woodland species, *A. sylvaticus* is a widespread and catholic species, found in habitats ranging from woodland to sand dunes. It is opportunistic in feeding, taking a great variety of seeds, fruits, buds and shoots and supplementing its diet with insect larvae, snails and arthropods. It generally excavates its own burrow. *Apodemus sylvaticus* is not recorded from modern Gibraltar (GOHNS 2006).

Eliomys quercinus (garden dormouse)

This type of dormouse is not restricted to woodland, and also inhabits scrub vegetation 'especially among rocks and stone walls' (Mitchell-Jones *et al.* 1999, 298), and will hibernate in hollow trees, rock cavities or caves (Macdonald and Barrett 1993). It feeds on a wide range of resources – nuts, seeds, buds, fruits, insects, snails and birds' eggs.

Microtus brecciensis (Cette's vole, extinct)

As with all extinct species, the habitat of this vole is conjectural. However, extensive biometrical research on large collections of *Microtus brecciensis* teeth from the site of Orgnac 3 (Ardèche, France) by Marcel Jeannet offers a better insight into its requirements than is usually available for extinct rodents. He defines the prime habitat of *M. brecciensis* as a shrubby environment, well shaded and not dry, to the extent that '*il montre une forte répulsion pour la prairie*' – it shows a strong dislike for open grasslands (Jeannet 2000, 354). The species avoids high temperatures and cannot stand prolonged frosts or snow cover (Jeannet 2000). The hypsodont teeth of voles are adapted for grazing, and the degree of angularity suggests the coarseness of forage, ranging from the more rounded shape of the *Clethrionomys* voles, which feed on softer shoots, to the extreme angularity seen in the teeth of collared lemmings (*Dicrostonyx torquatus*) which inhabit tundra environments and feed on tough vegetation. *M. brecciensis* teeth are very much at the lemming end of the scale, suggesting their diet consists of coarse grasses and woody shoots.

Pitymys (Microtus) duodecimcostatus (Mediterranean pine vole)

In common with other *Pitymys* species, the Mediterranean pine vole is an extensive burrower, preferring 'open habitats and ground sufficiently loose and deep for digging' (Mitchell-Jones *et al.* 1999, 232). It 'tolerates more adverse temperatures and drought than other *Microtus* species' (ibid.), and feeds largely on grasses and legumes.

Taphonomy

Understanding the processes involved in small mammal bone deposition in caves is complicated by the fact that a combination of factors is invariably involved. Some small mammals arrive in the cave voluntarily, either as inhabitants, such as bats, or seeking food or temporary shelter, such as the rats which were observed during excavation. These might die naturally, leaving their carcasses to decompose *in situ*, or to be scavenged by other animals. Others might be brought to the cave dead, as prey items of either avian or mammalian carnivores, leaving feeding remains and pellets or scats as part of the cave fill. Alternatively, they might be consumed away from the cave, and only the digested remains brought in. Further to this, the scats or pellets and the bare bones lying on the cave floor might then be trampled by either the carnivores responsible for their presence or by different animals using the cave afterwards – there are indications that the cave was used as shelter by ibex (Chapters 3 and 4) as well as by Neanderthals and modern humans. There is also evidence of bioturbation, particularly in the LBSmcf sequence, and cracking of the fill surface (Chapter 2) which could have resulted in movement of small bones within the fill.

The condition of the small mammal remains from Gorham's Cave is generally good. Each sample was scored according to the completeness of the bones, on a scale A–F. In the vast majority of samples studied, the preservation was classified as B, that is, there were near-complete mandibles, maxillae and longbones, and complete isolated teeth, vertebrae and phalanges. Very few of the bones show clear signs of digestion, for example pitting of the bone surface. Digested rabbit bone was recovered from CHm.2, CHm.3 and LBSmff.8, and digested white-toothed shrew (*Crocidura russula*) remains from SSLm(Lsm).6. *This* indicates that some of the small mammal accumulation was the result of carnivores using the cave and leaving scats (faeces), but the majority was probably from the pellets of owls. Further breakage has occurred through trampling, either of pellets lying on the cave floor, or of scattered bones once the pellets had decayed. The larger bones of rabbits show clear indications of predation by large owls, probably eagle owls (*Bubo bubo*), which are known to have occupied and probably nested in the cave (Chapter 9). Comparison with material recovered from eagle owl nest sites in Finland demonstrates the typical breakage of the ascending ramus of the mandibles (Fig. 10.5) and of the innominate bones (personal observation). Smaller prey items such as voles would be swallowed whole, even by smaller owls, and consequently there is little damage to the bones resulting directly from predation. The stomach acid of owls is comparatively weak, the basal pH averaging 2.35 whereas that of diurnal raptors is about 1.6. This, and the fact that diurnal raptors tear up their prey and swallow only part of the prey item, means that owl pellets contain a significantly larger proportion of bone – averages of 45.8 per cent against 5.2 per cent in *Falconiformes* (Mikkola 1983). Roosting owls would therefore contribute a much greater number of small mammal bones per owl/day than would diurnal raptors. The breakage of vole and mouse maxillae, the majority of which are divided into left and right halves, is also typical of owl pellet material.

Earlier work on the lower levels of the Gorham's sequence (Cooper 1995) suggests that the taphonomy of the samples examined indicates accumulation was due largely to mammalian predators rather than raptors, though the latter 'probably made some contribution to the concentration of micromammal remains' (ibid., 80). The main reasons given for this conclusion, following the principles given by Andrews (1990), are the low number of vole remains and high counts of individual teeth rather than complete mandibles. It is quite possible that Cooper's conclusion is correct, but it is also plausible that the dearth of voles is due to an actual shortage of voles in the landscape surrounding the cave, or to the fact that fieldmice were plentiful and more easily caught than voles. This would certainly be the case if, as suggested by Jeannet, *Microtus brecciensis* shunned open areas and kept to more scrubby vegetation while the fieldmice ventured into the grassland. Owls are generally opportunistic feeders, taking the most easily available prey – if fieldmice were readily available, and the similar sized voles more difficult to locate, the owls would eat a much larger proportion

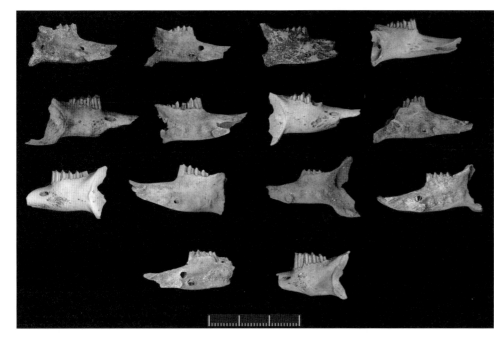

Fig. 10.5 *Oryctolagus cuniculus* mandibles from Gorham's sequence, showing breakage typical of predation by owls. Photo: Ian Cartwright, copyright Institute of Archaeology.

of mice. Complete mandibles are readily fragmented by trampling – in Andrews' experiment they were 'unrecognisable ... and all the teeth were exposed as isolated teeth' (Andrews 1990, 8) after the pellet had been trodden on six times. One feels that the hooves of ibex might have the same effect in an even shorter time.

It seems likely, then, that throughout the accumulation of the cave deposits a variety of different processes added small mammal bones to the sediments and altered their condition. This has led to the bones showing a range of preservation states, from tiny unidentifiable fragments to the partial skeleton of a juvenile rabbit preserved in anatomical position in concreted sediment from SSLm(Lsm).7 (Fig. 10.7). If this partial rabbit skeleton was a fresh kill, the pattern of consumption would indicate it to be the victim of a lynx, as this species habitually decapitates its prey (Brown *et al.* 1984). However, there is no way of knowing what alterations have occurred since deposition. The high proportion of relatively complete bones suggests a fairly rapid build-up of cave sediments, covering the bones before too much damage and degradation occurred.

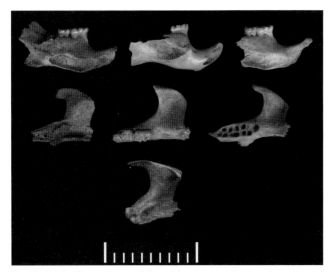

Fig. 10.6 Maxillae and mandibles of *Apodemus sylvaticus* from Gorham's sequence, showing breakage typical of predation by owls. Photo: Ian Cartwright, copyright Institute of Archaeology.

Burning as evidence of human predation of rabbits

Particular attention was paid to the examination of rabbit bones for any major evidence of modification by humans in the form of cut-marks or of burning No cut-marks were detected, and although there were identifiable examples of burnt or charred rabbit bone fragments from BEm.2, CHm.3, UBSm.6, LBSmcf.2, LBSmcf.4, LBSmcf.12, LBSmcf.13, LBSmff.8, LBSmff.10, LBSmff.11 and SSLm(Usm).3, initially it was thought more likely that these had resulted from accidental contact with fire rather than by cooking. However, a more detailed examination of samples particularly rich in complete or near complete rabbit bones was conducted in the hope of finding indications of human exploitation. The very abundance of rabbit remains in contexts with human occupation debris implies that what must have been a prolific and very obvious potential source of meat in the area might not have been ignored by human hunters.

Despite relatively large quantities of rabbit from the Gorham's Upper Palaeolithic layers (CHm) the bones show no obvious cut-marks or other signs of human exploitation. Stiner *et al.* consider the inclusion of small game in the Palaeolithic diet. They suggest that, while 'small animals were important to human diets in the Mediterranean Basin from at least the early Middle Palaeolithic onward' (2000, 39), it was mainly static or slow-moving creatures such as shellfish or tortoises which were the focus of gathering activities, and that rabbits and hares were not exploited until the Epipalaeolithic (ibid.). However, since there is conspicuous evidence for the exploitation of this species in the Upper Palaeolithic levels at Picareiro Cave, Portugal (Hockett and Bicho 2000), and Cueva del Higueral de Valleja, Andalucia (Turner, pers. comm.), it seemed likely that similar examples might be found in the Gorham's material. It is interesting to note that, though burning on bones occurred at both sites, cut-marks on the shafts of long bones were only present at Higueral. Both sites produced high proportions of mid-shaft bone cylinders, thought to be indicative of anthropogenic assemblages. This feature is not evident in the Gorham's material

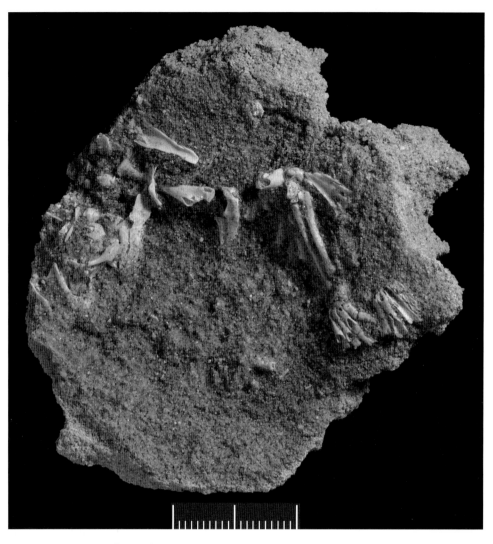

Fig. 10.7 Bones of *Oryctolagus cuniculus* preserved in anatomical position (Gor98/230). Photo: Ian Cartwright, copyright Institute of Archaeology.

Earlier work by Vigne and Marinval-Vigne (1983) focused on the bones of *Prolagus sardus* (Sardinian pika), an extinct small lagomorph, from deposits at Araguina-Sennola (Corsica). They suggested that human exploitation can be inferred from patterns of burning alone, without cut-marks necessarily being evident (Vigne and Marinval-Vigne 1983). The Sardinian pika is estimated to have been around 200–250 mm long, compared with 350–450 mm for European rabbits (Nowak 1999), and appears to have been extremely common in Corsica and Sardinia where it survived into historic times. Cetti, writing in 1774, described them as 'giant rats whose burrows are so abundant that one might think the surface of the soil had been recently turned over by pigs' (Nowak 1999, 1720). Clearly, the rabbits in Iberia would have been rather different, providing more calories per prey item, but probably less abundant and more widespread and so more difficult to catch. The samples from Araguina-Sennola are from levels dated from the Pre-Neolithic to the Iron Age, and so fit better with Stiner *et al*'s pattern of small game exploitation.

Vigne and Marinval-Vigne suggested that the cooking of small game such as pikas produced burning mainly to the animal's extremities – the distal ends of the lower limbs, the nasal end of the maxillae and the frontal mandibles. They also noted that the burnt area was always clearly delimited, suggesting that the remainder of the bone was protected by flesh (1983, 239).

In order to explore Vigne and Marinval-Vigne's ideas further, a single sample containing a variety of rabbit bones, including burnt specimens, was considered as possible evidence of human use of the species. The sample was from LBSmcf.2, a deposit rich in lithic artefacts but with very few burnt lithic finds (Chapter 12).

Table 10.6 shows the representation of charred and uncharred bones in the sample. There are no bones from the lower front limbs. Of the lower hind limbs, there are no tibiae or fibulae, and five of the six ankle and foot bones are unburnt. This might indicate that the extremities, which have little meat on them, were simply broken off and discarded, as is the practice in certain parts of Europe today – this would facilitate skinning the rabbit and would be easily done without making cut-marks on the bones. Ben McNutt, principal trainer at the Woodsmoke Bushcraft and Wilderness Survival School, UK confirms that 'the lack of lower limbs would indicate that [the rabbits] were eaten, as in prepping rabbits … you usually snap back the feet, twist them free of the longbones and cut the tendon with a blade' (pers. comm.). The scapulae and innominates show no sign of burning, nor do either of the proximal humeri – all of these bones would be protected by the flesh of the rabbit if it were roasted. Unlike the examples from Araguina-Sennola, burnt vertebrae are present. I suggest that it is possible that the rabbits here were cooked in a slightly different way – while Vigne and Marinval-Vigne considered the Araguina-Sennola pikas to have been cooked 'after jointing' (1983, 239), it seems likely that the rabbits in Gibraltar, if they were indeed cooked, were not jointed, but roasted whole on a

Table 10.6 Charred and uncharred rabbit bone from sample 139 (LBSmcf.2).

Skeletal Part	Charred	Uncharred
Mandible (frontal)	1	4
Maxilla	2	2
Lower incisor	1	2
Upper incisor	2	10
Lower molar	1	23
Upper molar	8	13
Femur – proximal	0	2
Femur – distal	1	3
Humerus – proximal	1	1
Humerus – distal	3	3
Vertebra	6	7
Scapula	0	4
Innominate	0	2
Calcaneum	1	2
Astragalus	0	2
Phalange	1	0

spit. The relatively unprotected spine would, in this case, be sufficiently exposed to the fire to cause charring. A modern reconstruction of this cooking method indicates that by the time the creature was cooked sufficiently to show charring of the bones, the meat would be dry to the point of inedibility. This perhaps supports the theory that consumption of rabbits was more common than the bones suggest, and that treating rabbits in this way would not necessarily cause any discernible alteration to the bones. It is not suggested that the sample analysed here represents the discrete remains of an instance of rabbit consumption (or, indeed, of burning it until it was unfit for consumption), but it is possible that part of the debris from such an event is combined here with detritus of other origins.

While there is insufficient evidence to prove human exploitation of rabbits conclusively, there is enough to suggest that even in the absence of cut-marks, it is quite possible that the human inhabitants of Gorham's Cave made at least the occasional meal of these small mammals. Historical and modern hunter-gatherer populations do not scorn such small game, even where larger prey is available – 'Hunting of small animals … is not a rare phenomenon. Among such peoples as the Shoshoni and the Aboriginal Australians it is, in fact, a woman's occupation' (Watanabe 1968) – and the exploitation of a reliable source of meat close to home would offer a valuable addition to the more time- and energy-expensive hunting of large game.

Environmental reconstruction

The range of small mammals recovered from Gorham's Cave indicates a temperate climate without extreme cold or aridity. The terrain around the cave would offer a variety of ecological niches, supporting the requirements of the different species. Hence, there are species which need soft ground for burrowing – rabbits, moles and pine voles; species which prefer broken rocky ground such as scree – greater white-toothed shrew; those whose preferred habitat is open grassland, such as hare, and those who like scrub vegetation and a degree of cover, such as *Microtus brecciensis* and rabbit; and the water vole which is dependent on streams or freshwater marshy areas. The majority of the small mammals would have inhabited the narrow coastal plain in front of the cave – the limited modern faunal range of the Rock itself suggests that the cliffs and stony ground are inhospitable to most small mammal species, except bats. Unfortunately the bat remains from the site are not identifiable to species, as most are too fragmentary to provide a definite identification. There are at least two species present, though, one large and one small. The modern fauna of Gibraltar includes four species of bat, *Myotis myotis* (greater mouse-eared bat), *Pipistrellus pygmaeus* (Mediterranean pipistrelle), *Miniopterus schreibersii* (Schreiber's bat) and *Tadarida teniotis* (European free-tailed bat), populations of which are all declining on the Rock (GOHNS 2006). The presence of bats indicates only that the climate was warm enough to support populations of flying insects on which they could feed. Recently published work by López-Garcia *et al.* (2011) lists *Myotis myotis*, *Myotis nattereri* (Natterer's bat) and *Miniopterus schreibersii* recovered from levels III and IV (Middle and Upper Palaeolithic) at the back of the cave in the 1999–2005 excavation campaign (see Chapter 1). Schreiber's bat and greater mouse-eared bat are both specifically cave-dwelling species, while Natterer's bat is described as 'predominantly a woodland bat' (Schober and Grimmberger 1989, 123), though more specifically from open woodland 'especially with areas of open water or marsh' (Macdonald and Barrett 1993, 60).

The coastal plain might have sustained areas of dehesa, with isolated trees in open grassland, interspersed with patches of maquis and softer vegetation around streams, and perhaps with dunes of blown sand. As the percentage of bones from true open grassland species such as hare is very low, it is suggested that the landscape was largely one of scrubby vegetation, with more restricted areas of grass-dominated cover. While this would have been a naturally changing environment over the long period of deposition in the cave, there is no indication of any particularly radical change, either of landscape or of climate and vegetation. This in itself raises questions, as environmental records for Europe in general show cyclical warming and cooling as the glaciers advanced and retreated further north.

Three possible explanations are offered for this apparent stability throughout the build-up of the cave fill.

- There was no deposition of fauna during cold periods, or the deposits covering these periods were insufficiently sampled, or
- There were *no* cold periods – or at least not sufficiently cold to markedly affect the environment, or
- There were changes, but the physical isolation of the area prevented any influx of species which could out-compete those already in residence.

With no cold fauna to indicate climatic deterioration(s), it was necessary to look more closely at the available species to attempt to identify any oscillations. Although rabbit teeth were most numerous, biometric analyses would be invalidated by the presence of sub-adult specimens, which are difficult to separate from fully adult by morphology. It was therefore decided to use a simplified version of Jeannet's

Table 10.7 Measurement of *Microtus brecciensis* m₁ (x – length; y – width).

Context																			Average
LBSmcf.2	x	3.34	2.79	3.72	2.81	3.4	3.22	3.1	2.91	3.51	3.17	3.15	3.09	3.48	3.8	2.9	3.21	3.24	3.23
	y	1.35	1.33	1.58	1.21	1.44	1.3	1.36	1.23	1.43	1.41	1.36	1.34	1.38	1.44	1.14	1.44	1.33	1.36
LBSmcf.9	x	3.25	3.21	3.41	3.26	3.75	3.75	3.18	3.21	3.17	3.3	3.14	3.27	3.44	3.22	2.97			3.3
	y	1.22	1.39	1.37	1.45	1.52	1.54	1.47	1.43	1.37	1.41	1.37	1.39	1.38	1.14	1.31			1.38
LBSmcf.11	x	3.03	3.43	3.31	3.2	3.55	3.32	3.15	3.15	3.28									3.27
	y	1.27	1.5	1.39	1.29	1.39	1.49	1.31	1.31	1.39									1.37
SSLm.2	x	3.28	3.38	3.12	3.53	3.25	3.22	3.56	3.2	3.43	2.98	3.3	3.18	3.11					3.27
	y	1.26	1.21	1.42	1.4	1.46	1.53	1.27	1.4	1.45	1.26	1.33	1.28	1.46					1.36
SSLm.6	x	3.24	3.03	3.15	2.86	3.28	3.11	3.4	3.46	3.51	3.11	3.42	3.55	3.3	3.19	3.1			3.24
	y	1.32	1.4	1.38	1.34	1.28	1.4	1.34	1.5	1.55	1.49	1.44	1.49	1.44	1.41	1.26			1.4

methods to investigate potential changes in *Microtus brecciensis* (Jeannet 2000).[1]

Biometrical analysis of Microtus brecciensis

Jeannet (2000) used measurements on the well stratified and abundant first lower molars of *Microtus brecciensis* from the site of Orgnac 3 (Ardèche, France), combined with ecological data, to show that the development of the m₁ is indicative of the climatic conditions prevalent during its growth. His work demonstrates that the length and width of the m₁ are affected by different climatic and environmental factors. It seems that the teeth become wider in damper conditions, shorter from front to back in warmer climates, and taller in drier environments. The measurement of tooth height seems to me to be problematic, as the unrooted molars grow continuously up to a certain age, but once the vole has passed this age, the teeth wear down with no growth to compensate. The result is that a vole of advanced years in vole terms would have short teeth, regardless of the conditions. The relationship between length and width of the occlusal surface, however, might be used to detect climatic changes, and so a limited study of these aspects was undertaken.

Methods

Only those contexts with a sufficient number of *Microtus brecciensis* m₁s were included. Five contexts were selected, LBSmcf.2, with 18 measurable specimens, LBSmcf.9 with 16, LBSmcf.11 with nine, SSLm.2 with 13 and SSLm.6 with 16. Only complete adult teeth, either isolated or in a mandible, were examined. Following Jeannet's methods, the length of the m₁ was measured along a line running through the isthmuses isolating triangles t1 from t3 and t5 from t6 (see Fig. 10.4). The width was measured at right angles to this as shown in the diagram. This is a simplified version of Jeannet's exhaustive measurements, but it was felt that if significant differences were found in teeth from different levels, a more comprehensive investigation could be pursued. Each measurement was taken to one hundredth of a millimetre (Table 10.7), and the results plotted on a scatter graph with length as the x axis and width as the y axis.

1 Other elements of the rabbit post-cranial skeleton could have been used for biometric and other studies but here there were morphological problems in separating rabbit from hare bones.

Table 10.8 Measurement of *Microtus brecciensis* m₁, averages.

Context		Average (mm)
LBSmcf.2	Length	3.23
	Width	1.36
LBSmcf.9	Length	3.30
	Width	1.38
LBSmcf.11	Length	3.27
	Width	1.37
SSLm.2	Length	3.27
	Width	1.36
SSLm.6	Length	3.24
	Width	1.40

Results

The scatter graph showed no discernible patterning in the distribution, suggesting that there is no strong variation in the length/width ratio from context to context. However, if the results are reduced to averages (Table 10.8), it could be argued that the teeth of *Microtus brecciensis* in layer SSLm.6 are significantly wider and shorter than those in the other layers investigated, and those from LBSmcf.2 are narrower and shorter. Using Jeannet's parameters, this could be taken to indicate a warmer, damper climate in SSLm.6, and warmer, drier conditions in LBSmcf.2. I am not, however, fully confident that this is truly significant, given the lack of patterning in the scatter graph.

Conclusions

The most obvious finding of this research is that the small mammal fauna of Gorham's Cave is remarkably stable throughout the period represented by the cave fills sampled. While the relative proportions of the different species vary slightly, the species representation remains constant. There are no indicators of cold environments, such as are found on sites further north in Spain – for example, *Stenocranius gregaloides* (the extinct ancestor of *S. gregalis*, the Siberian vole) which is found with cold faunas in many Lower and Middle Pleistocene European sites including Gran Dolina (Atapuerca) in north-west Spain (López Antoñanzas and Cuenca Bescós 2002), or at higher altitudes, such as *Chionomys nivalis* (snow vole), found at Cueva de la Boquete de Zafarraya, near Malaga in Andalucia, at an altitude of 1100 m (Jennings 2006).

Looking again at the three possible explanations offered above for this apparent stability, it is possible that there was

little or no deposition of small mammal bones during cold periods, perhaps because of an absence of suitable predators. However, if this were the case, it seems unlikely that no variation existed in the lead-up to cold periods, where one would expect to see an alteration in the fauna with incoming species driven south or to lower altitudes by the increasing cold.

During the timespan of the deposition in the cave, there must have been colder periods but perhaps not sufficiently long or cold markedly to affect the environment. It is certainly true that the environmental effects seen in the Mediterranean during glaciations were different from the radical changes seen further north – 'Although trees and other pollen-bearing plants retreated southwards, indicating generally lower temperatures, the effects of dryness are more conspicuous than those of cold' (Grove and Rackham 2001). The result of this is calculated to be an increase in grassland and herbs at the expense of trees – 'the characteristic vegetation of southern Europe during glaciations was steppe' (Grove and Rackham 2001) – and as none of the small mammals from Gorham's Cave are obligate arboreals, they could survive the changes.

The survival of the existing fauna would be abetted by the physical isolation of the area, though it must be remembered that Pleistocene Gibraltar, with a wide coastal plain, would be much less isolated than in its present condition. Despite this, there seems to have been no invasion of refugees to out-compete and displace the existing fauna, and, in fact, the southern European peninsulae operated as centres for endemism rather than refugia (Bilton *et al.* 1998). The large number of endemic plants and terrestrial animals in Iberia, compared with northern Europe is indicative of this. Gibraltar's position at the most southerly tip of Iberia, and so as far south in Europe as it is possible to go, would make it least likely to be invaded by more northern species fleeing glacial conditions. This contrasts with the evidence provided by the more mobile avifauna (Chapter 9).

It is likely, then, that at least two of the three hypotheses given above for the stability of the fauna are probably accurate, and that a combination of relatively minor changes in the environment and lack of new species moving in to pressurize the existing fauna led to a noticeable stability in the small mammal fauna. This is perhaps significant when considering the long survival of Neanderthals in the area.

Acknowledgements

The preliminary work for this project was funded by the Dr M. Aylwin Cotton Foundation. Thanks are also due to the Natural History Museum, London, and particularly to Mr A. Currant, for access to the material and to comparative material. Dr Seppo Sulkava provided comparative taphonomic specimens from eagle owl nest sites, Ben McNutt gave information on the preparation of rabbits for consumption and experimented with primitive cooking methods, and the technical translation from French was by Pierre Schreve. The project would not have been possible without the input and stimulation of the other members of the team.

References

Andrews, P. 1990: *Owls, caves and fossils: predation, preservation and accumulation of small mammal bones in caves, with an analysis of the Pleistocene cave faunas from Westbury-sub-Mendip, Somerset, UK* (London, Natural History Museum Publications).

Bilton, D. T., Mirol, P. M., Mascheretti, S., Fredga, K., Zima, J. and Searle, J. B. 1998: Mediterranean Europe as an area of endemism for small mammals rather than a source for northwards postglacial colonization. *Proc. R. Soc. Lond. B* 265, 1219–1226.

Brown, R. W., Lawrence, M. J. and Pope, J. 1984: *Animals: Tracks, Trails & Signs* (London, Hamlyn).

Cabrera-Millet, M., Lopez-Martinez, N. and Michaux, J. 1982: Un example de lignée endémique ibéroccitane, les campagnols *Microtus brecciensis* et *Microtus cabrera* (Mammalia, Rodentia). Étude phylogénétique et contexte écologique d'un phénomème évolutif recent. *Actes du symposium paléontologique Georges Cuvier* (Montbéliard), 69–83.

Cooper, J. H. 1995: *Aspects of Taphonomy and Palaeoecology of Gorham's Cave, Gibraltar, based on its Microvertebrate Fauna* (Unpublished dissertation, University of London).

Corbet, G. B. 1994: Taxonomy and origins. *The European Rabbit – The History and Biology of a Successful Colonizer*, eds. H. V. Thompson and C. M. King (Oxford), 1–7.

GONHS (Gibraltar Ornithological and Natural History Society) website 08/07/06: www.gibnet.gi/gonhs

Grove, A. T. and Rackham, O. 2001: *The Nature of Mediterranean Europe – an Ecological History* (New Haven, Yale University Press).

Hockett, B. S. and Bicho, N. F. 2000: The Rabbits of Picareiro Cave: Small Mammal Hunting During the Late Upper Palaeolithic in the Portuguese Estremadura. *Journal of Archaeological Science* 27(8), 715–723.

Jeannet, M. 2000: Biométrie et écologie de *Microtus brecciensis* (Mammalia, Rodentia). *Revue Paléobiologique, Genève* 19(2), 339–357.

Jennings, R. 2006: *Neanderthal and Modern Human Occupation Patterns in Southern Iberia during the Late Pleistocene Period* (Unpublished D.Phil. thesis, Oxford).

López AntoÑanzas, R. and Cuenca Bescós, G. 2002: The Gran Dolina site (Lower to Middle Pleistocene, Atapuerca, Burgos, Spain): new palaeoenvironmental data based on the distribution of small mammals. *Palaeogeography, Palaeoclimatology, Palaeoecology* 186, 311–334.

López-García, J. M., Cuenca-Bescós, G., Finlayson, C., Brown, K. and Giles Pacheco, F. 2011. Palaeoenvironmental and palaeoclimatic proxies of the Gorham's cave small mammal sequence, Gibraltar, southern Iberia. *Quaternary International* doi: 10.1016/j.quaint.2010.12.032.

Macdonald, D. and Barrett, P. 1993: *Collins Field Guide – Mammals of Britain and Europe* (London, HarperCollins).

Mikkola, H. 1983: *Owls of Europe* (London, Poyser).

Miller, G. S. 1912: *Catalogue of the Mammals of Western Europe* (London, British Museum, Natural History).

Mitchell-Jones, A. J., Amori, G., Bogdanowicz, W., Kryštufek, B., Reijnders, P. J. H., Spitzenberger, F., Stubbe, M.,

Thissen, J. B. M., Vohralík, V. and Zima, J. 1999: *The Atlas of European Mammals* (London, Poyser).

Nowak, R. M. 1999: *Walker's Mammals of the World* (sixth edition) (Baltimore, Johns Hopkins University Press).

Rogers, P. M., Arthur, C. P. and Soriguer, R. C. 1994: The rabbit in continental Europe. *The European Rabbit – The History and Biology of a Successful Colonizer,* eds. H. V. Thompson and C. M. King (Oxford), 22–63.

Schober, W and Grimmberger, E. 1989: Bats of Britain and Europe. (London, Hamlyn).

Stiner, M. C., Munro, N. D. and Surovell, T. A. 2000: The tortoise and the hare – small-game use, the broad-spectrum revolution and Palaeolithic demography. *Current Anthropology* 41(1), 39–73.

Vigne, J. D. and Marinval-Vigne, M. C. 1983: Methode pour la mise en evidence de la consummation du petit gibier. *Animals and Archaeology: 1. Hunters and their Prey,* eds. J. Clutton-Brock and C. Grigson (Oxford, BAR International Series 163).

Watanabe, H. 1968: Subsistence and ecology of northern food gatherers with special reference to the Ainu. *Man the Hunter,* eds. R. B. Lee and I. DeVore (New York).

11 The large mammal remains from Gorham's Cave

A.P. Currant and C. Price
with addendum by
A.J. Sutcliffe and C.B. Stringer

Introduction

The Gibraltar Caves Project excavations at Gorham's Cave yielded surprisingly little identifiable large mammal bone. The reasons for this are discussed below. The paucity of evidence means that the study of the bones adds little to our previous knowledge of the fauna extant in the environment of the cave during its lengthy inhabitation by Neanderthals and humans (Currant 2000). However, the homogeneity of the fauna throughout the period of deposition serves to underline the stability of the environment at that time, in comparison with the major changes occurring in more northern reaches of Europe.

The material evidence

Bones were collected both as numbered finds during excavation and from samples taken for wet-sieving post-excavation. Identifications were made by comparison with known specimens in the Natural History Museum, London. Table 11.1 shows the species identified.

CHm.2 Only one identified bone, a *Capra ibex* (ibex) tooth (p⁴), not cut or burnt.

CHm.5 Two identifiable specimens, both carnivore metapodial fragments, which were not identifiable to species.

UBSm.4 Three identified bones, including one incomplete burnt *Cervus elaphus* (red deer) 1st phalange (Fig. 11.1), and one fragment of *Felis sylvestris* (wild cat) dentary.

UBSm.5 Only one bone was tentatively identified as a femur shaft fragment from a juvenile felid.

UBSm.7 Three bones were identified. One, a *C. ibex* 1st phalange, was noted as from a large individual.

BeSm(OSsm).1 The 12 identifiable bones were all from large herbivores. Most (six) were tooth or dentary fragments and three were foot bones. One cut artiodactyl tibia shaft fragment was recovered. A bovid tooth (p_2) was also noted.

BeSm(OSsm).2 Fourteen pieces were identified, including one *Crocuta crocuta* (spotted hyaena) terminal phalange. No cut or burnt specimens were identified. Nine of the bones are tooth or dentary fragments, and three are foot bones.

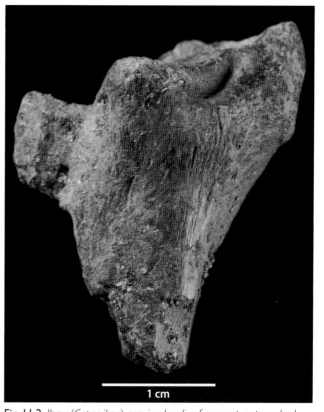

Fig. 11.1 Red deer (*Cervus elaphus*) phalange, burnt (Gor97/17). Photo: Natural History Museum, London.

Fig. 11.2 Ibex (*Capra ibex*) proximal radius fragment, cut-marked (Gor 97/133). Photo: Natural History Museum, London.

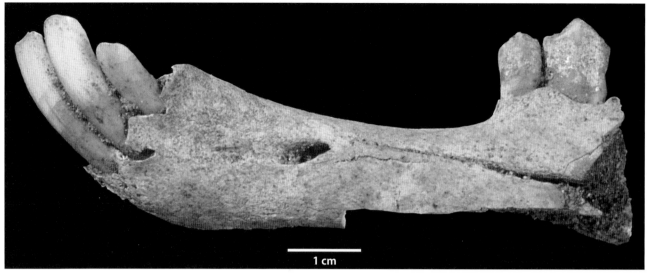

Fig. 11.3 Ibex mandible (Gor 96/163). Photo: Natural History Museum, London.

LBS(mff).1 Three bones were identified including associated burnt *C. ibex* teeth (p³–m¹).

LBS(mff).4 The five identified bones include a small charred fragment of cervid antler, and a cut-marked *C. ibex* proximal radius fragment (Fig. 11.2).

LBS(mff).7 The single identified bone fragment is from an artiodactyl tibia shaft.

LBS(mff).8 Six bones were identified, including the proximal part of a *Panthera pardus* (leopard) femur. An artiodactyl radius shaft fragment was observed to be possibly water-worn.

LBS(mff).10 Sixteen pieces, mostly of large herbivore, were identified, including cut fragments of *C. ibex* tibia and artiodactyl tibia. A thoracic vertebra of *Lynx lynx* (lynx) was recovered, but a deciduous premolar (dp_4) from a small carnivore could not be identified to species.

LBS(mff).11 Twenty-three specimens were identified. One unidentified possible humerus fragment was cut-marked. A juvenile *Monachus monachus* (Mediterranean monk seal) dentary fragment (Gor96 263b) was recovered, as was a *Vulpes vulpes* (red fox) scapula. A large fragment of *C. ibex* mandible was also found (Fig. 11.3).

LBS(mcf).2 Twenty-two bones were identified. None were cut or burnt. Interesting specimens include a *Rhinoceros* sp. limb bone fragment (Gor95 87), a *Panthera leo* (lion) caudal vertebra (Gor95 125), the 2nd phalange of a lynx, a *Canis lupus* (wolf) upper incisor (i¹), a *Vulpes vulpes* lower canine, and a possible *Megalocerus* (giant deer) metatarsal fragment. Carnivore remains are much more abundant in this context than elsewhere in the stratigraphy. Further specimens were collected from levels identified only as LBS(mcf).1–.4, including a *C. crocuta* metacarpal, a *L. lynx* innominate (Fig. 11.4) and a tibia fragment of *C. elaphus* (Fig. 11.5). The heavily digested 2nd phalange of *Cervus elaphus* and digested 1st phalange of a large carnivore, with a coprolite, probably of *C. crocuta*, confirm the activity of carnivores within the cave at this time.

LBS(mcf).4 Twenty-six pieces were identified, none of which were cut or burnt. All but one were from large herbivores. One almost complete *C. crocuta* ulna was identified.

LBS(mcf).5 Of the 22 identified bones, 20 are from large herbivores. In addition, one tooth fragment of *Sus scrofa* (wild boar) was recovered, and a 1st phalange of an immature large carnivore was tentatively identified as *Ursus* sp. (bear). The head of a large ungulate rib was cut.

LBS(mcf).8 The only identifiable bone was a fragment of right maxilla of *C. elaphus* with one tooth (p⁴).

LBS(mcf).9 Ten bones were identified, nine of which were from large herbivores. A small fragment of maxilla and partial tooth root was tentatively identified as *Monarchus monarchus*. A bovid radius shaft fragment is described as 'chopped' (Fig. 11.6), and a *Bos primigenius* 3rd phalange was also recovered.

LBS(mcf).11 Twenty-seven pieces were identified. These include one burnt cervid metatarsal fragment, a 'well-marked' *C. elaphus* radius shaft fragment 'retoucher' and a very weathered cervid 3rd phalange. One *Equus ferus* (horse) 1st phalange was identified. *Felis sylvestris* was represented by a proximal ulna fragment.

LBS(mcf).12 The 13 identifiable bones were all of large herbivore. None are cut or burnt.

LBS(mcf).13 The nine identified pieces are all large herbivore. No cut or burnt fragments were found.

SSLm(Usm).1 Eight specimens were identified, all of large herbivore. None were cut or burnt. One small fragment of *Equus ferus* upper molar was collected.

SSLm(Usm).2 Eight identified bones were found. One unidentified 'odd little piece' is noted as bearing cut-marks.

SSLm(Usm).3 The two identified pieces are both *C. elaphus* (one incisor and one 2nd phalange).

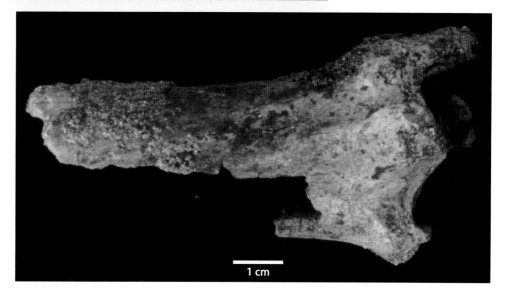

Fig. 11.4 Lynx (*Lynx lynx*) innominate fragment. Photo: Natural History Museum, London.

1 cm

Fig. 11.5 Red deer (*Cervus elaphus*) tibia fragment (Gor 95/91). Photo: Natural History Museum, London.

1 cm

SSLm(Usm).4 Only one bone was identified to species, a *C. elaphus* tooth (p³). A small fragment of artiodactyl tooth was also found.

SSLm(Usm).5 Two identifications were made. One was a digested deciduous *Equus ferus* incisor, the other a small fragment of artiodactyl tooth.

SSLm(Lsm).6 Four bones were identified. Three of these were of *Cervus elaphus*, including a cut fragment of femur shaft and a deciduous tooth (dp⁴).

Ecological indications
The overwhelming majority of identified remains are from two species – *Cervus elaphus* (red deer) and *Capra ibex* (ibex). Both of these species are attractive prey for either human or carnivore hunters, and many of the bones show signs of digestion or modification by butchery (cut-marks). Red deer is primarily a species of open woodland – the peculiarly British association of the creatures with open moorland is the product of human interference. Deer left to their natural habitats graze open patches in the woodland and along the woodland edges, lying up in the shade of the trees for shade and safety. The ibex, a large goat, is a denizen of mountainous regions, browsing and grazing alpine vegetation and only descending below the tree line in the spring, when they seek out the first flush of fresh grasses. The dominance of the two species shows the range of habitat available around Gorham's Cave, with stands of open woodland on the coastal plain and the steep slopes of the Rock rising up above the caves offering abundant opportunity for hunters, both hominid and carnivore, to ambush prey.

The other large herbivores in the Gorham's Cave fauna are horse (*Equus ferus*), rhinoceros (*Rhinocerotidae*), aurochs (*Bos primigenius*) and a possible *Megalocerus* (giant deer). These all contribute only a very minor element of the fauna, which suggests that either they were scarce in the area, or that they were not perceived as favoured prey species. Wild horse, rhinoceros and giant deer are all considered to be part of an open country fauna. Aurochs, extinct since AD 1627 when the last population died out in Poland (Corbet and Harris 1991, 540), inhabited woodlands. While there may have been suitable habitat for the species, they would have been a ferocious choice of prey when there were less daunting creatures available. Wild boar (*Sus scrofa*) is also a woodland species. Modern populations are widespread in the deciduous woodland of central and western Europe, including Iberia. They require good cover but will forage in more open areas.

The presence of bovid remains in several contexts (see Table 11.1) suggests that these contexts at least were not laid down during particularly arid periods. European cattle-type bovids (*Bos* sp.) have a high fluid requirement, and are not found naturally in arid areas. The theory that cold stages in more northern latitudes might lead not to cold

Fig. 11.6 Bovid longbone shaft fragment – chopped (Gor 96/30). Photo: Natural History Museum, London.

but to dry conditions in the Mediterranean is not supported by the evidence here, at least according to the faunal remains. Finlayson *et al.* (2008) conclude that at the Last Glacial Maximum, 'rainfall regimes are similar, or slightly more arid, than at present ... in the range of 350–1000mm per annum, compared to 600–1000mm' (p. 58). The general theory of this seems to be supported by the faunal evidence from Gorham's Cave, as we see it.

The collected fauna from Gorham's Cave does not include any cold environment species, such as mammoth, reindeer or woolly rhinoceros. In spite of very extensive searching, there *is* no characteristic cold stage vertebrate assemblage for southern Iberia and at least at our present state of knowledge, no conclusions can be drawn from internal evidence concerning the likely age of the Gorham's Cave mammal fauna. Little change is seen in the fauna throughout the excavated sequences, mirroring the

findings from the small mammals and the herpetofauna. It has been remarked that 'the southern peninsulas ... maintained a constant suite of species and the "cold" fauna never reached these latitudes' (Finlayson and Carrión 2007, 215), extending only as far south as a line roughly drawn between Lisbon and Montpellier (op. cit., fig. 2, p. 218).

Taphonomy

One thing that became obvious in the course of digging in Gorham's Cave is that, although small finds are relatively numerous, large bones are effectively absent from the core area. Very few large pieces of bone were recovered from any excavated context. The majority of identifiable fragments are tooth and mandible fragments or foot and ankle bones. By comparison with many other sites this absence is notable. It is very difficult to attribute a cause to this lack of large material other than to draw the conclusion that the site has been deliberately cleared, and kept clear over a protracted period. Those things that do remain are perhaps best explained as the kinds of material which could easily be lost in the sediment on the sandy floor of the cave. In this respect it is interesting to compare Gorham's Cave with nearby Vanguard Cave. Both sites appear to have been extensively used during the period of Neanderthal occupation, but the sedimentary fill of Vanguard is much more loose and uncompacted, and the number of large finds significantly greater. Over any significant period, large material can be much more readily incorporated and lost within the currently accessible fill of Vanguard than at Gorham's. There is a very strong impression that the cave's inhabitants deliberately chose to keep their living areas clear and clean other than where the high rate of sedimentation made this unnecessary.

The abundance of small fragments of digested bone and also coprolites indicates the use of the cave by denning carnivores as well as hominids, presumably at different times. It must be assumed that any larger bone remains left by the carnivores were cleared out by the Neanderthal and human inhabitants on their return to the cave in the same way as they disposed of their own refuse.

The very fact that there is no significant concentration of faunal material at any one level perhaps underlines the very prolonged and concentrated human use of Gorham's Cave. If it were merely a short-term hunting camp or temporary shelter, larger remains could be abandoned. However, if longer-term occupation was intended, an accumulation of animal remains would attract vermin and larger scavengers such as hyaenas, which would pose a real danger to the cave-dwellers. Few humanly modified bone pieces were recovered. Table 11.2 shows where bones showing cut-marks or digestion were present, and the species involved.

Conclusion

The excavations at Gorham's Cave have not produced sufficient faunal remains to allow us to comment on the economic strategies of the past inhabitants, though they offer a potential insight into their housekeeping habits.

The apparent stability of the environment surrounding the cave throughout the period of occupation investigated here supports the theory that southern Iberia did not suffer

Table 11.1 Gorham's Cave large mammals NISP.

	CHm.2	CHm.5	UBSm.4	UBSm.5	UBSm.7	BeSm(OSsm).1	BeSm(OSsm).2	LBSmff.1	LBSmff.4/LBSmcf.2	LBSmcf.4	LBSmff.5/LBSmcf.5–.7	LBSmff.7	LBSmff.8/LBSmcf.9	LBSmcf.8	LBSmff.10/LBSmcf.11	LBSmff.11/LBSmcf.12	LBSmcf.13	SSLm(Usm).1	SSLm(Usm).2	SSLm(Usm).3	SSLm(Usm).4	SSLm(Usm).5	SSLm(Lsm).6
C. lupus	1
V. vulpes	1	1
F. sylvestris	.	.	1	1
L. lynx	1	1
P. pardus	1
Cf. *P. leo*	1
?Felid	.	.	.	1
C. crocuta	1	.	1c	1
Small carnivore	2
Large carnivore	.	2	1	.	1
Cf. *Monachus*	1	1
E. ferus	1	.	.	.	1	.	.	1	.
Cf. *Rhinocerotidae*	1
S. scrofa	1	.	.	.	2	.	.	.	?1	2
C. elaphus	.	.	1	.	1	5	2	.	4	2	5	.	2	1	7	6	4	1	3	2	1	.	3
Cf. *Megalocerus*	1
Cervid	.	.	.	1	1	.	.	.	3	.	3	6	.	1	1
Cf. *B. primigenius*	1
Bovini	1	2	.	1	.	.	.	1	.	2	3	.	.	1
C. ibex	1	.	1	.	2	2	3	2	11	19	11	.	3	.	20	14	5	5	3
Artiodactyl	3	4	1	1	.	4	2	1	2	5	2	1	1
Large ungulate	1	.	1

Table 11.2 Gorham's Cave large mammals: condition.
Ct – cut; B – burnt; D – digested; Co – coprolite

	CHm.2	CHm.5	UBSm.4	UBSm.5	UBSm.7	BeSm(OSsm).1	BeSm(OSsm).2	LBSmff.1	LBSmff.4/LBSmcf.2	LBSmcf.4	LBSmff.5/LBSmcf.5–.7	LBSmff.7	LBSmff.8/LBSmcf.9	LBSmcf.8	LBSmff.10/LBSmcf.11	LBSmff.11/LBSmcf.12	LBSmcf.13	SSLm(Usm).1	SSLm(Usm).2	SSLm(Usm).3	SSLm(Usm).4	SSLm(Usm).5	SSLm(Lsm).6
C. lupus	+
V. vulpes	+	+
F. sylvestris	.	.	+	+
L. lynx	+	+
P. pardus	+
Cf. *P. leo*	+
?Felid	.	.	.	+
C. crocuta	+	.	Co	+
Small carnivore	+
Large carnivore	.	+	D	.	+
Cf. *Monachus*	+	+
E. ferus	+	.	.	.	+	.	.	D	.
Cf. *Rhinocerotidae*	+
S. scrofa	+	.	.	.	+	.	.	.	?+	+
C. elaphus	.	.	B	.	+	+	+	.	D	+	+	.	+	+	+	+	+	+	+	+	+	.	Ct
Cf. *Megalocerus*	+
Cervid	+	.	.	.	B	.	.	.	+	.	B	+	.	+	+
Cf. *B. primigenius*	+
Bovini	+	+	.	+	Ct	Ct	+	.	.	+
C. ibex	+	.	+	.	+	+	+	B	Ct	D	+	.	+	.	Ct	+	+	+	+
Artiodactyl	Ct	+	+	+	.	+	+t	+	.	+	+	+	+
Large ungulate	Ct	.	+

the extreme cold of glaciations or the aridity potentially caused by it. This underlines the potential of the area as a refugium during the Glacial Maximum, and its role in producing the endemism apparent in the Iberian fauna. It is probable that, in the absence of major environmental shifts, any small-scale environmental and climatic changes would be better detected by close study of the smaller mammals, birds, herpetofauna and land molluscs than by searching for major alterations in the larger fauna.

From the perspective of a British Quaternary worker, the Gorham's Cave assemblage screams 'interglacial', but so it would to anyone used to the strong contrasts between warm and cold stage assemblages occurring in north-west Europe. It is extremely difficult to make the mental adjustment necessary to understand what is actually happening through time in such a strongly Mediterranean environment. To get anywhere at all with these finds, either they or some other associated material needs to be directly dated.

Addendum by C. B. Stringer

Dr Anthony Sutcliffe was invited to describe the mammalian fauna found during John d'Arcy Waechter's excavations at Gorham's Cave, from 1951–1954. He wrote his report in 1958 and it was intended that it would be published in the full report of the excavations, a report that was never completed. However, a summary of it appeared as 'Preliminary report on the Mammalia of Gorham's Cave, Gibraltar' under the authorship of F. E. Zeuner and A. J. Sutcliffe in Waechter (1964). The report contains important observations on the mammalian remains, which are now curated at the Gibraltar Museum (with a few exceptions such as coprolites, retained at the Natural History Museum, London). Before he died in 2004, Dr Sutcliffe gave permission for it to be published as written, whilst acknowledging that it does not take into account palaeontological and taxonomic reconsiderations since 1958, and was written using Waechter's stratigraphy and stratigraphic assignments (see Chapter 2 for correlations). The lack of small mammal remains reported by Sutcliffe is no doubt a reflection on the methods of excavation, which evidently did not use screening for small finds. This is also reflected by the amount of material that can still be found in the spoil heaps below the cave.

Faunal report by A. J. Sutcliffe
Homo cf. sapiens

The only human remains are a left fifth metacarpal, a right second metatarsal and an incisor, all from layer B. These were scattered and do not represent a burial.

Erinaceus sp.

Hedgehog is represented by a left maxilla, from which all the teeth have been lost, from layer C.

Talpa sp.

An imperfect right mandibular ramus of a mole, with the first premolar, was found in layer U.

Canis lupus (Linn.)

Wolf remains are not very plentiful. They occur in layers B, D, K, M and P. Most of the specimens are isolated bone

fragments and tooth, but there is also an imperfect right mandibular ramus with premolars 2–4 and molar, from layer P. All the remains lie within the size range of Recent wolves from the Iberian Peninsula. Wolf remains have twice previously been recorded from Gibraltar:- from Sewell's Cave and from Devil's Tower.

Ursus arctos (Linn.)

Bear is represented by fragments of an axis and an atlas vertebra and right mandibular ramus with the alveoli of molars 2 and 3 from layer K, a fragment of the distal end of a left humerus from layer M and an unworn left second upper molar from layer L. The latter measures 38.5 mm. in length at the base of the crown, a little greater than the corresponding measurements of two specimens from the Devil's Tower, referred by Miss Bate to the Brown Bear, *U. arctos*, which are only 35 and 35.5 mm. in length. Although larger than the Devil's Tower specimens, this molar is still too small to be regarded as coming from a Cave Bear. This view is supported by the size of the alveoli in the lower jaw fragment. The remains may be referred to *U. arctos*, a view with which Dr. B. Kurten agrees. Busk (1877) figured some well preserved remains of *U. arctos* from Genista Cave.

Crocuta crocuta (Erzlebun)

Skeletal remains of hyaena are present in layers G, K, M, P, Q and T. In addition, 36 coprolites found in layers F–R should probably be attributed to this species. The remains are mostly footbones and isolated teeth, but there are also three imperfect maxillae, one of them of a juvenile animal, from layers M and K, and an imperfect mandibular ramus from layer Q. All the remains which are sufficiently complete for specific determination can be referred to the Spotted Hyaena, *Crocuta crocuta*. This genus differs from the Striped Hyaena, *Hyaena hyaena* by the absence of an upper molar and in other details of the form of the teeth. There is no evidence that this latter genus is also present. The cheek-tooth row of the mandibular ramus from layer Q has an antero-posterior length of 91 mm., a measurement which exceeds that of most Recent examples of *C. crocuta* but agrees closely with that of the Cave Hyaena, *C. crocuta* race *spelaea*. The coprolites are of considerable size, the largest measuring 115 mm. in length and 42 mm. in breadth. Specimens from British hyaena dens, on the other hand, are frequently very much smaller. It is worthy of note that all the juvenile remains (three specimens including an imperfect mandibular ramus with the third milk molar) and more than half the coprolites are from layer K, suggesting that the cave may have been temporarily occupied as a hyaena den at this period. There is no evidence of the presence of hyaena in layers A–B.

Felis silvestris (Schreber)

A wild cat is represented by bone fragments from layers D, E, G and M and a large left mandibular ramus of a young adult animal with a strongly developed canine, fourth premolar and molar, from layer N. The third premolar has been lost. The length of the cheek-tooth row (measured from the anterior margin of the alveolus of the third pre-molar to the posterior margin of the molar) is 24 mm. This ramus

resembles that of a typical present-day Spanish Wild Cat, *F.s. tartessia* by being of large size and having disproportionately large teeth. It differs from that of other subspecies from the mainland of Europe which have less massive teeth and a cheek-tooth row seldom exceeding 23 mm. in length. A mandibular ramus of a wild cat recorded by Miss Bate from Devil's Tower also has a cheek-tooth row length of 24 mm.

Felis lynx pardina (Terminek)
Remains of lynx occur in layers A, D, F, G, K, M, P, Q and R, being most abundant in D and G. They include an almost complete right mandibular ramus from layer Q, a pair of maxillae with cheek and canine teeth from layer G and other skull remains and limb bones and vertebrae. Two forms of lynx inhabit Europe at the present day. These are the Northern or European lynx, *Felis lynx lynx*, which is the larger, and the Southern or Spanish lynx, *Felis lynx pardina*. According to Miller (1912), they may be distinguished by *Felis lynx lynx* having a mandibular cheek-tooth row which generally measures about 35 mm.; by it commonly having a small basal cusp (metaconid) on the posterior border of the lower molar; and by the interorbital convexity being only moderate. In *Felis lynx pardina*, on the other hand, the mandibular cheek-tooth row usually measures only about 30 mm.; the lower molar commonly lacks the posterior basal cusp; and the inter-orbital convexity tends to be abrupt. The skeletal remains from Gorham's Cave range in size from those of a large present-day Southern lynx to those of a small Northern lynx. The mandibular ramus has a cheek-tooth row measuring 32.7 mm., which agrees with measurements of 30–34 mm. for the rami from Devil's Tower, and, as in the case of the specimens from that site, there is no posterior basal cusp on the molar. All the remains from both sites apparently represent this Southern lynx, which is still found in Spain. Their average size is slightly greater than that of the present-day Spanish lynx, but does not approach that of the living Northern subspecies, in which rami with a cheek-tooth row of 37–38 mm. are not uncommon. There is no evidence that any of the remains attributed here to lynx could, in fact, be those of caracal, which still occurs only a short distance away, in Morocco and Algeria. Teeth of the caracal can be distinguished from those of lynx by the 'felid slit' being absent from the canine teeth, or only poorly developed, and by the anterior and posterior basal cusps of the fourth lower premolar being relatively smaller in proportion to the principal cusp. All the specimens examined which are sufficiently complete for determination are referable only to lynx.

Panthera pardus (Linn.)
Remains of leopard occur at several horizons. There are the distal ends of a left and right humerus from layer K, an imperfect scapula from layer P–Q, metapodials and phalanges from layers G, E, Q and M, and a canine tooth from layer M. Remains of this animal have been recorded from Gibraltar at least twice previously, from Genista Cave (Busk 1877) and Devil's Tower (Bate 1928).

?Panthera cf. leo
There are two phalanges from layers B and G, and a metatarsal from layer K, of a felid which is too large for a leopard,

and is tentatively referred to a small lion. The evidence for this determination, however, is highly questionable.

Halichoerus grypus (Fabricius)
The Grey Seal is represented by a right femur, a right first metacarpal, a fifth left proximal phalanx and a second or first left distal phalanx, both of the fore limbs, and a right fifth distal phalanx of the hind limb, all from layer D. All these remains can be referred to the Grey Seal, in which the well developed claws are especially diagnostic. In the Monk Seal, which still inhabits the Mediterranean region at the present day, the claws are more rudimentary. Two thoracic vertebrae, from layers D and F, are probably also of the Grey Seal. The discovery of remains of Grey Seal in Gibraltar is of special interest as this species has never previously been recorded so far south. At the present day it is seldom found any great distance south of the British Isles.

Monachus monachus (Hermann)
A lower molar from layer D is referred to the Monk Seal. This tooth differs from the peg-like cheek-teeth of the Grey Seal by being larger and by being antero-posteriorly elongated. The Monk Seal has twice previously been recorded from the Pleistocene deposits of Gibraltar, at Devil's Tower and in Sewell's Cave.

Dicerorhinus cf. hemitoechus
A rhinoceros is represented by a fragment of a lower molar from layer G; by a second phalanx from both layers K and M; and by the proximal end of a small radius from layer J. An ascending ramus of a mandible of a juvenile animal from layer K is probably also of a rhinoceros. There are insufficient specimens to permit specific determination but the remains from Genista Cave described by Busk are of *D. hemitoechus* and it is most likely that those from Gorham's Cave also belong to this species. The Woolly Rhinoceros, *Coelodonta antiquitatis*, never spread so far south.

Equus caballus (Linn.)
A horse is represented by thirteen specimens, nine of which (an associated group of two upper milk molars and three unerupted permanent cheek-teeth; an imperfect upper cheek-tooth of another older animal; a fragment of right ischium; part of the shaft of a right femur and a fragment of a proximal phalanx) were found in layer M. There is also an astragalus of a juvenile animal from layer D, an upper and lower cheek-tooth from layer C and an upper cheek-tooth from layer R. Although nearly all these specimens are fragmentary or of juvenile animals, the relatively large size of the adult skeletal remains, the massive proportions of the imperfect phalanx and the large size, doubled stili and concave interstilar faces of the upper cheek-tooth from layer R are sufficient criteria for the determination of a horse of the *E. caballus* group. There is no evidence that *E. asinus* is also present.

Sus scrofa (Linn.)
A pig is represented by fourteen specimens from a wide range of levels. These include a fragmentary maxilla, with molars 1 and 2, and an atlas vertebra from layer B; an astragalus and

scaphoid and a fragment of mandible with premolar 3 from layer D; a metapodial and the distal end of a humerus from layer K; a third lower molar and an associated calcaneum, astragalus and navicular from layer M; a metapodial from layer N; another from layer P/Q and a fragment of a lower canine from layer T. An associated cuboid and navicular were found in disturbed ground (layers A–D). With the exception of the maxilla and mandible fragments from layers B and D, which are of young adult animals, all the remains are of fully grown and even old individuals. In this respect the remains from Gorham's Cave differ from those from Devil's Tower, which were mostly of young animals.

Cervus elaphus (Linn.)

Remains of red deer, which number over two hundred specimens, were found in all layers except C, H, I, J and O. They were particularly abundant in layers D, G, K and M. They include two antler bases from layer G, several dozen imperfect jaws (including eight mandibular rami still retaining part of the milk dentition), numerous teeth and a lesser number of other skeletal remains. The remains show a considerable variation of size. Both the antler bases showed the development of a bez as well as a brow tine. In the living Spanish race of Red Deer, *C. e. hispanicus* the bos tine may or may not be present. Most of the red deer remains from layer D were found to be charred.

Bos cf. primigenius (bojanus)

A large ox is represented by nearly thirty specimens. These include a right mandibular ramus with milk dentition from layer P; the distal ends of a pair of metacarpals from layer G; an astragalus from layer K; fragments of upper and lower jaws and crushed parts of a horn-core, of which about 40 cms. is preserved, from layer M, and a number of isolated teeth. The horn-core, even towards its apex, is reinforced by lateral buttresses and a few transverse septa, as is characteristic of horn-cores of the group of Bovini. It differs from those of the *Homoioceros-Bularchus* group which are internally reinforced by a more compact network of septa, the airspaces between which become progressively smaller towards the apex. Though its crushed condition prevents satisfactory examination, the horn-core clearly shows a curvature in two planes and is therefore referred to *Bos* rather than to Bison. The absence of a groove (regarded by Schertz, 1936, as diagnostic of Bison but not of *Bos*) between the articulations of the calcaneum and navicular on the plantar side of the astragalus from layer K is in agreement with this conclusion. The astragalus, which has a maximum length of 96 mm., agrees closely in size with the larger specimen of this bone (B.M. No. 13440) described by Miss Bate from Devil's Tower, in which this measurement (her 'maximum diameter') is 93 mm. Miss Bate mentions also the occurrence of two small foot bones at this site which seemed to indicate to her the presence of a second species of *Bos* or possibly Bison. There is no evidence of this smaller species being present also at Gorham's Cave.

Capra cf. ibex

Remains of ibex, which number nearly five hundred specimens (in order of abundance taking second place only to those of rabbit), were found in all strata except the unfossiliferous or almost unfossiliferous layers H, I, J, O and S. They are especially numerous from layers B, D, K and M. They include approximately fifty imperfect upper and lower jaws, fragments of forty metapodials and lesser numbers of other skeletal parts. Most of the remains are of adult animals but there are also some of juveniles. These include two imperfect mandibular rami, with milk dentition, from layer D and another from layer B. A few of the specimens from layer D are charred. It is not inconceivable that some of the bones assigned to ibex from the upper strata of the cave could belong to sheep or goat but there is no undoubted evidence of this. At most horizons remains of ibex greatly outnumber those of red deer (in layers B, D, K and P respectively by seven, two, five, two and a half and three times the number of specimens). In layer G, on the other hand, remains of red deer outnumber those of ibex by nearly five to one, but there is also a slightly greater abundance of red deer in layers H and T. These variations do not appear to be the result of selective hunting by man, who was present at each of the periods in question. The former specimen shows flattening of the anterior surfaces of the horn-core bases and strongly arched frontals, thereby differing from this part of *C. pyrenaica* but agreeing closely with that of *C. ibex*. At the present day two species of ibex are found in Western Europe the Alpine Ibex, *Capra ibex* (Linn.), and the Spanish Ibex, *Capra pyrenaica* (Schinz). These differ from one another in a number of characters, especially by the form of the horns in adult male animals. The horns of the male Alpine Ibex are typically large and curve backwards in a single plane, whereas those of the Spanish Ibex are smaller and curve upward, backward and outwards. In the former species the horncores tend to be laterally flattened on the anterior surface, the sides converging to a vertical ridge behind, whereas in the latter species the opposite arrangement occurs. As the result of this the angle between the planes of the surface of the anterior and posterior parts of the frontal bone tends to be considerably more acute in the Alpine Ibex than in the Spanish form. Only three specimens of horn remains from Gorham's Cave are sufficiently complete to permit study. These are: a pair of frontals bearing the basal 10 and 30 mm. of the horn-cores of a male ibex, from layer U; a fragment of the base of a horn-core of another male animal from layer B; and a right frontal bone with an almost complete horn-core, measuring 73 mm. in length, of a female animal from layer D. There is also the posterior part of a skull of a large male ibex, from which the horns have been lost, from layer P. The former specimen shows flattening of the anterior surfaces of the horn-core bases and strongly arched frontals, thereby differing from this part of *C. pyrenaica* but agreeing closely with that of *C. ibex*. The horn-core fragment from layer B, of which only the outer margin is preserved, likewise agrees more closely with that of the Alpine species. Throughout its length of 117 mm. this specimen is almost straight and shows none of the curvature which would be apparent in the Spanish form. Horn-cores of females of the two species of ibex are of less diagnostic value than those of male animals but, in recent specimens used for comparison, a slight difference

was observed in the cross-section of the horn-cores. These are more laterally flattened in the Alpine Ibex, and almost round in *C. pyrenaica* from central Spain. In this respect the horn-core from layer D is even more extreme than the Alpine specimen. From this evidence the ibex remains from Gorham's Cave are tentatively referred to *C. ibex* or a form close to it. They cannot be referred to the present-day Spanish Ibex. *C. ibex* is also recorded from the Cave of Toll, near Barcelona (Thomas and Villalta 1957).

Oryctolagus cuniculus (Linn.)

Remains of rabbit outnumber those of all the other mammals from the cave together. There are approximately fourteen hundred specimens, including over two hundred mandibular rami and many complete limb-bones, from all horizons of the cave except layers B, D, K andvN. Only one rabbit burrow was encountered during the course of the excavation (in layer B) and it is believed that most of the remains are contemporaneous with the layers in which they were found. The present-day wild rabbit of Western Europe is divided into two subspecies; the larger, *Oryctolagus cuniculus cuniculus* of Central Europe north of the Mediterranean region (including Britain); and the smaller, *o. c. huxleyi*, which inhabits the Mediterranean region and also Madeira and the Azores. In his key to these subspecies, G. S. Miller (1912) gives measurements only of the skull and of the hind foot, parts which are unfortunately too incomplete for study in the Gorham's Cave collection. Only one recent skeleton of *o, c. huxleyi* (B.M. Specimen no.1868.2.19.93. from Porto Santo off Madeira, presented by C. Darwin) was available to the writer. The skull and foot measurements of this specimen lie within the size range cited by Miller for this subspecies and the other parts of the skeleton show a similar small size. With few exceptions, the rabbit remains from Gorham's Cave equal in size remains from cf. *o. c. cuniculus* which were used for comparison and are considerably larger than the Porto Santo specimen. From this evidence it would appear that the Upper Pleistocene rabbit of Gibraltar was considerably larger than the present-day *o. c. huxleyi* to which it may have been ancestral. In addition to the many hundreds of relatively large rabbit remains already mentioned, there are in the Gorham's Cave collection two calcanea and five metapodials of apparently adult animals, from layer D, which agree more closely in size with these parts of *o. c. huxleyi*. It is quite possible, therefore, that the smaller subspecies of rabbit had already appeared towards the end of the sequence, in addition to the large form. The collection was carefully examined for remains of *Prolagus*, but there is no evidence that this animal was also present.

Lepus sp.

The collection contains several lagomorph bones which are too large for rabbit but agree closely in size with those of hare. They include a calcaneus and three metapodials from layer D, a metapodial from layer B and an os innominatum from layers A–D (disturbed). Miss Bate notes that Busk (1877) recorded remains of two species of "Lepus" from Windmill Hill Cave, the larger corresponding in size with those of hare, but she did not record this genus from Devil's Tower, concluding at that time that there was no satisfactory record of the occurrence of hare remains in Pleistocene deposits of the Iberian Peninsula. The present specimens, however, suggest that a hare may have arrived in Gibraltar before the end of this period. It is of interest to note that, in the Cave of Toll, near Barcelona (Thomas and Villalta 1957) remains of hare are likewise present in the uppermost strata.

Rodentia

A few limb bones of small rodents were found in layers B and D.

Cetacea spp.

There are two bones of whales; a vertebra from layer B and a fragment of an epiphysis of another vertebra from layer D. The former suggests a small toothed whale of dolphin size and the other a somewhat larger species.

Summary of Sutcliffe's work

1 On the whole, the fauna is fairly constant in composition throughout the sequence. It does not show any marked fluctuations of species in the different strata, such as commonly occur in caves in France and England.

2 The fauna appears to be typically European. There is no North African influence.

3 The occurrence of remains of Grey Seal in D could (if this animal is regarded as a northern species) be interpreted as evidence of a cold phase at this period.

4 The greater abundance of red deer over ibex in layer G compared with the greater abundance of ibex in most of the strata may be of significance.

5 There is a special abundance of remains of carnivores in layer K. The occurrence of coprolites and of remains of juvenile hyaenas suggests that during this period the cave was temporarily vacated by man long enough for the carnivores to take residence. Carnivores are also well represented in layer M.

6 There is a faunal impoverishment at the end of G. Gone are such forms as the hyaena and leopard, leaving only man, wolf, wild cat, lynx, grey and monk seals, horse, pig, red deer, ox, ibex, rabbit, whale and rodents.

7 As in the Cave of Toll, the hare is a late arrival, appearing only in the uppermost layers, but the rabbit is abundant throughout the sequence.

Sutcliffe seems to have been remarkably prescient in his comments. His report fits well with the findings of the later excavations, despite the limitations of the 1951–1954 fieldwork (see Chapter 1).

References

Bate, D. M. A. 1928: Excavation of a Mousterian Rockshelter at Devil's Tower, Gibraltar. The Animal Remains. *Journal of the Royal Anthropological Institute* 58, 91–113.

Busk, G. 1877: On the Ancient or Quaternary Fauna of Gibraltar. *Transactions of the Zoological Society of London* 10, 53–136, pls. 1–27.

Corbet, G. B. and Harris, S. 1991: *The Handbook of British Mammals*, third edition (Oxford, Blackwell Science).

Currant, A. 2000: A review of the Quaternary mammals

of Gibraltar. In Stringer, C. B., Barton, R. N. E. and Finlayson, J. C. (eds.), *Neanderthals on the Edge* (Oxford, Oxbow Books), 201–206.

Finlayson, C. and Carrión, J. S. 2007: Rapid Ecological Turnover and its impact on Neanderthal and other human populations. *Trends in Ecology & Evolution* 22(4), 213–222.

Finlayson, C., Fa, D. A., Jiménez Espejo, F., Carrión, J. S., Finlayson, G., Giles Pachecho, F., Rodríguez Vidal, J., Stringer, C. and Martínez Ruiz, F. 2008: Gorham's Cave, Gibraltar – The persistence of a Neanderthal population. *Quaternary International* 181, 64–71.

Miller, G. S. 1912: *Catalogue of the Mammals of Western Europe* (London, British Museum Natural History).

Schertz, E. 1936: Zur Unterscheidiing von Bison priscus Boj. und Bos primigenius Boj. an Metapodien und Astragalus. *Senckenberg.* 18, 37–71.

Thomas, J. M. (Casajuana) and Villalta, J. F. de 1957: Le Ruisseau Souterrain du «Toll». *INQUA. V Congres Intern.* (Madrid-Barcelona), 11–26.

Waechter, J. d'A. 1964: The excavation of Gorham's Cave, Gibraltar, 1951–4. *Bulletin of the Institute of Archaeology* 4, 189–221.

12 The lithic artefact assemblages of Gorham's Cave

R.N.E. Barton and R.P. Jennings

Introduction

The lithic artefacts described here are grouped into assemblages according to the stratigraphic units in which they were recovered. In keeping with the other specialist reports in this volume the units are dealt with in order of youngest to oldest. Within each assemblage the lithic artefacts are sub-divided into the categories of debitage and retouched tools. Whereas debitage consists of all primary products of the flaking process, items that have been modified either by secondary chipping or deliberate breakage are classified as retouched tools. By far the richest collections come from the Middle Palaeolithic units which make up the majority of the sequence and consist of artefact assemblages from 22 individual beds. In contrast, the Upper Palaeolithic assemblages are of very restricted size and are limited to only two main horizons identified by excavation. The artefact descriptions broadly follow the technological and typological conventions devised for the Middle Palaeolithic by Bordes (1950; 1961) and adapted by other authors (Boëda 1986; 1993; 1994; Van Peer 1992; Kuhn 1995). Descriptions of the Upper Palaeolithic artefacts rely on the typology of Sonneville-Bordes (1960) and further elaborated by Brézillon (1977) and by Demars and Laurent (1989).

Methods and terminology

In this study we examined in detail only individually numbered small finds, that is, ones that had been three-dimensionally recorded. This was due partly to the concern for maintaining strict stratigraphic control but also to more practical considerations of how to manage the recording of enormous quantities of sieved finds and the related issue of time constraints and the need to return the collections to Gibraltar Museum. In consequence, lithic artefacts such as those recovered in dry sieving (2 mm mesh sieve) were counted and typed but were otherwise not subjected to further detailed analysis. A similar approach was adopted for artefacts from wet-sieved bulk samples. These were found incidentally during fine sieving for charcoals and other palaeoenvironmental remains; it was not a method applied routinely in all layers. Lithic residues from wet sieving produced mainly chip-size material (microdebitage <0.5 mm). This provided a useful proxy for identifying the existence of *in situ* knapping activity as well as a method for evaluating whether the sediments had been subjected to any major post-depositional disturbance. The results of this study are presented at the end of this chapter.

Based on core attributes and flake types, the most common method of flake production identified in the Middle Palaeolithic levels was that of the discoidal core

technique (Bordes 1961). According to Bordes the reduction method is closely allied to the Levallois technique in that it allowed numbers of flakes of predetermined but diverse form to be struck from one or more surfaces of a core. Boëda (1986), on the other hand, recognizes a marked separation between the two methods. The idea that the discoidal technique lies outside the Levallois concept is also shared by Kuhn (1995) who regards it as a non-Levallois radial method of core reduction.

Following Boëda's (1993) definition there are six principal criteria for recognizing discoidal reduction (Fig. 12.1):

1 The three-dimensional shape or volume of the core consists of two asymmetrical surfaces of opposed convexity of which the intersection delimits one plane.
2 The two surfaces of the core are non-hierarchical: one is primarily a flaking surface (*surface de débitage*), while the other is the surface from which flakes are detached (*surface de plans de frappe*). But the function of the two surfaces can be reversed sometimes during the same flaking sequence.
3 The flaking surface has a more or less pronounced convexity around the circumference of the core which is an essential technical precondition for allowing the production of predetermined flakes.
4 The striking platforms of predetermined flakes are prepared so that removals will be steeply angled and not parallel to the intersecting plane.
5 Predetermined blanks are likewise detached at an angle to the intersecting plane.
6 Hard hammer direct percussion is used throughout the reduction process. The point of percussion is also positioned some millemetres back from the intersection of the two surfaces.

According to Boëda (1994) there are three main ways in which a discoidal core can be reduced: either 1) by detaching flakes initially from one surface then from the other, or 2) by using the core surfaces alternately for removing flakes, or 3) by using mainly one side of the core for striking flakes. Wherever possible we have tried to mirror these definitions in the typological classification of the discoidal cores from Gorham's. The cores are thus sub-divided into types A, B and C (Fig. 12.2).

Besides the cores themselves, the flake debitage from discoidal technology includes distinctive and highly recognizable forms (Boëda 1993). Boëda draws attention in particular to two categories of flakes which he terms 'centripetal' and 'chordal' (Boëda 1993, fig. 6) according to

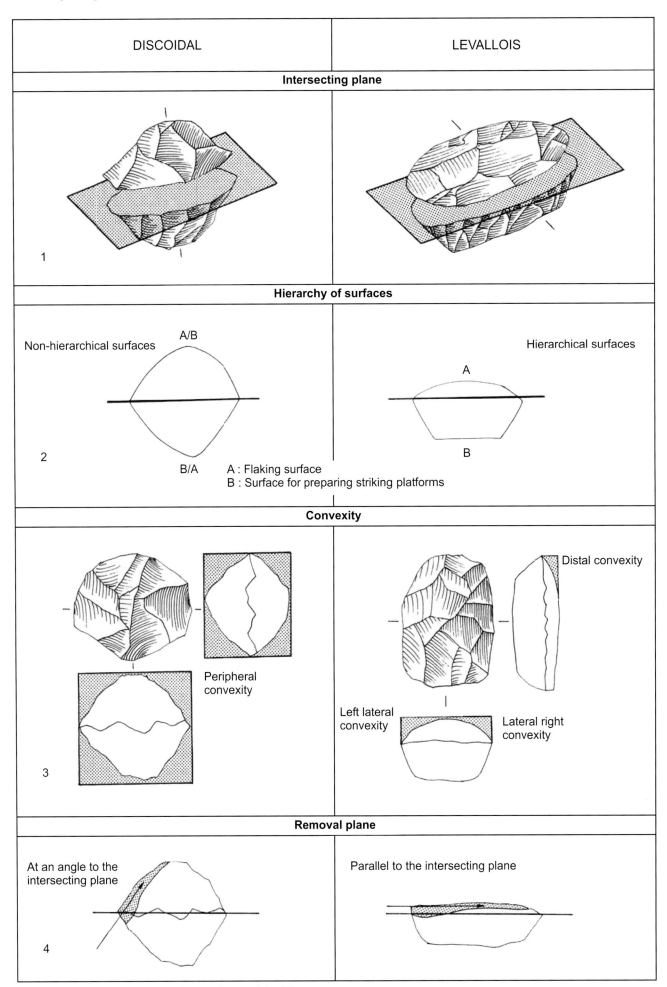

Fig. 12.1 Schematic diagram illustrating the characteristic differences between discoidal and Levallois core reduction (after Boëda 1993, fig. 1).

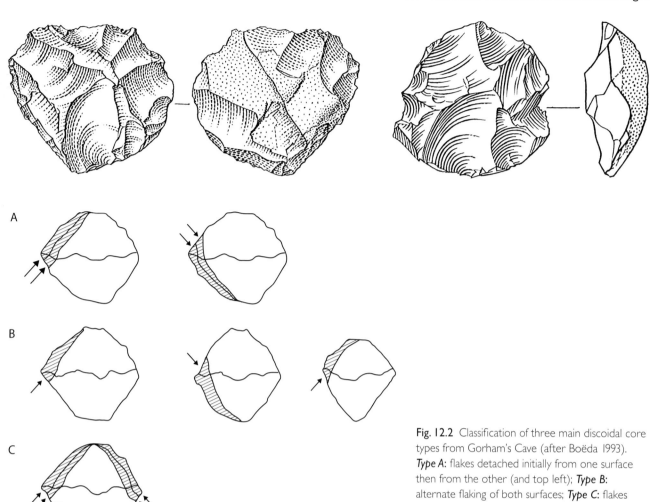

Fig. 12.2 Classification of three main discoidal core types from Gorham's Cave (after Boëda 1993). *Type A*: flakes detached initially from one surface then from the other (and top left); *Type B*: alternate flaking of both surfaces; *Type C*: flakes detached mainly from one surface (and top right). Drawings: Hazel Martingell.

whether they were struck from the edge to the centre of the core or more tangentially to it (Fig. 12.3). Both of these flake types are present in the excavated assemblages at Gorham's Cave. Within the group of tangential flakes Boëda singles out pseudo-Levallois points and core edge removal flakes (*éclats débordants*) as the most characteristic by-products. The former may be triangular but differ from ordinary Levallois points in that the axis of percussion does not bisect the point (Bordes 1961, 29). The defining attribute of an *éclat débordant* is that it retains a removed portion of the core edge superficially giving the flake a 'backed' appearance. Various authors have tried to identify further criteria for differentiating such artefacts on the basis of dorsal scar patterns and overall shape (Locht and Swinnen 1994; Depaepe *et al.* 1994) but this can be problematic, as illustrated by the existence of irregular (non-pointed) pseudo-Levallois forms (Bordes 1961, fig. 13). The other common form of flake debitage consists of 'centripetal' flakes which often have multiple dorsal flake scars arranged in a radial fashion. Such flakes are frequently relatively thin and may display a prominent bulb of percussion. Boëda differentiates between short broad flakes and four-sided flakes in this category (Fig. 12.3) but no such distinction could be recognized in the Gorham's assemblages.

A second technique recognized at Gorham's Cave is the recurrent centripetal Levallois method (Boëda 1986) or the recurrent radial Levallois method (Kuhn 1995). As with discoidal reduction it describes a technique of detaching several flakes from a core in a radial fashion but a key distinction for Boëda is that one of the core's surfaces remains subordinate to the other (Fig. 12.1). In other words the surfaces are organized hierarchically so that one serves as a striking platform from which the other is worked. A second major difference lies in the angle of detachment: flakes are struck in parallel to the intersecting plane between the two core surfaces (Fig. 12.1). Of interest also is that whereas the discoidal technique may enable ten or more flakes to be removed without substantial remodification (Boëda 1993, fig. 2), the recurrent centripetal method results in relatively few predetermined flakes. Nonetheless as anticipated long ago by Bordes (1961), the two 'methods' may not be so sharply segregated. Bordes envisaged that a core with recurrent Levallois removals could be reutilized as a discoidal core in a later stage of reduction. As we shall see below, this may have been the case in the Gorham's assemblages but given the very small size of the raw material it is also likely that the two techniques were used interchangeably. Finally, it should be noted that some by-products, such as centripetal flakes and cortically backed pieces, may result from either discoidal or centripetal Levallois methods of core reduction so in themselves are not particularly diagnostic.

A third technique, only recognized in the lowest excavated levels and on individual flakes, is the bipolar recurrent Levallois technique. This involves the detachment of Levallois flakes from opposed platform cores.

a. Direction of removal

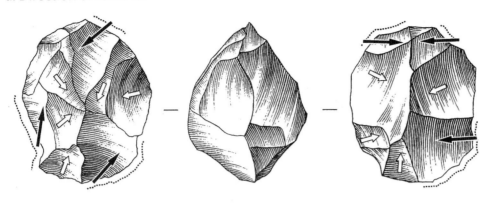

➤ Tangential

⇨ Centripetal

········ Length of core edge detached

b. Tangential flakes

Pseudo-Levallois point
(pointe pseudo-Levallois)

Core edge removal flake
(éclat débordant)

c. Centripetal flakes

Four-sided flake
(éclat quadrangulaire)

Short broad flake
(éclat plus large que long)

Fig. 12.3 Schematic discoidal core illustrating centripetal and tangential (chordal) flake removals and the typical by-products of discoidal core reduction (after Boëda 1993, fig. 6).

To recapitulate briefly: analysis of the flake debitage in the Middle Palaeolithic levels has identified the typical by-products of the discoidal and Levallois methods. The most numerous artefacts are **plain flakes**. These are artefacts with few distinguishing characteristics except that they have a length to width ratio of less than 2:1. In addition to these forms, diagnostic types include **naturally backed flakes** (*couteaux à dos naturel* or flakes with partial cortical covering down one edge), **core edge removal flakes (FCER)**, **pseudo-Levallois points (PsLP)** and **centripetal flakes**. For all of the numbered small finds the following attributes were recorded: completeness, presence/absence of burning, butt type, dorsal scar type and direction, cortical coverage and raw material type. These characteristics not only provide supplementary information on the 'chaîne opératoire' but also on much broader issues of human economic behaviour which will be discussed later in this chapter. Several types

of **discoidal core** are described which greatly outnumber **radial Levallois core** forms. Of the relatively few retouched tools recorded in the Middle Palaeolithic sequence, the most characteristic are **denticulates**, **notches**, **retouched flakes** and **side-scrapers**.

As regards Upper Palaeolithic artefacts, apart from flakes these are characterized by use of a bladelet technology. The term **bladelet** is used here to describe a narrow form of blade with a width of less than 12 mm. Amongst the few tools are **backed bladelets** defined as having a width of less than 9 mm (Tixier 1963).

Lithic raw materials

The knapped lithic raw material in all of these assemblages consists principally of fine-grained cherts and quartzites, with much lower quantities of limestone. All of the materials were classified by texture and by colour

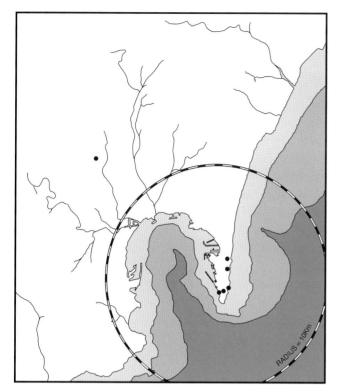

Fig. 12.4 Gibraltar: Lithic raw material sources. Solid circles represent known modern sources of cherts. The furthest point lies approximately 17 km north-west of Gibraltar and indicates the location of large nodules of honey chert.

Table 12.1 List of lithic artefacts in CHm.3.

Description	No.	Red Chert	Chert Undiff.	Quartz-ite	Other/ Unclassified
Plain flakes	7	1	4	2	
Bladelet	1		1		
Shatter	1			1	
Chips	3		1		2
Retouched blade	1		1		
Pièces esquillées	2	1	1		
Cobble and fragments	2			2	
Total	**17**				

Table 12.2 List of lithic artefacts in CHm.5.

Description	No.	Red Chert	Honey Chert	Black Chert	Chert Undiff.	Quartz-ite	Lime-stone	Other/ Unclassified
Plain flakes	10	1		1	3	4		1
Blade	1				1			
Shatter	1				1			
Chip	1							1
Backed blade	1				1			
Backed bladelets	2		1	1				
Notched flake	1						1	
Total	**17**							

using a standard Munsell chart. The cherts and quartzites are believed to be local in origin. They are predominantly in the form of rounded pebbles and small cobbles often displaying the distinctive chatter-marked surfaces present on rocks exposed in the raised beach outside the cave today. The geological sources of this raw material can be found on Gibraltar within a kilometre of the site. For example, the red, brown and greenish cherts are provenanced to the Late Triassic–Jurassic 'shales' within the Great Main Fault zone of the Rock of Gibraltar (Rose and Rosenbaum 1991, 146–148). Materials of this kind are also exposed in sections at the Devil's Bellows (UTM Grid reference 88989992) and at various other points across Gibraltar, including a number of exposures at Camp Bay (Fig. 12.4). The primary source of the quartzite is not known for certain but fairly abundant sources of this material have been observed in fossil beach deposits near Gorham's and Vanguard Caves. The knapped limestone is almost certainly derived from the walls and bedrock of the cave itself, and is sometimes hard to differentiate from naturally fractured material.

The only 'exotic' raw material so far recognized seems to be a distinctive, fine-grained honey-coloured chert. The material does occasionally occur in the form of tiny beach pebbles but more substantial nodules must have been employed for making flakes, some of which exceed 126 mm in maximum dimension. These are documented only in the lower part of the excavated sequence in the Sands and Stony Lenses. The nearest known source of such material occurs in terrace deposits approximately 17 km northwest of Gibraltar (Paco Giles and Finlayson, pers. comm.) (Fig. 12.4).

Description of Gorham's lithic assemblages
Cemented Hearths (CHm)
(CHm.2) Only four artefacts were associated with this context: a chert flake, a chert bladelet and two chips (one of chert and one of quartzite).

(CHm.3) Seventeen lithic artefacts were recorded in this context (Table 12.1). Of the seven flakes, only two retain their butts of which both are plain forms. Amongst the other finds is a distal end of a bladelet in a fine-grained chert. There is one retouched blade, modified by partial semi-abrupt retouch at its distal end. Perhaps the most significant artefacts in this small assemblage are two *pièces esquillées* or scaled flakes (Bardon *et al.* 1906). Both are extremely small (unlike the example from LBSmff.8). One displays bladelet-like removals (Fig. 12.5, Gor01/66). Similar finds have been described in association with backed bladelets in the Gravettian of Mediterranean Spain (Villaverde and Dídac 2004).

(CHm.4) There is only one artefact from this unit. It is a thick quartzite flake, heavily encrusted with sediment matrix making it difficult to discern any other detail.

(CHm.5) This is a restricted but potentially very significant group of artefacts because it comprises backed blade and bladelet material from a well dated context (see Chapter 5). The assemblage includes ten flakes of which the majority (nine) are broken and two are burnt. The flakes are small and nondescript and are made in a variety of raw materials of quartzite and several kinds of chert, including a distinctive black chert (Table 12.2). There are few other relevant attributes; five of the flakes are cortical and, where present, butts (four) are all plain or plain cortical. The only piece of blade debitage is a small broken specimen in red chert. They are characterized by a soft hammer mode of percussion.

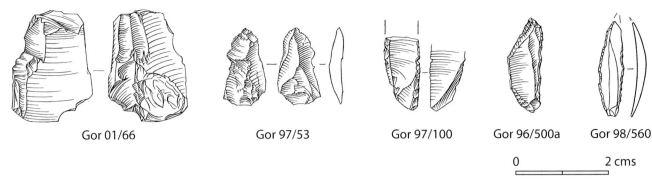

Gor 01/66 Gor 97/53 Gor 97/100 Gor 96/500a Gor 98/560

0 2 cms

Fig. 12.5 Gorham's Cave Upper Palaeolithic sequence (CHm.3 and CHm.5). **Gor01/66:** *Pièce esquillée* 23 × 18 × 6 mm; **Gor97/53:** *Pièce esquillée* (Scaled piece), 32 × 17 × 5 mm (CHm.3); **Gor97/100:** Distal end of a bilaterally backed bladelet, width <9 mm; **Gor96/500a:** Backed bladelet 29 × 7 × 2 mm with continuous direct abrupt retouch on one edge. Additional direct retouch is present on the opposite side at the distal end which converges to a point and is slightly worn (CHm.5). **Gor98/560:** Bilaterally retouched bladelet 20 × 5 × 2 mm in size (UBSm.6). All in chert. Drawings: Hazel Martingell.

The four retouched tools consist of a backed blade, two backed bladelets and a flake with a possibly fortuitous notch. The backed blade is a fragmentary specimen, burnt and broken at both ends but preserving the full width of 12 mm. Part of one edge is characterized by abrupt retouch. There is some spalling and damage on the ventral surface that might be attributed to thermal fracture or use. The raw material of this piece could only be ascribed to an undifferentiated chert. The two other backed pieces are unburnt and in better condition. One is a distal end of a bilaterally backed tool in honey chert (Fig. 12.5, Gor97/100). The second is in black chert and is unbroken (Fig. 12.5, Gor96/500a). Its pointed end shows a lightly developed, smooth polish visible to the naked eye. It is conceivable that it was some kind of drill bit. None of these backed pieces resemble *Lamelles Dufours* (Dufours bladelets) (Demars and Laurent 1989, 102–103). Nonetheless they show certain affinities with backed finds from the Iberian Initial Upper Palaeolithic (Villaverde *et al.* 1998).

Also recovered during excavations of CHm.5 were a single cowrie shell (*Trivia monacha*) (Fig. 12.6a) and a broken bone *sagaie* (Fig. 12.6b). The shell is pierced near one end but it is unclear whether this is a natural or deliberate perforation. Minute traces of red pigment appear to be preserved near the hole on the outer surface of the shell. This would repay further study.

Upper Bioturbated Sands (UBSm)

(*UBSm.1*) The only artefact from this unit is a red chert bladelet measuring 27 × 9 × 2 mm. It is not dissimilar to examples in the Cemented Hearths member and seems more likely therefore to derive from an overlying bed.

(*UBSm.2*) A single example of a small broken and burnt chert flake fragment is known from this unit.

(*UBSm.4*) Four artefacts can be assigned to this unit. They are a limestone flake, two pieces of chert shatter and a complete example of a Levallois point in quartzite (Fig. 12.8, Gor01/10) recovered *in situ* during examination of the section in 2001 by S. Collcutt.

(*UBSm.6*) This assemblage includes only 28 lithic artefacts (Table 12.3). Detailed information is recorded for nine of

the 16 plain flakes of which six are complete and three are broken specimens. Just two flakes have some cortex on their dorsal surfaces. Dorsal flake scar patterns reveal a mixture of unidirectional (three) and multidirectional (three) types. Plain butts (seven) are most common with only one linear type recorded. There is a single Levallois flake with a faceted butt (Fig. 12.7, Gor98/51). A FCER in a distinctive banded chert and refitting an artefact in an underlying bed (BeSm(OSsm).1 is the only other flake worthy of note (Fig. 12.7, Gor97/115 and 149). There is a single example of a core too broken to classify. Apart from a plain flake, none of the artefacts are burnt. It is noteworthy that where present the bulbar surfaces indicate a hard hammer mode of percussion, a feature shared in many artefacts in the Middle Palaeolithic assemblages.

The single retouched tool from this bed is very different from any of the other artefacts recovered in this context. It is a bilaterally retouched chert bladelet (Fig. 12.5, Gor98/560) found in the sieve. Because of its small size it is conceivable that it migrated down the profile from a higher level. Apart for this item all of the other artefacts in the assemblage are consistent with a Middle Palaeolithic technology. With the exception of one elongate sandstone hammer (95 mm long with battermarks at one end), the raw materials are dominated by cherts and quartzites. An unclassifiable core and a centripetal flake are in the same fine-grained honey-coloured chert. The small size of this chert suggests that it came from a beach pebble.

(*UBSm.7*) This context contains 110 artefacts (Table 12.4) of which 79 are numbered small finds. The plain flakes

Table 12.3 List of lithic artefacts in UBSm.6.

Description	No.	Banded Chert	Honey Chert	Chert Undiff.	Quartz-ite	Sand-stone	Other/Unclassified
Plain flakes	16			3	8		5
Centripetal flake	1		1				
Naturally backed flake	1			1			
Core edge removal flake	1	1					
Levallois flake	1			1			
Chips <15 mm	5				1		4
Core	1		1				
Retouched tool	1			1			
Hammerstone	1					1	
Total	**28**						

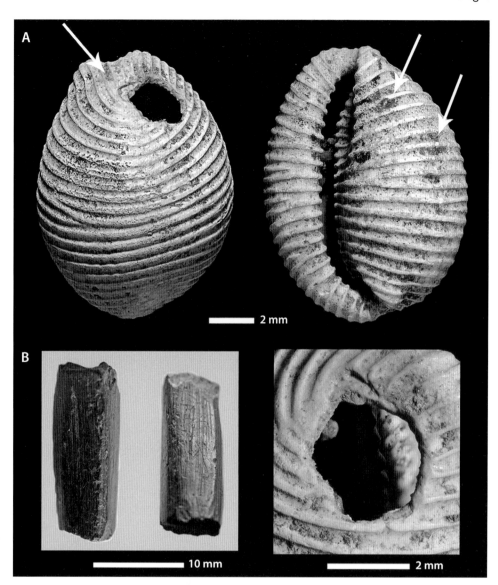

Fig. 12.6 Gorham's Cave. CHm.5: (A) Cowrie shell (*Trivia monacha*), arrows indicate flecks of red ochre, and (B) a fragment of a bone sagaie. Photos: Ian Cartwright, copyright Institute of Archaeology.

include slightly more complete (23) than broken (16) examples and a relatively high proportion are cortical or have partially corticated outer surfaces (36 per cent). The distribution of dorsal scar patterns shows more unidirectional (15) than multidirectional (six) or bi-directional (two) types. The butts display an overwhelming dominance of plain and plain cortical (30) over faceted and dihedral faceted forms (two). The rest of the flake debitage is made up of small numbers of centripetal, naturally backed, core edge removal and pseudo-Levallois forms. Of note is that one centripetal flake butt is faceted, the other is plain. The single Levallois point has a faceted butt (Fig. 12.7, Gor98/608). Just two of the artefacts are burnt and both are plain flakes.

Table 12.4 List of lithic artefacts in UBSm.7.

Description	No.	Brown Chert	Red Chert	Honey Chert	Chert Undiff.	Quartz-ite	Sand-stone	Other/ Unclassified
Plain flakes	54			1	12	25		16
Centripetal flakes	2			1		1		
Naturally backed flakes	3				2	1		
Core edge removal flakes	4				2	2		
Pseudo-Levallois points	4			1		3		
Levallois point	1				1			
Blade	1		1					
Shatter	3				3			
Chips <15 mm	21				3	3		15
Cores	4				2	2		
Flaked flake	1	1						
Hammerstone	1						1	
Notched flake	1					1		
Denticulates	5					5		
Retouched flakes	5				2	3		
Total	**110**							

Gor 97/115+149

Gor 98/51

Gor 98/547

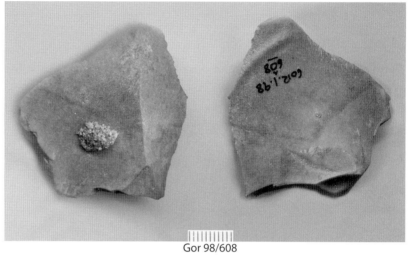

Gor 98/608

Fig. 12.7 Gorham's Cave Middle Palaeolithic sequence. **Gor97/115** distal (UBSm.6) and (BeSm(OSsm).7) **Gor97/149**: Proximal refitting fragments of a core edge removal flake from separate horizons; **Gor98/51**: Levallois flake measuring 41 × 31 × 5 mm; **Gor98/608**: Levallois point measuring 36 × 34 × 6 mm with unidirectional flake scars and a faceted butt (UBSm.7); **Gor98/547**: Retouched flake, part of a larger tool in creamy fine-grained chert (BeSm(OSsm).1). Photo: Richard Jennings.

There are four cores in the assemblage of which two are discoidal types, while the others are multiplatform examples. All are very heavily reduced and so cannot be classified with any further precision. One artefact is identifiable on morphological grounds as a blade. The only striking feature about this artefact is that it is the only item in this assemblage of red chert. There is a single flaked flake. It is laminar in shape and has a longitudinal secondary flake removal down one edge of its dorsal surface. It is reminiscent of the technique used to modify or resharpen edges of existing tools using a *coup de tranchet* and described at La Cotte de St Brelade, Jersey (Cornford 1986, 337). It is made on the only piece of brown chert recovered in this bed.

The average maximum dimensions of some of the main categories of debitage are presented in Table 12.5.

Table 12.5 Average maximum dimensions of flakes in mm from UBSm.7

Description	Sample size	Length mm	Breadth mm	Thickness mm
Plain flakes	17	36.1	27.8	7.2
Centripetal flakes	2	29	28	4
Naturally backed flakes	3	53.3	32.6	8.6
Core edge removal flakes	3	32	23.6	9.6
Pseudo-Levallois points	3	27.6	32	5
Levallois point	1	36	34	6

The retouched tools comprise one notched flake, five denticulates and five retouched flakes. The single notch and the denticulates are made on quartzite flakes as are three of the retouched flakes. In two of the denticulates the serrated edge is at the distal end, while the rest are modified on the lateral edge (Fig. 12.8, Gor98/910, Gor98/687). Two of the retouched flakes have inverse discontinuous semi-abrupt retouch on one lateral edge. One of them is a naturally backed knife with the retouch on the opposite side to the cortex and so could be a form of use-wear.

Raw materials in this assemblage indicate a more common use of quartzite. It is notable that both cores in this material are discoidal types, as are typical by-products (FCER and PsLP) and nine of the 11 recorded tools. The relatively high proportion of cortical flakes suggests knapping took place *in situ*.

Bedded Sand (BeSm)

(BeSm(OSsm).1) This is one of the largest lithic assemblages from the Middle Palaeolithic sequence (Table 12.6). It consists of 152 classified flakes as well as another 140 specimens from sieving residues. The flakes are dominated by plain examples with just over 60 per cent of them being complete. Amongst the broken artefacts proximal fragments are most abundant (26) with ten mesial and only

Table 12.6 List of lithic artefacts recorded in BeSm(OSsm).1.

Description	No.	Banded Chert	Speckled Chert	Grey-Green Chert	Red Chert	Honey Chert	Chert Undiff.	Quartz-ite	Lime-stone	Other/ Unclassified
Plain flakes	112	4				4	29	72	2	1
Centripetal flakes	7	1			1		1	4		
Naturally backed flakes	5	1					2	2		
Core edge removal flakes	13		1		1	3	2	6		
Pseudo-Levallois points	10					1	2	7		
Levallois flake	1						1			
Levallois points	3							3		
Intentionally broken flake	1			1						
Bladelet	1						1			
Shatter	22	1				1	7	13		
Chips (<15 mm)	14				1		6	7		
Cores	15						5	10		
Flaked flake	1							1		
Retouched tools	8	1					3	3		1*
Total	**213**									

* asterisk denotes speckled cream-coloured chert

Table 12.7 Flakes sub-divided by type in BeSm(OSsm).1.

Description	No.	Complete	Broken	Burnt	Cortex	Butt types					
						cortical plain	plain	dihedral faceted	faceted	linear	punctiform
Plain flakes	112*	65	42	3	54	6	71	3	5	3	
Centripetal flakes	7	6	1		1		3	1			2
Naturally backed flakes	5	3	2				3				
Core edge removal flakes	13	13			2		11	2			
Pseudo-Levallois points	10	9	1				5	3	1		
Levallois flake	1	1			1		1				
Levallois points	3	3					3				
Intentionally broken flake	1		1		1						
Total	**152**										

* total number of classified plain flakes excluding sieved samples

six distal fragments identified. There are a relatively large number of cortical pieces (54) and this in combination with other features such as the presence of *siret breaks* (five) amongst the debitage clearly indicates *in situ* knapping activity. Dorsal scar patterns on the plain flakes show a predominance of unidirectional scars (39) over multidirectional ones (24), with only two examples of bi-directional patterns. The butt types show an overwhelming majority of plain and plain cortical forms (87.5 per cent) over dihedral faceted and faceted types (7.9 per cent) (Table 12.7). As in the other Middle Palaeolithic assemblages in the sequence, there is a remarkable paucity of burnt lithic material. Only three plain flakes, two fragments of shatter and a core had any traces of burning.

Amongst the other flakes recovered are the typical by-products of discoidal core reduction such as naturally backed flakes (five), FCER (13) (Fig. 12.8, Gor98/733) and pseudo-Levallois points (PsLP) (ten). The only unambiguous products of radial Levallois technology are a single Levallois flake and three Levallois points. It is unclear whether the centripetal flakes (seven) are linked to the radial Levallois or discoid reduction methods. The butt features show a majority of six plain and very small plain (punctiform) types with only one dihedral form. On the other hand, their overall dimensions (Table 12.8) are slightly larger than the Levallois artefacts and, like the Levallois points, three of the centripetal flakes are in quartzite.

Table 12.8 Average maximum dimensions of flakes in mm from BeSm(OSsm).1.

Description	Sample size	Length mm	Breadth mm	Thickness mm
Plain flakes	65	29.4	25.3	5.8
Centripetal flakes	6	50	36.8	7.3
Naturally backed flakes	3	34	22	6
Core edge removal flakes	13	35.4	34.7	11
Pseudo-Levallois points	9	30.5	35.5	9.25
Levallois flake	1	41	34	11
Levallois points	3	40.3	28	7.3

Worthy of note is a rare example of an intentionally broken flake (cf. Bergman *et al.* 1983; 1987). It is a mesial fragment with percussive-induced breaks at either end. There are signs of invasive scalar damage on the left side of the segment on the ventral surface. This artefact (Gor98/442) is in a distinctive grey-green chert and is unique to this assemblage.

The 15 cores from this bed include six discoidal forms (one each of A- and B-types, two C-types and two that can be placed only within this broad category). Except for one core on a flake, the remaining examples are too reduced to be identified. Possibly also belonging within the core category is a flaked flake. This is a quartzite artefact with a negative flake scar on its ventral surface, at the distal end.

There are eight retouched tools that can be classified into four denticulates and four retouched flakes (Fig. 12.8,

Table 12.9 List of lithic artefacts in BeSm(OSsm).2 and BeSm(PLSsm).3.

Description	No.	Brown Speckled Chert	Grey-Green Chert	Red Chert	Chert Undiff.	Quartz-ite	Other/ Unclassified
Plain flakes	89	1	1		4	3	80
Centripetal flakes	2				1	1	
Naturally backed flake	1				1		
Core edge removal flakes	3	1			1	1	
Pseudo-Levallois flake	1					1	
Shatter	11						11
Chips <15 mm	45						45
Cores	2				1	1	
Cobble	1						1
Denticulate	1				1		
Total	156						

Table 12.10 List of lithic artefacts in LBSmff.1.

Description	No.	Black Chert	Chert Undiff.	Quartz-ite	Sand-stone	Other/ Unclassified
Plain flakes	6			1		5
Core edge removal flake	1	1				
Levallois flake	1		1			
Chips <15 mm	4					4
Denticulate	1		1			
Cobble	1				1	
Total	14					

Gor98/1096). Whereas the denticulates display a series of contiguous notches on one edge, the retouched flakes are characterized by irregular discontinuous retouch (in one case inversely) which may be the result of use-wear though this has not been formally demonstrated. The tools are in quartzite and chert. One retouched fragment is in a highly distinctive cream chert (Fig. 12.7, Gor98/547) and is the only example of such raw material in this context.

A cursory inspection of the artefacts in this assemblage produced two refitting groups of interest. One is a dorso-ventral refit between two plain flakes from a quartzite cobble (Gor97/137 and Gor 97/139). One of the two pieces unfortunately lacked *x* and *y* co-ordinates but the fact that a third piece clearly belongs to the same sequence (only an intervening flake is missing) suggests that *in situ* knapping occurred in this area of the cave. Two of the flakes come from adjacent square metres C96 and D96 and imply some dilation of the knapping scatter. The second refit comprises a core edge removal flake broken in two (Fig. 12.7, Gor97/149). The two pieces are from adjacent metre squares D96 and D97 and are separated by a vertical difference of about 9 cm. This suggests that localized bioturbation may have affected the horizontal and vertical distribution of artefacts in the bedded sands.

(BeSm(OSsm).2) and (BeSm(PLSsm).3) A total of 156 artefacts can be assigned to either the Orange Sand sub-member (OSsm) or the underlying Pale Loose Sand submember (PLSsm) (Table 12.9). Of 96 flakes recovered most of them (80) are specimens from sieving residues and were not further examined. Of the individually recorded plain flakes (nine), three were broken and six were complete. Most have unidirectional dorsal flake scars (four out of five) and there is a predominance of plain butts (seven out of eight). Four out of nine have remnants of cortex on their outer surfaces. The rest of the classified flakes include the typical by-products of the discoidal core technique and without exception they all exhibit plain butts. It is not surprising that of the two cores present one is a discoidal core (A-type) (Fig. 12.9, Gor95/48); the other is a multiplatform example. The only retouched tool in the assemblage is a denticulate. It is made on a Levallois-like flake (37 × 24 × 5 mm) with multidirectional flake scars and a faceted butt. The denticulated edge comprises a series of inversely retouched

notches. A second denticulate also with inverse notches was recovered from an adjacent square but could not certainly be assigned to the same layer (Gor95/14). A large cobble was found in section collapse of the deposits of this level but no other details were noted.

The raw materials include the same red and grey-green cherts observed in the layers above. Quartzite is also represented.

Lower Bioturbated Sands (LBSm)

(LBSmff.1) fine facies A small assemblage composed of 14 artefacts (Table 12.10) of which six are plain flakes, four are chips and there are individual examples of a FCER, a Levallois flake, a denticulate (Fig. 12.9, Gor97/112) and a cobble. Of interest is the relatively small size of the Levallois flake (32 × 27 × 5 mm), which is on a fine-grained chert. It is also the only piece that shows evidence of burning. It is characterized by multidirectional flake scars and has a plain butt.

(LBSmff.2) fine facies There are only four artefacts from this context comprising two plain flakes and two core edge removal forms.

(LBSmff.4) fine facies and (LBSmcf.2) coarse facies The amalgamated assemblage from these related contexts consists of 185 artefacts (Table 12.11) of which the majority are flakes (87) and chips (82). Most of the flakes are plain examples; there are only four centripetal flakes, three FCER, two PsLP and a single Levallois flake.

Of the individually numbered finds, a total of 48 plain flakes were examined in detail for technological and other attributes (Table 12.12). There are slightly fewer complete than broken flakes. Twenty-two (46 per cent) had some remnant of cortex on their dorsal surface although surprisingly only four revealed heavily chattered exterior surfaces typical of beach pebbles. Traces of burning were found on just four examples. Examination of the dorsal flake scar patterns shows that unidirectional features were twice as common as multidirectional ones. Butt types were dominated by plain and plain cortical forms (31) with only four having dihedral faceted forms. The rest of the flake debitage fits this pattern of butt preparation except the centripetal flakes, which include one dihedral and two faceted butt forms.

Analysis of the cores revealed that four out of five are small discoidal types, of which one shows traces of burning. They can be sub-divided into a B-type and two C-types (Fig. 12.10, Gor95/118 and Gor95/122) and one that is not complete enough to classify.

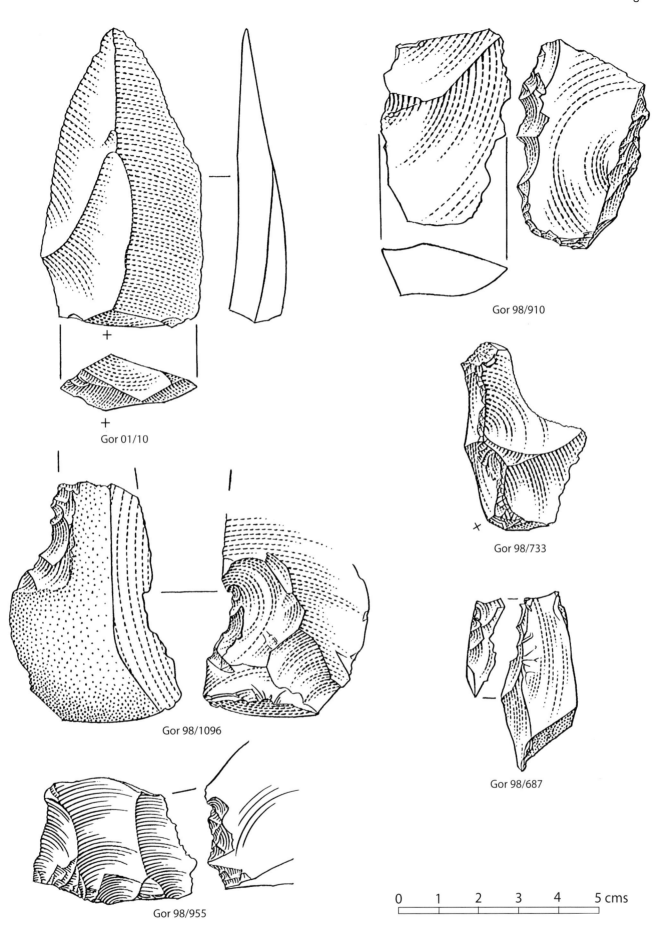

Gor 98/910

Gor 01/10

Gor 98/733

Gor 98/1096

Gor 98/687

Gor 98/955

0 1 2 3 4 5 cms

Fig. 12.8 Gorham's Cave Middle Palaeolithic sequence. **Gor01/10**: Levallois point (quartzite) measuring 70 × 43 × 13 mm (UBSm.4); **Gor98/910**: Denticulate (quartzite) with retouch scars on the ventral surface; **Gor98/687**: Denticulate (quartzite) with notches on part of its right edge (UBSm.7); **Gor98/733**: Core edge removal flake (quartzite); **Gor98/1096**: Denticulate (quartzite) with contiguous notches on its left side and a retouched notch on the ventral surface; **Gor98/955**: Retouched flake (chert) (BeSm(OSsm).1). Drawings: Hazel Martingell.

Table 12.11 List of lithic artefacts in LBSmff.4 and LBSmcf.2.

Description	No.	Black Chert	Brown Chert	Red Chert	Green Chert	Honey Chert	Chert Undiff.	Quartzite	Limestone	Sandstone	Other/ Unclassified
Plain flakes	77	1		3	1		24	16	3		29
Centripetal flakes	4					1	2				1
Core edge removal flakes	3						2	1			
Pseudo-Levallois points	2						1	1			
Levallois flake	1							1			
Shatter	5			1			1	1			2
Chips <15 mm	82						6	3			73
Cores	4		1				3				
Retouched tools	3			1			1	1			
Cobble/hammerstones	4						1	1		1	1
Total	**185**										

Table 12.12 Flakes sub-divided by type from LBSmff.4 and LBSmcf.2.

Description	No.	Complete	Broken	Burnt	Cortex	Butt types					
						cortical plain	plain	dihedral faceted	faceted	linear	punctiform
Plain flakes	48	21	27	4	22	6	25	4			
Centripetal flakes	4	4			1	1	3		2	1	
Core edge removal flakes	3	2	1				2				1
Pseudo-Levallois points	2	2		1			2				
Levallois flake	1	1					1				
Unclassified flakes	5										
Total	**63**										

Table 12.13 Average maximum dimensions of flakes in mm from LBSmff.4 and LBSmcf.2.

Description	Sample size	Length mm	Breadth mm	Thickness mm
Plain flakes	15	41.7	32.5	7.5
Centripetal flakes	4	37.5	27.5	6.2
Core edge removal flakes	2	32.5	20.5	3
Pseudo-Levallois points	2	40	32	7.5
Levallois flake	1	50	47	9
Transverse scraper	1	36	51	8

The three retouched tools consist of an offset transverse side-scraper (Fig. 12.9, Gor97/154), a notched flake and a retouched flake. In the last, the location of semi-abrupt retouch at the distal end is reminiscent of a spontaneous effect (cf. Newcomer 1976). In addition to these artefacts, there are four cobbles. Two of them are broken pieces of sandstone; the third is a quartzite fragment with extensive signs of battering at one end. This is identified as a hammerstone (98(1)355) although it is interesting to note small charcoal flecks at one end perhaps suggestive of use as a pestle or grinding stone. The last cobble is of chert and the fact that it is not elongate and has a fresh flake scar at one end implies that it might have been tested for its flaking properties.

The raw materials are mostly typical of beach-collected objects. Even the single centripetal flake of honey-coloured chert is small enough to have come from a pebble. The quartzites include pieces with beach-chattered outer surfaces. It is also interesting to note the use of the parent limestone material for manufacturing flakes. The average maximum dimensions of selected debitage are presented in Table 12.13.

(LBSmcf.4, mcf.5, mcf.6 and mcf.7) coarse facies Only a minority of artefacts are numbered small finds. They include 24 plain flakes more than half of which are broken (14). Where the proximal end is preserved the flakes showed exclusively plain (13) and plain cortical (one) butt types. Analysis of the dorsal flake scar pattern on the artefacts reveals a slightly higher number of unidirectional (eight) to multidirectional (six) examples. In addition, six of the flakes are partially cortical and only one is totally corticated. Four of the numbered flakes are burnt.

Besides the plain flakes, the classified flake debitage includes a naturally backed knife, a FCER, a PsLP and a *flanc de nucléus*. There are only two centripetal flakes. A similar scarcity was apparent in the representation of cores, with only one C-type discoidal form (Fig. 12.10, Gor95/200) in the whole assemblage. The core is in a distinctive red chert of a similar kind to some of the other flakes (Table 12.14) and it would be worthwhile in future to test whether any of these artefacts can be refitted.

A relatively large number of chips (285) and microdebitage were recovered during sieving. A cursory inspection revealed an absence of burning traces and there are no typical examples of the tiny curved chips from the resharpening of tools.

The six retouched tools comprise two side-scrapers, a denticulate, a scraper-like tool and two retouched flakes. One of the scrapers is a convergent form that has been extensively resharpened giving the scraper edges a semi-abrupt to abrupt appearance (Fig. 12.10, Gor95/202). The second side-scraper has a straight edge with inverse semi-abrupt retouch. The scraper-like tool resembles a convex side-scraper type but is made on a cortically backed flake with semi-abrupt direct retouch on one side and discontinuous scalar retouch on the cortical edge (Fig. 12.10, Gor95/228). The denticulate is on a broken flake and displays a series of contiguous notches down one side (Fig. 12.11, Gor95/257). The final two examples comprise a broken flake with

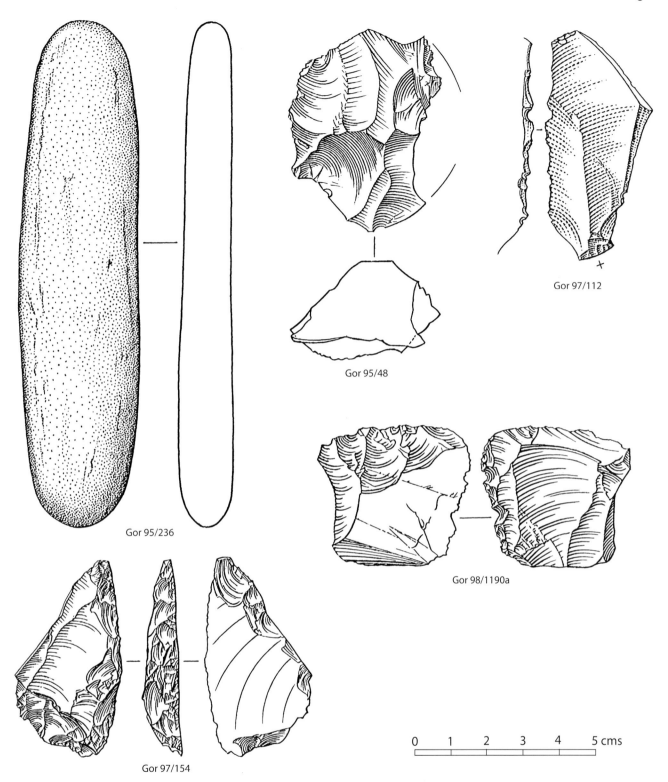

Fig. 12.9 Gorham's Cave Middle Palaeolithic sequence. **Gor95/48:** Discoidal A-type core (BeSM(OSsm).2 or BeSm(PLSsm).3); **Gor97/112:** Denticulate 58 × 29 × 4 mm (quartzite) (LBSmff.1); **Gor97/154:** Offset transverse side-scraper (LBSmff.4 and LBSmcf.2); **Gor95/236:** Cobble 'abrader' (LBS mcf.4–mcf.7); **Gor98/1190a:** Denticulate on a flaked flake (LBSmff.10 and LBSmcf.11). Drawings: Hazel Martingell.

discontinuous semi-abrupt retouch at the distal end and an artefact with a small area of irregular inverse retouch. In both cases the retouch might have been produced accidentally during debitage (cf. Newcomer 1976).

In addition to the flaked artefacts, five cobbles were recovered. They consist of three elongate cylindrical examples, a broken fragment and an irregularly shaped block. Two of the cylindrical examples are of broadly similar maximum length (136 mm and 132 mm respectively); one has signs of abrasion and percussive damage along one edge, the other seems to have been artificially smoothed along one side suggesting it may have served as an 'abrader' (Fig. 12.9, Gor95/236). Macroscopic pitting and percussive damage in the form of negative flake scars are also visible on the third and slightly shorter cobble (101 mm long). Similar damage patterns are present on one end of a broken cobble fragment (Fig. 12.10, Gor95/320). These presumed hammerstones or abraders were all made of quartzite (three) or of a similarly durable material (one). A large irregularly shaped stone (approximately 116 × 31 × 23 mm in maximum

Table 12.14 List of lithic artefacts in LBSmcf.4, mcf.5, mcf.6 and mcf.7

Description	No.	Brown Chert	Red Chert	Honey Chert	Chert Undiff.	Quartz-ite	Sand-stone	Other/ Unclassified
Plain flakes	94		3	1	6	13		71
Centripetal flakes	2		1			1		
Naturally backed flake	1				1			
Core edge removal flake	1				1			
Pseudo-Levallois point	1					1		
Flanc de Nucléus	1		1					
Shatter	5				2			3
Chips <15 mm	278							278
Core	1		1					
Retouched tools	6	1		1	1	2		1
Cobble/hammerstones	5					3	1	1
Total	**395**							

Table 12.15 List of lithic artefacts in LBSmff.8 and LBSmcf.9.

Description	No.	Black Chert	Red Chert	Speckled Chert	Chert Undiff.	Quartz-ite	Other/ Unclassified
Plain flakes	19	1		1	5	5	7
Centripetal flake	1		1				
Core edge removal flakes	2				2		
Pseudo-Levallois points	2					2	
Levallois flake	1				1		
Levallois point	1				1		
Shatter	2				1		1
Chips <15 mm	14				4	1	9
Cores	3	1	1		1		
Pièce esquillée	1				1		
Retouched tools	2				1	1	
Total	**48**						

dimension) with no apparent signs of use is the only one of softer sandstone.

Although study of the raw material was limited to the numbered artefacts, it is clear that most of it comprises cherts and quartzites derived from the beach or adjacent areas.

(LBSmff.7) fine facies There were only six plain flakes and two chips recorded in this context.

(LBSmff.8) fine facies and (LBSmcf.9) coarse facies Of the 11 plain flakes examined from these contexts, five are broken and six complete. The proximal ends of complete flakes reveal a dominance of plain butts (four) over dihedral (one) and linear (one) forms. Dorsal scar patterns are represented by unidirectional (eight) and multidirectional (two) types and only two flakes show small areas of preserved cortex. No burning is present on any of the flakes or other debitage.

In addition to the plain flakes, two FCER and two PsLP were recorded as well as a centripetal flake (Table 12.15). The other main points of interest are a Levallois flake and a Levallois point. The Levallois flake is of quartzite and measures 58 × 38 × 6 mm; it has a dihedral faceted butt (Figs. 12.11 and 12.12, Gor96/19). The Levallois point also of quartzite has a plain butt and the dorsal flake scar pattern reveals an opposed platform core origin. Interestingly, none of the three cores recovered are preferential Levallois types; two are discoidal forms (C-types) and one could not be typed.

The two retouched tools in this assemblage comprise a denticulate and a retouched flake. The denticulate has alternating contiguous and deep notches on one edge, and in some respects resembles a Tayac point. The second tool is a burnt chert flake with inverse semi-abrupt retouch along one edge (Fig. 12.11, Gor96/29). It has a punctiform butt and has a mostly cortical surface. Both tools are broken possibly as a result of use.

The only unusual item in this assemblage is a *pièce esquillée* (Fig. 12.11, Gor98/603). Such artefacts, sometimes also described as scaled flakes or *outils écaillés* (Bardon *et al.* 1906), can result from applying the anvil or bipolar technique in which a small pebble is placed on a stone and the ensuing blow removes tiny flakes from both ends of the object. Similar damage could result if the artefact were used as a wedge. This artefact is very different in size and shape from those reported above in CHm.3.

Despite the evidence of quartzite debitage there are no cores in this material. Nonetheless, indirect evidence of knapping comes from a discoidal core in the same distinctive black chert as one of the plain flakes, and a discoidal core and centripetal flake both in a very striking deep red chert. The items undoubtedly belong to two reduction sequences but unfortunately in both cases the intervening flakes are missing.

(LBSmff.10) fine facies and (LBSmcf.11) coarse facies Out of a total of 89 plain flakes (Tables 12.16 and 12.17) 43 were recorded as individual small finds. They include 21 complete and 22 broken examples. Where preserved, the butt types reveal a predominance of plain (16) over dihedral and dihedral faceted forms (ten). Dorsal scar patterns indicate a majority of multidirectional (12) over unidirectional (seven) and other types (two) which include one with bi-directional dorsal scars that came from an opposed platform core. The presence of cortex was noted on ten of the plain flakes. Only three examples display traces of burning.

Other forms of debitage include centripetal flakes (nine), PsLP (four) and single examples of a naturally backed flake and a FCER. There were also four Levallois flakes. Three of the four Levallois examples have faceted butts (Fig. 12.12, Gor96/249), the other being cortical plain (Figs. 12.11 and 12.12, Gor96/209). Significantly, four of the centripetal flakes display faceted or dihedral faceted butts (Fig. 12.12, Gor96/110), suggesting they were by-products of Levallois

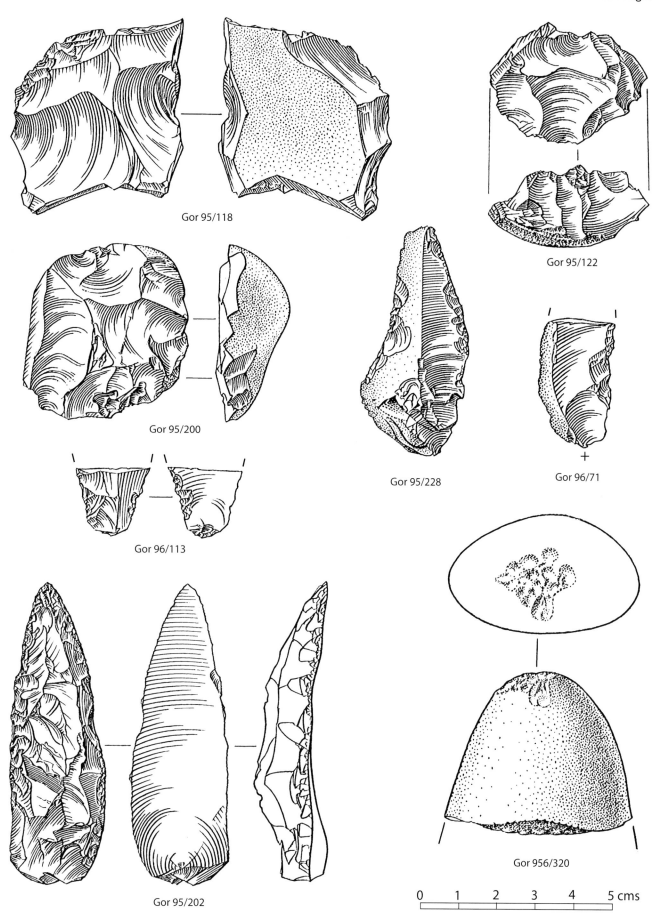

Gor 95/118

Gor 95/122

Gor 95/200

Gor 95/228

Gor 96/71

Gor 96/113

Gor 95/202

Gor 956/320

0 1 2 3 4 5 cms

Fig. 12.10 Gorham's Cave Middle Palaeolithic sequence. **Gor95/118, Gor95/122**: Discoidal C-type cores (122 is burnt) (LBSmff.4 and LBSmcf.2); **Gor95/200**: Discoidal C-type core; **Gor95/202**: Convergent side-scraper. The tool has a plain butt and is made on a hard hammer struck flake; **Gor95/228**: Scraper-like tool on a naturally backed flake; **Gor95/320**: Broken hammerstone (LBSmcf.4–mcf.7); **Gor96/71**: Retouched flake on naturally backed flake; **Gor96/113**: Retouched flake with alternate retouch (LBSmff.10 and LBSmcf.11). Drawings: Hazel Martingell.

Table 12.16 List of lithic artefacts in LBSmff.10 and LBSmcf.11.

Description	No.	Black Chert	Brown Chert	Red Chert	Grey-green Chert	Honey Chert	Chert Undiff.	Quartz-ite	Lime-stone	Other/ Unclassified
Plain flakes	89		3			3	26	10	1	46
Centripetal flakes	9			1	5		2	1		
Naturally backed flake	1						1			
Core edge removal flake	1						1			
Pseudo-Levallois points	4		1					3		
Levallois flakes	4					3		1		
Shatter	11						3	1	1	6
Chips <15 mm	39						4	1		34
Cores	7	1					2	2	1	1
Retouched tools	5			1		2	2			
Cobble	1							1		
Total	**171**									

Table 12.17 Average maximum dimensions of flakes in mm from LBSmff.10 and LBSmcf.11.

Description	Sample size	Length mm	Breadth mm	Thickness mm
Plain flakes	20	37.8	26.5	5.5
Centripetal flakes	6	37.8	25.6	4.2
Pseudo-Levallois points	2	42	30	7
Levallois flakes	4	44.2	30.7	6

Table 12.18 List of lithic artefacts in LBSmff.11 and LBSmcf.12.

Description	No.	Brown Chert	Red Chert	Honey Chert	Chert Undiff.	Quartz-ite	Other/ Unclassified
Plain flakes	20		1	2	6	10	1
Centripetal flakes	4				1	3	
Pseudo-Levallois points	3				1	2	
Levallois point	1					1	
Shatter	2				2		
Chips <15 mm	2	1			1		
Cores	3					3	
Retouched flake	1						1
Total	**36**						

reduction. A relevant observation here is that one of the cores has a large central removal and can be interpreted as a radial Levallois type (Fig. 12.11, Gor96/63). It is made on a beach pebble and fulfils Boëda's definition of a recurrent centripetal type by virtue of the orientation and angle of the single large flake removal which is parallel to the intersecting plane between the two core surfaces. The remaining six cores consist of two discoidal forms (C-type), two cores on a flake, and two indeterminate types (Fig. 12.13, Gor96/133).

No detailed analysis was undertaken of the shatter or the chips but it can be noted that only one artefact was burnt.

There are five retouched tools in this assemblage. They comprise two end-scrapers, two retouched flakes and a denticulate. One of the end-scrapers (Gor96/204) is on a cortical flake with retouch at its distal end. It can be refitted to another flake portion in the same layer (Gor96/206). The second tool is a round end-scraper on an uncorticated flake with a plain butt. The two retouched flakes consist of a broken naturally backed flake and a flake fragment (Fig. 12.10, Gor96/71 and Gor96/113). The denticulate is in a distinctive red chert and displays a series of prominent retouched notches along its right edge (Fig. 12.9, Gor98/1190a); it is on the broken distal end of a flake and appears either to have been deliberately thinned or served as a core, judging by several flake removals on its ventral surface.

There is one elongate cobble of quartzite. It measures 119 mm long, is roughly cylindrical in shape and shows some minor abrasion along one side, but otherwise shows no significant signs of use.

The raw materials are similar to those in the overlying layers. Locally collected cobbles seem to account for the presence of the dark red chert on which the denticulate and three plain flakes are made. There is a possibility that some of the larger Levallois flakes in a honey-coloured chert derive from further travelled material (discussed below).

One additional item of interest from LBSmcf.11 is a bone retoucher (Gor96/199). It is on the radius shaft fragment of red deer (*Cervus elaphus*). The damage patterns are consistent with the use of the object as a compressor or a retoucher for lithic reduction, as in the manufacture of tools such as scrapers. Though not unusual in Middle Palaeolithic contexts (Patou-Mathis and Schwab 2002), this is one of only two examples so far identified in our excavations at Gorham's Cave. The second is made on an ibex (*Capra ibex*) femur shaft fragment (Gor96/340d) but unfortunately no precise position was recorded. A further example is known from Vanguard Cave (Chapter 20).

(LBSmff.11) fine facies and (LBSmcf.12) coarse facies In these amalgamated beds were found 20 plain flakes (Table 12.18) of which 11 are complete and nine broken. Where proximal ends are preserved, plain butts (eight) slightly outnumber dihedral and dihedral faceted forms (six). The dorsal scar pattern reflects a marginally greater preponderance of unidirectional scars (seven) over multi-directional ones, although excluded from this total are two plain flakes where the dorsal scars seem to indicate that they were struck from opposed platform cores (though no evidence of the cores survives). Five plain flakes display some degree of cortex on their dorsal surfaces. Only one plain flake is burnt.

Besides the plain flakes, four centripetal flakes and three PsLP were recovered. The centripetal flakes reveal plain (two) and faceted (one) butts, while faceted dihedral butts were present on two of the PsLP. The single example of a Levallois point is of interest. It is a small flake on quartzite

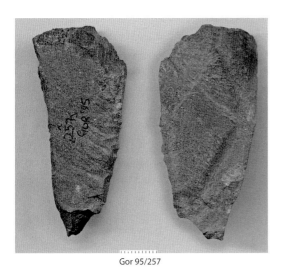

Gor 95/257

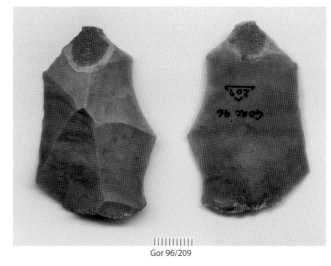

Gor 96/209

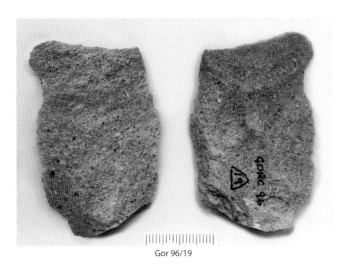

Gor 96/19

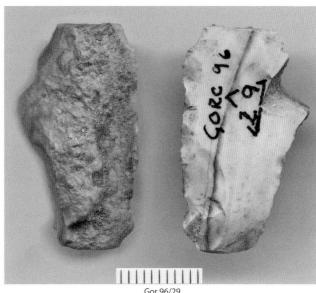

Gor 96/29

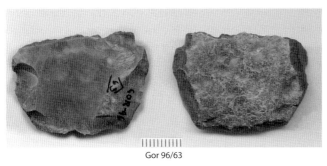

Gor 96/63

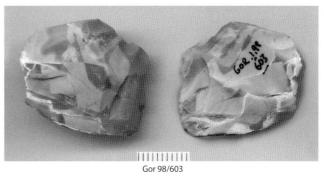

Gor 98/603

Fig. 12.11 Gorham's Cave Middle Palaeolithic sequence. **Gor95/257**: Denticulate (quartzite) (LBSmcf.4–mcf.7); **Gor98/603**: Pièce esquillée; **Gor96/19**: Levallois flake (quartzite); **Gor96/29**: Retouched flake (LBSmff.8 and LBSmcf.9); **Gor96/63**: Radial Levallois core with the central negative scar indicating removal of plunging flake; **Gor96/209**: Levallois flake (LBSmff.10 and LBSmcf.11). Photo: Richard Jennings.

measuring 40 × 25 × 4 mm. It has unidirectional flake scars and a dihedral faceted butt (Fig. 12.12, Gor96/152).

There are three cores in the assemblage of which two are discoidal forms (type-C, Fig. 12.12, Gor98/925) and one a diverse type. The only retouched tool is a flake with a double notch. None of these artefacts are burnt.

A relatively narrow range of raw materials is represented. Of particular note are the 17 quartzite flakes which include PsLPs, centripetal flakes and the single Levallois flake. Slightly surprising is the absence of any core in this material. The issue of whether PsLPs and centripetal flakes

originated from the same reduction sequences could be further explored through refitting studies.

(LBSmcf.13) coarse facies Both discoidal and radial Levallois debitage occurs in this unit (Tables 12.19 and 12.20). One FCER and three PsLP (Fig. 12.12, Gor96/268) offer evidence for the use of the discoidal core method, while the radial Levallois technique is represented by a Levallois point (Fig. 12.12, Gor96/269) and two Levallois flakes. The presence of both of these products in a similar type of quartzite suggests the possibility that they were different

Table 12.19 List of lithic artefacts in LBSmcf.13.

Description	No.	Brown Chert	Honey Chert	Chert Undiff.	Quartz-ite	Lime-stone	Other/ Unclassified
Plain flakes	36		2	4	3	1	26
Centripetal flakes	2	1			1		
Naturally backed flakes	3			2		1	
Core edge removal flake	1		1				
Pseudo-Levallois points	3		1		2		
Levallois flakes	2			1	1		
Levallois point	1				1		
Shatter	2			2			
Chips <15 mm	1						1
Core	1			1			
Notched flake	1			1			
Cobbles	2				1		1
Total	**55**						

Table 12.20 Average maximum dimensions of flakes in mm from LBSmcf.13.

Description	Sample size	Length mm	Breadth mm	Thickness mm
Plain flakes	2	29.5	26.5	4.5
Centripetal flakes	2	49	41	5
Naturally backed flakes	3	55.6	23.6	9.3
Core edge removal flake	1	32	20	9
Pseudo-Levallois points	2	35	34.5	5.5
Levallois flakes	2	42.5	33.5	4
Levallois point	1	31	28	7.5

stages of the same reduction process. This is something that might be tested via refitting studies. The only core is clearly unrelated. It is a multiplatform example in chert. None of these artefacts or others in the same layer is burnt.

There is one retouched tool, a proximally broken flake with a double notch at the distal end. Non-flaked lithic items comprise two cobbles neither of which shows any obvious signs of damage or use.

The raw materials indicate a heavy reliance on local sources of beach pebble chert and quartzite. That some of the primary reduction might have taken place outside the cave is implied by the existence of only eight artefacts with cortical covering. In this respect it is also worth drawing attention to the very small numbers of chips recovered either by excavation or in the sieved samples.

(LBSmff.12) fine facies Only two flakes are recorded in this bed. They are both plain flakes of chert.

Sands and Stony Lenses (SSLm)

(SSLm(Usm).1) Some uncertainty exists over the exact position of finds from this upper submember unit due to the fact that a number were recorded as 'disturbed' or from the boundary of Usm.1 and Usm.2. Relevant examples are

Table 12.21 List of lithic artefacts recorded in SSLm(Usm).1.

Description	No.	Brown Chert	Chert Undiff.	Other/ Unclassified
Plain flakes	20		3	17
Pseudo-Levallois point	1	1		
Levallois flake	1		1	
Chips <15 mm	34			4
Core	1		1	
Inversely retouched flake	1		1	
Total	**58**			

a Levallois flake (Fig. 12.13, Gor97/38), a PsLP and a flake all recovered from the boundary. Only a sieve sample of 17 flakes and three individual small finds (a retouched flake and two plain flakes) can be assigned with any confidence to Usm.1. The retouched flake is a mesial fragment with inverse retouch along one edge and no cortex (Fig. 12.14, Gor96/290). The two plain flakes are complete examples with unidirectional flake scars and plain butts. They are partially corticated, unburnt and are of an undifferentiated chert. A multiplatform core, also of chert, comes from a disturbed context (Table 12.21).

(SSLm(Usm).2) This is the richest assemblage of any of the units in the Sands and Stony Lenses member (Tables 12.22, 12.23 and 12.24). It comprises mainly plain flakes (60) of which 42 were examined in detail. The plain flakes show a surprisingly high percentage of complete pieces

Table 12.22 List of lithic artefacts recorded in SSLm(Usm).2.

Description	No.	Brown Chert	Speckled Chert	Red Chert	Honey Chert	Chert Undiff.	Quartz-ite	Lime-stone	Other/ Unclassified
Plain flakes	60	3	3	1	3	26	8	2	14
Centripetal flakes	6	1	1		2	2			
Naturally backed flakes	2					1	1		
Core edge removal flakes	7				2	4	1		
Pseudo Levallois points	3					2	1		
Levallois flake	1						1		
Levallois point	1						1		
Intentionally broken flake	1					1			
Blade	1					1			
Shatter	9					5			5
Chips (<15 mm)	10					4			10
Cores	2	1				1			
Hammerstones	7						6		1*
Natural pebbles/cobbles	18						9	7	2
Retouched tools	2								2
Total	**130**								

* asterisk denotes sandstone

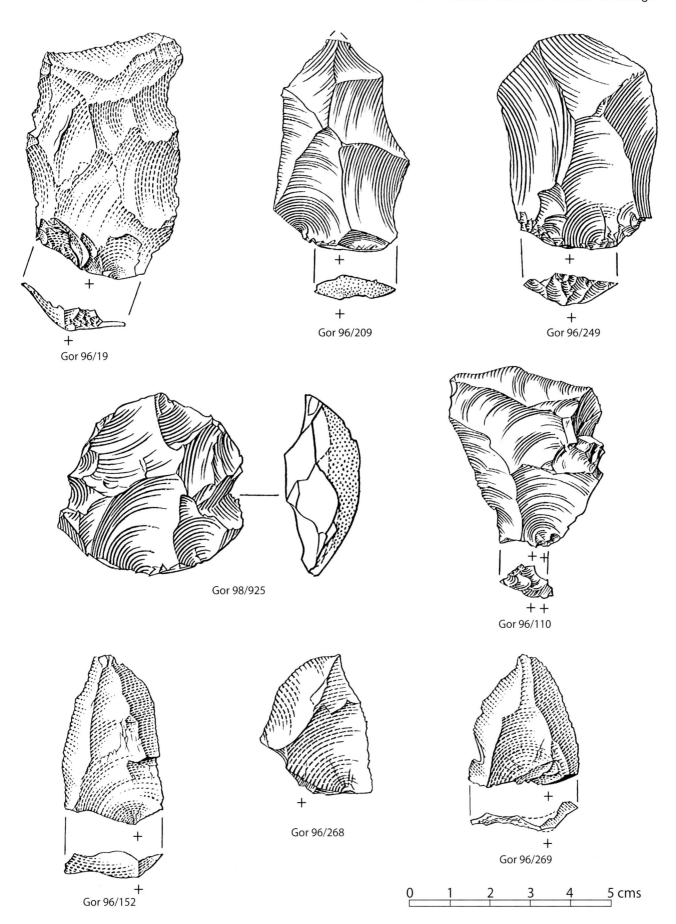

Fig. 12.12 Gorham's Cave Middle Palaeolithic sequence. **Gor96/19**: Levallois flake (quartzite) measuring 58 × 38 × 6 mm (LBSmff.8 and LBSmcf.9); **Gor96/209**: Levallois flake; **Gor96/249**: Levallois flake; **Gor96/110**: Centripetal flake (LBSmff.10 and LBSmcf.11); **Gor96/152**: Levallois point (quartzite); **Gor98/925**: Discoidal C-type core (LBSmff.11 and LBSmcf.12); **Gor96/268**: Pseudo-Levallois point (quartzite); **Gor96/269**: Levallois point (quartzite) (LBSmcf.13). Drawings: Hazel Martingell.

Table 12.23 Flakes sub-divided by type in SSLm(Usm).2.

Description		Complete	Broken	Burnt	Cortex	Butt types: cortical plain	plain	dihedral faceted	faceted	linear	punctiform
Plain flakes	46	31	15	4	15	6	22	2	6	1	
Centripetal flakes	6	6					3		2	1	
Naturally backed flakes	2	1	1		2	1				1	
Core edge removal flakes	7	6	1		3	1	3				2
Pseudo-Levallois points	3	3			1	1			2		
Levallois flake	1	1							1		
Levallois point	1	1							1		
Intentionally broken flake	1		1								
Total	81	49	18	4	21						

Table 12.24 Average maximum dimensions of flakes in mm from SSLm(Usm).2.

Description	Sample size	Length mm	Breadth mm	Thickness mm
Plain flakes	28	35.9	29.6	6.2
Centripetal flakes	6	42.6	21.1	4.8
Core edge removal flakes	7	40.3	39.1	8.8
Pseudo-Levallois points	3	32.6	31.3	7.0
Levallois flake	1	41.0	30.0	4.0
Levallois point	1	42.0	30.0	7.0

(67 per cent). Of 37 examples with preserved butts, 28 had plain and plain cortical forms and these outnumbered examples with dihedral and other faceted types (eight). About a third of all plain flakes displayed some cortex on their dorsal surfaces, implying primary knapping activity. In terms of the dorsal scar patterns there was a predominance of unidirectional scar patterns (50 per cent of the measured sample) although multidirectional dorsal scars (20 per cent) were also well represented. Only four of the plain flakes were burnt.

Radial Levallois and discoidal techniques are both documented. Amongst the discoidal core by-products there are FCER (seven) and PsLP (three). There is one Levallois flake and one Levallois point, both with faceted butts. It is not entirely clear to which category the centripetal flakes belong; half have faceted butts, the rest plain butts. There is no obvious indication from the raw material as the centripetal flakes are all of chert, while the Levallois products are on quartzite as is the case for some of the discoidal core debitage.

The two cores recorded are a type-C discoidal core (Fig. 12.14, Gor97(III)/68) and an unclassified burnt example. The discoidal core displays a cortical exterior on its underside. It is in a brown chert and its cortex has a typically beach-chattered surface appearance. Its maximum length is 33 mm. There are five flakes in the same raw material but no attempt was made to refit the pieces.

Only two retouched tools were recovered: a denticulate (Fig. 12.13, Gor97(III)/69) and a notch. The denticulate is on a broken flake and comes from a chert beach pebble as indicated by a heavily chattered cortical surface remnant. The other tool comprises a single notch and retouched edge on the left side of the proximal end of a flake. The flake is possibly burnt and is of chert.

Seven hammerstones, identified by characteristic pitting at one or both extremities, are recorded in this context. They are all on cobbles. The longest measures 104 × 91 mm in maximum dimensions and is made of quartzite. Four other complete hammerstones are of more spherical shape and have maximum diameters of 65–63 mm (Fig. 12.13, Gor97(III)87). One of these (Gor97(II)147) also has small flecks of charcoal visible at one end and may have been used as a grinding stone. Many charred hulls and burnt shell fragments of stone pine nuts and cone scales (*Pinus pinea*) were recovered in the same bed (see Chapter 7).

In addition to the hammerstones, at least 18 examples of natural cobbles and cobble fragments have been recorded. As these are mostly in the same quartzite raw materials as the hammerstones it is likely that some of them are broken percussors (seven), but efforts to refit the fragments proved unsuccessful. One of them (Gor97(III)/163) displays small spots of what appears to be ochre colorant adhering to it and requires further investigation. Of the remainder, a limestone cobble has smears of charcoal on one of its sides

The raw materials are dominated by local cherts but with significant quantities of quartzites. Some of the larger centripetal flakes and plain flakes, up to 60 mm in length, are in a characteristic fine-grained honey chert which might derive from 'exotic' sources to the west of Gibraltar (See Summary and Discussion below).

Table 12.25 List of lithic artefacts recorded in SSLm(Usm).3.

Description	No.	Brown Chert	Honey Chert	Chert Undiff.	Quartzite	Limestone	Other/ unclassified
Plain flakes	22	1		7	1	1	12
Centripetal flake	1				1		
Naturally backed flake	1						
Core edge removal flake	1			1			
Pseudo-Levallois point	1				1		
Chips (<15 mm)	59	1	1				57
Notched flake on an intentional break	1			1			
Total	**86**						

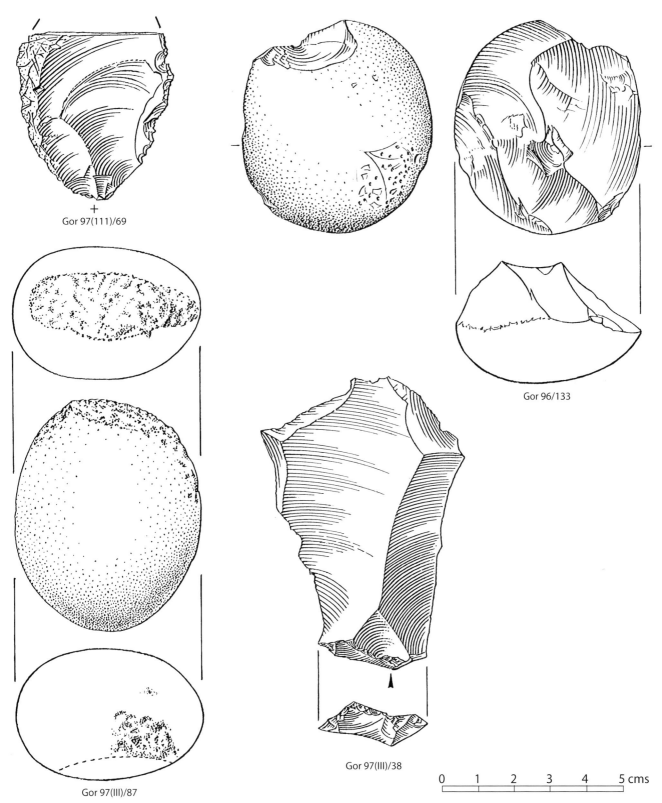

Gor 97(111)/69

Gor 96/133

Gor 97(III)/87

Gor 97(III)/38

0 1 2 3 4 5 cms

Fig. 12.13 Gorham's Cave Middle Palaeolithic sequence. **Gor96/133**: Limestone core of indeterminate type, possibly reused broken hammerstone (LBSmff.10 and LBSmcf.11). **Gor97(III)/38**: Levallois flake (SSLm(Usm).1); **Gor97(III)/69**: Denticulate on a flake; **Gor97(III)/87**: Hammerstone (SSLm(Usm).2). Drawings: Hazel Martingell.

(SSLm(Usm).3) Artefacts from this unit consist of 26 plain flakes, 59 chips (<15 mm) and one notched tool (Table 12.25). The debitage is in a variety of raw materials and includes cortical pieces with beach-chattered exteriors which suggest they were made on cherts collected near the cave. The dorsal scar patterns on the plain flakes are dominated by unidirectional types. Amongst the debitage is a FCER (Fig. 12.15, Gor97(III)/134) and a PsLP, considered to be diagnostic of a discoidal core technology.

There are no signs of burning or major post-depositional alteration amongst the debitage. Most of the finds are complete and in fresh condition. The only distinctive breakage pattern can be observed on the notched flake (Fig. 12.15, Gor97(III)/125). The retouched tool is on the distal end of a flake that appears to have been intentionally snapped. Signs of a percussion-induced fracture are present on the break surface (cf. Bergman *et al.* 1983; 1987). It is a technique that has previously been noted in Middle Palaeolithic

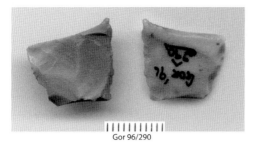

Gor 96/290

Gor 97/68

Gor 98/4

Fig. 12.14 Gorham's Cave Middle Palaeolithic sequence. **Gor96/290**: Retouched flake with inverse retouch on right lateral edge (SSLm(Usm).1); **Gor97(III)/68**: Discoidal C-type core (SSLm(Usm).2); **Gor98(III)/4**: Pseudo-Levallois flake (SSLm(Usm).5). Photo: Richard Jennings.

assemblages (Bordes 1953), including the cave site of Las Grajas near Màlaga (Benito del Rey 1982).

(SSLm(Usm).4) An unburnt flake, a lithic chip and part of a hammerstone are all that are recorded from this unit. No other details are available.

(SSLm(Usm).5) There are 19 plain flakes, four chips, a shatter fragment and one core in this assemblage (Table 12.26). The debitage includes two typical by-products of discoidal core reduction, a FCER and PsLP (Fig. 12.14, Gor97(III)/4). The core, however, is of potentially Levallois type with parallel flake scars. Multiple flakes and a large notch on one of its sides might show that it was converted into a tool (Fig. 12.15, Gor97(III)/194). None of the chert flakes in this layer resemble the raw material of the core.

Of interest in this small assemblage are eight flakes in a distinctive honey-coloured chert. The flakes include four artefacts >50 mm and six of the eight have intact butts and are all faceted or faceted dihedral examples with prominent bulbs consistent with a hard hammer mode of percussion. Unfortunately no refitting was attempted but it seems highly likely that they are all part of the same core reduction sequence. The existence of two small flakes in the same material less than 30 mm long lends further support to this idea that knapping occurred *in situ*. Also in the same chert is a FCER which implies that some reduction was of a discoidal type.

(SSLm(Lsm).6) Of the 36 artefacts recorded in this context, 32 are flakes, three are chips (<15 mm) and one is a flake of limestone (Table 12.27). The most noteworthy item in the assemblage is a very large laminar flake measuring 126 × 40 × 12 mm (Fig. 12.15, Gor97(III)/229). It displays sub-parallel dorsal ridges indicating it came from an opposed platform core. The butt is dihedral faceted, while a prominent cone on its ventral surface identifies a hard hammer mode of percussion. The raw material is a distinctive honey-coloured fine-grained chert, also seen in three other flakes from the same context. Technologically, the laminar flake probably represents use of a bipolar recurrent Levallois technique (Boëda 1986). This observation is interesting in the light of the recovery of other flakes in the same context more characteristic of a discoidal core technology. The latter includes one FCER and a PsLP (Fig. 12.15, Gor97(III)/22) as well as seven plain flakes mostly with plain butts and evidence of multiple flake scars on their dorsal surfaces. It is worth mentioning that as well as the laminar flake, three other plain flakes are much larger than the other artefacts in the collection (lengths >60 mm). The only other distinctive quality is that two of the plain flakes have plain butts and unidirectional flake scars, while the third has a faceted butt and multiple centripetal scars on its dorsal surface.

From the point of view of post-depositional effects, the majority of flakes are in fresh condition with no nicking or other damage along their edges. Ten of the flakes are snapped; the breakage patterns are consistent with those of knapping accidents. One of the breaks can be mended across an ancient fracture surface. None of the artefacts is burnt. According to technological and related characteristics mentioned above it seems clear that the knappers were using raw materials of two distinctive types: small local beach chert pebbles and at least one larger cobble of

Table 12.26 List of lithic artefacts recorded in SSLm(Usm).5.

Description	No.	Honey Chert	Chert Undiff.	Quartz-ite	Lime-stone	Other/ Unclassified
Plain flakes	16	6	7		1	2
Naturally backed flake	1			1		
Core edge removal flake	1	1				
Pseudo-Levallois point	1		1			
Shatter	1					1
Chips <15 mm	4					4
Core	1		1			
Total	25					

Table 12.27 List of lithic artefacts recorded in SSLm(Lsm).6.

Description	No.	Honey Chert	Chert Undiff.	Lime-stone	Other/ Unclassified
Plain flakes	25	3	20		2
Centripetal flakes	4		4		
Core edge removal flake	1		1		
Pseudo-Levallois point	1		1		
Levallois laminar flake	1	1			
Unclassified flake/natural	1			1	
Chips <15 mm	3		1		2
Total	36				

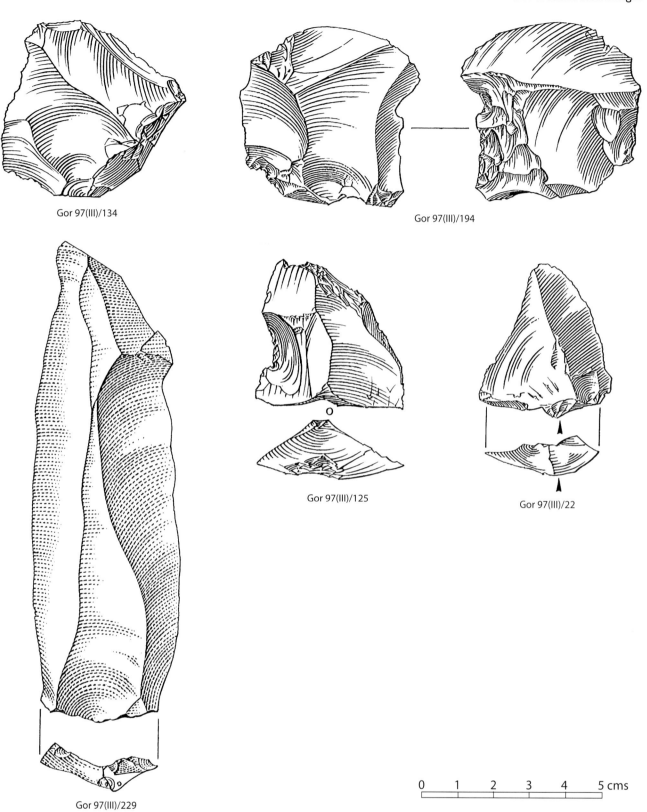

Gor 97(III)/134

Gor 97(III)/194

Gor 97(III)/125

Gor 97(III)/22

Gor 97(III)/229

0 1 2 3 4 5 cms

Fig. 12.15 Gorham's Cave Middle Palaeolithic sequence. **Gor97(III)/134**: Core edge removal flake and **Gor97(III)/125**: Notched flake on an intentional break (SSLm(Usm).3); **Gor97(III)/194**: Possible parallel Levallois core with additional retouch and notch (SSLm(Usm).5); **Gor97(III)/229**: Large laminar flake made using a bipolar recurrent Levallois technique; **Gor97(III)/22**: Pseudo-Levallois point (SSLm(Usm).6). Drawings: Hazel Martingell.

probably 'exotic' honey-coloured chert. The local beach pebbles are generally far too small to have produced any artefacts in the 130–60 mm size range.

Lower units

Although no formal analyses were carried out on the finds from layers beneath the excavated levels, it is important to observe that isolated artefacts have been recorded throughout the lower sequence in standing sections. Of interest are Middle Palaeolithic flakes in association with marine shells in a midden deposit in the Carbonate Sands and Silts (CSSm.1), visible in the deposits of the northern cornice. Artefacts were also recovered from contexts of the Governor's Beach formation (GBf).

The Waechter Collection: artefacts from layers B, D and F

Lithic artefacts in the Waechter Collection in Gibraltar Museum represent no more than a fraction of the total number of finds recorded in his excavations (Waechter 1951; 1964). The whereabouts of the bulk of these finds are presently unknown. A few observations relating to artefacts from the upper part of the sequence are offered here. These are based on a brief study of material in the Museum store made by one of the authors (NB) in 1995 and 1996.

Layer B Waechter (1964) described this layer as 'a fairly clean sand with pieces of angular limestone and traces of charcoal' that lay immediately beneath a stalagmitic floor, the equivalent of unit USFm.1 in our sequence (Chapter 2). No well defined sand deposit in this stratigraphic position was observed in our 1995–1998 excavations.

Of the artefacts seen in Gibraltar Museum (Table 12.28), nine were blades and bladelets in a variety of fine-grained raw materials. One of them was a small unidirectionally crested blade and from this and the presence of an opposed platform blade core (Fig. 12.16, 9/58) it is clear that they all derive from an Upper Palaeolithic blade/bladelet technology. The retouched tools included three burins: a multiple burin on truncation (Fig. 12.16, 10/58), a burin on a break and a burin on truncation. The most clearly diagnostic find is a broken half of a unifacially flaked 'Solutrean' point (Fig. 12.16, GC 48). None of the artefacts that were examined would look out of place in a Spanish Solutrean assemblage.

Of additional interest was a single bevelled bone point or *sagaie* (Waechter 1951, fig. 3.13) that still survives in the collection.

Layer D This layer was sub-divided by Waechter into two units D1 and D2. The upper sub-unit (D1) was described as 'Rather compact and slightly clayey in texture mixed with charcoal. At the base there are hearths over the whole

Table 12.28 Indicative list of lithic artefacts from Waechter's layer B.

Description	No.	Honey Chert	Red Chert	Green/ Grey Chert	Grey Speckled Chert	Chert Undiff.
Flakes	4		1		2	1
Blades	6*		1	1	1	3
Bladelets	3	2			1	
Bladelet Core Opposed Platform	1			1		1
Flake cores	2			1		1
End-scrapers	4			1		3
Burins	3	1	1			1
Unifacial 'Solutrean' point	1		1			
Retouched blade	1		1			
Burin spall	1				1	
Total	**26**					

* including a small unidirectionally crested blade

area. These hearths were apparently lined with flat, water-worn pebbles, but it was not possible to establish any clear arrangement as the majority of stones were not in their original position. Flint flakes, bones and shells were fairly plentiful' (Waechter 1951, 85). In contrast, the lower layer (D2) comprised '... the hearth level and the sands immediately below ...' (ibid., 85) and also contained an assemblage of flint, bone and shell. From comparative observations of the lithostratigraphy (Chapter 2) layer D correlates with the lower levels of the Cemented Hearths member.

Of a combined total of 568 lithic artefacts listed by Waechter in sub-units D1 and D2 (1951, 87) only 31 appear to survive today in Gibraltar Museum (Table 12.29). They comprise three bladelet cores, including one from D1 (Fig. 12.17, GC 50/TRA (N) 15/58) and small but significant quantities of blade and bladelet debitage. Most of the blades are fairly straight (Fig. 12.17, A and B) and there are no curved or twisted forms amongst the smaller debitage. No burin spalls were noted but the burins themselves are on thick supports. One of them is a multiple burin on a break

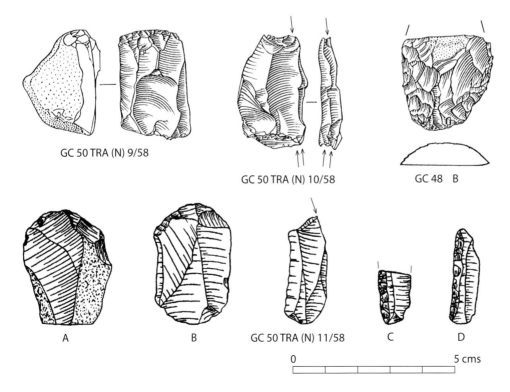

GC 50 TRA (N) 9/58

GC 50 TRA (N) 10/58

GC 48 B

A

B

GC 50 TRA (N) 11/58

C

D

0 5 cms

Fig. 12.16 Gorham's Waechter collection, layer B. **GC TRA (N) 9/58**: Opposed platform bladelet core; **GC 50 TRA (N) 10/58**: Multiple burin on truncation; **GC 48 B**: Solutrean point; A–B: End-scrapers; **GC 50 TRA (N) 11/58**: Burin on a break; C–D: Backed bladelets. Drawings: Hazel Martingell and from Waechter 1951.

Table 12.29 Indicative list of lithic artefacts from Waechter's layer D (amalgamated).

Description	No.	Brown Chert	Black Speckled Chert	Red Chert	Grey Chert	Banded Chert	Chert Undiff.	Quartz-ite
Flakes	4						2	2
Blades	7	2					4	1
Bladelet	1				1			
Shatter	1			1				
Core tablet	1		1					
Flake Cores one platform	4			1			3	
Flake Core two platform	1					1		
Flaked flake	1						1	
Bladelet Cores one platform	3					2	1	
End-scrapers	2					2		
Burins	3			1	1		1	
Retouched flake	1	1						
Marginally retouched bladelet	1					1		
Backed blade	1				1			
Total	**31**							

(Fig. 12.17, 18/58) from D2. The sub-parallel and very narrow scars on the burin edge could indicate that it was a method for manufacturing micro-bladelets, though without the spalls themselves this is difficult to verify. Besides one short flake end-scraper, there is a scraper on the end of a thick blade (Fig. 12.17, 23/58) from D2. It has a heavily hooked profile. Amongst the blades and flakes are three retouched forms. These were identified by Waechter in D1 and still exist in the Museum. They are all reproduced from Waechter's own illustrations in Figure 12.17. TRA (N) 25/58 is a flake partially modified by semi-abrupt retouch. It is burnt. TRA (N) 22/58 is a broken backed blade in a brownish-grey

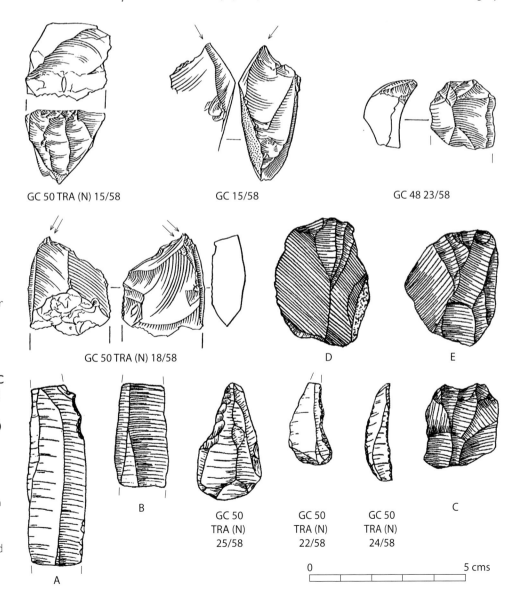

GC 50 TRA (N) 15/58 GC 15/58 GC 48 23/58

GC 50 TRA (N) 18/58 D E

Fig. 12.17 Gorham's Waechter collection, layer D. Finds from D1, **GC 50 TRA (N)**: Single platform bladelet core; **GC 15/58**: Notch-stopped burin on truncation; **A–B**: Blades; **GC 50 TRA (N) 25/58**: Retouched flake; **GC 50 TRA (N) 22/58**: Backed blade; **GC 50 TRA (N) 24/58**: Marginally retouched bladelet; **C**: 'Core scraper'. Finds from D2, **GC 48 23/58**: End of blade scraper; **GC 50/ TRA (N) 18/58**: Multiple burin on a break (possible bladelet core); **D–E**: 'Steep scrapers'. Drawings: Hazel Martingell and J. Waechter

A B GC 50 TRA (N) 25/58 GC 50 TRA (N) 22/58 GC 50 TRA (N) 24/58 C

0 5 cms

Table 12.30 Indicative list of lithic artefacts from Waechter's layer F (amalgamated).
Personal observation and A. Roberts and J. McNabb (pers. comm.).

Description	No.	Honey Chert	Brown Chert	Grey/Black Chert	Banded Chert	Red Chert	Green Chert	Chert Undiff.	Quartz-ite
Flakes	5							3*	2
Flakes Centripetal	2			1					1
FCER (core edge removal)	1			1					
Blades	8	2						5	1
Bladelet	1							1	
Flake Cores one platform	4			2		1			1
Flake Core multiplatform	1			1					
Bladelet Cores	2					1		1	
Core fragments and unidentified	3		1	1			1		
End-scrapers	3			1	1			1	
Burin	1	1							
Retouched Blade	1		1						
Denticulate	1								1
Burin spall	1	1							
Total	**34**								

* one is unconfirmed

fine-grained chert. TRA (N) 24/58 is a marginally retouched bladelet with additional marginal and fine retouch on its left lateral edge. This piece is potentially the most interesting as it is the only one in the collection that fits the description of a marginally backed piece and is of a kind that occurs in the western Aurignacian (Le Brun-Ricalens *et al.* 2009, fig. 2.3).

From this limited collection of surviving artefacts we would argue that there is nothing inherently Middle Palaeolithic in the typology of these finds. On the other hand, it is interesting that although the assemblage consists predominantly of fine-grained cherts of mainly non-local origin (Edward Rose, pers. comm.), there are three quartzites amongst the blades and flakes which would appear to be of a type native to Gibraltar. The use of this raw material is particularly characteristic of the Middle Palaeolithic levels of Gorham's Cave.

Layer F The oldest claimed Upper Palaeolithic artefacts came from layer F (Waechter 1964). This layer was separated into three sub-units, F1, F2 and F3, comprising alternating dark and light sandy horizons. Waechter revealed that 'F1 contained traces of small hearths, implements, bone and shells; there were also small traces of charcoal in F2, but very few implements' (Waechter 1964, 191). F3 consisted of 'a thin sterile layer separating the Mousterian from the later industry' (Waechter 1951, 92).

The total number of artefacts reported by Waechter in F1 and F2 was 54 and indicates that 20 pieces are missing from the Gibraltar Museum collection (Table 12.30). Waechter listed 34 flakes, four blades, six cores, two end-scrapers, four steep-scrapers, two core scrapers, one burin and one retouched flake (Waechter 1964, 194). Most of the finds were recovered in the first two seasons' work. Of the 48 artefacts referred to in the 1951 report, 23 came from F1 and 25 from F2. Unfortunately only seven of the artefacts in today's collection seem to carry indications of stratigraphic provenance. In addition, a further six artefacts were referenced in the 1964 report but these are not identified according to sub-layer.

A reanalysis of the assemblage reveals that amongst the flakes are two centripetal flakes and one core edge removal flake that could all be by-products of a discoidal core technology. The blades and one bladelet display unidirectional dorsal scar patterns and in four cases where the butts are preserved they show punctiform and plain types. The blades include very long straight examples that were not found in the overlying layers. There are six cores and three core fragments. Five of the seven examples seen are flake cores with removals from one platform (FCOPI: Flake Core One Platform Irregular) or multiple platforms (FCMPI: Multi-Platform Irregular). Two of the bladelet cores are single platform types although one is broken so it is difficult to be certain (Fig. 12.18, GC 52 31/58). One example originally figured by Waechter as a steep-scraper is in fact a bladelet core on a flake (Fig. 12.18, GC 50/TRA (N) 31/58). The bladelet removals are transverse to the flake axis, a feature untypical of carinated scrapers. The discrepancy between the numbers of cores identified here and by Waechter is undoubtedly explained by his 'core-scrapers' category.

Amongst the retouched tools, one of the three end-scrapers is very distinctive with additional retouch along the lateral edge (Fig. 12.18, GC 52/TRA (N) 31/58). The ventral surface scars at either end, if not the result of intentional thinning, may indicate use damage possibly in association with an anvil. The two other end-scrapers are made on blades and appear to be Upper Palaeolithic types. An atypical burin is present. It has a tiny burin facet that appears to be notch-stopped (Fig. 12.18, GC 50/TRA (N) 28/58). The tool is on a blade with a heavily abraded butt and ventral surface features that are consistent with a soft hammer mode of percussion. The remaining tools comprise a retouched blade with irregular semi-abrupt to abrupt direct retouch along one edge (Fig. 12.18, GC 52 32/58). Signs of probable use-wear are visible on the ventral surface of the opposite lateral edge. There is also a denticulate on a large quartzite flake similar to examples found in the Middle Palaeolithic. Finally, there is one piece of tool debitage. It is a burin spall with a triangular section measuring 10 mm thick and 55 mm long, with cresting along one edge. Its size suggests that it came from the edge of a large flake rather than blade. It could therefore also be a preparatory removal of a core on a flake.

The raw materials examined in layer F comprise a variety of fine-grained cherts including a characteristic honey chert. The presence of artefacts in locally sourced materials such as quartzite and of identifiably Middle Palaeolithic technology implies that the collection is mixed.

In addition to the lithic artefacts attributed to layer F, there was 'a bone point, made on the ulna of what appears to be Equus' (Waechter 1951, 87). The exact provenance of this find, however, was unclear since it was recovered from a section collapse and thus could have come from either E or F1 or F2 (ibid., 87). This piece has unfortunately now been lost or mislaid and its identification cannot be confirmed. In addition, a second bone implement was described from F2. The object was described as 'a long narrow bone point. The centre of this point is slightly flattened on both faces, and the lower half is badly crushed so it is not possible to see if this flattening continues all the way down' (ibid., 87). The bone is housed with the rest of the collection in Gibraltar Museum. Under the naked eye the piece reveals no obvious signs of deliberate shaping (such as abrading or polishing) and in NB's opinion it is doubtful whether it is an artefact at all.

To sum up, it is extremely difficult to correlate layer F with individual sediment units of our stratigraphic sequence. It is highly likely that the collection is a mixture of Middle and Upper Palaeolithic artefacts and this resulted either from the accidental conflation of layers by Waechter or because the artefacts represent a palimpsest of finds from different periods. We strongly suspect the latter and it is entirely possible that the finds derive from the equivalent of the Upper Bioturbated Sands member (Chapter 2).

Discussion
Technological and typological analyses
Early Upper Palaeolithic
Upper Palaeolithic artefacts are recorded in two beds of the Cemented Hearths member near the top of the Gorham's sequence. The stratigraphically higher bed, CHm.3, has a small collection of artefacts that includes a retouched

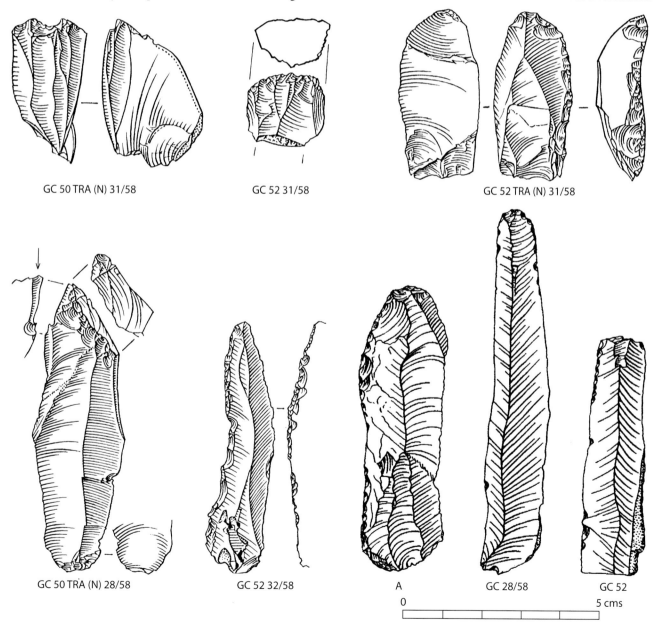

GC 50 TRA (N) 31/58 GC 52 31/58 GC 52 TRA (N) 31/58

GC 50 TRA (N) 28/58 GC 52 32/58 A GC 28/58 GC 52

0 5 cms

Fig. 12.18 Gorham's Waechter collection, layer F. Finds from F1, **GC 50 TRA (N) 28/58**: Plunging blade with burin facet at the distal end (possible bladelet core); **GC 52**: Blade. Finds from F2, **GC 50 TRA (N) 31/58**: Single platform bladelet core. Finds from undifferentiated F, **GC 52 31/58**: Bladelet core; **GC 52 31/58**: End-scraper; **GC 52 32/58**: Retouched blade; A: Retouched blade; **GC 28/58**: Blade end-scraper on retouched blade. Drawings: Hazel Martingell and J. Waechter.

blade and a bladelet, plus two examples of distinctive *pièces esquillées* (scaled flakes) (Fig. 12.5). Despite intensive sieving of this bed no other examples of bladelets or micro-bladelets were recovered. Although the restricted size of the collection makes it difficult to provide an unequivocal cultural attribution the lithics do invite comparisons with other southern Spanish Gravettian assemblages. Well-known cave sites with Gravettian assemblages are known from Bajondillo and Nerja, both in Màlaga. At Nerja, three dates on charcoal of 24,200 ± 200 (BETA-189080), 24,480 ± 110 (BETA-131576) and 24,730 ± 250 (GifA-102.023) provide secure dates for the Gravettian levels (Aura Tortosa *et al.* 2010). Another site at Cova de les Cendres, Alacant, also contains Gravettian artefacts including backed blade-lets and *pièces esquillées* in levels XV and XVI which have associated radiocarbon ages of around ~25,000 BP (Vil-laverde and Dídac 2004, 38 and fig. 6). The finds from Gorham's Cave are not very well dated. The single AMS radiocarbon date on charcoal from CHm.3 of (OxA-7792) 28,680 ± 240 BP is likely to be a maximum age for this small assemblage (see Chapter 5).

Further examples of Upper Palaeolithic artefacts have been recovered in bed CHm.5 which appears to be the lateral equivalent of Waecher's layer D. Here again the assemblage is very restricted in size but contains several backed blades and narrow bladelet forms in non-local raw materials (Fig. 12.5; Table 12.2). Despite systematic search-ing and careful sieving, no straight or twisted bladelets with fine, semi-abrupt inverse retouch fitting the description of Dufours bladelets, or their sub-type, or Roc du Combe sub-forms were discovered (Demars and Laurent 1989, 102). The absence of such tools or diagnostic bladelet debitage would appear to rule out any clear-cut affinities with the succes-sive stages of the 'classic' Aurignacian sequence (Le Brun-Ricalens *et al.* 2009; Teyssandier 2007; Mellars 2006). The only conceivable exceptions are some of the artefacts in Waechter's layers D and F. They include a retouched bladelet (Fig. 12.17, GC 50/TRA (N) 24/58) closely similar to straight bladelets with marginal retouch found in the western Aurignacian (Le Brun-Ricalens *et al.* 2009, fig. 2.3). Some of the large, straight and well made blades in layers D and F (Fig. 12.18) are also reminiscent of forms that occur in the Aurignacian.

What other analogies might there be for the Gorham's lithic assemblage? Potential candidates include a number of so-called 'transitional industries' that existed in western Europe such as Châtelperronian (Castelperronian), Proto-aurignacian, Neronian and Uluzzian (Palma Cesnola 1989; Perasani 2008; Combier 1967; Teyssandier 2006; 2008). However, only the Châtelperronian (Castelperronian) and the Protoaurignacian are so far known from the Iberian Peninsula but are restricted mainly to the north. According to Zilhão (2006) neither of these industries is present south of about latitude 41°N, coinciding approximately with the boundary of the Ebro valley, or the line of modern summer drought (Grove and Rackham 2001). This would appear to rule out the presence of either of these industries in Gibral-tar. It also fits the argument put forward by Zilhão of a prolonged presence of the Middle Palaeolithic, south of a line stretching from Alicante to northern Portugal, and the relatively late introduction of the Aurignacian into south-western Iberia. The precise timing of the Aurignacian in these regions is unfortunately still poorly understood but it is proposed that this is likely to have occurred no later than 35 ka cal BP (calendar years ago) or the equivalent of about 31–32 ka radiocarbon years (Zilhão 2006). This inter-pretation would appear to support a less complicated and relatively late Middle to Upper Palaeolithic succession than in Europe north of the Ebro.

If these arguments are correct, it would help explain the occurrence of an Aurignacian II industry in layer 11 at Bajon-dillo rockshelter in the Bay of Málaga (Cortés-Sánchez 2000; 2007). This site lies less than 100 km north-east of Gibral-tar and the occupation layer contains thick-nosed scrapers, twisted bladelet debitage and small marginally retouched curved bladelets, including an inversely retouched Dufour bladelet (Cortés-Sánchez, pers. comm.), typical of forms that occur in Aurignacian II assemblages (Zilhão 2006, 44). The dating of layer 11 is, however, problematic with radio-carbon determinations of c.39–38 ka cal BP range seeming anomalously too high (Zilhão 2006, 46).

While the industry from Gorham's shares a few of the Aurignacian features mentioned above we would urge a certain amount of caution before assigning it to a particular technology. Apart from the very small size of the assemblage, we are also aware that variation can exist in late Middle Pal-aeolithic industries. An example of this kind in the western Mediterranean is the 'Neronian' (Combier 1967). The industry has been documented at a number of locations in the lower Rhône including Grotte de Néron and Grotte Mandrin (Slimak *et al.* 2006; Slimak 2008). At Grotte Mandrin, the Neronian is interstratified between Mouste-rian layers near the top of the cave sequence. The critical changes in the Neronian are marked by the appearance of points and bladelets, and by a particular type of Levallois point with semi-abrupt marginal retouch on its ventral surface, known as a Soyons Point. Some of the bladelets are tiny (<10 mm long) and are made on cores using a crest-ing technique similar to that seen in the Upper Palaeolithic (Slimak 2008). Significantly, the industry is made on high quality raw materials imported from 20 km away or more. The late Mousterian that succeeds the Neronian reflects a return to flake-based technology and includes the presence of large side-scrapers. The lithic types on which these are made are of coarser quality and reflect local sources of raw material.

Assuming that the sequence described for Grotte Mandrin has not been affected by the admixture of Upper Palaeolithic artefacts, we cannot rule out the possibility that a similar situation may have existed at Gorham's Cave. The arguments for this, however, are less compelling because of the overlying Upper Palaeolithic industry in CHm.3 and the total absence so far of anything resembling the Neronian in southern Iberia. For these reasons we believe it more prudent for the moment to assign the artefacts in CHm.5 to an as yet poorly characterized Initial Upper Palaeolithic.

Middle Palaeolithic

The Middle Palaeolithic deposits are especially well devel-oped in Gorham's Cave. The uppermost limit of the Middle

Palaeolithic levels in this part of the cave is probably marked by a Levallois point in UBSm.4 of the Upper Bioturbated Sands member.

In terms of approaches to flaking, three potentially different reduction techniques have been recognized at Gorham's Cave. They comprise the discoidal core technique, the recurrent centripetal Levallois method and, very rarely, a bipolar recurrent Levallois technique. The repeated use of the discoidal technique is evidenced by diagnostic core forms throughout the sequence (Table 12.32). However, it should also be noted that characteristic by-products of centripetal Levallois reduction also occur in many of the same beds and it is clear that the two techniques were used contemporaneously. The possibility that such forms may even have resulted from the same reduction process was recognized long ago by Bordes (1950) who concluded that centripetal Levallois cores were sometimes transformed into discoidal forms in their final phase of reduction. While we do not necessarily agree with this interpretation at Gorham's, we feel that the issue has been unnecessarily complicated by the classification of discoidal reduction as a 'non-Levallois' technique. In our opinion, the distinctions can sometimes be fairly arbitrary especially when the raw material is so small. The difficulty in distinguishing the differences has also been referred to by Kuhn (1995). In describing the Italian Pontinian variant of the Mousterian, which is also made on small cobbles and pebbles, he refers to a 'centripetal scheme of core preparation, beginning from a chopper/chopping-tool-like form, and progressing to a classic disk *or* Levallois core' (Kuhn 1995, 104, our emphasis).

Based on the presence of both Levallois and discoidal core debitage in the same archaeological horizons it would be hard to conclude that the two methods were not used interchangeably according to the knappers' preferences and also to factors such as the quality and size of the raw material. The chances that they were part of the same single transformational process are considered less likely because of the lack of a clear distinction in length measurements of the characteristic by-products. Where some measurable differences do exist (Tables 12.13 and 12.17) these can be better explained in terms of raw material selection or the presence of more than one core type. Of course, it cannot be entirely discounted that some Levallois products (e.g. points) were preferentially transported to the cave in ready-made form, but this is not the most parsimonious explanation given the obvious similarities in the sources of raw material. Ultimately, the only satisfactory way of testing such a proposition would be through a comprehensive programme of refitting but this was beyond the scope of the present study.

Only in one of the lower Middle Palaeolithic units, the Sands and Stony Lenses member, is there evidence for the use of bipolar recurrent Levallois technology. This was noted specifically on artefacts from beds SSLm(Usm).5 and (Usm).6 and coincides with the appearance of lithic material of a size not seen in any of the presently exposed fossil beach deposits outside the cave. The artefacts include laminar flakes more than 12 cm in length with bi-directional dorsal scars and made on a distinctive honey-coloured chert (Fig. 12.15, Gor97/229). Quite why Neanderthals decided to make longer flakes in this context is unknown but it demonstrates a capacity to locate good quality raw materials and transport them over distances of 17 km and implies some degree of forward planning in their behavioural repertoire. An alternative explanation is that such raw materials were exposed in a nearby offshore source during a phase of lowered sea-level.

A uniform feature of all of the Middle Palaeolithic assemblages is the general scarcity of retouched forms. Of these, the majority consist of flakes with semi-abrupt retouch (21) and denticulates (19) with very small quantities of other tools such as notches (seven) and side- and end-scrapers (seven). Another observable characteristic is that hardly any of these are on classic Levallois flakes. Instead, the flake scar pattern on the tools generally reflects the same range of types found on the plain flakes and other discoidal debitage. The average length dimension of the denticulates (40.8 mm) implies they were made on blanks from the earlier stages of core reduction, although there are slightly fewer examples with cortex (seven) on their dorsal surfaces than those without (12). The raw materials on which they are made are the same as other debitage, indicating that most if not all were manufactured for immediate use on site.

Is the Gorham's Middle Palaeolithic similar to the Italian Pontinian?

Potential parallels for the Gorham's Middle Palaeolithic technology may be sought in the small flake assemblages found at sites along the Mediterranean margins. A relevant example is that of the Pontinian from the central Tyrrhenian coast of Italy, which has been extensively researched and described by various authors (Bietti *et al.* 1991; Kuhn 1995; Mussi 1999). On one level there appear to be clear affinities with Gorham's: the raw materials in the Pontinian consist of small pebbles, the core morphologies seem to be closely influenced by pebble shape and there are not many classic Levallois flakes struck from centripetal cores (Kuhn 1995). Despite the constraints imposed by the raw materials, Kuhn points out that the majority of radially prepared cores are characterized by flat flake surfaces with angled and faceted striking platforms. Moreover, he suggests that flakes were mainly struck parallel to the intersecting plane between the core surfaces and thus qualify as Levallois types (Kuhn 1995, 104). The dearth of archetypal Levallois flakes is explained by the fact that the flakes '... tend to have relatively few dorsal scars and because so many preserve traces of cortex' (ibid., 104). Finally, based on core morphology, Kuhn recognizes a predominance in the use of the recurrent Levallois technique at the expense of non-Levallois radial (i.e. discoidal) methods.

While no direct analyses have been made by us of the Pontinian, we would suggest on the basis of Kuhn's observations that there are some conspicuous differences between the Italian coastal assemblages and those of Gorham's Cave. To begin with, at Gorham's there appears to be much less diversity in core forms than in the Pontinian, with centripetal examples most common, and only rare examples of the bipolar technique. Pseudo-prismatic and prepared platform cores are all but absent. Secondly, the by-products of the discoidal technique, such as core edge removal flakes and pseudo-Levallois points, reported as rare in the Pontinian, are

relatively common in the Gorham's collections (Tables 12.3–12.27). Thirdly, although core surfaces may sometimes be relatively flat, the flake removals often emanate from both surfaces of the core and the platform angles are fairly steep. Moreover, the proximal ends of flakes reveal a much higher proportion of plain butts than faceted forms. All of these features are consistent with a discoidal core technology. Despite an obvious convergence in the physical appearance of the lithic industries, we would suggest the Iberian and Italian examples differ in essential detail.

Taphonomy and spatial patterning of the assemblages

Post-depositional disturbance
Although bioturbation structures suggestive of disturbance are undoubtedly present in the sediments (ranging from large animal burrows to barely visible ones made by insects as well as rootlet traces), we do not believe that these have affected the overall integrity of the Middle Palaeolithic horizons or have led to major mixing. Our confidence in this assertion is based not only on the homogeneity and distribution of artefact scatters (except in the middle-to-upper parts of the UBSm where a few artefacts were found in near-vertical position indicating disturbance) but also on the surface condition of the lithic artefacts which can generally be described as extremely fresh or even mint. Despite the fact that many of the artefacts are broken, the bulk of fractures can be explained by simple knapping accidents rather than a post-depositional origin. Similarly, in the great majority of cases the edges of flakes are undamaged and exhibit no heavy nicking or other modification along their sides. One immediate consequence of these observations is that it makes it much easier to separate waste from utilized flakes.

Such observations of course do not rule out all possibility of smaller-scale movements caused by repeated trampling or resulting from the natural effects of slope or wash processes. There is no doubt, for example, that post-depositional processes have influenced the horizontal and vertical distribution of artefacts to some small degree, and not always in equal measure. This can be shown, for instance, in the Bedded Sand member where refits indicate horizontal displacement of debitage by up to 2 m but only relatively limited vertical shifts in the region of 9 cm (e.g. Fig. 12.7). Such a pattern could indeed have resulted from an overprinting of both natural and anthropogenic processes, but given the unconsolidated nature of the sediments we do not find this kind of separation especially surprising. Indeed, that artefacts migrate through soft sediments and that some low energy winnowing may take place through wind or minor wash effects are all commonly observed phenomena in sandy sites (see Collcutt 1992 and references). We suspect therefore that over time there has been a slight blurring in the overall resolution and shape of the Gorham's lithic scatters, but this has not been enough to obscure completely patterns arising from human activity.

Spatial distribution of artefacts
Evidence for the intact nature of artefact distributions is present in the Middle Palaeolithic sequence. This is based on observable criteria that relate specifically to the various stages of the manufacturing process. The advantage of using this approach is that knapping produces a distinctive and tangible set of archaeological signatures that are well established and are supported by the results of empirical studies (Newcomer and Sieveking 1980). We would suggest that three conditions would normally have to be met in order to demonstrate the undisturbed nature of a lithic knapping scatter:

1 The presence of microdebitage. These are chips <5 mm in maximum length that are the immediate by-products of knapping and thus not subject to the same conditions of selection, use and discard that may apply to larger artefacts and tools (Newcomer and Karlin 1987). They are also highly susceptible to displacement by low energy processes.

2 The occurrence of many cortical flakes. These provide a proxy for the earlier stages of core reduction and, because of their size, are generally less likely to be moved far from their original positions except by higher energy processes.

3 The close spatial relationship between various forms of debitage of the same raw material. In this case, we are mainly concerned with discoidal cores and their typical by-products such as core edge removal flakes and pseudo-Levallois points.

Middle Palaeolithic artefact scatters from eight different levels in Gorham's Cave are presented in Figures 12.19 and 12.20. They illustrate the spatial distribution of individually numbered artefacts from each of these contexts and provide further information on the nature and scale of activities within the cave.

A relatively typical example of an *in situ* knapping scatter is the one from BeSm(OSsm).1 (Figs. 12.19 and 12.21). This reveals a concentration of quartzite cores, including discoidal forms, FCER (core edge removal flakes) and PsLP (pseudo-Levallois points). These can be shown to form an elongate cluster centring on squares B97 and C97. The homogeneous nature of the raw materials implies that they relate to the same reduction processes and it is interesting to note the presence of microdebitage (110 chips) in the same scatter (Table 12.31). There are a relatively large number of cortical pieces (54) and the occurrence of *siret breaks* (five) from knapping accidents positively identifies this as an area where primary flaking took place. This concentration would be a good candidate for attempting refitting studies.

Another representative example is from LBSmff.10 and LBSmcf.11, respectively fine and coarse facies of the same bed. At face value this seems a fairly diffuse scatter (Figs. 12.20 and 12.22), with a spatial distribution of finds extending over a broad area of 12–13 m². On closer inspection, however, within the broad spread of artefacts is revealed a slightly denser concentration of finds in adjacent square metres (B103 and B104). Interestingly, while several Levallois and centripetal flakes occur in B104, other finds of FCER, PsLP and cores are focused immediately adjacent to this in square B103 (Fig. 12.22). The possibility that these may be the product of separate knapping events is increased

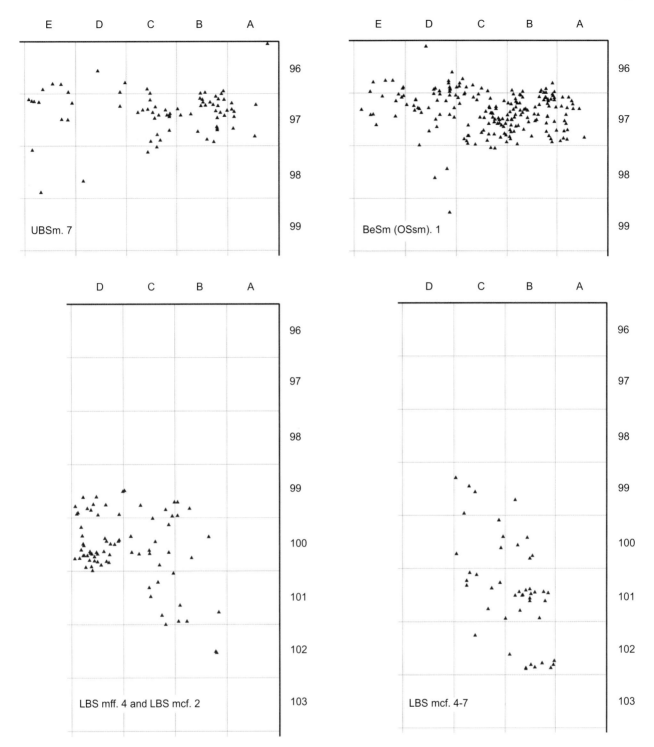

Fig. 12.19 Gorham's Cave spatial distribution of lithic finds from beds UBSm.7; BeSm(OSsm).1; LBSmff.4/LBSmcf.2 and LBSmcf.4–7.

by the fact that the Levallois and centripetal flakes are in the same honey-coloured chert, while the discoidal products are mostly of quartzite (Table 12.16). Despite the occurrence of chip-size artefacts in these deposits (Table 12.31), there is a paucity of the smallest sized material (<5 mm), suggesting the disappearance of microdebitage perhaps removed by low energy slope-wash events (evidence for the latter can be found in the sediments in the form of clay drapes and sand lensing; Collcutt, pers. comm.). Nevertheless some of the details of the original knapping clusters are preserved in this dilated (enlarged) flake distribution. The presence of retouched tools and a bone retoucher in B103 indicates that tool making and use also occurred in this area.

A slightly different example exists in beds LBSmcf.4–7 (Figs. 12.19 and 12.22). Here a diffuse spread of lithic material can be shown covering 8 m² with a somewhat higher concentration of finds in square B101 (the A squares are undug). The scatter includes a mixture of quartzite and chert artefacts with no discernible separation of the two raw material types (Fig. 12.22). It can be noted that four out of the six retouched tools are in chert and that two scrapers (cherts), a denticulate (quartzite) and two retouched flakes (quartzite and chert) are in B101 and immediately adjacent squares. In addition to the flaked artefacts there are a number of imported sandstone cobbles, two of which reveal battermarks and fit the description of hammerstones.

Table 12.31 Chip abundance per bed from samples sieved at 2 mm.

Bed	Total number of 2 mm sieved samples	Total chips <15–5 mm	% Chips per sample (chips >5)	Microdebitage <5 mm
UBSm.6	3	5		
UBSm.7	3	15	5	
BeSm.1	22	110	5	a
BeSm.3, BeSm.2	18	45	2.5	
LBSmff.1	1	4		
LBSmff.4, LBSmcf.2	17	82	4.8	a
LBSmcf.4–LBSmcf.7	71	276	3.8	a
LBSmcf.8, LBSmff.6	3	7	2.3	a
LBSmff.7	2	2		
LBSmff.8, LBSmcf.9	11	14	1.2	
LBSmff.10, LBSmcf.11	43	48	1.1	
LBSmff.11, LBSmcf.12	1	2		
LBSmcf.13	5	1		
SSLm.1	2	34	17.0	
SSLm.2	4	11	2.7	
SSLm.3	2	59	29.5	
SSLm.4	2	1		
SSLm.5	2	4		
SSLm.6	1	3		

The position of one of the percussors in the densest area of finds (B101) implies an association with knapping activity. Although this would seem to be confirmed by the high number of chips recovered (Table 12.31), we would argue that other activities took place here as well, as indicated by the discarded tools. Curiously, no retouch chips could be identified amongst the smaller flaking debris.

A fourth artefact distribution presented here is from SSLm(Usm).2 (Fig. 12.23). It shows a concentration of quartzite cobbles some of which are elongate forms with battermarks on one or both extremities, identifying them as hammerstones. This horizon also produced large quantities of charcoal and charred seeds, including burnt stone pine nut residues (see Chapter 7), but only six artefacts with traces of burning. Our interpretation is that this was an area in which pine nuts were processed using the cobbles and hammerstones but there is also an overprinting of other activity represented by densities of chert flakes (Fig. 12.23). The two chert cores are not enough to account for the sheer quantity of flake debris, while the occurrence of chips in the size range 15–5 mm implies that some knapping or tool manufacture took place in this area. The deposits do not seem to have been greatly affected by post-depositional disturbances and may warrant refitting studies especially between the chert artefacts.

In summarizing this section, we would suggest that given the presence of cores and knapping debris, one of the clearest indicators of whether or not the scatters are *in situ* comes from the study of chips and microdebitage (Table 12.31). An analysis of the yields of these small artefacts provides a crude but effective relative measure of the degree to which each of the different units may have been affected by bioturbation or other natural disturbances. Using these criteria we would suggest that the Lower Bioturbated Sands member was the least affected by post-depositional disturbance because it contains the highest concentrations of microdebitage. An obvious caveat is of course that wash events could

also serve too concentrate fine debitage but this is unlikely to have displaced the chips more than a very short distance from their original position (Collcutt, pers. comm.). What seems clear is that the debitage was not being moved far, even if it was sometimes affected by small shifts. Despite evidence for the roasting and processing of stone pine nuts and repeated episodes of knapping and tool use, we do not believe that any of these activities is diagnostic of long-term residential activity. To test this idea further we now turn to the evidence of the lithic technology itself.

Mobility patterns and lithic technology

The organization of Middle Palaeolithic technologies has been widely discussed by Binford and particularly with regard to his conceptual models of 'curated' and 'expedient' behaviour (Binford 1977; 1979). Tools in curated assemblages were defined as those transported and returned to residential locations for repair, while in non-curated assemblages the by-products of the activities in which tools were used and manufacturing debris were generally found together. Although Binford (1979) regarded Middle Palaeolithic technologies as largely belonging within the expedient category, Geneste (1989) showed that in some cases Neanderthals manufactured items, notably Levallois products, that could be regarded as curated because they were maintained and carried across the landscape in anticipation of future use.

Such ideas have recently been elaborated by Wallace and Shea (2006) who have used the definitions of 'formal' and 'expedient' to cover specific core reduction methods. They also suggest a link between core techniques and different mobility strategies by hunter-gatherers in the landscape. Specifically, they base their arguments on a potential correlation between decreased mobility patterns (seen in later prehistoric societies) and a heavier reliance on expedient methods of core reduction (Parry and Kelly 1987). In the context of the Levantine Mousterian, three core groupings are recognized: a) Formal: defined as Levallois and prismatic cores; b) Expedient: defined as discoidal cores and irregular forms; and c) a third category of cores on flakes. The last group was not considered particularly indicative except that small numbers of such cores 'might be a further indication of the low importance of prehistoric provisioning of places with bulk raw material' (Wallace and Shea 2006, 1298). The authors concluded that based on the presence of core types Levantine Neanderthals were associated with assemblages made up mostly of expedient core use and comparatively lower numbers in the formal category. They proposed that this was consistent with the projected model of low residential mobility.

Applying the same criteria to the Gorham's Cave Middle Palaeolithic assemblages it immediately becomes apparent that the cores and flake debitage would mostly fit into Wallace and Shea's expedient category of discoidal and irregular forms (Tables 12.32 and 12.33), rather than formal types. This seems to be a general pattern repeated throughout the whole Middle Palaeolithic sequence, except for two beds (SSLm(Usm).5 and .6) in which recurrent unidirectional-parallel and bi-directional-opposed core techniques were recorded (formal types). If we were to follow the implications of their argument, we could deduce that

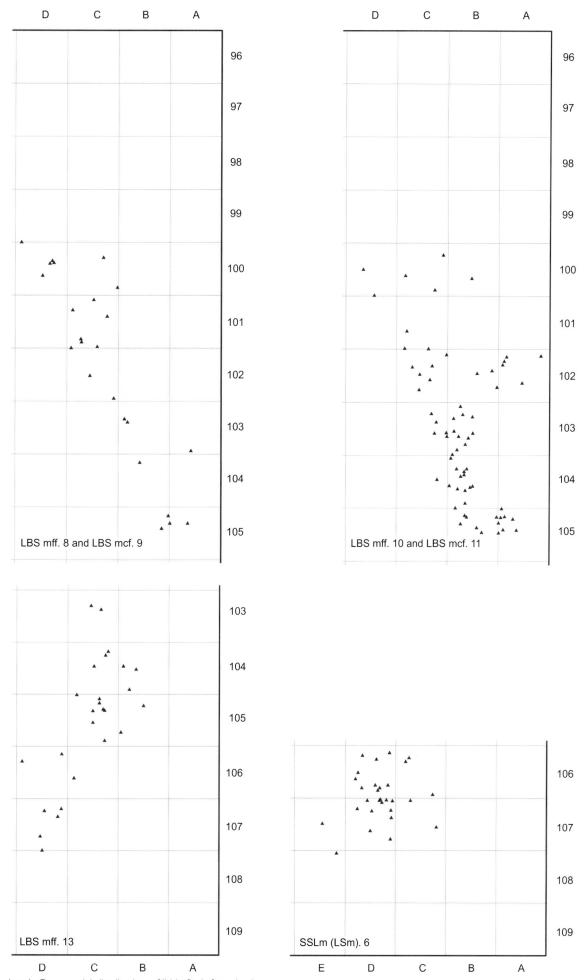

Fig. 12.20 Gorham's Cave spatial distribution of lithic finds from beds
LBSmff.8/LBSmcf.9; LBSmff.10/LBSmcf.11; LBSmff.13 and SSLm(LSm).6.

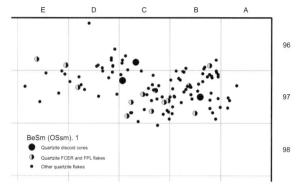

Fig. 12.21 Gorham's Cave distribution of artefacts from BeSm(OSsm).1.

the Gibraltar Neanderthals practised generally expedient patterns of behaviour, with a land-use strategy consisting of localized and relatively low levels of residential mobility. Such an interpretation is largely in accordance with our own reading of the evidence. Based on the analysis of raw materials we can show that Neanderthals were exploiting highly localized sources of lithic materials, many of them available immediately outside the caves. There is no suggestion (from the raw materials) that they ever moved very far from these resources, except potentially for the periods covered by beds SSLm(Usm).5 and .6, and then only over distances of 20 km or so. We do not find this at odds with the evidence of occupation inside the caves which suggests mainly episodic and ephemeral activities within the area of the cave drip line. It is possible, for example, that hearths and more extensive living areas were situated closer to the entrance or possibly just outside the caves on the less

steeply sloping and sheltered west side of Gibraltar. None of this evidence need contradict the basic premise of low residential mobility.

Where Wallace and Shea's model may be in need of further refining and testing is in relation to the category of cores-on-flakes. According to their interpretation, 'using flakes as cores probably reflects a response to raw material scarcity' and conversely 'low frequencies of cores-on-flakes might be a further indication of the low importance of prehistoric provisioning of places with bulk raw material' (2006, 1298). In the case of Gorham's Cave, while it is true that plentiful raw materials lay outside the cave or in nearby fossil beaches, we would contend that there was a much more subtle relationship involving the dynamics of core reduction and the immediate requirements of the knappers. This is further complicated by the relatively low numbers in *all* categories of core throughout. In other words, we would see a range of factors influencing the use of core type. The low numbers of cores-on-flakes may not thus be solely attributable to relatively plentiful raw material sources but also to the size and quality of the raw material as well as the immediate tasks at hand. Thus, where cores-on-flakes were used at Gorhams's we see this as a flexible response to expedient needs rather than in response to raw material scarcity, which clearly it is not. The small size of the pebbles meant that only a restricted number of usable flakes could be detached from a single core and this led to the recycling of some of the primary flakes (as cores). In this case the cores-on-flakes simply acted as supplementary sources of small flakes. We could envisage the same happening in

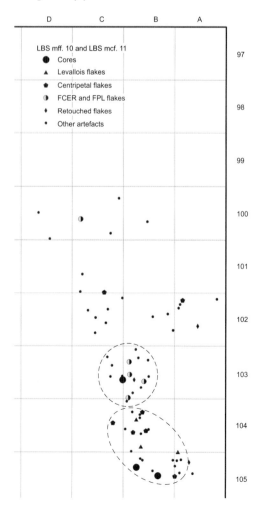

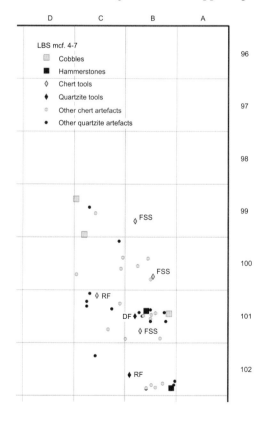

Fig. 12.22 Gorham's Cave distribution of artefacts from LBSmff.10 and LBSmcf.11, and from LBSmcf.4–7. RF-retouched flake, DF-denticulate, FSS-flake side-scraper.

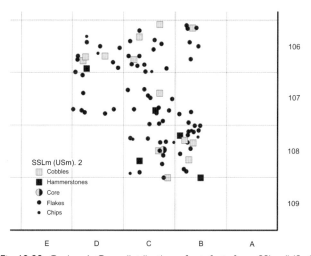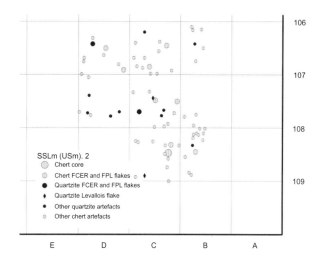

Fig. 12.23 Gorham's Cave distribution of artefacts from SSLm(USm).2 showing a concentration of cobbles including elongate quartzite hammerstones. The same scatter illustrating the dominance of fine-grained cherts over quartzites.

Table 12.32 Cores from the Middle Palaeolithic layers.

Member Bed	Radial L	Discoidal	C on flake	Other
Upper Bioturbated Sands				
UBSm.6				1
UBSm.7		2		2
Bedded Sand				
BeSm.1		6	1	8
BeSm.2, BeSm.3		1		1
Lower Bioturbated Sands				
LBSmff.4, LBSmcf.2		4		1
LBSmcf.4 to LBS.mcf.7		1		
LBSmff.8, LBSmcf.9		2		1
LBSmff.10, LBSmcf.11	1	2	2	2
LBSmff.11, LBSmcf.12		2		1
LBSmcf.13				1
Sands and Stony Lenses				
SSLm.1				1
SSLm.2		1		1
SSLm.5				1

Table 12.33 Levallois and discoidal by-products from the Middle Palaeolithic layers.

Member Bed	Lev Flake	Lev Point	Pseudo-LP	FCER
Upper Bioturbated Sands				
UBSm.6	1			1
UBSm.7	1		4	4
Bedded Sand				
BeSm.1	1	3	10	13
BeSm.2, BeSm.3			1	3
Lower Bioturbated Sands				
LBSmff.1	1			1
LBSmff.4, LBSmcf.2	1		2	3
LBSmcf.4 to LBS.mcf.7			1	1
LBSmff.8, LBSmcf.9	1	1	2	2
LBSmff.10, LBSmcf.11	4		4	1
LBSmff.11, LBSmcf.12	1		3	
LBSmcf.13	1	1	3	1
Sands and Stony Lenses				
SSLm.1	1		1	
SSLm.2	1	1	3	7
SSLm.3			1	1
SSLm.5			1	1
SSLm.6	1		1	1

cases where the raw material was in short supply, so the category may not in itself be a very useful indicator of raw material in plenty or mobility patterns.

This section completes the description and analysis of lithic assemblages from Gorham's Cave. In the final chapters of this book we will return to the question of human behaviour, to discuss the nature of activities focused around the Gibraltar caves and to examine how Gibraltar fits into the wider regional pattern of Upper and Middle Palaeolithic human settlement of southern Iberia.

Acknoweldgements
The authors would like to thank Simon Collcutt and an outside referee for their constructive comments on this chapter.

References
Aura Tortosa, J. E., Jordá Pardo, J. F., Avezuela Aristu, B., Pérez Ripoll, M., Tiffagom, M. and Morales Pérez, J. V. 2010: La Cueva de Nerja (Málaga, España) y el Gravetiense en Andalucía. Cuaternario y Arqueología : Homenaje a Francesco Giles Pacheco. 125-132.

Bardon, L., Bouysonie, A. and Bouysonie, J. 1906: Outils écaillés par percussion. *Revue de l'Ecole d'anthropologie de Paris* 16, 170–175.

Benito Del Rey, L. 1982: Outils fractures intentionellement dans le Moustérien de la Grotte de las Grajas, à Archidona (Màlaga, Espagne). *Bulletin de la Société Préhistorique Française* 79(8), 231–239.

Bergman, C. A., Barton, R. N. E., Collcutt, S. N. and Morris, G. 1983: La fracture volontaire dans une industrie du Paléolithique superieur tardif du sud de l'Angleterre. *L'Anthropologie* 87(3), 323–337.

Bergman, C. A., Barton, R. N. E., Collcutt, S. N. and Morris, G. 1987: Intentional breakage in a late Upper Palaeolithic assemblage from southern England. In Sieveking, G. de G. and Newcomer, M. H. (eds.), *The human uses of flint and chert* (Cambridge, Cambridge University Press), 21–32.

Bietti, A., Grimaldi, S., Mancini, V., Rossetti, P. and Zanzi, G.-L. 1991: Chaînes opératoires et experimentation: Quelques exemples du moustérien de l'Italie

centrale. In 25 *ans d'études technologiques en préhistoire: Bilan et perspectives. Actes des XIe Rencontres Internationales d'Archéologie et d'Histoire d'Antibes* (Jaun-les-Pins, Editions APDCA), 109–124.

Binford, L. R. 1977: Forty-seven Trips: A case study in the character of archaeological formation process. In Wright, R. V. S. (ed.), *Stone Tools as Cultural Markers* (Canberra, Australian Institute of Aboriginal Studies), 24–36.

Binford, L. R. 1979: Organization and formation processes: Looking at curated technologies. *Journal of Anthropological Research* 35(3), 255–273.

Boëda, E. 1986: *Approche technologique du concept Levallois et évaluation de son champ d'application: étude de trois gisements saaliens et weichséliens de la France septentrionale* (Paris, Unpublished Ph.D. dissertation, Université de Paris X).

Boëda, E. 1993: Le débitage discoïde et le débitage levallois récurrent centripète. *Bulletin de la Société Préhistoire Française* 90(6), 392–404.

Boëda, E. 1994: *Le concept Levallois: variabilité des méthodes* (Paris, Centre National de la Recherche Scientifique, Monographie du CRA 9).

Bordes, F. 1950: Principes d'une méthode d'étude des techniques et de la typologie du Paléolithique ancien et moyen. *L'Anthropologie* 54, 393–420.

Bordes, F. 1953: Notules de typologie paléolithique: I. Outils moustériens à fracture volontaire. *Bulletin de la Société Préhistorique Française* 50, 224–226.

Bordes, F. 1961: *Typologie du Paléolithique ancien et moyen*, 2 vols. (Bordeaux, Delmas, Publication de l'Institut de Préhistoire de l'Université de Bordeaux 1).

Brézillon, M. 1977: *La Dénomination des Objets de Pierre Taillée* (Paris, CNRS IVe supplément à Gallia Préhistoire).

Collcutt, S. N. 1992: Site formation processes at the Hengistbury sites. In Barton, R. N. E. (ed.), *Hengistbury Head. Vol. 2: The Late Upper Palaeolithic and Early Mesolithic Sites* (Oxford, Oxford University Committee for Archaeology Monograph No. 34), 78–95.

Combier, J. 1967: *Le Paléolithique de l'Ardèche dans son cadre paléoclimatique* (Bordeaux, Delmas, Mémoire de l'Institut de Préhistoire de l'Université de Bordeaux 4).

Cornford, J. M. 1986: Specialised resharpening techniques and evidence of handedness. In Callow, P. and Cornford, J. M. (eds.), *La Cotte de St Brelade 1961–1978. Excavations by C. B. M. McBurney* (Norwich, Geo Books), 337–352.

Cortés-Sánchez, M. 2000: Bajondillo Cave (Torremolinos, Malaga, Andalucia) and the Middle-Upper Palaeolithic Transition in Southern Spain. In Stringer, C. B., Barton, R. N. E. and Finlayson, J. C. (eds.), *Neanderthals on the Edge* (Oxford, Oxbow Books), 123–132.

Cortés Sánchez, M. (ed.) 2007: *Cueva Bajondillo (Torremolinos)* (Málaga, Centro de Ediciones de la Diputación de Málaga).

Demars, P.-Y. and Laurent, P. 1989: *Types d'outils lithiques du Paléolithique supérieur en Europe* (Paris, Centre National de la Recherche Scientifique, Cahiers du Quaternaire No. 14).

Depaepe, P., Locht, J.-L. and Swinnen, C. 1994: Pointes pseudo-Levallois et éclats débordants sur le site de Beauvais (Oise, France). *Notae Praehistoricae* 14, 25–28.

Geneste, J.-M. 1989: Economie des ressources lithiques dans le Moustérien du sud-ouest de la France. In Otte, M. (ed.), *L'Homme de Néandertal. Vol. VI: La subsistence* (Liège, ERAUL), 75–97.

Grove, A. T. and Rackham, O. 2001: *The Nature of Mediterranean Europe: an ecological history* (New Haven, Yale University Press).

Jennings, R. P., Giles, F., Barton, R. N. E., Collcutt, S. N., Gale, R., Gleed-Owen, C., Gutierrez Lopez, J. M., Higham, T. F. G., Parker, A., Price, C., Rhodes, E., Santiago Perez, A., Schwenninger, J. L. and Turner, E. 2009: New dates and palaeo-environmental evidence for the Middle to Upper Palaeolithic occupation of Higueral de Valleja Cave, southern Spain. *Quaternary Science Reviews* 28, 830–839.

Kuhn, S. L. 1995: *Mousterian Lithic Technology. An ecological perspective* (Princeton, Princeton University Press).

Le Brun-Ricalens, F., Bordes, J.-G. and Eizenburg, L. 2009: A crossed-glance between southern European and Middle-Near Eastern early Upper Palaeolithic lithic complexes: Existing models, new perspectives. In Camps, M. and Szmidt, C. (eds.), *The Mediterranean from 50,000 to 25,000 BP: Turning points and new directions* (Oxford, Oxbow Books), 11–34.

Locht, J.-L. and Swinnen, C. 1994: Le debitage discoïde du gisement de Beauvais (Oise): aspects de la chaîne opératoire au travers de quelques remontages. *Paléo* 6, 89–104.

Mellars, P. 2006: Archaeology and the dispersal of Modern Humans in Europe: deconstructing the "Aurignacian". *Evolutionary Anthropology* 15(5), 167–182.

Mussi, M. 1999: The Neanderthals in Italy: a tale of two caves. In Roebroeks, W. and Gamble, C. (eds.), *The Middle Palaeolithic occupation of Europe* (Leiden, University of Leiden), 49–80.

Newcomer, M. H. 1976: Spontaneous retouch. In Engelen, F. H. G. (ed.), *Second International Symposium on Flint, Staringia 3* (Maastricht, Nederlandse Geologische Vereiniging), 62–64.

Newcomer, M. H. and Karlin, C. 1987: Flint chips from Pincevent. In Sieveking, G. de G. and Newcomer, M. H. (eds.), *The Human Uses of Flint and Chert* (Cambridge, Cambridge University Press), 33–37.

Newcomer, M. H. and Sieveking, G. de G. 1980: Experimental flake scatter patterns: a new interpretative technique. *Journal of Field Archaeology* 7, 345–352.

Palma Cesnola, A. 1989: L'Uluzzien: Faciès italien du leptolithique archaïque. *L'Anthropologie* 93, 783–812.

Parry, W. A. and Kelly, R. L. 1987: Expedient core technology and sedentism. In Johnson, J. K. and Morrow, C. A. (eds.), *The Organization of Core Technology* (Boulder, Colorado, Westview Press), 285–304.

Patou-Mathis, M. and Schwab, C. 2002: Fiche générale. In Patou-Mathis, M. (ed.), *Industrie de l'Os préhistorique Cahier X, Compresseurs, Percuteurs, Retouchoirs* (Paris, Éditions Société Préhistorique Française), 11–20.

Peresani, M. 2008: A new cultural frontier for the last Neanderthals: The Uluzzian in Northern Italy. *Current Anthropology* 49(4), 725–731.

Rose, E. P. F. and Rosenbaum, M. S. 1991: *A Field Guide to the*

Geology of Gibraltar (Gibraltar, The Gibraltar Museum and Gibraltar Heritage Trust).

Slimak, L. 2008: The Neronian and the historical structure of cultural shifts from Middle to Upper Palaeolithic in Mediterranean France. *Journal of Archaeological Science* 35, 2204–2214.

Slimak, L., Pesesse, D. and Giraud, Y. 2006: Reconnaissance d'une installation du Protoaurignacien en vallée du Rhône. Implications sur nos connaissances concernant les premiers hommes modernes en France méditerranéenne. *Comptes Rendues Palevol.* 5, 909–917.

Sonneville-Bordes, D. 1960: *Le Paléolithique Supérieur en Périgord* (Bordeaux, Delmas).

Teyssandier, N. 2006: Questioning the first Aurignacian: mono or multicultural phenomenon during the formation of the Upper Palaeolithic of Central Europe and the Balkans. *Anthropologie* 44(1), 9–29.

Teyssandier, N. 2007: *En route vers l'ouest. Les débuts de l'Aurignacien en Europe* (Oxford, BAR International Series S1638).

Teyssandier, N. 2008: Revolution or evolution: the emergence of the Upper Palaeolithic of Europe. *World Archaeology* 40(4), 493–519.

Tixier, J. 1963: *Typologie de l'Epipaléolithique du Maghreb* (Alger and Paris, Mémoires du Centre de Recherches Anthropologiques, Préhistoriques et Ethnographiques).

Van Peer, P. 1992: *The Levallois Reduction Strategy* (Madison, Prehistoric Press, Monographs in World Archaeology 13).

Villaverde, V. and Dídac, R. 2004: Avance al studio de los niveles Gravetienses de la Cova de las Cendres. Resultados de la excavacíon en el contexto del Gravetiense Mediterráneo Ibérico. *Archivo de Prehistoria Levantina* 25, 19–59.

Villaverde, V., Aura, J. E. and Barton, M. C. 1998: The Upper Palaeolithic in Mediterranean Spain: A review of the current evidence. *Journal of World Prehistory* 12(2), 121–198.

Waechter, J. d'A. 1951: The excavation of Gorham's Cave, Gibraltar: preliminary report for the seasons 1948 and 1950. *Proceedings of the Prehistoric Society* NS 17, 83–92.

Waechter, J. d'A. 1964: The excavation of Gorham's Cave, Gibraltar 1951–54. *Bulletin of the Institute of Archaeology (University of London)* 4, 189–221 (plus plate 13 on p. 269).

Wallace, I. J. and Shea, J. J. 2006: Mobility patterns and core technologies in the Middle Paleolithic of the Levant. *Journal of Archaeological Science* 33, 1293–1309.

Zilhão, J. 2006: Chronostratigraphy of the Middle-to-Upper Paleolithic Transition in the Iberian Peninsula. *Pyrenae, Journal of Western Mediterranean Prehistory and Antiquity* 37(1), 7–84.

Gorham's Cave Summary

R.N.E. Barton and S.N. Collcutt

Stratigraphy and dating

An approximately 16 m sequence of deposits is described for this cave and summarised in Fig. 3.1. It consists of mainly terrestrial sediments that overlie a complex of raised marine beach deposits likely to be of MIS 5 age. Evidence for at least two stages of elevated sea level comes from a lower true raised beach with intertidal deposits, and an upper series of well-sorted, marine-derived sands with shells that are separated by a terrestrial breccia. The beach-derived sands in the upper series were probably introduced into the cave by (saltational) wind action from the adjacent shore. It is also worth noting the common presence of varied marine shells as high as the Carbonate Sands and Silts member. Together, the sediments seem to represent highstands during MIS 5e (~125 ka) and MIS 5c (~105 ka). Their present-day altitudes of about +3.25 m and +7.2 m (or slightly higher) above sea level are best explained by a relatively modest scale of tectonic uplift probably accompanied by a slight tilting of Gibraltar in a southwards direction. The proposed formation of this lower sequence is discussed extensively in Chapter 3. It is also worth noting the common presence of varied marine shells as high as the Carbonate Sands and Silts member.

Above the uppermost coarse sands of the CSm (Coarse Sands member) is a succession of beds with medium and finer quartzitic sands interspersed with cemented breccias and sometimes speleothem formation. Fragmented stalagmites and stalactites occur within the lower of these deposits in RSSm (Reddish Silt and Sands member) but these also contain an interval of finer sediments, including strongly phosphatized material. The finer deposits represent major wash events that are also present further up the sequence (see below). These sediments are in turn succeeded by layers of cleaner, usually unconsolidated sediments such as VSSm (Variegated Sands and Silts member) and SSLm (Sands and Stony Lenses member) both of which increasingly contain fine sands with small-scale, cross-bedding structures indicating aeolian origin. Dating of the SSLm by optically stimulated luminescence (OSL) provides ages of between 67.9 ka and 89.6 ka which would broadly correlate with MIS 4, allowing for the large error brackets associated with these dates (see Chapter 6).

In the middle levels, above c. +11m, deposits forming the LBSm (Lower Bioturbated Sands member) contain clays and silts with localised fine laminae indicating repeated fine wash events and in some cases even persistent waterlogging. Sandier units within this sequence show signs of animal burrowing, hence the reference to bioturbation. Although near the limits of the method,

associated charcoal within LSBmcf.4 has yielded an age of between 55.9–45.3 ka calendar years ago (Chapter 5), which would place these layers within the early phase of MIS 3. The UBSm (Upper Bioturbated Sands member) is separated from the LBSm by a poorly studied sequence of Bedded Sands (BeSm), probably ultimately referable to major dune formation but including local wash events; the sequence is cut internally by a major unconformity, possibly coinciding with a truly wet interval. Dating evidence for the overlying bioturbated sands implies that there may not have been a major temporal gap in sedimentation. Above this are a series of major hearth deposits (CHm – Cemented Hearth member) the oldest of which can be securely dated to between 34–33.2 ka cal BP. Sediments of MIS 2 age are not well represented in this part of the cave. Here, the top of the sequence is capped by sands and an overlying flowstone that are likely to be MIS 1 (Holocene) in age.

Gorham's Cave: Radiometric Chronology.

Stratigraphy	AMS Cariaco-Hulu BP (95.2% probability)	OSL results Modelled ages at 1 sigma	Marine Isotope Stage (MIS)
Bem. 1-3	Undated		MIS 1
USFm.1	Undated		MIS 1–2
CHm.3	31 540 – 29 860		MIS 3
CHm.5	34 000 – 33 200		
UBSm.2	34 280 – 32 916		
UBSm.4	35 820 – 32 210		
UBSm.6	38 070 – 35 070	38 500 ± 5800	
UBSm.7	48 520 – 43 130 30 350 – 27 040*		
BeSm (OSsm).1	55 130 – 44 190 55 910 – 43 000 62 720 – 45 620 40 450 – 34 060*		
BeSm (PLSsm).3		48 700 ± 4000	
LBSmcf.4	55 920 – 45 340		MIS 3
SSLm (Usm).5		67 900 ± 5150	MIS 4
SSLm (Lsm).10		89 600 ± 7700	
CSm		119 300 ± 14 800	MIS 5

* Possible contamination

Palaeoenvironmental reconstruction

Information concerning former climatic and environmental conditions comes from a number of proxy indicators including sediments, charcoal, amphibians, reptiles, avifaunal remains, and small and large mammals (Chapters 3–4 and 7–11).

The basal 7-8 m of the sequence covers various substages of MIS 5. Unfortunately these layers were not sampled for palaeoenvironmental remains so that

interpretation rests entirely on data extrapolated from the sediments and dating analyses (Chapters 2–6). Warm, damp conditions consistent with an Interglacial are indicated by stalagmite growth and active soil formation. These phases were interspersed by at least one period of potential climatic deterioration indicated in the brecciated deposits of 'Unit D'.

Post-MIS 5 environments are represented in layers SSLm and above. Seasonally drier conditions marked by increased aeolian sand mobility are shown in SSLm 8–7, although not arid enough to inhibit the growth of stone pine (*Pinus pinea*) (Chapter 7). Small mammals from these levels include field mouse (*Apodemus* sp.) but the near absence of water vole (*Arvicola* sp) suggests slightly drier conditions. Somewhat cooler and more arid habitats are implied in the lower SSLm(Lsm).6 unit by the occurrence of the extinct microtine (*Microtus cabrerae* cf. *dentatus*) (Chapter 10). Similarly, small reptiles and amphibians suggest a replacement of comparatively moist woodland by drier Mediterranean shrub in these same deposits (Chapter 8). Amongst the large mammals horse (*Equus ferus*) makes a rare appearance (SSLm 5 and 1) confirming the local presence of relatively open habitats.

In the middle layers of +11 m and above, relatively humid conditions can be inferred from minor stalagmite regrowth and by repeated ponding events in the lower LBSm units, but drier conditions are indicated also by sand mobility. The sedimentary sequence shows a great deal of environmental fluctuation though probably without extremes. There was a relatively high floristic diversity in the surrounding landscape. A woodland savannah with high grass cover and patchy distribution of shrubs and trees is indicated by pine, oak, juniper, mastic and a range of other shrubs in the macroscopic charcoal samples. The reptiles and amphibians do not reflect any great changes, except in the rise of the spadefoot toad (*Pelobates cultripes*) in the LBSm units which may have responded to the slightly damper conditions and ponding in the cave. The avifaunal evidence is largely consistent with the interpretation of lightly wooded conditions outside the cave, except for the appearance of immature Common Scoter (*Melanitta nigra*) and Velvet Scoter (*M. fusca*) in unit 8 of the LBSmff sequence which may indicate nesting during brief cooler intervals within MIS 3. The persistence in the biota clearly indicates that the species present in the region were able to tolerate the variability in the physical environment; the signs of change so far recognised are subtle and mostly restricted to the marine fauna (birds and mammals), that may have been more susceptible to large-scale shifts in oceanic circulation.

The evidence for palaeoenvironmental change in the upper part of the stratigraphic sequence continues to be muted. In the Upper Bioturbated Sands (UBSm) certain herpetofaunal species disappear, such as common toad, grass snake, viperine snake, skink and ocellated lizard (Chapter 8). However this is not accompanied by major changes in composition of the anthracological, mammal (large and small), or bird species. In the Cementented Hearths member (CHm) it was originally believed that typical lowland pines were replaced by upland species,

which would have significant implications for climate change. However, this interpretation has been revised and it seems more likely that degradation of some of the charcoal led to species misidentification. It nevertheless remains interesting that bones of Atlantic grey seal (*Halichoerus grypus*), though not abundant, are recorded in layer D of Waechter's excavations (the equivalent of CHm.5), and the sands and fine screes in the CHm may indicate seasonally cooler conditions. On the other hand, there are no typical cool climate indicators amongst the small mammals or the avifaunas in these levels.

Archaeological evidence

The cave itself appears to have been used intermittently by humans and other animals. Nearly all of the sediments examined show reworked guano from the droppings of birds and bats as revealed in micromorphology thin sections (Chapter 4). Other phosphate inputs from carnivore coprolites indicate that hyaenas must have been frequent visitors to the cave. Signs of human activity come from lithic artefacts, bone and combusted materials including charcoal, burnt bone and more rarely ash. Thin section analysis suggests that except for the uppermost layers (CHm and above) there is no evidence for *in situ* hearths. In most cases the charcoal was probably locally displaced by minor wash events, and the paucity of obvious ash might be explained by decalcification processes linked to the presence of guano.

Typical Middle Palaeolithic lithic assemblages occur throughout the lower and middle layers of the Gorham's sequence (Chapter 12). The discoidal core technique was commonly used, though there is a noticable rise in the incidence of laminar flakes struck from bipolar Levallois cores in SSLm.5-6, in deposits which may be of MIS 4 age. The latest Middle Palaeolithic is likely to be represented by a Levallois point in UBSm.4. Artefacts of Upper Palaeolithic types can be identified from CHm.5 in the present excavations and from layer D of the Waechter collections. Amongst the diagnostic artefacts are bladelet cores, blade and bladelet debitage and a number of tools including a marginally retouched bladelet that would not be out of place in an Aurignacian or Initial Upper Palaeolithic industry. It may be relevant that a small cowrie shell with minute traces of red ochre was also recorded in CHm.5 (Chapter 12). Such items would not be unexpected in early Upper Palaeolithic contexts. In CHm.3 a small assemblage of artefacts with affinities to the Mediterranean Gravettian was also recovered.

In terms of available dietary resources it is clear that the palaeoenvironments surrounding the cave offered a wide range and diversity of foodstuffs. Evidence from the Middle Palaeolithic levels shows that Neanderthals exploited Stone Pine (*Pinus pinea*) nuts, and that these were processed inside the cave (Chapter 7). Cut-marked and sometimes charred bones of red deer (*Cervus elaphus*), Ibex (*Capra ibex*) and bovids indicate the likely range of larger mammals exploited (Chapter 11), while the presence of burnt tortoise scutes and rabbit bones attest to the availability and use of these smaller animals (Chapter 10). Quantities of charred bones of ducks and pigeons were

recorded particularly in the LBSm layers and may suggest that they were roasted and eaten and/or tossed into the fire afterwards (Chapter 9). Another use of bone is shown by the presence of a bone retoucher or compressor also in one of the LBS layers (Chapter 12), typical of the kind used for retouching stone tools such as scrapers. Another example is also known from Vanguard Cave. Very few faunal remains of any type were recorded from the Upper Palaeolithic layers (CHm.5 and above), although the report on the Waechter collections suggest an abundance of red deer, ibex and horse in layer D (CHm.5), and wild boar in layer B (CHm.3).

Vanguard Cave

In this section the results of the 1995 to 1998 excavations are presented. Chapters 13 and 14 deal with the description of sediments and the OSL chronology, while subsequent chapters describe palaeoenvironmental studies of residues including charcoal and charred plant remains (Chapter 15), amphibians and reptiles (Chapter 16), bird faunas (Chapter 17), and large mammals (Chapter 18). The results of thin-section studies on animal coprolites are given in Chapter 19. The final chapters focus on the Middle Palaeolithic artefact assemblages (Chapter 20) and the examination of taphonomic factors relating to mammal remains in the archaeological layers (Chapter 21). The section concludes with an examination of seasonality patterns in the human occupation evidence (Chapter 22). A summary of the main results and interpretations is presented at the end of the section.

13 Vanguard Cave sediments and soil micromorphology

R.I. Macphail, P. Goldberg and R.N.E Barton

Introduction
Vanguard Cave contains a sequence of over 17 m of deposits, generally made up of massive, coarse to medium sands interfingered with tabular to lenticular units of silts and silty sands (Fig. 13.1). The major body of sediment rests on a wave-cut platform preserved under a heavily cemented sand unit. The latter correlates with the raised beach deposits at the same elevation that form the base of the Gorham's Cave sequence. Most of the Vanguard sediments are calcareous with little diagenesis (Goldberg and Macphail 2000; Macphail and Goldberg 2000). In rarer cases, as in the Upper Area of the cave, the sands are interdigitated with black humic clays that display evidence of phosphatization. The paucity of visible karstic cave ornamentation (e.g. stalactites) suggests relatively dry conditions within the cave throughout most its history. The units of specific interest in this study are those that have produced human occupation evidence in the form of lithic artefacts, faunal remains and sometimes hearths or more diffusely defined combustion features. Four distinctive loci were investigated (Figs. 13.2 and 13.3).

Methodology
Several field and laboratory methods permit the detailed characterization of 'sediment types' according to a number of broadly defined attributes described below. Undisturbed samples for soil micromorphology were collected as small oriented blocks and in 30–40 cm long plastic downpipes (Fig. 13.4; Goldberg and Macphail 2006, fig. 15.13). Contexts, main stratigraphic units and layers within contexts were all sampled for bulk analyses in the field and also subsequently in the laboratory at the Institute of Archaeology, University College London.

Soil micromorphology
Undisturbed samples collected in the field were oven dried at 60°C and then impregnated with a crystic polyester resin diluted with styrene or acetone (Murphy 1986). After curing

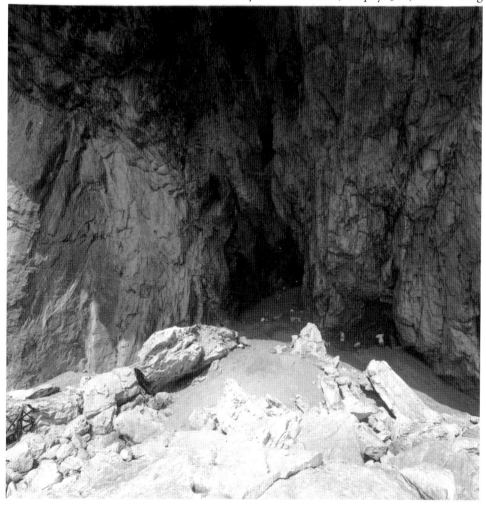

Fig. 13.1 Vanguard Cave. View of excavations in progress in the Middle Area of the main chamber (left) and of the Northern Alcove (right). Photo: Natural History Museum, London.

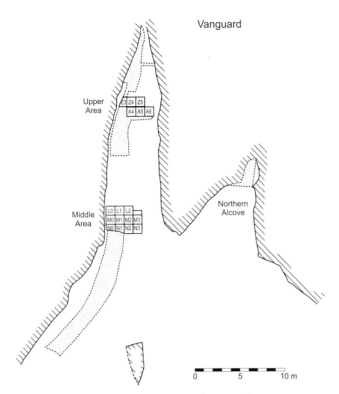

Fig. 13.2 Vanguard Cave. Plan location of excavated areas.

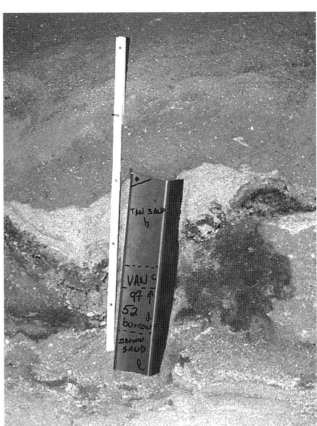

Fig. 13.4 Vanguard Cave Upper Area B. Position of long monolith sample 52, across sands and a possible guano/phosphate transformed combustion zone. Photo: R. Macphail and P. Goldberg.

for several weeks they were then placed overnight in an oven at 60°C. Slices from these blocks were manufactured into large-format thin sections (~4.5 × 7 cm observable area) by Spectrum Petrographics (Vancouver, WA, USA), or at the thin section laboratory of the Natural History Museum, London. Forty-two thin sections were made and described according to Bullock *et al.* (1985) and Courty *et al.* (1989). They were viewed at a number of magnifications from ×1, up to ×400 under a polarizing microscope, employing plane polarized light (PPL), crossed polarized light (XPL), oblique incident light (OIL), and blue light (BL) (cf. Stoops 1996; 2003, 24–25). The combined use of these different types of illumination permits a large number of optical inquiries to be made, for example forms of apatite (bone, guano and coprolites) which are autofluorescent under BL. The authors made extensive use of their own thin section reference collections and material from other cave studies (e.g. Meignen *et al.* 1989; Schiegl *et al.* 1996; Weiner *et al.* 1993; 1995).

Microchemistry

Micromorphological thin section data and bulk chemical findings were supplemented by microprobe analyses. Sediments from a column sample from the top of Area B (layers 52a, 52b and 52c) were subjected to microprobe (line and elemental map) studies (see below). This work

was carried out at University College London, using a Jeol JXA8600 EPMA microprobe.

Chemistry and magnetic susceptibility

Samples were analysed both at UCL, Institute of Archaeology (by Dr Cyril Bloomfield, retired from Rothamsted Experimental Station, Harpenden), and at Umeå University, Sweden (by Johan Linderholm). Bulk samples (<0.5 mm) were analysed for pH (2.5 H_2O), Loss-On-Ignition (LOI @ 550°C), total Phosphorus (P) employing ignition, HCl pre-treatment and 2N nitric acid extraction (UCL) and low frequency magnetic susceptibility (χ) studies at Umeå University, Sweden (Holiday 2004, appendix 2; Linderholm 2007).

Upper Area

The sands of the upper sequence extend almost to the cave roof, some 30 m from the present dripline (Fig. 13.3). As in other parts of the cave the sediments can be divided into buff- and pink-coloured (7.5YR7/4 – moist) sands interstratified with lenses of dark brown (7.5YR4/4 – moist) silts and silty sands (Figs. 13.5 and 13.6). The latter include a wash component, with transient pooling, followed by desiccation cracking. Similar phenomena have also been noted in various levels of Gorham's Cave (cf. LBSm). In some places the darker lenses are capped by consolidated crusts that can be traced back into the cave as continuous surfaces. The uppermost dark lenses investigated (contexts 50–55; Figs. 13.7–13.9) yielded some rare faunal remains including wild pig but no *in situ* artefacts. In Upper Area B, a 30 cm long column sample Van 97-52 was examined in detail (Table 13.1; Fig. 13.4).

Table 13.1 Van 97/52, a 30 cm long column sample from near the top of Upper Area B (Fig. 13.4).

Context & sub-unit	Sediment description	Munsell colour
52a	Brown silt	7.5YR5/6 (strong brown)
52b	Tan sand	7.5YR7/4 (pink)
52c	Hard, cubic clay	10YR4/4 (dark yellowish brown)
52d	Brown crumbly clay/silt sand (includes burrow)	7.5YR4/4 (brown to dark brown)
52e	Light crumbly sand	7.5YR5/4 (brown)

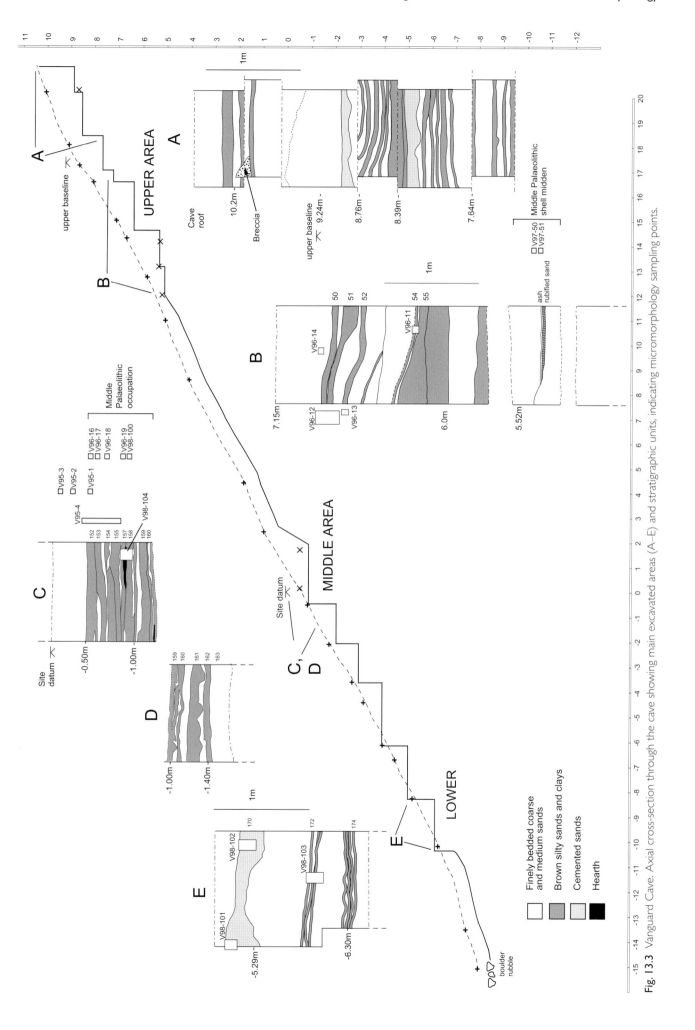

Fig. 13.3 Vanguard Cave. Axial cross-section through the cave showing main excavated areas (A–E) and stratigraphic units, indicating micromorphology sampling points.

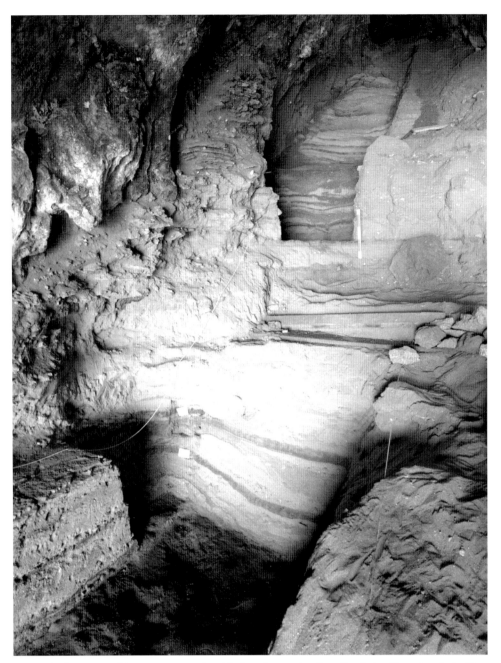

Fig. 13.5 Vanguard Cave Upper Areas A and B facing back of cave. Foreground: Area B from base of context 54. Photo: Natural History Museum, London.

Five sub-divisions of layer 52 were identified and examined through soil micromorphological thin section and bulk studies. Microprobe analysis of sample layers 52b and 52c was carried out because this location appeared to be the best expressed area of guano concentrations at Vanguard Cave. In contrast to Gorham's Cave, guano and phosphate features are relatively uncommon.

The first horizon with recognizably Middle Palaeo-lithic finds is situated about 5.4 m above datum in Area B (Fig. 13.10). It is marked by a pinkish-grey ashy deposit resting on more consolidated silty sands that can be followed for a few metres as a sub-horizontal surface dipping gently towards the back of the cave. The presence of a hearth is indicated by pinkish grey (7.5YR7/2) ash (~1.5 cm thick), overlying buff- coloured silty sands that are characterized in places by a 10 mm thick reddening or rube-faction (reddish brown 5YR5/4) where the sediments have been altered by heating. The hearth (sample Van 97-51) (Fig. 13.11) is associated with a scatter of burnt marine shells and a concentration of knapping debris, and is interpreted as the remains of activities involving the processing of marine

foods by Neanderthals (Barton 2000; Fernández-Jalvo and Andrews 2000; Stringer *et al.* 2008). Also present in the ashy deposits were a number of animal coprolites that are reported in Chapter 19. The Middle Palaeolithic artefacts associated with this surface are described in Chapter 20.

Middle Area

The Middle Area is located close to where we placed the site datum, about half way up the cave sequence and 15 m in from the present dripline. The deposits in this part of the cave are also characterized by alternating bands of finely bedded coarse and medium sands interdigitated with brown silts and clays (Table 13.2; Fig. 13.12). The bands are associated with a number of well defined, discrete archaeological horizons. There is a major sand unit between the Middle and Upper Areas consisting of coarse and fine sands that we tested but were found to be more or less archaeologically sterile.

The deposits in this area on the south side of the cave were examined in detail. They revealed at least 12 separate pairs of brown silty sand and lighter sand bands which formed

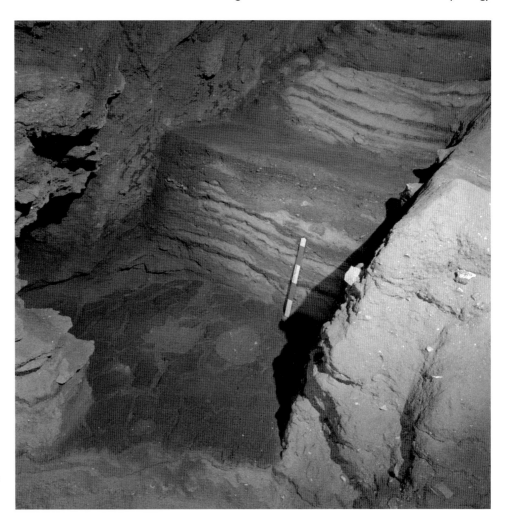

Fig. 13.6 Vanguard Cave Upper Area A. Darker and lighter bands of silts and silty sands. Photo: Natural History Museum, London.

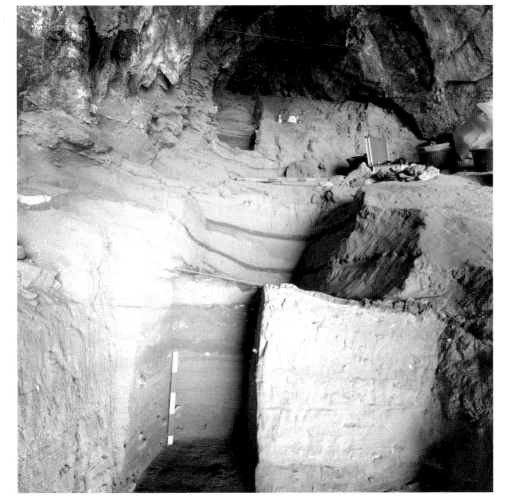

Fig. 13.7 Vanguard Cave Upper Areas A and B. The string in the foreground marks the top of context 54. The two overlying darker bands indicate contexts 52 and 50 (top). The long monolith sample was taken across context 52. Scale bar in 10 cm. Photo: Natural History Museum, London.

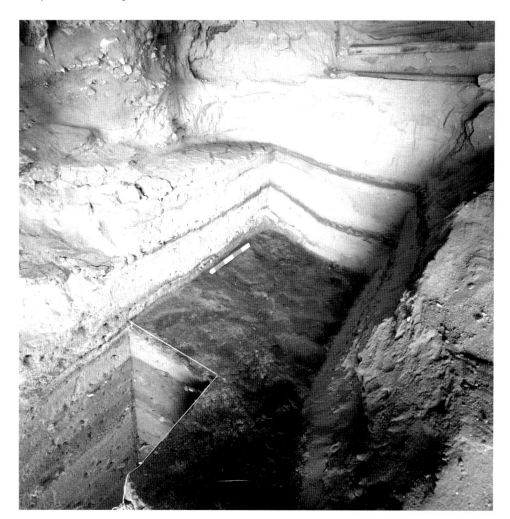

Fig. 13.8 Vanguard Cave Upper Area B. Similar view to 13.7. It shows 'desiccation surfaces' of context 54, with 25 cm scale bar, and contexts 52 and 50 above. Photo: Natural History Museum, London.

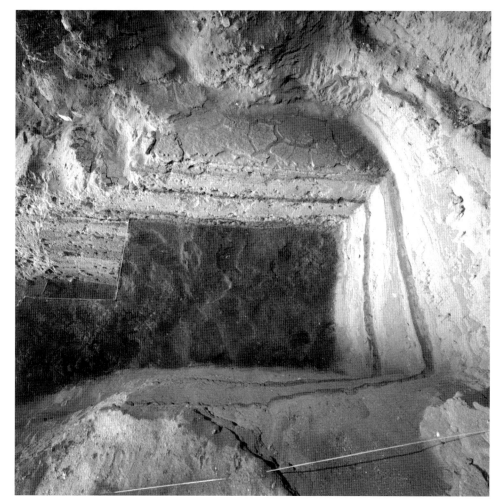

Fig. 13.9 Vanguard Cave Upper Area B. View from above showing 'desiccation surfaces' of context 50 (upper) and context 54 (lower). Photo: Natural History Museum, London.

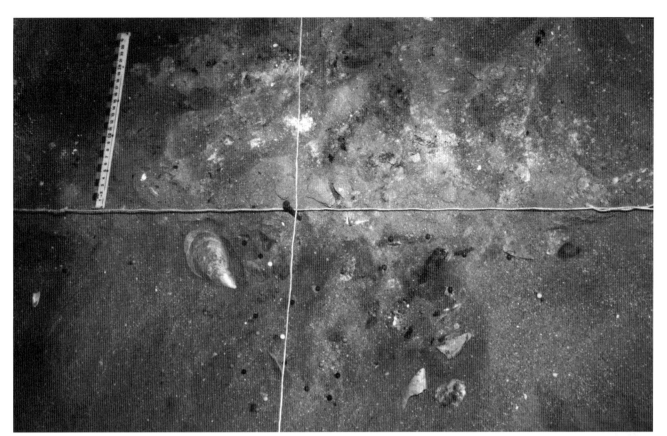

Fig. 13.10 Vanguard Cave Upper Area B. Image of Middle Palaeolithic shell midden. Photo: Natural History Museum, London.

more or less continuous compact surfaces that could be followed as they dipped gently towards the back of the cave. Finds of lithic artefacts and bone seemed to be concentrated mainly within these silty sub-units, the intervening sands being more or less devoid of any archaeological material. Each of the silt and sand pairs was described as a 'context' (Table 13.2). We interpreted those with artefacts as forming occupation episodes separated by small accumulations of clean blown sand, the latter probably representing relatively short interruptions in the silty sequence. According to the refitting of bones between different contexts (Chapter 21), the deposits appear to have been disturbed very locally by such processes as small-scale burrowing.

Individual charcoal-rich hearths and more diffuse combustion horizons were recorded within the brown silty sands and clay layers. The most completely excavated sample occurred within contexts 157–158 (Fig. 13.13). This large hearth was given the context number 150 (Table 13.2; Fig. 13.14). A sediment column was obtained through this feature which revealed two dark reddish brown organic-rich layers (each ~2 cm thick) separated by a possible ash layer about 1 cm thick (Table 13.3); the five units (150a–150e) were analysed for total Phosphorus and LOI (see Table 13.6, samples 19a–19e). Much charcoal was noted in the silty clay sediments and appeared widespread over an area some ~60 cm in diameter.

In contrast to the large hearth (150) a more enigmatic combustion feature was also investigated (context 156). It was interpreted as the remnants of a hearth or a localized inwash fill from a nearby hearth. Five sub-units were identified in the monolith box and the sediments were tested for magnetic susceptibility (see below and Table 13.4).

Fig. 13.11 Micromophology sample Van 97/51 thin-section scan. Upper Area B shell midden and hearth. Note 15 mm of ash over reddened sands containing shell fragments that recorded diminishing magnetic susceptibility through undisturbed hearth deposits. Width is ~50 mm. Photo: R. Macphail and P. Goldberg. (Colour versions of all thin sections available online)

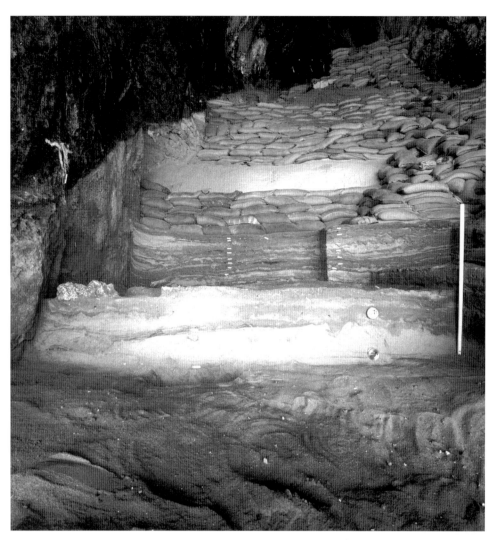

Fig. 13.12 Vanguard Cave Middle Area. Interdigitated sands and silts. The hearth feature (context 150) is just visible in the labelled section as a darker patch of silt. Two OSL samples (OSL 98/4 and OSL 98/5) can be seen in the foreground. The site datum can be seen as the nail at the centre of a white-painted T on the south wall of the cave. Photo: Natural History Museum, London.

Table 13.2 Vanguard Middle Area. Stratigraphic sub-divisions and 'contexts' and showing the concordance between unit labels from different seasons.

Contexts	Sediment	Sediment descriptions	Unit nos. used in 1995–6	Context nos. used in 1997–8	Context descriptions
152	Sand	Yellow-brown sand	100		
	Sand	Pink sand	101		
	Silt	Dark brown clayey silt + sands	102	52	
153	Sand	Pale pink/yellow coarse sands	103	53	
	Silt	Dark brown clayey silt	104	53	
154	Sand	Pinkish coarse-medium sands	105	54	
	Silt	Dark brown clay sand	106	54	
155	Sand	Pink coarse-medium sand	107		
	Silt			55	Brown clayey silt containing C[1] (156)
157	Sand	Dark brown clayey sand			
	Silt		108	57	Dark brown clayey sand + sand lenses containing Large hearth H[2] (150)
151	Silt		108 lower		Dark brown clayey sand underlying H
158	Sand	Pink coarse-medium sand	109	58	Pink coarse-medium sand
	Silt				Brown clayey silt
159	Sand			59	Pink coarse-medium sand
	Silt				Brown clayey silt
160	Sand			60	Pink coarse-medium sand
	Silt				Brown clayey silt
161	Sand			61	Pink coarse-medium sand
	Silt				Brown clayey silt
162	Sand			62	Pink coarse-medium sand
	Silt				Brown clayey silt
163	Sand			63	Pink coarse-medium sand
	Silt				Brown clayey silt

1 Shallow depression with charred base (C-Combustion feature = context 156).
2 Large hearth (H) (= context 150).

Table 13.3 Van 96/19, a monolith box sample through the large hearth (context 150).

Context & sub-unit	Sediment description	Munsell colour
150a	Charcoal-rich dark reddish brown clay	5YR3/2
150b	Brown ashy	7.5YR5/4
150c	Dark reddish brown, part burned clay	5YR3/2
150d	Reddish brown, rubefied clay	5YR4/4
150e	Strong brown silty clay	7.5YR5/6

Table 13.4 Van 97/54, a monolith box sample through combustion feature (context 156).

Context & sub-unit	Sediment description	Munsell colour
156a	Reddish brown silts	5YR4/4
156b	Dark reddish brown silts	5YR3/2
156c	Strong reddish brown silty clay	7.5YR4/6
156d & e	Yellowish brown sand	5YR4/6

Lower Area

A trench contiguous with the Middle Area deposits was extended down to approximately 6.5 m below datum beyond the cave entrance drip line and near the rock-cut platform close to present sea-level. Only in Area E were a series of well defined light brown clay bands with intervening clean sands recorded (Fig. 13.3). Apart from some isolated faunal remains (none with cut-marks) there were no artefacts.

Northern Alcove

Excavation was undertaken on the north side of the main chamber (Figs. 13.2 and 13.15). The sediments in this area are characterized by more massive sands punctuated by numerous reddish brown clay and silt stringers that thin in a direction away from cracks in the cave walls. It suggests that the brown silty units, e.g. sample Van 97-53 (Figs. 13.16 and 13.17), here and more generally within the cave, were washed in along joints and fissures of the bedrock. In the alcove area the sands were much less consolidated and the banding more diffuse than elsewhere in the main sequence. The sediments lay at more or less the same altitude as the deposits of the Middle Area and may have formed continuous layers, although no attempt was made to link the two areas stratigraphically. Only relatively few archaeological finds were recovered in the Northern Alcove. One of the more important features recorded in this area, however, was a small oval hearth measuring about 50 × 25 cm (Fig. 13.18; Table 13.5). It consisted of a 1–2 cm thick layer of laminated ash overlying a further 2 cm thickness of burnt sand and charcoal with some patches of underlying rubified sand. With the exception of a few scattered flakes there was no other evidence of human activity in the sediments immediately surrounding the hearth. A few artefacts were recorded from lower down in the sequence but not in any great density (Fig. 13.19).

Sediment micromorphology, chemistry and magnetic susceptibility

The aim of this study was to assess site formation processes using a combination of thin section, microchemistry, bulk chemical and magnetic susceptibility analyses

Table 13.5 The Northern Alcove. Stratigraphic subdivisions and 'contexts'.

Contexts 1996–7	Unit Number 1995–6	Sediment description
1000	500	Brown clayey silt. Bioturbated, homogeneous with infrequent sand lenses
1001	500	Coarse sand, yellowish brown with broken shells (bioturbated)
1002	501	Two consolidated narrow dark brown bands of sandy clayey silt
1003	502	Coarse sand light yellow/brown
1004	503	Narrow dark brown clayey silt
1005	504	Light brown, coarse sandy layer. HEARTH at interface of 504/505
1006	505/506	Dark brown clayey silt
1007		Light yellowish brown sand
1008		Light yellowish brown sand with brown clayey silt, probably mixed
1009		Dark brown clayey silt
1010		Undescribed
1011		Light yellowish brown sand
1012		Dark brown clayey silt
1013		Light yellowish brown sand (heavily bioturbated)
1014		Dark brown clayey silt with thin intervening light yellowish sand band
1015		Light yellowish brown sand
1016		Dark brown clayey silt
1017 1018		Light yellowish brown sand with thin continuous lenses of dark brown clayey silt
1019		Light yellowish brown sand
1020		Dark brown clayey silt (discontinuous)
1021		Light yellowish brown sand and overlying band of dark brown clayey silt
1022		Light yellowish brown sand and overlying band of dark brown clayey silt
1023		Dark brown clayey silt

in cave sediments composed dominantly of sand, silt and some guano. It permitted the detailed characterization of sediment types according to a number of broadly defined attributes, such as micro-facies (including components, grain size and sorting, microfabric type), and chemical and magnetic signature.

Soil micromorphology results

Sediment types are grouped according to their facies and sub-facies characteristics, namely,

S Sands: clean fine- to medium-size sands; massive to very coarsely bedded, commonly well sorted, with few charcoal, and very few humic and excremental inclusions (Fig. 13.20). A variant of this is moderately sorted sands containing land snail shell fragments.

Si Silts: calcitic and non-calcitic silts; finely bedded, commonly well sorted with few fine sand, charcoal and few humic fragments (Figs. 13.20 and 13.14). Variants include a calcitic, in places probably ashy, fine fabric, and planar pseudomorphs of plant fragments (sample Van 97-53; Figs. 13.16 and 13.17).

G Guano: the guano facies is composed dominantly of two sub-facies. Subtype *Gi* is heterogeneous, reddish brown, porous, highly humic and excremental (burrowed) in character, and may contain inclusions of bone,

Fig. 13.13 Vanguard Cave Middle Area. Image of Middle Palaeolithic hearth (context 150) set in dark silts (samples Van 96/19 and Van 98/104); a vertical sequence of bulk analyses (sample layers a–e) were also taken through the hearth. Photo: P. Goldberg and R. Macphail.

charcoal and plant fragments. Irregular-shaped, amorphous material, sometimes containing plant material and autofluorescent under BL, may also occur as inclusions (sample Van 52c; Table 13.6). The second type, *Gii*, is homogeneous, pale grey, massive/bedded, non-birefringent, and is highly autofluorescent under BL (sample Van 52c; Table 13.6; Figs. 13.21–13.28). It is similar to secondary phosphates observed in other prehistoric caves in the Mediterranean region (Weiner *et al.* 1995; Schiegl *et al.* 1996).

H Hearths and Combustion features: variants include rubified, finely bedded silts (Si) and can contain sand, fine charcoal, charred organic matter, burned bone and ash crystals (e.g. sample Van 97-54 Middle Area (context 156); Figs. 13.29 and 13.30). In the case of sample Van 97-51 (Upper Area 'B'), weakly rubified sands (S) occur, with a 10–20 mm thick ash layer composed of micritic remains of wood ash (but no phytoliths) (see Figs. 13.11, 13.31 and 13.32). This ash exhibits

Fig. 13.14 Micromophology sample Van98/104 thin-section scan. Middle Area context 150, showing rubefied hearth deposits (facies CZ) sealed by ensuing silt-dominated sediments (facies Si) themselves intercalated with sand (sub-facies S). Width is ~50 mm. Photo: R. Macphail and P. Goldberg.

pseudomorphs of very thin burrows and broad excrements (including biogenic calcite). Bedding and welding of micrite and the increasing abundance upwards of sand testify to exposure and weathering of the hearth followed by relatively rapid burial by blown sand.

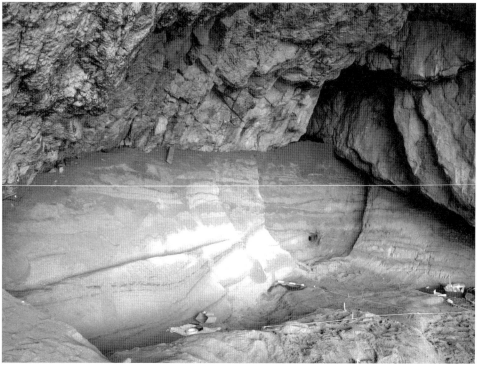

Fig. 13.15 Vanguard Cave Northern Alcove, viewed west and showing small hearth feature (context 1005) indicated by scale bar. Photo: Natural History Museum, London.

Table 13.6 Bulk data associated with sediment and micro-facies types identified in thin section at Vanguard Cave.

Samples	Sediment Types	Facies types	Total P ppm	MS (χ x 10-8 Si/Kg)	pH (H_2O)	% LOI
Van 97/51a	H	A/S		76		
Van 97/51b	H	A/B/S		31		0.3
Van 97/52a	S	S	1880			2.5
Van 97/52b	S	S	850			1.1
Van 97/52c	G	G/OM/S	18000			3.9
Van 97/52d	S	S	760			1.3
Van 97/52e	S	S	2300			1.2
Van 97/54a	H	S/OM (G, C, A)		234		2.4
Van 97/54b	H	S/A/OM (B, C)		223		3.8
Van 97/54c	H	S/A		128		2.5
Van 97/54d	S	S		90		1.8
Van 96/13	Si	S/Si/OM		98	8.1	2
Van 96/16	Si	Si (OM)		99	8.1	2.6
Van 96/17	Si	Si/S (OM)		63	7.8	1.3
Van 96/18	Si	S/Si (OM)		93	8.3	1.8
19a	H	S/OM (G, C, A)	3210			3.3
19b	H	S/A/OM (B, C)	4860			2
19c	H	S/OM (G, C, A)	2300			3
19d	H	S/OM (A, B)	2060			1.6
19e	H	S/OM (G, C, A)	3060			2
53	Si	Si	1740	107		0.55
Van 98/100		C		72	7.8	2.6
Van 98/101	S	S/Si		22	8.6	0.7
Van 98/102	S	S/Si		14	8.7	0.8
Van 98/103	Si	S/Si (A?)		22	7.8	1.3

Key to Sediment (Facies) type:
 H – Hearth/Combustion Zone, G – Guano, S – Sands, Si – Silts.
Key to micro-facies present:
 A – ash, B – burrows (biological activity), C – charcoal,
 Ca – secondary calcium carbonate, G – guano, OM – organic matter,
 S – sands, Si – silts.

Fig. 13.16 Micromorphology sample Van97/53 (Northern Alcove). Photomicrograph of interbedded silts (micro-facies *Si*) and sands (micro-facies *S*) that records inwash of fine (silt and clay) soil through the cave's karstic system (possibly seasonally) and sand blowing from coastal dunes. PPL, width is ~3 mm. Photo: R. Macphail and P. Goldberg.

Fig. 13.17 As Fig. 13.16, employing XPL; note that even the silts can include wind-blown sand grains. Photo: R. Macphail and P. Goldberg.

 In Table 13.6 further information is presented on the different micro-facies of the sediment types.

Chemical and magnetic susceptibility results

These are presented in Table 13.6 and with data from V97-54 (context 156, combustion feature; see Table 13.4 and Fig. 13.33a and b). All sediments are alkaline (mean pH 8.1, range pH 7.8–8.6). Scattergrams were employed to compare the sediments of Vanguard and Gorham's Caves (Macphail and Goldberg 2000). Generally, the sediments from Gorham's Cave have higher amounts of phosphate and organic matter, but a similar range of magnetic susceptibility values,

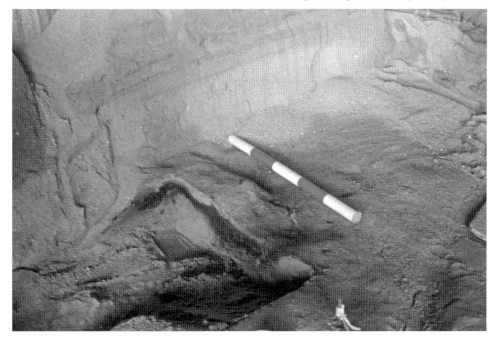

Fig. 13.18 Vanguard Cave Northern Alcove. Close up of small hearth feature (context 1005). Cross section left of the nail in the foreground. Photo: Natural History Museum, London.

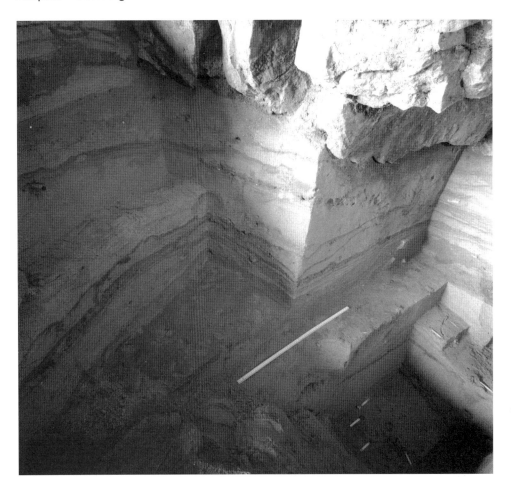

Fig. 13.19 Vanguard Cave Northern Alcove. View of sediments below context 1006. One metre scale. Photo: Natural History Museum, London.

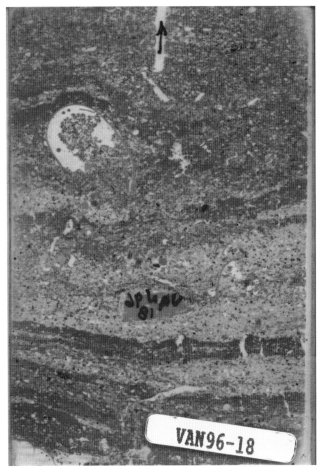

Fig. 13.20 Micromorphology sample Van 96/18 thin-section scan. This shows dominant silts (facies *Si*) with interbedded sands (sub-facies *S*) in Middle Area of cave at approximately context 154 (see Table 13.2). Frame width is ~50 mm. Photo: R. Macphail and P. Goldberg.

Fig. 13.21 Photomicrograph of mixed guano (micro-facies *Gi*) from Van 97/52 (Upper Area), showing dark reddish phosphate crust below a blown sand layer. It is possible that the dark reddish colours are indicative of heating consistent with the presence of charcoal in this context (see Fig. 13.32). PPL, frame width is ~3 mm.

as compared to those of Vanguard Cave. Low amounts of organic matter occur at Vanguard Cave (mean 2% LOI; max. 3.9% LOI), with the highest amounts associated with 'Guano' (3.9% LOI) and 'Combustion Zones' (3.8% LOI), compared to 'Sand' (0.7–2.5% LOI) and 'Silt' (0.5–2.6% LOI) sediment types. Equally, these ('Sand': 760–1880 ppm P; 'Silt': 1740 ppm P) are less rich in P compared to 'Combustion Zones' (2060–4860 ppm P), and very much less enriched in P compared to a 'Guano' layer (18,000 ppm P) (see microchemistry). Some high magnetic susceptibility values are coincident with known 'Combustion Zones' (CZ: max. 234 $\chi \times 10^{-8}$ Si/Kg) compared to 'Sand' (14-90 $\chi \times 10^{-8}$ Si/Kg) and 'Silt' (22-107 $\chi \times 10^{-8}$ Si/Kg) sediment types, but it

Fig. 13.22 As Fig. 13.21, in XPL, showing isotic organic matter-stained phosphate (P-Ca-Fe-Mn), with possible calcitic traces (arrows) as evidence of an earlier existing combustion zone (possibly ashes) here; deposition of guano led to the phosphatization of this hearth. Photo: R. Macphail and P. Goldberg.

can be noted that ash-rich layers show poor enhancement (sample 51b) presumably because of the lack of ferruginous mineral matter.

Microchemistry results

Quantitative microprobe analysis was performed on the column sample from the top of Area B (layers 52a, 52b and 52c; see Tables 13.1 and 13.6). These samples come from a microfabric within a 'Guano' (G) type sediment and were analysed by elemental mapping and by line analysis. They

yielded mean values of 9% Si, 7% Ca, 2.9% P, 1.8% Al, 1.5% Fe and 0.8% Mn (n=227), with maximum values of 41% Si, 36% Ca, 14% P, 35% Al, 27% Fe and 42% Mn, respectively. Layer 52a (type Gi) although dominated by Ca-P contains biologically mixed layers and fragments of Fe-rich material (Figs. 13.23 and 13.24). In contrast, layer 52b (type Gii) is composed of layers of little disturbed Ca-P (presumed to be pure guano formed of hydroxyapatite) with intercalated Fe-Mn (relict of organic matter?) and layers of mixed Al-Si-Fe-Mn cave earth (Figs. 13.25–13.27). Layer 52c (type Gi) is heterogeneous and contains patches again rich in Ca-P biologically mixed with areas of Fe-Mn (Fig. 13.28).

Discussion

The identification and recognition of sediment facies and micro-facies types permit us to extend our interpretations of site formation processes and human activities at Vanguard Cave. These are discussed in terms of the major sediment (facies) types.

S Sands: Clean, well-sorted, fine to medium sands are likely to reflect episodes of dry conditions and wind-blown deposition of sands from coastal dunes present along the coastline when sea-levels were lower than today (Davies *et al.* 2000; Finlayson and Pacheco 2000). This origin and mode of deposition is reflected in their low LOI (Loss-On-Ignition) phosphate content and magnetic susceptibility values. The sands can contain rounded sand-size shell, limestone and fossil fragments

Fig. 13.23 Microprobe elemental map: Van 97/52, layer 6b; P in guano – micro-facies *Gi*. Frame width is ~9 mm. Photo: R. Macphail and P. Goldberg.

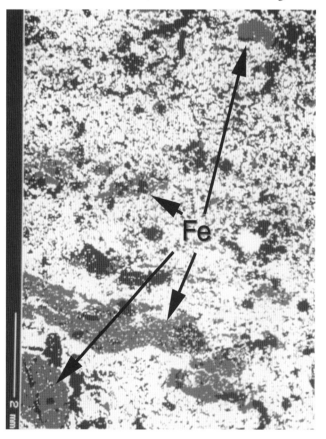

Fig. 13.24 As Fig. 13.23, microprobe elemental map: Van 97/52, layer 6b; Fe-P-Ca in guano – micro-facies Gi. Phosphorus mapped as P (1.07%), P-Ca (26.88%), P-Fe (0.49%) and P-Fe-Ca (9.41%), with 1.61% Ca and mixed layers of (23.19%) Fe. Frame width is ~9 mm. Photo: R. Macphail and P. Goldberg.

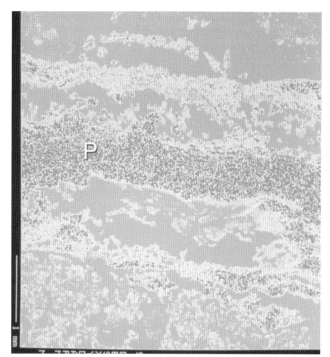

Fig. 13.25 Microprobe elemental map: Van 97/52, layer 6a; P in guano – micro-facies *Gii*. Frame width is ~4.5 mm. Photo: R. Macphail and P. Goldberg.

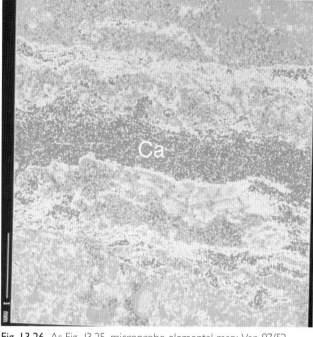

Fig. 13.26 As Fig. 13.25, microprobe elemental map: Van 97/52, layer 6a; Ca in guano – micro-facies *Gii*. Frame width is ~4.5 mm. Photo: R. Macphail and P. Goldberg.

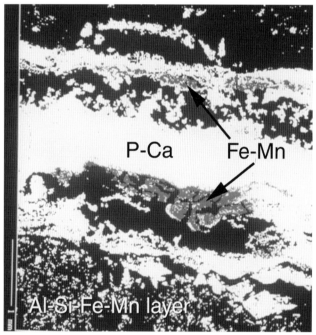

Fig. 13.27 As Fig. 13.26, microprobe elemental map: Van 97/52, layer 6a; Ca-P (35.35%) in guano – micro-facies *Gii*, with layers of mixed Al-Si-Fe-Mn and Fe-Mn. Frame width is ~4.5 mm. Photo: R. Macphail and P. Goldberg.

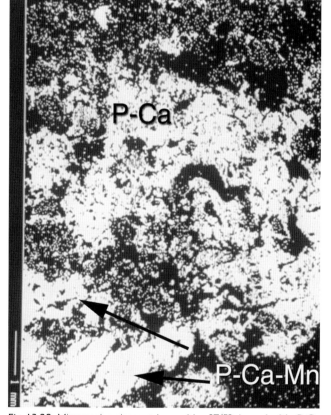

Fig. 13.28 Microprobe elemental map: Van 97/52, layer 6c; Mn-P-Ca in guano – micro-facies *Gi*. Phosphorus is mapped as P (0.96%), P-Ca (25.91%), P-Mn (0.15%) and P-Mn-Ca (6.20%). Frame width is ~8 mm. Photo: R. Macphail and P. Goldberg.

from these putative dunes. Massive sands are typically interbedded with silts, which may overall represent cyclical/seasonal climatic/weather (i.e. wetter/drier) fluctuations.

Si **Silts**: These are finely bedded, and may contain planar voids that are presumably pseudomorphs of plant remains. The proposed origin of the silts (e.g. Van 97-53), as derived from surface soils washed through fissures in the karstic system, is supported by their relatively low LOI values (even compared to the sands), and apparently high magnetic susceptibility values. As burned

sediments are not obviously present outside the areas of combustion features, they therefore are the likely result of in-wash of long-weathered and strongly oxidized Red Mediterranean (*terra rossa*) soils (Collins *et al.* 1994; Crowther, University of Wales Lampeter, pers. comm.). The occasional fine bone and charcoal content ultimately

Fig. 13.29 Micromorphology sample Van 97/54 thin-section scan. Middle Area (context 156), showing some of the charcoal-rich lenses of the combustion zone (facies *CZ*); sample layers a–d were collected in the field (see text, Tables 13.2 and 13.5), over rubefied sands (facies *S*). This complex hearth feature, with very locally transported sedimentary hearth deposits, infills a depression (note layering), which then became a new *in situ* hearth. The magnetic susceptibility profile is as follows: χ = 234, 223, 128 and 90 × 10-8 Si/Kg, and demonstrates very clearly a reuse of the combustion zone/hearth. Width is ~75 mm. Photo: R. Macphail and P. Goldberg.

represents the influence of fauna and humans within the cave (see hearths and combustion zones).

G *Guano*: The chief guano layer at Vanguard Cave is present towards the top of the sequence in the Upper Area B (Fig. 13.2), which was studied in detail in long monolith sample 52 (Table 13.1; Fig. 13.4). This sample is generally organic and extremely phosphate rich because of its guano content. This material is autofluorescent under blue light implying an inorganic hydroxyapatite mineralogy as can be shown for guano deposits investigated in other caves (Karkanas *et al.* 2000; Wattez *et al.* 1990). Two main micro-facies are recognized. The first comprises dark stained biologically worked/burrowed guano layers (Gi) showing mixing of calcium phosphate-rich guano and other mineral material of anaerobic origin that is dominated by iron and manganese (Figs. 13.21–13.24). In contrast, massive, homogeneous grey- coloured guano layers (Gii) are very pure, layered calcium phosphate representing undisturbed surface accumulation of guano intercalated with cave earth and blown sand deposition and now Fe-Mn-replaced probable organic matter layers (Figs. 13.25–13.27). The presumed source of guano is from birds and these are not uncommon elements in the cave fauna (Chapter 17). Numerous recent studies have been made of cave phosphates in contexts that stretch from temperate Europe (Macphail and Goldberg 1999; Andrews 1990) down to the Mediterranean (Goldberg and Macphail 2006; Courty *et al.* 1989). In the latter region, bone, ashes and other sediments in Pleistocene caves have been replaced by a variety of secondary phosphates (Weiner *et al.* 1995), and it is possible that at Vanguard Cave some examples of Gii result from the similar replacement of ash. Inputs of guano are also recorded in some combustion zones (samples V96-19a/19c and V97-54a), contributing to phosphate levels.

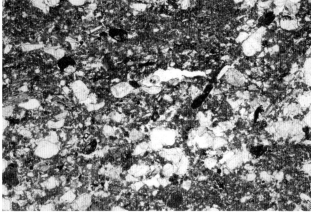

Fig. 13.30a and b Photomicrograph(s) of layered hearth deposits from Van 97/54, showing local redistribution of combustion zone (micro-facies CZ) organic silts and clays.
Top: Upper layer of dark brown bedded charred (blackened and rubefied) organic silt and clay, showing increasing amounts of blown sand upwards. XPL, frame width is ~3 mm.
Bottom: Lower layer of beige-coloured (and less burned) bedded organic silts and clays, with few intercalated blown sand. PPL, frame width is ~3 mm. Photo: R. Macphail and P. Goldberg.

H *Hearths and Combustion zones*: Combustion zones and hearths occur as barely disturbed ash layers overlying rubefied sediments. One good example is the hearth at the base of the shell midden in Area B (sample Van 97-51; Table 13.6; Figs. 13.10, 13.11 and 13.31); another is from the Middle Area (context 156). Both of these show layered, rubefied and charcoal-rich 'silts' (sample Van 97-54; Table 13.6; Figs. 13.29 and 13.30). There are also examples of guano and phosphate transformed deposits (Figs. 13.21 and 13.22). These findings show that human occupation and burning activity took place on both sandy and silty substrates. It is also worth noting that the 50 mm thick succession of burnt silts and sands making up Van 97-54 (the combustion feature in context 156) demonstrates likely repeated episodes of use. This inference is further indicated by the magnetic susceptibility values of the washed CZ deposits which increase upwards, implying final heating of this multi-laminated combustion zone deposit (Table 13.6; Fig. 13.33a and b).

The presence of charcoal in sample Van 97-52 and traces of possible ash also indicates that the reddish brown guano deposits (Gi; Figs. 13.22–13.24) are most likely the result of

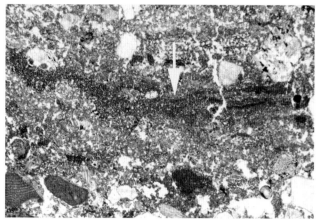

Fig. 13.31 Photomicrograph of Van 97/51 (see Fig. 13.11); mainly coarse calcite wood ash crystals including a thin layer of welded ash, forming a thin pan-like feature (arrow). This well-preserved *in situ* CZ micro-facies can be compared to the CZ formed in silts. PPL, frame width is ~3 mm. Photo: R. Macphail and P. Goldberg.

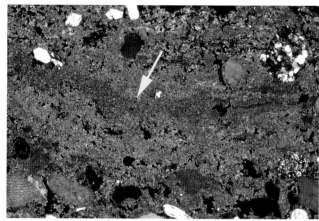

Fig. 13.32 As Fig. 13.31, in XPL; slightly lower birefringence of the welded ash layer (arrow), probably indicates minor weathering of the hearth; note the few blown sand grains present. Here the hearth is located on, and buried by, sand. Photo: R. Macphail and P. Goldberg.

rubefaction by heating. On the other hand, the Gii layer mentioned above (Figs. 13.25–13.28) could constitute the phosphatized remains of an earlier ash layer (cf. Schiegl *et al.* 1996). Both of these observations are interesting because they indicate a human presence despite the absence of any lithic artefacts or other archaeological evidence. In combustion feature 150 it can be noted that the ashy brown unit (150b) is the most phosphorus-rich (4860 ppm P, Table 13.6, sample Van 96-19b).

Microprobe analysis at Vanguard Cave showed that sediments can be influenced by the mobilization, leaching and redeposition of iron and manganese (cf. Hill and Forti 1997).

Our present thinking substantiates the thoughts of Waechter (1951) by postulating a coastal environment dominated by a large dune system. At Vanguard Cave, for instance, the entire accumulation of ±17 m of sediments is overall inclined toward the rear of the cave, suggesting that the bulk of the sand mass would have been situated further seaward when sea-levels were lower. Furthermore, the sand is interspersed with silty washed accumulations, which gave rise to the interbedding of the sands and silts. Aeolian and sheet wash processes moved and reworked many of the sediments associated with Middle Palaeolithic occupation layers, resulting in slight redistribution of artefacts and hearth material. Within Vanguard Cave, only three, unequivocal *in situ* areas tied to use of fire were recognized.

Although it is clear that there was probably a constant rain of guano and phosphate, much of this was diluted by dune sand accumulation. On the other hand, the preservation of ephemeral surfaces with evidence of combustion can show that some of these display guano concentrations, and it is possible that as in sample Van 97-52 a combustion zone was transformed by phosphatization associated with later guano inputs. In one of the hearths (the midden deposit, sample Van 97-51) scavenging by canids is recorded by the presence of coprolites (sample 371; Chapter 19). This type of scavenging and associated disturbance of occupation surfaces is well known from a number of other soil micromorphological studies of hunter and gatherer sites (Goldberg and Byrd 2000; Goldberg *et al.* 2007). The well preserved nature of hearths and reused hearth features argues strongly in favour of very rapid sedimentation rates.

Conclusions

This detailed study, supported by analysis of soil micromorphology and chemistry, has brought to light a number of depositional and post-depositional processes linked to geogenic, biogenic and anthropogenic activities. The major findings can be summarized within two broad categories:

Cave sedimentation

Sediments at Vanguard Cave are less phosphatic and organic, and generally have undergone fewer diagenetic changes

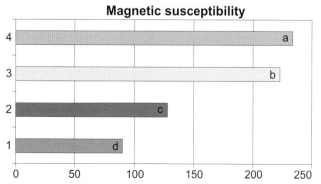

Fig. 13.33a Van 97/54 sample layers a–d; magnetic susceptibility sequence, demonstrating probable *in situ* burning of these layers.

Fig. 13.33b Van 97/54 sample layers a–d; percentage LOI sequence.

compared to Gorham's Cave (Chapters 2–4). Exceptionally well preserved *in situ* hearth deposits with ash layers survive in Vanguard Cave, with one example showing rapid burial by blown sand. Although sedimentation is affected by probable seasonal/climatic fluctuations in cave water, it is interesting that karstic activity, for example the formation of speleothems, is absent (at least near the present front) in Vanguard Cave, despite the evident occurrence of waterlain silts. Animals, especially birds, have contributed far less substantially to organic and phosphatic sedimentation, in comparison to Gorham's Cave. Their deposits (organic matter, guano, phosphate) have been generally strongly diluted by rapid dune sand deposition, but concentrations are evident where ephemeral surfaces and associated hearths and combustion zones occur on silts for example. These impermanent surfaces were subjected to intense biological activity, including the presence of humans, and also affected by local (very shallow) erosion and colluviation. However, the degree and vertical range of bioturbation is relatively low in all observed sections. Indeed, in the Middle Area (adjacent to hearth 150), the fine stratigraphic detail continues right to the cave wall.

Human activity

From the microstratigraphic analysis of the hearths, there is compelling evidence that Neanderthals reused these features. We have also noted that they apparently showed no preference for occupying sandy or silty substrates.

Acknowledgements

The authors thank the National Geographic Society for funding this research, and the Natural History Museum and Gibraltar Museum for discussion, collaboration and support especially through Chris Stringer and Clive Finlayson, respectively. The Institute of Archaeology, University College London is also thanked for support especially through Sandra Bond (SEM/EDXRA), Kevin Reeves (microprobe) and Cyril Bloomfield (analysis of Phosphorus); additional analyses including magnetic susceptibility were carried out by Johan Linderholm (Environmental Archaeology Laboratory, Umeå University, Sweden), who is gratefully acknowledged. Thin sections were manufactured by Spectrum Petrographics (Vancouver, Washington, USA). In addition we gratefully thank the following for their contribution to this study: Peter Andrews, Gerry Black, Andy Currant, Clive and Geraldine Finlayson, Lorraine Cormish, Jo Cooper, Yolanda Fernández-Jalvo, Frank Greenway and Chris Stringer.

References

Andrews, P. 1990: *Owls, Caves and Fossils* (London, Nat. Hist. Mus. Publications).

Barton, R. N. E. 2000: Mousterian Hearths and Shellfish: Late Neanderthal Activities on Gibraltar. In Stringer, C. B., Barton, R. N. E. and Finlayson, J. C. (eds.), *Neanderthals on the Edge* (Oxford, Oxbow Books), 211–220.

Bullock, P., Fedoroff, N., Jongerius, A., Stoops, G., Tursina, T. and Babel, U. 1985: *Handbook for Soil Thin Section Description* (Wolverhampton, Waine Research).

Collins, M. B., Gose, W. A. and Shaw, S. 1994: Preliminary geomorphological findings at Dust and nearby caves. *Journal of Alabama Archaeology* 40, 35–56.

Courty, M. A., Goldberg, P. and Macphail, R. I. 1989: *Soils and Micromorphology in Archaeology* (Cambridge, Cambridge University Press).

Davies, W., Stewart, J. and van Andel, T. H. 2000: Neanderthal landscapes – a preview. In Stringer, C. B., Barton, R. N. E. and Finlayson, J. C. (eds.), *Neanderthals on the edge* (Oxford, Oxbow Books), 1–8.

Fernández-Jalvo, Y. and Andrews, P. 2000: The taphonomy of Pleistocene caves, with particular reference to Gibraltar. In Stringer, C. B., Barton, R. N. E. and Finlayson, J. C. (eds.), *Neanderthals on the Edge* (Oxford, Oxbow Books), 171–182.

Finlayson, C. and Pacheco, F. G. 2000: The southern Iberian peninsula in the late Pleistocene: geography, ecology and human occupation. In Stringer, C. B., Barton, R. N. E. and Finlayson, J. C. (eds.), *Neanderthals on the Edge* (Oxford, Oxbow Books), 139–154.

Goldberg, P. and Byrd, B. 2000: The interpretive potential of micromorphological analysis at prehistoric shell midden sites on Camp Pendleton. *Pacific Coast Archaeological Society Quarterly* 35(4), 1–23.

Goldberg, P. and Macphail, R. I. 2000: Micromorphology of sediments from Gibraltar caves: some preliminary results from Gorham's Cave and Vanguard Cave. In Finlayson, C., Finlayson, G. and Fa, D., *Gibraltar during the Quaternary* (Gibraltar, Gibraltar Government Heritage Publications, Monograph 1), 93–108.

Goldberg, P. and Macphail, R. I. 2006: *Practical and Theoretical Geoarchaeology* (Oxford, Blackwell Publishing).

Goldberg, P., Macphail, R. I. and Homburg, J. 2007: *Playa Vista Archaeological and Historical Project (California): soil micromorphology report* (Tucson, Statistical Research Inc.).

Hill, C. and Forti, P. 1997: *Cave Minerals of the World* (Huntsville, National Speleological Society).

Holiday, V. T. 2004: *Soils in Archaeological Research* (Oxford, Oxford University Press).

Karkanas, P., Kyparissi-Apostolika, N., Bar-Yosef, O. and Weiner, S. 2000: Mineral assemblages in Theopetra, Greece: a framework for understanding diagenesis in a prehistoric cave. *Journal of Archaeological Science* 26, 1171–1180.

Linderholm, J. 2007: Soil chemical surveying: a path to a deeper understanding of prehistoric sites and societies in Sweden. *Geoarchaeology* 22, 417–438.

Macphail, R. I. and Goldberg, P. 1999: The soil micromorphological investigations of Westbury Cave. In Andrews, P., Cook, J., Currant, C. and Stringer, C. (eds.), *Westbury Cave. The Natural History Museum Excavations 1976–1984* (Bristol, CHERUB), 59–86.

Macphail, R. I. and Goldberg, P. 2000: Geoarchaeological investigation of sediments from Gorham's and Vanguard Caves, Gibraltar: microstratigraphical (soil micromorphological and chemical) signatures. In Stringer, C. B., Barton, R. N. E. and Finlayson, J. C. (eds.), *Neanderthals on the Edge* (Oxford, Oxbow Books), 183–200.

Meignen, L., Bar-Yosef, O. and Goldberg, P. 1989: Les

Structures de Combustion Moustériennes de la Grotte de Kébara (Mont Carmel, Israel). *Mémoires Du Musée de Préhistoire d'Ile de France* 2, 141–146.

Murphy, C. P. 1986: *Thin Section Preparation of Soils and Sediments* (Berkhamsted, A B Academic Publishers).

Schiegel, S. G., Goldberg, P., Bar-Yosef, O. and Weiner, S. 1996: Ash mineralogical observations and their archaeological implications. *Journal of Archaeological Science* 23, 763–781.

Stoops, G. 1996: Complementary techniques for the study of thin sections of archaeological materials. In Castelletti, L. and Cremaschi, M. (eds.), *XIII International Congress of Prehistoric and Protohistoric Sciences Forlì-Italia-8/14 September 1996, 3 Paleoecology* (Forlì, A.B.A.C.O.), 175–182.

Stoops, G. 2003: *Guidelines for Analysis and Description of Soil and Regolith Thin Sections* (Madison, Wisconsin, Soil Science Society of America, Inc.).

Stringer, C. B., Finlayson, J. C., Barton, R. N. E., Fernández-Jalvo, Y., Caceres, I., Sabin, R., Rhodes, E. J., Currant, A. P., Rodriguez-Vidal, J., Giles Pacheco, F. and Riquelme Canatal, J. A. 2008: Early Neanderthal exploitation of marine mammals, Quaternary Science Reviews. *Proceedings of the National Academy of Sciences USA* 105(38), 14319–14324.

Waechter, J. d'A. 1951: The excavation of Gorham's Cave, Gibraltar: preliminary report for the seasons 1948 and 1950. *Proceedings of the Prehistoric Society* NS 17, 83–92.

Wattez, J., Courty, M. A. and Macphail, R. I. 1990: Burnt organomineral deposits related to animal and human activities in prehistoric caves. In Douglas, L. A. (ed.), *Soil Micromorphology: a basic and applied science* (Amsterdam, Elsevier), 431–441.

Weiner, S., Goldberg, P. and Bar-Yosef, O. 1993: Bone Preservation in Kebara Cave, Israel Using On-Site Fourier Transform Infrared Spectrometry. *Journal of Archaeological Science* 20, 613–627.

Weiner, S., Schiegel, S. G., Goldberg, P. and Bar-Yosef, O. 1995: Mineral assemblages in Kebara and Hayonim Caves, Israel: Excavation strategies, bone preservation and wood ash remnants. *Israel Journal of Chemistry* 35, 143–154.

14 OSL age estimates from Vanguard Cave

E.J. Rhodes

Introduction

Two suites of sediment samples were collected for OSL dating from which a total of seven were measured in this study. One sample, laboratory code X369, field code VAN98-OSL8, was part of a suite collected in 1998 using steel tubes; OSL results reported by Pettitt and Bailey (2000) also formed part of the same sample suite. A second suite was collected in August 2001, by pushing opaque black PVC tubes into cleaned sediment sections. During the 2001 visit, *in situ* NaI gamma fspectrometer measurements were made at each sampling location (including several 1998 locations), in order to provide a direct measurement of gamma dose rate. Standard sample preparation methods (described in detail below) were used to extract quartz grains from each sediment, and these were measured using a conventional multiple grain single aliquot regenerative-dose (SAR) protocol (Murray and Wintle 2000, 2003).

For several samples, the sediment was observed to be well sorted, clean medium to coarse sand, some having a prominent shell fragment component, while other samples were collected in finely laminated interbedded silts and fine to medium sands. The deposits appear to contrast with the lower part of the Gorham's Cave sequence however. This may be explained partly by the generally much higher sedimentation rate and lower bioturbation level in Vanguard Cave than in Gorham's (Collcutt, pers. comm.). In parallel with these observations, the measured OSL single aliquot equivalent dose distributions from the Vanguard Cave samples were generally much more tightly grouped than those from Gorham's Cave, giving the impression of less incomplete bleaching at deposition, and less post-depositional mixing of grains from different horizons and of different ages. These combined observations lead the author to have a greater degree of confidence in these multiple grain SAR determinations from Vanguard Cave than those measured in Gorham's Cave (Chapter 6), which were demonstrated by subsequent single grain measurements to suffer from incomplete zeroing and post-depositional mixing.

In order to confirm this interpretation, and to confirm the veracity of the OSL age model, single grains were measured for sample X729 (field code VAN01-U01), collected at the same location as Pettitt and Bailey's VAN 1 (see below), relatively high in the stratigraphy and a key location for assessing the apparent age disagreement with both the radiocarbon and OSL determinations of Pettitt and Bailey (2000). The measured single grain age distribution confirms only a degree of incomplete zeroing for this sample, and lends support to an older chronology for sediment deposition in comparison to that published (Pettitt and Bailey 2000). The stratigraphic position of this key sample places a minimum age constraint on the sediments beneath, which represent the majority of the deposits preserved within the cave, and the age estimate suggests that most of the sequence was deposited within or before MIS 5.

The seven samples measured span the main bulk of sediments within the cave, and provide an age model for some of the more important archaeological horizons, including layers associated with the working of marine mammals (Stringer *et al.* 2008). The present paper represents a formal record of the procedures used and the results obtained. At this stage, it is not necessarily considered a definitive statement of the age of these sediments, and important points are made in the discussion, below. As there was a degree of incomplete zeroing witnessed by single grain measurements for sample X729, it seems likely that other samples in this sequence may suffer from similar, relatively modest, age overestimation caused by this effect.

Sample location, preparation and measurement

Sample locations are shown by context number in Table 14.1, and graphically in Figure 14.1. Samples were opened in controlled laboratory lighting within the Research Laboratory for Archaeology and the History of Art (RLAHA), Oxford, UK and the outer 1 to 2 cm from both ends used for water content determination and NAA measurement. The inner sediment from each tube was treated with dilute HCl to remove carbonate and disaggregate grains. Samples were wet sieved, and grains of between 180 and 255 μm were treated in concentrated (40%) HF plus HCl, continuously agitated for around 100 minutes. This treatment removes feldspar grains and etches the surface of each quartz grain. After rinsing and drying, each sample had heavy minerals removed using a sodium polytungstate solution, density 2.68 g.cm^{-3}. The remaining quartz-rich lighter fraction was rinsed and dried, and sieved a second time to remove grains smaller than 180 μm. For conventional multiple grain measurement, grains were mounted on 9.7 mm diameter aluminium or stainless steel discs using a viscous silicone oil, with the sample covering approximately the central 5 mm, corresponding to around 300 grains per aliquot. For single grain OSL measurement, sample X729 was re-sieved using a 212 μm mesh, and only the finer fraction used.

Preheating was conducted at 260°C for 10s before natural and regenerative-dose OSL measurements and a heat treatment of 220°C for 10s before each sensitivity measurement was used. Routine assessment of IRSL as a measure of feldspar contamination demonstrated only negligible signals (<0.5% OSL). All measurements were made

Table 14.1 Parameters used to calculate quartz OSL age estimates for samples from Vanguard Cave.
For sample X729 both multiple grain and single grain OSL results are shown (note that dose rate data remain the same for both). For other samples, data are for multiple grain SAR data.

Field code	Lab. code	Stratigraphic context range	K (%)	Th (ppm)	U (ppm)	Gamma dose rate (mGy/a)		1 sigma uncertainty (mGy/a)	Total dose rate (mGy/a)		1 sigma uncertainty (mGy/a)	Equivalent dose (Gy)		1 sigma uncertainty (Gy)	Age (years before present)		1 sigma uncertainty (years)
VAN01-U02	X730	1 to 49	0.37	2.81	0.89	0.31	±	0.01	0.71	±	0.03	52.0	±	2.8	73700	±	5300
VAN01-U01	X729	50	0.12	0.91	0.40	0.16	±	0.01	0.30	±	0.02	40.7	±	1.5	134900	±	10200
								Single grain data X729:				30.9	±	1.5	102400	±	8300
VAN01-M02	X724	51 to 150	0.21	1.90	0.38	0.18	±	0.01	0.40	±	0.02	46.4	±	1.8	116800	±	8300
VAN01-M06	X728	151	0.19	2.03	0.36	0.19	±	0.01	0.39	±	0.02	52.2	±	2.6	133100	±	10300
VAN98-OSL8	X369	154–155	0.21	3.43	0.51	0.31	±	0.01	0.57	±	0.03	70.5	±	4.8	123500	±	10100
VAN01-L01	X720	169	0.31	2.29	0.45	0.21	±	0.01	0.50	±	0.03	58.7	±	2.1	116700	±	7800
VAN01-L03	X722	174	0.21	1.88	0.35	0.20	±	0.01	0.42	±	0.02	54.6	±	3.8	131100	±	11700

using a Risø TL-DA-15 Minisys automated reader fitted with clusters of Nichia NSPB500S blue-green diodes with a peak emission at 470vnm, and an IRSL laser diode centred at 830 nm, and detection made with an EMI 9235QB15 PMT through 7.5 mm of Hoya U340 filter. A measurement temperature of 125°C was used in order to keep the 110°C TL empty during OSL measurement. Following the measurement of the natural OSL and sensitivity measurement SAR cycle, four regenerative dose cycles were administered in turn, followed by a full zero dose cycle, and a repeat of the first regenerative dose cycle, to assess the recycling ratio. Analysis was made using weighted linear fitting based on propagation of all measurement errors, using an orthogonal fitting procedure, designed to reduce error correlation problems.

Dose rates were determined for each sample using neutron activation analysis (NAA) of U, Th and K content to estimate the beta dose rates, using the energy conversion figures of Adamiec and Aitken (1998), allowing for grain size attenuation using the values of Mejdahl (1979) and water content attenuation (assuming a uniform value of 10 ± 5%) using the equations in Aitken (1985). Gamma dose rates were based on the *in situ* determinations made in each sampling location, which also provide an independent measure of U, Th and K content. Following the approach described in Rhodes *et al.* (2006), this comparison can be used to provide a first order assessment of the degree of U disequilibrium for each sample and to assess the spatial inhomogeneity of sediments at each location. As the principal cause of departure between the OSL age estimates presented here and those documented by Pettitt and Bailey (2000) arises from differences in dose rate, this comparison assumes an enhanced importance for this site, and is discussed further below. The cosmic dose rate contribution was estimated for both Vanguard and Gorham's Cave samples using the equations of Prescott and Hutton (1994), assuming an effective burial depth of 50 m.

OSL dating results

These samples are characterized by relatively intense, rapid OSL decays, typical of quartz from aeolian contexts, and similar to signals observed elsewhere in Gibraltar and Morocco (e.g. Rhodes *et al.* 2006; Bouzouggar *et al.* 2007). As mentioned above, the measured SAR equivalent dose distributions showed relatively little variation between aliquots. As discussed for the samples from Gorham's Cave

(Chapter 6), the interpretation of the degree of variation observed in multiple grain SAR distributions depends subtly on details of the single grain sensitivity distribution. In summary, observed variation between aliquots clearly signals problems of mixed dose populations, but tightly grouped distributions (such as those observed here) may be caused either by very little variation between the equivalent dose values of individual grains, or alternatively may result from averaging of the signals where the characteristics of the single grain sensitivity distribution have this property. A fuller examination of this issue goes beyond the scope of this paper; Rhodes (2007) provides examples and discussion. However, samples from a single region often share luminescence characteristics, so the observation of mixed dose populations using multiple grain SAR determinations within Gorham's Cave (Chapter 6) tends to support the suggestion that these sediments from Vanguard Cave, which do not show the same degree of variation, in general do not suffer from severe incomplete zeroing or post-depositional grain mixing.

In order to assess the veracity of these age estimates, one sample from a key stratigraphic position was selected for single grain analysis, using similar methods to those described for samples from Gorham's Cave. The multiple grain SAR age estimate for sample X729 of 134,900 ± 10,200 years is strikingly higher than those samples located beneath it (Table 14.1), and is therefore a prime candidate to have suffered from age overestimation owing to incomplete zeroing at deposition. It also comes from the same location as sample VAN 1 of Pettitt and Bailey (2000), who determined an age of 46,320 ± 3300 years, in apparent agreement with uncalibrated radiocarbon determinations ranging from 46,900 ± 1500 to 54,000 ± 3300 years. The disagreement between the two OSL datasets is discussed further below.

Figure 14.2 shows a radial plot of the single grain results for this sample. Whilst a few grains display higher values, probably caused by incomplete zeroing during deposition, the majority of grains cluster around an age of about 100 ka. Using a finite mixture model (FMM), three dose populations were isolated. The youngest of these comprises 82 per cent of the grains measured, and suggests that this sample suffered only low to moderate effects of incomplete zeroing; the single grain age estimate based on this lowest FMM dose population is around 25 per cent lower than the multiple grain age, and provides an age of 102,400 ± 8300

Vanguard Cave

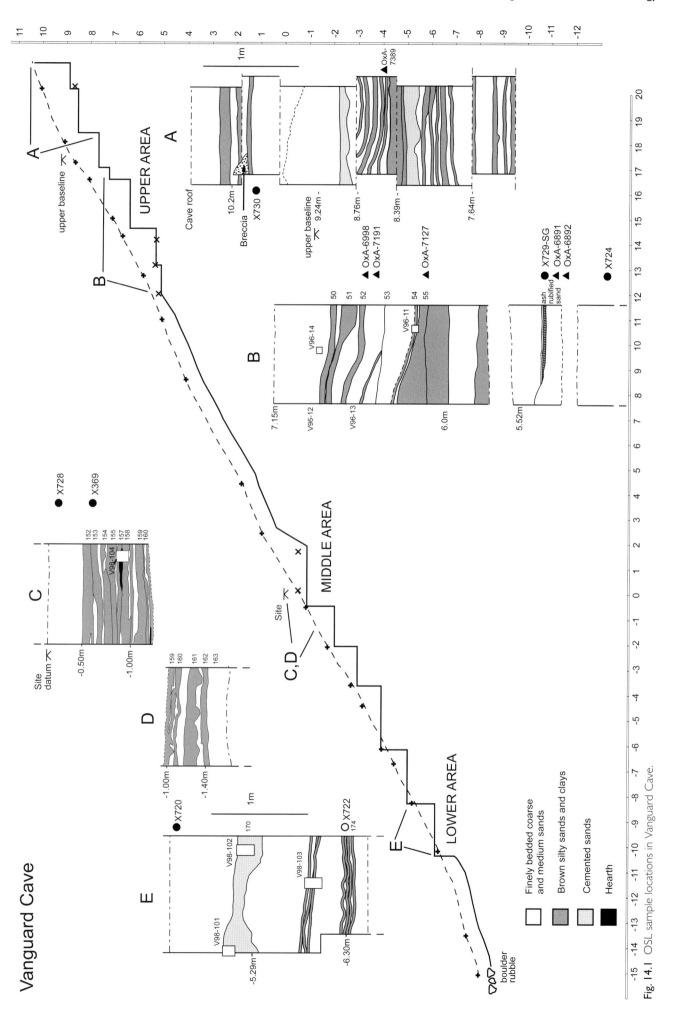

Fig. 14.1 OSL sample locations in Vanguard Cave.

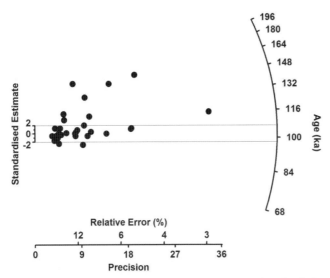

Fig. 14.2 Radial plot showing individual age estimate values for single grains of sample X729. 82 per cent of grains are consistent with the lowest value of three at 102,400 ± 8300 years isolated using a finite mixture model.

years. The multiple grain age estimate from this sample was the one which appeared most divergent from the other samples (Table 14.1), lending further support to the suggestion that in Vanguard Cave, the samples have a relatively simple history, representing transport outside the cave with a high degree of signal resetting, transport into the cave, and deposition incorporating only a small fraction of unexposed grains from within the cave. Subsequently, little modification, burrowing or mixing appears to have taken place.

Bayesian age model

Following the methods outlined in Rhodes *et al.* (2003), the radiocarbon calibration program OxCal was used to construct a Bayesian age model for these seven OSL age estimates. The single grain result from sample X729 was incorporated with the multiple grain results from the remaining six samples, and analysis boundaries were inserted at the top and bottom of the sequence, and also between X729 and the overlying sample, X730. The analysis provides an overall agreement index of 90 per cent, indicating a high degree of internal consistency. The resulting age model estimates are provided in Table 14.2, in all cases with 1 sigma (68%) uncertainties.

Discussion

The OSL data presented here are consistent with a relatively simple history of grain movement into and within

Vanguard Cave. The single grain determination for sample X729 from relatively high in the succession provides a firm minimum age for the underlying deposits, and as the underlying samples all provide age estimates which are not a great deal older, it constrains their deposition to be within MIS 5 or older. Sample X729 clearly did suffer from a degree of incomplete signal zeroing, while samples from nearby Gorham's Cave also suffered from post-depositional mixing. Therefore, until further single grain analyses are performed for other samples, these multiple grain age estimates, and the age model based on these, should be treated with a degree of caution.

These age estimates and age model are considerably older than radiocarbon and OSL ages presented by Pettitt and Bailey (2000). The radiocarbon estimates range from 46,900 to 54,000 radiocarbon years BP, and are at the extreme upper age limits of this technique, where a very small amount of contamination with modern carbon can cause significant underestimates. The OSL age estimate for sample VAN 1, collected from the same location as X729 (the 1998 collection hole was clearly visible in 2001), is 46,320 ± 3300 years. However, the equivalent dose value for this sample determined by Pettitt and Bailey (2000) of 36.28 ± 1.03 Gy lies between the multiple grain determination for X729 of 40.7 ± 1.5 Gy and the single grain value of 30.9 ± 1.5 Gy for the lowest peak in the FMM analysis (Table 14.1). The significant difference in the ages comes from differences in the dose rate values used. For the dates presented here, gamma dose rate values were based on *in situ* NaI gamma spectrometry while beta dose rates were calculated using NAA; Pettitt and Bailey (2000) used ICPMS measurements to estimate both gamma and beta dose rates. The same water content value was used in both studies.

It is clearly important to assess which dose rate values are reliable. The present study used two methods, NAA performed at Becquerel Laboratories, Lucas Heights, New South Wales, Australia, and *in situ* NaI gamma spectrometry using a portable Ortec microNomad machine calibrated in concrete blocks doped with U, Th and K. The dose rates and effective radioactive isotope concentrations in these calibration blocks are well established (Rhodes and Schwenninger 2007), and this same gamma spectrometer and NAA approach was used to determine OSL ages of samples from archaeological sites with exceptionally good independent age control, for which the OSL determinations were in excellent agreement with uncertainties of only a few per cent (Rhodes *et al.* 2003). These observations, besides

Table 14.2 Results of a Bayesian age model, based on the single grain age estimate for sample X729 and on multiple grain results for all other samples. Overall agreement index was 90 per cent.

Field code	Lab. code	Stratigraphic context range	Measured age (years before present)		1 sigma uncertainty (years)	Model age (years before present)		1 sigma uncertainty (years)
VAN01-U02	X730	1 to 49	73700	±	5300	75100	±	5300
VAN01-U01	X729-SG	50	102400	±	8300	108500	±	7000
VAN01-M02	X724	51 to 150	116800	±	8300	114000	±	5000
VAN01-M06	X728	151	133100	±	10300	118000	±	4500
VAN98-OSL8	X369	154-155	123500	±	10100	121600	±	4600
VAN01-L01	X720	169	116700	±	7800	123200	±	5000
VAN01-L03	X722	174	131100	±	11700	126500	±	6800

Table 14.3 Summary of *in situ* portable NaI gamma spectrometry measurements made during 2001 field visit for both Vanguard Cave and Gorham's Cave.

Measurement code	OSL field code or context	OSL lab. code	NaI-GS K conc. (%K)		1 sigma uncertainty	NaI-GS U conc. (ppm U)		1 sigma uncertainty	NaI-GS Th conc. (ppm Th)		1 sigma uncertainty	Sediment gamma diose rate (mGy/a)		1 sigma uncertainty
Vanguard Cave														
U1A	VAN01-U01	X729	0.161	±	0.003	0.471	±	0.019	1.277	±	0.040	0.158	±	0.003
U2A	VAN01-U02	X730	0.424	±	0.007	0.851	±	0.034	2.511	±	0.072	0.312	±	0.006
U3A			0.269	±	0.005	0.664	±	0.029	1.715	±	0.058	0.230	±	0.005
U5A			0.447	±	0.008	0.823	±	0.038	2.685	±	0.084	0.326	±	0.007
U6A			0.277	±	0.005	0.548	±	0.025	1.911	±	0.057	0.217	±	0.004
U7A			0.167	±	0.005	0.461	±	0.027	1.407	±	0.059	0.161	±	0.006
U8A			0.165	±	0.004	0.434	±	0.023	1.191	±	0.049	0.143	±	0.005
U9A			0.119	±	0.003	0.340	±	0.019	0.794	±	0.038	0.107	±	0.002
984A1			0.356	±	0.005	0.666	±	0.025	2.213	±	0.055	0.261	±	0.005
985A1			0.270	±	0.005	0.538	±	0.025	1.875	±	0.057	0.217	±	0.004
986A1			0.353	±	0.006	0.693	±	0.031	2.132	±	0.067	0.268	±	0.005
987A1			0.386	±	0.006	0.706	±	0.027	2.267	±	0.059	0.283	±	0.006
988A1	VAN98-OSL1	X369	0.432	±	0.006	0.704	±	0.030	2.541	±	0.068	0.311	±	0.006
M1A			0.202	±	0.004	0.475	±	0.024	1.744	±	0.055	0.184	±	0.004
M2A	VAN01-M02	X724	0.208	±	0.005	0.454	±	0.024	1.659	±	0.055	0.182	±	0.004
M3A			0.427	±	0.006	0.765	±	0.029	2.419	±	0.065	0.309	±	0.006
M4A			0.344	±	0.004	0.622	±	0.018	2.089	±	0.041	0.260	±	0.005
M6B	VAN01-M06	X728	0.207	±	0.002	0.474	±	0.012	1.721	±	0.029	0.187	±	0.004
L1A	VAN01-L01	X720	0.260	±	0.005	0.510	±	0.024	1.837	±	0.054	0.209	±	0.004
L2A			0.276	±	0.005	0.405	±	0.025	1.768	±	0.059	0.200	±	0.004
L3A	VAN01-L03	X722	0.236	±	0.004	0.560	±	0.021	1.693	±	0.046	0.202	±	0.004
LM1	Limestone niche		0.038	±	0.004	0.425	±	0.016	0.145	±	0.016	0.067	±	0.001
MM2			0.378	±	0.004	0.704	±	0.016	2.147	±	0.036	0.272	±	0.006
RB1	Recent beach		0.215	±	0.003	0.555	±	0.018	1.330	±	0.037	0.177	±	0.004
Gorham's Cave														
GOR95-L1A	JR95GorL1		0.323	±	0.008	0.843	±	0.047	2.376	±	0.097	0.286	±	0.006
GOR95-BAA			0.287	±	0.004	0.760	±	0.024	1.939	±	0.048	0.257	±	0.005
GOR01-01A	GOR01-01	X714	0.179	±	0.005	0.546	±	0.029	1.263	±	0.057	0.165	±	0.006
GOR01-02A	GOR01-02	X715	0.176	±	0.005	0.457	±	0.028	1.468	±	0.060	0.168	±	0.006
GOR01-03A	GOR01-03	X716	0.226	±	0.006	0.594	±	0.031	1.470	±	0.061	0.198	±	0.004
GOR01-04A	GOR01-04	X717	0.235	±	0.006	0.606	±	0.032	1.561	±	0.065	0.208	±	0.004
GOR01-05A	GOR01-05	X718	0.229	±	0.004	0.545	±	0.022	1.511	±	0.047	0.189	±	0.004
GOR01-06A	GOR01-06	X719	0.268	±	0.006	0.643	±	0.032	1.950	±	0.068	0.228	±	0.005
GOR01-LM1	Limestone niche		0.099	±	0.002	0.571	±	0.012	0.315	±	0.015	0.110	±	0.002

results from many additional samples treated using a similar methodology, provide a high degree of confidence in the accuracy of the combined *in situ* NaI and NAA approach used in this study.

Table 14.3 contains a summary of all the NaI gamma spectrometer measurements made during the 2001 site visit, along with associated 1 sigma uncertainties, including measurements made at Gorham's Cave. This provides the opportunity to assess the range of values recorded for K, U and Th content, and the total gamma dose rate using a threshold technique. For each OSL sample that was dated in this study, results of U, Th and K content were determined using NAA. Comparison of the *in situ* NaI gamma spectrometry results and NAA results provides the opportunity to assess spatial inhomogeneity and severe U-series disequilibrium besides the consistency between the two techniques (Table 14.4, upper part). Some samples show signs of spatial inhomogeneity in dose rate such as X369, while others show very little such as X730 or X724. One sample (X722) from

Vanguard Cave and two from Gorham's Cave show indications of U-disequilibrium, though this is unlikely to have adversely affected their age estimates significantly, owing to the methods of dose rate estimation adopted. Overall, the averages of the ratios for K, U and Th for the two independent techniques, at 1.17, 1.23 and 0.93 respectively, provide evidence for the robusticity of these methods and increase the confidence in dose rates calculated by these means.

The lower part of Table 14.4 compares the K, U and Th concentrations measured by both *in situ* NaI and NAA (X729 = VAN 1) and just *in situ* NaI (987A1 = VAN 7) with the two sets of ICPMS data for K, U and Th presented by Pettitt and Bailey (2000). In contrast to the NaI-NAA comparisons above, there is a strong disagreement in all three concentrations for the first sample (X729 = VAN 1), and for the second comparison there is just a moderate departure for K and U values, while Th concentration is within 20 per cent of unity. The K and U ICPMS values for samples VAN 1 and VAN 7 lie outside the range of all

Table 14.4 Upper part: Comparison of *in situ* NaI gamma spectrometer measurements and NAA results for dated samples from Vanguard and Gorham's Caves, with ratios between K, U and Th data from each method to the right. Note that departures from unity may be caused by spatial inhomogeneities in the sediment, and do not necessarily indicate problems. Lower part: Comparison between average of NaI and NAA (X729) and NaI only (987A1) data from 2001 and the ICPMS data of Pettitt and Bailey (2000). The ratios between the ICPMS data and NaI-NAA (or just NaI) are shown to the right. The ICPMS data provide significantly higher values and are considered unreliable.

Measurement code	OSL field code or context	OSL lab. code	NaI-GS K conc. (%K)	NaI-GS U conc. (ppm U)	NaI-GS Th conc. (ppm Th)	NAA K conc. (%K)	NAA U conc. (ppm U)	NAA Th conc. (ppm Th)	K NaI/NAA	U NaI/NAA	Th NaI/NAA
In-situ NaI gamma spectrometer measurements compared to NAA of same samples											
Vanguard Cave											
U1A	VAN01-U01	X729	0.161	0.471	1.277	0.121	0.40	0.91	1.33	1.18	1.40
U2A	VAN01-U02	X730	0.424	0.851	2.511	0.374	0.89	2.81	1.13	0.96	0.89
987A1			0.386	0.706	2.267						
988A1	VAN98-OSL1	X369	0.432	0.704	2.541	0.209	0.51	3.43	2.07	1.38	0.74
M2A	VAN01-M02	X724	0.208	0.454	1.659	0.207	0.38	1.9	1.00	1.19	0.87
M6B	VAN01-M06	X728	0.207	0.474	1.721	0.192	0.36	2.03	1.08	1.32	0.85
L1A	VAN01-L01	X720	0.260	0.510	1.837	0.308	0.45	2.29	0.84	1.13	0.80
L3A	VAN01-L03	X722	0.236	0.560	1.693	0.213	0.35	1.88	1.11	1.60	0.90
Gorham's Cave											
GOR01-01A	GOR01-01	X714	0.179	0.546	1.263	0.144	0.35	1.27	1.24	1.56	0.99
GOR01-02A	GOR01-02	X715	0.176	0.457	1.468	0.140	0.27	1.50	1.26	1.69	0.98
GOR01-03A	GOR01-03	X716	0.226	0.594	1.470	0.186	0.53	1.52	1.22	1.12	0.97
GOR01-04A	GOR01-04	X717	0.235	0.606	1.561	0.208	0.60	1.49	1.13	1.01	1.05
GOR01-05A	GOR01-05	X718	0.229	0.545	1.511	0.294	0.74	2.07	0.78	0.74	0.73
GOR01-06A	GOR01-06	X719	0.268	0.643	1.950	0.280	0.59	2.16	0.96	1.09	0.90
								Averages:	1.17	1.23	0.93

			Combined NaI-NAA K conc. (%K)	Combined NaI-NAA U conc. (ppm U)	Combined NaI-NAA Th conc. (ppm Th)	P & B ICPMS K conc. (%K)	P & B ICPMS U conc. (ppm U)	P & B ICPMS Th conc. (ppm Th)	K ICPMS/ NaI&NAA	U ICPMS/ NaI&NAA	Th ICPMS/ NaI&NAA
Comparison of above data with ICPMS values of Pettitt and Bailey (2000)											
U1A	VAN01-U01	X729	0.141	0.436	1.094	0.52	1.2	2.2	3.69	2.76	2.01
987A1	No NAA data		0.321	0.607	2.986	0.45	0.9	2.4	1.40	1.48	0.80
								Averages:	2.55	2.12	1.41

Table 14.5 Radiocarbon dates on charcoal (Bronk Ramsey *et al.* 2002); for locations see Figure 14.1.

OxA no.	Sample no.	Area Context	Conventional radiocarbon age BP	δ13C (‰)
OxA-7389	Van96 377	A upper	45200 ± 2400	-25.5
OxA-6998	Van96 245	B 52	41800 ± 1400	-25.1
OxA-7191	Van96 230	B 52	10170 ± 120**	-15.1
OxA-7127	Van96 347	B 55	>49400	-24.4*
OxA-6891	Van96 285a	B hearth	54000 ± 3300	-22.1
OxA-6892	Van96 285b	B hearth	46900 ± 1500	-22.6

* TM 13C ** bone date

NaI and NAA measurements at Vanguard and Gorham's Caves (Table 14.3), though only marginally for the latter sample. On balance, the relatively high degree of concordance between *in situ* NaI and NAA measurements, and the atypical U and K ICPMS values in particular for VAN 1, call into doubt the ICPMS results of Pettitt and Bailey (2000). Clearly, this issue is worthy of further investigation in the future using independent techniques.

Conclusions

Quartz OSL data from seven samples, including single grain measurements for sample X729 at a key point in the succession, allow a coherent age model to be constructed

(Table 14.2) which indicates that much of Vanguard Cave was filled around the time of MIS 5. These age estimates provide a chronology for the use of marine mammals by Neanderthal populations (Stringer *et al.* 2008). The age estimates are older than the OSL chronology presented by Pettitt and Bailey (Table 14.5), but this is primarily caused by a difference in dose rate estimation. The techniques used for dose rate estimation in the present study have been shown to produce accurate OSL age estimates (Rhodes *et al.* 2003), and the relatively high degree of consistency between the two methods used here increases confidence in their veracity. A Bayesian age model based on the one single grain age estimate (X729) and remaining six multiple grain ages shows a high degree of internal agreement, and provides the best chronology for sediment deposition in Vanguard Cave available at present. This chronology can be further refined in the future by making additional dose rate determinations with independent techniques, measuring further samples using single grain methods, and increasing the number of age estimates within the profile.

Acknowledgements

The author would like to thank Roger Nathan for assistance in collecting samples and Jean-Luc Schwenning for

help in laboratory preparation. Nick Barton, Tom Higham, Clive Finlayson and Chris Stringer plus members of the 2001 excavation team are thanked for support and useful discussion.

References

Adamiec, G. and Aitken, M. J. 1998: Dose-rate conversion factors: new data. *Ancient TL* 16, 37–50.

Aitken, M. J. 1985: *An Introduction to Optical Dating.* Oxford University Press, Oxford.

Bouzouggar, A., Barton, N., Vanhaeren, M., d'Errico, F., Collcutt, S., Higham, T., Hodge, E., Parfitt, S., Rhodes, E. J., Schwenninger, J.-L., Stringer, C. B., Turner, E., Ward, S., Moutmir, A. and Stambouli, A. 2007: 82,000-year-old shell beads from North Africa and implications for the origins of modern behaviour. *Proceedings of the National Academy of Sciences* 104, 9964–9969.

Bronk Ramsey, C., Higham, T. F. G., Owen, D. C., Pike, A. W. G. and Hedges, R. E. M. 2002: Radiocarbon dates from the Oxford AMS system: Archaeometry datelist 31. *Archaeometry* 44(3), Supplement 1, 1–149.

Mejdahl, V. 1979: Thermoluminescence dating: beta-dose attenuation in quartz grains. *Archaeometry* 21, 61–72.

Murray, A. S. and Wintle, A. G. 2000: Luminescence dating of quartz using an improved single-aliquot regenerative-dose protocol. *Radiation Measurements* 32, 57–73.

Murray, A. S. and Wintle, A. G. 2003: The single aliquot regenerative dose protocol: potential for improvements in reliability. *Radiation Measurements* 37, 377–381.

Pettitt, P. B. and Bailey, R. M. 2000: AMS radiocarbon and luminescence dating of Gorham's and Vanguard Caves, Gibraltar, and implications for the middle to upper palaeolithic transition in Iberia. *Neanderthals on the Edge* (Stringer, C. B., Barton, R. N. E. and Finlayson, J. C., eds.), Oxbow, Oxford, UK, 155–162.

Prescott, J. R. and Hutton, J. T. 1994: Cosmic ray contributions to dose rates for luminescence and ESR dating: large depths and long-term time variations. *Radiation Measurements* 23, 497–500.

Rhodes, E. J. 2007: Quartz single grain OSL sensitivity distributions: implications for multiple grain single aliquot dating. *Geochronometria* 26, 19–29.

Rhodes, E. J. and Schwenninger, J.-L. 2007: Dose rates and radioisotope concentrations in the concrete calibration blocks at Oxford. *Ancient TL* 25, 5–8.

Rhodes, E. J., Bronk-Ramsey, C., Outram, Z., Batt, C., Willis, L., Dockrill, S. and Bond, J. 2003: Bayesian methods applied to the interpretation of multiple OSL dates: high precision sediment age estimates from Old Scatness Broch excavations, Shetland Isles. *Quaternary Science Reviews* 22, 1231–1244.

Rhodes, E. J., Singarayer, J. S., Raynal, J.-P., Westaway, K. E. and Sbihi-Alaoui, F. Z. 2006: New age estimates for the Palaeolithic assemblages and Pleistocene succession of Casablanca, Morocco. *Quaternary Science Reviews* 25, 2569–2585.

Stringer, C. B., Finlayson, J. C., Barton, R. N. E., Fernández-Jalvo, Y., Cáceres, I., Sabin, R. C., Rhodes, E. J., Currant, A. P., Rodríguez-Vidal, J., Giles-Pacheco, F. and Riquelme-Cantal, J. A. 2008: Neanderthal exploitation of marine mammals in Gibraltar. *Proceedings of the National Academy of Sciences* 105, 14319–14324.

15 Late Pleistocene vegetation reconstruction at Vanguard Cave

S. Ward, R. Gale and W. Carruthers

Introduction

Vanguard Cave presents a comparable thickness of deposits to Gorham's Cave but dates mainly to the last interglacial period. As part of the Gibraltar Caves Project excavations, both the sediments of the Main Chamber and to a lesser extent the Northern Alcove (Figs. 13.2 and 13.3) were investigated. From the Main Chamber sequence, samples for macroscopic charcoal, charred seeds and phytolith analyses were taken from Profile B of the Upper Area, and Profiles C and D of the Middle Area (Fig. 15.1). No botanical material was taken from the Lower Area of the Main Chamber for environmental analysis. The deposits of the Northern Alcove provided further opportunity for environmental analysis (Fig. 15.2).

As with Gorham's Cave, the aims of this study were to examine human uses of plants and to reconstruct the local vegetation dynamics surrounding the cave. At a broader level, we also wanted to investigate the sequence within the context of Late Pleistocene environmental change in the western Mediterranean region.

Methodology

The techniques for examining macroscopic charcoal, charred seeds and phytolith residues were the same as those outlined in Chapter 7.

Main Chamber: results
Macroscopic charcoal analysis

A presence-absence approach was adopted here due to the statistically insignificant fragment numbers available for analysis throughout the entire sequence. Macroscopic remains were recovered from seven sedimentary layers of the Main Chamber sequence, with six originating from the Middle Area (Profiles C and D), and one sample from a hearth context (Upper Hearth associated with the Middle Palaeolithic shell midden) in Upper Area B (Fig. 15.1).

In total, 139 macroscopic charcoal fragments were identified from 56 samples (Table 15.1). The Main Chamber sequence is not dominated by any one particular taxon, although *Pistacia* sp. (terebinth/lentisc/pistachio) is quite prominent throughout, especially in the upper part of the sequence.

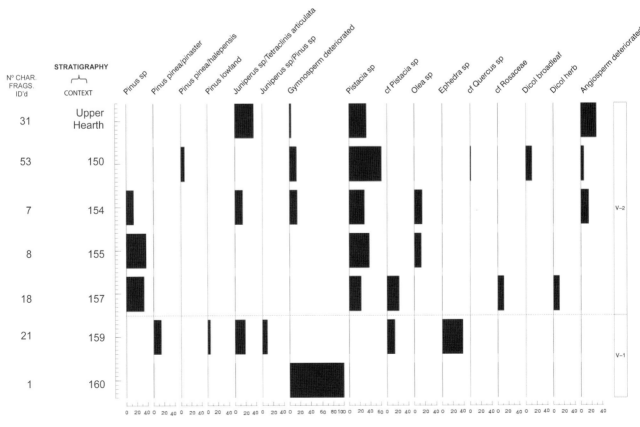

Fig. 15.1 Macroscopic charcoal relative percentage diagram for Upper and Middle Areas sequences (all macroscopic charcoal).

Quantified results (Table 15.1; Fig. 15.1)

The macroscopic charcoal sequence for the Main Chamber sequence was categorized into two zones using optimal splitting by information content, termed V-1 and V-2.

Zone V-1

This zone comprises layers 160 and 159 from the Middle Area (Fig. 15.2). Only one fragment was available for identification from layer 160, and so naturally displays 100 per cent attributable to a single taxon, *Pistacia* sp. For this reason, any reflection of the sum charcoal diagram would be inappropriate. In contrast, layer 159 exhibits a much wider diversity of taxa, with 21 charcoal fragments analysed. Of the identified fragments, 38.1 per cent comprise *Ephedra* sp. (joint pine), while *Pinus pinea/pinaster* (stone/maritime pine) is also a significant presence (both 14.3 per cent). *Juniperus* sp./*Pinus* sp. (9.5 per cent) and *Pinus* lowland defined as either of the low altitude pines *halepensis/pinaster/pinea* (Aleppo/maritime/stone pine) (4.8 per cent) comprise the remainder of the assemblage.

Zone V-2

This zone comprises layers 157, 155, 154 and 150 from the Middle Area, and the hearth in the Upper Area. The zone is dominated by *Pistacia* sp., present in all layers and reaching a peak of 60.4 per cent in layer 150. *Pinus* sp. is observed in the lower three layers (157, 155 and 154), while *Juniperus* sp. (juniper)/*Tetraclinis articulata* (Barbary arbour-vitae) is present in layer 154 and the Upper Hearth, where it peaks at 35.5 per cent. *Olea* sp. is present in layers 155 and 154 (12.5 per cent and 14.3 per cent respectively), although their

Table 15.1 Absolute macroscopic charcoal fragments counts for Upper and Middle Areas sequences.

	Upper Area	Middle Area					
	Upper Hearth	150	154	155	157	159	160
Pinus sp.			1	3	6		
Pinus pinea/pinaster						3	
Pinus pinea/halepensis		4					
Pinus lowland					1		
Juniperus sp./*Tetraclinis articulata*	11		1		4		
Juniperus sp./*Pinus* sp.					2		
Gymnosperm deteriorated	1	7	1				1
Pistacia sp.	10	32	2	3	4		
cf. *Pistacia* sp.					4	3	
Olea sp.			1	1			
Ephedra sp.						8	
cf. *Quercus* sp.		1					
cf. *Rosaceae*					2		
Dicot broadleaf		6					
Dicot herb					2		
Angiosperm deteriorated	9	3	1				
Monocot				1			
Total Fragments	31	53	7	8	18	21	1
No. Samples Analysed	12	20	6	4	6	7	1

low charcoal fragments counts must be a consideration (eight and seven respectively). The sole record for the presence of cf. Rosaceae (11.1 per cent) in layer 157 is also notable.

The sum charcoal diagram is dominated by angiosperms throughout. An increase in both 'Gymnosperm deteriorated' and 'Angiosperm deteriorated' levels is demonstrated in the upper three samples (154, 150 and Upper Hearth), both typically between 5–15 per cent, while monocots feature only in layer 155 at 12.5 per cent.

Density/fragmentation/preservation

Volumetric measurements were not taken during the excavation of the sediments and so no density calculations could be made. Likewise the Pr/Fr Index was deemed inappropriate due to the statistically insignificant charcoal fragments available for identification at this site.

Charred seed analysis

A total of 13 plant macrofossil fragments from the Main Chamber sequence were identified (Table 15.2), all of which were charred and derived from two sedimentary layers (150 and 157). The vast majority of these were identified as being cone scales derived from the stone pine, *Pinus pinea*. Macrofossil identifications of *P. pinea* were confirmed by analysing all *Pinus pinea* Herbarium species native to the area. Two macroscopic fragments were identified as probably being culm nodes, both from sedimentary layer 150.

Phytolith analysis

Nine samples covering two stratigraphic layers were analysed as part of this investigation (Table 15.3). However, no phytoliths were found in any of the samples studied. All nine phytolith samples were almost entirely composed of silt fragments. An average of one to three indeterminable silica morphotypes was observed per slide and so no statistically significant assemblage was demonstrated. Vanguard

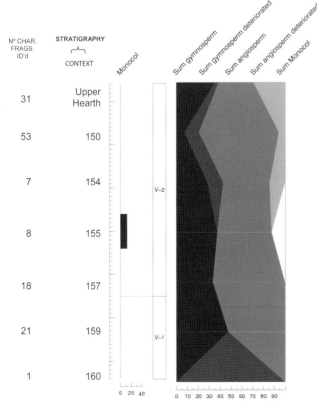

Fig. 15.1 continuation.

Table 15.2 Charred seed and macrofossil material absolute counts for Upper and Middle Areas sequences.

Absolute Fragment Count

Stratum	No. samples	P. pinea Cone scale	cf. P. pinea Cone scale	P. pinea Nut shell	cf. P. pinea Nut shell	Pine Kernel	Other charred remains	Unidentified fragments	Total
150	3	0	6	0	0	0	2 cf. culm nodes	0	8
157	1	4	1	0	0	0	0	0	5
Total	4	4	7	0	0	0	2	0	13

Table 15.3 Phytolith sample data for the Upper and Middle Areas sequences.

VAN...	Sample Number	Area	Sediment Profile	Layer	Context	Weight for start of phytolith prep (g)	AIF Weight (g)	pH	End sediment weight (g)	Resultant weight of residue on slide 1 (mg)	Resultant weight of residue on slide 1 (g)	Counted fields
U	371	Upper	B	Midden Deposit	Sediment	3	1.485	8.38	0.067	0.781	0.00078	44
U	227	Upper	B	Midden Deposit	Sediment	3	1.618	8.27	0.060	0.712	0.00071	42
U	97-291	Upper	B	Midden Deposit	Sediment	3	1.399	8.56	0.033	0.754	0.00075	40
U	97-367	Upper	B	Midden Deposit	Sediment	3	1.441	8.61	0.032	0.786	0.00079	42
U	97-369	Upper	B	Midden Deposit	Sediment	3	1.583	8.39	0.021	0.817	0.00082	40
U	97-372	Upper	B	Midden Deposit	Sediment	3	1.226	8.50	0.013	0.76	0.00076	42
U	97-373	Upper	B	Midden Deposit	Sediment	3	1.170	8.47	0.015	0.755	0.00076	38
U	97-394	Upper	B	Midden Deposit	Sediment	3	1.422	8.62	0.021	0.728	0.00073	40
M	98-1084	Middle	D	160	Sediment	3	1.831	8.30	0.027	0.866	0.00087	40

Cave phytolith samples had been processed in two separate batches which included samples from other sites involved in this thesis. The presence of phytoliths in other site samples therefore suggested that the absence of phytoliths in the Vanguard samples was not due to preparation methods but probably preservation conditions at the site.

Northern Alcove
Macroscopic charcoal analysis
Presence of taxa
A presence-absence approach was used in the analysis of macroscopic charcoal, due to the statistically insignificant fragment numbers counted throughout the entire sequence.

Seven sedimentary layers provided macroscopic data from the Northern Alcove sequence, with four originating from the 1000's sub-sequence, and three from the overlying 500s sub-sequence.

In total, 45 macroscopic charcoal fragments were identified from 13 samples (Table 15.4). Seven variations of taxa are observed, with the assemblage being largely dominated by gymnosperm taxa.

Quantified results (Table 15.4; Fig. 15.2)
The macroscopic charcoal sequence for this sequence was divided into two zones, termed V-1 and V-2, representing statistically distinct patterns in the assemblage data.

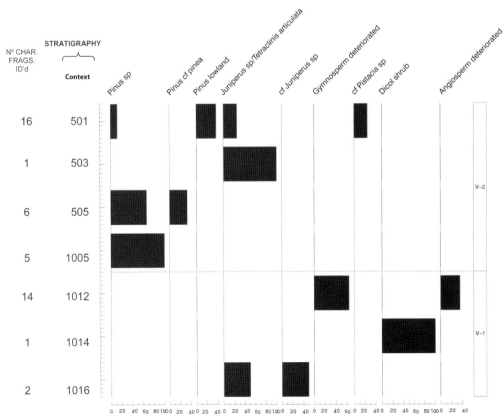

Fig. 15.2 Macroscopic charcoal relative percentage diagram for Northern Alcove Sequence (all macroscopic charcoal). See Table 13.5 for location of contexts.

Table 15.4 Absolute macroscopic charcoal fragments counts for Northern Alcove sequence.

Context	501	503	505	1005	1012	1014	1016
Species							
Pinus sp.	2		4	5			
Pinus cf. *pinea*			2				
Pinus lowland	6						
Juniperus sp./*Tetraclinis articulata*	4	1					1
cf. *Juniperus* sp.							1
Conifer deteriorated					9		
cf. *Pistacia* sp.	4						
Dicot shrub						1	
Dicot deteriorated					5		
Total Fragments	16	1	6	5	14	1	2
No. Samples Analysed	4	1	3	1	1	1	2

However, the low fragment counts for most layers must be of serious consideration in the descriptions below.

Zone V-1

This zone is composed of the three basal 1000 series layers (1016, 1014 and 1012) and is characterized by the presence of *Juniperus* sp./*Tetraclinis articulata* in layer 1016 and a single dicot shrub fragment in layer 1014. Layer 1012 is notable for the deteriorated anatomical state of all available fragments.

Zone V-2

This zone incorporates the uppermost 1000 series layer (1005) and the three overlying 500 series samples. The zone is characterized by the dominance of pine. *Pinus* sp. is present in all but layer 503 (where only one fragment was available). *Juniperus* sp./*Tetraclinis articulata* features in the upper two layers analysed. A notable feature in the uppermost layer 501 is the introduction of *Pistacia* sp., the first presence of angiosperms in zone V-2.

Density/fragmentation/preservation

Volumetric measurements were not taken during the excavation of the sediments and so no density calculations could be made. Likewise the Pr/Fr Index was deemed inappropriate due to the statistically insignificant charcoal fragments available for identification at this site.

Charred seed analysis

A total of 32 plant macrofossil fragments from the Northern Alcove were identified (Table 15.5), derived from three sedimentary layers (503, 505 and 1016). The vast majority of these were identified as being cone scales of stone pine, *Pinus pinea*. Macrofossil identifications of *P. pinea* were confirmed by analysing all *Pinus pinea* Herbarium species native to the area. Four macroscopic fragments were identified as probably being culm nodes, all from sedimentary layer 505.

Phytolith analysis

Four samples covering three stratigraphic layers were analysed as part of this investigation (Table 15.6). Two samples were from cave sediment, and two were from proposed coprolites. However, no phytoliths were found in any of the samples studied. Similar to that observed in samples from the Main Chamber sequence, phytolith samples were almost entirely composed of silt fragments. An average of one to three indeterminable silica morphotypes was observed per slide and so no statistically significant assemblage was demonstrated. Vanguard Cave sediment samples had been processed in two separate batches alongside sediment samples from other sites which also produced phytoliths, thus confirming the methodological robustness of the preparation technique.

Discussion
Reconstruction of vegetation dynamics

The arboreal component of the Main Chamber sequence was dominated by *Pinus* sp. and lowland forms of *Pinus* (i.e. *Pinus pinea, pinaster* or *halepensis*), indicating that pines were present in the landscape surrounding Vanguard Cave at this time. The lowland pines can thrive in relatively diverse environmental conditions, and any (or all three species) could have been present, based on the interpretation of their morphology.

The hearth in the Upper Area is characterized by the presence of *Juniperus* sp./*Tetraclinis articulata* and *Pistacia* sp. The assemblage composition is very similar to that observed in the underlying sedimentary layers of the Middle Area, which is separated by an unknown depth of

Table 15.5 Charred seed and macrofossil material absolute counts for Northern Alcove sequence.

Absolute Fragment Count

Stratum	No. samples	*P. pinea* Cone scale	cf. *P. pinea* Cone scale	*P. pinea* Nut shell	cf. *P. pinea* Nut shell	Pine Kernel	Other charred remains	Unidentified fragments	Total
503	1	7	6	0	0	0	0	0	13
505	3	1	11	0	0	0	4 cf. culm nodes	0	16
1016	1	0	3	0	0	0	0	0	3
Total	5	8	20	0	0	0	4	0	32

Table 15.6 Phytolith sample data from Northern Alcove sequence.

VAN...	Sample Number	Layer	Context	Weight for start of phytolith prep (g)	AIF Weight (g)	pH	End sediment weight (g)	Resultant weight of residue on slide 1 (mg)	Resultant weight of residue on slide 1 (g)	Counted fields
N	30		coprolite	3	1.138	8.56	0.007	0.768	0.00077	42
N	31		coprolite	3	1.452	8.73	0.0224	0.716	0.00072	42
N	28		sediment	3	1.879	8.44	0.0321	0.892	0.00089	40
N	96-415		sediment	3	1.484	8.81	0.017	0.674	0.00067	40

sterile sands estimated to be over 5 m in thickness but none-theless belonging to the same interglacial cycle. The macroscopic charcoal results from the Upper and Middle Areas are consistent with an identical arboreal landscape existing in the local area surrounding Vanguard Cave during these phases of cave habitation.

Despite the low numbers of charcoal fragments present, the range of understorey and shrub species represented in the Vanguard charcoal record was apparently quite diverse. It was composed of *Juniperus* sp./*Tetraclinis articulata*, *Pistacia* sp., *Quercus* sp. (oak) and *Olea* sp. (wild olive). This is consistent with initial macroscopic charcoal results reported in Gale and Carruthers (2000). Both *Pistacia* sp. and *Olea* sp. species are present today on Gibraltar. *Pistacia* sp. is a common small dioecious evergreen shrub, considered to be indicative of Mediterranean evergreen plant communities (Polunin and Smythies 1973), and generally found at altitudes up to 800 m in dry wood and scrublands (Dogan *et al.* 2003) within the Thermo-Mediterranean ecotone (Rivas-Martínez 1987). *Olea* sp. is indicative of similar environmental parameters, and is currently found above the cave today, along with *Pistacia lentiscus* (lentisc) and *Ephedra* sp. (joint pine), forming part of the maquis vegetation.

The range and composition of botanical finds, particularly in the Vanguard Cave Middle Area, are therefore very similar to those living around the cave at the present day. This is consistent with the dating evidence which suggests occupation occurred during the warmer parts of an interglacial period (see Rhodes, Chapter 14). An analogous, although very limited, macroscopic charcoal assemblage is apparently present in the Northern Alcove, believed to be contemporaneous with the main sequence at Vanguard (Chapter 13), though undated. Here, lowland pines, *Juniperus* sp., and *Pistacia* sp. were again identified, signalling very similar local vegetation at the time of occupation.

Anthropogenic vegetation use

Human diet

As in Gorham's Cave, the presence of substantial deposits of charred *Pinus pinea* cone fragments in several of the stratigraphic units at Vanguard Cave suggests that they are the result of human activity. The widespread charring of the macrofossil seeds indicates that the inhabitants may have used fire for processing the cones and extracting or roasting the pine nuts.

According to this evidence it is highly probable that the systematic processing of pine cone was a common practice in the last interglacial period and supports the idea that stone pine nuts were a regular component of the human diet.

Palaeoenvironmental change

The macroscopic charcoal results from Vanguard Cave spanning part of MIS 5 offer very little evidence of taxonomical change, with an arboreal landscape apparently dominated by warm-climate vegetation. The chief thermophilous indicator species are *Pistacia* sp. and *Olea* sp., with both species preferentially located presently within Thermo-Mediterranean bioclimates (<600 m a.s.l.) (Rivas-Martínez 1987; Finlayson *et al.* 2008) and currently part of the flora growing above Vanguard Cave.

The Vanguard charcoal assemblage is consistent with other environmental records attributable to the last interglacial from southern Iberia, namely pollen from marine cores (e.g. Pérez-Folgado *et al.* 2004), as well as terrestrial records at Carihuela Cave (pollen zone R) (Carrión *et al.* 1998) and Padul (St. Germain 1a interstadial) (Pons and Reille 1988). These records are characterized by the expansion of temperate (e.g. *Quercus* deciduous) and meso-thermophilous (e.g. *Olea, Pistacia, Phillyrea*, etc.) vegetation, and the decline of cold steppic (*Artemisia*, Chenopodiaceae, etc.) vegetation. While consideration must be given to the fact that both Carihuela (1020 m a.s.l.) and Padul (785 m a.s.l.) occur at significantly higher altitudes, they nevertheless display a clear similarity with the Vanguard finds. Further support for a warm environment around Vanguard Cave at this time has been provided by avifaunal records (Chapter 17), which include terrestrial species typical of woodland habitats.

Conclusions

The Vanguard Cave macroscopic charcoal record presents a useful archive of past vegetation history, and provides evidence that humans were certainly present during parts of the last interglacial when the climate was as warm as today. As with Gorham's Cave, further work is now required in order to generate statistically significant charcoal assemblages across the whole sequence, to fill in any temporal gaps and to improve our understanding of vegetational dynamics during the last glacial/interglacial cycle. The charred seed record, although still fairly limited at Vanguard, suggests that seeds were being processed and that *Pinus pinea* nuts no doubt formed part of the human diet during the last interglacial. This evidence of plant use suggests continuity between the mainly last glacial record of occupation at Gorham's Cave and slightly earlier activity represented in Vanguard Cave.

Acknowledgements

The funding for this D Phil. research was provided by the Natural Environmental Research Council (NERC). We thank Dr Tina Badal (Universitat de València) for assistance with identification of deteriorated charcoal fragments, and Dr Marco Madella for advice on phytolith methodology. Further thanks go to Dr Stephen Jury (University of Reading), Dr Norman Charnley (University of Oxford), and members of the Gibraltar Caves Project, past and present. Many thanks to Professor Kathy Willis and Professor Nick Barton for their valuable comments and advice throughout.

References

Carrión, J. S., Munuera, M. and Navarro, C. 1998: The palaeoenvironment of Carihuela Cave (Granada, Spain): a reconstruction on the basis of palynological investigations of cave sediments. *Review of Palaeobotany and Palynology* 99(3–4), 317–340.

Dogan, Y., Baslar, S., Aydin, H. and Mert, H. M. 2003: A study of the soil-plant interactions of *Pistacia lentiscus* L. distributed in the western Anatolian part of Turkey. *Acta Botanica Croatica* 62, 73–88.

Finlayson, C., Finlayson, G., Giles Pacheco, F., Rodríguez-Vidal, J., Carrión, J. and Recio Espejo, J. M. 2008: Caves as archives of ecological and climatic changes in the Pleistocene – the case of Gorham's Cave, Gibraltar. *Quaternary International* 181, 55–63.

Gale, R. and Carruthers, W. 2000: Charcoal and charred seed remains from Middle Palaeolithic levels at Gorham's and Vanguard Caves. *Neanderthals on the edge*, eds. C. B. Stringer, R. N. E. Barton and C. Finlayson (Oxford: Oxbow Books), 207–210.

Pérez-Folgado, M., Sierro, F. J., Flores, J. A., Grimalt, J. O. and Zahn, R. 2004: Paleoclimatic variations in foraminifer assemblages from the Alboran Sea (Western Mediterranean) during the last 150 ka in ODP Site 977. *Marine Geolog* 212(1–4), 113–131.

Polunin, O. and Smythies, B. E. 1973: *Flowers of South-West Europe: A Field Guide* (London, New York and Toronto: Oxford University Press).

Pons, A. and Reille, M. 1988: The Holocene and Upper Pleistocene pollen record from Padul (Granada, Spain): a new study. *Palaeogeography, Palaeoclimatology, Palaeoecology* 66, 243–263.

Rivas-Martínez, S. 1987: *Memoria del mapa de series de vegetacíon de España. 1:400.000* (Madrid, I.C.O.N.A.).

16 Herpetofaunal evidence from Vanguard Cave

C. Gleed-Owen and C. Price

Introduction

The examination of the reptile and amphibian remains from Vanguard Cave complements the work on those from Gorham's Cave presented in Chapter 8. Although only a limited number of samples from Vanguard Cave were examined, this was sufficient to add one further new species to the record. A minimum of 17 species were identified within the stratigraphy of the Middle Area of the cave.

Methods

The material from Vanguard Cave was treated in the same way as that from Gorham's Cave (Chapter 8). The results presented here are from a restricted selection of around 30 samples, mostly from the 1995 excavation season.

Middle Area: results (Table 16.1)
Contexts 152 and 153

Stratigraphically the highest included in this chapter, context 152 would seem to indicate a rather damper environment around the cave than is seen in earlier deposits. It includes the only recorded specimen of stripe-necked terrapin (*Mauremys caspica*) identified in this study. This species is found in larger water bodies than the similar European pond terrapin (*Emys obicularis*) and is tolerant of brackish conditions (Arnold and Ovenden 2002). This is currently the only context in which the species has been found. Context 153 produced a similar range of species, with the addition of four lizards. These are the spiny-footed lizard (*Acanthodactylus erythrurus*), a possible large psammodromus (*Psammodromus algirus*), ocellated lizard (*Timon lepidus*) and a skink (*Chalcides* sp.). These are all found in present-day southern Iberia, and are also frequently recorded from the Gorham's samples. The spiny-footed lizard is a denizen of open, sandy areas, whilst the large psammodromus is usually found in dense bushy places (Arnold and Ovenden 2002). The skink inhabits a wide variety of habitats, but is most commonly found in dry open woodland or scrub/matorral. It is a large lizard, reaching almost a metre in length, and is of potential interest as a human food resource. The two skinks present in modern Iberia, *Chalcides bedriagai* (Bedriaga's skink) and *Chalcides chalcides* (three-toed skink) have rather different habitat preferences, the former preferring sandy habitats with either sparse vegetation or low plant growth whilst the latter is usually found in damper environments with dense low vegetation. Both are intolerant of cold. *Chalcides* sp. was not recovered from any other context in this study. All of the lizards have southern European distributions.

Context 154

This context included the largest number of species in the sequence. Three species of snake were identified – grass snake (*Natrix natrix*), viperine snake (*Natrix maura*) and southern smooth snake (*Coronella girondica*). The grass snake occurs in a wide range of habitats, but in southern Europe is usually found near water. The viperine snake is more aquatic, preferring weedy ponds and rivers, but marshy or brackish wetlands are also inhabited. The southern smooth snake occurs in a range of dry habitats from open woodland to rock piles. It seems odd that no frogs, newts or salamanders were present in the samples examined from this context, as the habitat preferences of the *Natrix* species would also be ideal for these amphibians, and both snakes feed predominantly on amphibians and fish. Again, there may be taphonomic factors at work, such as selective accumulation by predators.

This is the latest context in this study to include either Hermann's or European tortoises (*Eurotestudo* sp.), although tortoise carapace fragments were also recorded as small finds in contexts 150 and 151 (Fig. 16.1). Tortoises are restricted to coastal Mediterranean areas with hot summers,

Table 16.1 Herpetofaunal species from Vanguard Cave, Middle Area (present +).

	152	153	154	155	157	158
Triturus pygmaeus					+	
Pelobates cultripes		+	+			+
Pelobates sp.	+	+	+	+	+	+
Bufo bufo spinosus						
Hyla meridionalis		+	+			
Hyla sp.	+	+	+	+	+	+
Rana sp.	+					
Eurotestudo sp.			+	+	+	+
Mauremys caspica	+					
Tarentola mauritanica	+	+	+	+	+	+
Acanthodactylus erythrurus		+				
Psammodromus cf. *algirus*		+	+			
Psammodromus sp.			+			+
Timon lepidus		+			+	
Lacertidae indet.	+	+		+	+	+
Chalcides sp.		+				
Sauria indet.	+	+	+	+	+	
Indeterminate lizard 1			+			
Indeterminate lizard 2			+			
Blanus cinereus	+	+	+	+	+	+
Natrix natrix			+		+	
Natrix maura			+			
Coronella girondica		+	+			
Minimum species count	**6**	**9**	**13**	**5**	**7**	**6**

Fig. 16.1 European tortoise, *Eurotestudo* sp. carapace fragment from Vanguard Middle Area. Photo: Museo Nacional de Ciencias Naturales, Madrid.

Fig. 16.2 Stripeless tree frog, *Hyla meridionalis* ilium from Vanguard Middle Area. Photo: Museo Nacional de Ciencias Naturales, Madrid.

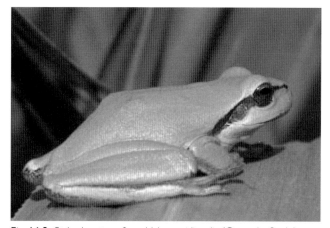

Fig. 16.3 Stripeless tree frog, *Hyla meridionalis* (Granada, Spain). Photo: Mick Richardson, Loja Wildlife.

where they are found in a variety of moist or dry habitats, usually with dense vegetation.

Contexts 155 and 157

Context 155 seems relatively impoverished in herpetofaunal species, but this might be a result of the limited number of samples examined rather than a reflection of actual quantities present or species diversity. The species recorded are largely those which occur throughout the rest of the sequence. Context 157 is slightly richer, and includes the only instance of pygmy marbled newt (*Triturus pygmaeus*) in this study. Newts require still freshwater with aquatic vegetation for breeding. Grass snake was also present in this context.

Context 158

Context 158 is once again largely restricted to the core species which are found throughout the sequence, with the only addition being psammodromus (*Psammodromus* sp.). This could be either *P. algirus* or the much smaller *P. hispanicus*, which prefers dry conditions, especially areas with a patchwork of low shrubby plants. There are no indicators of particularly wet environments.

Discussion

The Vanguard Cave samples show a similar range of species to those from Gorham's Cave, which, given the apparent lack of stratigraphic overlap between the sampled layers of both caves is perhaps surprising. A core group of four species were seen to occur throughout the contexts examined. As in Gorham's Cave, western spadefoot toad (*Pelobates cultripes*) is present throughout. Although not all of the specimens can be identified to species, *Pelobates cultripes* is the only species found in modern Iberia, and no other *Pelobates* species has been identified from the Gibraltar Caves. All enjoy similar habitats, being found in sandy and marshy places, often along sandy coastlines. Freshwater pools are needed for breeding. The stripeless tree frog (*Hyla meridionalis*) and/ or *Hyla* sp. also appear in most contexts. Two species of the *Hyla* genus are found in modern Iberia, but only *Hyla*

meridionalis has been specifically identified in the Gibraltar Caves Project samples (Figs. 16.2 and 16.3). Both *Hyla* species have similar habits, living in well vegetated land near reed beds, bushes or trees in which they climb. Freshwater is required for breeding. *H. meridionalis* has a restricted southerly range indicating its thermophilous nature. The third 'core species' is Moorish gecko (*Tarentola mauritanica*), another thermophilous species (Fig. 16.4). Modern populations make good use of human habitations, ruins, stone walls and other vertical surfaces where they hunt invertebrates. Prior to the availability of such resources, they would frequent cliffs, rocky outcrops and scree. Amphisbaenian or worm lizard (*Blanus cinereus*) (Fig. 16.5) is an interesting discovery, as this species is not recorded in any of the Gorham's Cave samples, but it occurs in almost all Vanguard contexts examined here. Amphisbaenians are small, worm-like reptiles that are rarely seen on the surface. As with other species mentioned above it is a thermophile. Amphisbaenians are today restricted to southern Europe where they lead an entirely subterranean life, burrowing in sandy soils or damp leaf-mould. They are often found by lifting rocks under which they warm themselves. They are also found in woodlands and matorral but tend to avoid areas of permanent herbaceous vegetation, as they appear to be rather weak burrowers and unable to cope with a dense mat of roots (Pleguezuelos *et al.* 2002). It is likely that the creatures found a refuge in the cave and their remains are the products of natural mortality rather than deriving from predator feeding remains or scats. The species is seldom predated by carnivores and unavailable to avian hunters. The tiny vertebrae of amphisbaenians are only about 1 mm across, and

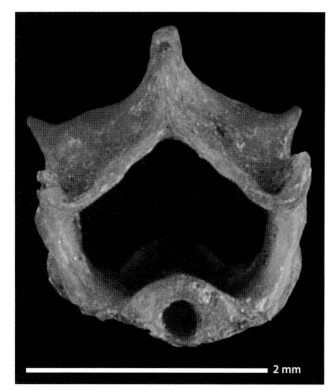

Fig. 16.4 Moorish gecko, *Tarentola mauritanica* vertebra from Vanguard Middle Area. Photo: Museo Nacional de Ciencias Naturales, Madrid.

Fig. 16.5 Worm Lizard or Amphisbaenian *Blanus cinereus* (Granada, Spain). Photo: Mick Richardson, Loja Wildlife.

their absence from the Gorham's assemblage may be a sampling (sieving) bias. It cannot be entirely ruled out that more recent amphisbaenians burrowed into the archaeological levels from the modern surface, but this is felt to be unlikely, as the bones of this species are taphonomically identical to those of other species from the same contexts. More recent bones could normally be distinguished by their paler colour. Neither is it thought that the species burrows deeply – it is usually found covered but close to the surface (Mick Richards, pers. comm.).

Overall, fewer snake bones were present in the Vanguard samples than in the Gorham's material, where southern smooth snake (*Coronella girondica*) occurred in 22 of the 28 contexts studied. It is noteworthy too that whereas ten species of snake were recorded at Gorham's, only three snake species were found at Vanguard. This discrepancy may be due to a number of factors. First, it may be a reflection of small sample size (only two contexts produced snake remains at Vanguard). Alternatively, it is possible that differential taphonomic processes were at work: either the examined sediments at Gorham's were further back inside the cave and more conducive to preservation, or perhaps the accumulating agents (predators) were different in each cave.

Conclusions

The herpetofaunal assemblage represented in this limited study of the Vanguard Cave material implies a remarkable environmental stability for deposits of this period. Many of the species are currently restricted to southern Europe by their thermophilous nature, and their northern range edges are generally limited by summer temperatures. Of the four core species (present throughout the stratigraphic sequence), two – *Blanus cinereus* and *Chalcides* sp. – are obligate thermophiles. *Tarentola mauritanica* does not tolerate 'excessively cool' environments (Pleguezuelos *et al.* 2002), and *Hyla meridionalis* is restricted to mesomediterranean biomes, having an overall dry climate (total rainfall of between 450 mm and 600 mm per year with major seasonal contrast) with warm summers and mild winters. There is no indication in the levels with seemingly impoverished herpetofaunas that this is due to colder or more arid climates. It is, however, possible that some species were able to survive cooler winters than the present day.

It is recognized that these findings are drawn from only a small database. There is potential for much further work on the Vanguard Cave material, which would almost certainly allow a finer resolution of environmental changes over the period of deposition.

Acknowledgements

Figures 16.3 and 16.5 are reproduced with the kind permission of Mick Richardson.

References

Arnold, E.N. and Ovenden, D.W. 2002: *Reptiles and Amphibians of Britain and Europe.* Collins Field Guide. Harper Collins, London.

Pleguezuelos, J.M., Márquez, R. and Lizana, M. (eds.) 2002: *Atlas y Libro Rojo de los Anfibios y Reptiles de España.* Dirección General de Conservación de la Naturaleza-Asociación Herpetologica Española (2nd impression), Madrid.

17 The Late Pleistocene avifauna of Vanguard Cave

J. H. Cooper

Introduction

Similar to the work on the Late Pleistocene birds of Gorham's Cave (Chapter 9), the present study investigates the palaeoenvironmental significance of Late Pleistocene avifaunal assemblages recovered by the Gibraltar Caves Project during the initial excavations of Vanguard Cave in 1995–1996. Paralleling the work at Gorham's Cave, the areas of particular interest at Vanguard were the taphonomy of the avian assemblages and possible evidence of the use of birds by Neanderthals, the reconstruction of the Late Pleistocene palaeoenvironments of Gibraltar and avifaunal evidence of palaeoenvironmental change.

The research presented here originally formed part of a doctoral thesis conducted on the Late Pleistocene birds of Gibraltar (Cooper 1999), as a contribution to the Gibraltar Caves Project.

Material and methods
Origins of the samples

Sediment samples from the 1995–1996 Vanguard excavations were treated in identical manner to their equivalents from Gorham's Cave (Chapter 9). Vanguard Cave's 1995–1996 avian assemblages are now held by the Gibraltar Museum. Pending final registration of the collection, reference numbers given for individual specimens are the original excavation find numbers.

Identification

Vanguard's avian assemblages were identified alongside the Gorham's assemblages, using the same comparative collections and approaches to identification of passerines and non-passerines. As at Gorham's Cave, the Vanguard assemblages contain numerous broken specimens, and material from osteological conservative families or genera. A number of identifications are therefore prefixed at genus or species level with 'cf.' or '?'. In addition to indicating a degree of uncertainty, 'cf.' has been used to indicate a comparison made on the grounds of morphology and '?' to indicate one made with regard to size. Avian taxonomy used here follows Snow and Perrins (1998).

Skeletal part frequencies

The relative frequencies of skeletal elements and ratios of anterior limb elements to posterior limb elements in different taxa groups were calculated for Vanguard Cave using the same methods as applied in Gorham's Cave (See Chapter 9).

Results
Overall summary

Avifaunal remains were retrieved from almost all levels, though not in the quantities found at Gorham's Cave. This may, however, reflect the fact that excavations in Gorham's were located relatively deeper within its chamber and on considerably more developed sections. From an overall collection of some 2900 remains, about 900 were referable at least to family, with a total of approximately 70 taxa identified (Appendix 4) (Cooper 1999). The pattern of occurrence of bird bones throughout the sequence revealed a few high-yielding horizons amid units with relatively sparse assemblages.

Similar to Gorham's Cave, a group of core common taxa could be identified across the 32 sampled units. The most stratigraphically persistent taxa were Rock/Stock Dove *Columba livia/oenas* (in 23 units); Alpine Swift *Tachymarptis melba* (in 18 units); *Alectoris* partridge (in 13 units); and chough *Pyrrhocorax* sp. (in nine units).

Reflecting the smaller number of recovered specimens in comparison to Gorham's, fewer non-analogue species associations were identified in single horizons, but overall the avifaunas do include species characteristic of both climate and habitat contrasts, such as Fulmar *Fulmarus glacialis* and Roller *Coracias garrulus* (Cooper 1999).

The sampled units span most of the main chamber's sequence, although not continuously.

Upper Area (A and B)
Spits

These were the highest levels sampled in Vanguard Cave, although the sequence reaches the roof of the cave, at least 2 m above these horizons. The sediments consist of consolidated bedded mid-brown clayey sands, which are in places banded and with intervening clean sands (Chapter 13). They contain abundant bones and some lithic artefacts. The uppermost beds were dug in successive spits, approximately 10 cm thick, and required the removal of superficial sediments that covered *in situ* layers. No detailed recording of individual layers within the sediments was made in this initial stage of work. This is unfortunate because the uppermost levels yielded a significant number of bird bones, including several key environmental indicator species. Notable recoveries from the spits were a number of bones from Griffon Vulture *Gyps fulvus*. Overall, more remains of *Gyps fulvus* were discovered in Vanguard than in Gorham's, primarily in these upper levels. Additionally, a fragmentary but distinctive premaxilla of Egyptian Vulture *Neophron percnopterus* (Fig. 17.1) found in the spits appears

Fig. 17.1 Premaxilla of Egyptian Vulture *Neophron percnopterus* (Van95/281, Spits), left lateral view. Photo: J. Cooper, Natural History Museum, London.

to represent the oldest Western Palaearctic record for this taxon (cf. Tyrberg 1998). An example of exceptional preservation was also recovered, the associated remains from the left wrist of a plover with certain of the bones cemented *in situ* (Fig. 17.2). However, it was not possible to identify the specimen definitively without disturbing its preservation; hence an identification of *Pluvialis/Vanellus* was recorded.

Also recovered from these upper levels were two specimens referred to Long-tailed Duck *Clangula hyemalis*. Remains of this species are extremely scarce in Vanguard (in contrast to Gorham's Cave); these represent the only stratified finds. Lower down in Areas A and B individual contexts were recorded (Fig. 13.3 for locations).

Context 49
Only one bone was recovered from this unit, from *Columba livia/oenas*.

Context 50
Bird bones are again scarce, but included two bones from a small *Branta* goose, tentatively referred to Brent Goose *Branta ?bernicla* and a further two bones from Tawny Owl *Strix aluco* in addition to core common species such as pigeons and choughs.

Context 51
Bird bones are scarce, with only one bone of *Columba livia/oenas* identifiable.

Context 52
Another low NISP (number of identified specimens) of mainly core common species, but one bone of shelduck *Tadorna* sp. represents the only Vanguard recovery of this taxon.

Contexts 53, 53b
Low numbers of bird bones, with a combined total of 20 remains and a NISP of ten. All remains were core common species, with the exception of single specimens of a harrier, provisionally referred to Hen Harrier *Circus ?cyaneus*, and a Little Owl *Athene noctua*.

Context 54
A total of 50 bird bones, with a NISP of 14, half of which were *Columba livia/oenas* and the rest core common species with the exception of a proximal left humerus from Chaffinch/Brambling *Fringilla coelebs/montifringilla*.

Context 55
Just over 40 bird remains were recovered in this horizon, with a NISP of 13. Of particular interest were single bones from an unknown pelagic gadfly petrel *Pterodroma* sp. and a possible Grey Phalarope *Phalaropus ?fulicarius*.

Middle Area (C)
Context 152 'upper'
This unit was only dug in 1995–1996 and yielded a NISP of only three from an overall total of 11 bones. In addition to *Apus apus/pallidus* and *Columba livia/oenas*, the interesting find of this unit was a specimen of a small *Larus* gull, which compares well with Black-headed Gull *Larus ?ridibundus*.

Context 152
Although a reasonably good overall number of bones were recovered (127) the NISP is low at 12. Nevertheless, some interesting taxa were identified, including single bones of Vanguard's only crake, a possible Spotted Crake *Porzana ?porzana*, and Puffin *Fratercula arctica*.

Context 153
Despite a relatively low NISP of 23, this unit still yielded additional species to the Vanguard list, notably a plover,

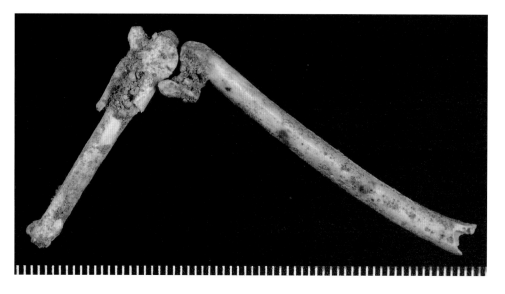

Fig. 17.2 Associated remains from left wing of unknown plover *Pluvialis/Vanellus* (Van96/77, Spits) in dorsal view, including almost entire ulna (at right) with ulnare *in situ* and carpometacarpus (at left) with alula *in situ*. Photo: J. Cooper, Natural History Museum, London.

compared to *Pluvialis* sp., Turtle Dove *Streptopelia turtur* and the only stratified example of Kestrel *Falco tinnunculus*. Amongst the passerines, most significant was a humerus of a large lark, probably Calandra Lark ?*Melanocorypha calandra*.

Context 154

This unit provided the most abundant and diverse assemblage from the main chamber. A total of 437 remains produced a NISP of 68. Key finds were the only stratified remains of Lesser Kestrel *Falco naumanni*, the highest unit NISP of *Alectoris* partridge and further material from *Phalaropus fulicarius*; also the only Vanguard examples of the waders Woodcock *Scolopax rusticola* and Whimbrel *Numenius phaeopus*. One specimen of Razorbill *Alca torda* was found, and also a complete right carpometacarpus of *Coracias garrulus*.

The smallest taxon in the Vanguard assemblages was also recovered; an almost entire right humerus from a medium-small *Sylvia* warbler, tentatively referred to Sardinian Warbler/Lesser Whitethroat *Sylvia melanocephala/curruca* (Fig. 17.3) on the grounds of size by comparison with Moreno (1987).

Context 153–154

A combined group of samples of imprecise origin yielded Vanguard's only example of *Fulmarus glacialis* from a NISP of four.

Context 151

From a total of 44 specimens, only eight proved identifiable. All of these were common core species, including four bones of *Tachymarptis melba*.

Context 157

Forty-three specimens were identified from this unit. Particularly noteworthy are remains from up to three species of auk, Guillemot *Uria aalge*, *Alca torda* and cf. *Fratercula arctica*. Additionally, this unit yielded Vanguard's only possible Common Scoter *Melanitta nigra*. In contrast to this 'cold' marine duck is a specimen of *Falco* cf. *naumanni*.

Context 158

Only five specimens were identified from a total of 31 bones. In addition to common core taxa such as *Alectoris* sp. and *Tachymarptis melba*, one specimen each was identified of a medium-sized wader and *Athene noctua*.

Context 157–158

A very small collection of specimens from imprecisely located samples. Only three specimens were identifiable, *Alectoris* sp., *Athene noctua* and a medium-sized corvid.

Lower Area (E)

Context 170

Dominating the NISP of 64 were 37 bones of *Tachymarptis melba* (MNI = 4). Additional taxa of interest were *Fratercula arctica* and a small lark, compared to Woodlark cf. *Lullula arborea*.

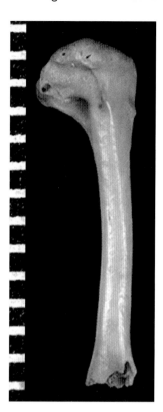

Fig. 17.3 Almost entire right humerus of Sardinian Warbler/Lesser Whitethroat *Sylvia ?melanocephala/curruca* (Van95/79, Context 154). Photo: J. Cooper, Natural History Museum, London.

Unstratified finds
Surface

As in Gorham's, the loose surface deposits (also termed Unit 100) produced a substantial quantity of bird material. This collection included additional specimens of birds found in the main sequence, for example *Pterodroma* sp., *Fratercula arctica* and an abundance of *Gyps fulvus* in the upper part of the cave, most of which probably represents a single individual. The surface deposits also produced a number of taxa not represented in the stratified units, notably several small passerines including a small *Calandrella* lark, Black Redstart *Phoenicurus ochruros*, Great Grey/ Lesser Grey Shrike *Lanius excubitor/minor* and Hawfinch *Coccothraustes coccothraustes*.

Northern Alcove

It should be noted that the assemblage reported here relates only to the 1996 season, and analysis refers only to the upper part of this sequence (Contexts 1000–1006 and see Table 13.5).

Context 1000–1001 (formerly Unit 500)

Very little bird material; only one identified bone present, from *Columba livia/oenas*.

Context 1002 (formerly Units 501, N501b, N501c, N501–502)

Very low totals of bird bones throughout Unit 501. All identified material is *Tachymarptis melba* or other swift *Apus* sp., with the exception of single specimens of *Columba livia/oenas* and a medium-large thrush *Turdus* sp. in Unit 501b.

Context 1003 (formerly Unit 502)

This unit yielded a small collection of mostly core common taxa, enhanced by the occurrence of specimens of *Pterodroma* sp., a possible *Branta* goose and Guillemot *Uria aalge*.

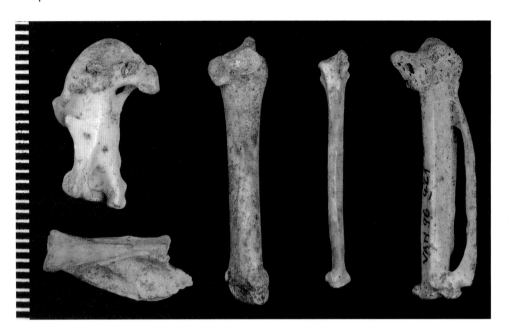

Fig. 17.4 Remains of Alpine Swift *Tachymarptis melba* from Vanguard Cave. From left to right: (above) left humerus (Van96/23, Context 170), caudal view; (below) left digit 2, phalanx 1, caudal view; right ulna, dorsal view; left radius, dorsal view; right carpometacarpus, ventral view (all from Van96/27, Unit 503). Photo: J. Cooper, Natural History Museum, London.

Context 1004 (formerly Units 503, N503a, N503b, N503c)
Identified specimens from Unit 503 and its subdivisions were almost exclusively *Tachymarptis melba* (Fig. 17.4). Unit 503 also yielded a small number of bones from *Alectoris* sp. and one of Sparrowhawk *Accipiter nisus*.

Context 1005 (formerly Unit 504)
Again dominated by *Tachymarptis melba*, but additional significant finds were two bones of a small falcon, possibly Hobby *Falco* cf. *subbuteo*, a partial dentary of a possible Rock Sparrow *Petronia petronia* and an immature proximal left humerus of Azure-winged Magpie *Cyanopica cyanus* (Fig. 17.5) (found also in LBSmcf.5 and LBSmcf.5 in Gorham's).

Context 1005–1006 (formerly Unit 505)
In addition to core common taxa, this unit produced a further specimen of *Falco* cf. *subbuteo*, a large duck

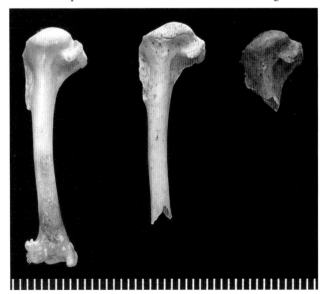

Fig. 17.5 Proximal left humeri of Azure-winged Magpie *Cyanopica cyanus* from Vanguard and Gorham's Caves, with modern comparative specimen (all in caudal view). From left to right: modern left humerus; immature specimen Van96/30 (Unit 504); Gor95/56 (LBSmcf.5). Photo: H. Taylor, Natural History Museum, London.

tentatively referred to scoter *Melanitta* sp., another thrush and an entire left humerus of Chaffinch/Brambling *Fringilla coelebs/montifringilla*.

Context 1006 (formerly Unit 505–506)
With an overall total of eight specimens, and a NISP of only five, the potential for new taxa in this level would appear low. However, retrieved from this unit were Vanguard's only examples of White-tailed Eagle *Haliaeetus albicilla* and Bonelli's Eagle *Hieraeetus fasciatus* (Fig. 17.6) and the only stratified example of a possible Skylark cf. *Alauda arvensis*.

Unstratified finds
Surface finds from the Northern Alcove largely consisted of core common taxa, but also included single specimens of *Fratercula arctica* and Shag *Phalacrocorax aristotelis*.

Evidence of human activity
No cut-marks were observed on any of the bird bones in the assemblages examined from Vanguard Cave. A very limited number of charred bones were recovered from the main chamber only (Table 17.1).

Taphonomy
Attritional accumulation
It might be anticipated that the potential for attritional accumulation in Vanguard Cave should compare closely with Gorham's Cave, given the sites' very similar general situations. However, there are some differences between the sites' probable attritional assemblages suggesting some spatial variations in on-site accumulation that may be affecting species representation.

As at Gorham's the dominant attritional candidate species in Vanguard Cave, *Columba livia/oenas*, is again the most numerous and persistent taxon in the assemblage. However, its dominance is considerably less pronounced, with *Tachymarptis melba* attaining almost similar levels of recovery. Although *Apus apus/pallidus* is one of the core common taxa in the Gorham's avifauna, *Tachymarptis melba* is absent in the assemblages examined. A colonial

Fig. 17.6 Right tarsometatarsus of Bonelli's Eagle *Hieraeetus fasciatus* (Van96/23, Unit 505–506), dorsal view. Photo: J. Cooper, Natural History Museum, London.

cliff-dwelling species with excellent preservation and identification potential thanks to its robust, distinctive wing elements, *Tachymarptis melba* is one of the most abundant species in the Late Pleistocene avifauna of Gibraltar, found in significant quantities at Ibex Cave and Devil's Tower (Cooper 1999; 2000a). It would be reasonable to expect it at Gorham's, and its absence suggests a taphonomic bias, probably introduced by the birds' own behaviour. In Vanguard, the majority of *Tachymarptis melba* specimens were recovered from towards the front of the cave, suggesting the overhanging yet wide open entrance might have been favoured for nesting or roosting. By contrast, the excavated areas in Gorham's are located deeper within the cave and may not overlap with the on-site territory of *Tachymarptis melba*. In a reverse of the situation, remains of *Columba livia/oenas* are slightly more common in units from the rear of Vanguard Cave than the front, hinting at a possible preference for deeper, more sheltered parts of the cave.

Predation and scavenging

Non-human activity

The Vanguard bird assemblages show very similar characteristics to those in Gorham's Cave, with a wide variety of species and habitats represented. As at Gorham's, it appears that *Bubo bubo* is a strong candidate for the principal accumulating predator. Although very little *Bubo bubo* material was recovered in the 1995–1996 assemblages, apparently associated remains of a juvenile cf. *Bubo bubo* were found in 1998 (Van 98 find numbers 514–517, 667), identified by myself during post-excavation processing. It seems that Vanguard was also used at times as a nesting site, allowing for the potential accumulation of prey remains from the typically catholic *Bubo bubo* diet (cf. Chapter 9).

Evidence for use of Vanguard Cave by mammalian carnivores is also present, particularly in the Northern Alcove. The presence of small toothmarks and strong digestive traces on smaller mammal remains from the Alcove area appears to indicate the presence of a small carnivore (Y. Fernández-Jalvo, pers. comm.). In 1997, a mandible of Wild Cat *Felis silvestris* was recovered (R. Jacobi, pers. comm.), suggesting the possible identity of the carnivore. Both *Felis silvestris* and Iberian Lynx *Felis pardina* take avian prey, and again, ground species such as *Alectoris* partridges are particularly vulnerable to their predation (Corbet and Ovenden 1980; Corbet and Harris 1991). They may also scavenge carrion. Given the problems of separating the taphonomic signatures of individual predators in complex assemblages such as the Gorham's and Vanguard collections, it may not prove possible to implicate felines conclusively in the accumulation of part of the bird fauna, but it must be regarded as a strong possibility.

Human activity

Evidence of human activity is present in all excavated areas of the cave, particularly in the form of well developed hearths (Barton 2000). However, there is little evidence of charring amongst the avian assemblage (Table 17.1). Additionally, the patterns of skeletal part representation are noticeably different to Gorham's Cave (Tables 17.2 and 17.3). While at Gorham's the Partridges, Marine and Ducks taxa-groups all showed low anterior ratios, at Vanguard only Ducks have a low anterior ratio, of 25 per cent, indicating over-representation of posterior elements. Also lower than figures reported by Livingstone (1989) or Ericson (1987), this ratio appears to be a parallel of the situation at Gorham's Cave suggesting possible human involvement in the accumulation of ducks. However, ducks are relatively scarce in the assemblages and consequently this figure may not be reliable. As with pigeons, duck remains have generally been restricted to deposits in the rear of the chamber. A genuine lack of ducks

Table 17.1 Incidence of charring, Vanguard Cave.
Numbers indicate number of charred specimens

	Context 152	Context 154	Context 155	Context 157
Marine	1	-	-	-
Partridges	-	1	-	-
Waders	-	1	-	-
Pigeons	-	-	1	1
Crows	-	-	-	1

Table 17.2 Overall relative frequencies of axial elements, Vanguard Cave.

Abbreviations used are as follows:
MNI - Minimum number of individuals; N - Minimum number elements.

	MNI	COR		SCAP		FURC		STERN		SYN		MAN		PREM		CRAN	
		N	%	N	%	N	%	N	%	N	%	N	%	N	%	N	%
Marine	13	8	31	1	4	1	8	3	23	0	0	1	8	3	23	0	0
Ducks	5	1	10	1	10	0	0	1	20	1	20	0	0	0	0	0	0
Birds of Prey	16	4	12.5	1	3	0	0	3	19	1	6	6	37.5	2	12.5	0	0
Partridges	7	7	50	8	57	1	14	7	100	0	0	0	0	0	0	0	0
Waders	10	8	40	0	0	0	0	2	20	0	0	0	0	0	0	0	0
Pigeons	17	26	76	23	68	0	0	9	53	5	30	0	0	1	6	0	0
Swifts	17	22	65	10	30	0	0	8	47	0	0	0	0	0	0	1	6
Crows	11	14	64	9	41	0	0	0	0	0	0	6	54	2	18	1	9
Small Passerines	108	95	44	41	19	19	9	37	34	0	0	0	0	13	12	6	5.5

Table 17.3 Overall relative frequencies of avian limb elements and anterior elements ratios, Vanguard Cave.

	MNI	HUM		ULN		RAD		CMC		FEM		TBT		TMT		%ANT
		N	%	N	%	N	%	N	%	N	%	N	%	N	%	
Marine	13	14	54	5	19	0	0	1	4	0	0	5	19	7	27	62.5
Ducks	5	1	10	0	0	0	0	1	10	2	20	1	10	3	30	25.0
Birds of Prey	16	9	28	6	19	1	3	4	12.5	5	16	5	16	4	12.5	58.8
Partridges.	7	7	50	4	29	0	0	7	50	7	50	2	14	5	36	56.2
Waders	10	6	30	3	15	0	0	3	15	0	0	3	15	7	35	54.5
Pigeons	17	32	94	14	41	7	21	12	35	10	29	9	26.5	14	41	64.1
Swifts	17	23	68	22	65	7	21	31	91	6	18	3	9	14	41	76.8
Crows	11	10	46	22	100	1	4.5	11	50	6	27	11	50	11	50	60.6
Small Passerines	108	160	74	201	93	29	13	134	62	44	20	92	43	56	26	72.0

Not included at Vanguard: Rallidae, NISP=1/MNI=1; Coracidae, NISP=2/MNI=1

in the Vanguard sequence could have taphonomic and environmental implications, but at this stage of the avifauna's discovery and description, it is too early to tell.

Exploitation strategies

The Vanguard assemblages suggest generalist tendencies in predators/scavengers opportunistically utilizing a wide range of local habitats. There is no apparent bias towards large prey species, though the occurrence of a few large raptors, e.g. *Gyps fulvus* and *Hieraeetus fasciatus*, suggests scavenging of the occasional larger corpse. Shoreline scavenging by humans is attested to by the presence of cut-marked remains of Mediterranean Monk Seal *Monachus monachus* (Chapter 21); similar behaviour by humans or other predators is probably the source of the marine bird species found within the cave.

Palaeoecology
Palaeoenvironments

All major habitat types identified at Gorham's Cave are also represented in Vanguard, with some variation in species composition. Despite the high degree of overlap between the caves' avifaunas, Vanguard includes a small number of mainly terrestrial birds not included at Gorham's, which add further detail to reconstruction of local habitats.

Cliffs

The immediate vicinity of the cave is well represented by a comprehensive cliff avifauna, including *Columba livia*, *Tachymarptis melba* and *Pyrrhocorax* sp. Two additional cliff-dwelling species recovered from Vanguard are *Hieraeetus fasciatus* and probable Black Redstart *Phoenicurus ?ochruros*, both of which use cliffs and also matorral.

Wetlands

A less diverse freshwater wetland assemblage – perhaps indicative of higher sea-levels – is preserved at Vanguard than at Gorham's, with fewer *Anas* ducks, rails and waders present. The wetland-dependent crake *Porzana ?porzana* is the strongest indicator for the habitat, though taxa such as snipe *Gallinago* sp. are also good evidence.

Woodlands

Species associated with both open and closed woodlands occur throughout the site. Generally, the woodland bird species in the Vanguard assemblages may be found in southern Iberian pine woods at the present day (Finlayson 1992). However, several species potentially associated with broadleaf woodlands also occur, such as Scops Owl *Otus scops* and *Scolopax rusticola*. But particularly interesting is *Coccothraustes coccothraustes*, a very large finch still common in the Gibraltar region, with a strong preference for mature broadleaf woodlands. Unfortunately, the only specimen was found in the superficial deposits and its temporal context is therefore uncertain.

Broadleaf species identified in the charcoal samples from Gorham's Cave appear to be more characteristic of matorral than of woodlands (Gale and Carruthers 2000 and Chapter 15), but palynological studies have identified southern Iberia as a refugium for Oak *Quercus* sp., Hazel *Corylus* sp. and Birch *Betula* sp. (e.g. Pons and Reille 1988; Willis 1996). Potentially, this specimen of *Coccothraustes coccothraustes* may be a strong indication of such woodlands

somewhere in the vicinity of Gibraltar; however, it is also worth noting that in Morocco, the species will also occur in conifer woodlands (Thévenot *et al.* 2003). More evidence of mature moist broadleaf woodlands than this single species is required to confirm their presence.

Matorral

Most of the matorral species from Vanguard also occur at Gorham's, and show a similar mix of cliff/matorral and open ground/matorral species such as possible Blue Rock Thrush *Monticola* ?*solitarius* and *Alectoris* sp. respectively.

Open ground

Vanguard has produced a small collection of remains from four species of larks, Family Alaudidae, including two likely species associated with open ground habitats, ?*Melanocorypha calandra* and *Alauda arvensis*. Also present are *Calandrella* sp. and cf. *Lullula arborea*, which may be found on open ground but also in matorral. They are rather suggestive of locally available mosaic habitats, with open areas between matorral patches.

Marine

A diverse marine assemblage is present, including both coastal and pelagic species though overall numbers are low. Several groups occur: marine ducks, notably *Clangula hyemalis*; petrels and shearwaters, including *Pterodroma* sp.; and auks, including *Uria aalge*, not found at Gorham's. Other coastal species are also well represented, including *Haliaeetus albicilla* which might have used local wetlands in addition to coastal areas. No remains of juvenile marine or coastal species were recovered from Vanguard Cave; without positive evidence of breeding, the presence of local breeding colonies of Vanguard's marine taxa cannot be definitively proved.

Seasonal status

Based on the biogeographic criteria used to infer the likely seasonal status of individual species at Gorham's Cave (Chapter 9), the avifauna of Vanguard Cave can be divided into resident, summer migrant and winter migrant species (Table 17.4).

Residents

Residents are defined as species with non-migratory populations still occurring in southern Iberia. A group of 12 species in the Vanguard assemblages fits this description, all of which are also present in Gorham's Cave, with the exception of *Hieraeetus fasciatus*. Immature or juvenile remains were identified from four species, including a proximal humerus of *Cyanopica cyanus* (Azure-winged magpie) from the Northern Alcove. The latter specimen is of particular importance as it demonstrates conclusively that *Cyanopica cyanus* was breeding locally during the Late Pleistocene, further evidence of the Iberian population's origin as a refugium relict (Cooper 2000b).

Several terrestrial species found in the Vanguard assemblages occur only as vagrants in southern Iberia, *Haliaeetus albicilla*, Alpine Chough *Pyrrhocorax graculus* and Carrion Crow/Rook *Corvus corone/frugilegus*. In its present

Table 17.4 Probable seasonal status of taxa in Vanguard Cave.

Resident	Summer migrant	Probable winterer
Broad range taxa		
Phalacrocorax aristotelis	*Neophron percnopterus*	*Fulmarus glacialis*
**Alectoris* sp.	**Falco naumanni*	*Branta* ?*bernicla*
Columba cf. *livia*	*Falco* cf. *subbuteo*	*Clangula hyemalis*
Bubo bubo	*Streptopelia turtur*	*Uria aalge*
Strix aluco	*Otus scops*	
cf. *Pica pica*	**Apus apus/pallidus*	
**Pyrrhocorax pyrrhocorax*	**Tachymarptis melba*	
Corvus corax	*Coracias garrulus*	
	Hirundo ?*rustica*	
Southern edge taxa		
Hieraeetus fasciatus		
Melanocorypha calandra		
Petronia petronia		
**Cyanopica cyanus*		

Evidence of breeding: * indicates juvenile or immature specimens; † indicates medullary bone
Additional breeding species: **Gyps fulvus*; **Columba* cf. *oenas*; **†Columba palumbus*; **Hirundo* sp.; **Corvus monedula*.

Palaearctic range, *Pyrrhocorax graculus* is sedentary and can probably be considered as a Late Pleistocene resident of the Strait region. *Haliaeetus albicilla*, *Corvus corone* and *Corvus frugilegus* are largely sedentary but have migrant populations in the north of their ranges. However, given that the Strait region is more likely to have been within their core ranges rather than marginal, they could also have been residents of the southern Iberian refugium.

Summer migrants

Summer migrants are defined as migrant breeding species presently occurring in southern Iberia only during summer, and therefore unlikely to have been present outside this season under conditions of climatic deterioration. This definition applies to a group of nine species, at least three of them (*Falco* cf. *subbuteo*, *Tachymarptis melba* and Roller *Coracias garrulus*) not found in Gorham's Cave. Summer migrants are probably least useful in highlighting palaeoenvironmental change, as their response to climatic deterioration would essentially be absence. Only in exceptional circumstances can absence be regarded as significant.

Winter migrants

The Pleistocene status of species presently occurring in southern Iberia as wintering migrants cannot be reasonably deduced; they might have been wintering during temperate phases or breeding during colder phases.

However, I consider that species in the Gibraltar assemblages presently recorded only rarely (if at all) in the Strait region, which breed in northern Europe and winter well to the north of southern Iberia, represent mainly wintering birds. The presence of three such species in Vanguard Cave is identifiable evidence of climatic deterioration. A fourth species may be *Uria aalge* (not found at Gorham's), but it does maintain small breeding colonies on the northern Spanish and Portuguese coasts, and wintering birds also occur there. However, it is only a scarce winter visitor to the Strait of Gibraltar. Overall, the probable wintering group is less diverse than at Gorham's and there is no evidence of breeding.

Palaeoenvironmental change

Vanguard Cave offers only two individual horizons, Contexts 154 and 157, with sufficient diversity potentially to compare differences in the avifaunal assemblages. However, as these are in close stratigraphic association, they offer little scope for comparing change over time. In order to make some broad palaeoenvironmental comparisons, the avifaunas from the Vanguard sequence can be lumped into three areas, Upper Area (Contexts 49–55), Middle and Lower Areas (Contexts 101–170) and the Northern Alcove (Contexts 1000–1006). Species of defined seasonal status from these areas' assemblages are presented in Table 17.5.

Change in the terrestrial environment

Vanguard's terrestrial avifaunas offer almost no evidence of Late Pleistocene climate change. The disappearance of Late Pleistocene species from southern Iberia is probably more closely linked with human activity than with climatic shifts, for example the disappearance of *Haliaeetus albicilla* from the western Mediterranean. However, the retreat of *Pyrrhocorax graculus* into isolated modern populations in alpine regions is probably a function of climatic amelioration (cf. Chapter 9).

The terrestrial signal from across the Vanguard sequence is emphatically one of long-term stability; most of these species were still present on or near Gibraltar to within the last 150–200 years (Reid 1871–1890).

Change in the marine environment

Evidence of palaeoenvironmental change is present in the marine avifaunal assemblage, but is less pronounced than the Gorham's equivalent. *Clangula hyemalis*, the most persistent and abundant of the cold indicators at Gorham's Cave, was only found in Vanguard's upper levels though displaced northern taxa do also occur in the lower main chamber and also in the Northern Alcove. As a minimum, these species record the regular southerly expansion of Boreal water masses up to and probably into the Mediterranean during winter months. Given the persistence of cold marine taxa throughout Gibraltar's fossil avifauna, such incursions appear to have been common throughout the Late Pleistocene, an impression that seems to correlate with western Mediterranean foraminiferal evidence (Pérez-Folgado *et al.* 2003).

Unfortunately, there is no positive evidence yet from this site of any cold marine taxa from Vanguard Cave breeding in the vicinity of Gibraltar. Such finds might have assisted in identifying levels associated with extreme periods of lowered sea surface temperatures when Boreal waters were also present at this latitude during summer, for example during Heinrich Events. Present interpretation of the site's dating (Chapter 14) suggests that virtually the whole of the Vanguard Cave sequence falls within MIS 5 and its sub-stages.

Conclusions

Early analysis indicates that Vanguard Cave's diverse Late Pleistocene birds comprise a 'classic' Gibraltar avifauna, combining a stable terrestrial avifauna with strong affinities to modern-day southern Iberian communities with

Table 17.5 Presence of taxa with seasonal status across stratigraphic sequence, Vanguard Cave.

Taxon	Upper Area	Middle Area	Lower Area	Northern Alcove
Residents				
Phalacrocorax aristotelis			x	
Hieraeetus fasciatus				x
Alectoris sp.	x	x	x	x
Columba cf. *livia*	x			
Strix aluco	x	x		
Melanocorypha ?*calandra*		x		
Cyanopica cyanus				x
cf. *Pica pica*				x
Pyrrhocorax pyrrhocorax	x	x		
Corvus corax	x			x
Petronia petronia				x
Summer migrants				
Neophron cf. *percnopterus*	x			
Falco naumanni		x		
Falco cf. *subbuteo*				x
Streptopelia turtur		x		
Apus apus/pallidus	x	x	x	x
Tachymarptis melba	x	x	x	x
Coracias garrulus		x		
Hirundo ?*rustica*	x	x		
Probable winterers				
Fulmarus glacialis		x		
Branta ?*bernicla*	x			
Clangula hyemalis	x			
Uria aalge		x		x

a marine avifauna dominated by Arctic/Boreal species. Despite the well preserved evidence of human usage of the site, thus far little has been revealed with regard to human activity in relation to birds.

It is apparent that there may be taphonomic and possibly ecological differences between Vanguard and Gorham's Caves, though further research is clearly needed. In particular, there may be spatial differences in species' representation on the two sites, possibly reflecting individual species' preferences in using specific areas of the sites. There may also be a reduced presence of 'cold' indicators, particularly of the ducks, such as *Clangula hyemalis*, common in Gorham's Cave. This could further be explained if the sequence at Vanguard were earlier than Gorham's and indeed mainly last interglacial in age as suggested by the OSL dating. However, careful investigation will be required to establish whether such an absence is indeed a significant environmental signal or taphonomic bias. As Vanguard's sequence is being explored from scratch, eventually this will hopefully allow comparison of samples from all levels of the stratigraphy, and from different regions of the site. This would provide not only temporal comparisons of the resulting avian assemblages to be made, but also spatial comparisons.

Presently, detailed comparisons with other sites are difficult due to the relatively small samples of birds examined so far. However, Vanguard Cave clearly has great potential. With future exploration and research, it seems entirely possible that it could even surpass Gorham's Cave as Gibraltar's premiere Late Pleistocene avifaunal site.

References

Barton, R. N. E. 2000: Mousterian hearths and shellfish: late Neanderthal activities on Gibraltar. *Neanderthals on the Edge*, eds. C. B. Stringer, R. N. E. Barton and C. Finlayson (Oxford, Oxbow Books), 211–220.

Cooper, J. H. 1999: *Late Pleistocene Avifaunas of Gibraltar and their Palaeoenvironmental Significance* (London, Royal Holloway, University of London).

Cooper, J. H. 2000a: A preliminary report on the Pleistocene avifauna of Ibex cave, Gibraltar. *Gibraltar during the Quaternary*, eds. C. Finlayson, G. Finlayson and D. A. Fa (Gibraltar, Gibraltar Government Heritage Publications), 272–232.

Cooper, J. H. 2000b: First fossil record of Azure-winged magpie *Cyanopica cyanus* in Europe. *Ibis* 142, 150–151.

Corbet, G. B. and Harris, S. 1991: *The Handbook of British Mammals* (Oxford, published for the Mammal Society by Blackwell Scientific).

Corbet, G. B. and Ovenden, D. 1980: *The Mammals of Britain and Europe* (London, Collins).

Ericson, P. G. P. 1987: Interpretations of archaeological bird remains: a taphonomic approach. *Journal of Anthropological Archaeology* 14, 65–75.

Finlayson, C. 1992: *Birds of the Strait of Gibraltar* (London, Poyser).

Gale, R. and Carruthers, W. 2000: Charcoal and charred seed remains from Middle Palaeolithic levels at Gorham's and Vanguard Caves. *Neanderthals on the Edge*, eds. C. B. Stringer, R. N. E. Barton and C. Finlayson (Oxford, Oxbow Books), 207–210.

Livingstone, S. D. 1989: The taphonomic interpretation of avian skeletal part frequencies. *Journal of Anthropological Archaeology* 16, 537–547.

Moreno, E. 1987: Clave osteológia para la identificatión de los passeriformes ibéricos, III. *Ardeola* 34(2), 243–374.

Pérez-Folgado, M., Sierro, F. J., Flores, J. A., Cacho, I., Grimalt, J. O., Zahn, R. and Shackleton, N. 2003: Western Mediterranean planktonic foraminifera events and millennial climatic variability during the last 70 kyr. *Marine Micropaleontology* 48, 49–70.

Pons, A. and Reille, M. 1988: The Holocene and Upper Pleistocene pollen record from Padul (Granada, Spain): a new study. *Palaeogeography, Palaeoclimatology, Palaeoecology* 66, 243–263.

Reid, P. S. G. 1871–1890: *Stray notes on Ornithology; a record of ornithological observations in Gibraltar, Bermuda, the British Isles, New York, the Canary Islands and Spain* (Tring, Ornithology Library, Natural History Museum).

Snow, D. W. and Perrins, C. M. (eds.) 1998: *The Birds of the Western Palaearctic*. Concise Edition (Oxford, Oxford University Press).

Thévenot, M., Vernon, R., and Bergier, P. 2003: *The birds of Morocco: an annotated checklist* (Tring, British Ornithologists' Union and British Ornithologists' Club).

Tyrberg, T. 1998: *Pleistocene birds of the Palearctic: a catalogue* (Cambridge, Mass., Nuttall Ornithological Club).

Willis, K. J. 1996: Where did all the flowers go? The fate of temperate European flora during glacial periods. *Endeavour* 20(3), 110–114.

18 The large mammal remains from Vanguard Cave

A.P. Currant, Y. Fernández-Jalvo and C. Price

Introduction

Vanguard Cave reveals a similar species range to that of Gorham's Cave. Most of the finds recovered are from the Middle Area that lies close to the entrance (Fig. 13.2). This chapter deals only with the bones that were individually recorded during excavation and given a find number; the bones were examined and identified by Andrew Currant and Roger Jacobi. Where possible they were listed according to species and body part. Included in this list are a number of bones of identified species that were recovered from loose material or from surface cleaning and could not be related precisely to stratigraphic context. The full species inventory is shown in Table 18.1. A more detailed analysis of the taphonomy of the Vanguard Cave faunal assemblage is presented in Chapter 21.

Biostratigraphy and context of the faunal remains
Upper Area

In Area B (Figs. 13.2 and 13.3) only two bone fragments were recovered from an occupation horizon that contained a well defined layer of ash associated with marine shells, a hearth and a concentration of knapping debris and Middle Palaeolithic stone tools. The area was excavated in 1997. The bones comprised a fragment of metacarpal shaft of an artiodactyl which could not be identified to species (Van97U/310), and a fragment of juvenile *Cervus elaphus* tibia shaft (Van97U/397). The latter is of interest because it shows signs of human modification (percussive damage).

Middle Area

This area comprises a series of well defined occupation horizons that contain a central hearth and considerable quantities of bones and lithic artefacts of a Middle Palaeolithic discoidal core technology. The excavation covered an area of approximately 12 m² and provided a rich species composition of terrestrial mammalian taxa such as ibex (*Capra ibex*), red deer (*Cervus elaphus*), wild boar (*Sus scrofa*) and bear (*Ursus arctos*), as well as evidence for marine mammals (seals and dolphins), molluscs, birds, tortoise and fish also from the same units (the smaller faunas are dealt with in Chapters 16 and 17).

Ibex (*Capra ibex*) is common throughout this sequence and is found in significantly greater numbers than any other of the represented large mammal species. Red deer (*Cervus elaphus*) is present in most contexts. Carnivores are relatively rare. Their influence as accumulators or scavengers was probably minimal (see below) and it is interesting to note that the majority of carnivore bones, including all of the hyaena specimens, were found in loose or surface deposits, suggesting a lack of direct association with the other species. Most of the mammals identified are either present in modern south-west Iberia or, as in the case of leopard (*Panthera pardus*) and brown bear (*Ursus arctos*), are absent due to human pressure rather than environmental constraints. The species composition is broadly the same as for Gorham's Cave and suggests that the local environment during the period of deposition was similar to naturally occurring habitats found in southern Iberia today.

Almost half of the fossil bones display humanly induced damage (stone tool marks, impact marks while opening the bone for marrow extraction, evidence of burning) affecting ibex, red deer, wild boar and seal, while less than 3 per cent of these fossils (mainly ibex and a middle sized artiodactyl, possibly red deer) have tooth marks made by carnivores

Table 18.1 Full species list of large mammals from Vanguard Cave.

Canis lupus	wolf
Ursus arctos	brown bear
Felis sylvestris	wild cat
Lynx lynx	lynx
Panthera pardus	leopard
Crocuta crocuta	spotted hyaena
Monachus monachus	Mediterranean monk seal
Delphinus delphis	common dolphin
Tursiops truncatus	bottle-nosed dolphin
Sus scrofa	wild boar
Cervus elaphus	red deer
Capra ibex	ibex

Table 18.2 Faunal remains, Vanguard Cave Middle Area (NISP).

Context	Surface/ Loose	150	151	152	153	154	155	156	157	158	159	160
Ursus arctos	1											
Canis lupus						1						
Felis sylvestris	2						1					
Lynx lynx	1								1			
Panthera pardus	2		1			1			2	1	1	
Crocuta crocuta	5											
Monachus			1				1		1		1	
Phocid/Cetacean						1						
Delphinus delphis	1					1						
Tursiops truncatus						1						
Sus scrofa	2	1	1			3		2				
Cervus elaphus	4		7			5	3		10	4	1	
Capra ibex	7	4	3	6	5	41	19	2	18	12	2	1
Artiodactyl		2	1	1	1	5	1		2	1		

Fig. 18.1 Monk seal (Monachus monachus) proximal phalanx from a hind flipper, with cut-marks (VAN 96/411). Photo: Natural History Museum, London.

Fig. 18.2 Juvenile monk seal scapula, with cut-marks (VAN 98/564). Photo: Natural History Museum, London.

Fig. 18.3 Common dolphin (Delphinus delphus) vertebra (VAN 96/25). Photo: Natural History Museum, London.

(Chapter 21). Carnivore fossil bones (including bear) have no damage produced by humans or other carnivores. Evidence of carnivore damage is thus almost negligible, and absent among the marine mammal fossils, and the scarce chewing marks are located in areas and anatomical elements that are not consistent with primary access to carcasses, but rather with scavenging. Carnivore tooth marks appear on the tibia, radius, scapula, mandible and phalanx, and are mainly grooves on bones previously exposed to fire (at an incipient stage of burning). Given the lack of evidence of other biological agents (carnivores) or post-depositional/ geological disturbances (e.g. storms, water streams) that could bring these marine fossils to the site, we infer that the remains of marine mammals result from Neanderthal transport and activity (Stringer et al. 2008).

In addition to the terrestrial fauna one of the most interesting aspects of this assemblage is the presence of marine mammal taxa (Stringer et al. 2008). Two monk seal (Monachus monachus) fossils show human modification and while these are the only examples so far recorded amongst

the marine mammals, all were recovered from Neanderthal occupation horizons and closely associated with terrestrial mammal remains that have cut-marks and other damage. The modified seal bones, a proximal phalanx from a hind flipper (VAN 96/411) (Fig. 18.1) and a juvenile monk seal scapula (VAN 98/564) (Fig. 18.2), are interpreted as evidence of flensing (defleshing) and are discussed in more detail in Chapter 21 (see also Stringer et al. 2008). Ethnographic studies (Henshaw 1999) observe that while the appendicular elements of seal carcasses were of lower dietary value than the axial parts, the former are also represented in the bone assemblages from excavated Inuit sites, indicating that carcasses were butchered at the habitation site rather than the kill site. However, the comparative size of the species involved must be taken into consideration. Henshaw's study refers mainly to the remains of ringed seals (Phoca hispida), which at an average body weight of around 50 kg in arctic waters are considerably smaller than Mediterranean monk seals with an average weight of 250–300 kg (Nowak 1999), and are therefore more portable. The presence of a humanly modified flipper bone suggests that whole carcasses were being processed by the Neanderthals and that maximum use was made of such resources. Clearly, the practices of specialized seal-hunters may differ considerably from the Gibraltar Neanderthals who also obtained significant amounts of meat from terrestrial game such as ibex. Identified monk seal bones are relatively uncommon in the assemblage, but occur in different contexts through the stratigraphy (see Table 18.2), suggesting that the species was utilized repeatedly over the period of occupation.

A high proportion (64 per cent) of the fossils in the Middle Area consisted of immature animals, and there were no old adult individuals present of any species (Stringer et al. 2008). With regard to marine mammals like seals, we would suppose that their exploitation by humans coincided with the breeding season when females had to calve on land and were at their most vulnerable. The dolphin bones (bottle nosed and common) recovered from these archaeological deposits (Figs. 18.3 and 18.4) possibly resulted from the scavenging of

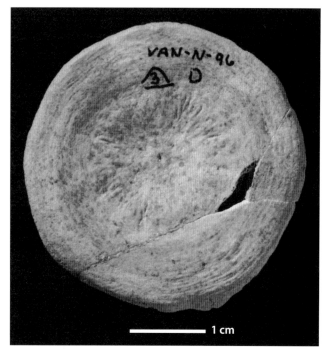

Fig. 18.4 Common dolphin intervertebral disc (VAN 96/3). Photo: Natural History Museum, London.

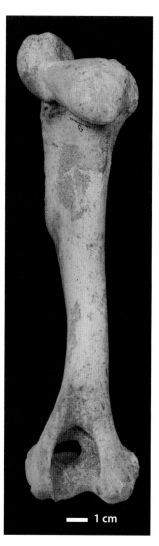

Fig. 18.5 Hyaena (*Crocuta crocuta*) humerus (VAN 97/66). Photo: Natural History Museum, London.

stranded animals, found either dead or dying on the shoreline. The thick subcutaneous fat layer possessed by these creatures is valuable to societies otherwise subsisting on the lean meat of terrestrial game (Muñoz 1996). It is thus possible that scavenging of such carcasses was highly selective. Whilst the stranding of common dolphin on British coasts today shows a degree of seasonality, with 27.8 per cent of 151 logged events occurring in the month of March and only 2.65 per cent in both May and September (National Whale Stranding Recording Scheme data), Mediterranean records show a much lesser degree of patterning, with the lowest records being in December and May (both 6.22 per cent) and the highest in January (10.17 per cent) (MEDACES data). Although the causes of cetacean strandings are debatable and there is no way of knowing whether modern records can be taken to represent the patterning of such events in prehistory, this suggests that utilization of such carcasses was almost certainly opportunistic but suggests that the Neanderthals, like other humans exploiting coastal habitats, regularly surveyed the shoreline for such occurrences.

Northern Alcove

This area was excavated in 1996 and 1997. Its physical separation from the rest of the cave made it difficult to correlate the stratigraphic sequence with the deposits of the Middle or Lower Area even though the sediments of the Alcove are at a comparable altitude.

The species recovered from the Northern Alcove show close affinities with those of the adjacent Middle Area. The presence of *Delphinus* sp., likely to be the common dolphin (*Delphinus delphis*), is interesting, though there are no cutmarks to show human modification. This species has a wide modern distribution, inhabiting pelagic temperate waters of the Atlantic, Mediterranean and Black Sea (Macdonald and Barrett 1993).

The finds from Northern Alcove are significant for a number of other reasons. To begin with it is the only

part of the site which has yet to provide stratified examples of spotted hyaena (*Crocuta crocuta*) (Fig. 18.5) and brown bear (*Ursus arctos*) (Fig. 18.6). Secondly, there is at least circumstantial evidence that part of the assemblage was generated by denning activities of carnivores. Hyaena coprolites were present in contexts 1006–1008, and smaller coprolites, possibly fox droppings, were found in context 1009. Gnawed bones associated with the coprolites from the same contexts were recorded in the field notebook (15/9/97), and a large bird coracoid (Van97N/29) from context 1006 shows chewing consistent with juvenile hyaenas. A terminal phalange of a small artiodactyl (Van97N/93) from context 1019 is digested, again suggesting carnivore activity.

Table 18.3 Faunal remains from Vanguard Cave Northern Alcove.

	C1000	C1004	C1005	C1006	C1009	C1012	C1013	C1019	C1020	C1021	C1022	C1023
Ursus arctos			+								+	
Felis sylvestris					+							
Crocuta crocuta	+	+				+	+					
Delphinus sp.	+											
Sus scrofa	+											
Cervus elaphus	+		+	+					+	+		
Cervid							+					
Capra ibex	+			+							+	+
Artiodactyl	+					+		+		+	+	

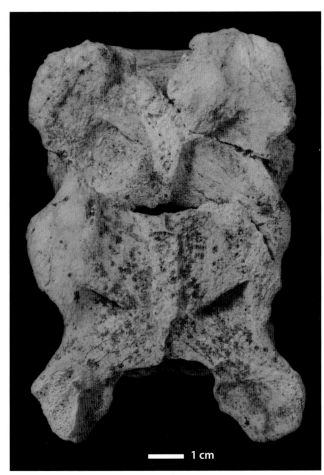

1 cm

Fig. 18.6 Brown bear (Ursus arctos), two cervical vertebrae, associated (VAN 96/413). Photo: Natural History Museum, London.

The only direct sign of human intervention from this area comes from a small phalange in context 1016 (Van97N/82). It was recovered in sieving residues, and is thought to have been modified by deliberate splitting (Y. Fernández-Jalvo, pers. obs.).

Conclusions

The Vanguard Cave fauna, like that of Gorham's Cave, shows little variation and seems to indicate environmental stability during the period of deposition. The number of identifiable bones recovered is modest (Table 18.2), but comes from a relatively limited area of excavation. It is likely that this mostly represents activities linked with the initial processing and butchery of carcasses in areas possibly peripheral to the main occupation zones of the site. To test this idea more fully will require further excavation of areas inside the cave entrance.

In addition to human presence, the faunal assemblage also reflects the activities of carnivores though presumably they occupied the cave at different times. It is likely, as in the case of Gorham's, that the majority of bone material was rapidly buried by natural processes. However, a proportion of the human refuse is likely to have been scavenged by carnivores and moved around, and possibly sometimes even introduced into the cave by this agency.

References

Henshaw, A. 1999: Location and appropriation in the Arctic: an integrative zooarchaeological approach to historic Inuit household economies. *Journal of Anthropological Archaeology* 18, 79–118.

Macdonald, D. and Barrett, P. 1993: *Collins Field Guide: Mammals of Britain & Europe* (HarperCollins, London).

Medaces Mediterranean Database of Cetacean Strandings *http://medaces.uv.es* (07/09/09).

Muñoz, A. S. 1996: Explotación de Pinnípedos en la Costa Atlántica de Tierra de Fuego. *Arqueologia* 6, 199–222.

National Whale Stranding Recording Scheme *http://nhm. ac.uk/research-curation/research/projects/strandings* (07/09/09).

Nowak, R. M. 1999: *Walker's Mammals of the World* (sixth edition) (John Hopkins University Press, Baltimore and London).

Stringer, C. B., Finlayson, J. C., Barton, R. N. E., Fernández-Jalvo, Y., Cáceres, I., Sabin, R., Rhodes, E. J., Currant, A. P., Rodríguez-Vidal, J., Giles Pacheco, F. and Riquelme Cantal, J. A. 2008: Neanderthal exploitation of marine mammals in Gibraltar. *Proceedings of the National Academy of Sciences USA* 105(38), 14319–14324.

19 Soil micromorphology of Gibraltar Caves coprolites

R.I. Macphail and P. Goldberg

Introduction

Several coprolites (fossil faeces) were collected from the Middle Palaeolithic levels in Gorham's and Vanguard Caves during the 1995–1998 excavations (Finlayson and Finlayson 2000; Stringer *et al.* 2000). Coprolites from Gorham's Cave were recorded from at least three localities (Table 19.1). Of particular interest in Vanguard Cave was a fragment of coprolite (sample 371), one of several recovered from on top of a hearth in the Upper Area near the top of the sequence (Fig. 19.1) (Macphail and Goldberg 2000; Goldberg and Macphail 2000). Here, the hearth is an *in situ* layer of reddened sand, capped by a well preserved thin ash layer (see Fig. 13.6). The principal question revolves around whether this was human or animal coprolite. We opted to use micromorphology to evaluate this issue since it permits observation of the mineral and organic composition, and fabric of the material. Furthermore, we have reference material of both human and animal coprolites and modern excrements from zoos, including herbivores and carnivores (Courty *et al.* 1989). Specifically, we compared them to ancient dog coprolites and wolf excrements, and reference modern excrements from several big cats, such as lion, leopard, and tiger. We also looked at a number of likely hyaena coprolites from the adjacent Gorham's Cave (samples 157, 179 and 185), employing reference material (Kolska Horwitz and Goldberg 1989; Larkin *et al.* 2000; Lewis 1997). We also attempted pollen preparations on all of the Gibraltar examples, but, unfortunately, all proved to be non-polleniferous (G. M. Cruise, Open University, pers. comm.)

Methods

From Vanguard Cave, three slices were taken of the same coprolite fragment (sample 371), which measured 1 × 1 cm. These pieces and the coprolites from Gorham's Cave were imbedded in methyl methacrylate from which small petrographic thin sections were made (Goldberg and Macphail 2006). The thin sections were examined with the petrographic microscope using plane-polarized (PPL) and cross-polarized (XPL) light, as well as with blue episcopic

Table 19.1 Location of coprolite samples.

Sample No.	Find number and location	Lithostratigraphic context
Vanguard		
371	VanU 97/371	Upper Area, Layer 1
Gorham's Cave		
157	Gor98 I/157 C97	19 BeSm(OSsm).1
179	Gor98 I/179 D107	22D LBSmff.4
185	Gor98 III/185 C106	Context 101 SSLm(Usm).2

illumination (490 nm excitation filter, 510 nm dichroic mirror, 525 nm barrier filter) for ultra violet light observation (UVL). Studies have shown that coprolites formed of 'apatite' are non-birefringent, but are autofluorescent under UVL and Blue Light (Courty *et al.* 1989; Larkin *et al.* 2000; cf. Stoops 1996; 2003).

Results and inferences

Vanguard Cave – coprolite sample 371 (Figs. 19.1–19.4)
This coprolite is a pale to dirty/cloudy grey colour (PPL), and generally non-birefringent under XPL apart from fine sand-size quartz inclusions and coarse (mm size) pieces of bone, the latter being evidence of ingested material. On the other hand, the coprolite is highly autofluorescent under UVL and Blue Light. The coprolite also exhibits narrow, tubular, curved voids that are likely pseudomorphs of fur. Some parts of the coprolite are porous with loose infillings of very thin excrements of mesofauna.

The inclusion of sand grains, bone and curved voids (possibly the remains of animal hair), in cement that is autofluorescent under UVL and Blue Light, is typical of coprolites and excrements of carnivores. The darkish colours (PPL) and inclusion of coarse bone fragments are typical of Canidae, as noted in Early Iron Age to Saxon British, American palaeoindian and Jomon Japanese dog coprolites (Courty *et al.* 1989; Matsui *et al.* 1996; Goldberg and Macphail 2006; Macphail 2000). The presence of loose excremental infillings indicates that the coprolite was exposed to a period of biological working – like the underlying ash – before being buried by the overlying wind-blown sands at Vanguard Cave (Goldberg and Macphail 2000; Macphail and Goldberg 2000). It can be noted, in contrast, that ancient human coprolites, although reflecting dietary variations, more commonly contain vegetal fragments, only very small pieces of bone, and have a cement that is often a pale yellowish colour (Courty *et al.* 1989, pl. IVa; Macphail *et al.* 1990, fig. 19.3).

Gorham's Cave – coprolite samples 157, 179 and 185 (Figs. 19.5–19.8)
Of the three coprolite examples studied from Gorham's Cave, samples 157 and 179 are pale grey to grey under PPL, non-birefringent (XPL), but highly autofluorescent under UVL and Blue Light. Sample 185 differs by featuring highly birefringent, invasive micrite (Figs. 19.7 and 19.8). All coprolites contain silt and fine sand, and fragments or traces of ingested bone. The coprolites are also characterized by areas of vesicular porosity (e.g. Fig. 19.6) and curved, tubular voids, perhaps indicating animal hair.

Fig. 19.1 Sample VanU97/371. Likely Canid (wolf ?) coprolite, showing fragment of bone (upper-centre) and biological burrowing (centre). PPL (plane polarized light); length of field c. 7 mm. Photo: P. Goldberg and R. Macphail.

Fig. 19.2 Sample VanU97/371. As in Figure 19.1 but showing curved tubular voids from fur inclusions. PPL; length of field c. 7 mm. Photo: P. Goldberg and R. Macphail.

Fig. 19.3 Sample VanU97/371. Bone (upper) and mineral inclusions. PPL; length of field c. 3.50 mm. Photo: P. Goldberg and R. Macphail.

Fig. 19.4 Sample VanU97/371. As Figure 19.3 but XPL (crossed polarized light), showing isotropic nature of matrix and included quartz sand; length of field c. 3.50 mm. Photo: P. Goldberg and R. Macphail.

Fig. 19.5 Sample Gor98/157. Hyaena coprolite showing darker edge and pale centre. PPL; length of field c. 7 mm. Photo: P. Goldberg and R. Macphail.

Fig. 19.6 Sample Gor98/179. Hyaena coprolite with vesicular porosity. PPL; length of field c. 7 mm. Photo: P. Goldberg and R. Macphail.

Fig. 19.7 Sample Gor98/185. Partially micritized hyaena coprolite surrounded by quartz sand. PPL; length of field c. 7 mm. Photo: P. Goldberg and R. Macphail.

Fig. 19.8 Sample Gor98/185. Same as Figure 19.7. XPL; length of field c. 7 mm. Photo: P. Goldberg and R. Macphail. (See online for colour photos of all thin sections)

The optical properties of these coprolites, the inclusion of silt and sand, and marked areas of vesicular porosity and curved tubular voids are all indications of these coprolites being from hyaenas (Kolska Horwitz and Goldberg 1989; Larkin *et al.* 2000).

Discussion and conclusions

The micromorphological study of more than 150 thin sections from Gorham's and Vanguard Cave has shown that fragments of coprolites of carnivores are almost ubiquitous, alongside guano (Goldberg and Macphail 2000; Macphail and Goldberg 2000). This study shows that when larger pieces are preserved it is possible to distinguish forms from different carnivores through thin section micromorphology. This demonstrates, along with faunal remains analysis, that the cave was occupied by different kinds of carnivores, in addition to humans and large numbers of birds. Consequently, we cannot ignore the effects of biogenic sediments and associated biological reworking of cave deposits at these sites.

When the Vanguard Cave coprolite (sample 371) is compared with reference material from humans, dog,

wolf, hyaenas and big cats, the most likely origin is from a Canidae (dog/wolf), because of its optical properties, internal structure and inclusions. The coprolite, like the *in situ* hearth ash, appears to have been exposed to short-lived biological working, before burial by blown sands.

Acknowledgements

We gratefully acknowledge thin section manufacture and pollen analysis by Harry Pratt and G. M. Cruise (Open University), respectively.

References

Courty, M. A., Goldberg, P. and Macphail, R. I. 1989: *Soil Micromorphology and Archaeology* (Cambridge University Press).

Finlayson, C., Finlayson, G. and Fa, D. A. (eds.) 2000: *Gibraltar during the Quaternary* (Gibraltar, Government Heritage Publications, Monograph 1).

Goldberg, P. and Macphail, R. I. 2000: Micromorphology of sediments from Gibraltar caves: some preliminary results from Gorham's Cave and Vanguard Cave. In Finlayson, C., Finlayson, G. and Fa, D. A. (eds.), *Gibraltar*

during the Quaternary (Gibraltar, Gibraltar Government Heritage Publications, Monograph 1), 93–108.

Goldberg, P. and Macphail, R. I. 2006: *Practical and Theoretical Geoarchaeology* (Oxford, Blackwell Publishing).

Kolska Horwitz, L. and Goldberg, P. 1989: A study of Pleistocene and Holocene Hyaena coprolites. *Journal of Archaeological Science* 16, 71–94.

Larkin, N. R., Alexander, J. and Lewis, N. D. 2000: Using experimental studies of recent faecal material to examine hyaena coprolites from the West Runton Freshwater Bed, Norfolk, UK. *Journal of Archaeological Science* 27, 19–31.

Lewis, M. 1997: *An analysis of the Early Middle Pleistocene hyena fauna coprolites from Boxgrove, Sussex* (Unpublished M.Sc. thesis, University College London).

Macphail, R. I. 2000: Soils and microstratigraphy: a soil micromorphological and micro-chemical approach. In Lawson, A. J. (ed.), *Potterne 1982–5: Animal Husbandry in Later Prehistoric Wiltshire* (Salisbury, Wessex Archaeology, Archaeology Report No. 17), 47–70.

Macphail, R. I. and Goldberg, P. 2000: Geoarchaeological investigations of sediments from Gorham's and Vanguard Caves, Gibraltar: microstratigraphical (soil micromorphological and chemical) signatures. In Stringer, C. B., Barton, R. N. E. and Finlayson, C. (eds.), *Neanderthals on the Edge* (Oxford, Oxbow Books), 183–200.

Macphail, R. I., Courty, M. A. and Goldberg, P. 1990: Soil micromorphology in archaeology. *Endeavour* (New Series), 14, 163–171.

Matsui, A., Hiraya, R., Mijaji, A. and Macphail, R. I. 1996: Availability of soil micromorphology in archaeology in Japan [in Japanese]. *Archaeology Society of Japan* 62, 149–152.

Stoops, G. 1996: Complementary techniques for the study of thin sections of archaeological materials. *Colloquium VI, XIII UISPP Congress (Forlì, Italy)* (Forlì, A.B.A.C.O.), 175–181.

Stoops, G. 2003: *Guidelines for Analysis and description of Soil and Regolith Thin Sections* (Madison, Wisconsin, Soil Science Society of America, Inc.).

Stringer, C. B., Barton, R. N. E. and Finlayson, C. (eds.) 2000: *Neanderthals on the Edge* (Oxford, Oxbow Books).

20 The lithic artefact assemblages of Vanguard Cave

R.N.E. Barton

Introduction

The lithic assemblages reported here mainly come from deposits in the Upper and Middle Areas of the cave. Except for a small number of finds from the very top of the sedimentary sequence the occupation layers in this cave are exclusively Middle Palaeolithic. The methodology used to describe the Vanguard Cave lithic assemblages is the same as that presented in Chapter 12.

Upper Area A

A small number of blades and blade fragments were recovered in 1995 during the cleaning of a section in the upper part of the cave. The artefacts were thinly scattered within sands and silts near the top of the sequence. A single undiagnostic bladelet located approximately 40 cm below the upper baseline in Area 'A' (Fig. 13.3) represents the lowermost record of an Upper Palaeolithic technology within the sediment series. It confirms that Vanguard was largely infilled by the time Upper Palaeolithic populations were present in the area, permitting only limited access to the cave.

Upper Area B midden and hearth

A midden deposit containing marine mussel shells and Middle Palaeolithic artefacts was discovered at approximately 5.4 m above the main site datum in Area 'B' (Figs. 13.2 and 13.10). The midden consisted of pinkish-grey ashy deposits underlain in places by rubified sands. On the surface of the ashy deposits was a scatter of almost exclusively quartzite artefacts. The finds were distributed over a total area of approximately 5 m² but with a notable concentration evident in 1 m² in the eastern and western halves of squares Z4 and A4 (Figs. 20.1 and 20.2). The scatter coincided with the thickest deposit of ash and an area of reddened sands that defined a roughly sub-circular hearth imprint of about 1.4 × 1.0 m (Fig. 20.1). Before excavation the presence of the central hearth location was obscured by lobes of the ashy sediments which covered much of the area and extended to the southern wall of the cave. Within these sediments were recovered large quantities of mussel shells of the species *Mytilus galloprovincialis* (Barton 2000; Fernández-Jalvo and Andrews 2000). Fragments of charcoal were also found at the base of the hearth which could be identified to warm Mediterranean genera (*Pistacia* sp., *Juniperus*, *Tetraclinus articulata*) (Gale and Carruthers 2000, 207; Barton 2000, 213; also see Chapter 15).

The lithic assemblage from the Upper Area midden contains plain flakes (55) and other debitage characteristic of a discoidal core technology (Table 20.1; Fig. 20.3). Although only one of the cores can be described as a typical discoidal form (C-type), it is clear from the similarity in raw material that the other two examples probably derive from the same cobble of quartzite. A notable feature in this concentration is the relatively large number of chips recovered.

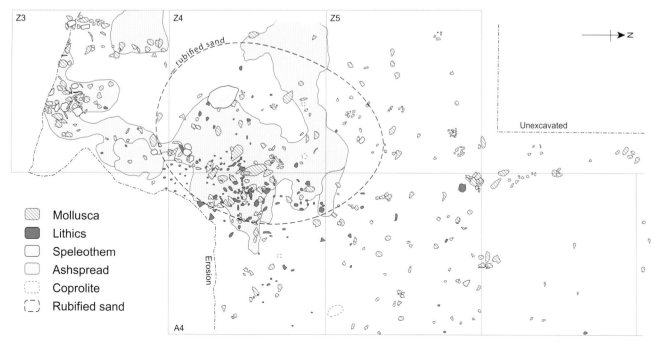

Fig. 20.1 Vanguard Cave Upper Area B. Middle Palaeolithic hearth and midden deposit.

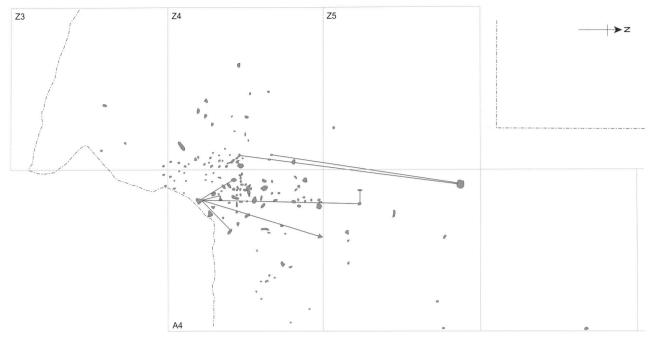

Fig. 20.2 Vanguard Cave Upper Area B. Spatial distribution of Middle Palaeolithic artefacts with refits indicated.

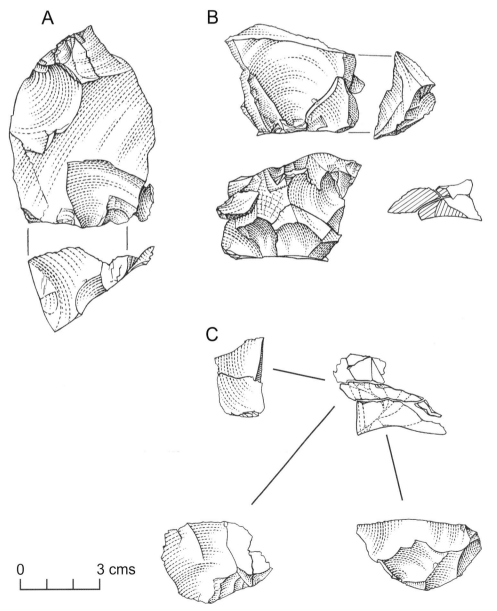

Fig. 20.3 Vanguard Cave Upper Area B. Three refit groups of Middle Palaeolithic quartzite artefacts probably from the same block. Group A is a discoidal core and conjoining flake; Group B is of flakes from the edge of a core; and C indicates successive removals of flakes with faceted butts. Drawings: Hazel Martingell.

Out of a total of 997 chips, 628 pieces lay directly within the richest area of the flake distribution (the eastern half of Z4 and western half of A4). The high concentration of tiny flakes is indicative of an *in situ* knapping scatter. Only four retouched tools were recorded and these comprised a double side scraper and three retouched flakes (Fig. 20.4). The scraper and two of the retouched flakes are on a fine-grained dark grey chert. Except for these three tools only a plain flake and core edge removal flake (FCER) are of fine-grained chert, the latter a distinctive dark red variety. The rest of the lithic finds from this level are all of a reddish-brown quartzite.

Plain flakes are the most numerous artefacts in this assemblage. Around a third of these are complete, the rest are represented by mainly proximal (14) and mesial (12) fragments with fewer distal elements (seven). Interestingly, there are not many cortical pieces (seven), and of these only two display more than 50 per cent cortex on their outer surface. Of the flakes complete enough for analysis, dorsal scar patterns on them indicate a slight preponderance of unidirectional (15) over multidirectional ones (ten) with only one example of a bi-directional scar pattern. The butt types are virtually all plain forms; the rarity of faceted examples is further illustrated by the fact that only the Levallois flake, a centripetal flake and two of the retouched tools (the double side scraper and a retouched flake) have faceted butts. In terms of their condition, very few of the plain flakes (four) or any other pieces (three) are burnt. At first glance this would appear surprising given the direct association of the artefacts with the hearth and ash scatter, but more careful reading allows us to reconstruct a sequence of events that places the knapping episode at the very end of the occupation event (see below).

The integrity of the artefact scatter is demonstrated by a rapid fall off in the numbers of finds as one moves away from the centre of the hearth zone. Refits between individual pieces reveal conjoins extend across the scatter (Figs. 20.2 and 20.3). From the spatial distribution of flakes and the overlapping distribution of chips it seems likely that they are the products of a single knapping event or related episodes very closely spaced in time. This is also supported by the dominance of only one raw material type (quartzite).

The preponderance of quartzite over any other raw material and the similarity in core preparation would indicate that a single block was carried into the cave for knapping.

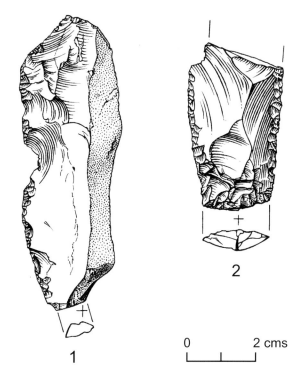

Fig. 20.4 Vanguard Cave Upper Area B. 1) Van 97/20 naturally backed chert laminar flake with edge damage; 2) Van 96/114 double side scraper in chert. Scale in cm. Drawings: Hazel Martingell.

One slight anomaly is the absence of many cortical pieces amongst the flakes and this suggests that primary preparation of the cobble took place elsewhere, either inside the cave mouth or very likely on the beach in front of the cave where material of this type (but not of this dimension) can be recovered even today. The presence of retouched tools in the grey chert and the absence of evidence of any flakes or chips in this material imply that the implements were brought to this area of the cave as prepared tool forms.

The close relationship between the lithic artefacts and the ash scatter containing the marine molluscs indicates that they were undoubtedly products of the same occupation event. As stated above, few of the artefacts appear to be burnt (Barton 2000, 214) and this led us to speculate that knapping had taken place in the ashes at some point after the fire had died down, possibly the next morning if the Neanderthal inhabitants had spent the night in the shelter of the cave. Further support for this interpretation of events is now provided by the analysis of the chip debitage which reveals a similar rarity of thermal alteration (Table 20.1).

Table 20.1 Vanguard Upper Area Hearth: artefacts, artefact condition and raw materials.

Description	No.	Complete	Cortical	Burnt	Red Chert	Fine-grained Grey Chert	Quartzite
Plain flakes	55	18	7	4		1	54
Centripetal flakes	2	2		0			2
Core edge removal flake	1	1		0	1		
Levallois flake	1	1		0			1
Shatter	26		3	1			26
Chips (<15 mm)	997		1*	14			997
Discoidal core type-C	1		1	0			1
Unclassifiable cores	2			0			2
Double side scraper	1			0		1	
Retouched flakes	3		1	0		2	1
Total	**1089**						
* not systematically recorded							

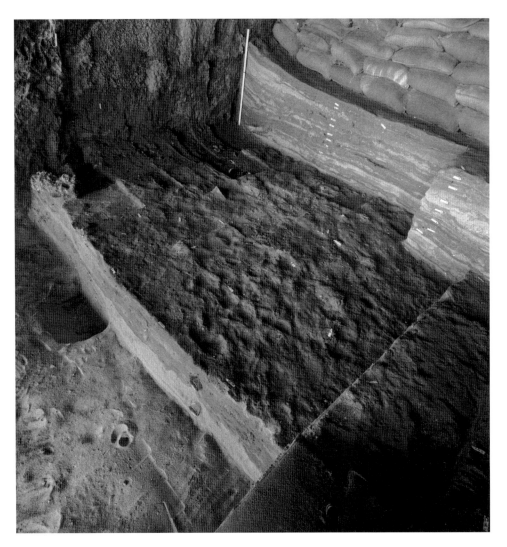

Fig. 20.5 Vanguard Cave Middle Area (C–D). View of the excavations towards the end of the 1998 season. Note the alternating silty clays and sand bands in section and the natural puddled surface of the deposits at top of context 159. The hearth feature (150) is just visible in section. Photo: Natural History Museum, London.

Very little bone was associated with the hearth and midden. It is therefore significant that one of the few pieces recorded from this area was a red deer tibia shaft fragment (Van07 U/397) with damage patterns on its exterior surface identifying it as a possible retoucher (see also Chapter 12). More information on the midden, in particular the season of exploitation of the molluscs, is discussed in Chapter 22.

Middle Area C and D

The excavation in this part of the cave covered an area of approximately 12 m². The artefacts were recovered from banded horizons of the brown silts and clays, but were rare or absent in the intervening lighter coloured sands. Each pair of silt and sand bands was treated as a separate stratigraphic context (Fig. 20.5; Table 13.2). Fourteen of these contexts were investigated in this part of the cave sequence. A vertical distribution of artefacts by context (Fig. 20.6) appears to show a series of clearly defined occupation horizons and it was believed that each of the silty horizons represented a short period of stability when occupation was established, separated by periods of absence coinciding with blown sand deposition. However, in the light of the results of refitting and taphonomic analyses of the faunal assemblage by Fernández-Jalvo and Cáceres (Chapter 21 and see Cáceres 2002) it may be necessary to revise this provisional interpretation. Their study suggests the presence of only three main occupation horizons consisting of: top (contexts 154–156), central (contexts 150–151

and 157–159) and basal (contexts 160–162). It should be noted that included in their central horizon is a hearth (context 150) and a dark brown (burnt) clayey sand immediately underlying the hearth (context 151). Context 156 is a shallow bowl-shape depression lying within context 155; it contains burnt material and may be the remnants of a hearth or a localized inwash fill from a nearby hearth (see discussion in Chapter 13). A further semi-circular patch of charcoal almost 50 cm in diameter was recorded in context 157 in the north-west quadrant of square Lo. No ash or large fragments of charcoal were present and there

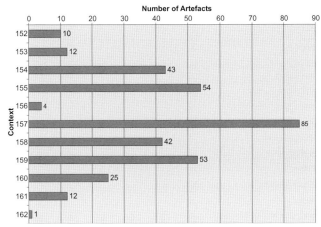

Fig. 20.6 Vanguard Middle Area (C–D). A vertical distribution of artefacts by context. Note that 157 includes artefacts from a hearth (150) and the underlying rubified sand (151).

were no artefacts associated with the circular patch itself. The only other feature of note was a consolidated animal burrow running partly in parallel with the cave wall and in contexts 158 and 159.

Contexts 154–156 (Upper Subunit)

This subunit is made up of contexts 154, 155 and a combustion feature 156. It contains 103 lithic artefacts (Table 20.2) made up mostly of plain flakes (32), small chips (50) and shatter (ten). The plain flakes include slightly more broken (16) than complete (13) examples (four were unrecorded) and about a third of the total (11) have outer surfaces covered by 10 per cent or more cortex. Where present, the distribution of dorsal scar patterns shows more unidirectional (ten) than multidirectional (four) or bi-directional (one) scar types. The flake butts display a clear predominance of plain and plain cortical (11) over faceted and dihedral faceted forms (three). The rest of the flake debitage is made up of four centripetal flakes and two pseudo-Levallois points. Two of the centripetal flakes have butts that are faceted, the other two are plain. The debitage is dominated by the products of a discoidal technology, also confirmed by the presence of a type-A discoidal core. The likelihood that knapping occurred here is supported by the occurrence of two hammerstones. One of them is broken in half and can be conjoined (Fig. 20.7). The refitting pieces were found less than a metre apart and show clear signs of battering and flaking damage at either end. The other hammerstone is complete with very distinctive battermarks at one end. Both are of quartzite. The only other noticeable feature in this small assemblage is the total absence of any burnt artefacts. This is an interesting observation given the presence of a combustion feature (context 156).

This combustion feature (156) occurred as an irregular sub-circular depression, a few centimetres deep and about 50 cm in diameter, with some fragmentary charcoal at its base. The rest of the depression was filled with coarse sand and included finds of limpet shell and a small cluster of unburnt and broken bone. The contents of the feature were sieved separately. Very few lithics were recovered. They included a plain flake, one multiplatform core in limestone and two chips, none of which were burnt. According to the micromorphological evidence successive fires were lit in

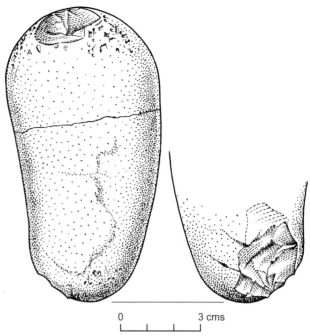

Fig. 20.7 Vanguard Middle Area (C–D). Quartzite hammerstone consisting of conjoined pieces. Top: Van 96/179; bottom: Van 96/193. Drawings: Hazel Martingell.

this feature or nearby. It is likely that the feature was made by deliberately scooping out sediments as no other natural depressions of this shape or size were observed anywhere else in the layer. It is nevertheless curious that no burnt bone or lithics were directly associated with this feature, suggesting that the objects probably accumulated gradually as a result of gentle inwash processes from the surrounding cave floor.

The raw materials in this upper subunit show a predominance of quartzite over other lithic types (Table 20.3). However, amongst the non-quartzite artefacts is a distinctive variety of dark red chert seen in the Upper Area and also recognized in Gorham's Cave. One slightly unusual aspect is that the only two cores recovered were both of limestone. Five flakes and some shatter testify to the presumably expedient knapping of these materials which may have been collected from the floor or walls of the cave. No chips in this material were found but it is possible that they were unrecognized at the time of excavation. That other knapping took

Table 20.2 Vanguard Middle Area: lithics classified by context. Note that 156 is a combustion feature (CF) and 150 is a hearth (H).

Description	No.	152	153	154	153/154	155	156 CF	157	150 H	151	158	159	160	161	162
Plain flakes	118	4	3	15		16	1	18	10	2	14	16	13	6	
Centripetal flakes	12		1			3		2		1	1	2	2		
Naturally backed flakes	2							1			1				
Core edge removal flakes	2											1		1	
Pseudo-Levallois points	4					2		1					1		
Levallois flake	1		1												
Shatter	32	1	1	5		5		4	4		2	7	2	1	
Chips <15 mm	152	4	7	21	1	26	2	31	3	3	22	24	5	2	1
Cores	4					1	1	1			1				
Chopping tool	1										1				
Cobble/hamerstones	11	1		1	1	1		3				2	1	1	
Pebble/pebble fragments	4									1		1	1	1	
Total	**343**														

Barton

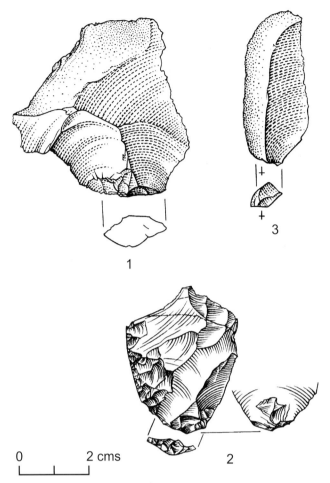

place here is also suggested by the relatively large numbers of quartzite chips found together with larger flakes in the same raw material. It is interesting that the few centripetal flakes are made of distinctive fine-grained red chert and one undifferentiated chert which might imply they were brought to the spot as ready-made artefacts, although the presence of chips in the same cherts would suggest otherwise.

Contexts 150, 151, 157–159 (Central Subunit)

The assemblage from this subunit is again composed almost entirely of flake debitage with only one possible retouched tool, a unifacial chopper found in context 158. There are 60 plain flakes, 84 chips and 17 fragments of shatter. Detailed information exists for 56 of the plain flakes which for the most part are complete specimens (35), the remainder being nine proximal, five distal and seven mesial fragments. None of the fragments could be mended. Four of the broken specimens had longitudinal *Siret* breaks typical of hard hammer knapping accidents. Interestingly, only about a third (19) of all plain flakes displayed evidence of original cortex on their dorsal surfaces, implying that the preliminary stages of core preparation and reduction probably took place elsewhere. In terms of other technological characteristics, of those flakes with preserved proximal end features, 27 have plain or plain cortical butts, which comfortably outnumber dihedral faceted (two), faceted (four) and linear (two) forms. Where visible, the dorsal scar patterns indicate an overwhelming predominance of unidirectional scars (27) over multidirectional (three) and opposed (one) types.

In addition to plain flakes, six centripetal flakes, two naturally backed pieces and one core edge removal flake (Fig. 20.8) and one pseudo-Levallois point were recovered. Except in one case, there is nothing particularly unusual

Fig. 20.8 Vanguard Middle Area (C–D). 1) Van 95/168 quartzite flake (context 155); 2) Van 95/169 core edge removal flake in red chert (context 155); 3) Van 96/155 naturally backed quartzite flake (context 150). Scale in cm. Drawings: Hazel Martingell.

Table 20.3 Lithic artefacts and raw materials in contexts 154–156.

Description	No.	Grey-green Chert	Red Chert	Chert Undiff.	Quartzite	Limestone	Other/ Unclassified
Plain flakes	32		4	2	21	5	
Centripetal flakes	4		3	1			
Pseudo-Levallois points	2				2		
Shatter	10		1		3	6	
Chips <15 mm	49	1	6	9	32		1
Discoidal core	1				1		
Multiplatform core	1				1		
Hammerstones	2				2		
Total	**101**						

Table 20.4 Lithic artefacts and raw materials in contexts 150, 151, 157–159.

Description	No.	Red Chert	Honey Chert	Chert Undiff.	Quartzite	Limestone	Sandstone	Other/ Unclassified
Plain flakes	60	7		12	32	8		1
Centripetal flakes	6	2	1	1	2			
Naturally backed flakes	2				2			
Core edge removal flake	1	1						
Pseudo-Levallois point	1			1				
Shatter	17	4		3	2	8		
Chips <15 mm	84	25		18	38	2		1
Cores	2			1		1		
Chopping tool	1				1			
Cobble/hammerstones	5				2	1	2	
Pebble/pebble fragments	2					1		1
Total	**181**							

248 Neanderthals in Context

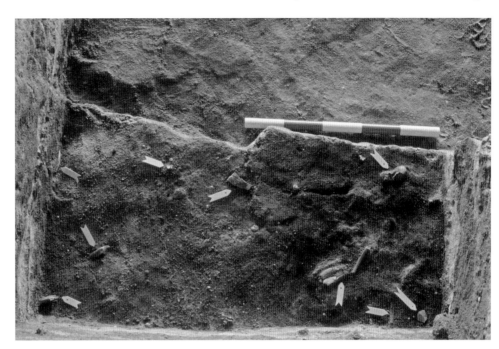

Fig. 20.9 Vanguard Middle Area (C–D). Hearth 150 in the course of excavation.

about the size of any of this debitage. When raw material type is taken into account all of the artefacts fall within the same size range as the plain flakes (Tables 20.4 and 20.5). The one exception is a centripetal flake in a honey-coloured chert which is of a larger size than the rest (Table 20.5). It was probably brought in ready made since no other debitage in this distinctive raw material is present. None of the centripetal flakes appear to be Levallois products in the classical sense. Instead, all of the debitage, including centripetal forms, are consistent with a discoidal core technology. The raw materials reveal a higher proportion of quartzite to any other rock-type, which includes evidence for the use of limestone. This is also reflected in the greater representation of quartzite chips (38), although there is a noticeable presence, too, of chips in red chert (24).

A large hearth covering an area of approximately 1.5 × 1.2 m and marked by a spread of charcoal about 2–3 cm thick is also associated with this subunit (Figs. 20.9 and 20.10). Field observations by Goldberg suggested that the hearth might have been reused because of the presence of successive charcoal and ash layers. Despite the substantial size of the hearth (150) and the underlying rubified sediment (151) only eight of the 26 lithic artefacts showed any signs of burning. Two of them are flakes from the hearth itself, whilst a burnt centripetal flake of quartzite was found in the underlying sediment. The rest include a flake, two chips, and the unifacial chopper (see below) which come from the surrounding deposit. The rarity of burnt artefacts is emphasized by the observation that out of a total of ten altered specimens, eight of them come from 150 and 151.

The horizontal distribution of flakes and their spatial distribution in relation to the hearth are shown in Figure 20.11.

The two cores recorded are much reduced multiplatform types. One of them is in the same limestone as the cave bedrock and it is interesting that this material was judged suitable for use since it is slightly softer and the edges crush more easily than the quartzite and chert. Regardless of such potential drawbacks the immediate availability of the bedrock was clearly an advantage. There are 18 other artefacts of limestone showing that it was definitely flaked on site. A slightly unusual item from this subunit is a unifacial chopping tool made out of quartzite. Although such artefacts are common in the Pontinian and sometimes interpreted as partially worked cores (Kuhn 1995, 95), it seems unlikely in this case. No similar items have been found and in the absence of any other tools in this subunit it could be argued that the chopping tool would have been a useful implement for processing the butchered animal and sea mammal bone also recorded in these levels (Stringer et al. 2008, and Chapter 18).

Three clear examples of hammerstones are recorded in this subunit. They are characterized by battermarks at the extremities. Two are of quartzite and one of sandstone.

Finally, some interesting observations can be offered on the distribution and quantity of chips recovered in these contexts and in comparison to those from the Upper Area hearth. The totals, presented in Table 20.6, show that despite the extensive nature of the charcoal spread (150) and underlying rubified sediment (151) no more than six specimens can be definitely attributed to this feature and

Table 20.5 Lithic artefact dimensions by raw material type for contexts 150, 151, 157–159.

Description	No.	Raw Material	Length + sd	Breadth + sd	Thickness + sd
Plain flakes	21	Quartzite	37.1 ± 23.9	27.7 ± 11.6	6.2 ± 3.4
Centripetal flakes	2	Quartzite	38 ± 5.6	25.5 ± 9.2	6.5 ± 2.1
Plain flakes	4	Red chert	26 ± 4.2	32 ± 6	5.5 ± 0.5
Centripetal flakes	2	Red chert	31 ± 1.4	23.5 ± 7.7	3.0 ± 1.4
Core edge removal flake	1	Red chert	21	16	5
Plain flakes	5	Undiff. chert	18.2 ± 2.7	18.6 ± 3.8	3.8 ± 0.8
Centripetal flake	1	Honey chert	54	30	7

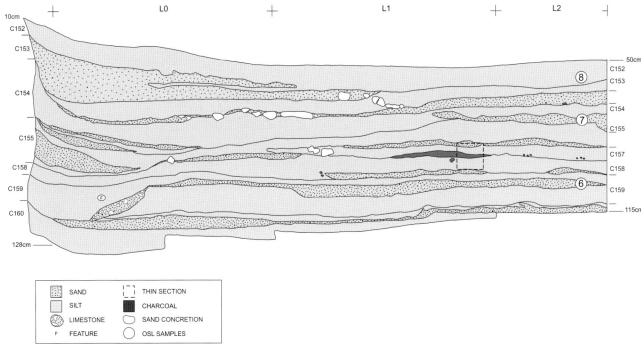

Fig. 20.10 Vanguard Middle Area (C–D). South–north stratigraphic section through the main artefact-bearing layers, at K–L interface, squares L0–L2. Hearth 150 is indicated in the section as are the positions of OSL samples.

only two of them were burnt. Elsewhere in the surrounding sediment 77 chips are recorded. These are mainly in quartzite but there is nevertheless a significant presence of fine-grained red chert. It is possible that some of the quartzite chips originated from the flaking or use of the unifacial chopper, which is in the same material, but it is more difficult to explain the red chert. The latter is poorly represented in the other debitage and it may suggest that whatever was manufactured was probably transferred from the immediate area. Despite intensive efforts to refit flakes and small chips (including chips to the unifacial chopper) these did not meet with much success. The only conjoins possible were *not* amongst the larger flakes, as might be expected, but between a number of smaller chert flakes and chips belonging to the earlier stages of core reduction (Fig. 20.12). All the refits are of cortical pieces and are focused on the peripheral zone of the hearth in squares M0 and M1.

In terms of the overall density of chips, the 77 examples recorded in this subunit come from a much larger area (12 m²) than the Upper hearth and shell midden, where 997 chips were recovered from an area of 5 m². Based on these observations it is clear that, unless they were removed by taphonomic processes, very little primary knapping took place around the hearth (context 150). There are also no retouch chips to signify the resharpening of tools. At first glance this evidence appears to be at odds with the concentration of faunal remains and the condition of the bone, which shows clear evidence of carcass processing and marrow fracturing (Chapter 21). If taken at face value, this would imply that the activities near the hearth were not carried out with the aid of stone tools. While some explanation is needed to account for the low numbers of chips present in this area, the discrepancy between the bone and lithic distributions is not irreconcilable. For example, hammerstones and pebbles were noted in the assemblage (Table 20.4) and this may help explain the abundance of percussion marks and breakages observed on the bones.

As a postscript, after writing this section I was made aware of a single quartzite scraper recovered in context 158. The artefact (Van 98-387) had been separated for microwear analysis and had been returned to Gibraltar Museum before it could be examined. Reference to it is made in an entry in the Vanguard notebook for 10th September 1998 (coordinates x = 21, y = 21, z = 100).

Contexts 160–162 (Basal Subunit)

Of the 19 plain flakes recorded in these two contexts, nine are complete and the rest broken. The proximal ends of 14

Table 20.6 Lithic chip totals by raw material type for contexts 150, 151, 157–159.

Chips <15 mm	150 H	151	157	158	159
Quartzite	2	2	15	12	7
Red chert			10	5	10
Undifferentiated chert	1	1	6	2	7
Total	3	3	31	19	24

Table 20.7 Lithic artefacts and raw materials in contexts 160–162.

Description	No.	Red Chert	Chert Undiff.	Quartz-ite	Lime-stone	Other/ Unclassified
Plain flakes	19	1		17	1	
Centripetal flakes	2			2		
Core edge removal flake	1			1		
Pseudo-Levallois point	1			1		
Shatter	3			3		
Chips <15 mm	7		3	4		
Cobble/hammerstones	2			1	1	
Pebble/pebble fragments	2			1		1
Total	37					

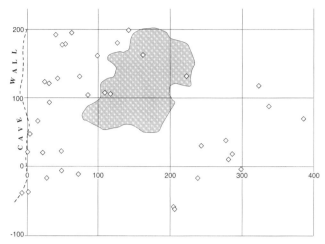

Fig. 20.11 Vanguard Middle Area (C–D). Spatial distribution of lithic artefacts in relation to 150–151 (hearth) and 157–159 showing refitting hammerstone fragments (see Fig. 20.7).

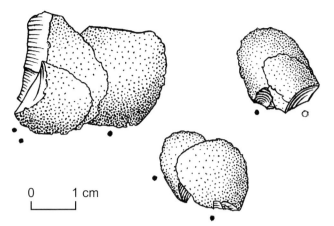

Fig. 20.12 Vanguard Middle Area (C–D). Refitting chert artefacts from context 157. Scale in cm. Drawings: Hazel Martingell.

of the complete flakes again exhibit a predominance of plain butts (12) with just one dihedral faceted and one faceted butt. Dorsal scar patterns are represented by unidirectional (eight) and multidirectional (three) types. Only three out of the 19 plain flakes show any preserved areas of exterior cortex. In addition to the plain flakes there are two centripetal flakes, and single specimens of a core edge removal flake and a pseudo-Levallois point (Table 20.7). The features of this admittedly small sample of flake debitage are all consistent with a discoidal core technology. Only one of the items from this context is burnt. It is a broken plain flake.

No cores or formal tools were identified in these two contexts. As in the subunits above, the basal occupation horizon is dominated by the use of quartzites. In this case it is possible that they represent the remains of one flaking episode but refitting would need to be undertaken to test this proposition. The chips in these sediments derive mostly from 160 (13), with only six from the underlying context.

Northern Alcove

A separate niche on the northern side of the main chamber was also investigated (Fig. 13.2). Although there were very few lithic artefacts, a small, well preserved hearth was discovered at about 7–8 m above the raised beach and therefore approximately at the same altitude as the sediments of the Middle Area. However, a link was never formally established through excavation and the precise relationship between the two sequences is still to be confirmed.

The hearth has already been described in detail (Barton 2000, 216). In summary, the feature recorded at the top of context 1005 was visible as a roughly oval-shaped charcoal patch, 50 × 25 cm in maximum dimension and no more than a few centimetres thick (Fig. 13.18). In section, the hearth revealed a 1–2 cm layer of laminated ash overlying a further 2 cm thickness of burnt sand and charcoal with some patches of underlying rubified sand. The fact that the fire must have been sealed by sands fairly soon after it had died down is illustrated by the preservation of the fragile laminated ash layers. Charcoals at the base of the ash layer and in the reddened sand were identified (Chapter 15) and indicate that branches of maritime and stone pine were used as firewood.

Only eight lithic artefacts were recorded as single finds. They comprised five flakes, two pieces of shatter and a chip. The raw materials include quartzite, chert, red chert and limestone. There was only one limestone flake from the same level as the hearth (context 1005). A further test pit 'deep sounding' was dug in the corner of the alcove which revealed numbers of artefacts amongst the sieved finds. These are not reported here but form part of the preserved archive in Gibraltar Museum.

Conclusions

Study of the lithic artefacts suggests that there is little variation over time in the assemblages that make up the present Vanguard sequence. Technologically, the artefacts from the Middle Area are no different from the finds of the Upper Area, except at the very top where Upper Palaeolithic artefacts have been found. In the Middle Palaeolithic layers there is little change in the dominance of quartzite as a raw material over finer-grained cherts, which probably reflects the more common availability of this material in comparison to other rocks immediately outside the cave. The fact that limestone from the cave bedrock was sometimes employed for making artefacts suggests that the Middle Palaeolithic occupants also made expedient use of raw materials closer to hand. The impression of short-term occupation events in this part of the cave is supported by the low diversity of raw materials and the limited range of tools in the assemblages. This would not be contradicted by the other evidence. For example, the reuse of hearths could well indicate repeated use of the same location within the cave for no more than three or four days (or nights). Certainly the size and density of the associated bone and artefact scatters in the Middle Area would not be in conflict with this suggestion. Following this theme further, the smaller examples of hearths in the Northern Alcove and in the Upper Area seem to represent events of even shorter duration, perhaps no more than the equivalent of overnight stays inside the cave. Overall, while we do not yet know the full extent of occupation evidence which certainly extends much further back into the cave, the present impression is of expedient patterns of behaviour similar to those already noted in Gorham's Cave (Chapter 12) and that the use of these caves was linked to localized and relatively low-level residential mobility. This picture may of course change once further excavations have

taken place, but there is no reason at present to believe that the uses of Vanguard Cave differed substantially from those of Gorham's Cave.

Acknowledgements

I would like to thank in particular Alison Roberts for her assistance with the database and in producing the tables and Figures 20.6 and 20.11. She and Yolanda Fernández-Jalvo also helped comment on an earlier draft of the text. I am grateful to Hazel Martingell for the lithic illustrations and to Alison Wilkins for help in producing the final figures.

References

Barton, R. N. E. 2000: Mousterian hearths and shellfish: late Neanderthal activities on Gibraltar. In Stringer, C. B., Barton, R. N. E. and Finlayson, J. C. (eds.), Neanderthals on the Edge (Oxford: Oxbow Books), 211–220.

Cáceres, I. 2002: Tafonomia de Yacimientos Antrópicos en Karst. Complejo Galería (Sierra de Atapuerca, Burgos), Vanguard Cave (Gibraltar) y Abric Romani (Barcelona) (Unpublished doctoral thesis, Universidad Rovira I Virgili, Tarragona, Spain).

Fernández-Jalvo, Y. and Andrews, P. 2000: The taphonomy of Pleistocene caves, with particular reference to Gibraltar. In Stringer, C. B., Barton, R. N. E. and Finlayson, J. C. (eds.), Neanderthals on the Edge (Oxford: Oxbow Books), 171–182.

Gale, R. and Carruthers, W. 2000: Charcoal and charred seed remains from Middle Palaeolithic levels at Gorham's and Vanguard Caves. In Stringer, C. B., Barton R. N. E. and Finlayson, J. C. (eds.), Neanderthals on the Edge (Oxford: Oxbow Books), 207–210.

Kuhn, S. L. 1995: Mousterian Lithic Technology. An ecological perspective (Princeton: Princeton University Press).

Stringer, C. B., Finlayson, J. C., Barton, R. N. E., Fernández-Jalvo, Y., Cáceres, I., Sabin, R. C., Rhodes, E. J., Currant, A. P., Rodríguez-Vidal, J., Giles Pacheco, F. and Riquelme Cantal, J. A. 2008: Neanderthal exploitation of marine mammals in Gibraltar. Proceedings of the National Academy of Sciences USA 105(38), 14319–14324.

21 Taphonomy of the fossil bone assemblages from the Middle Area in Vanguard Cave

I. Cáceres and Y. Fernández-Jalvo

Introduction

This chapter refers to the fossil assemblages recovered from the Middle Area of Vanguard Cave. The excavated faunal remains come from an area of around 12 m² (Barton *et al.* 1999; Barton 2000) that yielded Middle Palaeolithic artefacts and hearth evidence. The aim of this section is to ascertain the nature of activities carried out by humans in this part of Vanguard Cave and to obtain a better perspective of the living strategies and exploitation of food resources by Neanderthals. Comparisons are drawn with broadly contemporary Neanderthal occupation units from Abric Romaní, Capellades, in north-east Spain.

The fossil assemblages

Vanguard Cave has provided a diverse and ample faunal list (Currant 2000) including *Cervus elaphus* (red deer), *Capra ibex* (ibex), *Sus scrofa* (wild pig) and marine mammals comprising *Monachus monachus* (monk seal), *Delphinus delphis* (common dolphin) and *Tursiops truncates* (bottle nose dolphin). Carnivores identified include *Canis lupus* (wolf), *Crocuta crocuta* (spotted hyaena), *Felis sylvestris* (wild cat), *Panthera pardus* (leopard) and *Ursus arctos (*brown bear*).* Tortoise (*Testudo hermanni*) though present is not common. There is also an abundance and diversity of avian fossils (Cooper 2000; Chapter 17). Invertebrate marine molluscs identified include *Patella vulgata*, *Patella caerula*, *Mytilus galloprovincialis*, *Balanus* sp. *Acanthocardia tuberculata*, *Callista chione* (see Fernández-Jalvo and Andrews 2000). Overall, the vertebrate and invertebrate faunas present indicate Mediterranean conditions not greatly different from those of southern Iberia today, and this is consistent with the inferred MIS 5 age of most of the sequence in this cave (Currant 2000).

The taphonomic analysis described here is based on a total of 857 vertebrate fossils (97.44 per cent fossil bones and 2.56 per cent isolated teeth) which come from three main subunits of the Middle Area (see below). The most immediate trait of this fossil assemblage is the high rate of fragmentation with more than 91 per cent of the fossils showing evidence of breakage. Only 23.2 per cent of these fossils could be identified taxonomically or anatomically (Tables 21.1 and 21.2). Despite the small size of excavation and fragmented nature of the bones they show an interesting range of large animal species. Carnivores are more diverse than herbivores, although the former group is represented by only a few fossil remains. Amongst herbivores, *Capra ibex* is the most abundant followed by *Cervus elaphus* with a scarcity of *Sus scrofa* (1.28 per cent). The presence of marine mammals is based on a few remains of *Monachus monachus* and representatives of the family Delphinidae (Table 21.1).

The collection as a whole was examined under a binocular microscope. Some specimens were also analysed using scanning electron microscopy (SEM), an ISI ABT55 SEM-fitted with an environmental chamber, operating in the back-scattered electron emission mode at 20 kV, which is housed at the Natural History Museum (London). The use of the environmental chamber enables specimens to be directly analysed with no necessity for coating or any special preparation.

Capra ibex shows the greatest diversity of anatomical elements present, followed by *Cervus elaphus* (Table 21.2). Nevertheless, absences noted include the patella and fibula in ibex; the cranium, scapula, coxals, femurs, metatarsals and sesamoids in red deer. Suids are represented by only isolated teeth and dissociated elements of postcranial material. Carnivores are basically represented by postcranial elements, except brown bear for which there are only individual teeth. Given the difficulties of high fragmentation and problems of identification, we have grouped these fossils according to established weight categories (Blumenschine 1986):

- Large sized mammals (>350 kg) which in Vanguard include the marine mammals.
- Medium sized mammals (115–350 kg) which here include deer and adult suids.
- Small sized mammals (<115 kg) which include ibex, immature deer and pig.

Table 21.1 Taxonomic identification of remains recovered from Vanguard Cave (Currant 2000; Chapter 18).

Taxa	NR	%
Cervus elaphus	40	4.7
Capra ibex	121	14.1
Sus scrofa	11	1.3
Monachus monachus	3	0.4
Delphinus delphis	2	0.2
Tursiops truncatus	1	0.1
Delphinidae indet.	1	0.1
Diplodus sargus/vulgaris	1	0.1
Canis lupus	2	0.2
Crocuta crocuta	5	0.6
Felis sylvestris	4	0.5
Panthera pardus	7	0.8
Ursus arctos	2	0.2
Unidentified	658	76.8
Total	857	100.1

Cáceres Fernández-Jalvo

Table 21.2 NISP of the species identified at Vanguard Cave Middle Area.

Element	C. elaphus	C. ibex	S. scrofa	C. lupus	C. crocuta	F. sylvestris	P. pardus	U. arctos	M. monachus	D. delphis	T. truncatus	Delphinidae	Unidentified	Total
Skull	-	3	-	-	-	-	-	-	-	-	-	-	12	15
Maxillae	-	3	-	-	-	-	-	-	-	-	-	-	2	5
Mandible	3	3	-	-	-	-	-	-	1	-	-	-	8	15
Hioides	-	-	-	-	-	-	-	-	-	-	-	-	1	1
Teeth	5	7	2	-	-	-	-	1	-	-	-	-	7	22
Rib	1	13	1	-	-	-	-	-	-	-	-	-	87	102
Vertebrae	2	8	3	-	1	-	-	-	-	2	1	-	72	89
Scapula	-	4	1	-	-	-	-	-	1	-	-	-	9	15
Humerus	1	4	-	-	-	-	-	-	-	-	-	-	8	13
Radius	1	6	-	-	-	-	2	-	-	-	-	-	2	11
Ulna	2	3	-	-	-	-	-	-	-	-	-	1	1	7
Metacarpal	2	9	-	-	1	1	-	-	-	-	-	-	2	15
Carpals	4	3	-	-	-	-	1	-	-	-	-	-	-	8
Innominate	-	3	-	-	-	-	-	-	-	-	-	-	1	4
Femur	-	4	2	-	-	1	-	1	-	-	-	-	8	16
Patellae	-	-	-	-	-	-	-	-	-	-	-	-	-	-
Tibiae	9	10	-	-	-	-	-	-	-	-	-	-	6	25
Fibulae	1	-	-	-	-	-	-	-	-	-	-	-	-	1
Metatarsal	-	8	1	1	2	-	1	-	-	-	-	-	-	13
Metapodial	1	1	1	1	1	-	-	-	-	-	-	-	15	20
Tarsal	2	4	-	-	-	2	-	-	-	-	-	-	2	10
Phalange	6	24	-	-	-	-	3	-	1	-	-	-	16	50
Long Bone	-	-	-	-	-	-	-	-	-	-	-	-	210	210
Flat Bone	-	-	-	-	-	-	-	-	-	-	-	-	57	57
Articular Bone	-	1	-	-	-	-	-	-	-	-	-	-	24	25
Non-assigned	-	-	-	-	-	-	-	-	-	-	-	-	108	108
Total	40	121	11	2	5	4	7	2	3	2	1	1	658	857

Table 21.3 NME of weight-size categories of animals and skeleton parts (cranial vs. axial vs. appendicular). N-A = Non-assigned.

Anatomical Segment	Element	Large Size	Medium Size	Small Size	Total
Cranial (14)					
	Skull		2	4	6
	Mandible	1	4	2	7
	Hioides			1	1
Axial (56)					
	Vertebrae	2	13	16	31
	Rib	1	8	12	21
	Innominate		1	3	4
Appendicular (112)					
Anterior (39)					
	Scapula	1	2	2	5
	Humerus		2	4	6
	Radius		3	5	8
	Ulna	1	3	1	5
	Metacarpal		2	6	8
	Carpal		1	6	7
Posterior (31)					
	Femur		4	2	6
	Tibiae		4	6	10
	Fibulae		1		1
	Metatarsal		1	6	7
	Tarsal		2	5	7
N-A (42)					
	Metapodial		5	2	7
	Phalanges	1	10	18	29
	Sesamoid		3	3	6
	Total	7	71	104	182

In order to evaluate the integrity of the carcasses represented in the Middle Area, several indices have been calculated, such as MNI (Minimum Number of Individuals) and MNE (Minimum Number of Elements) according to the weight size classes described above. To calculate the MNI and MNE, anatomical position, age, portion and size have been taken into account for each identifiable anatomical element. The MNI consists of 19 individuals sub-divided into six small sized mammals, four medium sized and four large sized animals, plus five of carnivores. Most of these individuals are immature, and there is no record of senile individuals. The MNI of large sized mammals corresponds to an adult and an immature *Monachus monachus*, one immature *Delphinus delphis* and an adult *Tursiops truncatus*. The medium sized class (deer and wild pig) adults were identified from dental microwear and immature individuals from incomplete surface bone formation and non-fused epiphyses.

The age profile of the small sized animals is made up of four infants, one juvenile (five immature) and one adult. Carnivores have an MNI of five, all of them adults. In general, around 64 per cent represent immature individuals and there are no diagnostically old individuals of any species from the Middle Area.

Table 21.3 shows the MNE obtained from this assemblage and indicates a relative abundance of vertebrae, phalanges and ribs. The appendicular skeleton is the best represented, with a similar proportion of forelimbs to hindlimbs. Axial elements are more common than cranial ones. The index of survival or relative abundance

(Brain 1969; Dodson and Wexlar 1979; Andrews 1990; Lyman 1994) was also calculated in order to evaluate the number of anatomical elements relative to their presence in the skeleton.

> ***Relative abundance*** $_i$ = number of element $_i$ recovered / (number of element $_i$ in a single animal skeleton . MNI).
>
> $$Ri = Ni/MNI \times Ei$$
>
> Where Ri = the relative abundance of the element i
> Ni = the number of element i in the sample
> MNI = minimum number of individuals
> Ei = the number of element i in the animal skeleton.

In order to avoid anomalies due to high fragmentation, and thus low identification of anatomical elements or taxonomic species, the relative abundance is illustrated in Figure 21.1. It shows a similar representation of medium and small sized animals with a high relative representation of cranial parts (heads) and a low frequency of axial elements (below 10 per cent). The large size class containing marine mammals shows a comparatively low presence of axial, appendicular and cranial skeletal segments (below 5 per cent).

To compensate for the high fragmentation observed in this sample (only 8.4 per cent are complete), the broken pieces have been sub-divided into groups (Table 21.4). This shows that articular bones, e.g. wrist and ankle bones, sesamoids and phalanges, which are less frequently broken at other sites, are heavily broken at Vanguard. Fragment sizes from category B (2–5 cm) and category C (5–10 cm) are the most abundant classes represented here (Table 21.4).

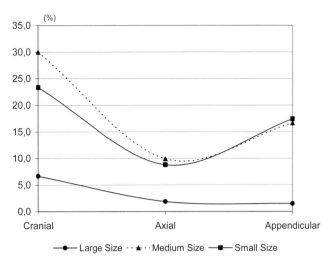

Fig. 21.1 Relative abundance of skeletal parts according to weight size classes.

Humanly induced damage

The scarcity of complete bones recovered from the Middle Area indicates a strong influence of destructive taphonomic agents in this part of the site. The most commonly observed damage relates to human modification (Table 21.5), such as cut-marks made by stone tools (20.3 per cent), breakage associated with marrow extraction (0.7 per cent adhering bone flakes and 3.5 per cent percussion pits and conchoidal scars), and burned bones (31.8 per cent).

Burning mainly affects the bones of medium and small sized mammals, around 70 per cent of which show incipient

Table 21.4 NISP of size categories of fragments (complete elements have not been included). Percentages refer to the total number of remains.

	Large Size		Medium Size		Small Size		Carnivores		Unidentified		TOTAL	
	NR	%	NR	%	NR	%	NR	%	NR	%	NR	%
A (<2 cm)	1	0.13	10	1.27	18	2.29	0	0.00	38	4.84	67	8.54
B (2–5 cm)	4	0.51	187	23.82	151	19.24	4	0.51	96	12.23	442	56.31
C (5–10 cm)	1	0.13	134	17.07	77	9.81	1	0.13	12	1.53	225	28.66
D (>10 cm)	2	0.25	25	3.18	21	2.68	1	0.13	2	0.25	51	6.50
Total	8	1.02	356	45.35	267	34.01	6	0.76	148	18.85	785	

Table 21.5 Taphonomic modifications of bones according to weight-size categories.

Bone Modifications	Large Size		Medium Size		Small Size		Unidentified		Total	
	NR	%	NR	%	NR	%	NR	%	NR	%
Human Damage										
Cut-marks	3	0.4	91	10.9	64	7.6	11	1.3	169	20.3
Percussion pits			16	1.9	10	1.2			26	3.1
Flakes			16	1.9	1	0.1			17	2.0
Conchoidal scars			4	0.5	2	0.2			6	0.7
Peeling	2	0.2	7	0.8	8	1.0	1	0.1	18	2.2
Adhered flakes					6	0.7			6	0.7
Burnt bones	1	0.1	147	17.6	85	10.2	31	3.7	264	31.8
Carnivore Damage										
Tooth marks			15	1.8	10	1.2	4	0.5	29	3.5
Digestion			1	0.1					1	0.1
Post-Depositional Damage										
Trampling			15	1.8	8	1.0	1	0.1	24	2.9
Cracking			10	1.2	4	0.5	2	0.2	16	1.9
Rounding			1	0.1					1	0.1
Polish			1	0.1					1	0.1
Root etching			21	2.5	10	1.2	3	0.4	34	4.1
Chemical corrosion			2	0.2	1	0.1	1	0.1	4	0.5

signs of burning or grade 1 types of alteration. This is identified by small brown points well dispersed over the whole surface of the bone (Table 21.6). We have experimentally observed that this type of alteration occurs when bones are in contact with embers, but not directly exposed to flames. Intermediate grades 2 to 4 cover examples with brown to blackish grey areas and with medium to strong cracking (Fernández-Jalvo and Perales 1990). This occurs on bones that are directly exposed to flames and/or exposed to fire during prolonged time intervals. At Vanguard, such examples are much less in evidence than those of grade 1. Bones at the maximum grade of burning (grade 5, white and very fragile, broken, heavily cracked bones) are absent.

Cut-marks are present on 20.3 per cent of the total number of bones examined. They include examples with incisions, sawing marks, scrapes and chop marks and are all related to butchery activities. Almost 11 per cent of the cut-marked bones are from medium sized animals while 7.5 per cent belong to smaller mammals. Only a tiny percentage of bones are from larger sized animals (0.35 per cent) but it is interesting that they include seal bones and provide evidence that marine mammals were exploited by Neanderthals. Incision marks are the most abundant type of cuts associated with the Vanguard mammals (Fig. 21.2).

The analysis of breakage patterns (Table 21.5) suggests the use of two techniques of bone fragmentation to extract marrow as well as blood and fat: by direct percussion and by bending. The use of direct percussion is indicated by adhering bone flakes, percussion pits and conchoidal scars (Blumenschine and Selvaggio 1988). Bending or peeling has been described by White (1992) as a roughened surface with parallel grooves or fibrous texture, produced 'when fresh bone is fractured and peeled apart similar to bending a small fresh twig from a tree branch between two hands' (White 1992, 140). Peeling was recorded as present or absent for each fossil in the Vanguard sample, and it has been seen to be more frequent on thin bones, such as ribs, vertebrae and mandibles. The fractures have been classified according to the categories of Villa and Mahieu (1991). These authors compared three different French sites, Fontbrégoua, a Neolithic site (c. 4000 BC), and the collective burials of Besouze and Sarrians (Late Neolithic, c. 2500 BC). At Fontbrégoua there is evidence of cannibalism and hence frequent traces of long bone breakage when still green or fresh (Villa and Mahieu 1991). At Besouze, the sub-fossil bones were broken

Table 21.6 Number of burnt bone fossils.

Grade 1: small brown spots relatively dispersed all over the surface. Grade 2: brown colour all over the surface. Grade 3: black colour. Grade 4: grey colour. Grade 5 is the maximum characterized by carbonized bones which acquire a white colour on their surface. This grade has not been detected in any of the Vanguard Cave fossils. Percentages are shown as relative to the total number of burnt fossils and to the total number of fossils recovered in Vanguard Cave.

	Total number of burnt fossils	%Relative	%Total
Grade 1	184	69.17	21.98
Grade 2	32	12.03	3.82
Grade 3	44	16.54	5.26
Grade 4	6	2.26	0.72
Total	266	100.00	31.78

by impact, equivalent to dry bone broken by falling blocks, and at Sarrians fossil bones were broken by sediment pressure, equivalent to diagenetic breakage. The analysis shows an abundance of curved, oblique and smooth broken edges (Fig. 21.3) that are identical to the experimental breakage of fresh bone.

There are slight differences, however, such as a higher than expected incidence of mixed fracture angles, and these suggest that the bones were heated before they were broken. This form of heat pre-treatment has been used experimentally and facilitates breakage and marrow extraction, especially as the marrow solidifies when heated (Cáceres *et al.* 2002).

All categories of humanly induced damage are represented across the three different mammal size classes and across different anatomical elements (mainly appendicular but also axial elements). Together they suggest an intensive exploitation of meat protein from both terrestrial and marine resources.

Carnivore damage

Evidence of carnivore damage is minimal with only 3.5 per cent (30 bones) bearing tooth marks and only one example of a digested bone. Tooth marks were described and measured separately for all anatomical items following the methodology of Andrews and Fernández-Jalvo (1997), which considers both the type of chewing and anatomical element affected. The eight categories are as follows:

A Carnivore pits on bone surface (minimum dimension).
B Carnivore gnawing on bone surface (transverse measurement of grooves; see Fig. 21.2).
C Carnivore pits on articulation surfaces.
D Carnivore punctures on spiral breaks.
E Carnivore punctures on transverse breaks.
F Carnivore punctures on split shafts.
G Multiple molar pits made by multi-cuspid teeth.
H Carnivore punctures on intact bone edges.

As observed for cut-marks, chew marks mainly occur on medium and small sized animals, and consist most abundantly of pits (A), grooves (B), and punctures (F and H) mainly affecting long bones. Other bones affected by chew marks are a fragment of mandible, three fragments of vertebrae and two ribs. Dimensions of these tooth marks are around 1.5 mm for categories A and H, and between 1.3 and 2.5 mm for categories B and F. The small number of fossils showing tooth marks on their surfaces makes it difficult to identify the predator, although it was clearly not a small sized carnivore such as a red fox, frequent predator/scavenger in the area (Fernández-Jalvo and Andrews 2000). The absence of chew marks on the broken edges implies secondary access and therefore probably connected with scavenging the residues left by a previous predator, in this case *Homo*.

Post-depositional modifications

Signs of post-depositional modification on the bones are very scarce (Table 21.5). This is especially relevant since the cave has a wide entrance which would have been open

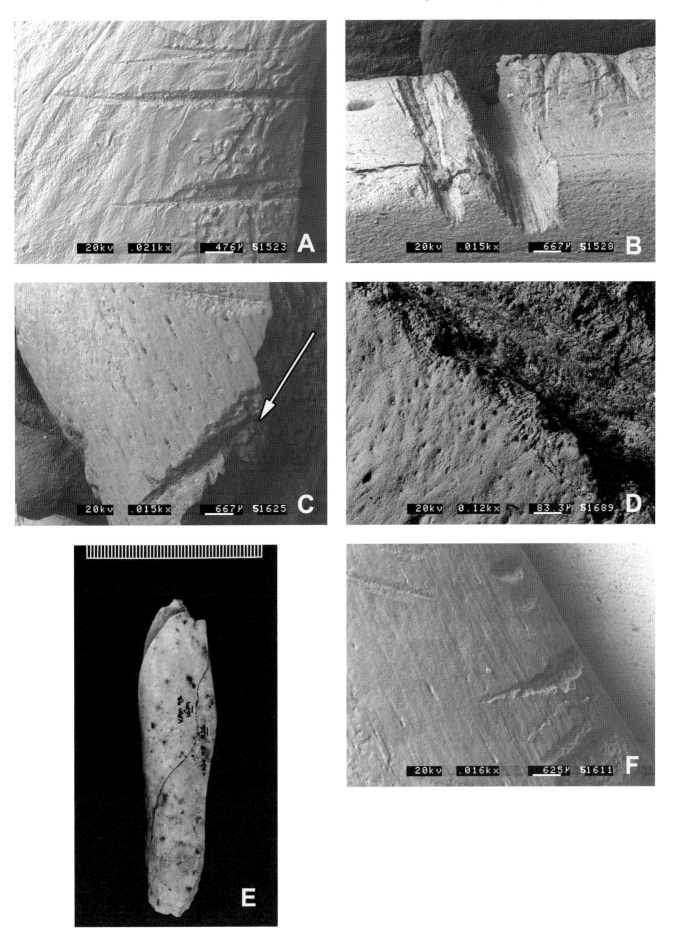

Fig. 21.2 Scanning electron micrographs of cut-marks from fossils recovered at Vanguard Cave. A: incisions on a vertebra of goat possibly made to dismember. B: sawing cuts on a rib, nearby the articulation. C: stroke with a stone tool edge on an unidentified fossil fragment. D: incisions on an immature long bone shaft. E: a refitted bone fragment showing incipient cremation spots all over the surface. F: tooth mark grooves on the edge of a rib fragment. Photo: Natural History Museum, London.

Fracture Outline

Fracture Angle

Fracture Edge

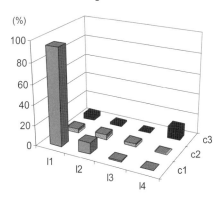

Shaft length and circumference

Fig. 21.3 Diagrams showing the different categories of breakage analysed at Vanguard Cave Middle Area fossil collection according to the method of Villa and Mahieu (1991):

1 Fracture outline: curved-V-shaped/intermediate/ transverse/ longitudinal.
2 Fracture angle: oblique/right/mixed (oblique and right).
3 Fracture edge: smooth/jagged.
4 Shaft circumference: 1, circumference is <½ of the original; 2, circumference is >½ of the original; 3, complete.

Vanguard fossil assemblage is compared to Abric Romaní and Fontbrégua (see text) as examples of fresh bone breakage to extract the marrow, Besouze, as equivalent to breakage by falling blocks, and Sarrians as equivalent to diagenetic breakage.

during this period. The bone remains should, therefore, have been directly exposed to weathering agents, but fossil surface modifications indicative of weathering (Behrensmeyer 1978) are largely absent. Trampling effects (Andrews and Cook 1985; Behrensmeyer *et al.* 1986) can be seen on around 2.2 per cent of the sample, while rounding, polishing and corrosion modifications are negligible. The complete absence of bones chewed by rodents is also interesting since these animals are often present in caves and were certainly frequently found in the Middle Palaeolithic layers in Gorham's Cave (see Chapter 10). Rodents chew dry bones to wear down their continuously growing teeth, and the presence of gnaw marks on bone would indicate relatively prolonged exposure of such objects on the surface. The scarcity of modifications by pre-burial taphonomic agents (especially trampling) suggests rapid burial of surfaces by sands as observed in the Upper Area of this cave by Fernández-Jalvo and Andrews (2000).

The rapid accumulation of wind-blown sand deposits would most likely have prevented major soil development and plant growth, and this would also explain the infrequent presence of root-marking (4.1 per cent of all fossils) or the effects of soil corrosion (0.5 per cent), which is slightly surprising given the proximity of the cave entrance.

Fossil bone distribution and refitting

The deposits of the Middle Area comprise relatively continuous sands and silty horizons that sometimes show interbedded darker horizons of charcoal and ash marking the positions of hearths. The bones (Table 21.7) were nearly always recovered from the silty clay contexts rather than the sands, but it was

Table 21.7 Anatomical and taphonomic traits of fossils in each subunit based on the fossil distribution.

%T = Percentage respective to the total number of fossils recovered from Vanguard Cave Middle Area. %NR = Percentage referred to fossil remains recovered from each subunit.

Features	Top subunit NR 152 (24.2%) NMI 6			Central subunit NR 292 (46.4%) NMI 8			Basal subunit NR 185 (29.4%) NMI 8		
	NR	%T	%NR	NR	%T	%NR	NR	%T	%NR
Sized class									
Large size	1	16.7	0.7	5	83.3	1.7	2	0.3	1.1
Medium size	88	30.7	57.9	128	44.6	43.8	71	24.7	38.4
Small size	26	12.0	17.1	112	51.9	38.4	78	36.1	42.2
Segments									
Cranial	6	20.7	3.9	14	48.3	4.8	9	31	4.9
Axial	55	28.5	36.2	99	51.3	33.9	39	20.2	21.1
Appendicular	64	20.3	42.1	144	45.7	49.3	107	34	57.8
Dimensions									
<2 cm	10	25	6.6	15	37.5	5.1	15	37.5	8.1
2-5 cm	89	26.6	58.6	152	43.8	52.1	106	30.5	57.3
5-10 cm	42	22.1	27.6	94	49.5	32.2	54	28.4	29.2
>10 cm	10	20.4	6.6	29	59.2	9.9	10	20.4	5.4
Human damage									
Cut-marks	32	22.5	21.1	66	46.5	22.6	44	31	23.8
Breakage	9	15.3	5.9	34	57.6	11.6	16	27.1	8.6
Burnt bones	70	32.6	46.1	100	46.5	34.2	45	20.9	24.3
Tooth marks	5	22.7	3.3	13	59.1	4.5	4	18.2	2.2
Trampling	3	16.7	2	11	61.1	3.8	4	22.2	2.2
Cracking	4	33.3	2.6	5	41.7	1.7	3	25	1.6
Root etching	8	23.5	5.3	15	44.1	5.1	11	32.4	5.9

not always possible to trace individually separated silty clay horizons over much distance and it was hard to recognize individual occupation events or moments in time (Pettitt and Bailey 2000; Barton *et al.* 1999; Stringer 2000a; 2000b). However, using both the spatial distribution of bones and refitting evidence (Tables 21.8 and 21.9) it may be possible to separate out such events and solve the problem of palimpsests. According to the projections in longitudinal sections from the cave entrance, we have been able to distinguish at least three episodes of occupation (Fig. 21.4). By further considering the taphonomic modifications to bones we believe it may also be eventually possible to show seasonality differences between the occupations. Based on our refitting observations we would recognize three archaeological subunits: a

top subunit consisting of contexts 154–155, a central subunit comprising 151 and 157–159 and a basal subunit relating to contexts 160 and 161 (Fig. 21.5).

In general terms, the finds found in the subunits are characterized by a predominance of medium sized animals, a higher abundance of appendicular skeleton and a high incidence of human damage. All these three episodes also show presence of marine mammals, with the lowest representation in the basal subunit. But this could be due to small sample size or seasonality factors. The only way to resolve this uncertainty will be through further excavation.

Marine mammal and fish fossil remains excavated from contexts 154–157 are displayed in Table 21.1. We have identified cut-marks on a scapula and phalanx of *M. monachus*

Table 21.8 Features of refitting bones from Vanguard Cave.

Level/#: Contexts	Element	Label (SQ/depth)	Modifications
Basal level			
#1: Context 160	Femur *C. elaphus* adult	Van98-1051 (L0/-130cm)	Burnt (1); cut-marks; chem. corrosion
Context 160		Van98-929 (M0/-124cm)	Flake; burnt (1); cut-marks
#2: Context 160	Long Bone – Medium Size	Van98-995 (L0/-122cm)	Burnt (1)
Context 160		Van98-947 (L0/-133cm)	Burnt (3); cut-marks; percussion; chem. corrosion
#3: Context 160	Long Bone – Medium Size	Van98-926 (M0/-115cm)	Burnt (1)
Context 160		Van98-1079 (M0/-121cm)	Burnt (1); cut-marks; percussion pits; chem. corrosion
#4: Context 160	Long Bone – Medium Size	Van98-1081 (L0/-132cm)	Burnt (3)
Context 160		Van98-1082a (L0/-130cm)	Burnt (3)
Context 160		Van98-1088 (L0/-130cm)	Burnt (3)
Central level			
#5: Context 158	Long Bone – Medium Size	Van98-391 (M0/-98cm)	Cut-marks
Context 158		Van98-392 (M0/-97cm)	Cut-marks
#6: Context 158	Humerus *C. ibex* adult	Van98-385 (M0/-101cm)	Trampling
Context 151		Van97-396 (M0/-103cm)	Adhered flake
Context 158		Van98-757 (L0/-111cm)	Burnt (1)
#7: Context 157/158	Tibia *C. elaphus* adult	Van98-55 (N3/-91cm)	Burnt (1)
Context 158		Van98-66 (L0/-104cm)	Cut-marks
Context 159		Van98-120 (L3/-102cm)	Burnt (1); cut-marks
Context 151		Van97-405 (M0/-107cm)	Burnt (1)
Context 151		Van97-406 (M3/-104cm)	Burnt (1)
Context 151		Van97-410 (M3/-99cm)	Burnt (1); cut-marks; chemical corrosion
#8: Context 151	Long Bone – Medium Size	Van97-377 (M0/-100cm)	No modifications
Context 151		Van97-383 (M0/-101cm)	
Top level			
#9: Context 154	Metacarpal *C. ibex* adult	Van97-35 (M2/-70cm)	No modifications
Context 154		Van97-36 (M2/-70cm)	Cut-marks

Table 21.9 Features of anatomical connections of bones from Vanguard Cave.

Level/#: Contexts	Element	Label (SQ/depth)	Modifications
Basal level			
#1: Context 160	Metapodial + First Phalanx – Medium Size	Van98-939 (M0/-130cm)	Burnt (1)
Context 160		Van98-970 (L0/-130cm)	No modifications
#2: Context 161	Lumbar vertebra and vertebral disc – Small Size	Van98-354 (O2/-118cm)	Peeling
Context 161		Van98-366 (O2/-118cm)	No modifications
Central level			
#3: Context 158	Phalanges *C. ibex*	Van97-348 (L2/-93cm)	Distal end of first phalanx
Context 158		Van97-349 (L2/-93cm)	Second phalanx complete
Context 158		Van97-350 (L2/-92cm)	Third phalanx complete
Context 158		Van97-351 (L2/-92cm)	
#4: Context 159	Metapodial + articular bones	Van98-73a (L3/-99cm)	Proximal epiphysis and shaft of metapodial
Context 159		Van98-73b (L3/-99cm)	No modifications
Context 159		Van98-73c (L3/-99cm)	
#5: Context 157	Tibia + Tarsal bone C. elaphus	Van95-258a (N1/-98cm)	Burnt (1)
Context 157		Van95-258b (N1/-98cm)	Burnt (1); cut-marks; percussion
Top level			
#6: Context 155	Metapodial + First Phalanx *C. ibex*	Van98-334 (L1/-90cm)	Phalanx is burnt (1)
Context 155		Van98-336 (L1/-89cm)	No modifications
#7: Context 155/154	Tibia + Fibula + maleolar of *C. elaphus*	Van96-35 (M1/-84cm)	
Context 155/154		Van96-35 (M1/-84cm)	No modifications
Context 155		Van96-40(M1/-84cm)	

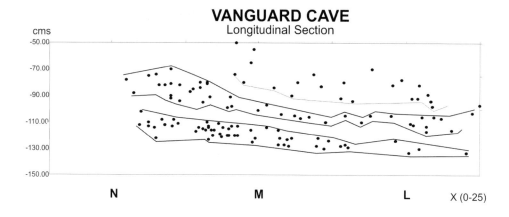

VANGUARD CAVE
Longitudinal Section

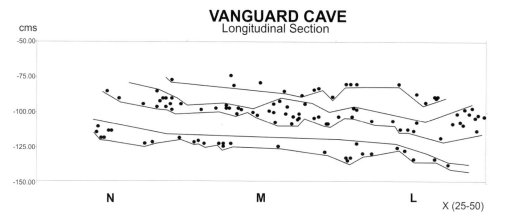

VANGUARD CAVE
Longitudinal Section

Fig. 21.4 Three subunits have been distinguished when projecting the fossils in lateral sections along the length of the cave, from the outside – left hand – to the interior – right side of the diagram.

(Stringer *et al.* 2008). Two groups of cut-marks can be distinguished on the proximal phalanx from the hind limb VAN 96 (411), which is missing its proximal articulation. One group of cut-marks is on the lateral side, transverse to the length of the bone. The other group is formed by three parallel cut-marks, again transverse to the long axis of the bone, on the ventral side. The location and distribution of cut-marks suggest that these relate to defleshing of seals. Breakage on the proximal end of the phalanx shows peeling on the broken edge, consistent with disarticulation activity.

Reddish brown stains are dispersed on the bone surface as in the case of bones of the terrestrial mammalian fauna of red deer (*Cervus elaphus*) and ibex (*Capra ibex*) recovered from the same contexts, and in proximity to hearth features.

To test the integrity of the different contexts we undertook refitting of fragments and considered the distribution of elements formerly in anatomical connection (Tables 21.8 and 21.9). We also referred to the preservation state of bones according to the list of taphonomic traits described above. Our results showed that, for example, refit No. 7

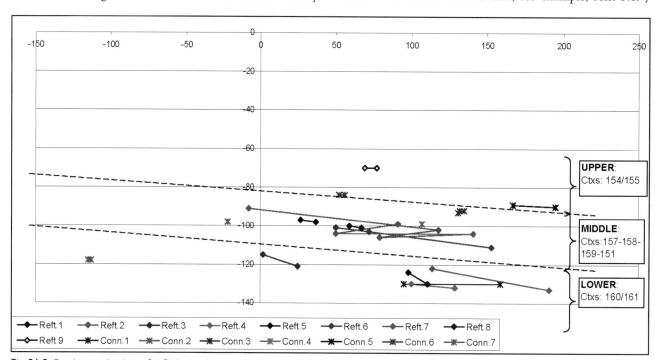

Fig. 21.5 Section projection of refitting and anatomical connections from Vanguard, relating contexts and the three subunits distinguished here based on bone distribution (Fig. 21.4). (Colour version available online)

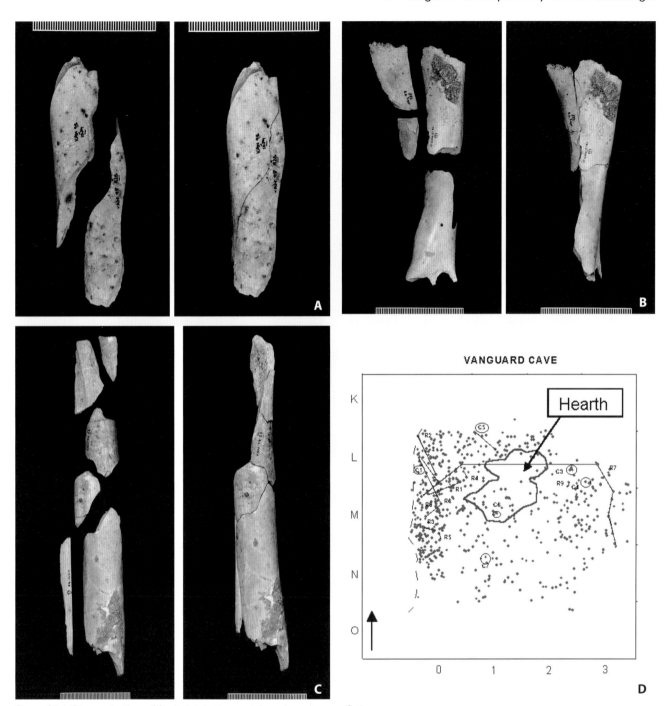

Figure 21.6 Plan projection of fossil distribution and three large bone refitting examples around the hearth (150). Photo: Natural History Museum, London.

(Table 21.8) is composed of fragments of a tibia of *Cervus elaphus* (Fig. 21.6c) recovered from contexts 151, 157, 158 and 159. These are stratigraphically contiguous contexts covering a total thickness of no more than 8 cm (151 is a dark brown clay sand lens between 157 and 158); the refit and other information suggest that these contexts (151, 157, 158 and 159) contain material that comes from one single synchronous event. Similarly, it was noted that refits connected objects in contexts 154 and 155 (Fig. 21.5).

A plan projection of bone also indicates a higher abundance of fossils located close to the cave wall. There is no evidence to suggest that they were emplaced by water or wind transport or gravitational rearrangement or by other processes, such as trampling or carnivore activity which are almost negligible. Several bone fragments, most of them with humanly induced modifications, can be refitted or

show that connections existed between related anatomical elements (see Fig. 21.6; Tables 21.8 and 21.9), and all of them have random directions.

Comparison between Vanguard Cave Middle Area and Abric Romaní

In order to know whether such a bone distribution (between the cave wall and the hearth) could be accidental or have an intentional rearrangement, as well as gain a more complete view of the site, we have compared Vanguard Cave to Abric Romaní (Capellades, Barcelona, Spain). Abric Romaní has an excavated area of 400 m² and has yielded a number of Neanderthal occupation layers. In each of these levels, a complex site structure can be recognized with finds distributed around a number of contemporary hearths and with distinct areas where specific activities (butchery,

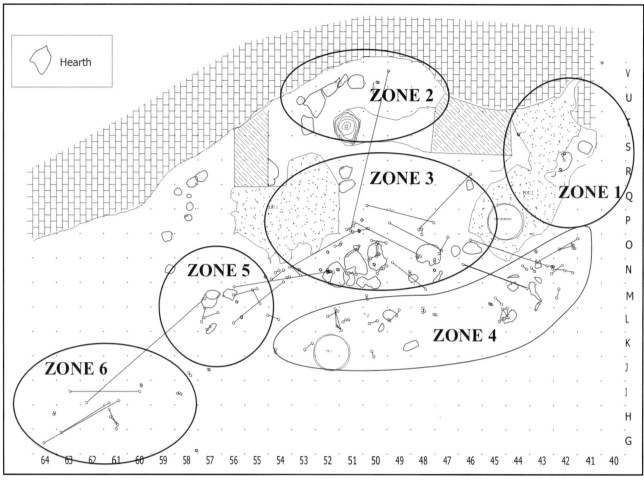

Fig. 21.7 Plan projection of finds from Abric Romaní. Level Ja. Each letter and number indicates one square metre. Three zones (encircled) were compared to Vanguard Middle Area.

Zone 2, the cave wall area is similar *a priori* to the excavated area at Vanguard. A higher density of fossils near the wall and next to the hearth was also observed in Abric Romaní. Taphonomic traits, however, show higher fragmentation and greater burning.

Zone 3, in the centre of the occupation level, fossils are also described as smaller than 4 cm and carbonized.

Zone 5, the cave entrance shows more taphonomic similarities with Vanguard, i.e. bigger size of fragments (>5 and up to 10 cm) and incipient grades of burning.

cooking, knapping) can be identified (Carbonell *et al.* 1996; Vaquero 1997; Carbonell and Vaquero 1996). One of the most extensive and best documented levels is subunit Ja which dates to around 50,000 BP. This subunit contains 50 hearths, 7000 bone fossils and more than 5000 pieces of knapping debris and retouched stone tools. Three distinct areas of Ja (Fig. 21.7) were compared to Vanguard, according to geomorphological features and observations on the bone and fossil distribution patterns. The three zones at Abric Romaní relevant to our observations are the cave wall and its concentration of fossils (Zone 2); the central area of the occupation level (Zone 3); and the cave entrance (Zone 5) (Cáceres 2002).

These three zones yielded 61.1 per cent of the total fossil bones of subunit Ja. Zone 2 alone produced 709 fossils, i.e. 11.16 per cent of the total fossil assemblage of Ja. The zone also revealed several hearths aligned parallel to the cave wall. The fossil bone fragments that were recovered were generally of small dimension (95 per cent <5 cm long) and mostly occurred in the space between the cave wall and the hearths, but with a high number found inside the hearths themselves. The bones appear to have been subjected to burning at high temperatures with grades 4 and 5 representing 59 per cent of the burnt sample. In the central

part of the Abric Romaní site (Zone 3) small size fragments are well represented with 40 per cent <2 cm and more than 90 per cent <5 cm). Most of these fragments occur inside hearths and show heavy signs of burning (13 per cent of burnt bones are grade 5). Both Zones 2 and 3 differ from the Middle Area of Vanguard Cave because of the high numbers of extremely burnt bones and the small size of bone fragments. At Abric Romaní several fragments from Zones 2 and 3 also refit with fragments from other zones, indicating a clear relationship with activities in other parts of the site.

Fossil bones from Zone 5 of Abric Romaní's cave entrance appear dispersed around three superimposed hearths. The bones from this zone are only slightly burnt (>62 per cent) and are characterized by small brown stains all over their surfaces. This is the area where the biggest fragments were found, few smaller than 2 cm and the highest percentage of bones >5 cm (Table 21.10). Most fossils around the hearths bear abundant cut-marks and evidence of breakage to extract the marrow. It is also common to find refitting between bone fragments in this area of the site and so offers obvious comparisons with Vanguard. At Abric Romaní refitting can also be extended to the lithic artefacts and shows links between the cave entrance and the central area of the site.

Table 21.10 Taphonomic traits of Zone 2 (cave wall), Zone 3 (central part) and Zone 5 (cave entrance) of unit Ja from Abric Romaní (Barcelona, Spain).

NR = Number of remains; %NR = Percentage referred to fossil remains recovered from each zone.

Features	Zone 2 A. Romaní NR = 709 (11.16%)		Zone 3 A. Romaní NR = 2516 (39.96%)		Zone 5 A. Romaní NR = 626 (9.94%)	
	NR	%NR	NR	%NR	NR	%NR
Sized class						
Large size	50	7.05	472	18.76	192	30.67
Medium size	238	33.57	843	33.51	206	32.91
Small size	17	2.40	86	3.42	19	3.04
Segments						
Cranial	19	2.68	161	6.40	104	16.61
Axial	22	3.10	98	3.90	32	5.11
Appendicular	192	27.08	786	31.24	204	32.59
Dimensions						
<2 cm	306	43.16	1010	40.14	178	28.43
2-5 cm	368	51.90	1265	50.28	318	50.80
5-10 cm	32	4.51	190	7.55	98	15.65
>10 cm	3	0.42	51	2.03	32	5.11
Human damage						
Cut-marks	40	5.64	210	8.35	52	8.31
Breakage	54	7.62	181	7.19	58	9.27
Burnt bones	183	25.81	1201	47.73	153	24.44
Tooth marks	1	0.14	8	0.32	4	0.64
Trampling	4	0.56	57	2.27	18	2.88
Cracking	1	0.14	3	0.12	3	0.48
Root etching	40	5.64	452	17.97	184	29.39
Hidric abrasion	3	0.42	14	0.56	12	1.92

Taphonomic modifications and related bone-hearth distribution suggest that the central zone (Zone 3) and the area near the wall (Zone 2) of Abric Romaní were related to cooking, eating and knapping activities. The cave entrance area (Zone 5) was a primary butchery location where carcasses were treated when brought to the site (Cáceres *et al.* in press a). This also seems to be the most likely explanation for the Middle Area of Vanguard Cave.

Site formation at Vanguard Cave and discussion

Vanguard Cave has a large and wide entrance. The taphonomic analysis carried out here shows strong evidence for human activity in the Middle Area with only minimum signs of post-depositional processes. We believe this is due partly to the nature of activities involving the intensive consumption of nutrients by hominins (abandoning almost no edible remains for scavengers), and also partly to the rapid burial of the occupation areas by active sand deposition. The fossilization environment has preserved very fragile remains such as hyoid bones. The virtual absence of destructive post-depositional agents, the lack of preferred orientation of the bone and indications of rapid burial all suggest that the bone assemblages are *in situ* with almost no movement, rearrangement or disturbance other than by humans. We therefore consider that the fossil assemblage of the Middle Area has its origin in butchery activities, with Neanderthals bringing terrestrial and marine mammals into the site and leaving discarded food residues.

The highest frequency of cut-marks in the medium and small sized animal carcasses can be observed on the largest meat-bearing bones of the appendicular and axial skeleton such as the femur, humerus, radii and ribs. All of the evidence of burning, breakage and cut-marks suggests that these animals were brought to the cave for dismembering and processing of meat, ligaments, skin, fat and blood, and for marrow extraction.

Taphonomic analyses indicate that medium and small sized animals were subject to similar patterns of human butchery within the three subunits distinguished here. Only the middle subunit (contexts 157–159 including 150 and 151) seems to show minor differences due to slightly more intensive or prolonged occupation. The spatial distribution and refitting of bones in each subunit also show similarities regarding the dispersal mechanism of discarded bone fragments. Given the larger number of bones in the central subunit this offers the clearest patterning, with bones being fairly abundant around the hearth, rarer inside the hearth and much more abundant closest to the cave wall. This distribution could be due to cleaning the site, piling them closer to the cave walls as examples of *toss zones* (Binford 1981). Comparing Abric Romaní and Vanguard there are some indications that Neanderthals in Vanguard Cave were performing different activities and these may have been spatially organized.

Each of the three subunits has produced bones of marine mammals. Although the relative scarcity of such finds makes it impossible to establish an accurate pattern of exploitation, it is clear that the remains are mixed with terrestrial mammals and reveal identical signs of butchery activity, e.g. cut-marks, burning and breakage. In addition, about 170 shells of edible marine molluscs have also been uncovered from these Middle Area units. Furthermore, the Upper Area of Vanguard, where mussels were selected, cooked and eaten, represents a very clear case of exploitation of marine food resources similar to that seen in anatomically modern humans. The evidence from these two areas of Vanguard is significant because it suggests that the acquisition and importing to the cave of these food products by Middle Palaeolithic Neanderthals were not accidental or isolated events (Stringer *et al.* 2008). The recurrent presence of immature individuals of Mediterranean Monk seal suggests seasonal practices, probably exploiting these animals in the breeding season when they gave birth on shore.

In order to understand the organization of bones and hearths, Vanguard has been compared to the more complex and extensively excavated site of Abric Romaní. Despite the obvious distance between Vanguard Cave and Abric Romaní, both in terms of space and in time, there is a high degree of resemblance in the activity patterns left by the Neanderthals at each of these locations. In particular, these similarities include the presence of an initial processing area or zone in which primary butchery was undertaken of carcasses brought to the site. The parallels also suggest that if excavations at Vanguard Cave are extended further into the cave, a complex, diverse and well organized spatial distribution of finds will be discovered closely matching those of Abric Romaní.

Fire clearly had an important role with regard to human occupation. Apart from the use of fire for cooking or as

light and heat sources, it can be shown experimentally that breakage of bone is made much easier by heating it and that because marrow solidifies under heat it can be removed intact much more easily (Cáceres *et al.* 2002). The frequency of incipient burning on the fossil bones from the Vanguard assemblage and the types of breakage pattern (more variable fracture angles than produced by fracturing fresh bone) strongly suggest that the Neanderthals were deliberately pre-treating the bone. Hearth-bone distributions also show that the use of space around the hearth was similar to that of Abric Romaní.

The observed fracture patterns on individual bones are consistent with the rapid desiccation caused by placing them in the embers of a fire and resulting in a rapid loss of water and fat from the periosteum. When bone is then subjected to impact it behaves superficially much like dried bone. However the 'dry bone' effects are seen mainly in the periosteum layer; the other traits of fracture (outline, edge, shaft circumference and length) agree more with human breakage of fresh bones (Villa and Mahieu 1991). Bonnichsen (1973) has observed the same uses of heating prior to fragmentation, ethnographically. The same traits as seen at Vanguard have also been recognized at Gorham's Cave (Fernández-Jalvo and Cáceres in press) and Abric Romaní (Cáceres 2002; Cáceres *et al.* in press b).

So far, one noticeable feature has been the uneven representation of skeletal parts of large sized marine mammals, in contrast to medium and small sized animals present at Vanguard. This may correspond to a different strategy of obtaining and transporting such animals to the site. It appears that the medium and small sized mammalian carcasses were transported complete or almost complete, while the larger sized mammals were subjected to a more selective transport or 'schlepp effect' (Daly 1969).

Different authors have discussed how marine mammals were exploited and captured by *Homo sapiens* groups (Lyman 1995; Cruz-Uribe and Klein 1994). These discussions have centred on the ability of modern humans to use boats for offshore fishing and to systematically survey the coast during breeding seasons or to exploit strandings on the beach.

At Vanguard it is possible that Neanderthals also surveyed the seashore, searching for seals when they were accessible and at their most vulnerable. Dolphins, according to Muñoz (1996), have high amounts of fat and this could be why they were selected by Neanderthals. But the high levels of fat also meant fast decay and this would have reduced the time available to reach carcasses good enough for use and such occasions may have been relatively uncommon. This would suggest a rather opportunistic gathering strategy.

All the evidence examined here suggests that Neanderthals were gaining primary access to medium and small sized mammals, possibly through hunting, and that their carcasses were brought to the cave nearly whole. This is in marked contrast to large sized marine animals that show selection of anatomical elements and thus may have been the result of secondary access by scavenging. The exploitation of marine resources observed at Vanguard provides further evidence of a modern complex behavioural strategy of food extraction by Neanderthals. The distinction of

three subunits based on fossil distribution and supported by refitting, all three containing juvenile marine mammals, suggests seasonal occupation possibly based on the known breeding pattern of seals as well as knowledge of the behaviour of terrestrial animals.

Acknowledgements

ICC obtained a European Research Exchange grant through the Bioresource Program to join YFJ at the NHM and where the fossil collection of Vanguard was temporarily hosted. Chris Jones and Alex Ball are also thanked for their assistance at the Electron Microscopy unit of the Natural History Museum (NHM), as well as the department of photography of the NHM.

References

Andrews, P. 1990: *Owls, caves and fossils: predation, preservation and accumulation of small mammal bones in caves, with an analysis of the Pleistocene cave faunas from Westbury-sub-Mendip, Somerset, UK* (London, Natural History Museum Publications).

Andrews, P. and Cook, J. 1985: Natural modifications to bones in a temperate setting. *Man* (N.S.) 20, 675–691.

Andrews, P. and Fernández-Jalvo, Y. 1997: Surface modifications of the Sima de los Huesos fossil humans. *J. Hum. Evol.* 33, 191–217.

Barton, R. N. E. 2000: Mousterian Hearths and Shellfish: Late Neanderthal Activities on Gibraltar. *Neanderthals on the Edge*, eds. C. B. Stringer, R. N. E. Barton and J. C. Finlayson (Oxford, Oxbow Books), 211–220.

Barton, R. N. E., Currant, A. P., Fernández-Jalvo, Y., Finlayson, J. C., Goldberg, P., MacPhail, R., Pettit, P. B. and Stringer, C. B. 1999: Gibraltar Neanderthals and results of recent excavations in Gorham's, Vanguard and Ibex Caves. *Antiquity* 73, 13–23.

Behrensmeyer, A. K. 1978: Taphonomic and ecologic information from bone weathering. *Paleobiology* 4, 150–162.

Behrensmeyer, A. K., Gordon, K. and Yanagi, G. 1986: Trampling as cause of bone surface damage and pseudo-cutmarks. *Nature* 319, 768–771.

Binford, L. R. 1981: *Bones. Ancient Men and Modern Myths* (New York, Academic Press).

Blumenschine, R. J. 1986: *Early Hominid Scavenging Opportunities: Implications of Carcass Availability in the Serengeti and Ngorongoro Ecosystems* (Oxford, British Archaeological Reports International Series 283).

Blumenschine, R. J. and Selvaggio, M. M. 1988: Percussion marks on bone surfaces as a new diagnostic on hominid behavior. *Nature* 333, 763–765.

Bonnichsen, R. 1973: Some Operational Aspects of Human and Animal Bone Alteration. *Mammalian Osteo-Archaeology: North America*, ed. B. M. Gibert (Columbus, Special Publications of the Missouri Archaeological Society), 9–24.

Brain, C. K. 1969: The contribution of Namib desert Hottentots to an understanding of australopithecine bone accumulations. *Scientific Paper Namib Desert Res. Stn.* 39, 13–22.

Cáceres, I. 2002: *Tafonomía de yacimientos antrópicos en Karst. Complejo Galería (Sierra de Atapuerca, Burgos),*

Vanguard Cave (Gibraltr) y Abric Romaní (Capellades, Barcelona) (Unpublished Doctoral Thesis, Dpto. Historia y Geografía, Universitat Rovira i Virgili, Tarragona).

Cáceres, I., Bravo, P., Esteban, M., Expósito, I. and Saladie, P. 2002: Fresh and Heated Bones Breakage. An Experimental Approach. *Current Topics on Taphonomy and Fossilization*, eds. M. De Renzi, M. Pardo Alonso and M. Belinchón (Valencia, Ayuntamiento de Valencia), 471–479.

Cáceres, I., Bennàsar, Ll., Huguet, R., Saladié, P., Rosell, J., Allué, E., Solé, A., Blasco, R., Campeny, G., Esteban-Nadal, M., Fernández-Laso, C., Gabucio, J., Ibáñez, N., Martín, P., Muñoz, L., Rodríguez, A. in press a. Level J Taphonomy. *High Resolution Archaeology and Neandertal Behavior: Time and Space in Level J of Abric Romani (Capellades, Spain)*. ed. E. Carbonell. (Vertebrate Paleobiology and Paleoanthropology Book Series. Springer, Dordrecht, The Netherlands).

Cáceres, I., Fernández-Jalvo, Y. and Andrews, P. in press b: Neanderthals in Vanguard Cave (Gibraltar). *Neanderthals and Modern Humans in Late Pleistocene Eurasia*, ed. C. Finlayson (Gibraltar).

Carbonell, E. and Vaquero, M. (eds.) 1996: *The Last Neandertals – The First Anatomically Modern Humans. Cultural Change and Human Evolution: The Crisis at 40 Ka BP* (Tarragona, Universitat Rovira i Virgili).

Carbonell, E., Cebrià, A., Allué, E., Cáceres, I., Castro-Curel, Z., Díaz, R., Esteban, M., Ollé, A., Rodriguez, X. P., Rosell, J., Sala, R., Vallverdú, J. and Vergès, J. M. 1996: Behavioural and Organisational Complexity in the Middle Paleolithic from the Abric Romaní (Capellades, Anoia). *The Last Neandertals – The First Anatomically Modern Humans. Cultural Change and Human Evolution: The Crisis at 40 Ka BP*, eds. E. Carbonell and M. Vaquero (Tarragona, Universitat Rovira i Virgili), 385–434.

Cooper, J. H. 2000: A preliminary report on the Pleistocene Avifauna of Ibex Cave, Gibraltar. *Gibraltar during the Quaternary*, eds. J. C. Finlayson, G. Finlayson and D. Fa (Gibraltar, Gibraltar Government Heritage Publications, Monograph 1), 272–232.

Cruz-Uribe, K. and Klein, R. 1994: Chew marks and cut marks on animal bones from the Kasteelberg B and Dune Field midden Later Stone Age sites, Western Cape Province, South Africa. *Journal of Archaeological Science* 21, 35–49.

Currant, A. 2000: A review of the Quaternary mammals of Gibraltar. *Neanderthals on the Edge*, eds. C. B. Stringer, R. N. E. Barton and J. C. Finlayson (Oxford, Oxbow Books), 201–206.

Daly, P. 1969: Approaches to faunal analysis in archeology. *American Antiquity* 34(2), 146–153.

Dodson, P. and Wexlar, D. 1979: Taphonomic investigation of owl pellets. *Paleobiology* 5, 275–284.

Fernández-Jalvo, Y. and Andrews, P. 2000: The taphonomy of Pleistocene caves, with particular reference to Gibraltar. *Neanderthals on the Edge*, eds. C. B. Stringer, R. N. E. Barton and J. C. Finlayson (Oxford, Oxbow Books), 171–182.

Fernández-Jalvo, Y. and Cáceres, I. in press: Métodos y técnicas para la recuperación de datos tafonómicos para la interpretación de procesos naturales y antrópicos. *Métodos en Arqueología*, eds. García Diez and Zapata Peña (Vizcaya, Arial).

Fernández-Jalvo, Y. and Perales, C. 1990: Análisis macroscópico de huesos quemados experimentalmente. *Tafonomia y Fosilizacion*, ed. S. Fernández-López (Madrid, Universidad Complutense de Madrid), 105–113.

Lyman, R. L. 1994: *Vertebrate Taphonomy* (Cambridge, Cambridge University Press).

Lyman, R. L. 1995: On the evolution of marine mammal hunting on the west coast of North America. *J. Anthrop. Archaeol.* 14, 45–77.

Muñoz, A. S. 1996: Explotacion de pinnipedos en la Costa Atlantica de Tierra del Fuego. *Arqueologia* 6, 199–222.

Pettitt, P. B. and Bailey, R. M. 2000: AMS radiocarbon and luminescence dating of Gorham's and Vanguard Caves, Gibraltar and implications for the Middle-Upper Palaeolithic transition in Iberia. *Neanderthals on the Edge*, eds. C. B. Stringer, R. N. E. Barton and C. Finlayson (Oxford, Oxbow Books), 155–162.

Stringer, C. 2000a: Gibraltar and the Neanderthals 1848–1998. *Neanderthals on the Edge*, eds. C. B. Stringer, R. N. E. Barton and J. C. Finlayson (Oxford, Oxbow Books), 133–138.

Stringer, C. 2000b: Gibraltar and the Neanderthals. *Gibraltar during the Quaternary*, eds. J. C. Finlayson, G. Finlayson and D. Fa (Gibraltar, Gibraltar Government Heritage Publications, Monograph 1), 197–200.

Stringer, C. B., Finlayson, J. C., Barton, R. N. E., Fernández-Jalvo, Y., Cáceres, I., Sabin, R., Rhodes, E. J., Currant, A. P., Rodríguez-Vidal, J., Giles Pacheco, F. and Riquelme Cantal, J. A. 2008: Neanderthal exploitation of marine mammals in Gibraltar. *Proceedings of the National Academy of Sciences USA* 105(38), 14319–14324.

Vaquero, M. 1997: *Tecnología Lítica y Comportamiento Humano: Organización de las actividades técnicas y cambio diacrónico en el paleolítico medio del Abric Romaní (Capellades, Barcelona)* (Unpublished Doctoral Thesis, Universitat Rovira i Virgili, Tarragona).

Villa, P. and Mahieu, E. 1991: Breakage patterns of human long bones. *J. Hum. Evol.* 21, 27–48.

White, T. D. 1992: *Prehistoric Cannibalism at Mancos 5MTUMR-2346* (Princeton, Princeton University Press).

22 Marine resource exploitation and the seasonal factor of Neanderthal occupation: evidence from Vanguard Cave

K. Douka and T. F. G. Higham

Introduction

A scheduled round of activities allows hunter-gatherers to take advantage efficiently of the seasonal appearance of certain resources in often diverse geographical regions. At certain periods, human groups plan their mobility to coincide with anticipated seasonal abundance and the presence of resources that are optimally available. In this way, the group is able to maximize its subsistence strategy. Seasonality has been proposed as one of the most important aspects of site settlement patterning and its assessment is vital in elucidating site-function and developing an integrated view of prehistoric social and behavioural structure.

For several decades, the seasonal factor in archaeology, whilst being seen as a key variable in understanding hunter-gatherer behavioural complexity, was largely ignored. That was mainly due to the lack of expertise in decoding the seasonal information archived in archaeological remains. Several methods for the reconstruction of site seasonality are applicable in the wake of some significant developments in the field of archaeological science. The most comprehensive overview on these methods still remains that published by Monks (1981). He defined seasonality as the temporal concurrence of human activity with naturally occurring phenomena. His suggestion was that the most effective approach for delineating seasonality was to apply a range of methods: confidence in diagnosing the season or seasons of occupation increases if the results of more than one method are in agreement.

In this chapter, we report the results of an investigation into the seasonality of a shell midden feature associated with Neanderthal occupation at the site of Vanguard Cave, Gibraltar (Barton 2000, Fernández-Jalvo and Andrews 2000) and recently redated to *c.* 108,000 years ago using OSL techniques (Chapter 14). The archaeological assemblage consisted of a feature dominated by common mussels (*Mytilus galloprovincialis* Lamarck, 1819). Some of the shells were analysed in order to (i) assess the seasonal nature of the midden deposit and to test the hypothesis that the assemblage represented a short-term episode; (ii) investigate Neanderthal coastal adaptation to understand the ways in which they exploited different resources; and (iii) use and compare the results of two independent but complementary analytical techniques (growth-ring analysis of shell rings coupled with limited oxygen isotope analysis) to add confidence to the results obtained. The study is one of the very few (also Emiliani *et al.* 1964; Stiner 1994) that deals with the seasonal factor of a Middle Palaeolithic site through the analysis of archaeo-malacological material, and the only one (to our knowledge) to do so using growth-ring analysis.

Archaeological considerations

A number of scholars have posited differences between the subsistence adaptation of Neanderthals (*Homo neanderthalensis*) and anatomically modern humans (*Homo sapiens sapiens*). They suggest that moderns were seemingly able to exploit a wider spectrum of resources, a fact that apparently offered them a competitive advantage (O'Connell 2006, 50; but see Stewart 2004). By comparison, Neanderthals have often been considered to be top-level carnivores (Bocherens *et al.* 1991, 490; Richards *et al.* 2000, 7663), with an emphasis on animal hunting (Burke 2000; Marean and Kim 1998 *inter alia*) and scavenging (Binford 1985, 319; 1991, 113; Stiner 1994, 21, 257, 367; Brugal *et al.* 2006, 8), but unable to adapt and exploit diverse resources even when these are located in direct proximity. At the same time, theoretical models and archaeological data support the notion of a highly mobile strategy for Neanderthals (Gardeisen 1999, 1152; Patou-Mathis 2000, 393; Boyle 2000, 353; Münzel and Conard 2004, 225; Hockett and Haws 2005, 27; Gaudzinski 2006, 138). Unfortunately, however, seasonal evaluations of Neanderthal sites are extremely rare and mainly made through the study of faunal remains (e.g. Stiner 1994; Patou-Mathis 2000; Valensi and Psathi 2004), which often lacks precision. Nevertheless, some significant results have been obtained from various Mousterian sites. Work on the Levantine Mousterian, for instance, has focused on variations in size and density of lithic assemblages, site size and distribution, and other more direct techniques, particularly teeth cementum increment analyses, seasonality according to sex ratios and seasonal growth or reproductive conditions (Lieberman 1991; Speth and Tchernov 2001). In general, little can be concluded with confidence, although the overall consensus is that in Hayonim Cave the occupation had an ephemeral character whilst in Kebara hunting was mainly a winter and spring activity (Meignen *et al.* 2006, 156). Some faunal research undertaken on the French (Brugal and David 1993; Valensi 2000) and Spanish (late) Middle Palaeolithic (Pike-Tay *et al.* 1999) showed that animals were hunted during the cooler periods of the year and especially during autumn and winter. At Mezmaiskaya Cave in the North Caucasus, the alpine location probably implies a summer occupation (Baryshnikov *et al.* 1996) while in northern Germany, at the Salzgitter Lebenstedt site, reindeer were hunted during autumn by Middle Palaeolithic hominins (Gaudzinski and Roebroeks 2000).

Given the few direct examples from this period demonstrating seasonal procurement strategies, any opportunity to sharpen the picture of Neanderthal resource exploitation and seasonal adaptation must be very attractive for the prehistorian.

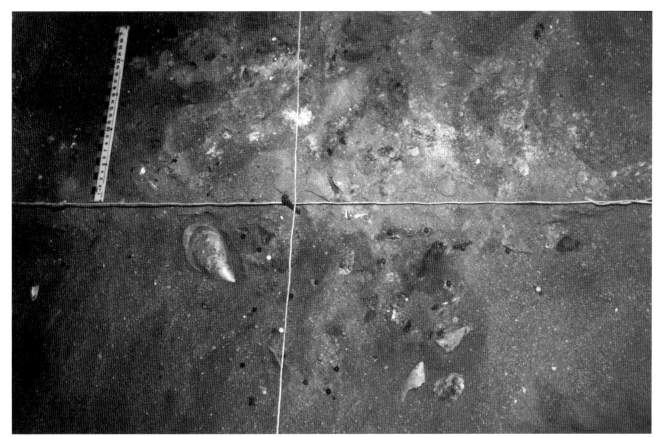

Fig. 22.1 Vanguard Cave Upper Area B. Middle Palaeolithic hearth and midden deposit.

Material

Vanguard Cave was excavated under the auspices of the Gibraltar Caves Project (Stringer *et al.* 2000). In the Upper area, covering the grid squares A4–A6 and Z3–Z5A, a shallow shell 'midden' deposited during the Neanderthal occupation of the cave was revealed (Barton 2000, 212). The midden contained a limited number of refittable Mousterian lithic remains and their horizontal distribution was associated with the spread of white ash from an *in situ* hearth (Fig. 22.1).

The molluscan assemblage consisted mainly of marine molluscan shells, dominated by *Mytilus galloprovincialis, Callista chione, Acanthocardia tuberculata, Patella vulgata, Patella caerula* and a few barnacles (*Balanus* sp.) (Barton 2000, 213). The mussel shells (*Mytilus* sp.) were well preserved and showed very little surficial damage caused by heat (on the occurrence of fire in the proximity of molluscan shells assemblages see Stiner 1994, 187).

Forty-two *Mytilus galloprovincialis* valves with surviving margins were selected for analysis from the Gibraltar Museum, where most of the material is kept, while two modern samples of the same species were obtained alive from beaches close to Vanguard Cave by Julie Ferguson (Department of Earth Sciences, University of Oxford) for oxygen isotope analysis. The archaeological material, when complete, was of a comparatively large size (8–12 cm), whereas the two modern shells were much smaller, 3 and 4.5 cm respectively.

The uniformly large size of the archaeological mussel samples was consistent throughout the accumulation, perhaps suggesting an estuarine/lagoonal provenance along with a degree of selectivity in their collection.

Methods

We used a growth-ring method for estimating the season of death of a number of the archaeological shells. We also performed selected oxygen isotope analysis on certain specimens. This work is still in progress; the first results are encouraging but some technical limitations in the analysis of the mussels have to be resolved and therefore no results are reported here.

One of the main aims was to investigate whether shells from this archaeological assemblage were collected at the same time. This would shed light on Neanderthal behaviour and seasonal adaptation, and enable us to diagnose a season or seasons of occupation.

Marine mollusc shells can be described as 'biological chart recorders' (Goodwin *et al.* 2003, 110) that produce discernible concentric lines marking various ontological, environmental, biological and metabolic events. We analysed the mussels on the basis of a clear correlation of growth macro-rings with temporal (annual) periodicity, which is well attested by studies of modern populations. Since the early 1960s various researchers have investigated the growth patterns on external surfaces of molluscan shells principally in order to deduce age and growth rate (Wells 1963; Craig and Hallam 1963; Pannella and MacClintock 1968). Wells (1963) drew attention to the usefulness of analysing the fine growth microstructures in corals and shortly afterwards Craig and Hallam (1963) measured size-frequency and growth-line patterns from living communities of *Mytilus edulis* and the edible cockle, *Cardium edule.* Pannella and MacClintock (1968) showed that the lines observed on the surfaces and cross-sections of some bivalves reflect biological and environmental influences and have a temporal significance in certain species. These

researchers concluded that the prominent growth rings, or *annuli*, in molluscan shells represent periods of growth cessation usually associated with the mantle's withdrawal from the shell margin during the colder months, and have been shown to form annually (Barker 1964, 84; Lutz 1976, 725; Richardson 2001, 107). The methodology was eventually applied in archaeological contexts (Coutts 1970) and widely used in the study of archaeomalacological remains (e.g. Europe: Deith 1983a; 1986; Milner 2001; Dupont 2006; America: Quitmyer *et al.* 1985; Lightfoot and Cerrato 1988; Claassen 1986; Australasia: Coutts and Higham 1971; Japan: Koike 1973; 1979; 1980 *inter alia*).

Several scholars have shown that the most effective method for observing growth lines in mussels is to examine them in polished thin or thick sections (Lutz 1976, 726; Sheppard 1984, 117; Claassen 1998, 155), or to use acetate peels (Pannella and MacClintock 1968, 66; Rhoads and Pannella 1970, 146; Kennish *et al.* 1980, 597). In our study, sections were found to be of limited use and acetate peels failed to produce effective results. A review of the literature revealed that some researchers had faced similar problems and attributed them variously to (i) the recrystallization of the material (Berry and Barker 1975, 15); (ii) the process of fossilization; (iii) the limited Mediterranean intertidal zone that results in low line visibility (Deith 1985, 121); (iv) the non-reflected shell margin (Pannella and Mac-Clintock 1968, 66); and (v) the unfavourable angular relationship of growth lines to the growing margin and the crystalline elements of the shell structure in this species (Pannella and MacClintock 1968, 75; Richardson 1989, 477).

Another challenge was successfully to resolve annuli and disturbance rings along the surface of the mussel. Usually, bivalve annual growth rings are preceded by several ridges that cluster very closely together. These have been proposed to be a reliable way of distinguishing between annual and spawning or disturbance rings. Disturbance rings, on the other hand, are unrelated to the annual growth of the organism and are produced by various environmental influences, such as storms, reproductive processes (spawning rings), predation threats (shock rings) or even anthropogenic disturbances. These changes are abruptly registered on the outer surface and subsequent growth begins in an equally abrupt manner (Deith 1983a, 433). Disturbance rings do not usually encircle the shell along its margins and the striae preceding and following the rings are equally spaced (Richardson 2001, 105). During our analysis, attention was paid to exclude rings that did not seem to correspond to annuli. In addition, biometric analysis was employed to investigate the conditions within which the mussels lived. In shell-secreting organisms the shell shape is defined by a set of metric relationships, related both to genetic and environmental factors. Comparison of the relative measurements exhibited by a group of samples can support inferences on the environment the shells lived in and were collected from.

Preservation is of crucial importance, since the season-at-death can be inferred only if the final stage of growth, that immediately prior to the death of the animal, is still present and readable. For shell analyses, this means that the posterior and ventral margins should be preserved, particularly at the area where the axis of maximum growth (AMG) meets

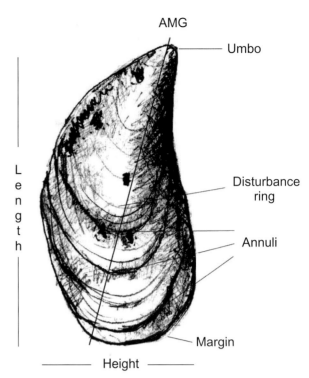

Fig. 22.2 Illustration of a fossil mussel shell (*Mytilus galloprovincialis*) from Vanguard's Cave (sample 23) with anatomical features and terms mentioned in the text.

the lip or edge of the specimen (see Fig. 22.2). Fortunately, the majority of shells from the assemblage were well preserved. Shells that were less well preserved, or ambiguous in terms of their edge characteristics, were excluded.

Seasonal estimates obtained through growth-ring analysis should ideally be undertaken with reference to a modern control population (Deith 1983a, 428; Claassen 1998, 154). Unfortunately, this could not be undertaken on a large scale in this research programme owing to time constraints, and only two modern individuals were examined. A review of the literature to identify suitable work for comparison was undertaken, however without success.

Each specimen was initially cleaned in an ultrasonic bath, in Milli Q (ultrapurified) water, for 30 min and left to dry for 48 hours. In general, no hard accretions were observed. The analysis (measuring and counting) was undertaken on the surficial bands, using an optical microscope (Prior MP3502K), at 20× and 40× magnifications with external illumination. Measurements of the increment distances were made using a stage, to the nearest 0.1 mm, along the AMG from umbo to margin (Fig. 22.2). Under this magnification the external surface of *Mytilus* had a pattern of continuous, concentric brown bands separated by whiter striae. Special attention was given to the areas where the outer surface of the shell changed its orientation, with the faster, new spring growth, producing a step-like section and marking an annual growth ring (*annulus*).

Results

Some of the mussels exhibited up to eight annuli, and up to 260 observable bands between them. Measurements were compiled on an Excel spreadsheet and plots of the data were constructed. These included the number and width of bands against the number of annuli or the total size of the

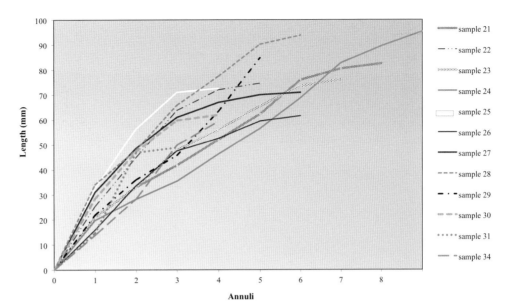

Fig. 22.3 Growth curve for the twelve complete mussels.

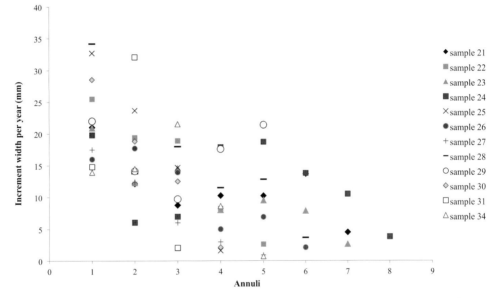

Fig. 22.4 Plot illustrating the gradually declining trend of the absolute growth increment width per year. Some of the outliers can be attributed to either misidentification of annuli or unexpected growth achieved in certain years.

shell, allometric charts to infer observed growth rates and percentages of new growth compared to that recorded on the penultimate annual increment.

Of the 42 specimens analysed under microscope, 34 were acceptably well preserved (with a minimum of two to three surviving annuli prior to death) while the remainder had broken edges and were not considered further. Twelve were identified as complete with intact shell margins and for these we compiled a growth rate chart. Reduced growth rates with increasing age are apparent, especially after sexual maturity (Fig. 22.3). The initial phases of the estimated growth curves are quite steep and indicate higher actual growth during juvenility whereas growth during senility and the years before death is considerably decreased. When the absolute widths between annual increments are plotted against the annuli one can clearly observe the expected incremental width reduction with subsequent growth years (Fig. 22.4).

The decrease or even cessation in absolute growth rates with age is well attested in most biological growth studies. Likewise, it has been suggested that after reaching sexual maturity in year 2–3 of life, mussel growth is reduced because energy is channeled towards the production of eggs and sperm (Richardson 2001, 111). Taken together, these observations imply that the growth expectancy for the year during which

the animal died will probably be lower than anticipated, particularly if the animal is older than three years of age.

The relationships commonly in use to evaluate the intrinsic parameters and growth conditions of shellfish are those concerning the ratios of total length to maximum height and width of the valve. In our case, allometry was used for the 12 complete valves and the compiled charts were in good agreement with examples published by earlier researchers in which the relationships tended to be linear for all shells. A relatively strong correlation is apparent between height and width to length, with an increase in one corresponding to a relative increase in the other (Fig. 22.5). There is small relative allometric variation amongst the specimens analysed which allows us to comment on the environmental or biological influences experienced by the mussels during their lifetime. Mussels high in the intertidal zone or in the absence of major predators live to a considerable age and morphological differences may be attributed to genetic or environmental influences (Kemp and Bertness 1984, 811). This may suggest stable environmental conditions, with minimal mechanical influences (wave action or predators) and large food availability.

In estimating a season-at-death one is aiming to measure the final shell carbonate deposited and calculate a

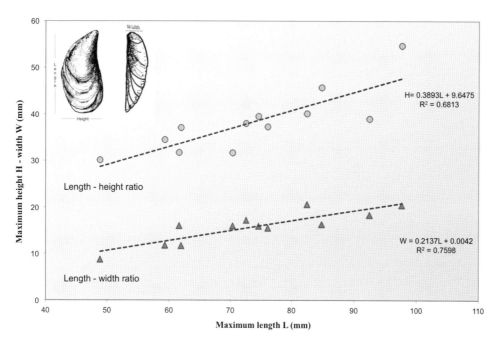

Fig. 22.5 Shell length to width/height regressions for the twelve complete Mytilus examples. Better fit for linear trendline. L, maximum length; W, maximum width; H, maximum height; r2, correlation coefficient.

season based on a comparison with previous annual growth cycles. This is difficult, and previous research has focused on applying two different methods. One method is based on absolute growth rate measurements for living mussels (e.g. Seed 1973; Amano *et al.* 2000) and estimations of the percentage of new growth expected to occur at each season of the year (Quitmyer *et al.* 1985). This is calculated by taking a ratio of the values measured for the penultimate year and the final increment of growth. A second is to use the width of the last annual increment or the average width of the last one to three annual increments in order to infer percentages of the growth at the time of death. These methods have

been criticized (Claassen 1998, 152–173) because they have a tendency to overlook the fact that growth is not uniform within the same species, same calendar years or even same population. Moreover it has been suggested that these incremental growth techniques overestimate the actual season-at-death and give generally an earlier calendar approximation. Experiments using marked modern controls, for instance, have proved that some species will never give reliable results (Claassen 1998, 155). Clearly, careful selection of reliable specimens and recognition of the limitations of the technique in terms of precision, allied where possible with the use of modern control samples, is the most effective approach one can take.

Micro- and macroscopic observations of the surfaces of the 34 specimens revealed that in the majority of examples (60 per cent), only a very low percentage of new growth had begun prior to death (Fig. 22.6). In the remainder there was variation in the size of the final growth increment (Fig. 22.8a). This could be taken as evidence for a range of seasons-at-death within the population. However, further, closer analysis of these individuals (N = 13) revealed that small new layers of carbonate had been deposited on the interior of the shell *below* the previous annual growth increment (Fig. 22.7). These accounted for all of the examples identified as initially having large final increments. The small size of the new growth increment on these individuals supports the interpretation that this has not been incorporated into the main carbonate skeleton, strongly suggesting that the death of the organism occurred during the early stages of the yearly growth cycle. With this in mind, the complete final growth increments uniformly and consistently give low values (Fig. 22.8b).

For the 21 specimens that passed our selection criteria (up to two to three annuli, intact shell margins, last increment attached to the exoskeleton), the average width measured was 1.92 mm which comprised ~12 per cent of the penultimate year of growth. We assume that little or no carbonate deposition occurs between November and March at the latitude at which Gibraltar is located, and over 90 per cent of the total annual growth occurs between April and October

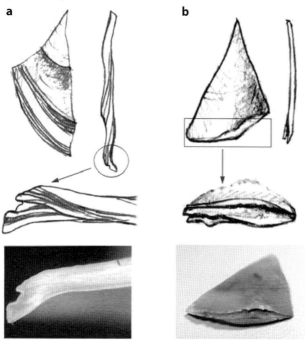

a **b**

Fig. 22.6 Detail of two shell fragments with new carbonate layers on the surface of the shell indicating the commencement of the growth season. Twenty one individuals exhibited this type of growth.

a Sample 4l a- Exterior and profile sectioned along the axis of maximum growth (AMG) with detail of the final growth increment.

b Sample 42c- Exterior and profile sectioned along the AMG and detail of the margin showing the new growth layer.

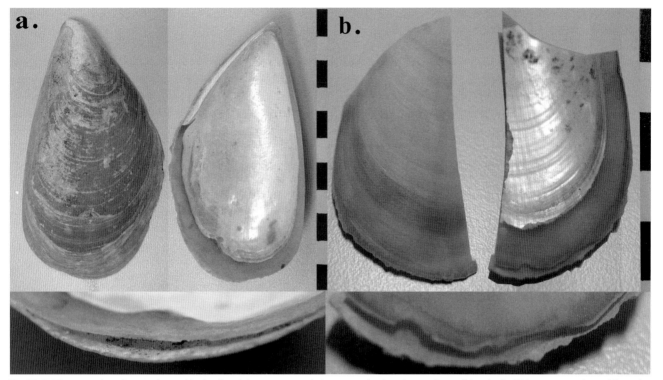

Fig. 22.7 Photographs of two valves with details of the new growth layers on the interior surface of the shells. This new growth could not be measured and quantified (see text). Thirteen individuals such as these were identified.
a. Sample 24- Exterior and interior sides of a complete left valve, with detail of the new, still internal, layer at the ventral margin.
b. Sample 43a- Exterior and interior sides of a fragmented, possibly right, valve with detail of the new growth layer along the ventral margin.

Fig. 22.8 Last increment width plotted against sample reference number. In 8a, the hatched columns indicate the samples exhibiting carbonate growth on the internal surface of the shell (see text for discussion and Fig. 7a &b). In 8b, the plot shows all of the shells studied after the removal of the 13 samples with this internal growth. This growth increment was not able to be directly measured.

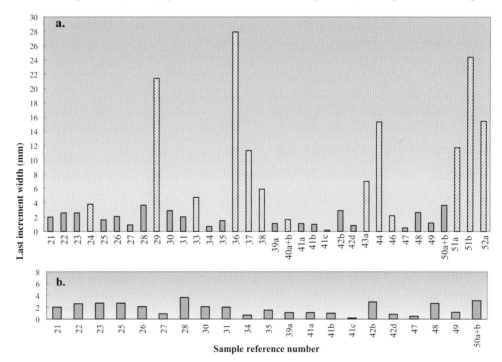

(a period of seven months). In addition, if we also consider that the Gibraltar mussels exhibited a highly seasonal preference for growth, then the low percentage of final growth, allied with a rapid deposition of material after the formation of the winter annuli, would suggest that the most likely period of harvesting was *spring* – probably mid-spring.

Modern samples were collected at the end of the growth season (November 2005) for oxygen isotope analysis and two were incrementally analysed. Measurement of the final year of growth showed that this was ~70 per cent of the width of the penultimate increment, the size of which is consistent with the completion of a final annual growth

cycle for older mussels, such as the ones studied. The lack of an acceptable number of modern control samples and the unsuccessful attempt to observe growth lines in sections hampered more precise analysis of the seasonal signals.

Growth-ring analysis, and the preliminary oxygen isotope analysis not reported here, yielded similar results for all analysed shells, providing strong support for a mid-spring collection.

Discussion

As mentioned previously, there has been a strong historical tendency to consider Neanderthals less capable of

responding to environmentally induced challenges compared with anatomically modern humans, a fact which ultimately may have been linked with their extinction. Stringer and Gamble (1993, 168), for instance, state that '... the intricate matching of personnel to resources in the highly seasonal habitats of Europe seems to have been beyond their (i.e. the Neanderthals) organizational abilities; their modern successors could take advantage of less important foods as they briefly become available ... we can find no evidence that the Neanderthals were capable of such complex behaviour'. More recent archaeological research, as well as the reassessment of previously excavated material, has modified this view and suggested that in their subsistence activities Neanderthals were close to, or at least as competent as, modern populations (e.g. Sorensen and Leonard 2001, 492). Stringer (2002, 58) has suggested that '... recent research on Neanderthal occupation sites certainly requires us to upgrade our views of their capabilities; ... there is apparent evidence of "advanced" behavior by some Neanderthal groups, such as the exploitation of marine resources'. Erlandson (2001) has favoured a re-evaluation of the role of aquatic resources in human evolution. In the case of shellfishing at Gibraltar he noted that without further evidence that associates the aquatic fauna to human predation with confidence, it is difficult to be sure how significant these resources were for Neanderthal subsistence strategies (Erlandson 2001, 321). The data we have obtained further strengthen the conclusion that the shell remains from Vanguard Cave evidence deliberate Neanderthal collection, for the reasons outlined earlier. This implies a selective and well planned harvesting action, elucidating one aspect of the adaptation and resource management strategy of the Neanderthals of Gibraltar.

Coastal adaptation

The question of the antiquity of coastal adaptation by prehistoric communities is particularly challenging, often hindered by taphonomic and preservation issues and, generally speaking, impeded by methodological, interpretive and theoretical biases. For many scholars, water has been seen as a physical and psychological barrier, under-utilized in terms of its resource opportunity until the late Upper Palaeolithic (Washburn and Lancaster 1968, 294; Osborn 1977, 157–158; but see Sauer 1962). Yesner (1987, 733) has considered the presence of marine food remains at early sites dating to the Middle Stone Age in Africa (e.g. Sea Harvest, Hoedjies Punt, Klasies River Mouth and Haua Fteah) and Europe (e.g. Terra Amata and Devil's Tower) as evidencing only isolated instances of the use of marine resources. Straus (1990, 291) argued that Middle Palaeolithic people ignored aquatic foods. When Gamble (1994, 10, 182–202) listed four important ecological settings as significant to human evolution in the Old World (major habitats: plains, deserts, mountains and forests, and ten sub-settings), no aquatic habitat was listed.

Once again, recent work (Walter et al. 2000; Erlandson 2001) has significantly altered our perception of this issue. On the one hand, a range of archaeological evidence for hunter-gatherer adaptation to coastal marine environments has been identified, some of which is contemporary

with the Gibraltar sites (in Figure 22.9 are shown archaeological sites from around Europe and North Africa associated with archaic Homo/Neanderthal industries and reported to contain shellfish remains). On the other, ecologic and ethnographic observations have clearly illustrated the high levels of productivity and species diversity associated with ecotones (Odum 1983, 430–435), the transitional zones between different ecosystems. People living in such areas maintain greater capacity for diversification and are able to maximize their subsistence strategies by drawing on multiple ecosystems and the resources they contain. Turner et al. (2003, 444) have argued that such optimal zones might embrace marine or estuarine environs, well known for their consistent biomass productivity, with woodlands close by. We may find parallels with the situation in Gibraltar as adaptation to an ecological edge-zone and exploitation of the nearby aquatic resources are evident amongst the human occupants of the caves in Gibraltar during the last interglacial.

Wider consideration of this type of coastal adaptation is hampered significantly, of course, by changes in sea-level during the Pleistocene, which have resulted in the inundation of large tracts of land, and with it archaeological sites. Climate oscillations and sea-level variations have accelerated the erosion of coastal sites and seriously blurred, if not obliterated them, and along with these any evidence for earlier coastal settlement and marine resource exploitation. Fortunately, this is not the case with Vanguard Cave during the last interglacial, when sea-levels were much higher (Shackleton et al. 1984, 313) and the local shoreline would have close to where it is today (see Chapter 3).

Despite the inherent difficulties in addressing issues such as these, there is a growing consensus that perceptions that 'peripheralize the significance of aquatic habitats in human subsistence patterns, relegating them to an essentially incidental role' (Erlandson 2001, 289) can no longer be valid at a universal scale.

Shellfish exploitation

Generally speaking, shellfish collection is not particularly labour-intensive and requires minimal specialization for the prehistoric forager (Mannino and Thomas 2002, 469). Ecological sampling implies that the common mussel is able to return high outputs of calories. Kopp et al. (2005) recently found, for instance, after cage experiments with Mytilus galloprovincialis, that the content in lipids and proteins reaches a maximum in early spring and late winter, respectively. Traditionally, shellfishing has been associated with a summer collecting season, in the main because it was thought that winter conditions in many locations were too severe for marine shellfish gathering (Lightfoot and Cerrato 1988, 142). However, actual case studies from archaeological accumulations or shell middens support a different conclusion. Several examples from the literature, such as the Sungic midden site in New York (Lightfoot and Cerrato 1988), Nelson Bay Cave in South Africa (Shackleton 1973), research from various Cantabrian sites (Deith 1983b; 1986), Moscerini Cave in Italy (Stiner 1994) and Shag Mouth in New Zealand (Higham 1996) inter alia, have consistently produced a picture of early/late spring

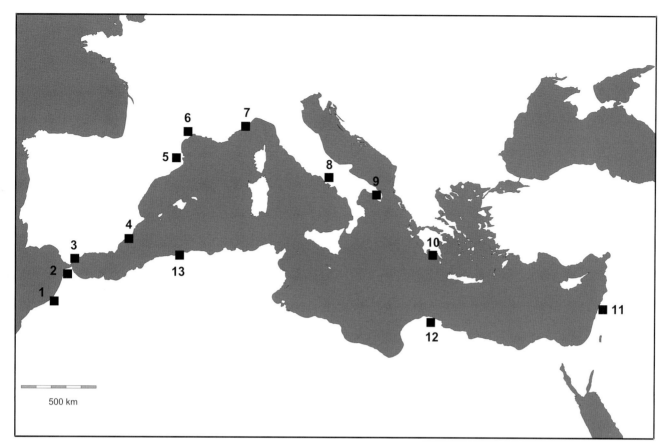

Fig. 22.9 Map of Europe and North Africa showing Middle Paleolithic sites with reported shellfish remains associated with archaic Homo/ Neanderthal industries and fossils.

I. Kebibat, Rabat (Morocco); 2. Mugharet el' Aliya (Morrocco); 3. Gorham's Cave-Vanguard Cave- Devil's Tower (Gibraltar); 4. Cueva de los Aviones (Spain) 5. Le Lazaret (France) 6. Ramandils (France); 7. Grimaldi Caves (Italy); 8.Grotta dei Moscerini (Italy); 9. Grotta del Cavallo and other Apulian sites; 10. Kalamakia Cave and Lakonis Cave 1; II. Ksar Akil (Lebanon); 12. Haua Fteah (Libya); 13. Presqu'île du Canal, Berard (Algeria).

shellfishing, as well as a possible year-round occupation or visitation of the sites. This pattern supports a model of shellfish consumption in many contexts during the late winter to mid-spring months, when there is general dearth of other resources. Shellfish comprise a secure and dependable food source, often exploited when other resources are scarce. Whilst these examples are interesting in the light of our results, it is important to remember that they mainly relate to much more recent periods.

Further work

As far as the Gibraltar case is regarded, we cannot of course assess seasonality in detail by examining a unique, one-off event from a single site. The major problem when attempting to determine the function of Vanguard in terms of seasonal occupation and place it within the context of an overall settlement system is that whereas the evidence of Middle Palaeolithic occupation in the area is abundant no major, wide-scale seasonal studies have been attempted.

Mussel shells are relatively common in Palaeolithic archaeological sites around the Mediterranean compared with other species. There is, therefore, considerable potential for these methods to be applied to other archaeological assemblages to evaluate further issues such as behavioural and cultural similarities and differences attributed to human species in terms of environmental adaptations, subsistence strategies and resource scheduling, site-use patterns and more.

Conclusions

A seasonal date has been obtained for the Neanderthal shell assemblage excavated at Vanguard Cave, Gibraltar. Shells that were well preserved yielded consistent results, showing mid-spring collection from a nearby marine or estuarine environment. This is the first time, to our knowledge, that Middle Palaeolithic shellfish remains have been analysed incrementally in order to determine a seasonal date. Its success raises exciting prospects for future work in the area.

Some mollusc species appear to be problematic for use in growth-ring analysis, not only because it is difficult to identify the annual rings and distinguish them from random surficial disturbance rings, but also because even in section the growth lines can be obliterated. Thus, the species under investigation should be already tested for suitability and the preservation issues regarding the fossil shells should be considered before bivalve growth increments are used as seasonal indicators from archaeological sites. Any future research requires a modern control collection, preferably with the same species from the same location (if known) to that of the archaeological material, which would enable the proper interpretation of the archaeological data. Within the framework of this brief investigation, only a small study was able to be made of a modern control, but the results were very encouraging.

The presence of other later Neanderthal contexts containing shell midden remains along the Iberian coast suggests that this methodology could be extended far more

widely. Molluscan shells are also relatively common in Palaeolithic archaeological sites around the Mediterranean Rim. Hence, there is considerable potential for these methods to be applied to other archaeological assemblages to construct a more complete pattern of seasonal site use, mobility and coastal adaptation among both Neanderthals and modern humans, in Europe and the Levant.

Acknowledgements

This work was the result of an M.Sc. dissertation undertaken by K. Douka at the Research Laboratory for Archaeology and the History of Art, University of Oxford. We are very grateful to Dr P. Ditchfield (RLAHA) for his input to the research and technical advice. Dr C. Finlayson from the Gibraltar Museum gave permission to sample the shell material. Mr R. Jennings selected the samples from the museum and brought them to Oxford. We are particularly grateful to Ms J. Ferguson (Department of Earth Sciences, University of Oxford), who has provided us with the two modern controls and is currently performing the oxygen isotope analysis.

We should like to thank Professor Nick Barton for inviting us to contribute to the present volume and we greatly acknowledge his constructive comments at the earlier stages of this work and information on the current status of parallel research. Also, Dr John Stewart, who reviewed the paper prior to final submission and provided useful comments.

This research was funded by the Greek Foundation I.K.Y. and Keble College, University of Oxford.

References

Amano, S., Oshika, T., Tazawa, Y., Tsuru, T., Chicharo, L. M. Z. and Chicharo, M. A. 2000: Estimation of the life history parameters of *Mytilus galloprovincialis* (Lamarck) larvae in a coastal lagoon (Ria Formosa – south Portugal). *Journal of Experimental Marine Biology and Ecology* 243, 81–94.

Barker, R. M. 1964: Microtextural variation in pelecypod shells. *Malacologia: International Journal of Malacology* 2(1), 69–86.

Barton, N. 2000: Mousterian hearths and shellfish: late Neanderthal activities on Gibraltar. In Stringer, C. B., Barton, R. N. E. and Finlayson, C. (eds.), *Neanderthals on the Edge* (Oxford, Oxbow Books), 210–220.

Baryshnikov, G., Hoffecker, J. F. and Burgess, R. L. 1996: Palaeontology and Zooarchaeology of Mezmaiskaya Cave (Northwestern Caucasus, Russia). *Journal of Archaeological Science* 23(3), 313–335.

Berry, W. B. N. and Barker, R. M. 1975: Growth increments in fossil and modern bivalves. In Rosenberg, G. D. and Runcorn, S. K. (eds.), *Growth Rhythms and the History of the Earth's Rotation* (New York, Wiley and Sons), 9–25.

Binford, L. R. 1985: Human ancestors: Changing views of their behavior. *Journal of Anthropological Archaeology* 4, 292–327.

Binford, L. R. 1991: Review of P. Mellars and C. Stringer (Eds) The Human Revolution: Behavioural and Biological Perspectives on the Origins of Modern Humans. *Journal of Field Archaeology* 18(1), 111–115.

Bocherens, H., Fizet, M., Mariotti, A., Lange-Badre, B.,

Vandermeersch, B., Borel, J. P. and Bellon, G. 1991: Isotopic biogeochemistry (^{13}C, ^{15}N) of fossil vertebrate collagen: application to the study of a past food web including Neandertal man. *Journal of Human Evolution* 20, 481–492.

Boyle, K. V. 2000: Reconstructing Middle Palaeolithic subsistence strategies in the South of France. *International Journal of Osteoarchaeology* 10(5), 336–356.

Brugal, J.-P. and David, F. 1993: Usure dentaire, courbe de mortalité et "saisonnalité": les gisements du Paléolithique moyen à bovidés. In Desse, J. and Audoin-Rouzeau, F. (eds.), *Exploitation des animaux sauvages a travers le temps* (Juan-les-Pins, APDCA), 63–77.

Brugal, J.-P., Haws, J. A. and Hockett, B. (eds.) 2006: *Paleolithic Zooarchaeology in Practice* (Oxford, Archaeopress).

Burke, A. (ed.) 2000: Hunting in the Middle Palaeolithic. Special issue: *International Journal of Osteoarchaeology* 10(5), 281–406.

Claassen, C. 1986: Shellfishing Seasons in the Prehistoric Southeastern United States. *American Antiquity* 51(1), 21–37.

Claassen, C. 1998: *Shells* (Cambridge, Cambridge University Press).

Coutts, P. 1970: Bivalve-growth Patterning as a Method for Seasonal Dating in Archaeology. *Nature* 226, 874.

Coutts, P. and Higham, C. 1971: The Seasonal Factor in Prehistoric New Zealand. *World Archaeology* 2(3), 266–277.

Craig, G. Y. and Hallam, A. 1963: Size-frequency and growth ring analyses of *Mytilus edulis* and *Cardium edule*, and their palaeoecological significance. *Palaeontology* 6, 731–750.

Deith, M. R. 1983a: Molluscan calendars: the use of growth-line analysis to establish seasonality of shellfish collection at the Mesolithic site of Morton, Fife. *Journal of Archaeological Science* 10(5), 423–440.

Deith, M. R. 1983b: Seasonality of shell collecting determined by oxygen isotope analysis of marine shells from Asturian sites in Cantabria. In Grigson, C. and Clutton-Brock, J. (eds.), *Animals and Archaeology: 2. Shell Middens, Fishes and Birds* (Oxford, BAR International Series 183), 67–76.

Deith, M. R. 1985: Seasonality from shells: an evaluation of two techniques for seasonal dating of marine molluscs. In Fieller, N. R. J., Gilbertson, D. D. and Ralph, N. G. A. (eds.), *Palaeobiological Investigations Research Design, Methods and Data Analysis* (Oxford, BAR International Series 266), 119–130.

Deith, M. R. 1986: Subsistence strategies at a Mesolithic camp site: Evidence from stable isotope analyses of shells. *Journal of Archaeological Science* 13(1), 61–78.

Dupont, C. 2006: *La malacofaune de sites mésolithiques et néolithiques de la façade atlantique de la France. Contribution à l'économie et à l'identité culturelle des groupes concernés* (Oxford, Archaeopress, BAR International Series 1571).

Emiliani, C., Cardini, L., Mayeda, T., McBurney, C. B. M. and Tongiorgi, E. 1964: Paleotemperature analysis of fossil shells of marine molluscs (food refuse) from the Arene Candide cave, Italy, and the Haua Fteah cave, Cyrenaica. In Craig, H., Miller, S. L. and Wasserburg, G. J. (eds.),

Isotopic and cosmic chemistry (Amsterdam, North-Holland Publishing Company), 133–156.

Erlandson, J. M. 2001: The Archaeology of Aquatic Adaptations: Paradigms for a New Millennium. *Journal of Archaeological Research* 9(4), 287–350.

Fernández-Jalvo, Y. and Andrews, P. 2000: The taphonomy of Pleistocene caves, with particular reference to Gibraltar. Neanderthals on the Edge, eds. C. B. Stringer, R. N. E. Barton and J. C. Finlayson (Oxford, Oxbow Books), 171–182.

Gamble, C. S. 1994: *Timewalkers: The Prehistory of Global Colonization* (Cambridge, Harvard University Press).

Gardeisen, A. 1999: Middle Palaeolithic Subsistence in the West Cave of "Le Portel" (Pyrenees, France). *Journal of Archaeological Science* 26(9), 1145–1158.

Gaudzinski, S. 2006: Monospecific or Species-Dominated Faunal Assemblages During the Middle Paleolithic in Europe. In Hovers, E. and Kuhn, S. L. (eds.), *Transitions before the Transition* (New York, Springer), 137–147.

Gaudzinski, S. and Roebroeks, W. 2000: Adults only. Reindeer hunting at the Middle Palaeolithic site Salzgitter Lebenstedt, Northern Germany. *Journal of Human Evolution* 38(4), 497–521.

Goodwin, D. H., Schone, B. R. and Dettman, D. L. 2003: Resolution and Fidelity of Oxygen Isotopes as Paleotemperature Proxies in Bivalve Mollusk Shells: Models and Observations. *Palaios* 18(2), 110–125.

Higham, T. F. G. 1996: Shellfish and seasonality. In Anderson, A. J., Allingham, B. and Smith, I. W. G. (eds.), *Shag River Mouth: The Archaeology of an Early Southern Maori Village* (Canberra, Australian National University, Archaeology and Natural History Publications 27), 245–253.

Hockett, B. and Haws, J. A. 2005: Nutritional ecology and the human demography of Neandertal extinction. *Quaternary International* 137, 21–34.

Kemp, P. and Bertness, M. D. 1984: Snail Shape and Growth Rates: Evidence for Plastic Shell Allometry in *Littorina littorea*. *Proceedings of the National Academy of Sciences* 81(3), 811–813.

Kennish, M. J., Lutz, R. A. and Rhoads, D. C. 1980: Preparation of acetate peels and fractured sections for observation of growth patterns within the bivalve shell. In Rhoads, D. and Lutz, R. (eds.), *Skeletal Growth of Aquatic Organisms* (New York, Plenum Press), 597–601.

Koike, H. 1973: Daily growth lines of the clam, *Meretrix lusoria*; A basic study for the estimation of prehistoric seasonal gathering. *Journal of Anthropological Society of Nippon* 81, 122–138.

Koike, H. 1979: Seasonal dating and the valve-pairing technique in shell-midden analysis. *Journal of Archaeological Science* 6(1), 63–74.

Koike, H. 1980: *Seasonal Dating by Growth-line Counting of the Clam,* Meretrix Lusoria: *Toward a Reconstruction of Prehistoric Shell-collecting Activities in Japan* (Tokyo, University of Tokyo Press).

Kopp, J., Cornette, F. and Simonne, C. 2005: A comparison of growth and biochemical composition of *Mytilus galloprovincialis* (Lmk.) and *Mytilus edulis* (L.) on the West coast of Cotentin, Normandy, France 1999–2000. *Aquaculture International* 13(4), 327–340.

Lieberman, D. E. 1991: Seasonality and gazelle hunting at Hayonim Cave: New evidence for "sedentism" during the Natufian. *Paléorient* 17, 47–57.

Lightfoot, K. G. and Cerrato, R. M. 1988: Prehistoric Shellfish Exploitation in Coastal New York. *Journal of Field Archaeology* 15(2), 141–149.

Lutz, R. A. 1976: Annual growth patterns in the inner shell layer of *Mytilus edulis* L. *Journal of the Marine Biological Association of the United Kingdom* 56, 723–731.

Mannino, M. A. and Thomas, K. D. 2002: Depletion of a resource? The impact of human foraging on intertidal mollusc communities and its significance for human settlement, mobility and dispersal. *World Archaeology* 33(3), 452–474.

Marean, C. W. and Kim, S. Y. 1998: Mousterian Large-Mammal Remains from Kobeh Cave: Behavioral Implications for Neanderthals and Early Modern Humans. *Current Anthropology* 39(2), 79–113.

Meignen, L., Bar-Yosef, O., Speth, J. and Stiner, M. 2006: Middle Paleolithic Settlement Patterns in the Levant. In Hovers, E. and Kuhn, S. L. (eds.), *Transitions Before the Transition* (New York, Springer), 149–169.

Milner, N. 2001: At the Cutting Edge: Using Thin Sectioning to Determine Season of Death of the European Oyster, *Ostrea edulis*. *Journal of Archaeological Science* 28(8), 861–873.

Monks, G. 1981: Seasonality studies. In Schiffer, M. B. (ed.), *Advances in archaeological method and theory* (New York, Academic Press), 177–240.

Münzel, S. C. and Conard, N. J. 2004: Change and continuity in subsistence during the Middle and Upper Palaeolithic in the Ach Valley of Swabia (south-west Germany). *International Journal of Osteoarchaeology* 14(3–4), 225–243.

O'Connell, J. F. 2006: How did modern humans displace Neanderthals? Insights from hunter-gatherer ethnography and archaeology. In Conard, N. J. (ed.), *Neanderthals and Modern Humans Meet?* (Tubingen, Kerns Verlag), 43–64.

Odum, E. P. 1983: *Basic Ecology* (London, Saunders College Publishing).

Osborn, A. J. 1977: Strandloopers, Mermaids, and Other Fairy Tales: Ecological Determinants of Marine Resource Utilization – The Peruvian Case. In Binford, L. (ed.), *For Theory Building in Archaeology: Essays on Faunal Remains, Aquatic Resources, Spatial Analysis, and Systemic Modeling* (New York, Academic Press), 157–205.

Pannella, G. and MacClintock, C. 1968: Biological and Environmental Rhythms Reflected in Molluscan Shell Growth. *Memoirs (The Paleontological Society)* 42, 64–80.

Patou-Mathis, M. 2000: Neanderthal subsistence behaviours in Europe. *International Journal of Osteoarchaeology* 10(5), 379–395.

Pike-Tay, A., Cabrera Valdés, V. and Bernaldo De Quiros, F. 1999: Seasonal variations of the Middle-Upper Paleolithic transition at El Castillo, Cueva Morin and El Pendo (Cantabria, Spain). *Journal of Human Evolution* 36(3), 283–317.

Quitmyer, I. R., Hale, H. S. and Jones, D. S. 1985: Paleoseasonality Determination Based on Incremental Shell Growth

in the Hard Clam, *Mercenaria mercenaria*, and Its Implications for the Analysis of Three Southeast Georgia Coastal Shell Middens. *Southeastern Archaeology* 4(1), 27–40.

Rhoads, D. C. and Pannella, G. 1970: The use of molluscan shell growth patterns in ecology and paleoecology. *Lethaia* 3, 143–161.

Richards, M. P., Pettitt, P. B., Trinkaus, E., Smith, F. H., Paunovic, M. and Karavanic, I. 2000: Neanderthal diet at Vindija and Neanderthal predation: The evidence from stable isotopes. *Proceedings of the National Academy of Sciences* 97(13), 7663–7666.

Richardson, C. A. 1989: An Analysis of the Microgrowth Bands in the Shell of the Common Mussel *Mytilus edulis*. *Journal of the Marine Biological Association of the United Kingdom* 69(2), 477–491.

Richardson, C. A. 2001: Molluscs as archives of environmental change. *Oceanography and Marine Biology – An Annual Review* 39, 103–164.

Sauer, C. O. 1962: Seashore—Primitive Home of Man? *Proceedings of the American Philosophical Society* 106(1), 41–47.

Seed, R. 1973: Absolute and allometric growth in the mussel, *Mytilus edulis* L. (Mollusca Bivalvia). *Journal of Molluscan Studies* 40(5), 343–357.

Shackleton, N. J. 1973: Oxygen isotope analysis as a means of determining season of occupation of prehistoric midden sites. *Archaeometry* 15(1), 133–141.

Shackleton, J. C., Van Andel, T. H. and Runnels, C. N. 1984: Coastal Paleogeography of the Central and Western Mediterranean during the Last 125,000 Years and Its Archaeological Implications. *Journal of Field Archaeology* 11(3), 307–314.

Sheppard, R. A. 1984: Growth patterns in shells: methods of preparation and examination of transverse sections. *New Zealand Journal of Science* 27, 117–122.

Sorensen, M. V. and Leonard, W. R. 2001: Neandertal energetics and foraging efficiency. *Journal of Human Evolution* 40(6), 483–495.

Speth, J. D. and Tchernov, E. 2001: Neandertal hunting and meat-processing in the Near East: evidence from Kebara Cave (Israel). In Stanford, C. B. and Bunn, H. T. (eds.), *Meat-eating and human evolution* (Oxford, Oxford University Press), 52–72.

Stewart, J. R. 2004: Neanderthal-Modern Human Competition?: A comparison between the mammals associated with Middle and Upper Palaeolithic industries in Europe during OIS 3. *International Journal of Osteoarchaeology* 14, 178–189.

Stiner, M. C. 1994: *Honor among thieves: a zooarchaeological study of Neandertal ecology* (Princeton, Princeton University Press).

Straus, L. G. 1990: The Early Upper Palaeolithic of southwest Europe: Cro-Magnon adaptations in the Iberian peripheries, 40 000–20 000 BP. In Mellars, P. (ed.), *The Emergence of Modern Humans: An Archaeological Perspective* (Ithaca, Cornell University Press), 276–302.

Stringer, C. 2002: New Perspectives on the Neanderthals. *Evolutionary Anthropology* 1, 58–59.

Stringer, C. and Gamble, C. 1993: *In search of the Neanderthals: solving the puzzle of human origins* (London, Thames and Hudson).

Stringer, C. B., Barton, R. N. E. and Finlayson, C. 2000: *Neanderthals on the Edge* (Oxford, Oxbow Books).

Turner, N. J., Davidson-Hunt, I. J. and O'Flaherty, M. 2003: Living on the Edge: Ecological and Cultural Edges as Sources of Diversity for Social–Ecological Resilience. *Human Ecology* 31(3), 439–461.

Valensi, P. 2000: The archaeozoology of Lazaret Cave (Nice, France). *International Journal of Osteoarchaeology* 10(5), 357–367.

Valensi, P. and Psathi, E. 2004: Faunal Exploitation during the Middle Palaeolithic in South-eastern France and North-western Italy. *International Journal of Osteoarchaeology* 14, 256–272.

Walter, R. C., Buffler, R. T., Bruggemann, J. H., Guillaume, M. M., Berhe, S. M., Negassi, B., Libsekal, Y., Cheng, H., Edwards, R. L. and Von Cosel, R. 2000: Early human occupation of the Red Sea coast of Eritrea during the last interglacial. *Nature* 405(6782), 65–69.

Washburn, S. L. and Lancaster, C. S. 1968: The evolution of hunting. In Lee, R. B. and DeVore, I. (eds.), *Man the Hunter* (Chicago, Aldine), 293–303.

Wells, J. W. 1963: Coral growth and geochronometry. *Nature* 197(4871), 948–950.

Yesner, D. R. 1987: Life in the "Garden of Eden": Constraints of marine diets for human societies. In Harris, M. and Ross, E. (eds.), *Food and Evolution* (Philadelphia, Temple University Press), 285–310.

Vanguard Cave Summary

R.N.E. Barton and S.N. Collcutt

Stratigraphy and dating

Vanguard Cave presents a less complicated stratigraphy than that of Gorham's Cave. An approximately 17 m sequence of sediments filled the cave almost to roof level, all with a gentle dip into the cave. In the Holocene, the seaward sediments were eroded and the old sequence was covered by a thin layer of superficial sands that has formed a slope from the back of the cave down to the beach below. No previous excavations had taken place at this site, and once the loose sands were stripped away they revealed a series of *in situ* units made up of alternating bands of medium to fine sands (probably the tail of the coastal dune system) and darker silts and silty sands. The alternating units were particularly visible in three main areas of the cave designated as (1) Upper Area, (2) Middle and Lower Area, and (3) Northern Alcove (Chapter 13, Fig. 13.2). Examination did not extend to the base of the sequence, due to the fact that the lower slopes beyond the cave mouth were strewn with large boulders. Nevertheless it was possible to observe that at the very base were heavily cemented beach sands that lay on a rock-cut platform near present sea level and at the same elevation as in Gorham's Cave.

Dating of sediments by OSL in the Upper Area suggests that the cave had already become extensively refilled by about 75 ka, though it is possible that erosion subsequently removed some of the upper sands followed by further deposition (as the youngest OSL date was on brecciated deposits adhering to the rock wall). Chapter 14 explains the rationale behind the OSL dating and notes that the results are more coherent than those from Gorham's Cave, which is in keeping with the inferred faster sedimentation rates and lower degree of bioturbation seen at Vanguard Cave. This work calls into question the age of a hearth in the Upper Area previously dated by radiocarbon but it should be noted that the age lay close to the limits of that method. A series of dates from the Middle and Lower Area confirms that the sediments in this part

of the cave were laid down in the last Interglacial (MIS 5). Except for one sample (X729-SG) all sediments were dated using multigrain measurements.

Palaeoenvironmental reconstruction

Chapters 15 to 18 deal with the palaeoenvironmenatal evidence from this cave, remembering that these assemblages are all older than those described from Gorham's Cave. Macroscopic charcoal analysis (Chapter 15) has revealed the presence of plants typical of interglacial conditions, including thermophiles such as terebrinth-lentisc (*Pistachia* sp.) and wild olive (*Olea* sp.). The warm and stable climates implied by the vegetational data are also confirmed by the presence of thermophilous reptile and amphibian species (Chapter 16) including Amphisbaenian or worm lizard (*Blanus cinereus*), skink (*Chalcides* sp.) and stripeless tree frog (*Hyla meridionalis*), all of which have present-day southern European distributions. This is also consistent with the avifaunal remains (Chapter 17), which show a persistence of light woodland near the cave, throughout the sequence. However evidence for less open woodland, specifically of mature broad leaf type may be inferred from the presence of birds such as Scops Owl (*Otus scops*) and woodcock (*Scolopax rusticola*). Turning to the large mammal remains (Chapter 18), these were recovered mainly from the Middle and Lower Area and represent many of the species that occur in Gorham's Cave. Of particular interest is the occurrence of Mediterranean Monk Seal (*Monachus monachus*) and common dolphin (*Delphinus delphis*) in the Middle to Lower Area and Northern Alcove some of which show signs of human modification and indicate a clear marine mammal input into the diet. Even if scavenged rather than actively hunted, these animals were brought into the cave for consumption from a nearby high sea level shoreline. Remains of spotted hyena (*Crocuta crocuta*), wolf (*Canis lupus*), brown bear (Ursus arctos) as well as wolf-like coprolites (Chapter 19) indicate that carnivores were also active in the cave in between human visits.

Archaeological evidence

The richest finds come from the Middle and Lower Area. The lithic assemblages (Chapter 20) and modified animal bone (Chapters 18 and 21) indicate the cave was repeatedly used for short-term occupation by Neanderthals. The principal activities centred around dismemberment, processing and consumption of meat from carcasses of medium to small size game such as red deer (*Cervus elaphus*), ibex (*Capra ibex*) and wild pig (*Sus scrofa*). Evidence of dietary behaviour also comes from cut-marked, burnt and broken

Vanguard Cave: Optically Stimulated Luminescence (OSL) Chronology.

Stratigraphy Fig. 14.1	Laboratory Code	OSL results Modelled ages at 1 sigma	Marine Isotope Stage (MIS)
Upper Area	X730	75 100 ± 5300	MIS 4-5
Upper Area	X729-SG	108 500 ± 7000	MIS 5
Upper Area	X724	114 000 ± 5000	MIS 5
Middle-Lower Area	X728	118 000 ± 4500	MIS 5
Middle-Lower Area	X369	121 600 ± 4600	MIS 5
Middle-Lower Area	X720	123 200 ± 5000	MIS 5
Middle-Lower Area	X722	126 500 ± 6800	MIS 5

bones of seal (*Monachus monachus*), mussel shells and charred stone pine (*Pinus pinea*), while tortoise (*Eurotestudo* sp.) and skink (*Chalcides* sp.) may have served as supplementary food sources. Lower representations of anterior to posterior limbs of duck may indicate that waterfowl were also eaten (Chapter 17). One of the interesting behavioural characteristics to emerge from a taphonomic study of the fauna (Chapter 21) is the correlation of incipient (superficial) burning and types of breakage pattern, which strongly suggest that Neanderthals systematically used heat pretreatment on the bone for marrow extraction.

The industries represented in the Lower, Middle and Upper Areas show the use of locally derived quartzites for making flakes that were struck from small discoidal cores. There are few tools present. Repeated but ephemeral stays at the site are indicated by small, shallow hearths in hollows scooped out of the sand. One exception (discussed in Chapter 13) is a large oval hearth in the Middle Area. This feature (context 150) had a maximum diameter of 1.5 m and consisted of multiple layers of ash and rubefied sand and revealed several episodes of hearth use. One of the most interesting hearths occurs in the Upper Area. It is associated with a relatively high density of mussels (*Mytilus galloprovincialis*) embedded in grey ashy deposits, suggesting how Neanderthals may have opened the shells by gently roasting them in the fire and eating them on the spot. Unburnt quartzite flakes from the same hearth can be refitted into larger nodules and provide a plausible sequence of events showing how, prior to departure, flakes had been knapped over the cool ashes of the fire with some flakes carried away (marked by gaps in the refitting) and other debitage left *in situ*. That this reflected anticipatory behaviour involving the replenishment and circulation of artefacts is also supported by a small number of broken and heavily used retouched tools in the hearth area. Unlike most of the flakes these were made in a fine grained chert. Since no debitage of this kind was found it can be surmised that they were brought to the site as ready-made items. This throws significant light on patterns of raw material procurement and use by the Gibraltar Neanderthals. Finally, growth ring studies on mussel shells from the same heartth in the Upper Area have been undertaken (as described in Chapter 22); they provide some of the strongest indications yet for seasonality and likely forward planning, showing that the shells were collected and eaten in mid-Spring from nearby marine or estuarine environments.

Gibraltar Caves
in their wider perspective

23 Middle Palaeolithic sites of Gibraltar and southern Iberia: a bioclimatic perspective

R. P. Jennings

Introduction

The results of fieldwork in the Gibraltar Caves have yielded significant amounts of palaeoenvironmental and archaeological evidence which suggest that high biodiversity and a warm and humid climate contributed to the prolonged survival of Neanderthal populations in the south of the Iberian Peninsula (Finlayson *et al.* 2006; 2008). Indeed, recently published radiometric dates from levels in the rear of Gorham's Cave suggest that Neanderthals potentially occupied the cave as recently as 28,000 years ago, which would make it the last known Neanderthal refuge anywhere in Eurasia (Finlayson *et al.* 2006). Although this age conflicts with the dating of an Upper Palaeolithic assemblage in the front of Gorham's Cave by the Gibraltar Caves Project to 28 ka ¹⁴C BP (Pettitt and Bailey 2000), there is consensus that Neanderthal populations survived in Gibraltar until at least >30–32 ka ¹⁴C BP (Stringer *et al.* 2008, but see Chapter 5). The idea that Gibraltar was a refugial environment for Neanderthals is further strengthened by the results of a recent programme of bioclimatic modelling in southern Iberia, which demonstrated that the locality was within a major lowland refugium (Jennings *et al.* 2011). The aim of this chapter is to evaluate how well the palaeoenvironmental and archaeological evidence recovered on the Gibraltar Caves Project and recorded at other Middle Palaeolithic site localities across southern Iberia supports the maps generated by the bioclimatic modelling. In so doing this will place the work of the Gibraltar Caves Project in a regional context.

Bioclimatic modelling

A bioclimatic approach involves looking at temperature and rainfall patterns and their influence upon biogeographical zones around the world. Two models are presented in this chapter depicting what the climate of southern Iberia may have been like during a warm/humid phase and a cool/dry phase of the Late Pleistocene. The methodology used to construct the models is described in detail in Jennings *et al.* (2011). The approach was inspired by Rivas Martínez (1987), who constructed biogeographical zones for the whole of the Iberian Peninsula using weather station and vegetation data. He divides the world into five macro-bioclimate zones. Southern Iberia is part of the Mediterranean macro-bioclimate zone with the region having considerable bioclimatic variability owing to its varied topography (Fig. 23.1). It has six thermotypes or temperature ranges (thermo-, meso-, supra-, oro- and cryo-Mediterranean) and six ombrotypes or rainfall ranges (arid, semi-arid, dry, sub-humid, humid and hyper-humid) (Rivas Martínez *et al.* 1997).

Present day temperatures and rainfall values were used to model a warm/humid climate phase for southern Iberia

during the Late Pleistocene. Present day conditions are a good analogy for how the climate may have been during MIS 5e or MIS 5a (Figs. 23.2 and 23.3). The modelling of a cool/dry climate phase was more challenging but by adopting bioclimatic principles it was possible to produce maps showing temperatures at 2.5 °C less than present levels and rainfall at 400 mm below current levels. These conditions were considered the most analogous to what may have been typical for MIS 4 or MIS 3 (Figs. 23.4 and 23.5). The decision to lower mean annual temperature by 2.5 °C was governed by the continued occurrence of the thermo-Mediterranean thermotype in the model. This zone must have been present throughout the last glacial period given the survival of endemic thermophilous taxa in the region. It disappears from the map when mean annual temperature falls by 3 °C. An assumption that rainfall patterns in the Pleistocene were broadly similar to today was made, which although not proven certainly is not improbable given the antiquity of global weather systems. A good example is the deep antiquity of the Asian Monsoon systems, some of which have been operating for millions of years (cf. Dennell 2009). The decision to lower annual precipitation levels by 400 mm for the cool/dry climate phase was influenced by pollen transfer data from marine core data retrieved off the coast of southern Iberia, which denote falls of this magnitude for Heinrich Events (cf. Sánchez Goñi *et al.* 1999). Terrestrial pollen core data, which would provide a more useful comparative measure, are not widely available because few such cores have been taken in southern Iberia for this period.

The Middle Palaeolithic dataset

There are more than 160 Middle Palaeolithic sites in southern Iberia of which only a handful have been radiometrically dated (Jennings 2007). These sites, dated or undated, have been georeferenced in a spatial database and displayed over the two climate models to assess whether their distributions can be explained at a basic level in terms of their bioclimatic setting. The paucity of accurately dated sites currently makes it difficult to quantify, but there does seem to be an underlying pattern of sites being located in habitats governed by thermo/meso-Mediterranean temperatures and dry/sub-humid rainfall. This is evident on the first pair of maps, which depicts potential warm and humid climate phases of MIS 5 (Figs. 23.2 and 23.3).

Site distribution in a warm and humid phase (MIS 5e/a)

Of all the sites shown on these two maps, Gorham's and Vanguard Caves are located well within the thermo-Mediterranean and sub-humid zones. Unfortunately, no

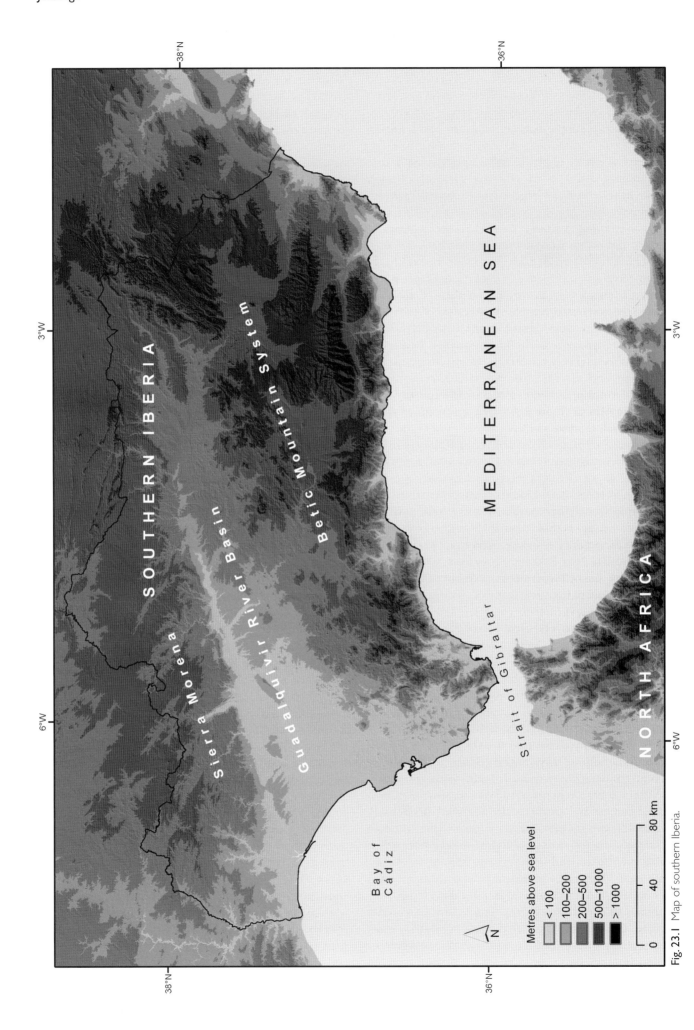

Fig. 23.1 Map of southern Iberia.

environmental samples have yet been examined from Gorham's Cave for contexts of this age, either in the present project or in the work of López-García *et al.* (2011) for sediments at the back of the cave. Palaeoenvironmental and dating evidence for Vanguard Cave show that layers covering MIS 5 include thermophilous reptile and amphibian species such Amphisbaenian or worm lizard (*Blanus cinereus*), skink (*Chalcides* sp.) and stripeless tree frog (*Hyla meridionalis*), all of which have present-day southern European distributions. However the excavations of this site have yet to yield large amounts of small mammal remains.

There is strong evidence to validate the mapping of Higueral de Valleja Cave, located north of Gibraltar in the catchment of the Guadalete River System, within the thermo-Mediterranean and sub-humid zones of MIS 5. Recent excavations in the front chamber of the cave revealed that long grass phytoliths, indicative of warm and humid conditions, were present within Layers X–VIII of the depositional sequence. The lithology of these layers told a similar story: highly rotted limestone, areas of manganese enrichment and localized laminar structures suggested that they formed in a mild and damp environment, probably during MIS 5a. These layers were encountered at the base of a small sondage and have not yet yielded sufficient archaeological or palaeoenvironmental material to confirm further that they belong to MIS 5 (Jennings *et al.* 2009). The location of Higueral within the Guadalete catchment and its proximity to the Betic Mountains suggest that the surrounding area would have been rich in economic resources during a warm and humid phase. If Higueral was occupied in MIS 5 then some of the many neighbouring open-air sites of the Guadalete River Basin may have been contemporary. The open-air site of José-Antonio-Majarromaque was the only one to yield palaeoenvironmental evidence including *Bos* sp. (bovid), *Cervus elaphus* (red deer) and fragments of *Palaeoloxodon antiquus* (straight tusked elephant) but the material is still undated (Giles Pacheco *et al.* 1998).

The two maps show that sites in the lower Guadalquivir basin were also situated in the thermo-Mediterranean temperature and sub-humid rainfall zones. Given the evidence of Middle Palaeolithic occupation in the Guadalete and at Gibraltar, it is possible that many of the 86 mostly open-air sites in this locality also belong to MIS 5. This is difficult to determine because they are undated and 55 of them had doubtful stratigraphic contexts and may derive from other bioclimatic zones. However, not all sites were in poor stratigraphic context and the open-air locality of Tarazona II, for example, was associated with lacustrine deposits which had formed on the surface of a river terrace rather than having been found within it (Vallespí Pérez and Díaz del Olmo 1996). That many of the sites contained bifaces and cleavers – tools often associated with the butchery of large mammals in river basin environments – further indicates that the assemblages if not in primary context have not been spatially displaced to the extent that they would be derived from an altogether different bioclimatic zone, for example of the more mountainous Cádiz-Málaga Sierras.

Whereas the sites at Gibraltar and in the Guadalete and lower Guadalquivir River Systems were firmly within

thermo-Mediterranean temperature and sub-humid rainfall zones, the next group of sites, situated beside or within inter-montane depressions of southern Iberia's Betic Mountain System, were in warm but less stable bioclimatic environments. Angel Cave in the upper reaches of the Guadalquivir basin was in the cooler meso-Mediterranean temperature zone although it continued to receive sub-humid rainfall. The location of this cave between the plain and the mountains and its associated high rainfall meant that surrounding habitats were probably economically rich and not dissimilar to those at Higueral Cave during MIS 5. The cave is known to have been inhabited at this time because it went out of use when its entrance collapsed 100,000 years ago. It is currently under excavation and some of the early field seasons revealed a chert/flint industry of 219 tools. These included four Levallois points, 63 scrapers, 24 denticulates and 11 notched pieces. Two bifaces in the assemblage probably indicate that the butchery of larger mammals took place. Animals with human butchery cut-marks at Angel included equids, cervids and bovids (Vera Rodríguez and Gavilán Ceballos 1993).

The recently discovered open-air site of Santa Ana was found adjacent to an old lake and given its similar bioclimatic parameters could conceivably have been contemporary with the occupation of nearby Angel Cave during MIS 5. Las Grajas Cave, an inter-montane site with a Middle Palaeolithic assemblage described by Benito del Rey (1976) as 'Quina Mousterian', also fits into this group. The range of small mammal species found in units D, E and F of the depositional sequence support this point: *Eliomys quercinus* (garden dormouse), *Arvicola sapidus* (southern water vole), *Microtus brecciensis* (Cette's vole) and *Apodemus* cf. *sylvaticus* (wood mouse) all indicate that human occupation could well have taken place in a sub-humid and meso-Mediterranean setting. The presence of *Allocricetus bursae* (hamster) suggests, however, that cooler open habitats were in close proximity to the cave.

The upland site of Carigüela Cave, which exceeds 1000 m in elevation, contains strong evidence for MIS 5 occupation. The sediment descriptions of Units XII and XI near the bottom of the known stratigraphic sequence at Carigüela support the results of the bioclimatic modelling in that they formed in a warm and relatively humid climate (in contrast to the supra-Mediterranean and semi-arid conditions that would have been more prevalent during MIS 4/3 – see below). Unit XII was rich in organic matter and stalagmitic crusts, while the presence of *Microtus cabrerae* cf. *dentatus* (extinct vole), *Microtus cabrerae* (Cabrera's vole), *Microtus [Pitymys] duodecimcostatus* (Mediterranean pine vole) and *Apodemus* cf. *sylvaticus* (wood mouse) in both units also suggests that they formed during a warm phase, probably in MIS 5. These units contained a Mousterian industry rich in side scrapers and predominantly made on local chert which was used to exploit a range of species available around the cave and in the extensive Guadix-Baza depression, such as *Equus* (horse), *Cervus elaphus* (red deer), *Bos* sp. (bovid) and *Testudo* sp. (tortoise) (Vega Toscano 1990). The level of biodiversity and availability of economic resources thus appears not dissimilar to that seen at Higueral de Valleja and Angel Caves in MIS 5.

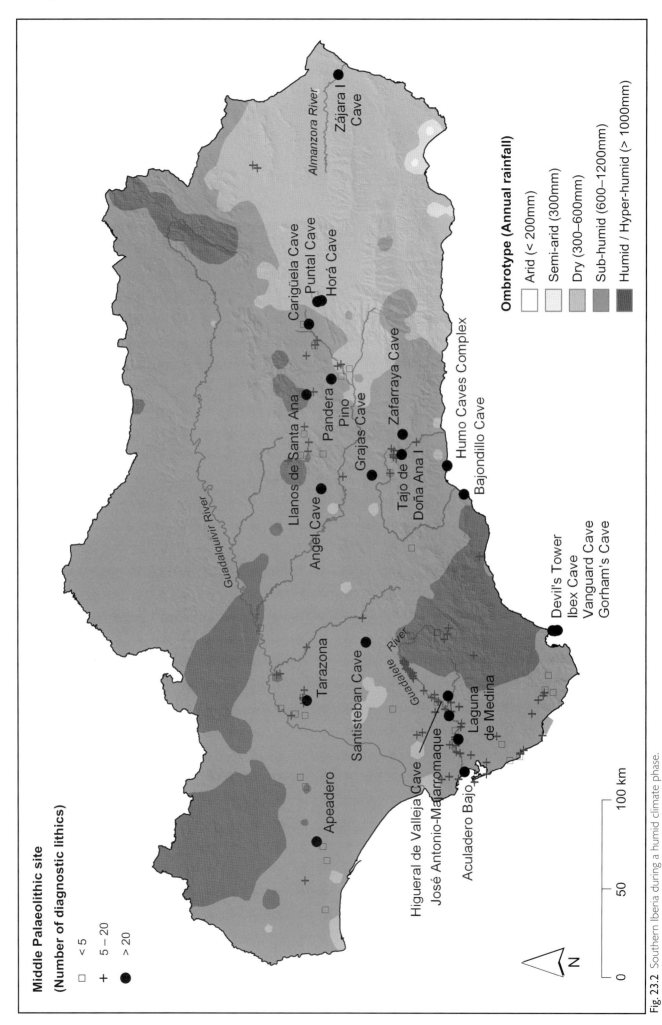

Middle Palaeolithic site
(Number of diagnostic lithics)

□ < 5

+ 5 – 20

● > 20

Ombrotype (Annual rainfall)

Arid (< 200mm)

Semi-arid (300mm)

Dry (300–600mm)

Sub-humid (600–1200mm)

Humid / Hyper-humid (> 1000mm)

Zájara I Cave

Almanzora River

Carigüela Cave
Puntal Cave
Horá Cave

Zafarraya Cave

Humo Caves Complex

Bajondillo Cave

Llanos de Santa Ana
Pandera
Pino
Grajas Cave
Tajo de
Doña Ana I

Angel Cave

Guadalquivir River

Devil's Tower
Ibex Cave
Vanguard Cave
Gorham's Cave

Tarazona

Santisteban Cave

Guadalete River

Laguna
de Medina

Apeadero

Higueral de Valleja Cave
José Antonio-Majarromaque

Aculadero Bajo

N

0 50 100 km

Fig. 23.2 Southern Iberia during a humid climate phase.

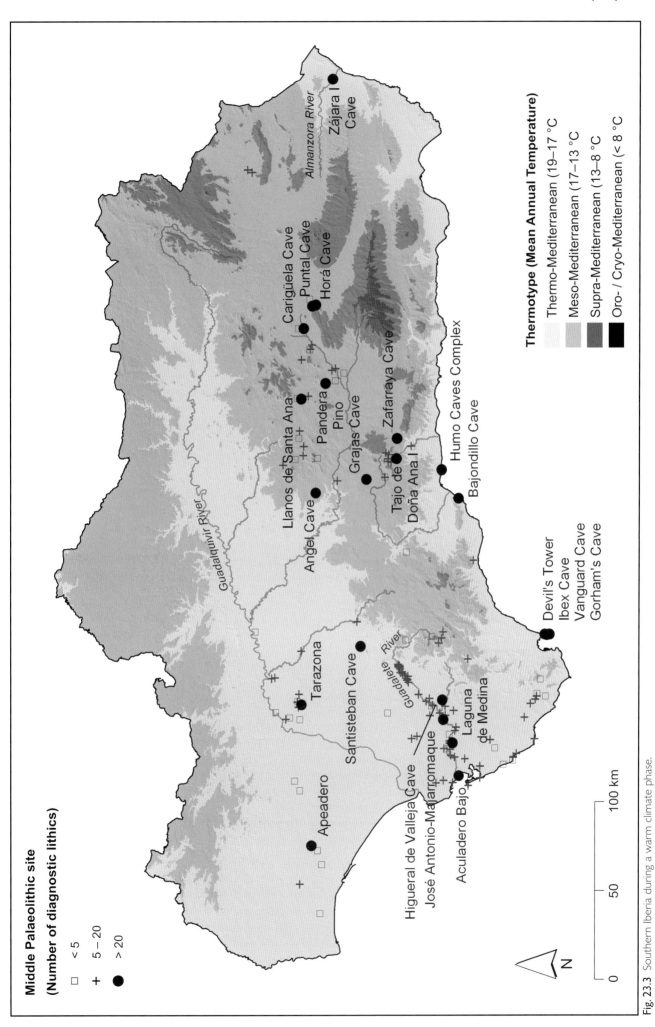

Middle Palaeolithic site
(Number of diagnostic lithics)

□ < 5

+ 5 – 20

● > 20

Thermotype (Mean Annual Temperature)

Thermo-Mediterranean (19–17 °C)

Meso-Mediterranean (17–13 °C)

Supra-Mediterranean (13–8 °C)

Oro- / Cryo-Mediterranean (< 8 °C)

Zájara I
Cave

Carigüela Cave
Puntal Cave
Horá Cave

Zafarraya Cave

Humo Caves Complex

Bajondillo Cave

Llanos de Santa Ana

Pandera

Pino

Grajas Cave

Tajo de
Doña Ana I

Angel Cave

Almanzora River

Guadalquivir River

Devil's Tower
Ibex Cave
Vanguard Cave
Gorham's Cave

Tarazona

Santisteban Cave

Guadalete River

Laguna
de Medina

Higueral de Valleja Cave

José Antonio-Majarromaque

Aculadero Bajo

Apeadero

N

0 50 100 km

Fig. 23.3 Southern Iberia during a warm climate phase.

Neanderthals in Context 285

Two sites near Carigüela have not been dated but do contain faunal assemblages which suggest they were also occupied in MIS 5 and/or perhaps earlier. Horá Cave on the edge of the Guadix-Baza depression and La Solana del Zamborino (Vega Toscano 1988) within the depression were in the meso-Mediterranean temperature and dry rainfall zones. The sites contained large mammalian fauna such as *Stephanorhinus kirchbergensis* (rhinoceros) and *Palaeoloxodon antiquus* (straight tusked elephant). These species were most often associated with grasslands rather than cool and dry steppe habitats that occurred intermittently in this area from MIS 4 to MIS 2. The presence of small mammals such as *Eliomys quercinus* (garden dormouse), *Arvicola sapidus* (southern water vole), *Microtus brecciensis* (extinct vole) and *Apodemus* cf. *flavicolis* (yellow necked mouse) is further evidence that warm and humid conditions prevailed at La Solana del Zamborino at the time of occupation. A large proportion of Mode 2 (Acheulian) technology at these sites suggests that there was a link between open terrain and the butchery of large mammalian fauna as was suggested for the lower Guadalquivir basin.

A pattern to emerge from the warm-humid composite map is that not one Middle Palaeolithic site, dated or undated, was located within the cooler supra-Mediterranean temperature zone or in the semi-arid/arid rainfall zone. This is not to say that such environments were never exploited by Neanderthal populations, as sites in northern Europe show that they exploited economic resources in cooler (but not arid) conditions. This was seemingly not a strategy followed in the warm/humid phases of MIS 5 in southern Iberia. The key point to determine now is whether this was the same for MIS 4/3 when habitats supported by warm and humid bioclimates began to contract.

Site distribution in a cool and dry phase (MIS 4–3)

The cool and dry climate maps reveal two areas which may be of significance in explaining the late survival of Neanderthal populations in southern Iberia as these may have acted as glacial refuges. The first is situated on the lower slopes of the Cádiz-Málaga Sierras and in Gibraltar and is regarded as a major lowland refugium because the area not only received thermo-Mediterranean temperatures and dry/sub-humid rainfall levels but it was also located close to ecologically rich coastal and fluvial habitats. The second area is centred on the uplands of Córdoba and Granada in the Betic Mountain System and is regarded as an upland refugium because it also received dry/sub-humid levels of rainfall, but in a cooler supra-Mediterranean context (Jennings *et al.* 2011). There were lakes in the area but overall it would not have been as resource-rich as the major lowland refugium given its inland setting.

The lowland refugium

Gibraltar was one of the main areas that received warm temperatures and high levels of rainfall during MIS 4/3. This is tentatively supported by palaeoenvironmental evidence recovered from the Gorham's Cave excavations. *Juniperus* sp. and *Pistacia* were found in the SSL, LBS and UBS members which span this period (Chapter 6) while *Juniperus* sp and low levels of Cistaceae in unit CHm.5

indicate that thermo-Mediterranean temperatures were present during MIS 3 (Chapter 7). These observations are supported by recent excavations at the rear of the cave (see Finlayson *et al.* 2008). The conclusions drawn in Chapter 7 and also by Finlayson *et al.* (2008) are that the environment during MIS 3 was not dissimilar to that recorded around Gibraltar today. This suggests that an economically rich and varied environment existed throughout the Late Pleistocene in this part of southern Iberia, something which is in keeping with the area being described as a refugium. The small mammal evidence from the Gibraltar Caves Project supports this premise given the continuity of *Apodemus sylvaticus* (field mouse), *Eliomys quercinus* (garden dormouse), *Microtus brecciensis* (Cette's vole) and *Pitymys duodecimcostatus* (Mediterranean pine vole) throughout the stratigraphic sequence.

Elsewhere, Higueral de Valleja Cave is depicted on the composite map as being on the border of the major lowland refugium, but in reality this site and the many open-air localities along the Guadalete River System probably belonged in the major lowland refugium because the Guadalete River System was effectively an extension of it (Darren Fa, pers. comm.). The highest rainfall in the entire Iberian Peninsula falls in the mountainous area in the centre of the major lowland refugium and much of this water is discharged into the Atlantic Ocean via the Guadalete River and its tributaries. Evidence for the strong flow of the Guadalete River and the habitats supported by it was noted by Giles Pacheco *et al.* (1998). They observed that a large proportion of the small sized Middle Palaeolithic sites found in the valley were often on hill wash deposits or in red clays on the surface of river terraces. It is likely that Neanderthal populations were exploiting prey that was dependent upon the river and its associated lacustrine areas as a source of water. Unfortunately, none of the sites are dated and they may belong to MIS 5 as much as to MIS 3. The same can be said of the aforementioned open-air localities along the lower Guadalquivir basin.

There is no question that Higueral was occupied during MIS 3 as Layers VI and IV have OSL dates of 54,900 BP ± 5600 BP and 33,200 ± 3100 BP respectively. Layers VI and V appear to have formed in a slightly cooler and drier climate than Layers X–VIII, but without evidence of significant climate fluctuations. This is indicated by the continued presence of *Apodemus sylvaticus* (wood mouse), *Microtus duodecimcostatus* (pine vole) and *Microtus brecciensis* (extinct vole), and the absence of cooler adapted small mammals such as those found at similar levels at Horá and Carigüela Caves (see below). The discovery of the *Pecten maximus* (large scallop) shell in Layer V of Higueral is of interest as it indicates a connection with the Atlantic coast, which was at least 40 km away during MIS 3. Of the limited number of lithics found at this level of the sondage during the excavations at Higueral (154 were recovered from Layer VI and Layer V, nine of which were retouched) none were as long as a blade-flake found in the lower levels which is provisionally attributed to MIS 5 (Jennings *et al.* 2009).

Another site to border the major lowland refugium was Bajondillo Cave along the Mediterranean coast. It received thermo-Mediterranean temperatures but marginally less

Middle Palaeolithic site

(Number of diagnostic lithics)

☐ < 5

✛ 5 – 20

⬤ > 20

Ombrotype (Annual rainfall)

☐ Arid (< 200mm)

☐ Semi-arid (300mm)

▨ Dry (300–600mm)

▨ Sub-humid (600–1200mm)

▨ Humid / Hyper-humid (> 1000mm)

Zájara I Cave

Almanzora River

Puntal Cave

Carigüela Cave

Horá Cave

UPLAND REFUGIUM

Pandera

Pino

Llanos de Santa Ana

Grajas Cave

Zafarraya Cave

Humo Caves Complex

Bajondillo Cave

Tajo de Doña Ana I

Angel Cave

Guadalquivir River

Devil's Tower

Ibex Cave

Vanguard Cave

Gorham's Cave

Tarazona

Santisteban Cave

Guadalete River

LOWLAND REFUGIUM

Laguna de Medina

José Antonio-Majarromaque

Higueral de Valleja Cave

Aculadero Bajo

Apeadero

N

0 50 100 km

Fig. 23.4 Southern Iberia during a dry climate phase. The dry phase derives from lowering present day annual precipitation by 400 mm.

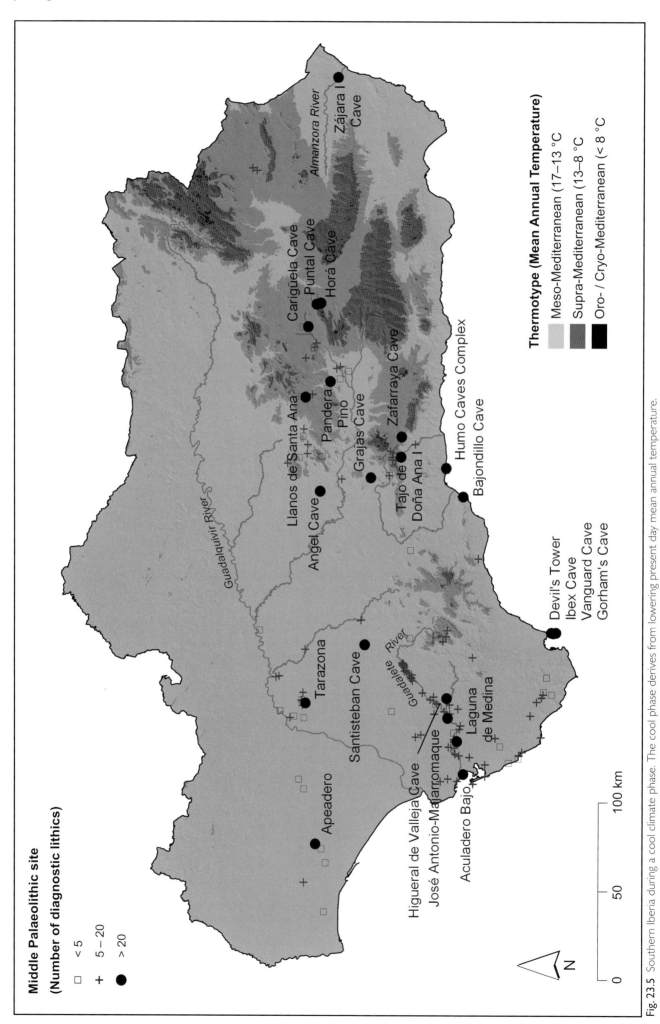

Fig. 23.5 Southern Iberia during a cool climate phase. The cool phase derives from lowering present day mean annual temperature.

rainfall than the Gibraltar Caves because of its positioning on the leeward side of the Cádiz-Málaga Sierras. The cave contained levels dating to the latter stages of MIS 3. Like the Gibraltar Caves, a coastal strip in front of Bajondillo would have also offered a range of possible terrestrial economic resources. Two caves of Complejo Humo, *c.* 20 km west of Bajondillo along the Bay of Málaga, have also produced Middle Palaeolithic assemblages (Cortés Sánchez 2007).

The upland refugium

The composite map for MIS 3 demonstrates a considerable expansion of supra-Mediterranean temperatures across the uplands of southern Iberia during a modelled cool phase. It also shows that rainfall levels were an important factor governing Middle Palaeolithic site distributions in this temperature zone. Fewer than ten sites are situated where the model predicts that there was little or no rainfall. The remainder have links with dry to humid levels. The highest rainfall levels occur in the Córdoba, Granada and Jaén uplands and it is here and along the rivers emanating from this area that the upland refugium is best defined.

The recently discovered open-air sites of Llanos de Santa Ana and Ermita Nueva on an old lake shore in the uplands of Jaén Province are located at the heart of the upland refugium. Unfortunately, no faunal assemblages were recovered and the lithic finds, although copious in number, are yet to be published or dated (Santiago Pérez *et al.* 2004). However, the continued rainfall, presence of the lake, and the varied surrounding topography meant it must have been an area of high biodiversity rich in economic resources. This suggests the site was in use throughout MIS 5–3.

One of the most well studied sites in the upland refugium is Cueva de la Carigüela (Vega Toscano 1990; Carrión *et al.* 1998). Evidence from Units X–VI of the stratigraphic sequence supports the modelling: two small mammal species, *Allocricetus bursae* (hamster) and *Microtus arvalis* (common vole), were present in all the units while *Microtus* (= *Chionomys*) *nivalis* (snow vole) made an appearance in the units in question. Interestingly, palynological evidence from the same unit indicated that a closed pine forest was near the cave. Despite the cool climate the five units have 19 occupation levels: 18 classified as typical Mousterian and one as denticulate Mousterian. However, Carrión *et al.* (1998) stated that there was a rise in carnivores and lagomorphs associated with these units, which suggested that Neanderthal occupation may have been discontinuous.

Horá Cave, although undated, also has deposits which probably formed in MIS 3. Typical Mousterian assemblages were recovered from Phases 2–6 of the sequence. The tools, predominantly side scrapers, were made on chert pieces that were accessible from flint/chert exposures less than 5 km from the cave (Vega Toscano 1988). The occupation evidence was associated with a series of climate fluctuations within Phases 3–6. The combination of *Allocricetus bursae* (hamster), *Pliomys lenki* (vole), *Microtus arvalis* (common vole) and *Microtus cabrerae* cf. *dentatus* (extinct vole) implied that the climate was cool and wet during Phase 3. The prevalence of *Microtus arvalis* in Phase 4 implies the climate became drier. It improved again in Phase 5 as attested by the presence of *Eliomys quercinus* (garden dormouse),

Microtys [Pitymys] duodecimcostatus (Mediterranean pine vole) and *Apodemus* cf. *sylvaticus* (wood mouse). Phase 6 saw the return of a drier climate with *Microtus arvalis* again dominant. Another site with environmental evidence suggesting that the climate frequently oscillated from a relatively warm and wet environment to a cool and dry one during MIS 3 was Boquete de Zafarraya Cave in the uplands of Málaga. Like Carigüela, it only took a small decrease in temperature for the change from meso- to supra-Mediterranean to occur. It appears that Zafarraya was quite susceptible to rapid climate oscillations. Palynological studies of the cave sediments identified large quantities of *Artemisia* and *Ephedra* in subunits 1a, 1c and 2 of the Middle Unit, and higher percentages of deciduous pollen in 1d. The steppe species recovered are indicative of a supra-Mediterranean climate. The identification of microfaunal species such as *Apodemus* cf. *flavicolis* (yellow necked mouse), *Microtus* cf. *cabrerae* (Cabrera's vole), *Pitymys duodecimcostatus* (Mediterranean pine vole) and *Eliomys quercinus* (garden dormouse) suggests that the cave at some stage was near or in a warmer and wetter zone. Six archaeological layers in the Middle Unit produced over 800 artefacts (Barroso Ruiz 2003). The integrity of the layers has been called into question by the results of the radiometric dates on charcoal, which indicated the layers were disturbed. However, the range of dates suggests that occupation took place during MIS 3. A high proportion of Typical Mousterian tools in the assemblage indicated that economic activity took place in the cave, such as animal butchery. There was also a high proportion (up to 90 per cent) of *Capra pyrenaica* (Spanish ibex) in the Middle Unit, although a large number of carnivores were also noted. This might mean that the cave was used only intermittently.

Other localities

There is some evidence of Middle Palaeolithic activity in what is the Cádiz-Málaga Sierras but this is insubstantial and undated. The most reliable evidence comes from Cueva del Peñón Grande, where a classic Mousterian point was discovered on the cave platform (Santiago Pérez *et al.* 2003). The remainder of the sites were all find-spot localities. If the area was inhabited during MIS 3 then it would represent occupation of a supra-Mediterranean and humid zone, which would be significant as these are the rarest form of the cool/wet refugial environments on the composite map. Cueva de los Murciélagos (Vera Rodríguez and Gavilán Ceballos 1993) is the only other site within a similar bioclimatic zone in the Betic Mountains in Córdoba Province although the lack of dating means it too could relate to MIS 5 occupation.

Finally, Zájara I Cave in Almería Province is in an arid environment on the composite map. It was originally approximately 10 km from the Mediterranean coast and overlooked the Almanzora River but it has since been quarried away. It once contained 4 m of deposits and 8300 lithics (Vega Toscano 1988). The area is naturally dry due to being on the leeward side of the Betic Mountains. The site probably does not represent Neanderthal exploitation of an arid environment. Instead, the lithics may simply date to MIS 5 when the area would have been less arid, or possibly the

nearby river and coastal habitats may have enabled the cave to be used in MIS 3. Vega Toscano noted that there was no significant variation in the lithic assemblage over time and that chert nodules acquired from the Almanzora River made up 95 per cent of the raw materials used. Unfortunately, no environmental evidence survives.

Concluding remarks

This review has shown that a bioclimatic approach to modelling the climate of southern Iberia in the Late Pleistocene is viable and worthy of development as the generated maps are broadly supported by published palaeoenvironmental and archaeological evidence. The conclusions drawn from the appraisal with regard to Neanderthal occupation strategies are:

1 MIS 5e/a: Neanderthal populations exploited environments governed by warm and, in particular, humid bioclimatic parameters. No Middle Palaeolithic sites were located in the coolest and driest parts of southern Iberia during this time. This suggests that Neanderthal populations in this area were more associated with Mediterranean rather than steppe habitats, in contrast to the traditional perception of Neanderthals as a cold adapted species. This is supported by the discovery of warm and/or humid favouring flora and herpetofaunas in MIS 5 deposits at Vanguard Cave. A range of thermophilous small mammal species were found in MIS 5 layers at Carigüela Cave, while long grass phytoliths, indicative of a warm/humid environment, were identified in a likely MIS 5 layer in Higueral Cave.

2 MIS 4/3: The habitats exploited by Neanderthals began to contract during the last glacial period as the climate became cooler and drier, leaving them two refugial environments: an upland refugium centring on lakes and rivers in the Granada Córdoba Mountains; and an economically rich major lowland refugium extending from the Cádiz-Málaga Mountains to the Rock of Gibraltar. The geographical extents of the refuges were principally defined by the high rainfall levels that each received. The major lowland refugium was unique in that it remained within the thermo-Mediterranean zone, making it a very stable environment. This environmental stability is reflected in the strong consistency in the make-up of the small mammal and faunal assemblages in the stratigraphic sequences at Gorham's and Higueral Caves. In contrast, cool-climate indicator species such as *Microtus* (= *Chionomys*) *nivalis* (snow vole), *Microtus arvalis* (common vole) and *Microtus cabrerae* cf. *dentatus* (extinct vole) were identified intermittently in upland sites such as Carigüela, Horá and Zafarraya Cave, indicating an unstable climate.

Working with the premises that (1) if Neanderthal populations in southern Iberia were adapted to warm and humid Mediterranean climates and that (2) these habitats contracted to localized areas such as the major lowland refugium and the upland refugium due to climate change, then such environments are where late surviving Neanderthals might be expected to be found. The results from the fieldwork at Gorham's Cave and Higueral Cave fully support this premise, with Middle Palaeolithic occupation conservatively dated to younger than 40,000 years, if not considerably more recent than this.

Acknowledgements

Many thanks to Clive Finlayson, Geraldine Finlayson, Darren Fa, Francisco Giles Pacheco, Nick Barton, Chris Stringer, José María Gutiérrez López, Antonio Santiago Pérez, Cath Price, Elaine Turner, Cóilín O'Drisceoil, José Ramos Munoz, Miguel Córtes Sánchez, Maria Simon Vallejo and José Carrion for their support and guidance in the research associated with this chapter. This study was supported by the Arts and Humanities Research Council, Project No. RG/AN1604/APN12435: The Biogeography of Human Populations in Southern Iberia in the Late Pleistocene.

References

Barroso Ruiz, C. (ed.) 2003: *El Pleistoceno Superior De La Cueva Del Boquete De Zafarraya* (Seville, Junta de Andalucía, Consejeria de Cultura, Direccion General de Bienes Culturales).

Benito del Rey, L. 1976: Excavaciones realizadas en el yacimiento musteriense de la Cueva de las Grajas, Archidona (Málaga). *Noticiario Arqueológico Hispánico* 5, 39–52.

Carrión, J.S., Munuera, M. and Navarro, C. 1998: The palaeoenvironment of Carihuela Cave (Granada, Spain): a reconstruction on the basis of palynological investigations of cave sediments. *Review of Palaeobotany and Palynology* 99, 317–340.

Cortés Sánchez, M. 2007: *Cueva Bajondillo (Torremolinos). Secuencia cronocultural y paleoambiental del Cuaternario reciente en la bahía de Málaga* (Málaga, Diputación Provincial de Málaga).

Dennell, R.W. 2009: *The Palaeolithic Settlement of Asia* (Cambridge, Cambridge University Press).

Finlayson, J.C., Giles Pacheco, F., Rodríguez-Vidal, J., Fa, D., Gutierrez López, J.-M., Santiago Pérez, A., Finlayson, G., Allue, E., Baena Preysler, J., Cáceres, I., Carrión, J., Fernández Jalvo, Y., Gleed-Owen, C., Jimenez Espejo, F., López, P., López Sáez, J.-A., Riquelme Cantal, J.-A., Sánchez Marco, A., Giles Guzman, F., Brown, K., Fuentes, N., Valarino, C., Villalpando, A., Stringer, C.B., Martinez Ruiz, F. and Sakamoto, T. 2006: Late survival of Neanderthals at the southernmost extreme of Europe. *Nature* 443, 850–853.

Finlayson, J.C., Fa, D., Jimenez Espejo, F., Carrión, J., Finlayson, G., Giles Pacheco, F., Rodríguez-Vidal, J., Stringer, C. and Martinez Ruiz, F. 2008: Gorham's Cave, Gibraltar. The Persistence of a Late Neanderthal Population. *Quaternary International* 181, 64–71.

Giles Pacheco, F., Gutiérrez López, J.M., Santiago Pérez, A. and Mata Almonte, E. 1998: Avance al estudio sobre poblamiento del Paleolítico superior en la cuenca media y alta del Río Guadalete. In Sanchidrián Torti, J.L. and Simón Vallejo, M.D. (eds.), *Las culturas del Pleistoceno Superior en Andalucía* (Málaga, Patronato de la Cueva de Nerja), 111–140.

Jennings, R.P. 2007: *The Human Occupation of Southern*

Iberia in the Late Pleistocene (Unpublished doctoral thesis, Oxford University).

Jennings, R. P., Giles Pacheco, F., Barton, R. N. E., Collcutt, S. N., Gale, R., Gleed-Owen, C. P., Gutiérrez López, J. M., Higham, T. F.vG., Parker, A., Price, C., Rhodes, E., Santiago Pérez, A., Schwenninger, J. L. and Turner, E. 2009: New dates and palaeoenvironmental evidence for the Middle to Upper Palaeolithic occupation of Higueral de Valleja Cave, southern Spain. *Quaternary Science Reviews* 28, 830–839.

Jennings, R. P., Finlayson, J. C., Fa, D. A. and Finlayson, G. 2011: Southern Iberia as a refuge for the last Neanderthal populations. *Journal of Biogeography*. 1-13. doi:10.1111/j.1365-2699.2011.02536.x

López–García, J. M., Cuenca-Bescós, G., Finlayson, C., Brown, K. and Giles Pacheco, F. 2011: Palaeoenvironmental and palaeoclimatic proxies of the Gorham's cave small mammal sequence, Gibraltar, southern Iberia. *Quaternary International*. doi:10.1016/j.quaint.2010.12.032

Pettitt, P. and Bailey, R. 2000: AMS radiocarbon and luminescence dating of Gorham's and Vanguard caves, Gibraltar, and implications for the Middle to Upper Palaeolithic transition in Iberia. In Stringer, C. B., Barton, R. N. E. and Finlayson, J. C. (eds.), *Neanderthals on the Edge* (Oxford, Oxbow Books), 155–162.

Rivas Martínez, S. 1987: *Memoria del Mapa de Series de Vegetacion de Espana* (Madrid, ICONA).

Rivas-Martínez, S., Asensi, A., Díez-Garretas, B., Molero, J. and Valle, F. 1997: Biogeographical synthesis of Andalusia (southern Spain). *Journal of Biogeography* 24, 915–928.

Sánchez Goñi, M. F., Eynaud, F., Turon, J. L. and Shackleton, N. J. 1999: High resolution palynological record off the Iberian margin: direct land-sea correlation for the Last Interglacial complex. *Earth and Planetary Science Letters* 171, 123–137.

Santiago Pérez, A., Giles Pacheco, F., Gutiérrez López, J. M., Finlayson, C. and Aguilera Rodríguez, L. 2003: Paleolítico Inferior y Medio en la Sierra de Cádiz: evidencias de grupos de cazadores-recolectores del Pleistoceno Medio y Superior. *Almajar: Revista de Historia, Arqueología y Patrimonio de Villamartín y la Sierra de Cádiz* 1, 8–35.

Santiago Pérez, A., Giles Pacheco, F., Gutiérrez López, J. M., Finlayson, C., Mata Almonte, E., Borrás Querol, C., Calvo, C., Finlayson, G. and Aguilera Garcia, J. 2004: Paleolítico Medio en Alcalá la Real. Tecnocomplejos líticos de ocupaciones de neandertales en el Pleistoceno medio-superior de los Llanos de Santa Ana y Ermita Nueva, Alcalá la Real, Jaén. Miscelanea en homenaje a Emiliano Aguirre. *Zona Arqueológica* 4, 72–78.

Stringer, C. B., Finlayson, J. C., Barton, R. N. E., Fernández-Jalvo, Y., Cáceres, I., Sabin, R. C., Rhodes, E. J., Currant, A. P., Rodríguez-Vidal, J., Giles Pacheco, F. and Riquelme Cantal, J. A. 2008: Neanderthal exploitation of marine mammals in Gibraltar. *Proceedings of the National Academy of Sciences* USA 105(38), 14319–14324.

Vallespí Pérez, E. and Díaz del Olmo, F. 1996: Industries in quartzite and the beginning of the use of flint in the Lower and Middle Palaeolithic Sequence of the Bajo Guadalquivir. In Moloney, N., Raposo, L. and Santonja, M. (eds.), *Non-flint stone tools and the Palaeolithic occupation of the Iberian Peninsula* (Oxford, BAR International Series 649), 135–140.

Vega Toscano, L. G. 1988: *El Paleolítico medio del sureste español y Andalucía oriental* (Madrid, Universidad Complutense).

Vega Toscano, L. G. 1990: La fin du Paléolithique moyen au sud de l'Espagne: ses implications dans le contexte de la Péninsule Ibérique. *Paléolithique moyen récent et Paléolithique supérieur ancien en Europe (Colloque International de Nemours, 9–11 mai 1988)* (Nemours, Mémoires du Musée de Préhistoire de l'Ile de France), 169–176.

Vera Rodríguez, J. C. and Gavilán Ceballos, B. 1993: Localizaciones y yacimientos del Paleolítico Medio en el extremo suroriental de la provincia de Córdoba. *Antiquitas* 4, 7–18.

24 The late Pleistocene human occupation of Gorham's and Vanguard Caves: some reflections

R. N. E. Barton, C. B. Stringer and S. N. Collcutt

Gorham's and Vanguard Caves

The co-editors of this volume began this project with the combined objectives of locating and providing a chronology for Middle and Upper Palaeolithic levels of Gorham's Cave, as well as investigating the previously undug and adjacent site of Vanguard Cave. The focus of this work was initially on the transition between Neanderthals and modern humans but as our fieldwork progressed it became increasingly apparent that the scope of the project needed to be broadened in order to encompass the much earlier and longer history of occupation presented by the deep stratigraphy in both caves. Thus in addition to detailed investigation of the Middle to Upper Palaeolithic sequence in Gorham's Cave we were also able to conduct work on parts of the long succession of Middle Palaeolithic occupation layers in both caves that extended back into last interglacial (MIS 5). Some of this work led to wholly unexpected discoveries and provided new evidence on early dietary practices of Neanderthals such as the regular exploitation of marine resources (Stringer *et al.* 2008). In other cases work was directed towards wider questions of seasonality, diet-breadth and site taphonomy and has provided preliminary results that show extreme promise for future studies. To what extent we succeeded in achieving the main objectives of this project can be judged by examining the data set out in the chapters contained in this monograph, and summarised at the end of each site section. In this last chapter we reflect on the Gibraltar Caves Project as a whole: weighing up the principal findings and potential implications of this work and how it has advanced our understanding of Neanderthals in this southernmost part of Europe.

Chronological relationships

The oldest part of the excavated Gorham's sequence for which we have direct dating evidence comes from the *Coarse Sands member* (CSm) with OSL providing a likely age of MIS 5c for these sediments. This is in reasonable agreement with uranium series estimates on spelaeothem from the *Carbonate Sands & Silts member* (CSSm) a little higher in the sequence (Rink *et al.* 2000), lending support to the overall age model. Thus one scenario is that the succession of sediments CSm to CCSm represents the interval MIS 5c, with high sea level marked by beach-derived sands and followed by marine regression (Fig. 3.1). An earlier high beach (MIS 5e) is exposed in the *Basal Coarsest Sands member* (BCSm) at the bottom of the whole sequence. Unfortunately, the lower half (~8 m) of the Gorham's deposits are not well exposed and were not studied in any detail during the recent campaigns. Despite this uncertainty it

is apparent that an archaeological presence persists more or less throughout; for instance, there are certainly lithic artefacts, charcoal and suspected shell-midden debris in the *Carbonate Sands & Silts member* (CSSm), more lithics in the *Coarse Sand member* (CSm) and a few conspicuous artefacts are cemented within the matrix of the *Rubified Speleothem Clast member* (RSCm), the earliest known terrestrial deposit in Gorham's Cave.

Turning to Vanguard Cave, the OSL determinations show that virtually the whole sequence dates from the various sub-stages of MIS 5. The presence of a heavily cemented deposit of intertidal coarse sands with marine shell fragments and pebbles, which forms a continuous platform in front of both caves, suggests a common basal unit that would appear to date from some part of MIS 5e. Despite the lack of precise stratigraphic correlation it is clear that the deposits in the two caves overlap in age; the presence of marine-derived coarse sand and shell debris in supratidal beds suggests that a level relatively high in the 17 m Vanguard sequence will match the *Coarse Sand member* (or even a level within the lower part of the *Carbonate Sands and Silts member*) at Gorham's Cave. It is likely that this distinctive sediment stock will provide a useful marker for other plausibly MIS 5c deposits all along the eastern flank of Gibraltar.

The dating of the youngest Middle Palaeolithic deposits in Gorham's Cave has become a contentious issue (Finlayson *et al.* 2006; Zilhão and Pettitt 2006; Tzedakis *et al.* 2007). From the perspective of the project excavation results, we can state with confidence that the latest Middle Palaeolithic layers *in the area of the cave described here* can be no younger than 34,000-33,200 cal BP. This is based on a strong suite of AMS dates from the *Cemented Hearths member* (units CHm1-5) which contain Initial Upper Palaeolithic artefacts and cap the Middle Palaeolithic sequence. The underlying unit that contains the first unequivocal, if sometimes disturbed, Middle Palaeolithic artefacts (as well as a few obviously displaced Upper Palaeolithic pieces) is the *Upper Bioturbated Sands member* (UBSm) which is characterized in all available exposures by common and major bioturbation features, as well as by plastic deformation structures. Following on from these observations it would therefore be unwise to rely on the inconsistent ages obtained from this context for dating the Middle Palaeolithic. Beneath this member, much better preserved Middle Palaeolithic layers are common and have been AMS dated to 45,000 cal BP and supported by OSL determinations. So far, the limited OSL dating that has been carried out at Vanguard Cave tends to suggest that the highest

Middle Palaeolithic encountered may not be younger than the end of MIS 5. Only the uppermost part of the section in Area A has yielded finds that are not diagnostically of Middle Palaeolithic types and this suggests the presence of a major stratigraphic gap in the sequence. Clearly, further dating evidence is required from these units before a more assertive statement can be made about the age of the latest Middle Palaeolithic in that cave.

Environmental change

The stratified deposits at Vanguard Cave are best understood in terms of a largely unvarying picture of conditions during MIS 5. Although as yet sparse, the evidence from charcoals in Vanguard Cave includes a variety of genera such as Stone pine (*Pinus pinea*), Juniper (*Juniperus*), Barbary arbour-vitae, (*Tetraclinis articulata*), Terebinth/lentisc/pistacio (*Pistacia sp.*), Joint pine (*Ephedra*), Oak (*Quercus*) and olive (*Olea*), all of which are consistent with 'interglacial' conditions and very similar to the modern natural flora in the vicinity. Amongst the herpetofauna, worm lizard or Amphisbaenian (*Blanus cinereus*) and skink (*Chalcides*) are obligate thermophiles, whilst Moorish gecko (*Tarentola mauritanica*) and stripeless tree frog (*Hyla meridionalis*) are typical Mediterranean species. The birds are varied and typical of Mediterranean habitats. Only some of the ducks, like *Clangula hyemalis* suggest the occasional displacement of usually more northern taxa, and such examples occur right at the top of the sequence. Amongst the larger mammals, the herbivores would indicate both rocky and at least lightly wooded environments, whilst the marine mammals, shellfish and fish show the undoubted proximity of the sea and estuarine habitats.

Layers relevant to the interglacial are also present in Gorham's Cave but, as stated above, have not yet been studied in detail. The examined sedimentary sequence is interpreted as covering MIS 5a (*Variegated Sands & Silts member*), MIS 4 (*Sands & Stony Lenses member*) and MIS 3 (from the top of the *Sands & Stony Lenses member* to the lower part of the *Cemented Hearths member*). Given the time depth represented and indications of at least local variations in the sedimentary record, we would expect to see some evidence for change through time in the palaeoenvironmental record. Perhaps surprisingly this seems not to be the case. Instead, only very slight signs of climatic change are discernible in the terrestrial environmental signal but this may be partly due to the limited nature of the sampling, for example in the interval MIS 5-4 where we might expect the greatest contrasts to exist. Except for herpetofaunal and some of the small mammal remains, there are relatively few samples or finds from the *Sands & Stony Lenses member* (SSLm) or below. In fact, the available evidence from the putatively MIS 4 sequence within SSLm indicates that the biological record is difficult to correlate directly with the marine isotope stages. For example, the herpetofaunal indicators suggest that there was an increase in drier Mediterranean shrub species, at the expense of woodland and moist well-vegetated habitats, in the interval SSLm.6-1. The sediments can be dated from ~68 ka to 56.5 kya and, as such, this does not show the expected trend of climatic improvement that would be expected towards the end of MIS 4, but

may reflect local conditions around Gibraltar with the sea never very far away.

Within the overlying sequence at Gorham's Cave, the palaeoenvironmental remains become richer and are indicative of moister conditions prevalent in MIS 3. Thus, at the broadest timescales, generally less arid environments are indicated by the presence of large mammals such as bovids in the *Bedded Sands* and *Lower Bioturbated Sands members*. The small mammals in these layers also reflect greater humidity and the existence of localised woodland with wood mouse (*Apodemus*), garden dormouse (*Eliomys*) and related faunas. At medium timescales, there are indications of significant loss of wetland habitats and increase in the importance of dune systems towards the top of the LBSm. The possibility of detecting even shorter episodes of 'cooler/drier' climate within MIS 3 (e.g. Heinrich Events) may be suggested by the brief appearance of locally breeding ducks, such as the Common Scoter (*Melanitta nigra*), in the sediments of LBS(mcf).5 and .8, as has been proposed by Cooper (Chapter 9). Also of relevance may be the development of a short phase of dry Mediterranean scrub, as inferred from the herpetofauna in *Upper Bioturbated Sands member* (unit UBSm.7), dated shortly before 38.5 kya (Chapter 5). Whilst it is tempting to correlate this phenomenon with Heinrich Event 4 or with Heinrich Event 5 (usually placed at around 49 kya) for the late-LBSm layers, in neither of these cases is the dating precise enough at Gorham's Cave to confirm links with specific Heinrich Events. Nonetheless, these subtle palaeontological clues, coupled with the ubiquitous signs of physical fluctuation in the sedimentary sequence, do at least imply a degree of variation in the palaeoenvironmental record that might be linked to fluctuations in the climate.

Finlayson *et al.* (2008b) and Jennings *et al.* (2011) suggest that Gibraltar sits within a very stable Thermo-Mediterranean bioclimatic zone. According to their studies on climate modelling, parts of southern Iberia including Gibraltar and its surrounding area were characterised by warm and generally humid conditions that persisted throughout much of MIS 5 and 3 and even during relatively cool episodes of MIS 4. The existence of what are termed 'refugia' would seem to be strongly supported by the palaeontological evidence from Gorham's and Vanguard Caves that shows no major signs of disturbance or change from the last Interglacial onwards. However, the impression of uniformity could possibly be somewhat misleading. For instance, Morales-Morino *et al.* (2011), working at El Asperillo Beach (Doñana Natural Park, Gulf of Cádiz), describe a high quality organic horizon, representing a wetland margin in a dune sequence, dating from a stadial of MIS 5 or from MIS 4. This horizon has provided pollen and macro-remains indicative of a dry and cool steppe-grassland but with local wetland species and, in addition to scattered pines, a few small stands of temperate trees. Although typical thermophilous Mediterranean vegetation was absent at El Asperillo at this time, the observed assemblage represents a grouping of taxa not commonly found together today. Whilst Gibraltar does have thermophilous elements at most levels in the Late Pleistocene, it is quite possible that we are not yet able to distinguish the slightly 'non-analogue' components,

disposed in a complex, relatively fine-grained, and shifting mosaic, which could be a response to environmental stress. That there simply must have been such stress in repeated episodes is now well established in the multi-proxy records from marine cores from around the Spanish coasts. Penaud *et al.* (2011) have provided quantitative reconstructions of sea-surface temperatures and salinities based on dinocysts, compared to SSTs derived from earlier published planktonic foraminifera and alkenone measurements, and to SSSalinities calculated from planktonic $\delta^{18}O$ and foraminiferal SST. Looking at their Alboran Sea core results, whilst the stadial events within MIS 3 are indeed muted compared with the nearby Atlantic, Heinrich Events are still strongly represented. Furthermore, the data imply marked seasonality increases, especially involving depression of winter temperatures, perhaps a factor which resilient or 'plastic' local biota could manage to cope without major taxonomic change. This brings us back to the observation at the Gibraltar caves that, whilst the signal from terrestrial biota shows considerable inertia, there are greater signs of change in marine organisms, less able to take advantage of buffering in local micro-climates. Indeed in a recent study on limpet (*patella*) shell from Gorham's Cave Ferguson *et al.* (2011) has shown unequivocally that winter temperatures dropped considerably in later periods of the last glacial cycle which fits the pattern of greater SST seasonality recorded in the marine cores. In addition to the instances reported from our recent excavations, one may recall the Atlantic grey seal (not found much further south than the British Isles today) recovered by Waechter from his layers D and F (CHm, possibly also upper UBSm). Certainly, in the future, a wider range of marine organisms should be extracted and analysed (e.g. shellfish, fish and possibly even micro-fossils).

Many of the ideas about the uneven characteristics of environmental change in southern Iberia during the last interglacial-glacial cycle echo those also put forward by Clive Finlayson and colleagues. In their 2008a paper they state that "we have used frequencies of occurrence of plants and birds in bioclimates as indicators of probability and have shown the south-western Iberian picture to be a mosaic and not one of clearly defined belts of vegetation. The tolerance to a range of bioclimates (with preference to particular ones) seems to be a feature of many southern Iberian organisms, in particular reptiles, amphibians but also mammals and birds […] and may reflect taxa that have avoided extinction during glaciations by their ability to shift position along a bioclimatic gradient." (2008a, 62).

Neanderthal resources and behaviour

The Mediterranean palaeoenvironment offered Neanderthals an enormous wealth and diversity of natural resources. Evidence of this comes from the rich species composition at both Gorham's and Vanguard Caves that comprises large terrestrial mammals such as ibex (*Capra ibex*), red deer (*Cervus elaphus*), wild boar (*Sus scrofa*), wild bovid (*Bos* sp.) as well as a range of edible smaller animals including rabbit (*Oryctolagus cuniculus*), tortoise (*Eurotestudo hermanni* and *Eurotestudo iberia*) and possibly skink (*Chalcides* sp.). Included in this menu of available foods were marine mammals such as Mediterranean monk seal

(*Monachus monachus*) and dolphin, as well as fish, birds including pigeon and duck, and a variety of different shellfish species (most notably *Patella* spp., *Mytilus* spp., *Oscilinus turbinatus*) (Colonese *et al.* 2010). The late Pleistocene Mediterranean woodlands also abounded in seasonally available plant foods, especially pine nuts.

Even allowing for fluctuation through time, all of these resources would have remained within close reach of the caves. Thus, one reason that Neanderthals deliberately favoured Gibraltar seems to have been due to its ecotonal position, on the margins of marine, terrestrial and wetland habitats that were rich in raw materials and food sources (Finlayson *et al.* 2008b). The position of the caves would also have allowed them to survey the shoreline to locate stranded carcasses of seals or vulnerable individuals but also to be within easy distance of estuarine and wooded environments on the north and west sides of Gibraltar. Lithic raw materials were in plentiful supply as small cobbles occurring in the geological formations of the Rock and in beach deposits outside the caves. It is perhaps interesting to note that the only major change in Middle Palaeolithic assemblage composition occurs in the form of very large blade-like flakes in the SSL member and it is possible that this coincided with a phase of newly lowered sea-level in MIS 4 when additional geological sources may have been exposed off the present coast. Except for this case no examples of lithic raw materials could be found to have originated more than 17 km away from Gibraltar, and the majority were from considerably closer. This observation is consistent with the view that the southern European Neanderthals generally exploited fairly small home ranges, exhibiting low mobility rates (or at least restricted to short distance movements) and a technology characterised by simple reduction sequences and expedient tool use. It should be emphasised, however, that this behaviour was also coupled with the ability to deliberately target seasonal resources and to use other forms of sophisticated forward planning. A good example of such anticipatory behaviour can be seen in the 'living floor' in the Upper Area at Vanguard Cave where a series of laminar flakes and tools in a fine-grained chert were clearly brought to the site, as there were no signs of small debitage in these materials. The tools showed visible signs of wear (though microwear analysis failed to identify any polishes) and were used and discarded around the hearth (Chapter 20). After what appears to have been a short (overnight?) stay, a quartzite of local beach origin was knapped *in situ* and gaps in the refitting sequences show that some of the flakes were carried away for use elsewhere. Even if the introduced chert tools had not travelled very far from where they were made, it indicates that such items were produced for future use and circulated in prepared form. It also implies a developed understanding by Neanderthals of their world and the ability to anticipate future needs in the scheduling of day-to-day activities.

Evidence for dietary behaviour comes principally from cut-marked and burnt animal bone. From detailed studies undertaken on the faunal material it appears that human scavenging played only a minor role in relation to the main prey species represented. For example a high proportion of the fossils in the Middle Area of Vanguard consisted of immature animals, and there were no old adult individuals

present of any species (Stringer *et al.* 2008). This implies that hunting tactics deliberately focused on certain age categories. Insights into butchery and processing methods show that Neanderthals regularly heat-treated bones of larger animals such as red deer and ibex and cracked them open in order to extract fat and marrow. The presence of charring on some of the bones of rabbit, tortoise and duck suggests that smaller animals may have been treated in the same way, and that cooking or partial roasting of meat was a common practice. However, there are also indications that at least some breakage and butchery was followed by the consumption of raw meat and marrow. Cut-marks on Mediterranean monk seal, and associated finds of the bones of dolphin and sea bream *(Diplodus sargus/vulgari)* in the same layers, imply that in parallel to hunting, a more passive form of exploitation involving food collection and even opportunistic scavenging may also have been practised along the seashore. Certainly the presence of edible mussels and stone pine nuts shows that foods were routinely collected and brought back to the caves from a variety of nearby habitats.

The abundance of food in these closely-spaced environments does not, of course, imply that such items were not subject to seasonal variability. The broad-spectrum nature of the diet can therefore also be interpreted in terms of maximising the exploitation of foods that were available at different times of the year. The vast amounts of charred shells and cone scales of *Pinus pinea* (stone pine) present in both Gorham's and Vanguard caves suggests that pine nuts formed a significant part of the diet especially during April when the temperature rises and the seeds ripen. However the collection times for cones may be considerably longer from the late autumn until mid-April. The nuts have high nutritional value in fats and proteins and they can be eaten fresh or stored for future consumption. The heating of the cones is an efficient way of releasing the nuts but roasting may also have been undertaken to improve the flavour of the nuts and would have extended the period of storage for later use. Many of the animals and birds exploited could have been caught throughout the year, although it is interesting that seals would have been at their most vulnerable during the breeding season when females have to leave the water to calve. For Mediterranean monk seal most births today take place over the period of September to October. If ducks were regularly eaten they too might have been sought in the autumn or mid-summer when many species moult and would have been flightless. A slightly different pattern is visible in relation to the collection of mussel shells, which so far has provided the strongest signal of seasonality of any of the resources recorded from the caves. According to the analysis of the shells from the upper hearth at Vanguard these were collected in the spring months, which would be when they were richest in essential fats and may suggest that they were deliberately harvested during this peak period of the late winter and early spring. When combined, these indicators provide plausible signs that Neanderthals planned how best to occupy and exploit areas in and around the Rock of Gibraltar for much of the year. This picture contrasts markedly with comparative dietary evidence from parts of northern Europe where isotopic indicators suggest that Neanderthals concentrated more narrowly on an animal meat rich diet (Richards *et al.* 2000).

Finally, the excavation of Middle Palaeolithic occupation levels has provided interesting new light on how Neanderthals organised their living spaces. For Gorham's Cave, much of the bone is fragmented but it may be significant that large bones are effectively missing from the core area of the cave and, in the absence of other explanations, it can be inferred that material was deliberately cleared out by Neanderthals perhaps to deter the attentions of other carnivores. A similar form of tidying though on a smaller scale can also be detected in the Middle Area of Vanguard Cave where bones were deliberately cleared from the hearth area and deposited in what appears to be a 'toss zone' against the cave wall. These forms of site management may not be uncommon in Middle Palaeolithic sites but this is the first time such behaviour has been observed during the last Interglacial (at Vanguard Cave) and suggests long term continuity in such practices.

Conclusions and future directions

In summary, most of the immediate objectives of this project have been met, though inevitably there are some aspects that could have been further developed if time and resources had permitted. In terms of the site archive, further study would be rewarded of the Gorham's fauna and in duplicating the refitting and spatial studies of both fauna and artefacts that was begun in Vanguard Cave. Equally, Gorham's Cave offers enormous scope for future excavation and dating work especially in the lower part of the Middle Palaeolithic sequence that was only superficially explored in our excavations. Of particular importance here would be to obtain further dating evidence for the last interglacial-early glacial cycle and there are speleothem samples, including *in situ* material, that was identified and would be suitable for Uranium Series dating. Of special interest here, too, is the question of the nature of Neanderthal adaptation to Mediterranean environments during MIS 5 and MIS 4, periods that are well represented in both caves and for which we have relatively little information elsewhere in Europe (but cf. Grotta dei Moscerini, Italy, or Lakonis, Greece). The Gibraltar caves are also important because they contain evidence of Neanderthal behaviour at exactly the same time and in very similar overall circumstances to those of early modern humans in South Africa and Northwest Africa. Mediterranean-type coastal regimes offer very rich nutritional resources, but it would be interesting to explore contrasts in the range of strategies used to exploit these habitats by contemporary human types. Vanguard Cave holds very high potential for further work of this kind, but the fragility of the deposits in this cave (soft sands) means that any excavation would need to proceed cautiously and with a view to stabilising the deposits and conserving sections for future scientific analysis. The importance of preserving sections is emphasised by the fact that only a few of the original trenches excavated 25 years earlier at Gorham's Cave have actually remained intact. Nonetheless it has been possible to provide broad lines of correlation with the Waechter stratigraphy and this considerably enhances the potential for further study of the older collections held

mote test

Final.

in the Gibraltar and Natural History Museums. As dating and other methods of analysis improve, all of the existing excavation archives will provide invaluable datasets for future generations of scientists studying the Neanderthals in Gibraltar and their environmental contexts.

References

Colonese, A.C., Mannino, M.A., Bar-Yosef Mayer, D.E., Fa, D.A., Finlayson, J.C., Lubell, D. and Steiner, M.C. 2011: Marine mollusc exploitation in Mediterranean prehistory: an overview. *Quaternary International* 239, 86-103.

Finlayson, C., Giles Pacheco, F., Rodriguez-Vidal, J., Fa, D., Guiterrez Lopez, J., Santiago Perez, A., Finlayson, G., Allue, E., Baena Preysler, J., Caceres, I., Carrion, J., Fernandez-Jalvo, Y., Gleed-Owen, C., Jiminez Espejo, F., Lopez, P., Lopez Saez, J., Riquelme Cantal, J., Sanchez Marco, A., Giles Guzman, F., Brown, K., Fuentez, N., Valarino, C., Villapando, A., Stringer, C., Martinez Ruiz, F., Sakamoto, T. 2006: Late survival of Neanderthals at the southernmost extreme of Europe. *Nature* 443, 850–853.

Finlayson, G., Finlayson, C., Giles Pacheco, F., Rodríguez-Vidal, J., Carrión, J.S. and Recio Espejo, J.M. 2008a: Caves as archives of ecological and climatic changes in the Pleistocene – the case of Gorham's cave, Gibraltar. *Quaternary International* 181, 55-63.

Finlayson, J.C., Fa, D., Jimenez Espejo, F., Carrión, J., Finlayson, G., Giles Pacheco, F., Rodríguez-Vidal, J., Stringer, C. and Martinez Ruiz, F. 2008b: Gorham's Cave, Gibraltar. The Persistence of a Late Neanderthal Population. *Quaternary International* 181, 64–71.

Ferguson, J.E., Henderson, G.M., Fa, D.A., Finlayson, J.C. and Charnley, N.R. 2011: Increased seasonality in the Western Mediterranean during the last glacial from limpet shell geochemistry. *Earth and Planetary Science Letters* 308, 325–333.

Jennings, R.P., Finlayson, J.C., Fa, D.A. and Finlayson, G. 2011: Southern Iberia as a refuge for the last Neanderthal populations. *Journal of Biogeography*. 1-13. doi:10.1111/j.1365-2699.2011.02536.x.

Morales-Morino, C., Postigo-Mijarra, J.M., García-Antón, M. and Zazo, C. 2011: Vegetation and environmental conditions in the Doñana Natural Park coastal area (SW Iberia) at the beginning of the last glacial cycle. *Quaternary Research* 75, 205–212.

Penaud, A., Eynaud, F., Sánchez-Goñi, M., Malaize, B., Turon, J.L. and Rossignol, L. 2011: Contrasting sea-surface responses between the western Mediterranean Sea and eastern subtropical latitudes of the North Atlantic during abrupt climatic events of MIS 3. *Marine Micropaleontology* 80(1-2), 1-17.

Richards, M.P. Pettitt, P.B., Trinkaus, E., Smith, F.H., Paunovic, M. and Karavanic, I. 2000: Neanderthal diet at Vindija and Neanderthal predation: The evidence from stable isotopes. *Proceedings of the National Academy of Sciences* (USA) 97 (13), 7663-7666.

Rink, W.J., Rees-Jones, J., Volterra, V. and Schwarcz, H. 2000: ESR, OSL and U-series chronology of Gorham's Cave, Gibraltar. *Neanderthals on the Edge* (Stringer, C.B., Barton, R.N.E. and Finlayson, J.C., eds.), Oxbow, Oxford, UK, 165–170.

Stringer, C.B., Finlayson, J.C., Barton, R.N., Fernández-Jalvo, Y., Cáceres, I., Sabin, R.C., Rhodes, E.J., Currant, A.P., Rodríguez-Vidal, J., Giles-Pacheco, F., Riquelme-Cantal, J.A., 2008: Neanderthal exploitation of marine mammals in Gibraltar. *Proceedings of the National Academy of Sciences* (USA) 105 (38), 14319-14324.

Tzedakis, P.C., Hughen, K.A., Cacho, I., Harvati, K., 2007: Placing late Neanderthals in a climatic context. *Nature* 449, 206-208.

Zilhao, J., Pettitt, P., 2006: On the new dates for Gorham's Cave and the late survival of Iberian Neanderthals. *Before Farming* 3, 1–9.

Appendices

Appendix I
Detailed sediment description and lithostratigraphy

S. N. Collcutt and A. P. Currant

Stratigraphic subdivision and previous unit names	Absolute height and thickness	Field observations

Upper Gorham's Cave fORMATION
Bioturbated Earth mEMBER (BEm)

BEm.1 Formerly: "U/C 1" "Context I"	1618-1606 12 cm	Pettitt (Section "xa" 1996 and 4.9.97) observations: "Unbrecciated red 'cave earth'. At top of upper section, located to left of stalactite (as one looks into the cave), and forms floor of upper (back) part of cave. c.10-12 cm thick. Abuts and overlies (unit)/context IIIb (stalactite) [cf. **USFm.1**] and <u>directly</u> overlies context II (combustion zone) [cf. **BEm.2**]. Upper section (Area 1), to left of E15 gridpoint. Range from modern pottery to Phoenician pottery." SNC (2001) observations: "1616-1606 cmaSD, min 10 cm thick; rich in Ca and P; clayey, gritty (limestone) silt/powder; dark brown (c.8YR 3/3), darkening downwards; disturbed surface and slightly disturbed throughout, no macro-structure; lowest 5 cm contain much charcoal and some burnt shell (matrix colour almost black), strong rubefaction of underlying speleothem (*in situ* burning). Possibly including mixed material derived from U/C 2 [cf. **BEm.2**] and 3a [cf. **BEm.3**]." S-N section "xa" recorded at Easting 95.5; SNC observations at Easting 95.0.
BEm.2 Formerly: "U/C 2" "Context 2" "Ctx 2" "Context II"	1608-1605 3 cm	Pettitt (Section "xa" 1996): "charcoal spread", "combustion zone". Shown on section as pre-dating outer parts of stalagmite U/C 3b [cf. **USFm.1**]. Pettitt (4.9.97) observations: "Thin combustion zone visible in upper section. c.2-5 cm thick. Underlies context 1 [cf. **BEm.1**] to left of cave (as one looks in) and to right of stalactite also. Overlies context 3b (stalactite) [cf. **USFm.1**] to left of cave, and overlies context 3a (silts) [cf. **BEm.3**] to right. <u>Overlain</u> in part by 3b stal [cf. **USFm.1**] to right. Upper section Area 1. Heavily mixed in with contexts 1 [cf. **BEm.1**] and 3a [cf. **BEm.3**]." Pettitt & Bailey (2000): "combustion zone". Not observed by SNC (2001). S-N section "xa" recorded at Easting 95.5; SNC observations at Easting 95.0.
BEm.3 Formerly: "U/C 3a" "Context 3a"	1605-1601 4 cm	Pettitt (Section "xa" 1996 and 4.9.97) observations: "Brown clayey silt. Interdigitates with context 3b (stalactite) [cf. **USFm.1**]. Underlies context 2 [cf. **BEm.2**], and overlies 3b [cf. **USFm.1**] also. Present only to right of section/stalactite. Upper section Area 1. Appears to be the same geological unit as context 1 [cf. **BEm.1**] and contains similar range of material." Shown on section as pre-dating outer parts of stalagmite U/C 3b [cf. **USFm.1**]. Not differentiated by SNC (2001). S-N section "xa" recorded at Easting 95.5; SNC observations at Easting 95.0.

Upper Stalagmitic Floor mEMBER (USFm)

USFm.1 Formerly: "U/C 3b" "Context 3b" "Context IIIb"	1606-1590 14 cm	Pettitt (Section "xa" 1996 and 4.9.97) observations: "Stalactite. Abuts and underlies contexts 1, 2, 3a [cf. **BEm.1-3**]. Overlies context 4 [cf. **CHm.1-2**] over whole upper section to left and right of section (i.e. away from its main body). It is c.20 cm thick. Upper section Area 1." Form on section suggests composite floor speleothem and major stalagmite; base horizontal in section. SNC (2001) observations: "1606-1585 cmaSD, 21 cm thick; laminated stalagmitic floor; base colour pale yellow (2.5Y 8/3); somewhat corroded/recrystallised in places; composite, vuggy with brown powdery lenses in the interval 1590-1588; apparently pierced by burrows nearer cave walls; welded but relatively sharp and horizontal lower boundary." S-N section "xa" recorded at Easting 95.5; SNC observations at Easting 95.0.

Exposed Unconformity (right across the mouth of the cave, assumed due to Holocene transgression)
Cemented Hearths mEMBER (CHm)

CHm.1 Previously unlabelled (but possibly upper part of "U/C 4")	c.1580 8 cm	Barton (undated annotation on Section "xa" post-1996): unlabelled "charcoal rich lens" shown in west E97/98 composite Section at c. 1580 cmaSD. SNC (2001) observations: "1585-1577 cmaSD, 8 cm thick; heavily cemented slightly fine-sandy loam, with medium (up to 10 cm diameter) angular limestone clasts; dark to very dark brown (7.5YR 3-2.5/2) with lenses of reddish brown to dark reddish brown (5YR 4-3/3); coarse or cryptic bedding but some interruption from bioturbation (burrows); much charcoal and reddened burnt lenses; well preserved small bone fragments; lower boundary relatively sharp." S-N section "xa" recorded at Easting 95.5; SNC observations at Easting 95.0.

CHm.2	1596-1564	Pettitt (Section "xa" 1996): "Brown breccia = 'Upper Light Horizon'; also includes localised brown silt/sand (Unit 5) and light brown brecciated sand (Unit 6)", the latter two shown on the section as lenses, 5 immediately above 6, at the base of U/C 4.
Formerly:	22 cm	
"U/C 4"		
"Context 4"		Pettitt (4.9.97) observations: "Brown breccia, including localised brown sand (context 5) and light brown brecciated sand (context 6). Formerly known as upper light horizon. Underlies context 3b (stalactite) [cf. **USFm.1**], contains contexts 5 and 6 in localised area (centre of section) and overlies context 7 [cf. **CHm.3**]. Upper section Area 1. Contains ceramics. Note proximity to context 7 [cf. **CHm.3**] means that ceramic items were stratified very close to context 7 [cf. **CHm.3**], but the stratigraphic break and nature of finds were very clear."
Contains:		
"U/C 5"		
"Context 5"		
"Unit 5"		
"U/C 6"		Pettitt (4.9.97) observations: "CONTEXT 5: Brown silt/sand unit observable as localised feature in centre of upper section (i.e. directly below main stalactite column). c.2-3 cm thick. Localised: c.25 cm in extent (i.e. length). Underlies/contained within context 4 and overlies context 6. Upper section Area 1."
"Context 6"		
"Unit 6"		

Pettitt (4.9.97) observations: "CONTEXT 6: Light brown brecciated sand. Occurs as localised feature, c.30 cm in length, c.2 cm thick in upper section. Contained in context 4, overlain by context 5. Overlies context 7 [cf. **CHm.3**]. Upper section Area 1."

SNC (2001) observations: "1577-1570 cmaSD, 7 cm thick; heavily cemented (but vuggy) medium sand, with floating angular limestone clasts; variegated browns (7.5YR 4-6/3-6); coarsely horizontally bedded; continuous recrystallisation void at top, moderately sharp lower boundary."

SNC (2001) observations: "1570-1562 cmaSD, 8 cm thick; cemented and recrystallised silty loam, with common fine angular grit and clasts; lenses (<0.5 cm thick) of charcoal at the top of the unit; brown to dark brown (7.5YR 4-3/3); some bone fragments (including rabbit); lower boundary moderately sharp."

S-N section "xa" recorded at Easting 95.5; SNC observations at Easting 95.0.

CHm.3	1576-1560	Pettitt (Section "xa" 1996): "combustion zone = 'Upper Hearth Complex'", charcoal lenses and burnt sediment; shown as containing context 15 at top.
Formerly:	4 cm	
"U/C 7"		
"Context 7"		Pettitt (4.9.97) observations: "Combustion zone. Formerly known as 'upper hearth complex' and 'unit VII'. c.2-5 cm thick. Underlies context 4 [cf. **CHm.2**] across whole of upper section and context 6 [cf. **CHm.2**] where it exists. Overlies context 8 [cf. **CHm.4**] across whole section. Part discontinuous to left of section, i.e. peters out for 20 cm or so. NB Contains context 15. Upper section Area 1. Contains context 15 - a discrete area of burnt (nut?) shell and bones, which [… …?] containing ashy matrix. […] Context 7 could largely be the burnt sediment of context 8 [cf. **CHm.4**]."
"Ctx 7"		
"Unit VII"		
Contains:		
"Context 15"		

Pettitt (4.9.97) observations: "CONTEXT 15: Area of numerous, very well-burnt bones and (nut) shells, etc., from within context 7 combustion zone. Stratified within (i.e. is part of) context 7. Area 1."

Pettitt & Bailey (2000): "Ctx 7 - combustion zone".

Goldberg & Macphail (2000,105) report cemented ash layers from the upper part of the sequence (possibly equivalent to this unit).

SNC (2001) observations: "1562-1556 cmaSD, 6 cm thick; multiple combustion zones (up to fourfold southwards, cf. square E96), charcoal above lighter cemented ashes (up to 1 cm thick bands); some interruption from bioturbation (burrows); true black to 'dark chocolate' (7.5YR 2.5/1) with varied lighter lenses; a few very rounded (corroded rather than corraded) limestone 'pseudo-pebbles/cobbles'; bone and chert (struck?) fragments; shell fragments (including scallops); moderately sharp lower boundary."

S-N section "xa" recorded at Easting 95.5; SNC observations at Easting 95.0.

CHm.4	1572-1552	Pettitt (Section "xa" 1996 and 4.9.97) observations: "Light brown brecciated sand. Formerly known as 'middle light horizon'. Underlies context 7 [cf. **CHm.3**] except for area where context 7 [cf. **CHm.3**] peters out, where it directly contacts context 4 [cf. **CHm.2**]. Overlies context 9 [cf. **CHm.5**]. Upper section Area 1. Presumably provided surface on which context 7 [cf. **CHm.3**] formed. A comparison of finds between the two would be informative, as would be a sedimentological comparison."
Formerly:	12 cm	
"U/C 8"		
"Context 8"		
"Ctx 8"		

Pettitt & Bailey (2000): "Ctx 8 - light brown brecciated sand".

SNC (2001) observations: "1556-1548 cmaSD, 8 cm thick; very heavily cemented and recrystallised, texture possibly originally fine/medium-sandy silty loam, with rare limestone grit; dark to very dark grey (7.5YR 4-3/1), probably due to Mn, although much lighter at outer crust of carbonate; a little charcoal (apparently reworked from below) near rather diffuse lower boundary."

S-N section "xa" recorded at Easting 95.5; SNC observations at Easting 95.0.

CHm.5	1562-1554	Pettitt (Section "xa" 1996 and 4.9.97) observations: "Combustion zone. Formerly known as 'lower hearth complex'. Underlies context 8 [cf. **CHm.4**]. Overlies context 10a [cf. **UBSm.1**] to left of section, and 10b [cf. **UBSm.1**] to right. Upper section Area 1. Probably is carbonised sediment of context 10a/10b [cf. **UBSm.1**]."
Formerly:	8 cm	
"U/C 9"		
"Context 9"		Partially below (with a void) and partially above a 'collapse ledge', as shown by dark line on section.
"Ctx 9"		

Pettitt & Bailey (2000): "Ctx 9 - combustion zone".

Barton (2000): "band of small rounded limestone cobbles".

SNC (2001) observations: "1548-1543 cmaSD, 5 cm thick; combustion zone, fine sandy loam with very common charcoal and burnt shell; true black to 'dark chocolate' (7.5YR 2.5/1); relatively sharp lower boundary."

APC & SNC (15.06.02) discussions on site resulted in the location of the mEMBER boundary at the base of this unit.

S-N section "xa" recorded at Easting 95.5; SNC observations at Easting 95.0.

Upper Bioturbated Sands mEMBER (UBSm)

UBSm.1	1558-1536	Pettitt (Section "xa" 1996): "Context 10a" "brecciated limestone fragments, in brown silt/sand matrix"; shown on section below U/C 9 [cf. **CHm.5**], south of discontinuity (collapse ledge); "Context 10b" "brown silt/sand with areas of brecciated limestone". On section, all of 10 north of discontinuity (collapse ledge) but only lower 10 south of discontinuity.
Formerly:	13/14 cm	
"U/C 10a"		
"Context 10a"		
"Ctx 10a"		Pettitt (4.9.97) observations: "Context 10a" "Brecciated limestone fragments - often quite […?] and even floor - located in brown silty sand matrix (context 10b). Directly underlies context 9 (combustion zone) [cf. **CHm.5**] and limestone fragments occasionally appear burnt. Upper section Area 1. Hearth/s of context 9 [cf. **CHm.5**] possibly lie directly atop this context?" "Context 10b" "Brown silt/sand containing fragments of brecciated limestone, which, to the left of the upper section, become a solid horizon (context 10a). Underlies context 9 [cf. **CHm.4**]. Forms same unit as context 10a (i.e. forms the matrix containing the context 10a limestone breccia). Overlies context 11 [cf. **UBSm.2**]. Upper section Area 1. Comparisons between 10b and context 9 [cf. **CHm.5**] would be informative (i.e. finds and sediment)."
"U/C 10b"		
"Context 10b"		

Pettitt & Bailey (2000): "Ctx 10a - continuous layer of brecciated limestone fragments very well rounded by erosion".

No significant stony unit observed by SNC. SNC (2001) observations: "Composite sandy sequence, thinning markedly southwards: 1543-1541 cmaSD, 2 cm thick; cemented relatively fine sand with limestone grit; yellowish brown (10YR 5/4); diffuse lower boundary; 1541-1538 cmaSD, 3 cm thick; lightly cemented, silty fine to fine medium sand, coarsely bedded, with a little corroded limestone grit and Mn-ghosts; dark yellowish brown (10YR 4/4); common dispersed charcoal; sharp lower boundary; 1538-1537 cmaSD, 1 cm thick; cemented relatively fine sand; brown (10YR 5/3); relatively sharp lower boundary; 1537-1531 cmaSD, 6 cm thick; very finely laminated, silt (and powder) and fine medium sand, laminations parallel and laterally persistent, 'wavy' (deformational) in geometry; rare small (4 mm) spherical quartzitic granules ("pebbles"); charcoal and white (Ca and/or P) flecks; brown (7.5YR 5/4) at top, darkening downwards in ground colour (7.5YR 4/3) with some even darker laminae; gradational lower boundary, with a few small-scale crinkles (deformation)."

SNC (2001) note: "The SNC 1543-1523 interval (i.e. UBSm.1-2) appears to contain related sediments, probably in simple cycles; more such cycles may be present slightly to the eastnortheast."

S-N section "xa" recorded at Easting 95.5; SNC observations at Easting 95.0.

UBSm.2 Formerly: "U/C 11" "Context 11" "Ctx 11"	1541-1520 15 cm	Pettitt (Section "xa" 1996 and 4.9.97) "Light brown sands. Mainly present to right of upper section; tapers out by location of E15 gridpoint. Underlies context 10b [cf. **UBSm.1**], overlies context 12 [cf. **UBSm.3**]. Upper section Area 1." Shown on section to wedge out just south of discontinuity (collapse ledge).

Pettitt & Bailey (2000): "Ctx 11 - light sands".

SNC (2001) observations: "1531-1523 cmaSD, 8 cm thick; cleaner fine medium sand, probably laminated but very loose; ground colour light yellowish brown (10YR 6/4) but 'blobs' of high chroma and light-coloured sand-sized flecks; very rare quartzitic pebbles; apparent bioturbation forms (tubes, c.1 cm diameter, very varied/tortuous angles); relatively sharp lower boundary."

SNC (2001) note: "The SNC 1543-1523 interval (i.e. UBSm.1-2) appears to contain related sediments, probably in simple cycles; more such cycles may be present slightly to the eastnortheast."

S-N section "xa" recorded at Easting 95.5; SNC observations at Easting 95.0.

UBSm.3 Formerly: "U/C 12" "Context 12"	1539-1499 30 cm	Pettitt (Section "xa" 1996 and 4.9.97) observations: "Brecciated limestone in light sandy matrix. Underlies context 11 [cf. **UBSm.2**], overlies context 13 [cf. **UBSm.4**]. Upper section Area 1." On section, apparently either side of discontinuity (collapse ledge); possibly another minor layer above.

SNC (2001) observations: "1523-1510 cmaSD, 13 cm thick; medium sand with a few angular limestone clasts, strongly cemented (apparently authigenic) at top and bottom but only weakly so in centre; very pale brown (10YR 7/4) with white flecks and some Mn (dark brown) stains; rare small flecks of charcoal; relatively sharp lower boundary."

S-N section "xa" recorded at Easting 95.5; SNC observations at Easting 95.0.

UBSm.4 Formerly: "U/C 13" "Context 13" Contains: "Unit 13a" "Ctx 13a"	1509-1494 15 cm	Pettitt (Section "xa" 1996): "brown silt/sand", containing in lower part a large lens (unit 13a) of "combustion zone", shown on section with at least two main charcoal layers separated by burnt sediment; complex/contorted internal lenses.

Pettitt (4.9.97) observations: "Brown silty sand. Underlies context 12 [cf. **UBSm.3**]. Contains discrete combustion zone (context 13a). Overlies context 14 [cf. **UBSm.5**]. Upper section Area 1." "CONTEXT 13a: Discrete combustion zone. Contained in context 13. Upper section Area 1. Was associated with small burnt bone, possibly indicates low density scatter of archaeological material. Our one feature was only excavated in section."

Pettitt & Bailey (2000): "Ctx 13a - [implied] combustion zone".

SNC (2001) observations: "1510-1499 cmaSD, 11 cm thick; medium (5-10 cm) limestone clasts in silty fine sand matrix; varied grades of brown, with streaks of light brown, ochres and white/cream in load structures; charcoal flecks; large load structures (passing downwards up to another 10 cm) at base; also very heavy bioturbation nearer base; triangular quartzite flake (assumed to be Mousterian) in one load pocket (at 1485 cmaSD)."

S-N section "xa" recorded at Easting 95.5; SNC observations at Easting 95.0.

UBSm.5 Formerly: "U/C 14" "U 14" "Context 14"	1494 down in "xa" 1450 up in "xb" min 30 cm	Pettitt (Section "xa" 1996 and 4.9.97) observations: "Light sands, containing some limestone fragments and small pieces of breccia. Some occasional traces of combustion adhering to surfaces of limestone and some bone finds. Underlies context 13 [cf. **UBSm.4**]. Upper section Area 1. Horizon is brecciated at extreme left of upper section, i.e. towards cave wall. Containing a number of bones but not necessarily archaeological in nature." Upper part only above base of drawn Section "xa"; implication that "U14" of Section "xb" (1998) correlates.

SNC (2001) observations: "1499-1480 cmaSD, 19 cm thick; very varied sequence of contorted carbonate-rich sands, laminated, variously loose to moderately cemented; apparent 'coarse' sand patches are largely due to recrystallisation of carbonates; very strong bioturbation penetrating from above; wide range of colours (mostly 'sandy' with thin 'chocolate' lenses), dark Mn-crust at the top, whitish 'chalky' accumulation (? guano) at base; lower boundary relatively sharp, apparent local slope (in Section "xb") eastwards (out of cave) [but this may be due to warping during recent collapse of materials further east, post-dating the Waechter campaign]."

SNC (2001) note: "The SNC interval 1523-1480 appears to repeat all the details of the interval 1538-1523, reinforcing the impression of cyclic style."

S-N section "xa" recorded at Easting 95.5; SNC observations at Easting 95.0. S-N section "xb" at Easting 96.5 (also observed by SNC).

UBSm.6 Formerly: "U 16" "Context 16" "Ctx 16" Contains: "Context 17" "Context 24" "Ctx 24"	1465-1378 60-80 cm	Pettitt (8.9.97) observations: "Mix of various lenses of dark brown clays, lighter brown silts and light brown and yellow sands. Underlies context 14 [cf. **UBSm.5**]. Forms same unit as context 18 [cf. **UBSm.7**]. Contains contexts 24 and 17. Area 1. Forms part of the same unit as context 18 [cf. **UBSm.7**]; the two <u>contain</u> context 17. Archaeologically sterile in the main. Containing numerous clusters of phosphatic material, i.e. very reworked and eroded bone, with the consistency of clay and orange in nature."

Pettitt (15.9.97) observations: "Context 17: combustion zone. Underlies context 16, overlies context 18 [cf. **UBSm.7**]. Area 1, Square D98. Very poorly defined and unclear as to whether this is simply mainly a dark, peaty organic horizon. Dips very strongly from 96/97 gridsquare point."

PMR (20.9.97) observations: "Context 24: sandy lens with remnants of combustion. Lens within context 16. Area 1, Square D96. Height 13.80."

Pettitt (Section "xb" 1998): unit shown on section as composite, with contorted and discontinuous lenses.

Pettitt (Section "xb" 1998): unit shown on section as composite, with contorted and discontinuous lenses.

Pettitt & Bailey (2000): "Ctx 24 - combustion zone at contact of ctx 16 and ctx 18 [cf. **UBSm.7**]".

Barton (2000): "Ctx 24: combustion zone contained within ctx 16".

Barton (pers comm 2001): "this 'context 16' contains context 24 (rather than [**LBSmcf.12**] which was also labelled 'U16'".

SNC (2001) observations: "1480-1415 cmaSD, 65 cm thick; at least 4 cycles, comprising medium sand, above dirty, organic-rich (cf. shrinkage when dry) clayey/dusty/powdery silt, each division of each couple probably being c.10 cm thick before later contortion; some bioturbation structures obvious in sand divisions; strong apparently phosphatic component (coprolite and/or guano); each organic division is dark reddish brown (5YR 3/2) towards upper and lower boundaries but slightly lighter in centre; sands vary from brown (10YR 4/3), especially in bioturbated zones, to patches of yellowish brown (10YR 5/4); rare charcoal flecks in organic divisions; relatively sharp internal and lower boundaries. No obvious sign of 'context 24' (if this was a 'combustion zone')."

S-N section "xb" at Easting 96.5 (also observed by SNC).

UBSm.7 Formerly: "U 18" "Context 18" "Ctx 18"	1404-1373 12-18 cm	Pettitt (15.9.97) observations: "Brown sandy silt. Clay lenses in places. Sloping in direction of front and centre of cave. Underlies context 17 [cf. **UBSm.6**], overlies context 19 [cf. **BeSm(OSsm).1**]. Area 1, Square D98. Forms part of the same unit as context 16 [cf. **UBSm.6**]; the two <u>contain</u> context 17. Deposit is very heterogeneous in clayeyness and colour. NB Some sediment loading deformation of contact between 18 and 19 [cf. **BeSm(OSsm).1**]; may explain the presence of finds in top of context 19 [cf. **BeSm(OSsm).1**] (i.e. they derive from context 18 originally). [APPARENT LATER CHANGE OF OPINION:] Abundance of small chipping flakes in the upper part of this context [19] make it likely that the archaeology in 18 and 19 [cf. **BeSm(OSsm).1**] was deposited below, and was worked <u>up</u> by sediment loading into 18, which is largely sterile." (Also sketch on context sheet, showing pockets of 18 passing downwards into level of 19 [cf. **BeSm(OSsm).1**].)

Pettitt (Section "xb" 1998): unit shown on section as pinched out in places; a little contorted.

Pettitt & Bailey (2000): "Ctx 18 and 19 [cf. **BeSm(OSsm).1**] - light sand which has clearly been subject to soft sediment loading distortion".

Probably equivalent to unit "800 dunes" of P. Bertran (1991 observations, pers.comm.).

SNC observations (extremely poorly exposed in 2001-2, broad description only): "1415-1395 cmaSD, 20 cm thick; dense 'orangey' fine medium to medium sands, with light reddish brown silty partings or thin intervening units; all finely bedded (laminated but not obviously cross-bedded) but with significant to extreme bioturbation (and probably some minor load deformation) in places; strong in apparently phosphatic matter (coprolites, coated/ crusted corroded limestone)."

S-N section "xb" at Easting 96.5 (also observed by SNC).

Bedded Sand mEMBER (BeSm)
Orange Sand sUBmEMBER (OSsm)

BeSm **(OSsm).1** Formerly: "Unit 1" "U 19" "Context 19"	1408 down in "xb" min 50 cm	Equivalent to "Unit 1 Orange Sand" of APC (and Barton) field note book (September 1995); "10YR 5/6 yellowish brown"; the annotated sketch suggests that there was a "lightish sand" (possibly slightly concreted) 'aureole' around the base/side towards the oblique contact with the underlying material.

Pettitt (15.9.97) observations: "Light sands, occasionally brecciated. c.1 metre in thickness, dipping towards Area 2. Underlies context 18 [cf. **UBSm.7**]. Area 1, Square D98 is main exposure. Generally undiagnostic lithics or of Middle Palaeolithic character. Some sediment loading deformation of contact between this and the bottom of context 18 [cf. **UBSm.7**]; may explain why some finds come from the top of this context, i.e. they originate in context 18 [cf. **UBSm.7**]. [APPARENT LATER CHANGE OF OPINION:] Abundance of small chipping flakes in the upper part of this context make it likely that the archaeology in 18 [cf. **UBSm.7**] and 19 was deposited here, and was worked <u>up</u> by sediment loading into 18 [cf. **UBSm.7**], which is largely sterile."

Pettitt (Section "xb" 1998): shows especially continuous cementation ("brecciated") relatively high in this unit, to both south and north (close to cave wall); upper part only above base of drawn section.

Pettitt & Bailey (2000): "Ctx 19 - light sands" [assume this to be the upper unit so named, rather than "U19" at [**LBSmcf.12**]]; "Ctx 18 [cf. **UBSm.7**] and 19 - light sand which has clearly been subject to soft sediment loading distortion".

SNC observations (extremely poorly exposed in 2001-2, broad description only): "1395-1265 cmaSD, up to 130 cm thick (probably capable of useful subdivision if better exposed); dense 'orangey' (commonly 10YR 6-7/6 with patches of higher chroma) fine medium to medium sands (usually very well sorted at any given level), with relatively rare light reddish brown silty partings; all finely bedded (laminated but not obviously cross-bedded) but with significant to extreme bioturbation (and probably some minor load deformation) in places; strong in apparently phosphatic matter (coprolites, coated/crusted corroded limestone); some cementation (possibly involving Fe as well as Ca) of upper level but apparently carbonate-poor overall (cf. total erosion of this interval, possibly of units 18-21 [cf. **UBSm.7** to **BeSm(PLSsm).3**] as a whole, in entrance Cornices); apparent bedding dip slightly eastwards (out of cave) at least in the middle parts of the unit. From c.1370 downwards, this unit appears to occupy a very steep-sided (60°-70° in S-N section) 'trough' (very poor and unstable oblique exposure between the base of "xb" and the top of "xc" in Easting Squares 97-99), which is definitely erosive of the underlying material (U20 [cf. **BeSm(OSsm).2**] and U21 [cf. **BeSm(OSsm).3**]); in the poor exposure available, the base of the trough appears to be descending eastwards (axis roughly along the D-C Square line) at a local dip of c.10° (there is insufficient evidence to decide whether the 'trough' would have drained right out of the mouth of the cave or whether it is a more local phenomenon, linked with some subsidence focus, although the former possibility seems more probable)."

S-N section "xb" at Easting 96.5 (also observed by SNC, together with the unstable oblique face below).

BeSm **(OSsm).2** Formerly: "Unit 2" "U 20"	1266 up in "xc" min 5 cm	Equivalent to "concreted Unit 2 dark manganese/Fe concretions" of APC (and Barton) field note book (September 1995); "steep and concretionary" junction between U19 [cf. **BeSm(OSsm).1**] and U21 [cf. **BeSm(OSsm).3**]. Pettitt (17.9.97) observations: "Thin brown clay lens. Underlies context 19 [cf. **BeSm(OSsm).1**], overlies context 21 [cf. **BeSm(OSsm).3**]. Area 1, exposed in Square D100." Possibly mislabelled "U21" on the original Section "xc"; if so, lower part only below top of Section.

SNC observations (extremely poorly exposed in 2001-2, hence retention as a possible 'depositional unit'; broad description only): "Very oblique exposure running between 1370 and 1260 cmaSD; c.5-10 cm thick alteration zone; dark brown phosphatic/Mn/Fe nodules, affecting the contact between Units 19 [cf. **BeSm(OSsm).1**] and 21 [cf. **BeSm(OSsm).3**]; probably postdepositional and not a 'layer' in its own right."

S-N section "xc" at Easting 98.5 (also observed by SNC, together with the unstable oblique face above).

Bedded Sand mEMBER (BeSm)
Pale Loose Sand sUBmEMBER (PLSsm)

BeSm (PLSsm).3 Formerly: "Unit 2" "U 21"	1269-1236 min 30 cm	Equivalent to "Unit 2 light yellow sand with flecks of charcoal and vertebrate microfauna, some scattered angular limestone gravel clasts" of APC (and Barton) field note book (September 1995); "10YR 6/4 light yellowish brown"; over 1 m thick; note seems to imply artefacts and charcoal restricted to upper part of unit (probably higher than shown in section "xc") but finds status difficult since much of the sediment dug was clearly collapsed material. Pettitt (17.9.97) observations: "Light brown silvery sand. Underlies context 20 [cf. **BeSm(OSsm).2**], overlies context 22 [cf. **LBSmff.1-3**]." Possibly mislabelled "U22" on the original Section "xc"; if so, possibly thickening southwards in Section. SNC observations (extremely poorly exposed in 2001-2, broad description only): "1370-1236 cmaSD, up to 130 cm thick towards northern wall of cave (probably capable of useful subdivision if better exposed); complex sequence of extremely loose ('running') fine to fine medium sands, with a few coarser/grittier stringers; colours very pale but quite bright, almost 'silvery', in places; strong calcareous and phosphatic component but no cementation in main body; finely bedded (laminated), horizontal in S-N plane but apparently dipping slightly westwards (inwards). This unit is deeply cut by the erosive trough of Unit 19 [cf. **BeSm(OSsm).1**]; the normally nearly horizontally bedded sands of Unit 21 are highly contorted and slumped close to the erosive contact (i.e. in a zone up to 30 cm wide between the intact sands and the boundary concretions of "Unit 19" [cf. **BeSm(OSsm).2**]) and there is a little (presumably postdepositional/erosional) carbonate cementation of the slumped zone." S-N section "xc" at Easting 98.5 (also observed by SNC, together with the unstable oblique face above).

Lower Bioturbated Sands mEMBER (LBSm)
Fine Facies (LBSmff)

LBSmff.1 Formerly: "Context 22a" "Ctx 22a" upper "Unit 3"	c.1244 thickness?	'Context 22a' not shown on Section "xc"; no context sheet; no possible correlate remaining in 2001 to be observed by SNC. Such a subdivision is inferred from the existence of the designation "Ctx 22 a-d" (see below). Possibly to be identified with the upper part of "Unit 3" (6-8 cm thick, common charcoal) of APC (and RNEB) field note book (September 1995), said to be the basal part of "Unit 2" [cf. **BeSm(PLSsm).3**]. Uppermost part of "Unit 3" of APC (and RNEB) field note book (September 1995) consisted of a thin (top) white/concretionary black/orange (base) sand sequence; "10YR 6/8 brownish yellow". Pettitt & Bailey (2000) imply that 22a is at top of 22 a-d sequence.
LBSmff.2 Formerly: lower "Unit 3" "U22b" "Context 22 [part]" "Ctx 22 [part]"	1244-1220 16 cm	Pettitt (21.9.97) observations: "Greeny olive layer, greasy in texture, c.6 cm thick in observable section. Located within Context 22, overlies 22c [cf. **LBSmff.3**] within 22. Area 1, Square D100. Fluoresced under X-ray conditions." Equivalent to main part of "Unit 3" of APC (and RNEB) field note book (September 1995). SNC (2001) observations: "1236-1218 cmaSD, 18 cm thick, thickening southwards in exposure; very finely laminated silty clay (usually reduces easily to a paste under pressure) with only rare silica sand grains (mostly in stringers); colours dark but variegated by lamina (2.5Y 3/3 to 7.5YR 2.5/2); common apparent phosphatic matter; sharp lower boundary." S-N section "xc" at Easting 98.5 (also observed by SNC).
LBSmff.3 Formerly: "U22c" "Context 22c" "Context 22 [part]" "Ctx 22 [part]"	1230-1217 4 cm	Pettitt (21.9.97) observations: "Black, peaty organic horizon. Located within (and to base of) context 22. Middle Palaeolithic." Pinching or slight faulting shown on Section "xc". SNC (2001) observations: "1218-1214 cmaSD, 4 cm thick, thickening southwards in exposure; very finely laminated silty clay with strong fine sand component; colours variegated by lamina light brown (7.5YR 6/3) and lighter; common apparent phosphatic matter; sharp lower boundary." S-N section "xc" at Easting 98.5 (also observed by SNC).
LBSmff.4 Formerly: "U22d" "Context 22 [part]" "Ctx 22 [part]"	1228-1200 22 cm	Pettitt (21.9.97) observations: "Dark brown sandy silt. Underlies context 22c [cf. **LBSmff.3**]. Area 1, Square D100. Abundant Middle Pal lithics." Possibly thickening southwards in Section "xc"; apparent large burrows and deformation structures drawn at base (still identifiable in detail on site by SNC in 2001). SNC (2001) observations: "1214-1201 cmaSD, 13 cm thick, thickening southwards in exposure; very finely laminated or lenticular silty clay (usually reduces easily to a paste under pressure), with greater medium sand component near base and wedging in from the north; colours dark but variegated by lamina (2.5Y 3/3 to 7.5YR 2.5/2); common charcoal, with lenses of particularly large (2 cm) fragments; common apparent phosphatic matter; sharp lower boundary." S-N section "xc" at Easting 98.5 (also observed by SNC).
LBSmff.5 Formerly: No label ?part of "U22"	1214-1188 22 cm	Several unlabelled units shown on Section "xc"; one case of apparent load-casted geometry (still observable to SNC in 2001). SNC (2001) observations: "1201-1197 cmaSD, 4 cm thick; slightly sandy 'loam', crudely laminated (micro-crinkling, suggesting significant loss of matter/volume); variegated, ground of light olive brown (2.5Y 5/3) but with various buffs, grey/greens and brick-reds; many burrows and load structures (specifically including apparent rotational load-casting through 10 cm vertical intervals) passing well down into underlying units. 1197-1184 cmaSD, 13 cm thick; very finely laminated or lenticular silty clay, with some medium sand component near base; colours dark but variegated by lamina (2.5Y 3/3 to 7.5YR 2.5/2), slight paling trend downwards; common charcoal; common apparent phosphatic matter; generally similar to 22d [cf. **LBSmff.4**]; gradational lower boundary." S-N section "xc" at Easting 98.5 (also observed by SNC).
LBSmff. 1-5 general Formerly: "Context 22" "Ctx 22a-d"		Pettitt (21.9.97) observations: "CONTEXT 22: Heterogeneous brown organic layer, comprised of various thin lenses of clays and silts, from dark brown to olive and red brown in colour. Underlies context 21 [cf. **BeSm(PLSsm).3**], overlies 22d [cf. **LBSmff.4**], contains 22b [cf. **LBSmff.2**] and 22c [cf. **LBSmff.3**]. Area 1, Square D100. Middle Palaeolithic in nature." Pettitt & Bailey (2000): "Ctx 22 [interpreted by SNC as referring to the a-d series] - heterogeneous brown organic layer"; "abundant charcoal lumps apparently not clustered in any one area"; "abundant but fragmentary bones"; "Ctx 22 a-d - rich in organic material (Goldberg pers comm)".

Goldberg & Macphail (2000, 98) report a sequence from squares B/C99-101, including: "finely laminated to finely bedded organic-rich sand and clayey sand, punctuated by two major ash lenses about 10 cm thick". SNC suggests that these "ash lenses" are the lighter units of LBSmff.3 and the upper part of LBSmff.5 (as represented by SNC's observation, whether or not the "22 a-d" attributions are correct).

There are obviously problems in the exact attribution of these four units (originally subdivisions a-d of "Context 22"); SNC's (2001) observations apply strictly to the units (still clearly identifiable on site) drawn on Section "xc" and labelled as "U22b", "U22c", "U22d" and unlabelled (at base), even though Pettitt's (1997) observations (on the contexts sheets for units "22 b-d") do not appear to match. These deposits are lenticular and extremely variable laterally. Goldberg & Macphail (2000, 98) report clear lateral differentiation: "The sediments in Sq. C102, for example, are calcareous, quite massive to sandy, and show some ashy bands and charcoal [...] but no evidence of in situ burning; the preservation of bone, shell and limestone clasts is good. Two metres away towards the rear of the cave, however (i.e., in the direction of Sq. B/C 99), laterally equivalent sediments are generally softer, finer grained and apparently much richer in organic matter. Furthermore, no bones or shells were recovered from these units, and limestone clasts are weathered and commonly phosphatised." These comments appear to refer broadly to the "22a-d" sequence (as shown in Section "xc" "towards the rear of the cave") and the lateral correlates (as shown in Section "xc-xd") in the LBSmcf (see below).

		S-N section "xc" at Easting 98.5 (also observed by SNC).
LBSmff.6 Formerly: "U23" "Context 23"	1192-1160 31 cm	On Section "xc", apparently a series of laminae/lenses; no context sheet. RPJ (20.9.98) Section "xc": full thickness shown as "U23". SNC (2001) observations: "1184-1158 cmaSD, 26 cm thick; poorly exposed (interrupted by very common bioturbation, including some large burrows) sequence of coarser medium sands with some darker 'earthy' laminations; ground colour yellowish brown (10YR 5/4-6), generally speckled with varied browns; much apparent phosphatic material; relatively sharp lower boundary. 1158-1147 cmaSD, 11 cm thick; cleaner laminated medium sand, but still some brown 'earthy' laminations; ground colour yellow (10YR 7/6) speckled; relatively sharp lower boundary." S-N section "xc" at Easting 98.5 (also observed by SNC).
LBSmff.7 Formerly: "U25" "U26" "U27"	?	None of the inferred units "U 25-27" are explicitly shown on Section "xc", nor are there any context sheets. In passing, it will be recalled that "U24" is a combustion zone within UBSm.6. RPJ (20.9.98) Section "xc": "26 not visible in this section". A single unit label (LBSmff.7) has been allocated in the present lithostratigraphic system, in case it is necessary for other team members to refer to finds or attributes from these (assumed) lenses (e.g. 'such-and-such a find was made in LBSmff.7("U26")') . S-N section "xc" at Easting 98.5 (also observed by SNC).
LBSmff.8 Formerly: "U28"	1169-1154 15 cm	RPJ (20.9.98) Section "xc": "U28" marked as including the whole series of beds shown on the drawing between U23 [cf. **LBSmff.6**] and U30 [cf. **LBSmff.10**], (top) "dark brown", "mid brownish grey silty sand" with contorted "yellowish lens", "light brownish grey silty sand", "yellow sand" (base). No context sheet. S-N section "xc" at Easting 98.5 (also observed by SNC).
LBSmff.9 Formerly: "U29"	? (4 cm)	Not explicitly shown on Section "xc"; no context sheet. A single unit label (LBSmff.9) has been allocated in the present lithostratigraphic system, in case it is necessary for other team members to refer to finds or attributes from this (assumed) lens. S-N section "xc" at Easting 98.5 (also observed by SNC).
LBSmff.10 Formerly: "U30"	c.1150 3 cm x 2	RPJ (20.9.98) Section "xc": "present [in "xc"] only as the orange yellow/black capping; much thicker and siltier in B-C-D/100". On Section "xc", apparently bifurcating and pinching lenses; no context sheet. S-N section "xc" at Easting 98.5 (also observed by SNC).
LBSmff.11 Formerly: "U31" "U32" "U33" "U34"	?	None of the inferred units "U 31-34" are explicitly shown on Section "xc", nor are there any context sheets. A single unit label (LBSmff.11) has been allocated in the present lithostratigraphic system, in case it is necessary for other team members to refer to finds or attributes from these (assumed) lenses (e.g. 'such-and-such a find was made in LBSmff.11("U33")') . S-N section "xc" at Easting 98.5 (also observed by SNC).
LBSmff.12 Formerly: "U35"	1150 down in "xc" min 20 cm	RPJ (20.9.98) Section "xc": "brown silts", "yellow sands", much "brecciation" (i.e. disruption and disjunction of beds). Complex/contorteds bedding; upper part only above base of drawn section; no context sheet. S-N section "xc" at Easting 98.5 (also observed by SNC).
LBSmff. 8-12 general Formerly: "U28-35"		SNC (2001) observations: "1147-1106 cmaSD (base of "xc"), at least 41 cm thick; complex laminated and/or lenticular sequence; ground colour light brown (7.5YR 6/3) with darker laminae; at least 5 intervals of darker brown sandy silt with charcoal flecks; common cemented nodules (both Ca and P), some of which appear to be coprolites; common bioturbation structures; base of section." Correlates with all or part of the "U28-35" series (allowing for the absence of some lenses at the section). S-N section "xc" at Easting 98.5 (also observed by SNC).

Lower Bioturbated Sands mEMBER (LBSm)
Coarse Facies (LBSmcf)

LBSmcf.1 Formerly: "U4a-b" part "U30"	?	APC field note book (September 1995): Top of U4a recorded at 1270-1283 (rising slightly northwards) at easting 100: "orange brown sand with more clay at base, sharp lower junction". Unit 4b "very dark chocolate brown silty clay, possibly with high organic content"; "subhorizontal sandy lenses, c.2 mm thick, also lenses of thin clay, no stones or artefacts; rare fauna; top at 1266. Dark Unit 4 material does not appear further eastwards than easting 100.5". APC B101-B102 Section (1998): "sand and phosphate". No longer available for observation by SNC in 2001; SNC suggestion: possibly correlating with (although different facies from) U22 [cf. **LBSmff 1-5 general**] in "xc". A single unit label (LBSmcf.1) has been allocated in the present lithostratigraphic system, in case it is necessary for other team members to refer to finds or attributes from this sequence (e.g. 'such-and-such a find was made in LBSmcf.1 ("U4b")').

LBSmcf.2
Formerly:
"U4c"
part "U30"

1236 up in
"xc-xe"
min 11 cm

Lower part only below top of Section "xc-xd"; differentiation difficult eastwards; no record east of "xd"; no context sheet.

APC field note book (September 1995): "biscuity/crumbly" texture in upper part; "sandy clay, strongly mottled, sandier downwards"; "still dark choc brown, mottled orange"; "10YR 2/2 very dark brown with 10YR 5/6 yellowish brown mottling (may be burrowing or bioturbation)"; "small, subrounded chert pebbles"; horizon with bird and amphibian bones, charcoal; "brown sand downwards", then "grey sandy silt lens"; occupation horizon at c.1257.

APC field note book (September 1995): "mineralised black concretionary horizon (Mn/Fe?)" fading quickly eastwards (not beyond square 101); increasing in thickness, becoming "rubbly" with "stones having white interiors".

Goldberg & Macphail (2000, 97) report a sequence from squares E-G100 and C100-103 in the interval c.1265-1250, including: "dark brown, organic-rich silty clay, with lighter and darker stringers"; "grey sand and irregularly bedded yellowish brown sand containing coarse charcoal fragments and yellow inclusions"; "brown black organic rich clay with whitish gritty phosphate lenses"; "interbedded massive homogeneous coarse brown (clayey) sand".

SNC (2001) observations: "(the extant lower part) appears to correlate with the lower part of 22d [cf. **LBSmff.4**]."

Mislabelled "U30" on the original Section "xd".

W-E section "xc-xe" 98.5-102 at Northing mid-B and W-E section 102-104 at Northing A/B (also observed by SNC).

LBSmcf.3
Formerly:
part "U4"
part "U30"

1247-1228
8 cm

Other lenses drawn on Section "xc-xd", apparently within "U4" as a whole; no record east of "xd"; no context sheet.

Mislabelled "U30" on the original Section "xd".

W-E section "xc-xe" 98.5-102 at Northing mid-B and W-E section 102-104 at Northing A/B (also observed by SNC).

LBSmcf.4
Formerly:
"U4d"
part "U30"

1240-1224
5 cm

APC field note book (September 1995): "dark horizon with bones between grey silts"; "dark sand with flecks of charcoal" at base; large bones, a few medium limestone blocks, stal fragments. Note: grey silts sometimes recorded as "basal complex 4c".

APC B101-B102 Section (1998): thin "clayier" lens at base of "U4" series.

Possible implication of an oblique (erosive, down-southwards) base of "U4" sequence in S-N Section "xd".

SNC (2001) observations: "Appears to correlate with the dark material at 1197-1184 [i.e. in the SNC record, cf. **lower LBSmff.5**] in section "xc"."

Mislabelled "U30" on the original Section "xd".

W-E section "xc-xe" 98.5-102 at Northing mid-B and W-E section 102-104 at Northing A/B (also observed by SNC).

LBSmcf. 1-4 general ?
Formerly:
"Unit 5"
"Unit 6a-b"

APC field note book (September 1995): "Faunally rich dark sands adjacent to wall in A100/A101" collected as "Unit 5"; "white rubble traceable from white pellet patch" (mostly in C-B squares but dying out northwards towards wall) collected as "Unit 6a"; the next 4 cm of "dark sand with white flecks and fauna" collected as "Unit 6b".

"White rubbly layer beneath Unit 6 with a sandy silt beneath containing bone and flecks of charcoal".

Not shown on this section; no context sheet.

In notebook, it is implied that everything collected as "Unit 5 or 6" is just lateral facies variation in the "Unit 4" sequence. Note that bone is always associated with the white material.

LBSmcf.5
Formerly:
"U7"

1243-1216
13 cm

APC field note book (September 1995): further west "impersistent horizon of grey 'clay' overlain by dusty, pale orange, powdery coating", 'clay' is fine powdery silt, mottled grey yellow and black which could be ash; eastwards shifting to "slightly rubbly material rich in bones" or "coarser orange sand with charcoal" at top, then "compact sand" with common charcoal; limpet shell.

APC B101-B102 Section (1998): "thin clay layer" at base.

On Section "xc-xd", wedging out eastwards just before "xd"; no context sheet.

Rink et al (2000): "Unit 4d, Level 7 at 1235 [4d or 7?]: stratified brown sand with clay"; APC notebook states the Rink sample was from "U7".

SNC (2001) observations: "Appears to correlate with the lower part of the 1197-1184 interval [i.e. in the SNC record, cf. **lower LBSmff.5**] in section "xc"."

W-E section "xc-xe" 98.5-102 at Northing mid-B and W-E section 102-104 at Northing A/B (also observed by SNC).

LBSmcf.6
Formerly:
"U8"

1244 down
c.15 cm ?

APC notebook (1995): "Thin clay seam overlies the paler sand of Unit 8"; "a very loose sand, much less consolidated than Unit 7 [cf. **LBSmcf.5**] and paler in colour"; "contains common, scattered limestone clasts, mostly rotten"; "at base, layer of small, angular limestone clasts forming a surface of a kind"; top of stony layer at base of Unit 8 at 1218 at easting 100 mid-B file.

APC B101-B102 Section (1998): "U8" labelled "phosphatic? sand"; thin "clay layer" shown at base.

Not shown explicitly on Section "xc-xd"; no context sheet.

SNC (2001) observations: "Appears to correlate with the lower part of the 1197-1184 interval [i.e. in the SNC record, cf. **lower LBSmff.5**] in section "xc"."

W-E section "xc-xe" 98.5-102 at Northing mid-B and W-E section 102-104 at Northing A/B (also observed by SNC).

LBSmcf.7
Formerly:
"U9"

1202 up
c.20 cm ?

APC notebook (1995): "Light sand unit designated Unit 9"; "loose yellow sand" with "wedge of darker material in the middle" or "earthy sand with charcoal flecks"; rabbit burrows.

APC B101-B102 Section (1998): "clayey sand".

Not shown explicitly on Section "xc-xd"; no context sheet.

SNC (2001) observations: "Appears to correlate with the lowest part of the 1197-1184 interval [i.e. in the SNC record, cf. **lower LBSmff.5**] in section "xc"."

W-E section "xc-xe" 98.5-102 at Northing mid-B and W-E section 102-104 at Northing A/B (also observed by SNC).

LBSmcf.8
Formerly:
"U10"
part "U14"
"U15"

1204-1197
2-3 cm

APC notebook (1995): Unit 10 "clay layer"; "varies from clay to clayey sand"; blackened sediment at top in B101/C101 labelled "10A"; "Unit 10 is the 1989 Frog Pond". NB: this correlates with "U15" of the following year (1996), as show on section drawing "xc-xd". "Unit 14" "probably a mixture of 10 [i.e.U15] and 11 [i.e. U16]"; "extensively bioturbated loose sand and earthy sand sandwiched between" (out of sequence).

APC notebook (1996): "The next available Unit number is 15" [starting work in 1996]; "the 'Frog Pond' is a unit found by us some years ago"; "cracked surface pattern" [SNC comments that photographs in the notebook show a complex polygonal shrinkage net]; "10-15 mm thick, tends to rise and thin towards cave wall"; "Unit 15 is Unit 10 of 1995".

On section "xc-xe", shown as far eastwards as "xd"; no context sheet.

APC B101-B102 Section (1998): "clay layer".

SNC (2001) observations: "Appears to correlate with the cleaner sand at c.1150 [i.e. in the SNC record, cf. lower **LBSmff.6**] in section "xc"."

W-E section "xc-xe" 98.5-102 at Northing mid-B and W-E section 102-104 at Northing A/B (also observed by SNC).

LBSmcf.9
Formerly:
"U11"
"U12"
"U13"
part "U14"
"U16"

1215-1168
30 cm

APC notebook (1995): "Unit 11" "pale loose sand" above "another clay layer with bits in it". "Unit 12" at western end of C101 (not necessarily directly below "Unit 11"); "concreted sand"; "rubble layer". "Unit 13" lies below "Unit 11". "Unit 14" "probably a mixture of 10 and 11"; "extensively bioturbated loose sand and earthy sand sandwiched between" (out of sequence).

APC notebook (1996): "U16" "very sandy at base".

APC Section "xe" (1996): "U16" composite series, including "darker sand", "clay lens" and, at base, "pale sand".

APC B103-B104 Section (1996): "U16" top "ashy unit", "dark sand & brown sand", "brown sand with small stones & phosphate", [persistent boundary], unlabelled material at base.

APC B101-B102 Section (1998): thin "fine sand" layer (possibly "U11") shown immediately below "U10=U15"; "U16" composite series of "clayey sands" with lenses (at mid-height and base) of "fine sand" sometimes with "clay layers".

On section "xc-xe", "U16" containing a lens at mid-height on west and possibly multiple layers on east; base not clear westwards; no context sheet.

SNC (2001) observations: "The upper part appears to correlate with "U28" [cf. **LBSmff.8**] of Section "xc"."

NB "U14" and "U16" of this sequence DO NOT correlate with "U14" and "U16" of Section "xb".

W-E section "xc-xe" 98.5-102 at Northing mid-B and W-E section 102-104 at Northing A/B (also observed by SNC).

**LBSmcf. 2-(upper)9
general**
Formerly:
"U4c-U16"

SNC (2001) observations: "The interval "4c-upper16" contains similar sediments; slightly 'wavy' false bedding; strong bioturbation structures and nodules (commonly phosphatic) throughout; colours are less yellow and more pink than correlates on Section "xc"; stringers, small lenses and dispersed examples of limestone grit and finer limestone clasts, increasing steadily eastwards.

The transition from the dark, laminated, fines-dominated beds seen in Section "xc" to the sand-dominated beds of Section "xc-xd" is remarkably abrupt but not due to unconformity (i.e. each unit shows this same sharp lateral transition)."

W-E section "xc-xe" 98.5-102 at Northing mid-B and W-E section 102-104 at Northing A/B (also observed by SNC).

LBSmcf.10
Formerly:
"U17"

1187-1172
7 cm

APC notebook (1996): "Clay or silt horizon"; "in some places more than one layer thick" (up to 3 cycles shown in sketch); "basal clay-rich band which is desiccated like the Frog Pond, but with finer desiccations; it is only a few millimetres thick".

APC Section "xe" (1996): (southwards) "silt layer".

APC B103-B104 Section (1996): "fine laminated sand" and "fine laminae", apparently between significant (silt?) bands.

APC B101-B102 Section (1998): marked simply as thickness of line at base of "fine sand" lens of basal "U16" [cf. **LBSmcf.9**].

The material apparently marked "U17" on the original Section "xd-xe" is in fact fine sand at base of "U16"; nevertheless, "U17" probably wedging out westwards by "xd" (thereafter, large disturbance feature); no context sheet.

SNC (2001) observations: "In Section "xd" and eastwards, slightly lighter, cleaner medium sand."

NB "U17" of this sequence DOES NOT correlate with "Context 17" of Section "xb".

W-E section "xc-xe" 98.5-102 at Northing mid-B and W-E section 102-104 at Northing A/B (also observed by SNC).

LBSmcf.11
Formerly:
"U18"

1183-1158
30-33 cm

APC notebook (1996): "Succession of similar thin clay units", one in particular noted 10 cm down; "stony layer at base".

APC Section "xe" (1996): "siltier patches" and a "charcoal line" roughly mid-way up this unit.

APC B103-B104 Section (1996): "variable, generally dark sand units", "gravel lens", "base of fine angular gravel".

APC B101-B102 Section (1998): "clayey sand" with thin, heavily contorted/bioturbated "fine sand" lenses.

On Section "xc-xe", summit not clear westwards; complex/multiple eastwards; no context sheet.

SNC (2001) observations: "Lenses of fine limestone clasts, especially at base. Notation "30" on original Section "xc-xe" might imply correlation with "U30" [cf. **LBSmff.10**] of "xc". Other contorted lenses of uncertain status drawn on Section "xd-xe" (possibly part of "U18")."

NB "U18" of this sequence DOES NOT correlate with "U18" of Section "xb".

W-E section "xc-xe" 98.5-102 at Northing mid-B and W-E section 102-104 at Northing A/B (also observed by SNC).

LBSmcf.12
Formerly:
"U19"
"U21"

1168-1137
22-24 cm

APC notebook (1996): "Loose sand unit"; "some ash and charcoal in upper part".

APC (and Cornish) notebook (1996): "U21" "Southerly sloping surface of sandy material containing much charcoal" in A105 and B106; said to "interdigitate" with "U19".

APC Section "xe" (1996): "stony sand", lower boundary uncertain.

APC B103-B104 Section (1996): "loose sand".

APC B101-B102 Section (1998): "clayey sand" with "ash layer" at summit.

Discontinuous and contorted lens, shown just west of Section "xe" only; overall, contorted, interrupted by common bioturbation features, dashed lower boundary; no context sheet.

SNC (2001) observations: "Cemented lens at top (1159-1150, 2 cm thick, labelled "U19" on section) might be the upper "ash layer". The remainder is a sequence of lightly cemented, cleaner, buff medium sands; appears to be wedging out eastwards. Incorrectly labelled "U20" on the original Section "xc-xe"; however, notation "32" on original Section "xc-xe" might imply correlation with "U32" (if any) [cf. part of **LBSmff.11**] of "xc"."

NB "U19" and "U21" of this sequence DO NOT correlate with "U19" and "U21" of Sections "xb" and "xc" and falling in between.

W-E section "xc-xe" 98.5-102 at Northing mid-B and W-E section 102-104 at Northing A/B (also observed by SNC).

LBSmcf.13
Formerly:
upper "U20"
"U22"

1172-1134
at Northing
A/B
10 cm

APC (and Cornish) notebook (1996): "U20" "Colour change to even looser, paler sands" (as compared with "U19" [cf. **LBSmcf.12**]); "less compact, yellower sand, shell fragments"; major "silt layer (is this equivalent of U21? [cf. **LBSmcf.12**])".

APC (and Cornish) notebook (1996): "U22" "Cracked and undulating" sediment; "the clay/mud is 1-2 cm deep and in some places it is missing altogether"; "heavily bioturbated"; "surface scatter of charcoal"; in D106/D107 "Unit 20 occurs under the clay layer (22) as well as over it".

APC B103-B104 Section (1996): upper part of "U20" consists of "paler, thin silt and sand laminae".

SNC (2001) observations: "Small stalagmitic boss just west of Section "xe" at very base of exposure, possibly lying stratigraphically on top of "U20". The uppermost unit in this dominantly sandy sequence is shown east of Section "xe" with a dashed upper boundary; the sands nevertheless have some thin, continuous loamy laminae. The next unit (actually within "U20" as originally defined) is shown within a distinctive geometrical setting (planar bed, thickening at eastern end, between burrows to the west and sample column GOR '96 to the east) which was clearly observable by SNC; the material is a pinkish brown, slightly clayey/silty medium sand, lightly indurated; this may be equivalent to "U22" (not "U21")."

APC & SNC (2002) observations: "the member boundary is best placed at the base of the continuous reddish clayey silt [SNC: "pinkish brown, slightly clayey/silty medium sand, lightly indurated"]; this silt can be traced across the very top of the extant sequence in Section "xg-xh" (Eastings 105-107)."

NB "U20" and "U22" of this sequence DO NOT correlate with "U20" and "U22" falling between Sections "xb" and "xc" and within Section "xc".

W-E section 102-104 at Northing A/B (also observed by SNC).; base traceable to "xg" in 106.

Lower Bioturbated Sands mEMBER (LBSm)
Fine Facies (LBSmff)- Coarse Facies (LBSmcf) Local Correlation

SSLm (Usm).1 Formerly: lower "U20" "100" "Unit 100" "Context 100"	1174-1084 40 cm	APC (and Cornish) notebook (1996): "U20" lower part consists of "loose sand", possibly including "loose sand with angular limestone" at base. In 1996, a W-E section was established at the D/C line (looking northwards) in Easting squares 106-107; the section drawing shows "U20" dipping increasingly strongly westwards into cave (reaching 4:10 gradient). Section "xf" (1996): "Unit 20" comprising "paler sand", "sand with gravel", "paler sand" sequence, down to 1082. Lorraine Cornish (6.9.97): "Loose sand with sparse clay banding (fine laminated approximately 5 mm) pale/yellow colour. Almost sterile. Relates to "unit 20" in the north section which was dug last year. Areas II & III, Squares B-C-D/106-107. Started at = 11.62 in B107; last year's notes state that we recorded a top height for "unit 20/context 100" as 11.41, which makes sense as the surface slopes south. Almost sterile sand with small blocks of limestone fragments." Tracy Elliot (22.9.97) Section "xg": "sand, mostly sterile"; shown to be thickening markedly southwards, dropping concave-up lower boundary, unit over 50 cm thick by D106; mostly horizontal bedding in bulk but, at base towards south, more stony lenses, rather contorted, plus cemented patches (possible local subsidence, then upper "unit 100" filling now stable 'basin' so formed). Section B106-B107 (22.9.97): "sand - mainly sterile", slightly contorted "clay layer", patch of "rock and shell fragments" at base. SNC (2001) observations: "35 cm thick; to the west, mostly loose medium sand, with some darker silt bands (max 8 mm thickness) and very thin stringers of finest limestone grit; slightly 'wavy' false bedding; sand very pale brown (10YR 7/4) speckled, silt pink to light brown (7.5YR 7-6/4); eastwards (by line of eastern Goldberg column, as drawn on section), strong limestone grit component; becoming contorted from bioturbation (burrows up to 10 cm diameter); southwards in "xg" fine sharp scree as highest surviving level (below spoil contact), and roughly planar horizontal bedding in sands below, cemented patches near base. The whole unit appears to become thicker southwards, filling (with horizontal bedding in upper part) the rather concave-up form of "units 101-104" [cf. **SSLm(Usm).2-4**] below (as seen in "xg"); this curved contact is not obviously erosive but there may have been some subsidence between of the lower units before deposition of (most of) "100". The sub-'clayey silt'-band part of "U20" further west is clearly correlated with "unit 100" in Easting squares 105-107." S-N section "xg" at Easting 105, W-E section "xg-xh" 105-107 at Northing mid-B, S-N section "xh" at Easting 107 and W-E section 108-111 at Northing E/F (also observed by SNC).
SSLm (Usm).2 Formerly: "U23" "101" "Context 101"	1142-1067 14 cm	APC (and Cornish) notebook (1996): "Another sandy unit"; "layer with charcoal and layers of sand in D106/D107; dark and convoluted stone scatter in this layer"; "in D106, a curious group of stones with a significant number of seeds and flecks of charcoal" [cf. "xg Unit 101"], also artefacts. Site photograph (in notebook) labelled: "D106/D107 at [i.e. excavated down to] surface of consolidated sands [cf. **SSLm(Usm).4**] showing plunging feature which may be outer lip of a sink hole down which deposits in the cave appear to be slumping." In 1996, a W-E section was established at the D/C line (looking northwards) in Easting squares 106-107; the section drawing shows "U23" dipping increasingly strongly westwards into cave (reaching 4:10 gradient). Section "xf" (1996): "Unit 23" comprising "earthy sand with charcoal", "sandy patch" (lens), basal subunit unannotated, in the interval 1082-1058. Lorraine Cornish (6.9.97): "Layer with finds underlying "context 100" [cf. **SSLm(Usm).1**]. Laminated clay bands present; also contains soft darker sand (demerara colour, rich in finds) and lenses of pale sterile sand. The finds are overlying the clay in the softer sand and charcoal is present. Area III, Squares B-C/107. Top of unit in Square C108: corners NW 11.56, NE 11.71, SE 11.54, SW 11.36 [SNC deduces slight local dip towards SW; confirmed in Squares C/107-106, for both top and base of unit]." Tracy Elliot (22.9.97) Section "xg": "dark sand and charcoal"; shown thinning and 'lenticular' southwards, very strong charcoal content. Section B106-B107 (22.9.97): "dark sand/charcoal". Largely cemented by "xh". Apparent southerly dip of up to c.6° in the S-N plane, and an apparent dip into the cave (westwards) of c.7-8°. SNC (2001) observations: "Typically 15 cm thick; well bedded (laminated with a few very minor cross-bedded subunits) slightly silty sand, with minor, very fine limestone grit stringers; slightly 'wavy' false bedding; patchy (nodular) cementation at eastern end of exposure at "xh"; field-dry colour brown (7.5YR 5/3) but individual laminae darker/lighter; very common large charcoal fragments (very obvious large black flecks); good bone preservation. "Unit 101" provides a good marker horizon across the western 'inner' face of the Northern Cornice; on the southern face, at Northing E/F, 101 lies immediately above the highest cemented unit shown on the section drawing. Correlates with "U23" in "xg" and "xf"." **NB "U23" of this sequence DOES NOT correlate with "U23" in Section "xc".** S-N section "xg" at Easting 105, W-E section "xg-xh" 105-107 at Northing mid-B, S-N section "xh" at Easting 107 and W-E section 108-111 at Northing E/F (also observed by SNC).
SSLm (Usm).3 Formerly: ? "U24" "102" "Context 02" "105"	1136-1068 10 cm	Tracey Elliott & Lorraine Cornish (9.9.97): "sands similar to "context 101", now with scarce flecks of charcoal and minimal general finds. Underlies "context 101" [cf. **SSLm(Usm).2**]. Area III, Squares B-C/107." Lorraine Cornish (14.9.97): "105""Lithics, bone, charcoal from "context 102" = discrete area - with burnt sand - possible combustion zone. Found within "context 102". Area III, Squares B-C/107." In passing, it may be noted that Lorraine Cornish (14.9.97) qualifies "103" [compound] as a "possible cemented version of "contexts 100, 101, 102 and 104". Area III, Squares B-C-D/108." Tracy Elliot (22.9.97) Section "xg": "lighter sand, sparse finds"; some fine limestone clast lenses shown. Section B106-B107 (22.9.97): "lighter sand, sparse finds"; shown 'abutting' a "cemented floor" at east end. Pinching out southwards (in "xg"). Apparent southerly dip of up to c.6° in the S-N plane, and an apparent dip into the cave (westwards) of c.7-8°.

SNC (2001) observations: "Typically 5 cm thick; well bedded sand, lighter in colour and very slightly coarser than in "[g-h]101" [cf. **SSLm(Usm).2**]; slightly 'wavy' false bedding."

SNC suggests a possible correlation with "U24" of APC notebook (1996): "Pale sand below "23" [cf. **SSLm(Usm).2**]"; "appears to be more or less restricted to D107". In 1996, a W-E section was established at the D/C line (looking northwards) in Easting squares 106-107; the section drawing shows "U24" dipping increasingly strongly west-wards into cave (reaching 4:10 gradient).

NB "U24" of this sequence DOES NOT correlate with "U24" in Section "xb".

S-N section "xg" at Easting 105, W-E section "xg-xh" 105-107 at Northing mid-B, S-N section "xh" at Easting 107 and W-E section 108-111 at Northing E/F (also observed by SNC).

SSLm (Usm).4 Formerly: ? "U25" "104" "Context 104"	1134-1061 20 cm	Lorraine Cornish (13.9.97): "Clay layer underlying context 102 [cf. **SSLm(Usm).3**]. Squares B-C/108. Height of top of context 11.44 at centre of Square C108."

Tracy Elliot (22.9.97) Section "xg": "clay band overlying darker sand"; shown thinning southwards under deforma-tional 'basin'; darker at top, "orange" below.

Section B106-B107 (22.9.97): "clay band overlying darker sand", rather irregular base with "clay" lens to west. Largely cemented by "xh". Apparent southerly dip of up to c.6° in the S-N plane, and an apparent dip into the cave (west-wards) of c.7-8°.

Cemented 5-8 cm at top (1186-1183 in Section at Easting 112.5) shown as "hard sand" on 2001 section of southern face at Northing E/F.

SNC (2001) observations: "Typically 17 cm thick; sand and limestone grit, lightly cemented at top to west, becom-ing strongly so eastwards; slightly 'wavy' false bedding. On western 'inner' face of Northern Cornice, upper part strongly cemented with lower darker parts only weakly cemented (therefore erosional notch); on the southern face, at Northing E/F, the upper cemented part of "104" is the highest cemented unit shown on the PJR (17.9.98) Section at E/F line in easting squares 109-110."

SNC suggests a possible correlation with "U25" of APC notebook (1996): "Consolidated rubbly sand layer with concre-tions and charcoal; forms prominent shelf in section; much angular limestone".

NB "U25" of this sequence DOES NOT correlate with "U25" subsumed under LBSmff.7.

S-N section "xg" at Easting 105, W-E section "xg-xh" 105-107 at Northing mid-B, S-N section "xh" at Easting 107, W-E section 108-111 at Northing E/F and W-E section (2001) 109-114 at Northing E/F (also observed by SNC).

SSLm (Usm).5 Formerly: "106"	1115-1032 32 cm	Plausibly correlates with the "breccia" (limestone clasts) of Cooper (1996) at her (arbitrary) 5 m datum (different from the site datum used in the present text); note that the correlations with Waechter's stratigraphy suggested to Cooper by the team (and thus published by her) are wholly incorrect.

Lorraine Cornish (18.9.97): "Orange/brown sand. Below "context 104 [cf. **SSLm(Usm).4**] and contemporaneous with cemented 'floor' dipping back from the cemented column. Areas II and III, Squares B-C-D/106-107 & B108. The top of the sand has some finds - lithics and fauna - grading into more sterile sand - no to very sparse charcoal."

Tracy Elliot (22.9.97) Section "xg": "sterile sand"; "thin clay layer" about 2/3 way down.

Section B106-B107 (22.9.97): "sterile sand" "with small shell fragments and stones".

PJR (17.9.98) Section "xh": probably "unsorted orange sand, subangular pieces of limestone at base, fining upwards" sandwiched between two major cemented zones.

PJR (17.9.98) Section at E/F line in Easting squares 109-110: probably subangular 2-10 cm limestone clasts in sand matrix, clasts becoming dominant eastwards. Apparent southerly dip of up to c.6° in the S-N plane, and an appar-ent dip into the cave (westwards) of c.7-8°.

"Scree" 27-48 cm (thickening eastwards to 55 cm, 1183-1131 at Easting 112.5) on 2001 section of southern face at Northing E/F.

SNC (2001) observations: "Typically 30 cm thick; light uncemented medium sand, rarer silt laminae and grit stringers (than above), slightly 'wavy' false bedding, but some more persistent silt lenses (washouts?) definitely dipping slightly eastwards (out of cave). On the southern face, at Northing E/F, 106 appears to include the major limestone clast zone shown on the 1998 section drawing."

S-N section "xg" at Easting 105, W-E section "xg-xh" 105-107 at Northing mid-B, S-N section "xh" at Easting 107, W-E section 108-111 at Northing E/F and W-E section (2001) 109-114 at Northing E/F (also observed by SNC).

Sands & Stony Lenses mEMBER (SSLm)
Lower sUBmEMBER (Lsm)

SSLm (Lsm).6 Formerly: "107" ? "108"	1117-1030 up to 45 cm	Lorraine Cornish (18.9.97): "Clay layer containing fauna. Areas II and III, Squares B-C-D/106-107." Plan (Tracey Elliott (19.9.97)) shows persistence of SE dip; also "shell beds" (patches 20-40 cm diameter).

Tracy Elliot (22.9.97) Section "xg": "clay overlying dark sand and moving into light sand"; "clay lenses" [apparently fragmented] lower in sequence.

Section B106-B107 (22.9.97): "clay overlying dark sand" passing downward to "lighter sand"; cementation starting at and around clay bands on eastern side. Apparent southerly dip of up to c.6° in the S-N plane, and an apparent dip into the cave (westwards) of c.7-8°.

APC notebook (1998): "Layer of hardened or compacted sand" sloping strongly down into cave; hyaena coprolite.

PJR (17.9.98) Section at E/F line in Easting squares 109-110: 15 cm cemented zone at top; 10 cm "zone rich in small limestone clasts and bone"; "thin layer of angular/subangular limestone clasts" mid-way up presumably otherwise sandy unit.

PJR (17.9.98) Section "xh": "unsorted yellow sand" dipping strongly southwards, especially at base.

"108" not shown on any sections; no context sheet; Rink et al (2000): "D108 at 1092: soft sand ".

On 2001 section of southern face at Northing E/F: a "hard-soft-hard sand" oscillation with a broken "stalagmitic boss" towards the base (1131-1123 hard cemented sand, 2-3 cm thick, at Easting 112.5); "soft sand", "line of small stones (at c.1100 at Easting 112.5) and globular concretions in soft sand", "soft sand", c.20-25 cm thick, thickening west-wards [lower boundary unclear].

SNC (2001) observations: "Top 3-5 cm thickness (thickening eastwards); cream-white cemented zone, apparently true dripstone (speleothem) component (not just authigenic). This speleothem provides a good marker horizon across the western 'inner' face of the Northern Cornice; on the southern face, at Northing E/F, the speleothem (including a large toppled stalagmitic boss) lies more or less immediately below the major limestone clast zone shown on the section drawing.

Typically 26 cm thick in "g-h"; slightly silty laminated medium sand, very minor cross-bedded lenses, with limestone grit; slightly cemented; many subdivisions possible.

On the southern face of the Northern Cornice, at Northing E/F, "107" appears to include:

- Cemented zone 8 cm thick (including uppermost speleothem).
- Bedded clean medium sand, with a few smaller stones; slightly indurated at top; 9 cm thick.
- A lens of medium limestone clasts; 6 cm thick.
- Slightly darker, silty sand, with shell fragments; 3 cm.
- At base, cleaner sand, well bedded, mostly lenticular; 19 cm thick."

S-N section "xg" at Easting 105, W-E section "xg-xh" 105-107 at Northing mid-B, S-N section "xh" at Easting 107, W-E section 108-111 at Northing E/F and W-E section (2001) 109-114 at Northing E/F (also observed by SNC).

SSLm (Lsm).7 Formerly: "109"	1110-1037 < 1 cm	PJR (17.9.98) Section "xh": very thin "band of clayey sand". PJR (17.9.98) Section at E/F line in easting squares 109-110: fading rapidly eastwards. No context sheet. Not observed by SNC (2001).

SSLm (Lsm).8
Formerly: "110"

1100-1000
30 cm

PJR (17.9.98) Section "xh": "unsorted orange sand, contains pieces of calcium-impregnated layer". Patchy cemented zone above "dark orange sand" from 1040 to 1030 and below.

PJR (17.9.98) Section at E/F line in easting squares 109-110 (noting general dip of 12° to bearing 265°): "medium coarse sand", with "calcium/sand concretions in rough layers"; 5 cm cemented lens, fading eastwards; 20 cm unsorted "medium coarse sand".

No context sheet.

On 2001 section of southern face at Northing E/F: soft sand, c.8 cm thick (upper boundary unclear, c. 1095-1087 at Easting 112.5); hard (cemented) sand, 2-3 cm thick (1087-1085 at Easting 112.5), fading eastwards; soft sand (1085-1069 at Easting 112.5, cf. Sample ND 91 further west), 16-20 cm thick.

SNC (2001) observations: "At top, generally indurated sand interval (although may be softer at top in places) with apparent lenticular speleothem reinforcement to east, 8 cm thick; cleaner sand, rather homogenous (bioturbation), with some small shell fragments, mostly terrestrial, 19 cm thick."

S-N section "xg" at Easting 105, W-E section "xg-xh" 105-107 at Northing mid-B, S-N section "xh" at Easting 107, W-E section 108-111 at Northing E/F and W-E section (2001) 109-114 at Northing E/F (also observed by SNC).

SSLm (Lsm).9
No former formal label

1080-995
6-16 cm

PJR (17.9.98) Section at E/F line in easting squares 109-110 (noting general dip of 12° to bearing 265°): Cemented lens, 15 cm thick, fading westwards.

On 2001 section of southern face at Northing E/F: hard (cemented) sand, 6-12 cm thick (1069-1063 at Easting 112.5).

SNC (2001) observations: "Alternating 5 mm laminations of pink silt and light buff sand, the sand largely auto-cementing to form 'ledges' (but possibly very thin dripstone drapes already present); 7 cm thick. Laminated silt/sands becoming more carbonate rich (speleothem input) and thickening to 16 cm eastwards on southern face of Northern Cornice; eventually, composite stalagmitic floor."

W-E section (2001) 109-114 at Northing E/F and S & E faces of North Cornice (also observed by SNC).

SSLm (Lsm).10
No former formal label

1075-980
46-56 cm

PJR (17.9.98) Section at E/F line in easting squares 109-110 (noting general dip of 12° to bearing 265°): 30 cm unsorted medium coarse sand.

On 2001 section of southern face at Northing E/F: mainly soft sand (sample OSL GOR 01-05 at top), 56 cm thick (1063-1005 at Easting 112.5).

SNC (2001) observations: "Medium sands; very good microvertebrate preservation; 16 cm thick. Medium sand with a little limestone grit; 6 cm thick. Loose, light-coloured medium sand; 12 cm thick. Slightly more dense (indurated), slightly silty sand; a little redder in colour (8.5YR 6/6) than above; 12 cm thick. Sequence thickening eastwards."

SNC (2002) observations: "Note some tiny cross-bedded ripple-forms in sands in a few places; very small, sometimes lightly concreted bioturbate structures (probably insect burrows)."

W-E section (2001) 109-114 at Northing E/F and S & E faces of North Cornice (also observed by SNC).

SSLm (Lsm).11
No former formal label

1020-965
c.10 cm

PJR (17.9.98) Section at E/F line in easting squares 109-110 (noting general dip of 12° to bearing 265°): 10 cm cemented lens, fading westwards.

On 2001 section of southern face at Northing E/F: discontinuous cemented lenses (at c.1005 at Easting 112.5, sample ND 91 GOR 41 roughly at this level).

SNC (2001) observations: "Medium sand with fine limestone clasts; lighter colour; 3 cm thick, becoming a major cemented zone eastwards and onto east face of Northern Cornice."

W-E section (2001) 109-114 at Northing E/F and S & E faces of North Cornice (also observed by SNC).

Variegated Sand & Silts mEMBER (VSSm)

VSSm.1
No former formal label

1005-945
c.25-35 cm

PJR (17.9.98) Section at E/F line in easting squares 109-110 (noting general dip of 12° to bearing 265°): 35 cm medium coarse sand, small 2-5 mm fragments of calcium [?].

On 2001 section of southern face at Northing E/F: mainly soft sand, 25 cm thick. (1000-975 at Easting 112.5).

SNC (2001) observations: "Dense redder unit of silty sand and apparent clayey peds (?); common terrestrial mollusca; 16 cm thick. Lighter sands with nodular concretions in places; 8 cm thick. Silty sands with some true silt/clay laminae; ground colour brown (7.5YR 4/4); good preservation of shell and microvertebrates; small load structures (including load-casting) into underlying sands; variable thickness averaging 7 cm."

SNC (2002) observations: "Note some very small, sometimes lightly concreted bioturbate structures (probably insect burrows)."

W-E section (2001) 109-114 at Northing E/F and S & E faces of North Cornice (also observed by SNC).

VSSm.2
No former formal label

978-940
c.2-5 cm

PJR (17.9.98) Section at E/F line in easting squares 109-110 (noting general dip of 12° to bearing 265°): 3-5 cm dark brown silty clay ("assoc. murid GOR 98 Area III").

On 2001 section of southern face at Northing E/F: Continuous but rather irregular brown clay lamina; 2 cm thick. (975-973 at Easting 112.5).

SNC (2001) observations: "Strong (darker 'chocolate') slightly contorted silt band with charcoal; shell and microvertebrates; small load structures (including load-casting) into underlying sands; 2-3 cm thick."

W-E section (2001) 109-114 at Northing E/F and S & E faces of North Cornice (also observed by SNC).

VSSm.3 No former formal label	975-915 c.12-25 cm	PJR (17.9.98) Section at E/F line in easting squares 109-110 (noting general dip of 12° to bearing 265°): 20 cm (assumed sand).
		On 2001 section of southern face at Northing E/F: Soft sand; 12-25 cm thick, thickening westwards. (973-961 at Easting 112.5).
		SNC (2001) observations: "Light medium sands; nodular concretions, increasing to massive cementation eastwards; 20 cm thick."
		SNC (2002) observations: "Note some tiny cross-bedded ripple-forms in sands in a few places; very small, sometimes lightly concreted bioturbate structures (probably insect burrows)."
		W-E section (2001) 109-114 at Northing E/F and S & E faces of North Cornice (also observed by SNC).
VSSm.4 No former formal label	950-912 c.5-10 cm	PJR (17.9.98) Section at E/F line in easting squares 109-110 (noting general dip of 12° to bearing 265°): 15 cm cemented lens, fading westwards.
		On 2001 section of southern face at Northing E/F: Hard (cemented) sand; 4-12 cm thick. (961-950 at Easting 112.5).
		SNC (2001) observations: "Very strongly cemented sand; 5+ cm thick."
		W-E section (2001) 109-114 at Northing E/F and S & E faces of North Cornice (also observed by SNC).

Reddish Silts & Sands mEMBER (RSSm)

RSSm.1 No former formal label	955-902 (possibly as high as 980 on E face) c.16 cm	PJR (17.9.98) Section at E/F line in easting squares 109-110 (noting general dip of 12° to bearing 265°): c.16 cm darker brown, rather silty sand; lithics; numerous shell fragments and calcium-rich fragments 5-10 mm; "NO-91 GOR 23" at base.
		On 2001 section of southern face at Northing E/F: "Dark brown soft sand", bone showing in section; 16 cm thick; sample ND 91 GOR 23 at base and a little into underlying strata. (950-934 at Easting 112.5). Discontinuous "dark pan"; c.1 cm thick.(934-933 at Easting 112.5).
		SNC (2001) observations: "Laminated silty to very silty medium sand; generally 'chocolate' colour; terrestrial mollusca; some charcoal; basal cementation; 7-8 cm, thickening southwards. Laminated silty medium sand; generally 'chocolate' colour; terrestrial mollusca; some charcoal; basal cementation; 7-8 cm, thickening southwards."
		W-E section (2001) 109-114 at Northing E/F and S & E faces of North Cornice (also observed by SNC).
RSSm.2 No former formal label	955+-889 c.10-15 cm	PJR (17.9.98) Section at E/F line in easting squares 109-110 (noting general dip of 12° to bearing 265°): c.9 cm lighter brown, slightly silty sand; lithics; numerous shell fragments and calcium-rich fragments 5-10 mm; contains "NO-91 GOR 23".
		On 2001 section of southern face at Northing E/F: "Medium brown soft sand"; 9-12 cm thick, possibly thickening westwards (933-923 at Easting 112.5).
		SNC (2001) observations: "Silty medium sand; colour a little 'rustier' (reddish brown 5YR 4/4); terrestrial mollusca; some charcoal; 16 cm thick. Clean medium sand stringer; c. 1-2 mm."
		SNC (2002) observations: "Note some very small, sometimes lightly concreted bioturbate structures (probably insect burrows)."
		W-E section (2001) 109-114 at Northing E/F and S & E faces of North Cornice (also observed by SNC).
RSSm.3 No former formal label	920+-885 3-5 cm	PJR (17.9.98) Section at E/F line in easting squares 109-110 (noting general dip of 12° to bearing 265°): 3 cm dark brown clay.
		On 2001 section of southern face at Northing E/F: Discontinuous "dark brown clay"; c.1-3 cm thick; mixed material (burrows?) in places. (923-920 at Easting 112.5).
		SNC (2001) observations: "Silty sand; reddish brown (6YR 4-5/4); charcoal and terrestrial mollusca; 5+ cm thick."
		W-E section (2001) 109-114 at Northing E/F and S & E faces of North Cornice (also observed by SNC).
RSSm.4 No former formal label	c.945-868 18 cm	PJR (17.9.98) Section at E/F line in easting squares 109-110 (noting general dip of 12° to bearing 265°): 20+ cm pale yellow medium coarse sand, quite sorted (base of 1998 cut).
		On 2001 section of southern face at Northing E/F: Soft sand; 19 cm thick, thickening eastwards. (920-901 at Easting 112.5).
		SNC (2001) observations: "Relatively clean medium sand, with some floating silty lenses; becoming a cemented 'ledge' outwards; 18 cm thick."
RSSm.5 No former formal label	c.915-860 2-20 cm	On 2001 section of southern face at Northing E/F: Major brown clay lens; 2 cm thick, thickening quickly to 20 cm westwards. (901-899 at Easting 112.5).
		SNC (2001) observations: "Red sandy silty clay (possible peds), with a few contorted lighter sand stringers; bone; 16 cm thick."
		SNC (2002) observations: "Note some very small, sometimes lightly concreted bioturbate structures (probably insect burrows)."
		W-E section (2001) 109-114 at Northing E/F and S & E faces of North Cornice (also observed by SNC).
RSSm.6 No former formal label	c.935-857 10-28 cm	On 2001 section of southern face at Northing E/F: Concreted zone; up to 25 cm thick, thinning westwards. (899-874 at Easting 112.5).
		SNC (2001) observations: "Massively cemented unit; 28 cm thick."
		W-E section (2001) 109-114 at Northing E/F and S & E faces of North Cornice (also observed by SNC).
RSSm.7 No former formal label	915-840 17-25 cm	On 2001 section of southern face at Northing E/F: "Blackish-brown silty clay"; 22-25 cm thick. (874-851 at Easting 112.5).
		SNC (2001) observations: "Partially indurated unit, some limestone clasts with point-to-point cementation; matrix with blotchy deep colours, 'reddish chocolate', black and 'phosphate/collophane' yellows/oranges at base; 17 cm thick."
		W-E section (2001) 109-114 at Northing E/F and S & E faces of North Cornice (also observed by SNC).
RSSm.8 No former formal label	896-820 15 cm	APC (1997 Section, approximately Easting 114, east face of North Cornice): "Dark unit" (+896-891). "Major stal fall at this level; stal sits on dark unit and rests on base" (891- 882).
		On 2001 section of southern face at Northing E/F: Hard (cemented) sand with fallen stal block; 12-15 cm thick. (851-840 at Easting 112.5).
		SNC (2001) observations: "Cemented, probably lighter brown silty carbonate-rich; may have some lenses of derived eucladiolithic 'tufa'; 15 cm thick. At base, member boundary."
		W-E section (2001) 109-114 at Northing E/F and S & E faces of North Cornice (also observed by SNC).

Carbonate Sands & Silts mEMBER (CSSm)

CSSm.1 No former formal label	882-806 12-30 cm	APC (1997 Section, approximately Easting 114, east face of North Cornice): "These units almost form a laminated stal sequence; heavy cementation increases laterally to N; light colour, chalky white partings". "Cave pearls" (871, 879); "*Patella* at this level, tracer [marker?] horizon 1" (866); "light pink" (861); "friable 'chalky' parting, almost white" (860); "light pink" (855). (Including annotations: 882-855).
		On 2001 section of southern face at Northing E/F: Broken stalagmitic floor, laminar structure; 15-25 cm thick. (840-825 at Easting 112.5).
		SNC (2001) observations: "Outwards onto the eastern face of the Northern Cornice: laminated calcareous sequence, with true stalagmitic floors outwards; massive marine shell content (apparently relatively wide species range) between speleothemic layers; artefacts and charcoal (especially towards northern end of outer face); very large fragments of fallen stalactite lie immediately above (welded to, and even piercing through) this unit; 12 cm, thickening eastwards to 30 cm; top of floor at c.880 cmaSD on eastern outermost face of Northern Cornice. This distinctive unit can be traced southwards, across the mouth of the cave, and into the Southern Cornice."
		W-E section (2001) 111-114 at Northing E/F and S & E faces of North Cornice (also observed by SNC).
CSSm.2 No former formal label	855-c.760 65-80 cm	APC (1997 Section, approximately Easting 114, east face of North Cornice): [Poorly consolidated, sandy?] (855-842).
		APC (1997 Section, approximately Easting 114, east face of North Cornice): "Prominent [cemented] ledge with distinctive middle sand unit in area around profile; base locally very shelly to E - mostly terrestrial mollusca; gravelly at base to north". "Tracer [marker?] horizon 3" [= middle sand unit] at 837. (842- 834).
		APC (1997 Section, approximately Easting 114, east face of North Cornice): [Poorly consolidated, sandy?] (834-825).
		APC (1997 Section, approximately Easting 114, east face of North Cornice): [Sandy (?) unit with cemented top] (825-815).
		APC (1997 Section, approximately Easting 114, east face of North Cornice): "Massive cemented sand, lumpy but prominent [cemented]; top irregular, base very irregular". (815-802).
		APC (1997 Section, approximately Easting 114, east face of North Cornice): "Irregular, laminated coarse sands"; several minor cycles (texture?) (802-786).
		APC (1997 Section, approximately Easting 114, east face of North Cornice): [Moderately cemented sand?] (786-777).
		APC (1997 Section, approximately Easting 114, east face of North Cornice): [Less consolidated at top, cemented sand (?) below]; "many terrestrial snail fragments and a stal fragment at 770". (777-765). Upper level may correlate approximately with **CSSm.3** below.
		Rink et al (2000): "Unnamed at 844: tabular speleothem"; [authors appear unsure as to whether the sample was a clast or *in situ*, "formed in small pools as small lenses of calcite"]; [APC notebook (1998) implies that these (and perhaps lower samples) are curtain speleothem clasts]. Unnamed at 838: "cylindrical speleothem"; [authors appear unsure as to whether the sample was a clast or "formed *in situ* as root casts"]. Unnamed at 819: "friable orange sand, 5 cm above hard yellow lens".
		On 2001 section of southern face at Northing E/F: Soft sand; "highest Rink samples from this layer"; 10-15 cm thick. (825-814 at Easting 112.5).
		On 2001 section of southern face at Northing E/F: Hard (cemented) sand; 17 cm thick. (814-797 at Easting 112.5).
		On 2001 section of southern face at Northing E/F: "Light brown sand lens"; 4 cm thick, wedging out eastwards. (797-793 at Easting 112.5).
		On 2001 section of southern face at Northing E/F: Brown clay; 5-10 cm thick. (793-788 at Easting 112.5).
		On 2001 section of southern face at Northing E/F: Concreted zone; 3-4 cm thick. (788-785 at Easting 112.5).
		On 2001 section of southern face at Northing E/F: "Soft light sand" lens; 1-2 cm thick, wedging out eastwards; "lowest Rink samples at this level" [not mentioned in Rink et al (2000)]. (785-784 at Easting 112.5).
		On 2001 section of southern face at Northing E/F: Brown clay, apparently becoming, or interdigitated with, concreted zone eastwards; 20-25 cm thick. (784-762 at Easting 112.5). Lowest interval may correlate with CSSm.3 below.
		SNC (2001) observations: "Complex sequence, with small-scale lenticular to tabular bedding, slightly disturbed in places; lighter (speckled) medium **coarse** shelly sands, redder silty sands, cleaner medium sands auto-cementing, few limestone grit stringers; marine shells, charcoal flecks, chert chips; 65 cm thick."
		SNC (2002) observations: "Note some very small, sometimes lightly concreted bioturbate structures (possibly rhyzoliths or insect burrows), and some possible eucladioliths, in sands below capping stalagmitic floor [**CSSm.2**]."
		W-E section (2001) 111-114 at Northing E/F and S & E faces of North Cornice (also observed by SNC).
CSSm.3 No former formal label	6 cm	APC (1997 Section, approximately Easting 114, east face of North Cornice): Possible approximate correlation with c.775 level.
		On 2001 section of southern face at Northing E/F: Possible correlation with the base of the brown clay noted above (at and above 762 at Easting 112.5).
		SNC (2001) observations: "Strong 'reddish' sandy clay ["REF" used below], apparent reworked soil peds; small speleothem clasts (?); rare, small quartzitic pebbles; brown to strong brown (7.5YR 4/4-6); common terrestrial mollusca; apparent basal dip (observed just south of standing southern face of Northern Cornice) both westwards into cave and slightly northwards, creating a slight angular unconformity; 6 cm thick."
		W-E section (2001) 111-114 at Northing E/F and S & E faces of North Cornice (also observed by SNC).
CSSm.4 No former formal label	base at c.720-698 50-60 cm	APC (1997 Section, approximately Easting 114, east face of North Cornice): "Prominent ledge traceable across Area III [i.e. cemented at top]; many terrestrial snail fragments; downwards, earth, softer units with snails and *Patella* - scattered; pebble at base". (765-742).
		APC (1997 Section, approximately Easting 114, east face of North Cornice): [Sandy? unit with cemented top]; artefact at mid-height; *Patella* at base. (742-718).
		On 2001 section of southern face at Northing E/F: "Light sand", with concreted lenses; 10-20 cm thick. (762-748 at Easting 112.5).
		On 2001 section of southern face at Northing E/F: "Brown", "loosely" to well "concreted sand"; >10 cm thick; SECTION BASE. (748 down at Easting 112.5).
		SNC (2001) observations: " Complex sequence; oscillations between reddish clays and coarse (very well sorted) sand lenses; loading distortion (cf. dish structures), sand becoming almost dominant downwards; distinctive sand colour very pale brown (10YR 8/2-4), speckled with very dark grains (implying a somewhat varied and perhaps immature mineralogy), although there may be 'reddish/chocolate' over-staining; > 30 cm thick."

SNC (2002) observations: "Note some very small, sometimes lightly concreted bioturbate structures (probably insect burrows)."

W-E section (2001) 111-114 at Northing E/F and S & E faces of North Cornice (also observed by SNC).

Coarse Sands mEMBER (CSm)

CSm No former formal label	APC (1997 Section, approximately Easting 114, east face of North Cornice): [coarse sands] (717-707).
	APC (1997 Section, approximately Easting 114, east face of North Cornice): "Very irregularly cemented, bioturbated coarse sands"; cemented top. (707-700).
	APC (1997 Section, approximately Easting 114, east face of North Cornice): "Very irregularly cemented, bioturbated coarse sands"; cemented top. (700-691).
	APC (1997 Section, approximately Easting 114, east face of North Cornice): "Very irregularly cemented, bioturbated coarse sands"; cemented top but apparently less consolidated downwards. (691-647 & below).
	Rink et al (2000): "Unnamed at 692: brown clay/sand unit with some shell and stone, characterised by local areas of harder cemented sand with curvate forms [? dish structures] and strong relief".
	Rink et al (2000): "Unnamed at 612: loose, brownish yellow sand, some 27 cm below a cemented sand layer".
	SNC (2001) observations: "On the outer, easternmost face of the Northern Cornice, at a point 110 cm below the 'reddish' sandy clay [marked as a "REF" above (cf. **CSSm.3**), the clay being estimated at roughly 775 cmaSD at this outer point]: very persistent bed entirely of well sorted <u>coarse</u> sand (visually estimated as mostly in the range 0.50-0.71 mm, only a few percent retained on a 1 mm sieve); indurated by convoluted nodular carbonate concretion (almost certainly authigenic); 20-25 cm thick. [10-20 cm above this sand unit, there are artefacts and small (c.3 cm) true quartzitic pebbles in a reddish slightly clayey matrix, whilst there are more 'red' beds below the sand unit.]
	NB. The Southern Cornice contains a good sequence of lower units; artefacts were noted at depths as least as great as 3.5 m below the main stalagmitic floor [**CSSm.1**]."
	W-E section (2001) 112-114 at Northing E/F and S & E faces of North Cornice (also observed by SNC).

Units of Uncertain Attribution

(1) Poorly consolidated yet coarsely bedded sands (with Pleistocene artefacts/fauna) generally at lower levels in the 'mouth' of the cave.

SNC (2001) observations: "Towards the southern outer part of the cave, there appear to be thick intervals of medium fine sand relatively low in altitude (below c.750 cmaSD), the stratigraphic position of which is unclear (Waechter (1964) seems to have thought this "wash" to have been a recent derived deposit due to erosion of the Cornices behind, an explanation not impossible but not obviously proven on present evidence)."

APC (1998) Plan has only occasional observations (i.e. not continuous sequence description):

- apparent spoil up-slope, towards cave.
- "bedded fine sands - 'running sands' - with cemented horizons" believed to be in situ.
- "material in shelf section is lateral equivalent of pinkish sand cave-earth towards edge of collapsed boulder pile" (on the southern seaward edge of outer platform).
- "hard reddish sand underlain by yellow sand".
- "poorly sorted beach gravel and marine shells, uncemented; unconformable lower contact with rubified horizon below".

APC notebook (1998): "Loose, poorly sorted beach gravel, with rounded, subrounded and angular clasts, coarse to fine sand and abundant marine mollusca; contains some quite big lumps of rock, some of which are clasts of older Quaternary deposits - breccia, stalagmite, etc."; highly unconformable junction at base with rubified sand [see below]"; (is this "part of the modern beach or a last interglacial feature?"); later conclusion that this 'storm beach' is relatively modern (a storm of 19-20 September 1998 reached and filled the whole trench).

SNC (2001) observation: "modern storm beach material (ballistic coarse sand and pebbles) at base of erosion notch in standing 'cliff' of Pleistocene sediment at c.500."

(2) Poorly exposed but apparently well bedded deposits towards the southern side of the cave entrance and outside, beyond the overhang.

	SNC (2001) observations: "There are relatively low, bedded sandy deposits all along the southern wall of the cave and beyond; uncertain status."
top at 025 base at -041 (BELOW SITE DATUM)	APC notebook (1998): "Rubified sand, partly indurated" (cf. GOR-98-160-163 of Goldberg [sketch section shows 160 and top of 161 in "rubified sand", the rest below simply in "sand"]). APC (1998) Plan: "hard reddish sand? rubified horizon"; top of GOR-98-160 at +0.254 m; base of 163 at -0.407 m."

(3) Various cemented 'cave-earths', sands and floor speleothems, surviving as discontinuous remnants adhering to the northern cave wall, lower in the entrance area.

Formerly: "Unit E"	c.500 at top APC notebook (1998): "Unit E: there are quite large patches of sediment on the walls above Unit D"; "at the base they are sandy with small fragments of weathered stal; higher up they contain a lot of angular to weathered limestone clasts and a lot of large stalagmite clasts, resembling Unit C [**RSCm** below]; in the mouth of the cave, the top of Unit E appears to be associated with a stal boss layer or floor and rises steeply seawards; this is a thick cave breakdown unit, with local sand (aeolian?) at base".
	SNC (2001) observations: "Towards the northern side of the cave exterior (and on its outer northern walls), the following general sequence is observed: major stalagmitic floor, reaching roughly 500 cmaSD; breccia in reddish silty matrix; dipping gently into cave".
	Northern cave wall near entrance.
Formerly: "Unit D"	APC notebook (1998): " Unit D: stratified cave earths and rocks [sketch implies cycles with coarse blocks at base of each] and in situ stal; terrestrial mollusca"; "mainly found cemented to the base of the cliff"; "like Unit C [**RSCm** below] they are red in colour and contain pieces of stalagmite, though generally much smaller pieces; there is rough bedding visible with a well defined upper unit which is stal impregnated and contains weathered subangular limestone boulders; the ground matrix is finer than Unit C and has a complex void structure [secondary vugginess]; fossils are patchy but terrestrial mollusca are locally abundant and pieces of bone are visible in section; rubification; the lower units are less well preserved but include layers of fine limestone breccia and scattered limestone clasts; more stal bits at top, former floor level ?".
	SNC (2001) observations: Including at top "stalagmitic floor (?) and fallen stalactite fragments".

		Northern cave wall near entrance.
		There are also significant exterior deposits which cannot yet be correlated with the cave sequence.
	c.1400-400	SNC (2001) observations: "Further north, at a point between Gorham's and Vanguard Caves, there is a cemented medium <u>coarse</u> sand 'dune' (rare floating limestone clasts; small shell fragments, mostly marine), plastered, with high-angle bedding, against the cliff, with red sharp breccias unconformably above and outward (strongly dipping unconformity). The sand is observed from about 400 cmaSD to a point some 1000 cm higher."

Rubified Speleothem Clast mEMBER (RSCm)

RSCm Formerly: "Unit C"	>200 cm	APC notebook (1998): "Unit C: cave breakdown and stal; thins seaward"; "similar background matrix to Unit B [**BCSm.1** below] coarse sand, but with admixture of a very large amount of broken, weathered stalagmite; deposit strongly red in colour"; comment on flat upper surface across cave ('wave-cut' erosion notch); "contains abundant limestone clasts, rather irregularly distributed, angular to subangular; broken stal scattered throughout but generally most dense at top; very poor sorting; contains terrestrial molluscan fragments".
		SNC (2001) observations: "Breccia in reddish silty matrix; in the lowest 50 cm, clasts are at least 70% large (20+ cm) stalactite fragments (highly reticulate forms similar to the modern roof 'pendants'), with the rest limestone, mostly limestone higher; dipping gently outwards at cave mouth but roughly horizontally bedded to north (within current cliff notch); apparent lithic artefacts present; terrestrial mollusca (APC); heavily cemented; > 200 cm thick."
		Northern cave wall near entrance and, in exposed patches, further south across cave mouth.

Governor's Beach fORMATION

Basal Coarsest Sands mEMBER (BCSm)

BCSm.1 Formerly: "Unit B"	top at -014 (BELOW DATUM) in cave mouth	APC notebook (1996): "Unit B: coarse sand with burrow structures; thickens seaward"; "cemented very coarse sand with occasional clasts, mainly of limestone; displays [ancient] branching burrow-like structures in [modern] spray zone where [modern] weathering picks out details; massive, no visible bedding, except locally at base, where it merges with Unit A [**BCSm.2**], cobble stringers, etc.; thickens seaward and northwards (outside cave), redder and more clasts in upper part northwards"; "no mollusca found, save for a shell set in a breccia clast".
	50-200 cm	Cf. description of raised beach deposits in Rose & Hardman (2000). [NB. These authors report the sand textures present as in the range 0.5-1.8 mm; they refer to material in the range 0.5-1.0 mm as "medium-grained" and above 1.0 mm as "coarse-grained", whilst SNC refers to sand above c.0.5 mm as '**coarse**'.]
		SNC (2001) observations: "Rather massive <u>**coarse**</u> sands, with a significant bioclastic component; heavily cemented; upper surface in cave mouth at 0.136 m BELOW site datum (APC); commonly 50-60 cm thick, thickening strongly (top rising, laminae thickening and fanning upwards) to the northeast up to 200 cm; gradational lower boundary. Some bedding suggests back of berm or even dune (i.e. subaerial) although Currant (pers.comm.) reports tubular ichnofossils (implying submergence); P. Jeffery (pers.comm. to APC) noted branching ichnofossils definitely implying submergence; P. Bertran (1991 observations, pers.comm.) also interprets these deposits as "upper-shoreface to foreshore".
		Particularly well exposed just north/east of the cave mouth.
BCSm.2 Formerly: "Unit A"	top at 065 BELOW DATUM	APC notebook (1996): "Unit A: indurated beach; thins seaward"; "indurated/cemented raised beach deposit"; "immediately in front of the cave, this unit thins to a bed of scattered rounded cobbles and pebbles of very varied lithology lying on the irregular and pocketed erosion surface of the Jurassic limestone"; "where the unit thickens it is often layered and quite well sorted with abundant shell debris"; "the boundary with the overlying Unit B [**BCSm.1**] is poorly defined".
	c.40 cm	
		SNC (2001) observations: "Very coarse, dominantly quartzitic sand/grit with very common shell frags; heavily cemented; rarely thicker than 20 cm. Below, true pebble beds (some limestone but dominantly a variety of siliceous lithologies); heavily cemented; rarely thicker than 20 cm (in places only present in potholes in platform)."
		Rock-cut platform.
		Particularly well exposed just north/east of the cave mouth.

Possible Buried Pleistocene Unconformity

Potential [Lower Gorham's Cave fORMATION]

Appendix 2
Micromorphology samples

P. Goldberg and R. I. Macphail

Location and field description of micromorphology samples (see also Fig. 4.1)

Sample No.	Location	Square	Depth	Colour	Industry	Field Description	RIM PG Level Nos	Spectrum #
GOR-89-01	Section A	H113?	810		MP	Alternative bedded white and reddish sandy bands. Up. 3/4=red; lwr 1/4=white sand. Rounded root-holes. Red=colluv?; white=blown?	4	
GOR-89-02	A	H113?	770		MP	Mixed white and red, possibly mottled by biological activity.	4	
GOR-89-03	A; E face	H113?	710		MP	Compact, mod. well sorted massive clayey sand. Overlain by loose white sand.	4	
GOR-89-04	W2; Area II	100F/G	1265		UP	Dk brown, OM-rich silty clay w/ ltr and dkr mm stringers. Grey sand at base (burrow?). Yellow=decayed ls (?).	9	
GOR-89-05	W2; Area II	100F/G	1280		UP	~89-4 but thinner mass of grey brown clay w/ cc and ash(?) toward base.	9	
GOR-89-06	W2; II	100F/G	1250			Irregularly bedded yellowish brown sand with coarse charcoal fragments and yellow inclusions.	9	
GOR-89-07	W2	100F	1255		UP	Laterally equivalent to between Ä5 and Ä6. Dark brown clayey, organic matter rich at top and yellow brown sand at bottom. Yellow chalky fragments and greenish rootlet fillings.	9	
GOR-89-08		100E	1250		UP	~89-7 but org. layer is blacker and more distinct at top. Bright yell. green spots more distinct.	9	
GOR-89-09		101C	1260		UP	Brown black organic matter rich clay with whitish gritty lens (leuco-phosphite? or hyaena?). Laterally, definite coprolite dolomite fragments. Separated to S (4 through 8) by trench dug by Waechter.	9	
GOR-89-10		102C	1250		UP	Elliptical grey stain impregnating alternating light and dark brown sands. Ashes or secondary calcite? Some flecks of charcoal. Possibly terrier.	9	
GOR-89-11		103C	1265		UP	Interbedded massive homogeneous coarse brown (clayey) sand with microfauna, limpets, hyaena(?) coprolites and mm-size limestone chips. Capped by 5 mm thick brown clay band which is laterally con-tinuous over 3-4 m. Laterally bifurcates and seems to show fine laminations. Some charcoal. Layer from runoff and not ponding since it dips to back of Cave; substrate is sandy and very permeable.	9	
GOR-89-12		G111	878		MP	Bright red clayey sand ~10 cm thick. Seems colluvial.	5	
GOR-89-13		G111	870		MP	Reddish brown clay/sand with abundand charcoal flecks. More clayey than 89-12 and with cutans. Ver-tical crack to top of unit below and filled w/ quartz sand. Drying--cracking--filling.	5	
GOR-89-14		G111	865		MP	Dark yellowish brown compact clay/sand; poorer sorting than 89-13. ~1 mm rootlets with clay coat-ings (?); perhaps some fragments of burnt clay. Partly concreted with fine transparent crystals coating voids: Hydroxyapatite or calcite?	5	
GOR-89-15		G111	850		MP	Reddish brown clayey sand with angular pieces of fresh dolomite. Porous and with clay coatings, charcoal fragments, and abundant bone. Top is cemented with apatite and shows dissolved bones. First srtatigraphic unit with stones. Laterally with gizzard stones and very organic looking.	5	
GOR-89-16		G111	842		MP	[Sample partially decomposed] ~ 89-14: dark brown clay/sand with snail shells, bones and large pieces of fallen dripstone. Rich in bone; charcoal.	5	

Sample No.	Location	Square	Depth	Colour	Industry	Field Description	RIM PG Level Nos	Spectrum #
GOR-89-17		G111	837		MP	This is similar to 89-16 but slightly lighter color and with less charcoal. The bottommost sample of dark brown clay sands. Laterally to N base becomes richer in stones and grades into cemented pink sands. Where sampled, rests on pink sands and clay silts with clear straight boundary.	5	
GOR-89-18		G111	829		MP	First and upper samp of tan/pink sands and clays. Irreg. bed. and ~ to 89-1, 2, 3. Interbedded white/light pink calcareous sand on pink clay/silty sand on loose, coarse whitish sand. Charcoal sparsely dispersed. Abundant limpets and shells and coarse, angular travertine roof fall.	4	
GOR-89-19		G111	801		MP	Soft, moist band of red brown clay/sand with snail fragments, some of which are weathered. At base are clayier, charcoal-rich layers. Clay rests on soft, coarse whitish sand with sharp boundary. Zones of red clay seem to represent biological activity). This sand/clay/sand sequence laterally continues for 50 cm. To N it is increasingly cemented.	4	
GOR-89-20		G111	809		MP	Cemented whitish sand between samples 89-18 and 89-19 in lower part of photo. Irregularly thickens and thins laterally and becomes more cemented to N where dip increases. Somewhat friable.	4	
GOR-89-21		C97	1580		UP	Top of profile. Hard and horizontally layered. Bone inclusions look transformed to apatite and dolomite fragment has mm-thick weathering crust. Laterally many blocks of eboulis. Spherical grains (5-15 mm) w/ concentric layers (algal?).	10	
GOR-89-22		D98	1550		UP	Dry brown crumbly lens with charcoal flecks and creamy white spots of hyaena coprolites or leucophosphite. Quite vughy and spongy and weathers to grey brown surface. Underlies irregularly cemented pinkish and brown sands and overlies charcoal-rich seam of 89-23.	10	
GOR-89-23A		D98	1555		UP	Irregular lens of blackish brown organic/charcoal-rich sand that thins and thickens laterally over 2m. Poorly preserved burnt(?) bone. Sand below locally pinkish, probably from burning; some cm size charcoal pieces.	10	
GOR-89-23B		C98	1550		UP	Laterally = 89-23A but of thin (1-2 cm) hardened chalky plate-like mass (=ash?). Undulating and where sampled dips to S.	10	
GOR-89-24		C98	1555		UP	Soft, pink sand w/ cc flecks on soft dker pinkish brown sand w/ cc flecks. Sharp contact in middle of sample. Bot. half looks like rewkord om-rich hearth mixed with sand. Mussel remains. To S pinches out and truncated by massive sand in center of profile.	10	
GOR-89-25			750			Tony Barham sample B214. Hard, moderately cemented but friable sand w/ somewhat cavernous weathering. Somewhat ~ to series in G111 but cemented version of it.	4	
GOR-89-26			800			Same as Tony Barham's B213A. Cemented red brown clayey sand. Seems = to first samples 89-1 to -3 but with cemented ghosts of snails and some clay coatings in pores.	4	
GOR-89-27A		C98	1525		UP	Soft, powdery pinkish brown ash (~5% qtz sand) w thin stringers (5-10 mm) of brown OM-rich sand (=insect burrows?). Locally cemented w/ calcite and richer in quartz.	10	
GOR-89-27B		D97	1515		UP	Very hard, cemented ash. Fine flecks of cc and some (5%) sand. Wavy bedding, ~1 cm thick. Greyer and more creamy portions. Looks like grass ash that is secondarily cemented.	10	
GOR-89-27C		D98	1523		UP	~to 89-27A but sandier and with cm thick band of pinkish ash. Some cc. Here seems ash fills depression me into pinkish sand. Pinches out to S. Weathers whitish grey and brown when scraped.	10	
GOR-89-28		C98	1445		UP	Brownish, organic matter-rich clayey (?) sand. Massive and ~10cm thick with streaks of charcoal, sand. Clear hyaena coprolites spread over at least 1m. Dips to ESE. Possibly grades into ash. Base with lens of sand.	9	

Sample No.	Location	Square	Depth	Colour	Industry	Field Description	RIM PG Level Nos	Spectrum #
GOR-89-29		C98	1435		UP	~89-28 but slightly darker and fewer cops. Top darker brwn, OM rich clay (?). With 89-28 represents ~50 cm thick interbedded sand and brownish OM-rich clay.	9	
GOR-89-30		D98	1405		UP	Sand/clay lens under 89-29. Irregular lens and inclusion of dark brown sand. Either biological reworking of sand or soft-sediment deformation under saturated slurry. Laterally continuous and found in C98 where interfingering with ash, and to F98.	9	
GOR-89-31		B103/104	1210		NA	Cracked sand and silt. Sands grading to silt at top, and cracked to form subcubic blocks 1-3 cm on side. Lizard and snake fragments indicating ponding of water and graded bedding.	7	
GOR-89-32					NA	Reddish clay sand from ledge on N side of cave entrance at 1.5-2.0 m ASL. Massive and concreted. Laterally variable with stones and shells.	2	
GOR-89-33	Area III	E	850			Corner of exterior face and roughly lateral, cemented equivalent to 89-20. Massive, cemented coarse ss. In places seems to be algal pebbles w/ concretions around rock nucleus.	4	
GOR-95-34		B102	1251		MP	Ash lens in sand with abundant charcoal. Looks finely laminated and could be reworked by wind or water. Truncated to NE.	7	
GOR-95-35	Entrance - alcove; Unit 7				MP	From alcove entrance area on path out to West part of cave. Sample consists of shell layer in massive sand. Nick Barton found MP artifact within this. Above this is wedge shaped deposits of clast supported, angular limestone breccia with clasts ~2-5 cm in diameter. Question is how the shells originated; are they human related or natural (check to see if shells are burnt.		EYZ-1
GOR-95-36		E107	??		MP	Cemented coarse sand horizon with granule size white spots (coprolite fragments ???).	3?	EYZ-2
GOR-95-37		B102	1276	7.5YR4/4 d; 7.5YR3/4 w	MP	Compact, clayey sand with dispersed charcoal and coprolites, some bone. Crumbly and some white spots (phosphate??).	7	FAA-13
GOR-95-38		B102	1266	7.5YR5/4 d; 7.5YR4/4 w. Dry: 7.5YR5/4; wet: 7.5YR4/4	MP	Similar to 95-37 but overall slightly lighter color, although with darker band at the base. Poor sorting.	7	
GOR-95-39		B102	1257		MP	Includes ashy layer of sample 95-34 as well as finely bedded (~3 mm thick beds) lighter colored silt or ashes. Could be water washed or aeolian.	7	
GOR-95-40		B102	1249	7.5YR5/4 d; 7.5YR4/4 w; 7.5YR6/4 d; 7.5YR4/4 w	MP	Interbedded greyer and yellower silty sands with charcoal. Darker, 2 cm band runs through middle of sample. Note included in core of 95-41. Somewhat sandier than above.	7	
GOR-95-41A		B102	1270		MP	Drain pipe core collected next to samples 95-37 to 95-39.	7	EYZ-3
GOR-95-41B		B102	1270		MP	Drain pipe core collected next to samples 95-37 to 95-39.	7	EYZ-4
GOR-95-41C		B102	1270		MP	Drain pipe core collected next to samples 95-37 to 95-39.	7	EYZ-5
GOR-95-41D		B102	1270		MP	Drain pipe core collected next to samples 95-37 to 95-39.	7	EYZ-6
GOR-95-41E		B102	1270		MP	Drain pipe core collected next to samples 95-37 to 95-39.	7	EYZ-7
GOR-95-42		F98	1530		MP/UP?	Loose, not dense, finely bedded brownish crumbly sand/silt/OM with abundant cc; below a cc-rich ashy unit.	10	
GOR-95-43		G111	789		MP	Similar to 89-19 and could be same sample, although the elevations are about 12 cm off. Soft, red clayey sand with some cc (?), weathered snail fragments.	4	
GOR-95-44		D98	1400	ashes: 7.5YR6/4 d [light brown; 7.5YR3/4 [dark reddish brown]; darker sediment: 7.5YR4/4 d [brown to dark brown].	MP/UP?	Top is ~2 cm thick and comprised of sandy ash overlying darker crumbly clayey/OM rich sand. Could be hearth or reworked hearth material.	10	FAA-8

Sample No.	Location	Square	Depth	Colour	Industry	Field Description	RIM PG Level Nos	Spectrum #
GOR-95-45	Outside of cave on E side; Probably =89-32.				MP?	Ledge of red, cemented sandy clay resting above wave cut platform, ~8 m E of cave entrance and ~1.5 m above wave cut platform. Some angular, cm size rocks, rare shell, and bone; some rhizoliths. Covered by stal showing fm before cave collapsed. Seems to pre-date wave-cut cliff.	2	
GOR-95-46	Catalan Beach Hotel: rube-fied horizon in cross-bedded aeolianites.					Block from uppermost reddened horizon to see fabric and geometry between clay and sands. MUNSELL. Clayey sands, massive and with some rockfall. Reddened horizon gres downward into x-bedded sand. OSL date.		
GOR-95-47(2)A	W face of UP/MP face	C99	1240	many	MP/UP?	Finely bedded to laminated, OM rich clays and sands that tend to thicken toward the center of the cave. The bottom third or so is characterized by two thick ashy sand lenses that appear truncated at the top	7	
GOR-95-47(2)B	W face of UP/MP face	C99	1240	many	MP/UP?	Finely bedded to laminated, OM rich clays and sands that tend to thicken toward the center of the cave. The bottom third or so is characterized by two thick ashy sand lenses that appear truncated at the top	7	EYZ-9
GOR-95-47(2)C	W face of UP/MP face	C99	1240	many	MP/UP?	Finely bedded to laminated, OM rich clays and sands that tend to thicken toward the center of the cave. The bottom third or so is characterized by two thick ashy sand lenses that appear truncated at the top	7	EYZ-10
GOR-95-47(2)D	W face of UP/MP face	C99	1240	many	MP/UP?	Finely bedded to laminated, OM rich clays and sands that tend to thicken toward the center of the cave. The bottom third or so is characterized by two thick ashy sand lenses that appear truncated at the top	7	EYZ-11
GOR-95-47(2)E	W face of UP/MP face	C99	1240	many	MP/UP?	Finely bedded to laminated, OM rich clays and sands that tend to thicken toward the center of the cave. The bottom third or so is characterized by two thick ashy sand lenses that appear truncated at the top	7	EYZ-12
GOR-95-47(3)A	W face of UP/MP face	C99	1240	many	MP/UP?	Finely bedded to laminated, OM rich clays and sands that tend to thicken toward the center of the cave. The bottom third or so is characterized by two thick ashy sand lenses that appear truncated at the top	7	EYZ-13
GOR-95-47(3)B	W face of UP/MP face	C99	1240	many	MP/UP?	Finely bedded to laminated, OM rich clays and sands that tend to thicken toward the center of the cave. The bottom third or so is characterized by two thick ashy sand lenses that appear truncated at the top	7	EYZ-14
GOR-95-47(3)C	W face of UP/MP face	C99	1240	many	MP/UP?	Finely bedded to laminated, OM rich clays and sands that tend to thicken toward the center of the cave. The bottom third or so is characterized by two thick ashy sand lenses that appear truncated at the top	7	EYZ-15
GOR-95-47(3)D	W face of UP/MP face	C99	1240	many	MP/UP?	Finely bedded to laminated, OM rich clays and sands that tend to thicken toward the center of the cave. The bottom third or so is characterized by two thick ashy sand lenses that appear truncated at the top	7	EYZ-16
GOR-95-48	Layer K of Waechter		727		MP	Outer, lower section. Layer K of Waechter; d=7.27 ad. Massive partly cemented reddish clayey sand just below large travertine rich face left by Waechter. Sample from between 2 cemented levels, with well preserved limpets and limestone blocks. Laterally, splotchy brown and yellow sand.	2?	EYZ-17
GOR-96-50	E96	E96	1575		UP	~10cm thick lens of stony sand with cm-size pieces of charcoal and some bone. Limestone fragments with apatitic crusts. Quite laterally continuous over ~120 cm. Lower, part of sample is quite black and prob MN stained.	10	FQZ-2
GOR-96-51		E96	1565	reddish brown [5YR5/3]	UP	~10 cm below sample 96-50. Hard, gritty cemented sand. Locally with black (Mn?) staining. Charcoal pieces, possibly apatie; also some white, chalky blob type phosphate. This and sample 96-50 dip to E; laterally grades into tan, charcoal-rich sand.	10	FQZ-3

Sample No.	Location	Square	Depth	Colour	Industry	Field Description	RIM PG Level Nos	Spectrum #
GOR-96-52		D96	1555		UP	Soft, sandy UP hearth (decalcified). Essentially soft black material over white ash. [Sample badly smashed and may not be in tact]. Trying to collect separate loose samples of white and dark ashes. Overlain by very hard breccia layer that contains angular scree and poss. some coprolites.	10	FQZ-4
GOR-96-53		D96	1575	light brown (7.5YR6/4)	UP	Hard, slightly friable cemented sand with some angular stones and some bone. Also some darker brown/black zones, possible from charcoal. Just above sample 95-52 and stratigraphically above 96-50.	Historic	FQZ-5
GOR-96-54		B104	1212	dark brown [7.5YR6/4]=up.; light brown [7.5YR6/4] =lwr	MP	Top of section. Darker brown silty clay [7.5YR5/4] at top overlying light brown [7.5YR6/4] friable, massive sand. Some stones. Laterally, upper darker zone seems to thicken and thin.	9	GLG-1
GOR-96-55		B104	1201		MP	Similar to sample 96-54, but with darker zone of clayey sand in the middle and some finer limestone (?) granules. Dark zone also thickens and thins irregularly and fades out to E.	9	GLG-2
GOR-96-56		B104	1177		MP	Thick block of generally massive brown clayey sand with charcoal, angular stone fragments. Generally no bedding but there are some thin clayey silty laminae at top [= water laid]. Harder and more clayey at the base. Laterally, w/ contorted bedding.	9	GLG-3, -4
GOR-96-57		B104	1158		MP	Clayey silty sand. Generally massive with some stones. Could be terrier since not signs of bedding are visible. Some gravelly stringers found laterally to N.	9	GLG-5
GOR-96-58		B104	1140		MP	Finely laminated silty clays within generally loose, massive sand. Laterally cut by ~ 32 cm Ø burrow (badger or porcupine?). Laminations are quite laterally continuous across the section: ~2 m S and ~ 1 m to N.	9	FQZ-6
GOR-96-59B		E111/112	910		MP	2 layered sample from E wall above sampling column from 1989 and between red markers 307 and 310 from Jill Cook s excavation. Upper half: brown (7.5YR5/4), compact silty sand with some white spots (carbonate??). Laterally with some stones and weathered shells. Looks like one of the brown guano layers from 1989, but could also be silt/clay. Lower half: similar but clayier and with redder color (yellowish red; 5YR5/6). Compact but friable. Lots of bone; some Levallois flakes. Lateral variations not clear because profile needs cleaning. In short, wish to see if darker/red color is due to guano or red clay/silt.		FQZ-7, 8
GOR-97-60		C106	1050	reddish yellow [7.5YR6/8]		Massive, reddish yellow [7.5YR6/8] coarse, slightly silty sand at bottom of excavation. Could be colluvially washed, emanating from travertine pillar. Under charcoal of 97-62.	6	GXW-02
GOR-97-61	C107		1100			Cemented coarse sand, stalagmitic crust with charcoal. Charcoal decreases to east, away from supposed location of fire.		
GOR-97-62		D105	1070			Ca. 5 cm thick, finely bedded charcoal layer within sand. Looks wind-dispersed charcoal concentration at base with secondary concentration about 1 cm above it. Charcoal layer dips to S and seems to climb to N. Lots of flints in this unit. Could be stratigraphic equivalent to 97-61.	6	GXW-03
GOR-97-63		D100	1260			Lower ~50 cm or so is generally sandier, more massive, and lighter color than upper part which seems to contain an ashy lens and assoc burned substrate. Above ~12 m there is a shift to more of an "organic facies" grading up to finely laminated water-laid/ponded facies. This organic layer is very roughly equivalent to GOR-89-9 which EDAX gave as phosphate. Fine, vein-like filling of mamillated apatite. 5 sub-units were recognized (a) dark red brown [5YR3/3] = coarse bedded organic rich silty clay; (b) brown [7.5YR5/4] = lens of altered ash (probably decalcified). (c) dark red [2.5YR3/4] = fire reddened (?) zone beneath ash.	9	GXW-01?

Sample No.	Location	Square	Depth	Colour	Industry	Field Description	RIM PG Level Nos	Spectrum #
						(d) dark brown [5YR4/4] = speckled white (AP) zone of phosphatic sediment.		
						(e) dark brown [5YR4/4] = similar to (d) but fewer speckles		
						Below this core, there are many more burrows as seen in Polaroid [see field book for photo].		
GOR-97-64		D101	1265			Laterally equivalent to 97-63. Consists of finely laminated organic clays and silts and coarse bedded brown sands. Brown laminae are more compact (clay?) than silty and sandy ones. Basically 3 subunits:	9	
						(a) dark reddish brown [5YR3/3] massive to crudely bedded, organic-rich sand with flecks of red (fire reddened clay (?); = 97-63(a).		
						(b) dark red [2.5YR5/4], organic clay, finely laminated. Partly equivalent to 97-63(c).		
						(c) strong brown [7.5YR5/4] laminated to coarsely bedded organic rich sand. Not apparently phosphatised and appears to be burrow, since much of lower part is burrowed.		
GOR-97-65		D98	1370	dark brown		Dark brown, irregular & interbedded light sand and dark organic sand; local zones and domains of tan sand. Irregular bedding poss. due to downward leaching of organic matter. Grades up to higher proportion of sand.	9	
GOR-97-66		96D	1530		UP	Finely laminated organic-rich silt/clayey sand, with about upper 2 cm being cemented. Charcoal dispersed below it. Perhaps some carnivore coprolites within it and decaying cm size rockfall. Seems to be de-calcified with some secondary incrustation of carbonate (recent??). Looks similar to organic sediments where abundant coprolites were found in 1989. Underlain by laminated sand containing stringers of clay, ~4-10 cm thick; i.e., sand underneath also looks like it is waterlain.	10	
GOR-97-67		D95	1565	grey [5YR4/3]		Upper hearth = grey [5YR4/3], charcoal/organic rich sand, about 2-3 cm thick with orange spots (bone?) and locally capped by ~ 5 mm thick tan silty sand layer. Lower contact is quite irregular and undulating and possibly bioturbated (insects). Unit is quite continuous across the cave and about 3 m across. It probably represents major burning event but much charcoal and little ash. The underlying sediment is cemented sand about 5-7 cm thick. This sand rest with sharp contact on lower charcoal-rich unit that is equally widespred across the cave. It too looks locally bioturbated by insects.	10	GXW-04
GOR-97-68		D95		very dark grey [5YR3/1]		Lower hearth. Very dark grey [5YR3/1] (~ 30 kyr). Small sample of organic and charcoal rich sand. Overlies with irregular contact lighter, organic-rich sand with cm size flecks of charcoal.	10	
						Upper hearth = grey [5YR4/3], charcoal/organic rich sand, c. 2-3 cm thick with orange spots (bone?) and locally capped by ~ 5 mm thick tan silty sand layer. Lower contact is quite irregular and undulating and possibly bioturbated (insects). Unit is quite continuous across the cave and c. 3 m across. Probably represents major burning event but lots of charcoal and little ash. Underlying sediment is cemented sand about 5-7 cm thick. This sand rest with sharp contact on lower charcoal-rich unit that is equally widespread across the cave. It too looks locally bioturbated by insects.		
GOR-97-69		C97	1405			(40 cm core) from crudely bedded, interbedded dark brown organic rich sand and irregular beds of loose sand. Bioturbation and/or soft sediment deformation. Sub samples	9	
						Dark sand (a); Tan sand (b); Dark sand (c); Dark sand (d)		
GOR-97-70		B106	1329			Interbedded sand and silty sand. 40cm core. 5 sub layers.	9	
						(a) Massive to weakly bedded sand rich in charcoal. 7.5YR5/4; 7.5YR6/4 (brown to light brown).		
						(b) Sandy layer 10YR7/6 (yellow) with mm size stony bits.		

Sample No.	Location	Square	Depth	Colour	Industry	Field Description	RIM PG Level Nos	Spectrum #
						(c) Dark brown (7.5YR3/4) Stringers of silty clay within darker brown massive silty sand of (d).		
						(d) Strong brown (7.5YR5/6) massive silty clay with some mm size angular stones.		
GOR-97-71		B107	1350			Upper continuation of 97-70. Finely bedded and coarser sand.	9	
						(a) 7.5YR4/4 finely bedded silty sand with calcium carbonate.		
						(b) 10YR6/6 crudely bedded sand grades up to (a). Locally cut by channel.		
GOR-97-72		D100	1265			Large block representing upward continuation of 97-63. Finely laminated organic rich silty/sandy clay. Basically 2 subunits.	7 or 8	GXW-06
						(a) 5YR/32 Dark reddish brown with some pale brown spots that in hand lens appear to be washed sands with no matrix. Highly fluorescent in UV (organic matter ?).		
						(b) 5YR3/2 Dark reddish brown but with fluorescent bulb looks light and very bottom is darker brown and or red.		
						Entire sequence is water laid but not clear how to get these washed zones		
GOR-97-73						NO SAMPLE?		
GOR-97-74		D101	1265			Next to 97-64 but is large plaster cast (15x15x35). Saved as an archive.	9	
GOR-97-75						Chunks of aeolianite at top of steps.	Pleist	
GOR-98-150	Context 26	D100	1171			Nigel collected sample [Nigel s notes: manganese pair layer, covering most of Sq. D100, some of C100, with limestone and concretion within it. And yellow/silver sands above and below]. Tabular sand, about 2 cm thick. Circular manganese domains about 5 mm in diameter. Definitely secondary.	7?	
GOR-98-151		G111	744	yellowish red [5YR5/6]	MP	Massive yellowish red [5YR5/6], clayey sand about 15 cm thick. Sharp upper and lower contact with lens of coarse sand; lower contact wavy and to E rests on clayey light brown sand. Seems too red to be guano but more likely terra rossa. Sample 89-16, etc. are in darker brown sediments. Contains snail shell fragments and some chips of limestone.	5	
GOR-98-152		G111	844	dark reddish brown [5YR3/3]	MP	Greasy sandy organic silty clay with much charcoal. Looks cultural but origin of clay is not clear. Likely equivalent to 89-13 or 89-14 (is located just above 89-14). Seems fine bedded to laminated.	5	
GOR-98-153		G111	829	dark reddish brown [5YR3/3]	MP	Plastic slightly sandy clay with charcoal or manganese? Stal pieces and inclusions. Abundant bone in condition. To W, sediment seem more phosphatic and limestone seems slightly altered. Some snails but they look slightly decalcified. Possibly mm thick ash layer in middle of sample. Could be mixture of charcoal, guano, and hearth ashes (decalcified??).	5	
GOR-98-154		E110	920	dark reddish brown [5YR3/3]	MP	Just below stal/plancher layer. Large sample. Upper 6 cm is finely bedded to laminated dark reddish brown organic silty clay sand with charcoal fragments and white flecks (limestone?).	5	
GOR-98-155		E110	938	dark reddish brown [5YR3/3]	MP	~2 cm thick layer of sandy silty clay (burrow). Very irregular shape and ~40 cm wide. Sample mostly clay but with some sand above and below it.	5	
GOR-98-156		E97	1387	several	MP	40 cm core below bench on top of Context 18. Core driven in below surface an to be collected after surrounding sediment is excavated. [SEE FIELD BOOK FOR DRAWING]. Generally from top down:		NHB-005
						1) Dense, moist, greasy, dark brown clay		
						2) Dense, organic matter-rich clay with possible fine bedding and sand stringers. Becomes lighter at base.		
						3) Reddish brown silty clayey sand. Probably phosphate. Laterally to E, sediments are phosphatic (apatite, leucophosphite and taranakite).		
						Entire complex dips strongly to S and rests on bedded calcareous sands (Context 19), particularly in E part of cave, where overall, sediments are more sandy, less organic and with lower amounts of silt and clay.		

Sample No.	Location	Square	Depth	Colour	Industry	Field Description	RIM PG Level Nos	Spectrum #
GOR-98-157		E97	1396	dark reddish brown [5YR3/2].	MP	Greasy sandy clay, massive, moist, blocky structure. Very organic. Lenses out ~1 m to E. Could be depression filled with standing water & clay.		KSD-1
GOR-98-158		E97	1388	dark reddish brown [5YR3/2].	MP	~ 98-157 but sandier, lighter color and less organic. But with numerous white (phosphatic) flecks on surface. Soft and moist, greasy. Orange streak through middle of sample (phosphate??).		KSD-2
GOR-98-159		E97	1375	reddish brown [5YR4/4]	MP	Large, massive sample of organic rich sandy clay at top; reddish brown [5YR4/4], grading downward to drier, clayey sand with many phosphatized limestone ghosts.		KSD-3 thru -5
GOR-98-159		E97	1375	reddish brown [5YR4/4]	MP	Large, massive sample of organic rich sandy clay at top; reddish brown [5YR4/4], grading downward to drier, clayey sand with many phosphatized limestone ghosts.		KSD-3 thru -5
GOR-98-160	Trench at base of profile, near surf zone			yellowish red [5YR5/6		Silty sand. Soft but slightly compact, massive silty sand with some limestone flecks but looks decalcified. Grual lower contact with 98-161.		KSD-6, 7; NHB-006, 007, 008
GOR-98-161	Trench at base of profile, near surf zone			yellowish red [5YR5/8]		Yellowish red [5YR5/8] silty coarse massive sand with snail fragments. Poorly sorted and looks colluvial. Iron coats on grains. Gradual lower contact.		
GOR-98-162	Trench at base of profile, near surf zone			reddish yellow [5YR6/6]		Partly cemented silty sand; less silt than above. Cementation possibly by clay or silica and cot calcite.		KSD-8
GOR-98-163	Trench at base of profile, near surf zone			pink [7.5YR7/4]		Friable to weakly cemented, poorly sorted sand. Very little red silt and probably represents parent material. Possibly carbonate cement? Distinct boundary with 98-162.		
GOR-98-164	inside cave	D97	-13.96			Sample is equivalent to sample 98-157: Dark, greasy silty sand, but thin laminar of orange material that has ~1-1 mm of phosphatic clearly brown cement below it (apatite?).		KSD-9
GOR-98-164	Beachrock/ soil					Beachrock/soil. Plate-like mass just down from JP s trench, immediately W of bedrock at surf zone. Well indurated coarse, well rounded sand with calcareous shells (marine??), but likely diagenetically altered by sea spray. Many heavies.		KSD-9
GOR-98-165		B108	1152	reddish brown [5YR4/4]		Finely bedded ash(?) and charcoal in reddish brown silty sand. Looks like small hearth. Very soft sample and possibly disturbed during sampling.		
GOR-98-166		C102	1156	light brown [7.5YR6/4]		Massive to light brown [7.5YR6/4] silty sand. To W of here sediments start to become more moist, organic, less sandy and more burrowed. Slightly darker sediment and finer sand at top. Bone and possible hyaena coprolite. Some whitish flecks in hand lens (decomposed limestone?). Thin slaking crust consisting of a clay layer at the top. Good shell (e.g., Turritella sp.) preservation here. Above this in Sq. B102, z=~~12.50, collected long core in bedded sandy calcareous facies.		
GOR-98-167		C99/100	1135			Unoriented, platy sample of phosphate crust which dips back to W. Samples for THIN SECTION and XRD. Reddish and root beer color (APATITE?). Below this, seem to get into more diagenetic areas.		
GOR-98-168	Orange label # 228	C99	1165			Unlocated sample. From lower part of profile, below massive hearth/black --> burrowed zone --> sand --> finely laminated om.		KSD-10
GOR-98-169	Area I (E) Orange label # 229	B100				Unlocated sample. From zone between calcareous and phosphatic sediments; base penetrates into organic rich horizontal layer, sand and massive brown laminated sand above that.		
GOR-98-170						Unknown sample collected by team on 4 Sept 1998. Sample (5), cxt 25		
GOR-98-171						Unlocated sample.		

Appendix 3
Dating methods referred to in Chapter 5
T. F. G. Higham, C. Bronk Ramsey, H. Cheney, F. Brock and K. Douka

FTIR, SEM and XRD

FTIR spectroscopy is an analytical technique mainly used in the identification of organic materials, but can be also used in some inorganic cases, such as the study of different calcium carbonate polymorphs. The carbonate ion in calcite has a planar symmetry, while the carbonate ion in aragonite has a non-planar symmetry (Hakanen and Koskikallio 1982); thus, IR spectroscopy has been used to distinguish between the two polymorphs (Subba Rao and Vasudeva Murthy 1972; Compere and Bates 1973; Xyla and Koutsoukos 1989; Balmain *et al.* 1999; Vagenas *et al.* 2003). It has been reported to detect very low mol-% in binary and tertiary mixtures of polymorphs; however, it has not been systematically applied on archaeological molluscan material prior to ^{14}C dating (but see Sivan *et al.* 2006).

Carbonate samples were prepared with KBr (1 mg of sample mixed with 100 mg of overnight-dried KBr) in 13 mm pellet die, which was then compressed for five minutes under 8 kPa cm^{-2} of pressure using a Graseby Specac® hydraulic press. The pellets were analysed in a Nicolet Magna-IR Spectrometer 550 and the spectra were recorded in adsorbance mode over the wavenumber range 4000–400 cm^{-1}. Each spectrum was averaged after 32 scans using a spectral resolution of 4 cm^{-1}.

The use of FTIR to obtain quantitative relative abundances of calcite and aragonite proved to be complicated, as a result of the extensive peak overlap between the polymorphs. This made the selection of appropriate bands for quantitative analysis and assignment of peaks a very difficult task. Moreover, the accuracy of FTIR was not sufficient to distinguish the presence of calcite reliably at the 1–3 wt-% levels required; therefore, the technique was not applied further to the archaeological samples.

Identification and quantification of minerals is the most common application of powder XRD (e.g. Milliman 1974; Bish and Post 1993). Quantitative determination of the mineralogical composition of carbonate mixtures with XRD has been the focus of many workers (Weber 1967; Gunatilaka and Till 1971; Gavish and Friedman 1973; Hakanen and Koskikallio 1982; Hardy and Tucker 1988; Kontoyannis and Vagenas 2000; Dickinson and McGrath 2001; Chiu *et al.* 2005; Reimer *et al.* 2006) but is still considered by many to be inaccurate, and is thus often described as semi-quantitative (for a discussion see Hillier 2003). Two main factors, sample preparation and method used to allow the quantification of the different phases in a mixture (for example Reference Intensities Ratios (RIR) method, Rietveld or 'full-pattern' method, the internal standard method), play a key role in the ability to improve detection and quantification

limits and obtain reliable and reproducible results within acceptable errors. Moreover, since the lower limit of detection for a given mineral is inversely proportion to its respective RIR, the best diffractors (larger RIRs) will have the lowest detection limits (Hillier 2003, 221). Since calcite is a much stronger diffractor compared to aragonite, detection of calcite traces in aragonite mixtures (as low as 0.1 wt-%) is feasible (S. Hillier, pers. comm.). Obviously this holds tremendous potential for improved AMS measurements of shell carbonates analysed to this detection level.

For this work, standards were prepared for quantitative analysis of the XRD spectra, using biogenic calcite (*Pachyteuthis* sp.) and aragonite (*Sepia officinalis*), in proportions of 1, 10, 20, 30, 40 and 50% by weight of each component. For all mixtures and both end members, 10 mg was prepared. The aim was to develop a calibration spectrum of known biogenic calcite/aragonite carbonates to enable quantitative estimates of any calcite present in the archaeological shells. XRD analysis was performed using a Philips PW 1729 XR diffractometer operating at 40 kV and 30 mA using Cu Kα radiation. Diffraction patterns were recorded by step scanning from 25–38°2θ on the Brag scale, with a step-size of 0.02° and counting for 2.5 s per step.

Unfortunately, the standards prepared did not enable us to achieve a reliable calibration curve, because they were derived from the shells of different species, which meant that their diffraction behaviour was different. This is most likely to be a result of differing amounts of both magnesium and strontium, which can substitute for calcium in the calcareous lattice. Since Mg^{2+} and Sr^{2+} ions are of a different size to the Ca^{2+} ion, there is a change in lattice spacing, which will shift and distort the diffraction peaks. The XRD data, therefore, were used only qualitatively. As mentioned above, this research is ongoing. In Figure 5.1, typical XRD spectra are shown for some of the Gorham's samples analysed.

SEM was also used to document directly the preservation state of the aragonite. A JEOL JSM-840A SEM in the Earth Sciences Department at the University of Oxford was employed in the analysis of sectioned shell carbonates. In the mussels, the arrangement of the nacreous aragonite comprises hexagonal platelets that grow by screw dislocation as laminae of horizontal tablets (England 2007, 308). This allows a straightforward estimation of the preservation state of this material. When micro-banding (and therefore calcite reprecipitation in the sample) was visible under SEM, these shells were excluded from dating. Even so, minor contamination cannot be completely ruled out and certain samples appear to have been affected by trace

diagenetic alteration despite these screening procedures. An additional caveat is that SEM analysis is restricted to a single portion of a shell and cannot be used to check all crystalline facies.

The samples examined showed a similar range in their preservation state. A qualitative assessment of the preservation state of each of the examined carbonate sections under SEM was given. Examples are given in Figure 5.2. At best, the nacreous layer was preserved in pristine condition (Figs. 5.2a, e, f, g) and these examples are therefore termed 'well-preserved' (Table 5.2). Individual laths were usually ~10 mm long and arranged in sheets parallel to the shell margins. In some examples, the nacreous structure had been totally replaced during recrystallization by coarser, prismatic calcite (Fig. 5.2b) (these were therefore termed 'recrystallized' in Table 5.2). In other cases, the occurrence of dissolution caused a lack of definition of the edges of laths in some examples, and in one instance resulted in an etched surface on the laths (Fig. 5.2d). In another instance, this was accompanied by cementation between laths (Fig. 5.2h). These examples were termed 'poorly preserved', despite the fact that visible diagenetically altered carbonate was very rarely observed. In other specimens, however, bands of recrystallized calcite were observed under SEM, typically occurring in bands between well preserved sheets of aragonite laths (see Fig. 5.2c micrograph; these were labelled 'poorly preserved, bands of recrystallization' in Table 5.2). The specimen shown in Figure 5.2c, for example, produced an XRD spectrum showing a possible trace calcite peak and the SEM seems to confirm this trace of diagenetic alteration. Cements typically fill pore space between laths; however, this is often difficult to identify even using SEM.

Radiocarbon AMS dating

Approximately 30 mg of each screened carbonate sample was ground in an agate pestle and mortar and reacted with 2–3 ml of 84% ortho-phosphoric acid *in vacuo* using a two-armed Pyrex reaction vessel. Pretreated samples of charcoal were combusted and mass spectrometrically analysed using a Europa ANCA Roboprep interfaced to a Europa 20/20 IRMS operating under continuous-flow mode. CO_2 from the combustion was cryogenically distilled and graphite prepared by reduction of CO_2 over an iron catalyst in an excess H_2 atmosphere prior to AMS radiocarbon measurement (Bronk Ramsey and Hedges 1997). CO_2 from the carbonate reaction was recycled through the mass spectrometer and purified and then graphitized prior to AMS dating (see Bronk Ramsey *et al.* 2004 for a review of the Oxford AMS system).

Laboratory and processing background for the carbonate samples was tested by running blanks of the IAEA C1 Carrara Marble standard. These gave an average background of 0.00057 ± 0.00062 fM (fraction modern, where 1.0 fM = 1950 AD and 0 fM is background), with the graphitization blank background subtracted. Three Vanguard samples were AMS dated to determine a more suitable background correction, because, as described above, it is useful to use a background material closely similar to the unknown samples they are compared to. The samples from Vanguard were obtained under the assumption that they were older

than the radiocarbon limit (*c.*50–55,000 BP) in order to be used to assess the necessary background correction for reliable shell carbonate dating. Previous researchers dating foraminiferal carbonate have found measurable amounts of ¹⁴C activity resulting in finite ages for material known to be beyond the radiocarbon limit (Schleicher *et al.* 1998). These low levels of activity persist despite modifications in preparative chemistry (Nadeau *et al.* 2001). It is likely that this residual radiocarbon activity originates from trace amounts of diagenetically recrystallized carbonate of a more recent age, although Schleicher *et al.* (1998) have suggested that another possibility might be that modern CO_2 may also be adsorbed onto shell carbonates after wet pretreatments. If it can be shown unequivocally that the carbonate selected for dating has not undergone isotopic exchange, the probability of obtaining reliable dates is increased. Both Schleicher *et al.* (1998) and Nadeau *et al.* (2001) found that using routine mineral backgrounds was not appropriate for determining actual background when dating biogenic carbonates >30 ka. They suggest obtaining background samples of the same species as the unknown material being dated, preferably from the same location. This methodology was initially adopted at ORAU for this programme of dating. Whilst the Vanguard samples were assumed to be of greater age than the radiocarbon limit, the results disclosed a higher concentration of radiocarbon than expected (Table 5.A1). OxA-12512 and OxA-12513 yielded radiocarbon ages of 37,640 ± 300 BP and 38,690 ± 320 BP respectively, despite producing XRD spectra that disclosed no significant calcite peaks. OxA-12648 produced a radiocarbon age of 46,900 ± 650 BP, which was the oldest date obtained in the study. This sample showed a small calcite trace in XRD although the sample appeared to be well preserved on SEM micrographs. How may these results be explained? There seem at least two possibilities. First, that there are low levels of unremoved contamination in two instances that have not proven detectable using our methods. Second, that the Vanguard Cave shell samples are not as old as thought (see Rhodes and Higham, this volume). The 46 ka result might represent the background attainable at these sites using marine shell carbonates, but further work is needed. Given the background results obtained using Carrara Marble, sample processing contamination can be set to one side and it seems likely, therefore, that the archaeological shells have been influenced by small amounts of precipitated carbon contamination. More measurements are clearly required to determine whether this is correct, but unfortunately few shells remain from Vanguard for further analysis. At this juncture, the application of a background correction value based on the Vanguard material is premature, given the variation in the measured ages, the poor shell preservation compared with carbonate from Gorham's Cave, and the few dated substrates.

Table 5.A1 AMS results for shell carbonates from Vanguard Cave.

OxA no.	Sample no.	Context	Conventional radiocarbon age BP	d13C (‰)
OxA-12648	Van98 1022	160	46900 ± 650	-0.04
OxA-12512	Van98 1024	160	37640 ± 300	-0.60
OxA-12513	Van98 1044	160	38690 ± 320	-0.50

Appendix 4
Occurrence of bird taxa by stratigraphic unit

J.H. Cooper

Species occurrence by stratigraphic unit, Gorham's Cave

Stratigraphy	Total Stratified NISP	Unstrat. NISP	Surface	BeSM (Ossm).1	BeSM (PLSsm).3	LBSmff.1-2	LBSmcf.1	LBSmcf.2	LBSmcf.4	LBSmcf1-4	LBSmcf.5	LBSmcf.6	LBSmcf.7	LBSmcf.8	LBSmcf.9	LBSmcf.10	LBSmcf.11	LBSmcf.12	LBSmcf.13	SSLm (usm).2	SSLm(usm).3	
Total no. samples	.	.	7	2	22	2	2	16	37	5	44	19	13	12	24	4	20	12	9	3	1	
Total NISP	2450	151	117	7	232	10	8	226	535	23	453	49	59	88	384	11	114	77	31	24	2	
Total Non-ids	6372	0	108	2	471	51	5	559	1371	43	1198	164	180	99	1212	37	358	292	74	139	9	
Overall Total	8822	151	225	9	703	61	13	785	1906	66	1651	213	239	187	1596	48	472	369	105	163	11	
Podiceps cristatus/grisegena	1	0	1	
Podiceps cf. *auritus*	1	0	1	
Fulmarus glacialis	1	0	1	
Pterodroma sp.	30	1	1	.	.	.	1	1	9	.	2	.	.	.	13	.	1	2	.	.	.	
cf. *Pterodroma* sp.	1	0	1	
Calonectris diomedea	2	0	1	1	.	.	.	
cf. *Calonectris diomedea*	1	0	1	
Puffinus ?mauretanicus	3	0	1	1	.	.	.	1	
Hydrobates pelagicus	3	1	2	1	
Phalacrocorax aristotelis	3	0	1	1	.	1	
Branta ?bernicla	2	1	1	.	.	1	
Branta sp.	1	0	1	
Tadorna sp.	1	0	1	
Anas cf. *platyrhynchos*	1	0	1	
Anas ?platyrhynchos/strepera	1	0	1	
Anas ?strepera/acuta	1	0	1	
Anas ?crecca/querquedula	4	0	.	.	1	.	.	.	2	.	1	
cf. *Anas* sp.	1	0	1	
cf. *Aythya ?fuligula*	1	0	1	
cf. *Aythya ?ferina/marila*	1	1	1	
cf. *Aythya* sp.	1	0	1	
Clangula hyemalis	18	1	5	8	.	1	.	.	1	3	
cf. *Clangula hyemalis*	22	5	3	5	.	3	.	.	2	4	.	1	1	3	.	.	
Melanitta nigra	4	0	1	3	
cf. *Melanitta nigra*	6	1	1	.	.	3	1	.	1	.	.	.	
Melanitta fusca	5	0	1	.	1	2	.	1	
cf. *Melanitta fusca*	1	0	1	
cf. *Melanitta* sp.	0	1	
Anatidae: Small	3	0	1	1	1	
Anatidae: Medium	58	0	3	12	13	.	6	1	1	2	13	1	1	3	1	1	.	
Anatidae: Large	4	1	2	.	.	1	.	.	.	1	
Milvus milvus/migrans	9	1	2	.	2	.	.	2	1	.	1	.	.	.	1	
cf. *Milvus milvus/migrans*	1	0	1	
Haliaeetus albicilla	1	0	1	.	
cf. *Neophron percnopterus*	1	0	1	
Gyps fulvus	8	0	2	1	.	1	1	2	1	.	.
Accipiter gentilis	1	0	1	
cf. *Accipiter gentilis*	2	0	1	.	.	.	1	
Accipiter nisus	10	1	6	.	4	
Aquila cf. *chrysaetos*	0	1	
cf. *Aquila* sp.	1	0	1	
Circus ?cyaneus	0	1	
Accipitridae	4	1	.	1	1	.	.	1	.	.	1	
Falco naumanni	12	0	2	3	1	3	.	.	1	.	1	.	1	.	.	.	
Falco cf. *naumanni*	16	0	1	2	.	6	.	.	1	2	.	3	1	.	.	.	
Falco tinnunculus	7	1	1	1	.	.	5	

Stratigraphy	Total Stratified NISP	Unstrat. NISP	Surface	BeSM (Ossm).1	BeSM (PLSsm).3	LBSmff.1-2	LBSmcf.1	LBSmcf.2	LBSmcf.4	LBSmcf1-4	LBSmcf.5	LBSmcf.6	LBSmcf.7	LBSmcf.8	LBSmcf.9	LBSmcf.10	LBSmcf.11	LBSmcf.12	LBSmcf.13	SSLm (usm).2	SSLm(usm).3
Falco cf. *tinnunculus*	19	0	1	6	1	5	1	.	.	3	.	1	.	.	1	.
Falco peregrinus	2	0	1	1
Falco sp.: Small	40	1	.	.	2	.	.	3	15	.	6	1	.	.	9	.	2	1	1	.	.
cf. *Falco* sp.: Small	1	0	1
Alectoris sp.	164	8	10	1	29	2	.	12	22	3	32	4	3	6	24	.	6	4	3	3	.
cf. *Alectoris* sp.	0	1
Coturnix coturnix	16	1	4	7	4	.	.	1	.	.	.
Rallus aquaticus	4	0	2	.	1	.	1	.	.
Porzana ?porzana	5	0	1	4
Fulica atra	3	0	1	.	2
Otis tarda	1	0	1
Glareola pratincola	1	0	1
cf. *Glareola pratincola*	1	0	1
Haematopus ostralegus	1	1	1
cf. *Haematopus ostralegus*	1	0	1
Burhinus oedicnemus	1	0	1
Vanellus vanellus	2	0	2
cf. *Vanellus vanellus*	2	0	.	.	1	1
Pluvialis ?squatarola	1	0	1
cf. *Pluvialis* sp.	4	0	2	1	.	.	1	.
Pluvialis/Vanellus	1	0	1
Charadrius sp.	2	0	1	1
cf. *Charadrius* sp.	0	1
Scolopax rusticola	13	0	.	.	2	.	.	.	6	.	4	1
Limosa sp.	2	1	2
cf. *Limosa* sp.	2	0	1	.	1
Numenius phaeopus	6	1	1	.	1	.	.	.	1	1	2
cf. *Numenius phaeopus*	15	0	1	.	8	3	1	2	.	.	.
Numenius arquata	12	1	1	.	1	.	.	1	3	.	2	.	.	2	2
cf. *Numenius arquata*	4	0	3	1
cf. *Tringa totanus*	7	0	1	3	1	.	1	1
cf. *Tringa* sp.	1	0	1
cf. *Arenaria interpres*	1	0	1
Calidris cf. *canutus*	5	0	2	.	3
Calidris sp.	3	1	2	1
Calidris alba/alpina	25	1	1	.	3	.	.	.	8	.	7	1	2	.	2	.	.	.	1	.	.
Phalaropus ?fulicarius	3	0	2	.	.	.	1
Scolopacidae: Small	46	0	1	.	2	.	.	3	15	1	8	2	1	.	10	.	3
Scolopacidae: Medium	26	0	.	.	2	.	.	3	5	.	6	1	.	1	5	.	2	.	1	.	.
Larus marinus	3	0	2	1	.	.	.
cf. *Larus marinus*	1	0	1
Larus argentatus complex	1	0	1
Larus ?ridibundus	1	0	1
Larus sp.	2	0	1	.	1
cf. *Rissa tridactyla*	1	0	1	.
Laridae	10	0	1	.	4	.	.	.	5
Sterna sp.	3	0	.	.	1	1	.	.	.	1
cf. *Sterna* sp.	1	0	1
Chlidonias ?niger	5	0	1	4
Chlidonias sp.	1	0	1
Sternidae	3	0	1	.	.	.	1	1
Pinguinis impennis	1	0	1
Alca torda	4	0	1	1	1	.	.	1	.	.	.
Fratercula arctica	2	1	1	1
cf. Alcidae	1	0	1
Columba cf. *livia*	27	0	4	.	6	.	1	3	6	1	3	.	.	.	3
Columba cf. *oenas*	7	0	.	.	1	.	.	.	2	.	2	.	.	.	2
Columba livia/oenas	1028	58	51	2	115	6	2	116	218	9	161	20	25	48	151	4	54	31	6	7	2
cf. *Columba livia/oenas*	5	1	.	.	1	.	.	1	1	.	1	.	1
Columba palumbus	18	3	2	2	3	.	7	.	.	.	1	1	1	1	.	.	.
cf. *Columba palumbus*	2	0	1	.	1	.	.
Streptopelia turtur	6	1	1	3	.	2
cf. *Streptopelia turtur*	1	0	1
Otus scops	8	1	1	1	.	1	.	.	.	3	.	1	.	1	.	.
cf. *Otus scops*	1	0	1

Stratigraphy	Total Stratified NISP	Unstrat. NISP	Surface	BeSM (Ossm).1	BeSM (PLSsm).3	LBSmff.1-2	LBSmcf.1	LBSmcf.2	LBSmcf.4	LBSmcf1-4	LBSmcf.5	LBSmcf.6	LBSmcf.7	LBSmcf.8	LBSmcf.9	LBSmcf.10	LBSmcf.11	LBSmcf.12	LBSmcf.13	SSLm (usm).2	SSLm (usm).3
cf. *Bubo bubo*	4	1	1	3
Athene noctua	58	5	1	1	13	.	1	1	5	.	9	.	4	1	19	.	2	1	.	.	.
cf. *Athene noctua*	5	0	3	.	.	1	.	.	1
Strix aluco	4	2	1	1	.	.	1	1
cf. *Strix aluco*	1	0	1
Asio flammeus	0	3
cf. *Asio flammeus*	0	1
Strigidae	3	0	.	1	1	1
Caprimulgus ?ruficollis	1	0	1
Apus apus/pallidus	62	12	1	1	4	.	.	3	15	.	18	3	1	1	4	1	5	2	3	.	.
cf. *Apus apus/pallidus*	1	0	1
Upupa epops	1	0	1
Picus viridis	2	0	1	1
Dendrocopos ?major	8	0	1	.	1	1	.	.	4	.	.	1	.	.	.
?Melanocorypha calandra	1	1	1
Hirundo ?rustica	3	0	.	.	1	.	.	.	1	.	1
Hirundo ?rupestris	4	0	.	.	2	.	.	1	1
Hirundo sp.	16	1	.	.	1	.	.	1	4	.	5	.	2	1	2
cf. *Hirundo* sp.	3	0	.	.	1	1	.	.	.	1
Delichon urbica	2	0	.	.	1	1
Anthus sp.	2	0	2
Anthus cf. *pratensis*	2	0	1	.	.	1
cf. Motacillidae	0	1
Prunella modularis	2	0	1	.	.	.	1
Oenanthe ?leucura	1	0	1
cf. *Erithacus rubecula*	1	0	1
Erithacus/Luscinia	1	0	1	.
Sylvia ?atricapilla/hortensis	0	1
Monticola cf. *solitarius*	1	0	1
Turdus sp.*	9	0	1	3	1	2	2	.
cf. *Turdus* sp.*	2	0	1	.	1
Turdus sp. Group 8*	1	0	.	.	1
Turdus sp. Group 9*	1	0	1
Turdidae*	3	1	1	.	.	1	.	.	1
Parus ?major	1	0	1
Parus sp.	1	0	1
Lanius excubitor/minor	1	0	1
Cyanopica cyanus	2	0	1	.	1
Pica pica	2	0	2
cf. *Pica pica*	2	0	1	1
Pyrrhocorax graculus	3	0	.	.	1	.	2
cf. *Pyrrhocorax graculus*	8	0	1	1	.	2	2	1	1	.	.
Pyrrhocorax pyrrhocorax	119	10	4	.	17	.	.	5	32	2	19	1	1	2	23	2	3	4	2	2	.
cf. *Pyrrhocorax pyrrhocorax*	89	4	3	1	8	.	.	10	19	.	17	2	2	3	13	.	7	2	1	1	.
Corvus monedula	10	0	2	.	1	.	.	1	1	.	2	.	1	.	1	.	1
cf. *Corvus monedula*	26	0	1	3	4	1	6	.	1	2	5	.	1	2	.	.	.
Corvus corone/frugilegus	8	1	3	1	.	1	.	.	.	2	.	1
cf. *Corvus corone/frugilegus*	5	0	1	3	.	.	.	1
Corvus corax	2	0	1	1	.
Corvidae: Small	11	0	1	.	2	.	.	1	1	.	1	1	.	.	1	.	2	1	.	.	.
Corvidae: Medium	76	1	4	.	4	.	.	4	21	.	21	1	5	.	11	.	1	2	.	2	.
cf. Corvidae	4	0	1	1	1	.	1
Sturnus sp.	15	0	1	.	3	1	.	.	1	1	3	1	1	.	2	.	.	1	.	.	.
cf. *Sturnus* sp.	8	1	2	1	2	1	1	1	.
cf. *Petronia petronia*	1	0	1
cf. *Fringilla coelebs/montifringilla*	3	0	1	2
Carduelis cannabina/carduelis	1	0	1
cf. *Carduelis chloris*	1	0	1
Pyrrhula pyrrhula	1	0	.	.	.	1
Fringillidae	3	3	1	1	.	1
Emberiza sp.	1	0	1
Indeterminate non-passerine	5336	0	82	1	334	42	5	462	1230	28	990	140	160	73	1074	20	296	238	61	92	8
Indeterminate passerine	1036	0	26	1	137	9	0	97	141	15	208	24	20	26	138	17	62	54	13	47	1

* Thrushes *Turdus* sp. were identified based on humerus length. Groups represented are as follows: Group 2 *Turdus ?iliacus/philomelos*; Group 3 *T. ?iliacus/philomelos/merula*; Group 4 *T. ?philomelos/merula*; Group 8 *T. ?merula/torquatos/pilaris/viscivorus*; Group 9 *T. ?torquatos/pilaris/viscivorus*.

Species occurrence by stratigraphic unit, Vanguard Cave

Units & Contexts	Total NISP	Surface	Spits	49	50	51	52	53	53b	54	55	152*	152	153	154	153-54	151	157	158	157-58	170	Nsur	N500	N501	N501b	N501c	N501-2	N502	N503	N503a	N503b	N503c	N504	N505	N505-6
Total NISP	912	392	103	1	10	1	6	1	9	14	13	3	12	23	68	4	8	43	5	3	64	9	1	2	6	3	4	25	26	4	1	5	24	14	5
Total Non-ids	2026	757	80	0	10	4	6	9	1	36	28	8	115	95	369	21	36	191	26	0	164	0	2	3	5	0	4	6	6	5	0	12	12	12	3
Overall Total	2938	1149	183	1	20	5	12	10	10	50	41	11	127	118	437	25	44	234	31	3	228	9	3	5	11	3	8	31	32	9	1	17	36	26	8
Fulmarus glacialis	1														1																				
Pterodroma sp.	4	2									1																	1							
Puffinus ?mauretanicus	2	2																																	
Phalacrocorax aristotelis	6	3																			2	1													
Phalacrocorax cf. *aristotelis*	9	1																			8														
Phalacrocorax sp.	2	2																																	
Branta ?bernicla	2				2																														
cf. *Branta* sp.	2		1																									1							
Tadorna sp.	1						1																												
Clangula hyemalis	1		1																																
cf. *Clangula hyemalis*	2	1	1																																
cf. *Melanitta nigra*	1																	1																	
cf. *Melanitta* sp.	1																																	1	
Anatidae: Medium	3	1					1																										1		
Milvus milvus/migrans	1	1																																	
Haliaeetus albicilla	1																																		1
Neophron percnopterus	1		1																																
Gyps fulvus	19	12	5								1				1																				
cf. *Gyps fulvus*	4	3	1																																
Gyps/Aegypius	3	3																																	
Circus ?cyaneus	1							1																											
Accipiter gentilis	1		1																																
cf. *Accipiter gentilis*	1	1																																	
Accipiter nisus	6	2													1			1			1							1							
cf. *Buteo* sp.	1												1																						
Aquila/Haliaeetus	1	1																																	
Hieraeetus fasciatus	1																																		1
Accipitridae	7	3												1	1													1							
Falco naumanni	3														3																				
Falco cf. *naumanni*	3														1						1														
Falco tinnunculus	2	1													1																				
Falco cf. *tinnunculus*	2														1						1														
Falco cf. *subbuteo*	3																																	2	1
Falco sp.: Small	2												1		1																				
Alectoris sp.	62	26	5										1	2	13	1		4	1	1	2	1						2	3						
Coturnix coturnix	5	1													2			1										1							
Porzana ?porzana	1												1																						
cf. *Pluvialis* sp.	2		1												1																				
Pluvialis/Vanellus	2		2																																
Calidris cf. *canutus*	2	2																																	
Calidris alba/alpina	7	1	2										1		1			1															1		
cf. *Gallinago* sp.	1	1																																	
Scolopax rusticola	1														1																				
cf. *Limosa* sp.	1		1																																
Numenius phaeopus	1														1																				
cf. *Numenius phaeopus*	1		1																																
cf. *Tringa totanus*	3	2	1																																
Phalaropus ?fulicarius	2										1				1																				
cf. *Phalaropus ?fulicarius*	1														1																				
Scolopacidae: Small	8		3											1	4																				
Scolopacidae: Medium	6	1	3															1	1																
Larus ?ridibundus	3	1									1				1																				
Larus argentatus complex	9	7												1	1																				
cf. *Rissa tridactyla*	1														1																				
Laridae	4	1	1												1			1																	
Sternidae	2														2																				
Uria aalge	2																	1										1							
Alca torda	2														1			1																	
Fratercula arctica	9	6											1								1	1													
cf. *Fratercula arctica*	1																	1																	

Units & Contexts	Total NISP	Surface	Spits	49	50	51	52	53	53b	54	55	152*	152	153	154	153-54	151	157	158	157-58	170	Nsur	N500	N501	N501b	N501c	N501-2	N502	N503	N503a	N503b	N503c	N504	N505	N505-6
Columba cf. *livia*	3	2							1																										
Columba cf. *oenas*	2						1						1																						
Columba livia/oenas	180	86	33	1	2	1	3		3	7		1		4	12		1	9	1		5	2	1		1			1					5	1	
cf. *Columba livia/oenas*	3													1			1															1			
Columba palumbus	7	4	1										1	1																					
Streptopelia turtur	1												1																						
Otus scops	1	1																																	
cf. *Bubo bubo*	3	2																	1																
Athene noctua	13	4	4						1					1				1	1	1															
Strix aluco	5	1	1		2									1																					
Strigidae	1		1																																
Apus apus/pallidus	27	14	4									1	1		4						2						1								
Tachymarptis melba	140	11	1												4		4	4	1		37	2		2	4	3	3	12	21	4	1	5	10	9	2
Apodidae	1																					1													
Coracias garrulus	2													1			1																		
?Melanocorypha calandra	1													1																					
Calandrella sp.	1	1																																	
cf. *Lullula arborea*	1																	1																	
cf. *Alauda arvensis*	2	1																																	1
Alaudidae	2	2																																	
Hirundo ?rupestris	11	9	1															1																	
Hirundo ?rustica	5	1	2										1	1																					
Hirundo sp.	82	68									4			2	5		1	1			1														
Anthus sp.	3	1	2																																
Anthus ?pratensis	3	2	1																																
Anthus ?trivalis/spinoletta	1		1																																
Anthus ?petrosus/spinoletta	1	1																																	
Motacillidae	2		1																1																
Prunella modularis	2	2																																	
cf. *Erithacus rubecula*	3														2		1																		
Phoenicurus ?ochruros	1	1																																	
Monticola ?solitarius	1	1																																	
cf. *Monticola ?solitarius*	1	1																																	
Turdus sp.*	7	1	1									1	2				1																	1	
cf. *Turdus* sp.*	1																	1																	
Turdus sp. Group 2*	1								1																										
Turdus sp. Group 3*	1													1																					
Turdus sp. Group 4*	1																									1									
Turdus sp. Group 8*	3	3																																	
Turdus sp. Group 9*	3	2																1																	
Turdidae*	2	1													1																				
cf. *Sylvia ?melanocephala/curruca*	1														1																				
cf. Sylvinae	1												1																						
Lanius excubitor/minor	1	1																																	
Cyanopica cyanus	1																																1		
cf. *Pica pica*	1																											1							
Pyrrhocorax graculus	2	1	1																																
cf. *Pyrrhocorax graculus*	3	2	1																																
Pyrrhocorax pyrrhocorax	35	18	4		1		1		2	2	3			1														2					1		
cf. *Pyrrhocorax pyrrhocorax*	12	10			1					1																									
Corvus monedula	13	12															1																		
Corvus cf. *monedula*	5	4	1																																
Corvus corax	4		3																				1												
Corvidae: Small	5	4																																	
Corvidae: Medium	41	21	7		1				1	1	2				2		2		1									2					1		
Sturnus sp.	5	2			1					2																									
cf. *Sturnus* sp.	4	2														2																			
Petronia petronia	2	1																															1		
Fringilla coelebs/montifringilla	3	1									1																							1	
Coccothraustes coccothraustes	1	1																																	
Fringillidae	2	1																1																	
Indeterminate non-passerine	961	183	48	0	6	4	2	9	0	16	15	4	62	50	244	6	25	129	22	0	84	0	0	2	4	0	2	6	6	1	0	11	7	10	3
Indeterminate passerine	1065	574	32	0	4	0	4	0	1	20	13	4	53	45	125	15	11	62	4	0	80	0	2	1	1	0	2	0	0	4	0	1	5	2	0

* Thrushes *Turdus* sp. were identified based on humerus length. Groups represented are as follows: Group 2 *Turdus ?iliacus/philomelos*; Group 3 *T. ?iliacus/philomelos/merula*; Group 4 *T. ?philomelos/merula*; Group 8 *T. ?merula/torquatos/pilaris/viscivorus*; Group 9 *T. ?torquatos/pilaris/viscivorus*.